Medieval Art, Architecture and Archaeology at ROCHESTER

General Editor Sarah Brown

Medieval Art, Architecture and Archaeology at ROCHESTER

Edited by
Tim Ayers and Tim Tatton-Brown

The British Archaeological Association

Conference Transactions XXVIII

The publication of this volume has been assisted by generous grants from
The Friends of Rochester Cathedral
The Kent Archaeological Society
The Isabel Nini Stewart Trust
The William and Edith Oldham Charitable Trust
The Rochester Bridge Trust
The City of Rochester Society

Cover illustration: J. Harris, *History of Kent* (London 1719)

ISBN Hardback 1 904350 76 3 (978 1 904350 76 7)
Paperback 1 904350 77 1 (978 1 904350 77 4)

MANEY
publishing

PUBLISHED BY THE BRITISH ARCHAEOLOGICAL ASSOCIATION AND MANEY PUBLISHING
HUDSON ROAD, LEEDS LS9 7DL, UK

Contents

CONTENTS

Editors' Preface

ROCHESTER is one of the least visited of the medieval cathedrals in England. It is also one of the poorest and has always been in the shadow of Canterbury, just 26 miles down the road. It is to be hoped that the holding of the British Archaeological Association's annual conference in the city, in 2002, and this resulting publication, will contribute to revealing what a remarkable and historic place this is, richly rewarding the visitor.

The conference ran from Saturday 27 to Wednesday 31 July. It was based in the cathedral precincts and lectures took place in the main assembly hall of the King's School. Some 120 members and guests attended from all over the United Kingdom, and from abroad. There was a full programme of lectures, nineteen of which are published here. Apart from new work on the cathedral, castle and city of Rochester, we include also a new survey of the Archbishop of Canterbury's large parish church in Maidstone nearby.

The delegates enjoyed much hospitality in a busy schedule. On the first evening, the President's reception was held in the cathedral crypt, where we were welcomed by the Dean, the Very Revd Edward Shotter. On the following morning, a walking tour of the castle, cathedral priory and city walls was undertaken. That evening a drinks reception was held in the Bridge Chapel and Chamber, thanks to the kindness of Rochester Bridge Trust. The following day the whole afternoon was taken up with a visit to the cathedral, which ended with choral evensong. After this, the Mayor of Rochester was our host in the Guildhall, and delegates were given a private view of the very fine neighbouring Rochester Museum. On Tuesday, there was a whole-day excursion to the area around Rochester, starting with Maidstone parish church and the neighbouring college, Archbishop's Palace and stables (carriage museum). Members were also able to see the fine collections in Maidstone Museum. After lunch, we were privileged to be able to visit St Mary's Abbey, West Malling, where we were welcomed by the Mother Abbess and the nuns. We were lucky to have lectures there from Martin Biddle (on his excavations in 1961) and John Newman (on Frazer Honeywood's mid-18th-century house). We then visited Cobham church and college, and had tea in the medieval college hall. Our final visit was to Stone church, near the Dartford Bridge, where we were privileged to have a talk by Paul Crossley. On our return to Rochester, we had dinner in the magnificent Corn Exchange.

From 1880 to 1885 W. H. (later Sir William) St John Hope was a schoolmaster at the King's School, and his fine architectural history of the cathedral and priory buildings was published in 1900. His career is assessed here, and the papers in this volume have been able to build upon his pioneering work, and that of other late-19th-century scholars like George Payne and G. M. Livett. More recent work on the cathedral has been undertaken and brought together in Phillip McAleer's *Rochester Cathedral, 604–1540, An Architectural History* (1999). At the castle, R. Allen Brown's exemplary 1969 'blue guide' for the Ministry of Works has been the best study, while the famous bridge has been well served in the definitive *Traffic and Politics: The Construction and Management of Rochester Bridge, AD 43–1993* (ed. N. Yates and J. M. Gibson, 1994).

Once again the conference was very lucky to have as its organiser Anna Eavis, who worked hard on all aspects of the programme, but especially on finding suitable accommodation in Rochester. Remarkably, she was able to arrange her own wedding in Hexham, Northumberland, to John McNeill just over a week after the conference

ended! Anna was ably assisted at the conference by Robert Gwynne, whose secretarial work behind the scenes was invaluable for the smooth running of the event. We are also most grateful to the Dean and Chapter and the King's School for their help on the spot, and especially to the head verger Colin Tolhurst and his staff in the cathedral itself.

The editors would also like to thank Jill Atherton, Linda Fisher and Dr Joseph Spooner for their help in the preparation of this volume.

Tim Ayers
Tim Tatton-Brown

List of Abbreviations

Antiq. J.	*Antiquaries Journal*
Archaeol. J.	*Archaeological Journal*
BAA Trans.	*British Archaeological Association Conference Transactions*
B/E	The Buildings of England
EH	English Heritage
JBAA	*Journal of the British Archaeological Association*
Med. Archaeol.	*Medieval Archaeology*
PRO	Public Records Office
RCHME	Royal Commission on the Historical Monuments of England
VCH	Victoria History of the Counties of England

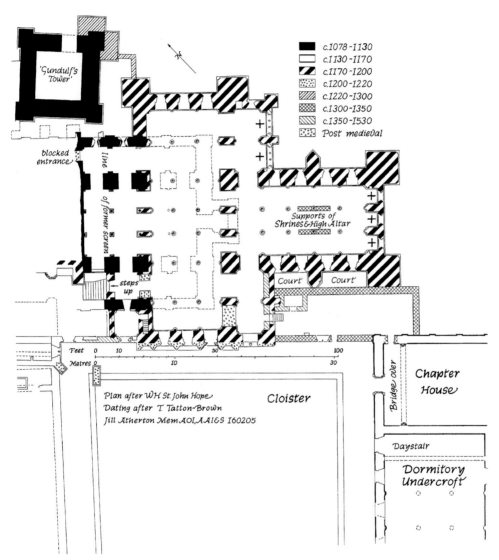

'Gundulf's Tower'

c.1078-1130
c.1130-1170
c.1170-1200
c.1200-1220
c.1220-1300
c.1300-1350
c.1350-1530
Post medieval

blocked entrance

line of former screen

Supports of Shrines & High Altar

steps up

Court Court

Feet 0 10 50 100
Metres 0 10 30

Plan after W.H St. John Hope
Dating after T. Tatton-Brown
Jill Atherton Mem AOI, AAIeS 160205

Cloister

Bridge over

Chapter House

Daystair

Dormitory Undercroft

Plan of Rochester Cathedral
© Jill Atherton

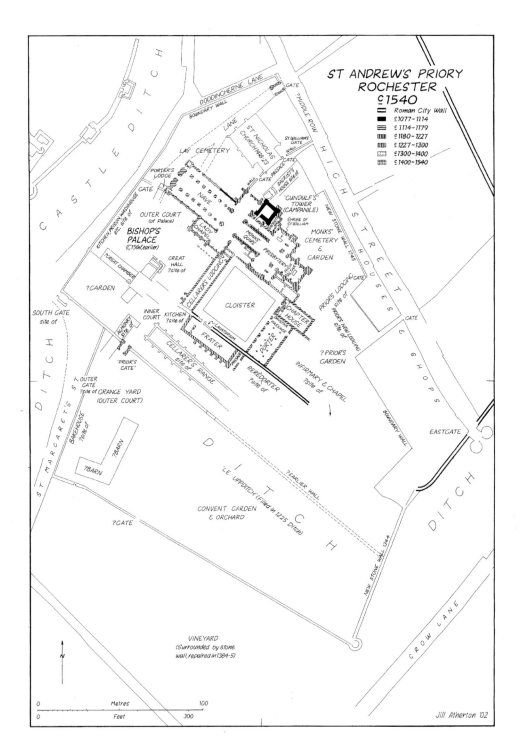

ST ANDREW'S PRIORY
ROCHESTER
c1540

Roman City Wall
c 1077~1114
c 1114~1179
c 1180~1227
c 1227~1300
c 1300~1400
c 1400~1540

DODDINGHERNE LANE
BOUNDARY WALL
?MIDDLE ROW
GATE
LANE
ST NICHOLAS CHURCH 1423
ST WILLIAM'S GATE
LAY CEMETERY
PORTER'S LODGE
GATE
PASSAGE
SACRIST'S HOUSE site of
NAVE
GATE
GUNDULF'S TOWER (CAMPANILE)
SHRINE OF ST WILLIAM
KITCHEN, PRISON, WASHHOUSE etc. site of
LADY CHAPEL
MONKS QUIRE
PRESBYTERY
MONKS' CEMETERY & GARDEN
OUTER COURT (of Palace)
BISHOP'S PALACE (C 15th & earlier)
?GREAT CHAMBER
GREAT HALL ?site of
CELLARER'S LODGING
PRIOR'S LODGING site of
PRIOR'S NEW LODGING site of
GATE
NEW STONE WALL 1345
HIGH STREET
SHOPS
GATE
?GARDEN
CLOISTER
INNER COURT
KITCHEN ?site of
CHAPTER HOUSE
PASSAGE
SOUTH GATE site of
ALMONRY site of
'PRIOR'S GATE'
FRATER
LAVATORIUM
DORTER
PASSAGE
?PRIOR'S GARDEN
?OUTER GATE
?site of GRANGE YARD (OUTER COURT)
CELLARER'S RANGE site of
RERE-DORTER ?site of
INFIRMARY & CHAPEL ?site of
ST MARGARET'S
DITCH
BAKEHOUSE ?site of
?BARN
?BARN
EASTGATE
BOUNDARY WALL
?EARLIER WALL
?GATE
'LE UPPDITCH' (filled in 1225 Ditch)
CONVENT GARDEN & ORCHARD
D I T C H
NEW STONE WALL 1344
DITCH
CROW LANE

VINEYARD
(Surrounded by stone wall, repaired in 1384-5)

N

0 Metres 100
0 Feet 300

Jill Atherton '02

xii

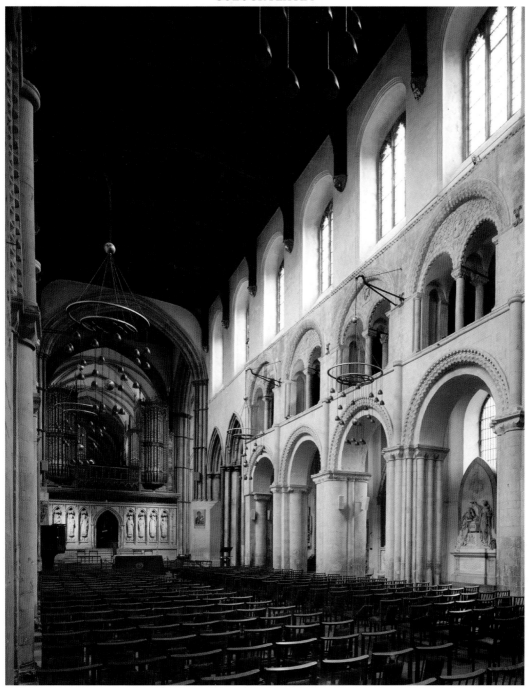

Rochester Cathedral: view of the nave looking east

© Dr John Crook

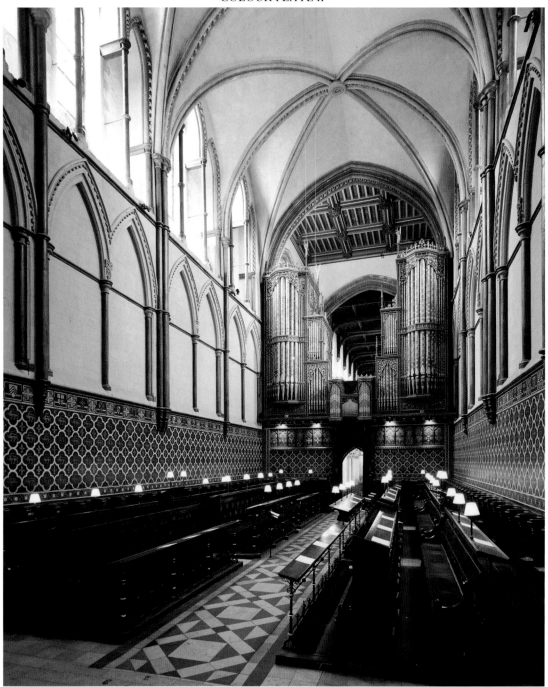

Rochester Cathedral: view of choir looking west
© Dr John Crook

COLOUR PLATE III

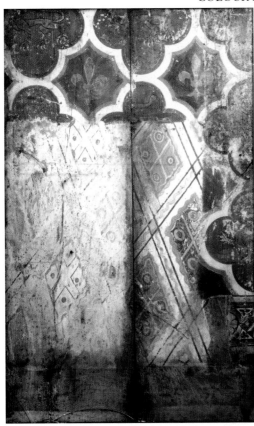

A. Rochester Cathedral: choir stalls, detail of the salvaged oak panels from the return stalls, with one painting campaign overlaid by another

© Dr John Crook

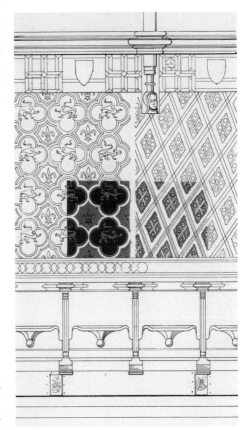

B. Rochester Cathedral: sketch elevation of the choir-stalls showing the different schemes of decoration on the back wall

© Paul Woodfield

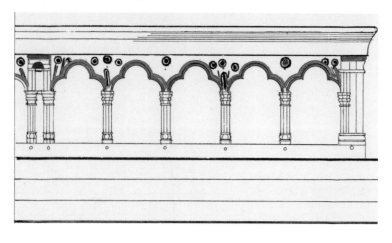

A–C. Rochester
Cathedral: A, B, low
arcaded railing in
front of the lateral
choir-stalls; C,
montage of the
painted spandrels on
the fronts

© Dr John Crook

Roman Rochester in its Wider Context

MARK HASSALL

Rochester, Durobrivae, *was an important river crossing and road station on Lower Watling Street, the great Roman road that linked Richborough* (Rutupiae), *the port of entry to the province in Roman times, with London* (Londinium), *the provincial capital. This short note examines first the possible role played by Rochester and the crossing of the Medway in the initial stages of the Roman invasion of* A.D. 43. *Attention then will be directed to the bridge that will have been erected soon after, and in particular to the theory of Professor Nicholas Brooks on the manner in which maintenance of the bridge may have been financed. Thirdly, something will be said about the role of Rochester as a way-station for the imperial posting system* (cursus publicus). *Finally, we shall look at the significance of the provision of defensive walls and what this may imply for the changed role of the place in the later 3rd and 4th centuries.*

THE 'BATTLE OF THE MEDWAY', A.D. 43

IN 1998, on the initiative of Nigel Nicolson, and in accordance with the traditional interpretation of events as recorded by the Roman historian Dio, a boulder bearing an inscription to commemorate the 'Battle of the Medway' was placed in a field near Snodland Church (Kent), half a dozen miles upstream from Rochester, on the east bank of the river: the Roman road from Richborough to London (passing through Snodland) is thought to have marked the line of the Roman advance in A.D. 43. Rochester — or Snodland at least — had entered history. Yet did the battle actually take place on the Medway at all? An extended discussion of this question (which in the present writer's opinion cannot be answered with certainty), would be out of place here. Basically there are three interpretations of Dio's text, each placing the events described in a different part of southern Britain.

1. *Kent (the 'traditional view')*

ACCORDING to this view, the Romans crossed the Channel by the shortest and safest route (from Boulogne to Richborough, Kent). Aulus Plautius, the Roman commander, landed at Richborough, where remains of the invasion base survive; fought the sons of Cunobelin in Kent; concluded a treaty with the Dobunni of Gloucestershire; forced the crossing of the Medway; and advanced to the Thames. Here he was joined by Claudius, who had crossed the Channel from Boulogne and then led the march to Colchester (*Camulodunum*).[1]

2. *Sussex*

ACCORDING to this view, the avowed intention of Claudius to reinstate the British dynast Verica, who ruled from Chichester (*Noviomagus*), was carried out so that a base

could be established in 'friendly' territory. The crossing may have been made from the mouth of the Seine and landing at Chichester harbour or nearby. Early Roman military occupation at Fishbourne (West Sussex) and Chichester goes back to this period. Engagements followed in Sussex/Hampshire with the sons of Cunobelin, Togodumnus and Caratacus, who minted coins at Silchester (*Calleva*), Hampshire. A treaty was concluded with the Dobunni (of Gloucestershire). The army then either struck across the Weald along the line later taken by Stane Street, or advanced northwards to Silchester. The first river engagement (if it had not already happened on the Arun) may have taken place on a minor river between Silchester and the Thames (Wey, Mole or Wandle). Having reached the Thames, the army was joined by Claudius and advanced on Colchester.[2]

3. *Kent and Sussex*

ERNEST BLACK has suggested that one part of the army under Aulus Plautius sailed from the mouth of the Seine with Verica, and landed in Sussex. Plautius then engaged the sons of Cunobelin and concluded a treaty with the Dobunni, before advancing along the line later taken by Stane Street for a rendezvous with the other part of the army under Sentius Saturninus. This part had crossed from Boulogne to Richborough and advanced up the line of Lower Watling Street. For Black, there may even have been only one contested river crossing, and he makes the interesting suggestion that Dio's accounts of two battles, at an unnamed river ('the Medway') and at the Thames, may derive from two different sources that in fact described the same battle.[3]

Comment

THE evidence of archaeology is very unlikely to be helpful in deciding, for example, the primacy of Roman military activity at Richborough or Fishbourne — even dendrochronology may be of no help, since it is quite possible that both places were founded in A.D. 43. There are some positive indicators, such as the location of Caratacus at Silchester and of the Dobunni in Gloucestershire, and perhaps the (overwhelming?) advantages of a short crossing from Boulogne to Richborough. Other arguments, for example that 'Colchester was the strategic objective and that once this were taken the restoration of Verica would be an easy matter', or 'no sane Roman commander would divide his forces', are subjective and carry less weight.

ROCHESTER BRIDGE

IT is generally agreed that the early medieval bridge, with its timber-planked superstructure, utilised the masonry piers of a Roman predecessor. In the latest discussion of the bridge, Colin Flight draws attention to the alignment of Strood High Street on the left (western) bank, which heads straight for the bridge. There is some evidence to suggest that the Roman road that underlay Strood High Street was not constructed until the 4th century, which in turn would suggest that the bridge itself was of that date. If this reasoning is correct, there should, of course, have been an earlier Roman bridge. Flight argues that the Roman road underlying Rochester High Street was probably aligned on this, and that it crossed the river at an angle to its successor. Its abutment on the Rochester side will have been slightly north of that of its successor, while its abutment on the Strood side will have been considerably further downstream.

To connect the new bridge with the existing Roman road through Rochester it will have been necessary to construct a new gate through the existing town wall. Perhaps the opportunity was taken to rebuild the whole of the defences on the riverside frontage, in the same way (to compare small things with great) that the riverside defences of the legionary fortress at York were remodelled at a similar period. In its construction the earlier Roman bridge — if indeed there were two bridges — will have been similar to the later one. In Flight's reconstruction, it consisted of abutments to east and west, with eight piers between them, the nine openings bridged by a timber framework and boarded over to form a carriageway.[4]

The original bridge will have been built by and for the military, just as the famous stone and timber bridge over the Danube was engineered by Apollodorus of Damascus for the Emperor Trajan in the early 2nd century. Yet who carried out and financed the periodic repairs on this or its putative successor? In the Middle Ages, this burden, and in particular the provision of timber, fell on certain designated estates in the lathe of Aylesford. Nicholas Brooks has made the exciting suggestion that the system in fact goes back to late Roman times, and that the boundaries of the lathe correspond to those of the *civitas Durobrivensis*.[5] Such a hypothesis cannot be proven, for the evidence simply not longer exists — though, ironically, two writing tablets from Roman London give us tantalising glimpses of what form that evidence may once have taken. The first is part of a letter, apparently written from Rochester (*Durobrivae*), referring to a boy who has absconded with some money;[6] the second is the record of a sale of a wood somewhere in Kent.[7] Epigraphic evidence from both inside and outside the province shows how civilians undertook major works of building and repair, including at Alcantara near Carceres in Spain.

The name Alcantara simply derives from the Arabic for bridge. The roadway across this structure passes under a triumphal arch, which carries a dedication to the Emperor Trajan dated to the year A.D. 106. A second text lists those 'municipalities of the Province of Lusitania which, after contributions had been gathered in, finished the building of the bridge' ('Municipia Provinciae Lusitaniae, stipe conlata, quae opus pontis perfecerunt'); there follow the names of eleven local communities.[8] There is nothing quite so relevant from Britain, but two series of inscriptions show native communities undertaking the maintenance of public works. The first are on milestones: from the 3rd century, some of these bear the names of the *civitates* that undertook the work.[9] The second are the building inscriptions from Hadrian's Wall, which record repair work undertaken by some of the southern *civitates*, perhaps during the Theodosian restoration of the late 360s.[10] The evidence cited here certainly shows local communities involved in public works — including bridge construction. It does not show how this work may have been allocated to subsections of those communities, as it was, for example, to the cohorts and centuries of the legions who originally built Hadrian's Wall. However, such subdivisions, whether villages (*vici*) or country districts (*pagi*), or indeed the villa estates themselves, existed, and there is therefore nothing inherently improbable in the suggestion that those in the *civitas Durobrivensis* had specified obligations in maintaining Rochester bridge.

ROCHESTER AND THE *CURSUS PUBLICUS*

FROM the time of the first emperor, Augustus, a system of posting stations (*mutationes*), where mounts could be exchanged, and inns (*mansiones*), was established along major routes in the empire. The facilities available at these establishments were

provided free to those who were on official business and could produce the necessary warrant (*evectio*) issued by the provincial governor. Our knowledge of the practical workings of the *cursus publicus*, as this posting system was known, is due partly to the law codes with numerous imperial rescripts issued in an attempt to prevent abuse of the system, and partly to a document known as the Antonine Itinerary (after the Emperor Antoninus Augustus, usually known by his nickname Caracalla), which seems to have been compiled from the 'office' copies in the provincial record offices of the routes taken by those to whom *evectiones* were issued. Each route commences with a heading, which states its start and termination, and then lists intervening *mutationes* and *mansiones* by name, with the distance between them. For Britain fifteen routes are recorded; three of these pass through or begin at London to head for the Channel ports, and unsurprisingly include Rochester.[11] At the *mutationes* only the most basic facilities will have been provided — a corral and stabling for the horses and some sort of tavern perhaps — but Rochester will certainly have boasted an official rest house or *mansio*, with suites of rooms grouped around a central colonnaded courtyard and an attached bath house, such as are known at Silchester and Wanborough (Wiltshire). But so little is known of the interior of Roman Rochester that not even the approximate location of such an establishment — let alone its plan — is known.

ROCHESTER IN THE FOURTH CENTURY

IN the 4th-century defensive scheme for the south-east of Britain, Rochester, as a walled city on the banks of a navigable river crossed by a bridge that carried the strategically vital road link between London and the Channel ports, will have been a place of obvious military significance. This may have invited the remodelling of the riverside defences at this period (if indeed it took place). *Durobrivae* is not listed as a garrison post under the command of the Count of the Saxon Shore (*Comes Litoris Saxonici*), but, like Canterbury, linked by road to four of the Shore forts (Reculver, Richborough, Dover and Lympne, all in Kent), could well have been a base for a detachment of the field army. Nine units of the field army are attested in Britain. They were under the command of the Count of Britain (*Comes Britanniae*), and unlike the low-grade frontier units (*limitanei*) commanded by his colleagues, the Count of the Saxon Shore and the Duke of the Britains (*Dux Britanniarum*), are not accorded fixed bases in the relevant section of the *Notitia Dignitatum*, a late Roman official handbook dealing with high-ranking military and civil officials.[12] It is usually assumed that the field-army troops were based in towns, and the semi-permanent quarters of a detachment of such troops may have been excavated at Catterick.[13] No buildings are known at Rochester, but as with the *mansio*, it is highly likely that they once existed.

NOTES

1. Recently restated in response to alternative explanations by S. Frere and M. Fulford in 'The Roman Invasion of AD 43', *Britannia*, 32 (2001), 91–104.

2. In its 'modern' form, the theory of a Sussex landing originated with John Hind's article 'The invasion of Britain in AD 43 — an alternative strategy for Aulus Plautius', *Britannia*, 20 (1989), 1–21. More recent variations of it have been proposed by David Bird in 'The Claudian Invasion Campaign Reconsidered', *Oxford Journal of Archaeology*, 19 (2000), 91–104, and 'The events of AD 43: Further Reflections', *Britannia*, 33 (2002), 257–63. See also John Manley, *AD 43: The Roman Invasion of Britain: A Reassessment* (Stroud 2002), where arguments are given for both Kent and Sussex.

3. Ernest Black, 'Sentius Saturninus and the Roman invasion of Britain', *Britannia*, 31 (2000), 1–10; 'How Many Rivers to Cross?', *Britannia*, 29 (1998), 306–07; cf. 'The First Century Historians of Roman Britain', *Oxford Journal of Archaeology*, 20 (2001), 415–28.

4. Colin Flight, *The Earliest Recorded Bridge at Rochester*, BAR British Series, cclii (Oxford 1997), esp. viii fig. 1 (map showing the position of the bridge and the approach roads); 44 fig. 10 (reconstruction of the Roman bridge); and 48–49 (Conclusion). For two recent studies of Roman bridges, see Colin O'Connor, *Roman Bridges* (Cambridge 1993), and P. T. Bidwell and N. Holbrook, *Hadrian's Wall Bridges*, English Heritage Archaeological Report, 9 (London 1989).

5. N. P. Brooks, 'Rochester Bridge AD 43–1381', in *Traffic and Politics: The Construction and Management of Rochester Bridge, AD 43–1993*, ed. W. N. Yates and J. Gibson, Rochester Bridge Trust and The Boydell Press (Woodbridge 1994), 1–40, esp. 34; see further N. P. Brooks, *Communities and Warfare, 700–1400* (London 2000), 219–65 (esp. 258–65).

6. E. G. Turner and O. Skutsch, 'A Late Roman Writing-Tablet from London', *Journal of Roman Studies*, 50 (1960), 108–11.

7. R. S. O. Tomlin, 'A Five-acre Wood in Roman Kent', in J. Bird, J. M. Hassall and H. Sheldon ed., *Interpreting Roman London: A Collection of Essays in Honour of Hugh Chapman*, Oxbow Books (Oxford 1996), 209–15.

8. H. Dessau ed., *Inscriptiones Latinae Selectae*, nos 287 and 287(a).

9. Milestones: R. G. Collingwood and R. P. Wright ed., *The Roman Inscriptions of Britain* (Oxford 1965) (1995) (hereafter cited as *RIB* and by item rather than page number): *RIB* 2222 *R(es) P(ublica) Bel(garum)* dates 238–44; *RIB* 2240 *R(es) P(ublica) L(indensis)* dates 253–59; *RIB* 2250 *R(es) P(ublica) C(ivitatis) D(obunnorum)* dates 283–84; and *Journal of Roman Studies*, 55 (1965), 224 *C(ivitas) Car(vetiorum)* dates 258–68.

10. Civilian building records from Hadrian's Wall: *RIB* 1843–44 *Civitas Dumnon(iorum)*; *RIB* 1672–73 *Civitas Durotrag(um) Lindinie(n)sis*; *RIB* 1962 *Civitas Catuvellaunorum* (also apparently mentioning an individual).

11. A. L. F. Rivet and Colin Smith, *The Place Names of Roman Britain* (London 1979), ch. 4, 'Itineraries: the Peutinger Table and the Antonine Itinerary', esp. 148–84, routes 2, 3 and 4 of the Antonine Itinerary; see also 346–48, 'Durobrivae (1)'.

12. On the *Notitia* and Britain in general, see Mark Hassall, 'Britain and the Notitia Dignitatum', in R. Goodburn and P. Bartholomew ed., *Aspects of the Notitia Dignitatum*, BAR Supplementary Series, XV (Oxford 1976), 103–17.

13. The buildings were excavated in Insula VII and probably postdate A.D. 380; see John Wacher, 'Yorkshire Towns in the 4th century', in R. M. Butler ed., *Soldier and Civilian in Roman Yorkshire*, Leicester University Press (Leicester 1971), 165–77 with fig. 25. It is now know that a fort also existed at Catterick in the 4th century. This, however, will have housed a regular limitanean unit, and does not necessarily invalidate Wacher's interpretation of the buildings in Insula VII.

Rochester, A.D. 400–1066

NICHOLAS BROOKS

Rochester was a small town whose Roman walls, Anglo-Saxon bishopric and strategic position at the Medway crossing gave it an importance beyond its size or population. The preservation of ten royal charters claiming to grant properties in the city or its suburbs enables the topography and growth of the town to be elucidated more fully from written sources than any other early medieval English town's, particularly between the years 604 and 868. The authority and interpretation of this evidence is assessed. It is possible to show how the bishop and cathedral community's control of the area within the Roman walls was steadily consolidated until lay lords were restricted to the suburbs. The impact of Viking attacks and of Scandinavian settlers on the town is assessed, and the nature of the pre-Conquest bridge and the antiquity of the arrangements for its maintenance by estates in the city's hinterland are discussed.

ROCHESTER's significance as an urban centre in the early Middle Ages owes almost everything to geography and to its Roman inheritance (Fig. 1).[1] Rochester is situated at the point where the river Medway breaks through the North Downs, on the inside (eastern) bank of an acute-angled meander of the estuary, within the river's gravel terrace and alluvial flood plain. This location proved to be the ideal Medway bridging point when the Roman road from Dover to London was constructed, in the 1st century A.D. We may presume that an early staging post (*mansio*) for the imperial post system (*cursus publicus*) was placed at the bridgehead. By the early 3rd century, the settlement had developed sufficiently to need a defensive circuit of stone walls. The Celtic or 'Brittonic' name for this settlement, *Durobrivae*, meaning 'the fortress by the bridges', cannot have been coined until this fortification had been constructed.[2] The name identifies the two dominant features of the late Roman settlement — the city walls and the great bridge by which the Roman Watling Street crossed the Medway estuary. As we shall see, both engineering achievements were to be important throughout the six Anglo-Saxon centuries from *c.* 450 to the Norman Conquest, though that does not imply that they were always in sound repair throughout that period. The area of this walled settlement is, however, tiny. It is just 23.5 acres or 9.5 hectares, that is less than a fifth of the 130 acres (52.6 hectares) of the walled area of Roman Canterbury.

1066 is a convenient terminal limit of this study, because Domesday Book provides information about England *tempore regis Eadwardi* (*TRE*), that is on the day of the death of King Edward the Confessor, 6 February 1066. Regrettably, however, the Domesday entry about Rochester is extremely brief.[3] It comprises just two lines of print at the end of an extensive section on other Kentish boroughs. However, we also learn that several manors in central Kent had altogether some 110 dependent burgesses, houses or 'haws' (urban properties), either in the city or in its suburbs.[4] In addition, there is an even briefer reference, hidden within the account of the royal manor of Aylesford, to arrangements to compensate the Bishop of Rochester for the loss he had

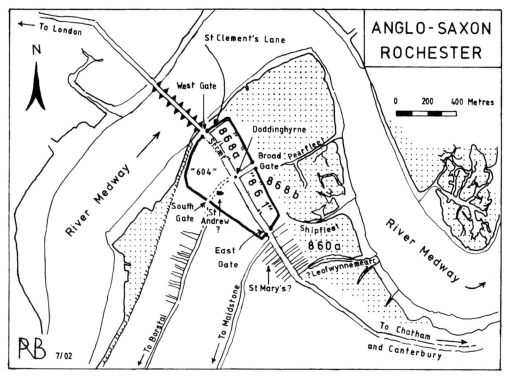

FIG. 1. Anglo-Saxon Rochester, showing the alluvial marsh to the north and south-west of the town, the Roman walls, the Anglo-Saxon bridge, and the main topographical features identifiable in the charters

incurred through the construction of the royal castle, seemingly at Rochester. He had been recompensed with land of that manor that lay close to the city, worth 17s. 4d. per annum.[5] A hint that conflicts of interest between king and the cathedral lie behind the brief Domesday reference to the castle may be found in a forged document purporting to tell us about early Anglo-Saxon Rochester.[6]

Despite its brevity, however, the Domesday entry can reveal something about the city in the years around the Conquest. Long before William the Conqueror's acquisition of the site for the castle in the south-western quarter of the town, the bishop, as we shall see, would seem to have become the dominant lord within the walls of the city. This may explain why Domesday records that 'the bishop' (i.e., Gundulf) rather than the sheriff of Kent, 'received' the town. That grant gave the bishop the king's share ($\frac{2}{3}$) of the fixed annual sum for customary rights and rents in the city, that is, the payment that elsewhere in Domesday Book is called the 'farm of the borough'.[7] The Rochester farm had been 100s. (that is £5) in 1066 and was still the same amount at the time when 'the bishop had received' it, perhaps at his consecration in 1077. But it had risen fourfold to £20 by 1086. Interestingly, however, it was not only the bishop who benefited from the increased farm, for Domesday records that the actual render was £40. This sum seems to have been the amount collected by the official who farmed the borough, presumably the city reeve, thus allowing the bishop to receive his £20 and the

7

reeve to retain the same amount himself. In other words, the Norman bishop had quadrupled his income from the city, while the burden of rent actually exacted from the burgesses of Rochester may have increased eightfold, from £5 to £40. We can only speculate to what extent in the twenty years after 1066 an influx of artisans and craftsmen engaged on new buildings, such as the Norman castle and cathedral, may have mitigated the burden of increased rents upon the inhabitants of the city. In comparison with other Kentish towns in 1066, the small city of Rochester was less than half as profitable to its lord as Dover was to the crown, and was 'worth' only a tenth of the city of Canterbury.[8] Despite its status as an episcopal see, Anglo-Saxon Rochester therefore seems (like its Romano-British predecessor) to have possessed only a modest position among the towns of Kent, and indeed those of the whole of southern England. However, its pre-Conquest burgesses, unlike their successors under Norman rule, seem to have been but lightly burdened.

The dominance of the late Anglo-Saxon walled city by its bishops was unusual in England for a see of Roman origin. There is an interesting contrast with Worcester, a Roman walled settlement that is comparably tiny though of less strategic significance. At Worcester the division between the king's and the bishop's halves of the town was a feature of the topography from the 9th century, but episcopal control declined throughout the Middle Ages.[9] It may be that a comparable division of lordship had once been the pattern at Rochester too. We are fortunate that several charters by which Kentish and Anglo-Saxon rulers granted away properties in and around the city enable us to trace the growth of the bishop's lordship within Rochester at the expense of that of the crown. Thanks to the care taken in *c.* 1120 to record all the see's title deeds or charters in a great register or cartulary, known to historians as the *Textus Roffensis*, we are indeed better informed about early properties in Rochester than about almost any other English city.[10] We can therefore hope to trace the extension of the bishop's control within the city from the foundation of the see by King Æthelberht I of Kent in 604. These charters provide a rich store of topographical information about Rochester between the 7th and 9th centuries to supplement the meagre material evidence from the archaeological record.[11]

THE FOUNDATION OF THE CATHEDRAL

OUR best authority for the establishment of the see is Bede's *Ecclesiastical History*, which tells us that in 604 'Augustine consecrated Justus [as bishop] also in Kent, in the city of *Dorubreuis* which the English call *Hrofæsceastræ*, after one of their former leaders whose name was Hrof. . . . and there King Æthelberht built 'the church of the apostle St Andrew'.[12] Bede goes on to describe the gifts of lands and possessions that the king made to Justus and to his church for the support of the community there. Unfortunately at Rochester (as at Canterbury and London) Bede gives us no specific details of these endowments. A 12th-century addition to the *Textus Roffensis*, however, has no qualms about filling this lacuna. It claims that in A.D. 600, the king had founded the church of St Andrew and given it a property known as 'Priestfield', plus the whole area from the Medway to the east gate of the city in the southern half, and other extra-mural lands to the north of the city.[13] In later times, Priestfield comprised an area of arable land immediately to the south of the city walls, so called because it had belonged to the Rochester community before it became a Benedictine chapter. The intra-mural property appears to have comprised everything to the south of the main street (High Street) of the city. There is nothing particularly implausible in this 12th-century

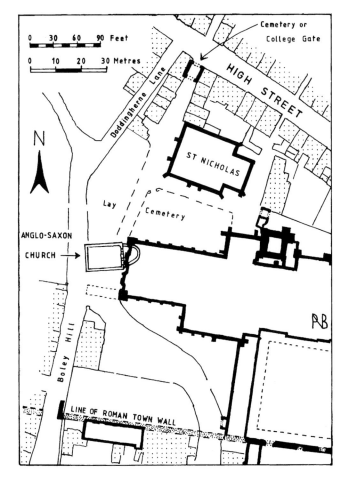

FIG. 2. The early Anglo-Saxon church, showing its relationship to the Roman walls, the medieval cathedral and priory buildings, and to the mid-19th-century housing and street layout

After W. H. St John Hope

conjecture about the foundation endowment of the church. But it is uncertain whether the cartularist had any evidence — documentary or from the community's memory — for his assertion, let alone for the date that he assigns to this founding gift, which is some four years too early according to Bede's information. With one very uncertain exception, which we shall examine, we do not have any later charter evidence for any grants of land within the southern half of the city. By the mid-8th century, the period of the first authentic Rochester charters, it would seem that this half of the city already belonged to the cathedral. Moreover, in 1889 Canon Livett excavated the east end and apse of what seems to be an early 'Kentish' church under the north-west end of the Norman cathedral (Fig. 2).[14] If this was indeed the original Anglo-Saxon cathedral church of St Andrew, it is instructive that it lies in the middle of the southern half of the town. Indeed, it seems to lie athwart the direct route from the central crossroads in Rochester to the Roman and medieval south gate and to have caused a slight diversion in the road to the line of the present Boley Hill. Constructing the early cathedral on that spot might only have been possible if the church had indeed received the whole area south of the High Street for its foundation, as the annals in the *Textus Roffensis* assert.

A different version of the church's foundation, however, seems to be represented by a charter purporting to be of King Æthelberht I of Kent and informing his son, Eadbald, in 604, that he has granted to the church of St Andrew a little bit of his property ('aliquantulum telluris mei').[15] Charters attributed to King Æthelberht have had a very poor reputation ever since Wilhelm Levison showed in 1948 that those from St Augustine's Canterbury, which Margaret Deanesley had used to depict a supposedly Frankish-style court in Æthelberht's Kent, were in fact forgeries of the late 11th century.[16] Levison was, however, much more cautious about this Rochester document than about the St Augustine's charters attributed to Kent's first Christian king. It bears the date 4 Kalends of May and the 7th indiction (that is, 28 April 604), which is exactly the formulation that we should hope to find in an early-7th-century charter. It does not use incarnation (A.D.) dating, which only became normal in the 8th century, but which would be expected in any later forgery. Moreover, most of this charter's Latin formulas can be paralleled in Italian private deeds of the late 6th century, especially in papal documents. This applies to the invocation ('Regnante in perpetuum domino nostro Iesu Cristo saluatore'), the grant directly to the saint, addressed in the second person singular, and his church ('tibi Sancte Andrea tuęque ecclesia ... ubi pręesse uidetur Iustus episcopus'), and to the blessing and anathema. If the charter were forged, one would expect Archbishop Augustine of Canterbury to attest, but the only witness listed is rather Bishop Laurence, whom Augustine before his death consecrated as his successor as metropolitan at some unknown date between 604 and 610. The attestation of Bishop Laurence is surely to the charter's credit. Equally curious is the initial address from King Æthelberht to his son, Eadbald, which could be explicable in terms of his holding some subordinate royal authority (in West Kent?) under his father.[17] The hybrid Latin spelling of the place-name ('in ciuitate Hrofibreui'), with its prefix derived from the English name but its suffix from the Celtic, is another odd feature, but again not one suggesting that the document should be discounted as a late forgery.

Entirely unacceptable in this charter, however, is the sequential description of the boundaries in Old English, a feature not found in Kentish charters before the later 9th century and here unlikely to have been composed before the late 11th century:

From the south gate, west along the wall as far as the north lane to the street; and so east from the street as far as *Doddinghyrne* ['Dodda's corner or horn'] opposite the broad gates.[18]

'Doddinghyrne' can be located from its appearance in 9th-century charters at the crossroads in the centre of the city and 'Doddingherne Lane' leading to it is recorded from the 15th century.[19] These bounds therefore describe the south-western quarter of the city (Fig. 1, marked '604'). In its present form the charter therefore asserts that the exact area which King William I was to take from the cathedral after 1066 in order to build Rochester Castle had been the original endowment of the see by King Æthelberht. We may surely suspect that the cathedral needed a document that gave them specific title to this land in order that they could secure compensation for its loss. As it stands, the charter of Æthelberht should therefore be regarded as a forgery, and it certainly bears comparison with other post-Conquest Rochester forgeries, which sought to adapt genuine documents to new purposes rather than to concoct wholly new texts.[20] But it seems likely that the forger had before him a grant to the church of Rochester of the year 604 — an older document than any that has survived — and that he may only have inserted a boundary clause in the language of his own day into it. Whether his model was originally a grant of the whole southern half of the town or was a grant of property elsewhere in Kent, we cannot tell.

CHARTERS GRANTING PROPERTY IN ROCHESTER

WE have no other charters from Rochester until the fourth decade of the 8th century, and none conveying land within the city until the 760s. Then we find two charters in the names of the last independent kings of Kent, Sigered and Ecgberht II, granting properties in the northern half of the city to Bishop Eardwulf of Rochester in the years 762 and 765 respectively. The first plot is said to be bounded on the east and west by other properties already belonging to the bishop. Evidently the church was consolidating holdings within the northern half of the city. The first grant is said to be of 1.5 *iugera*, the second to be a small plot (*uiculum*) of two *iugera*. Scholars have hesitated over what area the urban *iugerum* ('yoke') was intended to represent, but presumably already in the 8th century (as certainly later) it was an acre.[21] Bearing in mind that the whole northern half of this tiny city comprised no more than 10–11 acres, such grants of 1.5- or 2-acre plots were clearly of importance for the town's topography.

We may note, too, that within the city the cathedral and its domestic buildings (the *monasterium* or 'minster') were already enclosed by the year 762, for there was a 'north gate' seemingly giving access onto the High Street.[22] The gate must have lain close to (or very possibly actually on) the site of the present late medieval 'College' or 'Cemetery Gate' (Fig. 2), which controlled access to the cathedral from the town. This hints at a remarkable continuity in Rochester's urban topography. We should note, too, that the two-acre plot granted by King Ecgberht II in 765 had its southern boundary along the High Street (*platea*).[23] It is instructive that this charter was confirmed not only by King Heahberht (Ecgberht's co-ruler in Kent) and his retainers, but also 'at the request of Bishop Eardwulf' by King Offa of the Mercians. Offa had established his power in Kent in 764, the previous year, and the bishop had evidently supposed it wise to travel all the way to Offa's court at the monastery of Medeshamstede (Peterborough) in order to secure this confirmation. Just why he thought that necessary becomes evident from the charter that we shall consider next.

We have only a single charter granting property within Rochester that was issued in the name of the Mercian king, Offa.[24] It is dated to 789, is in favour of Bishop Wærmund, and seems to be a regranting of the property of 1.5 *iugera* that King Sigered of Kent had previously granted to Eardwulf. Offa's charter makes it clearer than Sigered's that the property lay in the north-east quarter of the town. But the identity of the acreage and indeed of much of the charter's wording, including the specific detail that the bishop already possessed the plots on both the east and west sides, establishes that the same property was involved in both this and the 762 charter. This grant seems to have completed a block of three large plots that comprised the town's north-eastern quarter. We know from Canterbury evidence that Offa took a very dim view of recent grants by the native Kentish rulers of land that he chose to regard as being in his own gift.[25] It seems likely that Offa had confiscated this Rochester property, perhaps in the course of his 764 campaign in Kent, and that he restored it to the cathedral only after a twenty-five-year interval, at a time when he was once more in secure control of Kent. Whoever drafted this charter (presumably a Rochester scribe) thought it politic not to mention that the property had been removed from the cathedral's possession, preferring to present it as a new grant by the Mercian king. Nor did he indicate what sweeteners the Mercian king may have required in order to grant the property to Bishop Wærmund. But at least the fortunes of Sigered's grant of 762 may help us to understand why Bishop Eardwulf had been so concerned in 765 to secure Offa's agreement to Ecgberht II's grant of two acres.

There is then a gap before we have a group of three charters in the 840s and 850s, in each of which the West Saxon ruler, King Æthelwulf, granted properties at Rochester.[26] In contrast to the earlier charters, these are not grants to the church of Rochester, but rather to important laymen. The earliest is a charter to the reeve (*praefectus*) Ceolmund (perhaps either the city-reeve of Rochester or an agent of the king in the Medway valley) in 842. The next is to Ealhhere, the ealdorman of Kent in 850, and the third to a king's thegn, Dunn, in 855. The last formed part of King Æthelwulf's 'tithing' of his property in that year, which he carried out just before he set out for Rome with his youngest son. This grant may therefore have been intended ultimately for a church. All three charters convey extra-mural properties, but we nonetheless meet in each an explicitly urban terminology. The plots are termed *uiculum* or *uilla* in Latin, *haga* ('haw') in Old English (i.e., burgage-plots); one is measured as half an *ager* in Latin, a 'half-acre' in English. The two earlier charters convey plots in the eastern suburb outside the east gate along the road to Canterbury, while the third grants a *haga* and ten adjoining acres to the south of the city, presumably along the Borstal road (Fig. 1). Included in the grant of 850 was a church of St Mary in the suburb outside the east gate and on the south side (of the street).[27] This church did not become a parish church in the 12th or later centuries and may not have survived the Viking siege of Rochester in 885. However, these charters are evidence that by the mid-9th century, the city of Rochester already had significant extra-mural suburbs, at least one of which was served by a private church.

The charters of 850 and 855 also include the increasingly standard reservation of the three 'common burdens': military service, borough-work and bridge-work. With the possible exception of this reservation, however, there is nothing in these or other charters of the period to indicate how Rochester was being affected by Viking activity at this time. The *Anglo-Saxon Chronicle* records 'great slaughter' ('micel wælsliht') at Rochester, London and Quentavic in 842.[28] Suburban secular settlements outside the walls may have been a particular target of such a sea-borne Viking force in 842, which was the year of Æthelwulf's grant to the *praefectus* Ceolmund. This, after all, is exactly the period when the undefended trading establishments of *Hamwic*, Ipswich, *Eoforwic* and *Lundenwic* in England, and of Quentavic and Dorestad and similar *emporia* across the Channel, were coming to violent ends, or were at least in rapid decline in the face of repeated Viking assaults. At Rochester we know of no such *emporium* on the shore of the Medway estuary. Rather the prevailing pattern of land-holding revealed by the charters seems to be clear: the cathedral gets land within the *castrum* or *ceaster*; laymen have suburban plots outside the walls, to the east or south.

This pattern seems to have been reinforced by three charters of the 860s, two of which survive on single sheets of parchment. One is certainly written in a contemporary hand, but both single sheets have been subjected to subsequent erasures and alterations. The first of these three charters is in the name of King Æthelberht of Wessex and Kent, whose reign over both territories can be dated to 860–65. It grants 60 acres of wood (*leah*) near Horsted (in Chatham), plus a half property ('unum uiculum dimidium') in Rochester itself and 20 acres of marshland dependent upon it.[29] The charter survives on a single sheet of parchment written by a contemporary Rochester scribe, and shows extensive traces of 9th-century Kentish dialect in those parts written in English.[30] Unfortunately a later scribe, who erroneously supposed the donor to be the 8th-century Kentish king, Æthelberht II, has tampered with the charter. He took it upon himself to alter the date from '*dccclx*' (or '*dccclxi*' or '*dccclxii*') to '*dccxc*' and to erase the original name of the episcopal beneficiary, substituting that of Wærmund (781x85–803x04).

The identity of the original recipient of the grant can be established from the witness-list, where the name of one bishop has been erased. It can, however, be read under ultra-violet light as '*Cuðwulf*', who was bishop of Rochester in the 860s and 870s. Despite these muddled attempts at 'correction', we can detect that an authentic charter of 860x62 granting Bishop Cuthwulf a half-plot in Rochester lies behind this document.

The second charter of this group is a grant of the year 868, by which King Æthelred I of Wessex (the elder brother of King Alfred) granted to Bishop Cuthwulf another property within the walls, plus an area of meadow and salt-marsh on the northern side of the city.[31] The intra-mural property proves, when we examine its bounds, to comprise the whole north-western quarter of the city.[32] In a unique display of ambitious drafting, part of the boundary clause is in Old English verse and part in a Latin version of English verse.[33] Seemingly the compiler (presumably also a Rochester scribe) was aware of the importance of this grant and wished to enhance it stylistically. The grant tidied up the bishop's title to the city by ceding the whole north-west quarter at one time, whether or not the church already possessed some plots in this area. The extra-mural area of meadow and salt-marsh on the north side of the city is adjacent to that already granted to Bishop Cuthwulf in the charter of 860x62 (Fig. 1). If there is any truth in the claim of the *Textus Roffensis* annals that some marshland north of the town had already been part of Æthelberht I's original endowment of the see in *c.* 600, then the church's control of the whole south bank of the Medway on the north side of the city walls would seem to have been completed by these two grants.[34]

The third charter is attributed to Æthelberht 'king of the West Saxons and of the men of Kent' (860–65), but is much more problematic.[35] The perambulation of the intra-mural property granted here goes east from the broad gate and then south to the east gate, before returning westwards along the street to its starting point at *Doddinchyrne*. It therefore describes the whole north-eastern quarter of the town (Fig. 1, marked '861'). In other words, it purports to grant the bishop the run of three plots that had actually been acquired piecemeal, with the last only finally acquired through Offa's 'grant' of the year 789. Also included in Æthelberht's purported grant were three burgage-plots (*hagan*) located outside the walls, east of the town (*be eastan porte*), and four acres of meadow, 'west of the river' (Medway). Unfortunately the authenticity of this charter is in doubt. Its script is an imitative insular minuscule, rather crudely and irregularly written. Whether it should be dated to the late 9th century — a time when English scriptoria were struggling to achieve basic literacy in Latin — or to a century, or even two centuries, later is very uncertain. Much of the formulation of the text of the charter agrees with Rochester charters of the mid-9th century,[36] but when we reach the charter's dating clause, we find it introduced by the words 'Actum dominice incarnationis'. This (with the missing word *anno*, which has here been carelessly omitted) is the standard formula for dating clauses in Rochester charters of the 8th century,[37] but had fallen out of use by the 9th. Moreover, the charter's date has been altered so that it now reads 781 (*dcc l'xx'xi*). It seems originally to have read 861, which would fit the reign of King Æthelberht. Two figures ('xx') have been crudely added above the line in a much darker ink, and one '*c*' seems to have been erased. The alteration of the date to 781 seems to have been associated with an alteration of the name of the episcopal recipient of the grant, for the name Deora has been rewritten over an erasure. Deora (who was bishop of Rochester in the 770s and early 780s) is, of course, inconsistent with any grant in the name of King Æthelberht of Wessex in 861. At that time, the episcopal beneficiary should have been Cuthwulf.

It is difficult to regard this as an authentic 9th-century charter that has been foolishly altered (in the manner with which we have become familiar) from a charter of 861 into one of 781. We have already seen that the formulation of the dating clause belongs to the 8th, rather than the 9th century, and the names of the witness-list, though written by the main scribe, belong to the 8th century. Thus the list is headed by Archbishop Jænberht, whose pontificate lasted from 765 to 792, and he is followed by his contemporary at Rochester, Deora. The secular witnesses, though written on the dorse of the charter, are in the main hand and also belong to the mid- or late 8th century. The absence of any indication of their rank would be very unusual in the 9th century, but had been normal practice in the mid-8th.[38]

It is instructive to consider how this charter could have reached its present extraordinary form. A charter with a dating clause, recipient and witness-list more than two generations earlier than its purported donor arouses suspicion as a forgery. That is probably the correct conclusion. The draftsman of the charter seems to have set out to produce a charter of Æthelberht of Wessex, but to have provided it with witnesses from a century earlier, perhaps through confusion with an earlier king of the same name. It is easier to imagine such confusion arising in the later 10th or in the 11th century than in the 9th, when Æthelberht's reign would have been fresh in the memory.

Another interpretation, however, may be possible. In 861 English literacy in Latin was at its nadir and Viking pressures were at their height. Could a scribe without any intention to deceive have produced a charter in the name of King Æthelberht of Wessex and Kent, intending to show him confirming an 8th-century grant of property in that vicinity to the cathedral? After all, we do have charters of the 860s and 870s that were produced by scribes who were struggling to write coherent Latin and who resorted to some astonishing short-cuts that would have been unacceptable in times when educational standards were higher. At the metropolitan see of Canterbury we can point to an original charter of 873, whose scribe erroneously copied out the witnesses from a charter of King Æthelwulf that he was using as a model. In that case the scribe actually unwittingly repeated the mistake, copying the out-of-date witnesses a second time.[39] Yet, despite the parallel in the anachronistic witnesses, our Rochester charter has some crucial differences. There is no sign that the Rochester scribe used an 8th-century model for the text of his charter because he was incapable of drafting a Latin charter on his own; there is no sign that his failure to update the witnesses was accidental. At best he wrote a charter in the name of King Æthelberht of Wessex, gave it an appropriate date, and then turned it into an apparently century-old charter by giving it a recipient and witnesses who were long dead. This does not seem to be credible as an honest mistake.

We can follow the inconsistency between the charter's donor and its witness-list a little further. The presence of Bishop Deora as a witness may have caused the donor to be identified at Rochester with the Kentish king Æthelberht II, who is now known to have reigned (in East Kent alone) from 725 to 762.[40] A Rochester monk, not knowing that several of the Kentish kings listed in regnal lists had ruled concurrently, may have calculated Æthelberht's reign to have belonged to the 780s, altering the date to 781 and changing the beneficiary to read 'Deora'. The charter's catalogue of errors may have been compounded in this way. Even in its earliest form, as a purported grant of Æthelberht of Wessex to Bishop Cuthwulf, but with 8th-century witnesses, it must be discounted as a forgery. It seems more likely to have been concocted in the 11th than in the 9th century.[41] Whatever its origin, it represents an attempt to tidy up the church's documentation of its properties in the north-east of the city and to consolidate the

church's control there. It can therefore be used as evidence for the bishops' continuing wish to legitimise their control over the walled area.

THE VIKINGS AND THE LATE ANGLO-SAXON TOWN

IN 855 a heathen Viking army had arrived in Kent and wintered on the island of Sheppey, just at the mouth of the Medway estuary; in 865 another Danish army wintered on Thanet. The following year the 'great heathen army' that was to spend the next fourteen years campaigning in Britain, arrived in East Anglia. The 860s were perhaps a strange time for the West Saxon kings to be ceding control of a fortified borough or *ceaster* to the bishop of Rochester, but that is clearly what Bishop Cuthwulf and his community sought. The evidence suggests that in Kent Alfred's brother, Æthelred, took the protection of the church just as seriously as his more famous younger brother was later to do, by granting the church of Rochester control of all the property within the Roman defences. In 885 a detachment of the Viking army that had been operating in the river basins of northern Francia came to Rochester and besieged the 'chester' and made 'a fortification around themselves' by the gate of the fortress.[42] These Scandinavian defences have never been identified, but they would seem likely to have utilised the meadows and creeks to the north of the city in order to secure access for their boats. They did not manage to breach the walls or gates, however, which were successfully defended by the citizens until Alfred relieved the siege. He captured the Viking horses and prisoners, which they had left behind in their abandoned fort in their haste to escape.[43] It seems clear that the West Saxon rulers' policy of collaborating with the territorial ambitions of the bishops of Rochester here proved successful. By 885 the Alfredian policy of ensuring that fortified centres or 'boroughs' had inhabitants (*burhware*, 'burgesses'), who could form an effective garrison at times of Viking assault, had evidently been applied effectively to Kent.

It is less clear whether the kings still maintained one of their own dependants as reeve in the city, or whether they had already handed over all control to the bishop. In this context it is instructive that in charters of the 8th and early 9th century we hear of a Kentish territory (*regio*) of the *Ceastersæte* or *Ceasterware*, that is, the people dependent on the 'Chester' (i.e., Rochester).[44] It is never mentioned thereafter by this name. Instead in Domesday this area of Kent appears as the 'lathe [*lestum*] of Aylesford', and the same territory seems to have been responsible for the upkeep of Rochester bridge in the late Anglo-Saxon period. Thus the administrative centre of the lathe may have been transferred from Rochester to the royal manor of Aylesford at some date between the 9th and the 11th century. A plausible explanation for the change is that the king no longer had an appropriate property in Rochester from which his reeve could administer the lathe, whose base was therefore transferred to Aylesford.

With the charters of the 860s our documentary information about the Anglo-Saxon city comes to an end. Surprisingly we do not have charters of the 10th and 11th centuries, either in Latin or in Old English, to add to our picture of the city and its suburbs. It will therefore be up to archaeologists to find ways of showing us what sort of urban housing and what sorts of crafts and businesses were undertaken within and outside the walls. Is the relative wealth of 9th-century charters reflected by a comparable wealth of artefactual evidence? Can Rochester's 'dark age' of the 10th and early 11th centuries be illuminated by excavation? The answers to such questions will require any opportunities for significant urban excavation in the town to be seized more vigorously than has been managed in the last generation. At present we have to rely on artefactual

evidence and on topographical arguments. Two fragments of early-11th-century grave-markers, decorated with Ringerike-style ornament, have been recovered after re-use in later cathedral or precinct buildings on the edge of the medieval 'lay cemetery'. They suggest the presence in the town, perhaps in the reign of Cnut or of his sons (1016–42), of Scandinavian settlers or traders. That is confirmed by the location of a church of St Clement in the lane of that name in the north-west corner of the town, close by the bridge (Fig. 1). The cult of St Clement appears to be associated in Scandinavia, Germany, Normandy and England with 11th-century Scandinavian trading settlements, and the churches are normally situated, as at Rochester, either on the harbour or close by the bridge.[45]

ROCHESTER BRIDGE

ONE further feature of the city's life can, however, be illuminated from pre-Conquest documentation, namely its bridge. A famous late Anglo-Saxon document has been preserved in the *Textus Roffensis*, the superb cartulary of the cathedral compiled in *c.* 1120 at the order of Bishop Ernulf. It throws remarkable light on the bridge and on the territory that supported it.[46] The 'bridge-work list' describes the arrangements for the repair of the timber superstructure of the bridge at Rochester carrying the Dover–London road across the Medway. The document assigns responsibility for providing both the beams to span the gaps between the piers of the bridge and the planking to form a flat walkway to groups of estates in central Kent. When these estates are mapped, they prove to comprise the large part of the medieval lathe of Aylesford.[47] There are strong reasons for thinking that the match between lathe and bridge-district had once been much closer. That is to say that changes in the manorial structure of this area of Kent in the 9th, 10th and early 11th centuries (i.e., the subdivision of large land-units) seem to have enabled some estates to escape responsibility for bridge-work, because they no longer appeared to be included.

Moreover the bridge-work list also enables us to reconstruct the bridge (Fig. 3). It seems to have been a typical Roman bridge, with a very simple plank superstructure carried on three beams that spanned the gaps between the Roman piers of stone. The structure required a considerable number of massive timbers, presumably from the

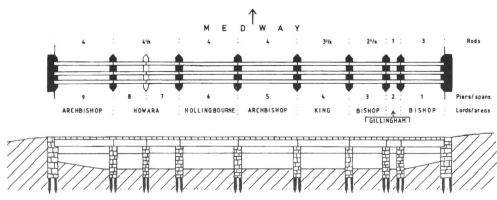

FIG. 3. Reconstruction of Rochester bridge, showing the nine spans (measured in rods), and the lord or lead estates responsible for overseeing provision of their three beams and of planking for the roadway, according to the late Anglo-Saxon bridge-work list

former Roman forest of the Weald.[48] High-quality carpenters must also have been available. We know that repairs to the bridge continued to be made according to the list's specifications throughout the 13th and 14th centuries, until the eventual collapse of the Roman and Anglo-Saxon structure in the savage winter of 1381.[49] Indeed, even after that date, until the year 1911, the listed communities retained ultimate financial responsibility both for the new bridge that was built in the 1390s and for its successor in the 1860s.[50] It remains uncertain just how old these late Anglo-Saxon arrangements to spread the burden of maintenance over a wide territory may have been by the 11th century. Bridge-work seems to have been a regular obligation on landowners in England at least as far back as the mid-8th century. Roman law, as preserved in the Theodosian and Justinianic codes of the late 4th and early 6th centuries, also assigns responsibility for bridge repair to the estates of landowners in the territory of the *ciuitas*.[51] It is therefore conceivable that the lathe of Aylesford that supported the Anglo-Saxon and medieval bridge was directly descended from the *ciuitas* of *Durobrivae* (Rochester), which would have maintained the Roman bridge. In that case, we may be looking in the Rochester bridge-work list at an Anglo-Saxon continuation of Roman arrangements to keep a Roman bridge in repair. Alternatively, the Rochester bridge-work arrangements may represent an attempt by the Kentish kings and their episcopal advisers in the 7th or early 8th century to recreate some approximation of a Roman bridge-maintenance system from a comparable (but essentially new) territory. What is clear is that the Roman bridge of Rochester, which in all probability had been constructed in the 1st century A.D., was either maintained or provided with a new Anglo-Saxon superstructure so that it endured for twelve or thirteen centuries. This was achieved by systems of bridge-work that laid effective responsibility on the major landowners of the Rochester district. These lords ensured that their free peasant tenants did the actual work. Indeed, the Rochester Bridge Trust of the last century, like its predecessors since the 1390s, has normally continued to be dominated by the gentry and the major landowners of the district, as its motto *Publica Privatis* ('public works by private men') still indicates.

NOTES

1. No attempt is made here to study the history of the Rochester mint, which deserves a monograph of its own, nor to trace that of the church of Rochester through the Anglo-Saxon period. For the latter, see M. Brett, 'The Church of Rochester, 604–1185', in *Faith and Fabric: A History of Rochester Cathedral, 604–1994*, ed. W. N. Yates and P. Welsby (Woodbridge 1996), 1–11. There have been two previous attempts to elucidate the Anglo-Saxon topography of Rochester: G. Ward, 'A Note on the Mead Way, the Street and Doddinghyrnan in Rochester', *Archaeologia Cantiana*, 64 (1949), 41–61, and T. Tatton-Brown, 'The Towns of Kent', in *Anglo-Saxon Towns of Southern England*, ed. J. Haslam (Chichester 1984), 1–36 (at 12–16). Ward's study is still of value despite its misunderstanding of all references to the river Medway as to an Anglo-Saxon road called the 'Mead Way'! I am indebted to Colin Flight and Tim Tatton-Brown, whose understanding of the topography of the town and cathedral, and of the work of Rochester antiquarians, has saved me from many errors.

2. A. L. F. Rivet and C. Smith, *The Place-Names of Roman Britain* (London 1979), 346–47; M. Gelling, *Signposts to the Past* (London 1978), 45, 56.

3. Conveniently printed and translated in *Domesday Book: Kent*, ed. J. Morris (History from the Sources, Chichester 1983), hereafter cited as *DB* and by folio number: 'Ciuitas ROVECESTRE T.R.E. ualebat .c. solidos. Quando 'episcopus' recepit similiter; modo ualet .xx. libros, tamen ille qui tenet reddit .xl. libros' (*DB*, I, 1: 'The city of ROCHESTER was worth 100 shillings TRE; when the bishop received it the same. It is now worth £20, but he who holds it pays £40'). The word *episcopus* is an interlineation by the original scribe. In the immediate vicinity of the name of the city of Rochester it is likely that the bishop of Rochester is meant, not Odo, bishop of Bayeux and earl of Kent. Though Odo is indeed referred to simply as *episcopus* in the

account of his own land-holdings (*DB*, I, 6–11v), in this preliminary section, as elsewhere in the account of Kent, he is always distinguished as *episcopus Baiocensis* to avoid confusion. The fact that the earl, Odo, in leading the 1088 rebellion in favour of Robert Curthose, treated Rochester castle as his own does not imply that he had the farm of the entire city, or that the castle had not been a royal castle. See *Anglo-Saxon Chronicle*, ed. and trans. D. Whitelock et al. (London 1961), s.a. 1088E.

4. The Archbishop of Canterbury had 5 burgesses in Rochester belonging to his manor of Darenth and worth 6s. 8d. (*DB*, I, 3r); the Bishop of Rochester had 80 properties ('mansurae terræ') in Rochester pertaining to his own manors of Frindsbury and Borstal, worth £3 TRE (*DB*, I, 5v). Odo of Bayeux had taken three houses in Rochester, worth 31d., into his own hand, which had belonged to the manor of Eccles held by his tenant, Ralf fitz Turold (*DB*, I, 7r); he had also retained 4 houses near to Rochester, belonging to the manor of Luddesdown (7v); his tenant Ansketel had 1 house in Rochester paying 30d., as part of his manor of Offham; Odo's tenant, Hugh de Port, had 3 burgages in Rochester, paying 5s. per annum, belonging to his manor of Allington (7v); Odo himself had had 9 houses in Rochester dependent on his demesne manor of Hoo, which had been removed by 1086 (8r), and had retained in his hand 3 haws in Rochester, worth 50d., belonging to the manor of Chalk. Finally Albert the chaplain held 2 haws in Rochester as part of the manor of Newington, which Sidgar had held from Queen Edith TRE (14v).

5. 'Rex W. tenet ELESFORD ... De hoc manerio tenet Ansgot iuxta Rouecestre tantum terre quod appreciabatur .vii. libros. Episcopus etiam de Rovecestre pro excambio terre in qua castellum sedet tantum de hac terra tenet quod .xvii. solidos ꝛ .iiiior. denarios ualet' (*DB*, I, 2v: 'King William holds Aylesford . . . Of this manor Ansgot holds near Rochester as much land as is worth £7. The Bishop of Rochester holds as much of this land as is worth 17s 4d in exchange for the land on which the castle sits').

6. See below, 8–10.

7. The best general discussion of the *firma burgi* remains that of J. Tait, *The Medieval English Borough* (Manchester 1936), 139–93. The earl's share of the city's farm (one-third) would have normally gone to Earl Odo, had he not been imprisoned in 1086. After the suppression of his second rebellion of 1088–89, no other earl was appointed in Kent, and the earl's 'third penny' therefore reverted to the crown. However, this earl's share continued to be separately accounted by the sheriff of Kent as 'the farm of the land of the Bishop of Bayeux' long into the mid- and late 12th century; see C. Flight, 'The Earldom of Kent from *c*.1050 to 1189', *Archaeologia Cantiana*, 117 (1997), 69–82.

8. Canterbury was worth £51 TRE, £54 in 1086; Dover was too burnt for assessment in 1066, but by 1086 was worth £20 to the King and £30 to the Earl.

9. See R. A. Holt and N. Baker, *Urban Growth and the Church: Gloucester and Worcester* (Aldershot 2003), 133–37.

10. Maidstone, Centre for Kentish Studies, DCR/R1, which has been facsimiled as *Textus Roffensis*, 2 vols, ed. P. H. Sawyer (Early English Manuscripts in Facsimile, VII, XI, Copenhagen 1957, 1962). The charters from the Rochester archive were printed by A. Campbell, *The Charters of Rochester* (Anglo-Saxon Charters, I, London 1973); others by W. de G. Birch, *Cartularium Saxonicum*, 3 vols (London 1885–98), hereafter cited as BCS and by charter number. They are listed by P. H. Sawyer, *Anglo-Saxon Charters: An Annotated List and Bibliography* (Royal Historical Society, Guides and Handbooks, 8, London 1968), hereafter referred to as S, with individual charters cited by number, not by page. I have used the 1998 revised version of S by S. E. Kelly, which is available on the web at <http://www.trin.cam.ac.uk/chartwww/>.

11. See S. C. Hawkes, G. Speake and P. Northover, 'A 7th-century bronze metal-worker's die from Rochester, Kent', *Frühmittelalterliche Studien*, 13 (1979), 382–92; and the silver penny (or *sceata*) of *c*. 725–30 from the cathedral precincts, reported in A. C. Harrison and D. Williams, 'Excavations at Prior's Gatehouse, Rochester, 1976–7', *Archaeologia Cantiana*, 95 (1979), 27. Two early Anglo-Saxon extra-mural cemeteries, at TQ 747680 and 740680 respectively and perhaps from just before and just after the Conversion period, are each some 500 yards from the Roman walls and therefore of uncertain relevance to the town. See A. Meaney, *Gazetteer of Early Anglo-Saxon Burial Sites* (1968), 134. I owe these references to the kindness of Tim Tatton-Brown.

12. Bede, *Historia ecclesiastica gentis Anglorum*, II.3, in *Ecclesiastical History of the English People*, ed. B. Colgrave and R. A. B. Mynors (Oxford 1969), 142. For the burial of Bishop Paulinus in 644 'in the sanctuary [*secretarium*] of St Andrew' and of Bishop Tobias in 726 'in the *porticus* of St Paul', which he had built for the purpose 'within the church of St Andrew', see Bede, *HE*, III.14, V.23 (245–56, 557). For a fragment of a building to the east of this church also under the north wall of the nave, see C. A. R. Radford, 'Rochester Cathedral: a new fragment of pre-Conquest wall', *Friends Annual Report for 1968* (Rochester 1969), 13–16. For possibly related Christian burials with some pottery and a spearhead, see *Med. Archaeol.*, 5 (1961), 309.

13. Maidstone, DCR/R1, fols 177–78r (*Textus Roffensis*, ed. Sawyer, II): 'Anno incarnationis domini sexcentessimo. Rex Æthelbertus fundauit ecclesiam sancti Andreæ apostoli rofi. et dedit ei Prestefeld et omnem terram que est a meduwaie usque ad orientalem portem ciuitatis in australi parte et alias terras extra murum ciuitatis uersus partem aquilonalem.'

14. G. M. Livett, 'Foundations of the Saxon cathedral church at Rochester', *Archaeologia Cantiana*, 21 (1889), 17–72. See also W. H. St John Hope, 'The Architectural History of the Cathedral Church and Monastery of St Andrew at Rochester, I: The Cathedral Church', ibid., 23 (1898), 194–328 (at 212), where Livett's discovery of the western extent of this building is reported. There is, of course, no proof that this was the Anglo-Saxon cathedral of Rochester, but in view of its location, there is no reason to doubt it. Full excavation to reveal any north or south *porticus* is urgently needed (see above, n. 12). The Roman foundations beneath the south wall of the nave of the cathedral (see H. M. and J. Taylor, *Anglo-Saxon Architecture*, II (Cambridge, 1965), 519) may have belonged to a Roman church on this sacred site. See N. P. Brooks, 'From British to English Christianity: deconstructing Bede's interpretation of the Conversion', in *Conversion and Colonisation in Anglo-Saxon England*, ed. C. Karkov and N. Howe (forthcoming).

15. Campbell, *Charters of Rochester*, no. 1 (S1).

16. W. Levison, *England and the Continent in the 8th Century* (Oxford 1948), 174–233. For his discussion of S1, see ibid., 223–25, 229.

17. As Levison emphasised (*England and the Continent*, 223–24), after the invocation and dating clause but before the proem this charter has an address: 'Ego Æthelberhtus rex filio meo Eadbaldo.' It is uncertain whether the following words ('admonitionem catholicæ fidei optabilem') belong to this address (and seek to reinforce Eadbald's faith), or to the proem.

18. 'Fram suðgeate west andlanges wealles oð norðlanan to stræte. ⁊ swa east fram stræte oð Doddinghyrnan ongean bradgeat.'

19. See below, 13 and nn. 31, 34 and 35. The Lane is mentioned in a private charter of 1475, cited by W. H. St John Hope, 'The Architectural History of the Cathedral Church and Monastery of St Andrew at Rochester, II: The Monastery', *Archaeologia Cantiana*, 24 (1900), 1–85 at 24.

20. For examples of Rochester forgeries, see Campbell, *Charters of Rochester*, 11, 24, 27 (S266, 327, 321).

21. Grants of urban properties reckoned in *iugera* are also found at Canterbury in the 9th century (BCS 317, 344, 373, 408, 426 and 449; S160, 176, 187, 1623, 287 and 296). In BCS 426 (S287) the 10th-century vernacular endorsement makes clear that the 13 *iugera* of the text are 13 acres.

22. King Sigered's grant to Bishop Eardwulf is Campbell, *Charters of Rochester*, 5 (S32). It declares that 'this land lies by the north gate of your minster, and extends to the north wall of the aforesaid city, between the properties that you already possess on the east and west' ('Hęc autem terrula ab aquilonali portę monasterii tui iacet. Et pertingit usque ad septentrionalem murum prefatę ciuitatis intra terras uidelicet quas ab oriente et occidente possedisti . . .').

23. Campbell, *Charters of Rochester*, 7 (S34): 'unum uiculum cum duobus iugeribus adiacentem plateę quę est terminus a meridie huius terrę quam tibi modo in presenti possidendam . . . perdono' ('a small property with two acres adjoining the street, which is the boundary of this land on the south, which I now at this time grant to you to possess . . .').

24. Campbell, *Charters of Rochester*, 13 (S131).

25. See N. P. Brooks, *The Early History of the Church of Canterbury* (Leicester 1984), 111–17.

26. Campbell, *Charters of Rochester*, 21, 22, 23 (S291, 299, 315/1514).

27. Campbell, *Charters of Rochester*, 22: '. . . unum dimidium agrum quod nostra lingua dicimus healue aker in orientali plaga extra murum ciuitatis Roffi in meridio parte quod multis notum est et in illa terra est ecclesia dedicata in honore sancte Marie uirginis' ('. . . a half field, which in our language we call 'a half-acre', on the eastern side outside the wall of the city of Rochester, on the south side, as is known to many; and on that property is a church dedicated in honour of the holy virgin Mary'). Here, as elsewhere in Kentish charters, *plaga* just means 'side' or 'area' and does not refer to the 'shore' of the Medway. The charter seems to be locating the property and its church on the south side of the road to Canterbury (Fig. 1), rather than on the north, as supposed by T. Tatton-Brown, 'The Towns of Kent' (as in n. 1), 15.

28. *Anglo-Saxon Chronicle*, s.a. 842. For the differing assessments of the effect of Viking raids on 9th-century trading *emporia*, see P. H. Sawyer, *Kings and Vikings* (London 1982), 78–97, and H. Clarke and B. Ambrosiani, *Towns in the Viking Age* (Leicester 1991), 24–45.

29. Campbell, *Charters of Rochester*, 24 (S327). The charter does not give the bounds of the half-plot in Rochester, but the dependent marsh land is described thus: 'Đanne sint ðęs londes gemæra an westhealfę Scipfliot an norðhalfe Meodowæge an easthalfe Liofwynnemearc ðanne fram Cioldryðelonde west be ðaræ aldan stærę swæ sio twoentig ęcra' ('Then the land's boundaries are: on the west side Shipfleet; on the north side the Medway; on the east side Liofwynn's boundary; then from Cioldryth's land west as far as is twenty acres').

30. London, British Library, Cotton charter viii.29; facsimile in E. A. Bond ed., *Facsimiles of Ancient Charters in the British Museum*, 4 vols (London 1873–78, hereafter cited as *B.M.Facs.*), II, 35. The charter is in the hand also responsible for Campbell, *Charters of Rochester*, 25 (S331) of 862; some scribal features recur in BCS 562

(S1276) of 889. For a detailed analysis, see N. P. Brooks, 'The Pre-Conquest Charters of Christ Church Canterbury' (D.Phil. thesis, University of Oxford, 1968), 147–51.

31. Campbell, *Charters of Rochester*, 26 (S339).

32. 'Her sint ða gemæra oð Miadowegan. fram Doddinghyrnan west andlanges stræte. ut oð weall ⅂ swa be norðan wege ut oð Liabinges cota. ⅂ swa be Liabingescotum oð þæt se weall east sciat. ⅂ swa east binnan weall oð ða miclan gatan angean Doddinghyrnan. ⅂ swa ðanne suð an geriaht fram ða gatan andlanges weges be eastan ði lande suð oð Doddinghyrnan' ('Here are the bounds as far as the Medway: from *Doddinghyrne* west along the street out to the wall; and then by the north way out to Leofing's cottages; and then by Leofing's cottages until the wall turns east; and then east within the wall as far as the big gates facing *Doddinghyrne*; and so then due south from the gate along the way on the east side of the property, south as far as *Doddinghyrne*'). The 'north way' could be represented by the later 'St Clements Lane' just inside the west wall, and 'Leofing's cottages' had presumably been built towards its northern end. The big gates (*miclan gatan*) are evidently the 'broad gate[s]' of Campbell, *Charters of Rochester*, 1, 11 (S1, 266) and the use of the plural probably indicates a double gate with two carriageways.

33. The use of verse forms here was elucidated by P. R. Kitson, 'Some Unrecognised Old English and Anglo-Latin Verse', *Notes and Queries*, 232 (1987), 147–51.

34. 'Þanne be norðan wealle mers ⅂ mæde. oð Mediwægan sindan ða gemæra . fram Miadawegan binnan twam fliatum tiala sint genemde; Pirifliat. ⅂ Scipfliot . ða gesceadað þæt land westan ⅂ eastan oð ðæt weallfæsten' ('Then to the north of the wall, marsh and meadow, the bounds are as far as the Medway: from the Medway between the two creeks; they are well-named Pearfleet and Shipfleet, that bound the land on the west and the east up to the wall-fortification').

35. Campbell, *Charters of Rochester*, 11 (S266); BL, Cotton charter vi.4 (*B.M.Facs.*, IV, 5), now bearing the date 781, but seemingly originally dated 861. I owe to Dr Julia Crick the suggestion that the imitative hand may be as late as *saec.xi/xii*. The land is said to lie 'within the walls in the northern part of the city, that is: 'fram Doddinchyrnan oð ða bradan gatan east be wealle ⅂ swa eft suð oð ðæt east geat ⅂ swa west be strete oð Doddinchyrnan. ⅂ ðreo hagan be eastan porte butan wealle ⅂ ðar to feower aeceras mæde be westan eē' ('From Doddinchyrne as far as the broad gates, east by the wall and so south again to the east gate; and so west by the street to Doddinchyrne. And three *hagas* to the east of the town outside the wall, and thereto four acres of meadow to the west of the river').

36. The words 'cui patent cuncta penetralia cordis et corporis', which are added to the invocation, recur in fuller form in the proems of two authentic charters of the 860s (BCS 507; S332 and Campbell, *Charters of Rochester*, 26; S339). The charter's blessing and anathema compare most closely with Campbell, *Charters of Rochester*, 21, 22 rather than with 8th-century texts.

37. Campbell, *Charters of Rochester*, 5, 7, 9, 10, 12, 14. 9th-century Rochester charters use instead 'Scripta est . . .' (ibid., 17, 18, 19, 20, 21, 22, 24, 27) or 'Actum est . . .' (ibid., 25, 26).

38. Walhard also attests Campbell, *Charters of Rochester*, 7, 9, and 10 (S34, 35, 36) of 765–79; Uba (here misread as Aba) attests Campbell, 7, 9, and 15 (S37) of 765–85; Uda attests Campbell, 7, 8 (S33), and 15; Ealhere does not attest these charters, but the mid-9th-century Kentish ealdorman of that name who attests charters of 841–50 (BCS 417, 437, 439, 449, 459, 460, 536 (S1510, 289, 291, 296, 300, 299, 344) was slain in 853 and therefore could not have attested a charter of the reign of Æthelberht of Wessex; Dudec and Wullaf similarly cannot be plausibly identified. The absence of any indication of rank in all the secular witnesses of the charter (apart from the king) is a normal feature of 8th-century Rochester charters (Campbell, *Charters of Rochester*, 3, 4, 5, 6, 7, 9, 10, 13, 14, 15, 16), but would be unique after *c*. 810 (ibid., 17, 18, 19, 20, etc.).

39. BCS 536 (S 344). For discussion of the circumstances of the production of this charter in the context of the collapse of Latin learning, see Brooks, *Church of Canterbury*, 171–74, and M. Lapidge, 'Latin Learning in 9th-century England', *Anglo-Latin Literature, 600–899* (London 1996), 409–54, esp. 452–53.

40. The chronology of the rulers of the Kentish dynasty has been established by S. E. Kelly, *Charters of St Augustine's Canterbury (Anglo-Saxon Charters*, IV, Oxford 1995), 195–204.

41. For forgeries of the early 9th century, see Brooks, *Church of Canterbury*, 191–97, and P. Wormald, 'Charters, Law and the Settlement of Disputes in Anglo-Saxon England', in *The Settlement of Disputes in Early Medieval Europe*, ed. W. Davies and P. Fouracre (Cambridge 1986), 149–68 (at 152–57).

42. *Asser's Life of King Alfred*, cap. 66, ed. W. H. Stevenson (Oxford 1904), 50 has information not found in the 885 annal of the Anglo-Saxon Chronicle: '. . . civitatemque . . . Hrofesceastre . . . in orientali ripa fluminis Medwæg sitam, obsedit. Ante huius portam pagani castellum sibimet firmum subito fabricauerunt' ('and besieged the city . . . [of] Rochester, situated on the east bank of the river Medway. In front of the gate the pagans straightaway constructed for themselves a strong fortress').

43. Again Asser's *Life* (ed. Stevenson, 50) has information (about the Viking horses and prisoners) not in the main text of the *Chronicle*.

44. 'In cæstruuarouualth' (Campbell, *Charters of Rochester*, 4; S30); 'on cæstersæta walda' (Campbell, 16; S157); 'in regione caestruuara' (BCS 199; S31). For the interpretation of the Kentish lathes followed here, see N. P. Brooks, 'The Creation and Early Structure of the Kingdom of Kent', in *The Origins of Anglo-Saxon Kingdoms*, ed. S. R. Bassett (Leicester 1989), 59–74.

45. D. Tweddle, M. Biddle and B. Kjølbye-Biddle, *South-East England* (Corpus of Anglo-Saxon Stone Sculpture, IV, Oxford 1995), Rochester nos 2 and 3, 165–67, pl. 1, ills 143–50. A major study of the St Clement dedications is in preparation by Dr B. E. Crawford, to whom I am indebted for guidance on their distribution and significance. Colin Flight has pointed out to me that in the 14th century the church was in the gift of the bishop; see *Diocesis Roffensis. Registrum Hamonis Hethe*, ed. C. Johnson, Canterbury & York Series (London 1914–48).

46. Maidstone, DCR/R1, fols 164–67 (*Textus Roffensis*, ed. Sawyer, II). The Old English version of the bridge-work list was edited by A. J. Robertson, *Anglo-Saxon Charters* (Cambridge 1939), no. 52; both the Latin and OE text by N. P. Brooks, 'Rochester Bridge AD 43–1381', in *Traffic and Politics: The Construction and Management of Rochester Bridge, AD 43–1993*, ed. W. N. Yates and J. Gibson (Woodbridge 1994), 1–40, 362–69 — reprinted with some corrections in my *Communities and Warfare, 700–1400* (London 2000), 219–65 (at 258–65).

47. I here follow the interpretation proposed in my 'Rochester Bridge, AD 43–1381'. A different interpretation is proposed in C. Flight, *The Earliest Recorded Bridge at Rochester*, BAR British series, CCLII (Oxford 1997), which has some valuable detailed points, but seems to me erroneous in its main criticisms; see my 'postscript' in *Communities and Warfare*, 256–57.

48. For the size of the timbers needed, in excess of the maxima available in the 13th-century England and later, see my 'Rochester Bridge AD 43–1381', 24–25. For the implications for Anglo-Saxon exploitation of Roman forest resources, see N. P. Brooks, 'Church, State and Access to Resources in Early Anglo-Saxon England', *Brixworth Lecture 2002* (Leicester 2003), 18–19.

49. Brooks, *Communities and Warfare*, 252–56; further details in Flight, *Earliest Bridge*, 52–53.

50. See the superb contributions of R. H. Britnell, J. M. Gibson, D. Ormrod and J. Preston in *Traffic and Politics*, ed. Yates and Gibson, 41–276.

51. *Theodosiani libri XVI cum constitutionibus Sirmondianis*, ed. T. Mommsen and P. H. Meyer, 2 vols (Berlin 1905), I (i), xi.10.2 (370); xi.16.15 (382); xi.16.18 (390); xv.3.6 (423); and ii Nov. Val. 10 (441). See N. P. Brooks, 'European Medieval Bridges: A Window onto Changing Concepts of State Power', *Journal of the Haskins Society*, 7 (1997 for 1995), 11–29 (at 5–6).

The Topography and Buildings of Medieval Rochester

TIM TATTON-BROWN

INTRODUCTION

IT is now well over twenty years since I first became interested in the history and topography of medieval Rochester. I was particularly interested in both the topography of the Anglo-Saxon town as a whole, and in the more specific problems of the evolution of the cathedral priory, and its buildings, from the 1080s to the later 15th century, and published brief notes on both these themes in 1984.[1] Most of the main work on these subjects was published a century or so ago by George Payne, G. M. Livett and W. H. St John Hope,[2] and little further work was done until the late Arthur Harrison and Colin Flight carried out small-scale excavations in the city in the 1960s and 1970s.[3] Although much more archaeological excavation is needed before we can really understand how the later Roman walled city evolved into the 11th-century borough, this paper will attempt to show briefly how the late Anglo-Saxon town changed topographically into the late medieval borough that was given a new charter by King Edward IV in 1461, and for the first time, a mayor.[4] The main topographical elements of medieval Rochester, which interlock and change between the 11th and 15th centuries, are the city walls, the great bridge over the Medway, the royal castle and the cathedral (with, from 1083, its expanding Benedictine priory on the south). The castle was also besieged on several occasions, and enlarged its own precinct in stages between the late 11th and 15th centuries.[5]

By the time of the earliest maps of Rochester, in the late 16th to early 17th centuries, the topography of the castle, walls and streets have become fixed, and after this few changes occurred until the destruction of the gates and the making of new roads in the 18th century, and finally the destruction of the great medieval bridge in 1857.[6]

ROMAN AND EARLY ANGLO-SAXON ROCHESTER

APART from the city walls, little is known about the topography of the Roman city. This is because up to the present time no large-scale excavations have taken place within the area. Smaller excavations in various places have, however, shown that an important 'Belgic' settlement called *Durobrivae* was succeeded by a small Roman town, which developed along Watling Street, the main Roman road south-east of a large bridge over the Medway. Towards the end of the 2nd century or in the early 3rd century A.D., a rampart and a stone wall were built around the settlement, which appears to have had four gates in it.[7] The area enclosed was only about 23 acres (cf. Canterbury with about 130 acres inside the walls), and part of a late Roman cemetery has been located outside the city walls on the south.[8] Little is known about the Roman streets of

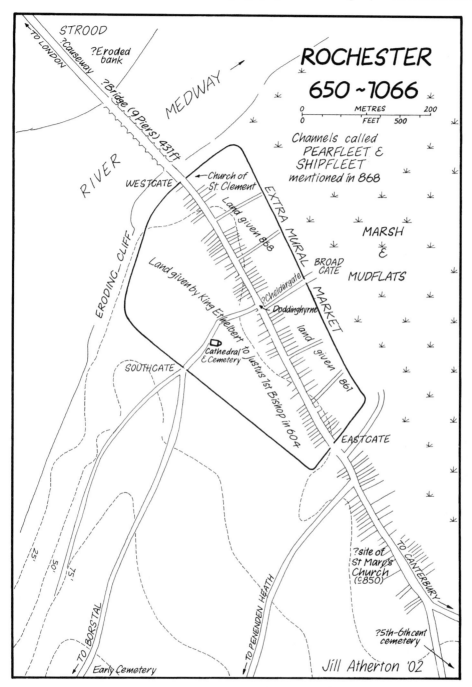

FIG. I.

Rochester, though Roman Watling Street must have passed through the centre of the city on roughly the same line as the High Street, from the bridge and the Westgate to the Eastgate (Fig. 1). The street then continued eastward to Canterbury, mainly following the line of the modern A2. Another Roman street is known to run south from Rochester to Maidstone, but whether it left the city by the Southgate or the Eastgate is uncertain. Alignments beyond the city perhaps suggest the Eastgate, but the cemetery outside the Southgate may indicate a minor road running south-south-west. There must also have been a Roman street running between the north and south gates.

In the early Saxon period, Rochester suddenly and briefly came to historical prominence. In A.D. 604, Hrofesceaster, as Bede calls it, became the seat of only the second bishopric in England,[9] and the Roman walls[10] soon sheltered a new cathedral. A very early charter[11] (which was forged in the Norman period and only seems to show the situation just after 1066) gives all the land in the southern walled area to the first bishop, Justus, in 604. In 676, however, we are told that Æthelred of Mercia invaded Kent and destroyed the city, and the bishop fled.[12] This was only a temporary setback, and throughout the later 7th and 8th centuries the cathedral and its clergy clearly flourished; a new settlement must have started to build up inside, and probably outside, the Roman city walls. After Bede's time information about the see becomes very scarce. Archaeology has uncovered very few remains of this period, though one early church, perhaps the original cathedral, was discovered at the west end of the medieval cathedral,[13] and what may be a very small part of another further east has been found.[14] Apart from a single sceatta of c. 725–30 found in the cathedral precincts in 1976[15] and a 7th-century bronze metalworkers' die,[16] little trace of early Saxon occupation has yet been found within the walls. Two early Saxon cemeteries have been found outside the city,[17] but these are far enough away from the city walls to represent cemeteries of pre-Christian extra-mural settlements. We also know when Bishop Paulinus died in 644, he was buried in the sanctuary (*secretarium*) of the cathedral church of St Andrew, while Tobias was buried in the *porticus* of St Paul in 726. Christian burial, unusually for this early period, was taking place within the city walls at the cathedral, unlike at Canterbury, where the archiepiscopal burials were outside the city walls, at St Augustine's Abbey. Some early burials are said to have also been found archaeologically under the later nave walls and by the south-west corner of Gundulf's tower in 1960.[18]

LATER SAXON ROCHESTER

IN the early 9th century Rochester was clearly a prosperous borough with its own mint or moneyers,[19] a market (a portreeve is mentioned), and probably quite a large population within the walls. It is also quite likely that the great bridge (presumably the repaired Roman one) was in use again.[20] We even hear of a church of St Mary outside the Eastgate in 850.[21] This prosperity was, however, soon shattered by the attacks of the Vikings, and the Anglo-Saxon Chronicle tells us that in 842 there was 'great slaughter' in Rochester among other places. The famous siege of 885, however, shows that the inhabitants of the city were able to use its repaired Roman walls to keep out the Vikings until the arrival of King Alfred and his relieving army. The accounts of this siege in the Anglo-Saxon Chronicle and Asser's *Life of Alfred*[22] indicate that the Vikings built a camp outside the city walls. The site of this camp has yet to be found, as the early suggestion that it was on Boley Hill has now been discredited (see below). The most likely site is somewhere outside the Eastgate on the edge of the marshes near where the church of St Mary might have been.[23]

For the end of the Anglo-Saxon period, when the borough was again fairly prosperous, but when the cathedral may have been at a low ebb, it is possible to reconstruct a map of the city (Fig. 1). Apart from the Roman city walls, it is fairly certain that Watling Street (the High Street) and the bridge were in existence at this time. One can also suggest that the long, thin 'burgage properties' fronting onto the High Street had already been formed, and perhaps some of the side lanes. It is, however, of interest that there is no evidence for an intra-mural street, of the kind found in other late Saxon burghs.[24] Early charters also give some information about the surrounding area; for example, two channels in the marshes on the north-east side of the city are called 'Scipfliat' and 'Pirigfliat' in a charter of 868.[25] Unfortunately Dr Gordon Ward's interpretation of four of these charters[26] was greatly muddled by his using the word 'Medu waie' or 'Miadowegan' to mean a street (the 'Mead Way') rather than the more obvious river Medway. It seems fairly certain at this period that the open river came close to the walls on the north-west side, but that on the north-east there was a series of channels in a salt-marsh which came close to the Roman city walls.[27] It is here, in an area that later became 'The Common', that one would expect the ships of the period to have been beached.[28] In early charters this area was connected with the intra-mural area and the High Street (just the Street in the charters), by the Broad Gate or Great Gate.[29] This may well refer to the site of the old Roman Northgate. This area, which more recently has been called Northgate or Pump Lane, was also called Cheldergate in the medieval period. The sites of the late Saxon markets inside Rochester have yet to be found, but a wide street inside the city walls near to where the ships were beached is one very likely site. It is also possible that there was a market on the other side of the High Street in the area belonging to the cathedral called Doddinghyrnan. This area, much later the site of the Epple Market, is now perhaps largely covered by the cemeteries of the cathedral and St Nicholas's church.

In the last years of the 10th and early years of the 11th century, Rochester would have again had trouble from the Danes. This is the period of weak rule under Æthelred ('the Unready'), and the Anglo-Saxon Chronicle tells how in 999 the Danes sailed up the Medway to Rochester and won a battle against the Kentish levies. By the time of the Norman Conquest the city must have been at a low ebb, and it is known that the last Saxon bishop, Siweard (1058–75), and his small group of secular canons were practically destitute. However, in the reign of King Cnut (1016–35), there may have been a major revival, and rebuilding work at the cathedral, as happened at Canterbury Cathedral. The only evidence for this at Rochester, however, are two Ringerike-style gravestone fragments, re-used in the later cathedral.[30] It is also in the early 11th century that we have the unique document called the 'Rochester bridgework list', recording the estates responsible for the upkeep of each part of the bridge.[31] By the 1020s the bridge must once again have been functioning, no doubt after major repairs had been carried out. Immediately to the east of the bridge was the church of St Clement, on the north side of the Westgate. Churches with this rare dedication usually originate in the early 11th century, and are found at sea ports like Sandwich and Old Romney.[32]

THE EARLY NORMAN CITY

SOON after the Norman Conquest, the first castle, almost certainly of the motte and bailey type, was built by William the Conqueror inside the rounded western corner of the Roman city (Fig. 2). Evidence for the bank and ditch has now at last been

conclusively proved by Arthur Harrison,[33] although up until the publication of this evidence in 1979 it had been assumed, rather illogically, that the original motte and bailey castle was outside the city wall on Boley Hill.[34] This castle, which is mentioned in Domesday Book,[35] was built on land formerly owned by the bishop of Rochester. Between November 1087 and May 1089, and almost certainly after the siege of the castle in May 1088, William II persuaded Bishop Gundulf (1077–1108) to fortify the castle 'for the king, in stone, at his own expense', and some sections of the stone wall that he built on top of the existing bank are still visible.[36]

At the same time as he was fortifying the castle, Gundulf was building a new cathedral and Benedictine priory on the old Anglo-Saxon cathedral site nearby. By 1100, the choir with its crypt (which still survives in part today), and most of the nave (housing the altar of the parish of St Nicholas) had been completed.[37] To the south of the nave, Gundulf possibly constructed a cloister surrounded by the first temporary buildings for the new Benedictine monks, though no evidence for this has yet been found. This area was extremely cramped, and early in the 12th century the cloister was moved eastwards, where Bishop Ernulf (1114–24) built a new series of monastic buildings for the greatly increased number of monks.[38] Gundulf also started to acquire more land outside the Roman city wall to the south, in the first place as a result of giving up land for the royal castle as mentioned above. One piece of 3 acres (called the 'Monks' Garden'), which came from Odo of Bayeux, is described as being 'beside the wall outside the gate towards the south part of the city outwards, which they have now enclosed with a wall on every side' (Fig. 2). A little later, Ansgot of Rochester, who had himself become a monk in old age, confirmed this and gave a further 5 acres of land beside Priestfield. Some of this land is subsequently called a vineyard,[39] and is presumably the same as the area still today called 'The Vines' to the south of the City. At this time also, Bishop Gundulf may have started to carve out a small episcopal precinct (as Lanfranc had done at Canterbury), which appears from the first to have been partly outside the Roman city wall. When the cloister was moved eastwards (see above), the bishop was able to acquire all the land at the south-west corner of the cathedral, and Ernulf and subsequent bishops (up to the early 17th century) had quite a large rectangle of land here for the buildings of their palace.[40]

Of the rest of the city, little is known in the late 11th century, with even Domesday Book being very disappointing. The latter, however, does tell us that in 1086 the bishop held 80 *mansurae*, 10 *hagae*, 5 burgesses, 3 *mansiones*, and 17 houses (*domus*) which make 115 in total. This must be far less than the total number,[41] and by *c.* 1100 Rochester was probably once again a prosperous place with a population of slightly below one thousand. The Roman walls were patched up by Bishop Odo in 1088 when Rochester was the rebel headquarters and was besieged by King William Rufus. By this time also, the bridge was certainly in use, and the main new road to London via Gravesend, Dartford and Deptford (much of it not following the Roman road), was in active use.[42]

TWELFTH-CENTURY ROCHESTER

LIKE Canterbury, Rochester was clearly a thriving town in the 12th century, with its expanding Benedictine priory. It was the third largest town in Kent (after Canterbury and Sandwich), and during the course of the century a great deal of building work must have taken place. This work is well documented at both the castle and the cathedral

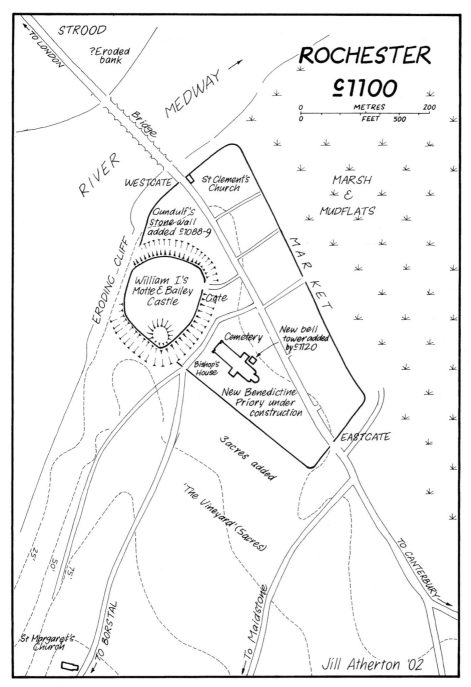

FIG. 2.

The map depicts Rochester c.1100 with the following labels:

STROOD
TO LONDON
?Eroded bank
MEDWAY
Bridge
RIVER
WESTGATE
St Clement's Church
Gundulf's Stone wall added c.1088-9
William I's Motte & Bailey Castle
Gate
ERODING CLIFF
Cemetery
New bell tower added by c.1120
Bishop's House
New Benedictine Priory under construction
3 acres added
'The Vineyard' (5 acres)
EASTGATE
TO CANTERBURY
TO BORSTAL
TO Maidstone
St Margaret's Church
25'
50'
75'
ROCHESTER c.1100
MARKET
MARSH & MUDFLATS
METRES 0 — 200
FEET 0 — 500
Jill Atherton '02

(and priory),[43] and the Anglo-Saxon Chronicle relates that on Ascension Day (8 May) 1130 the new cathedral church was solemnly hallowed by Archbishop William (de Corbeil) in the presence of Henry I and many English and Norman bishops.[44] Three years before this, however, Archbishop William had been granted the custody and constableship of the castle by Henry I, and had then built a 'noble tower' there. This 'tower' is clearly the great keep, which was probably nearing completion at this time,[45] and from this time onwards this great 125-foot-high structure has dominated the cathedral and town of Rochester (Fig. 3). By 1130, the keep was surrounded by its oval-shaped bailey, with an outer stone wall, ditch, gatehouse and probably a series of smaller towers. It was further strengthened in 1172–73, and again in 1206, and it was this castle which was besieged by King John in 1215.

By contrast the bishop's residence, immediately to the east, and the cathedral and the priory were probably only lightly protected by stone walls. On the south the Roman city wall had been demolished except where it was incorporated in the refectory and reredorter buildings, and this side of Rochester was effectively unprotected in the 12th century. A major fire occurred at the priory in 1137, and the monks were dispersed to many other Benedictine houses, while the see itself was looked after by John, Bishop of Sées, for three years (1137–40). Despite this, much rebuilding work took place, and the monks returned in 1142, once their accommodation had been rebuilt. The new bishop was Ascelin, formerly Prior of Dover, and after his death in 1148 he was succeeded by Walter, Archdeacon of Canterbury and brother of Archbishop Theobald. His long episcopate (1148–82) also covered the chaotic time of Thomas Becket's archiepiscopate (1162–80). Nevertheless, building work was continuing for much of this period, and we still have most of the cathedral nave and the west front, and the refaced façade of the chapter-house, which were all rebuilt at this time.[46] Towards the end of Walter's time as bishop, another major fire took place, on 11 April 1179, and it was recorded that 'the church of Rochester, with all the offices and the whole of the city within and without of the walls, was burnt a second time'.[47] As a result of this, the whole of the eastern arm of the cathedral was completely rebuilt over the next twenty years, with the roofs being finished at the very beginning of the 13th century.[48] As we have seen, the whole of the city, inside and outside the walls, was also burnt in 1179, and it is likely that there were major areas of housing outside the walls to the east (along the Canterbury road) and over the great bridge to the west, in Strood. In 1193, a new hospital of St Mary was built at the west end of Strood for Bishop Gilbert de Glanville, and this was perhaps on the limit of the built-up area.[49] There was also a built-up area around St Margaret's church, to the south, but between this and the south part of the city, was the priory's vineyard and farm buildings (Fig. 3).

THIRTEENTH-CENTURY ROCHESTER

AS is well known, Rochester Castle, which was in the custody of the archbishop of Canterbury, was seized by the rebels against King John in September 1215. After a major siege between 11 October and 30 November, the castle was taken by King John. The king's camp was clearly on the weak southern side of the city, in the area later called Boley Hill, and it was here that very large sums of money were spent in the 1220s rebuilding the keep, repairing the curtain wall, and making a completely new outer bailey (hence the name Boley Hill) to the castle on the south (Fig. 4). The very large ditch around the southern side of the new bailey can still be seen, and it is noticeable

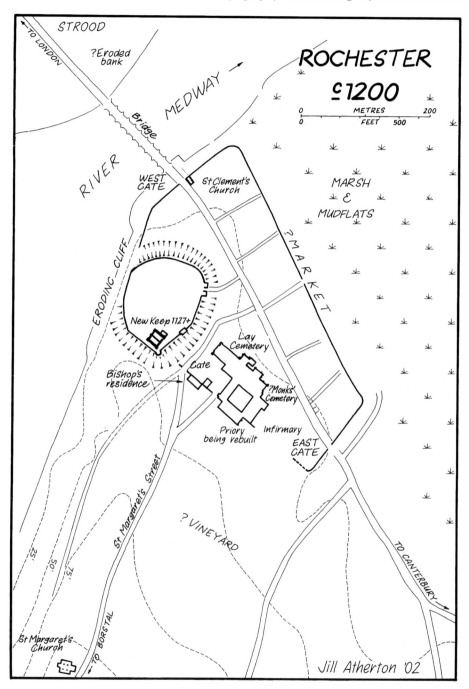

STROOD

TO LONDON

?Eroded bank

MEDWAY

Bridge

RIVER

WEST GATE

St Clement's Church

ROCHESTER
c 1200

METRES 200
0
FEET 500
0

MARSH
&
MUDFLATS

?MARKET

ERODING CLIFF

New Keep 1127+

Lay Cemetery

Gate

?Monks Cemetery

Bishop's residence

Priory being rebuilt

Infirmary

EAST GATE

St Margaret's Street

? VINEYARD

25'

50'

75'

TO BORSTAL

TO CANTERBURY

St Margaret's Church

Jill Atherton '02

FIG. 3.

how the lane approaching the castle from the south (now Love Lane), had to be diverted eastwards to St Margaret's Street.[50] The siege of 1215 caused much other damage in the city, and we know that the cathedral was desecrated and pillaged,[51] and also that the bridge was deliberately broken, to prevent any relief from the London side. It must have been repaired soon after the new king Henry III came to the throne in 1216, but was again broken and repaired in 1264 after another siege.

In 1225, according to a Rochester Chronicle,[52] 'the great ditch around the city of Rochester was begun'. Royal accounts tell us that from February 1225 for at least a year, a large number of men were engaged in ditch-digging and repairing the walls that enclosed the city. The best evidence for this large new ditch can be seen on the south-east side of the city, on either side of the east gate, though the ditch-digging was probably continued on the north to protect the city from attack across the marsh and mudflats. Beyond the defences on this side was 'The Common', where many of the markets were held.[53] At the southern corner of the city, the rounded angle of the Roman city wall still survives in a remarkable state of preservation. Leading off from it, and running southwards, is the later medieval city wall (see below), which at this point is built on relieving arches that run across the partially filled-in ditch of 1225. There has been much discussion over the sequence and dating of the city wall and its extensions here,[54] but it seems most likely that the large deep ditch that goes beneath the later medieval wall, which can still be seen in King's Orchard, is the great ditch of 1225. This great depression in the ground can then be followed north-westwards until it stops suddenly in the vicinity of King's School assembly hall.[55] Beyond this, in the area of the gardens of Minor Canon Row, there is no trace of it, and it seems likely that no new ditch was ever built here, probably because of the many outer-court buildings of the priory, which occupied the area.

The royal accounts relating to the work on the city defences suddenly cease in February 1226, and instead we find all the work of the next few years concentrating on the rebuilding of the keep, and on strengthening the defences of the castle to the south. As we have seen, this also included the making of a large new outer bailey to the castle, which overlooked and enfolded a new south gate to the city, which was only finally demolished in 1770.[56] Henry III came of age in 1227, and after 1230, all the work at the castle concentrated on the making of the new royal apartments in the inner-bailey area, to the north of the keep.[57] Work continued here, and on strengthening the castle, until the 1250s, but nothing further seems to have been done to complete the city defences on the south. In 1264 the city and castle were subjected to another siege during the Barons' War. There was a two-pronged attack from the south and from the west (over the bridge), and on Good Friday (18 April) Simon de Montfort managed to get into the city after having set fire to the timber fortifications. Then he entered the castle bailey and attacked the great keep. The keep was not taken on this occasion, as the rebels withdrew on 26 April, hearing that Henry III, and his son, the future Edward I, were advancing on Rochester. However, great damage was done to the castle and town at this time (the eastern suburbs of the city were also burnt by the castle garrison at the beginning of the siege), and the cathedral and priory were once again pillaged. Much damage is recorded, including the destruction of charters and muniments in the prior's chapel.[58] This siege effectively put an end to the 13th-century rebuilding of the cathedral, and one can still see where the work stopped at the eastern end of the nave and aisles. The castle also ceased to be a major royal residence, and much of the inner-bailey area was left in ruins under Edward I and II.[59]

THE FOURTEENTH CENTURY

AT the very end of the 13th century, and throughout the first half of the 14th century, three of the priors, Thomas of Wouldham, Hamo of Hythe and John of Sheppey, successively became distinguished bishops of Rochester. Hamo of Hythe (bishop 1319–52) did much for the priory, and most famously, in 1343, he 'caused the new steeple [*campanile*] of the church of Rochester to be carried up higher with stones and timbers, and to be covered in lead. He also placed in the same four new bells whose names were Dunstan, Paulinus, Ithamar and Lanfranc'.[60] This fine crossing tower, which was later called 'six-bell steeple', survived until 1826, when it was rebuilt by L. N. Cottingham.[61] The building of the new tower and spire was the culmination of various works carried out by Bishop Hamo at the priory, including repairs to the refectory and dormitory, and the making good of 'other defects' in the church. It was almost certainly at this time (1342), that the south choir aisle area was given its existing roof, and the magnificent 'chapter room' doorway was made. Next to it is a beautiful traceried window in the Decorated style.[62]

After completing the cathedral and priory buildings, the bishop and prior were forced to turn their attention to the outer court area of the priory and to its outer walls. On the south, their boundary was also that of the city, whose wall had never been completed. In 1344, an agreement was reached between Edward III (who was now five years into the 'Hundred Years War') and the prior of Rochester, John of Sheppey (who later became Treasurer of England, and from 1352 to 1360, bishop of Rochester). This agreement gave the priory the whole of the southern city wall between the Eastgate and the 'gate of the said prior towards the south', which, 'in divers places has been destroyed and prostrated to the ground', and allowed them to fill in the ditch outside it (the 1225 ditch), 'on condition that in place of the same wall the Prior and Convent at their own costs make (1) a new wall of stone sufficiently embattled, of the height of 16 feet, outside the said old ditch, and (2) a ditch on the ground of the same Prior and Convent in the same place sufficient in length, breadth and depth outside the wall'.[63] This new wall still survives on the south-east surrounding King's Orchard. It has a round corner bastion (beside the 1880 'School House' of the King's School), and its course to the west can still be followed, after a break at Oriel House, along the north side of the garden of the archdeacon's house, until it reaches St Margaret's Street (Fig. 5). It then ran north to a now-destroyed outer gate to the priory, which was situated, looking north-west, just outside the vaulted gateway known today, confusingly, as 'Prior's Gate'. This outer gate, which was probably destroyed in the 17th century,[64] was overlooked by the 13th-century outer bailey to the castle, so like the south gate to the city it could be well defended.[65] An inner gateway, the present 'Prior's Gate', was probably built at about the same time, with a wall on either side of it, to divide off the inner part of the priory, on the north, from the outer court with its brewhouse, bakehouse, granary and barns. On the north-east, the priory also built a new boundary wall, within the city, and at the same time probably rebuilt its gates here, including the principal gate from the high street into the lay cemetery. In 1345, the king allowed the priory to build 'a stone wall from the east gate of the city to the gate of St William', a postern gate opposite the north transept, used by pilgrims to St William's shrine in the cathedral, which was perhaps built after William of Perth's canonisation in 1256.[66] This work of fortifying the priory and the southern defences of the city may have been interrupted by the Black Death, but it was obviously efficiently done by the priory, as in the later 1360s John Hartlip (prior 1361–80) was made 'chief

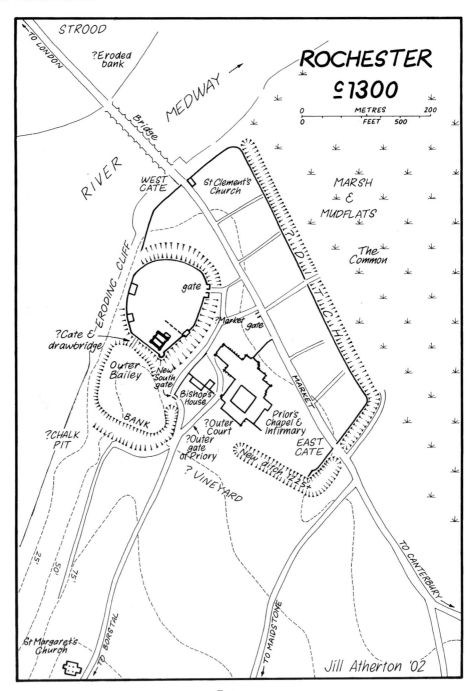

STROOD

?Eroded
bank

TO LONDON

MEDWAY →

ROCHESTER
c.1300

METRES
0 200
0 FEET 500

RIVER

Bridge

WEST
GATE

St Clement's
Church

MARSH
&
MUDFLATS

The
Common

gate

?Market gate

?Gate &
drawbridge

Outer
Bailey

?New
South
gate

Bishop's
House

Prior's
Chapel &
Infirmary

EAST
GATE

?CHALK
PIT

BANK

?Outer
Court

?Outer
gate
of Priory

New ditch 1225+

MARKET

? VINEYARD

25'

50'

75'

TO CANTERBURY

St Margaret's
Church

TO BORSTAL

TO MAIDSTONE

Jill Atherton '02

FIG. 4.

master of the works' at Rochester Castle when the towers on the east curtain wall were rebuilt. At the same time the castle's outer gate and drawbridge were perhaps rebuilt, and the roof of the keep was reconstructed and re-leaded.[67] The large ditch between the castle and cathedral and bishop's residence was also enlarged and deepened, though in the 19th century much of it was 'flattened off', exposing the arched foundations of the 1360s curtain wall, and filling in the bottom of the ditch. This was to make a larger churchyard for St Nicholas's church where, incidentally, Charles Dickens wanted to be buried. More work on the castle and city defences was carried out in the 1370s, and after the death of Edward III in 1377, when attack by the French was feared. Early in the reign of Richard II, in 1380–81, Canterbury's Westgate and northern City wall were being rebuilt, as was Cooling Castle on the Thames, five miles north of Rochester. It is possible that this was when the massive new drum-towers of Rochester's Eastgate were also built, and when the city wall was strengthened.[68]

The Peasants' Revolt in 1381 also had a great effect on Rochester,[69] but even more dramatic was the almost complete destruction of Rochester bridge at the beginning of February 1381. At the very beginning of the contemporary Westminster Chronicle, there is a description of how large blocks of ice, formed in the severe winter, broke up in the milder weather and smashed into and wrecked the bridge.[70] This finally destroyed the old Roman and early medieval bridge, and after much discussion, a totally new bridge was constructed instead, about eighty yards upstream, after quite a considerable time with only a ferry. Work on the new 560-foot-long bridge seems to have started in 1383 and was not completed for nearly ten years.[71] Even after that, the new bridge was modified with a drawbridge and a 'house called a Wyndynghous' built on the bridge between the sixth and seventh piers in 1395–96.[72] Before this, a massive new tower had been built at the northern end of Rochester Castle, which overlooked (and guarded) the south-east end of the new bridge. This tower was apparently started in the early 1380s, but only its lowest section and parts of the massive battered plinth survive.[73]

During the second half of the 14th century, the king, the bishop and the priory had worked closely together to transform the defences of the city, castle and priory,[74] and with the accession of the usurping King Henry IV to the throne in 1399 the city of Rochester must have been a very strong fortress. From this time, however, it was not to be attacked or besieged, and during the 15th century no new work on the defences was carried out. The biggest change of this period was the building of a completely new parish church of St Nicholas in the lay cemetery to the north side of the cathedral in 1418–23.[75] The two surviving gateways on the north of the cathedral also date to this period, with the Sacristy gate (later Sextry or Deanery gate),[76] probably dating to the later 15th century, and the Cemetery (later College) gate being built in the early 16th century. By this time, the bishop, John Fisher (1503–35), was living in a magnificent 'palace', comprising about a hundred rooms immediately to the south-west of the cathedral.[77] After the execution of Cardinal Fisher, as he became at the very end of his life, the palace briefly formed, in the 1540s, part of a new royal palace for Henry VIII. The buildings within the precinct of Rochester Cathedral Priory were transformed after the Dissolution, and the setting up of a new Dean and Chapter in 1542, but the boundaries of the precinct remained unchanged until the 19th century. In the same way, the buildings of the castle fell into decay, but the great building and ditch-digging works of the 11th to 14th centuries remained fossilised in the landscape. From the later part of Henry VIII's reign, the centre of military power moved one mile eastwards to Chatham dockyard, and the ancient centre of Rochester was soon to be eclipsed and

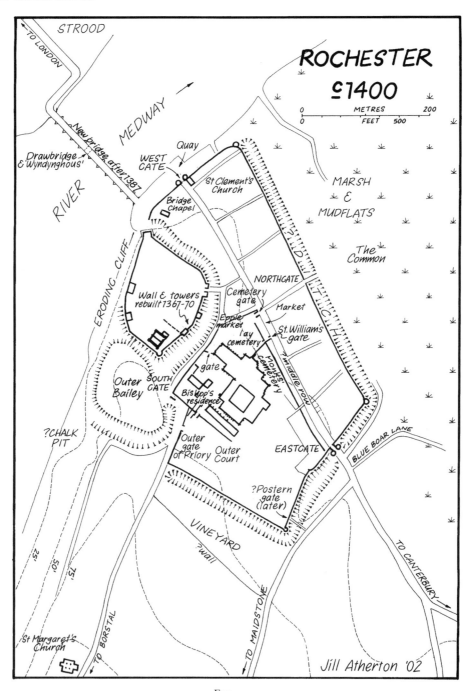

FIG. 5.

left behind as a small market town beside a major bridge on the road from London to Dover and the Continent.

ACKNOWLEDGEMENTS

I am very grateful to my wife, Veronica, for word-processing the original version of this paper, and to my daughter, Miranda, for reprocessing the whole document.

NOTES

1. T. Tatton-Brown, 'The towns of Kent', in J. Haslam ed., *Anglo-Saxon Towns in Southern England* (Chichester 1984), 1–36, and T. Tatton-Brown, 'Three great Benedictine houses in Kent: their buildings and topography', *Archaeologia Cantiana*, 100 (1984), 171–88.

2. G. Payne, 'Roman Rochester', and G. M. Livett, 'Medieval Rochester', *Archaeologia Cantiana*, 21 (1895), 1–16 and 17–72; and W. H. St John Hope, 'The Architectural History of the Cathedral Church and Monastery of St. Andrew at Rochester, I: The Cathedral Church,' *Archaeologia Cantiana*, 23 (1898), 194–328, and 'The Architectural History of the Cathedral Church anmd Monastery of St Andrew at Rochester, II: The Monastery', ibid., 24 (1900), 1–85.

3. A. C. Harrison and C. Flight, 'The Roman and Medieval defences of Rochester', *Archaeologia Cantiana*, 83 (1968), 55–104; A. C. Harrison, 'Excavations in Rochester,' *Archaeologia Cantiana*, 85 (1970), 95–112, and 'Rochester East Gate, 1969,' ibid., 87 (1972), 121–57; and C. Flight and A. C. Harrison, 'Rochester Castle, 1976', ibid., 94 (1978), 27–60, and 'The southern defences of Medieval Rochester', ibid., 103 (1986), 1–25.

4. It remained a borough until 1974.

5. See Jeremy Ashbee's paper in this volume, 250–64 and his Fig. 1.

6. The earliest maps are William Smith's of 1588, John Speed's of 1612, and Richard Smith's fine and little-known map of 1633 now in Alnwick Castle, a large copy of which can be seen in Rochester Museum.

7. Harrison and Flight, 'Roman and Medieval defences', 76; and Payne, 'Roman Rochester', 1–16.

8. VCH, *Kent*, III (1932), 80–88.

9. Bede, *Historia Ecclesiastica*, II, 3. London (St Paul's Cathedral) followed at about the same time. In the later medieval period, Kent was still the only English county with two dioceses.

10. Bede, *Historia*, IV, 5 calls Rochester a *castellum*.

11. A. Campbell ed., *Charters of Rochester* (1973), no. 1. See the discussion in this volume by Nicholas Brooks, 10.

12. Bede, *Historia*, IV, 12.

13. G. M. Livett, 'Foundations of the Saxon Cathedral Church at Rochester' *Archaeologia Cantiana*, 18 (1889), 261–78, and Livett, 'Medieval Rochester', 18.

14. A wall under the north wall of the later nave; see C. A. R. Radford, 'Rochester Cathedral: a new fragment of pre-conquest wall', *Friends Annual Report for 1968* (1969), 13–16.

15. A. C. Harrison and D. Williams, 'Excavations at Prior's Gatehouse, Rochester, 1976–77', *Archaeologia Cantiana*, 95 (1979), 27.

16. S. C. Hawkes, G. Speake and P. Northover, 'A 7th century Bronze metalworker's die from Rochester, Kent', *Frühmittelalterliche Studien*, 13 (1979), 382–92.

17. A. Meaney, *A Gazetteer of Early Anglo-Saxon Burial Sites* (1964), 134–35.

18. *Med. Archaeol.*, 5 (1961), 309.

19. R. H. M. Dolley, *Anglo-Saxon Pennies* (London 1964), 16 suggests that the mint started shortly before 820, and Athelstan's lawcode (925–39) says there were three mints at Rochester by the 10th century.

20. N. P. Brooks, 'Rochester Bridge, AD 43–1381', in N. Yates and J. M. Gibson ed., *Traffic and Politics, The Construction and Management of Rochester Bridge, AD 43–1993* (Woodbridge 1994), 14–16.

21. Charter 22 in Campbell, *Charters*, 25.

22. For both accounts, see D. Whitelock ed., *English Historical Documents*, I (2nd edn, 1979), 197.

23. No. 26 in Campbell, *Charters*, 31; the church is therefore not heard of again after 850.

24. M. Biddle and D. Hill, 'Late Saxon Planned towns', *Antiq. J.*, 51 (1971), 70–85. Later work by Biddle at Winchester has shown that the intra-mural street is an integral part of the plan.

25. No. 26 in Campbell, *Charters*, 31, though this volume is very disappointing for its lack of topographical discussion.

26. G. Ward, 'A note on the Mead Way, The Street and Doddinghyrnan in Rochester', *Archaeologia Cantiana*, 62 (1944), 37–44.

27. Channels and reclaimed salt-marsh are clearly shown on the first edition of the Ordnance Survey 6 inch map (1867), though the extent of marshland in Late Saxon times was probably much less.

28. In the year 893, the Anglo-Saxon Chronicle records many ships being bought to Rochester.

29. Campbell, *Charters*, charters 1, 11 and 26.

30. D. Tweddle, M. Biddle and B. Kjolbye-Biddle, *South-East England*, Corpus of Anglo-Saxon Stone Sculpture, IV (1995), 165–67.

31. Brooks, 'Rochester Bridge', 16–20.

32. E. Cinthio, 'The churches of St. Clemens in Scandinavia', *Archaeol. Lund.*, 3 (1968), 103–16.

33. Flight and Harrison, 'Rochester Castle', 30–32.

34. R. Allen Brown, *Rochester Castle* (1969), 5. This was the first edition of the DoE (now EH) guide.

35. VCH, *Kent*, II (1932), 209. The motte was probably roughly on the site of the 12th-century keep.

36. Flight and Harrison, 'Rochester Castle', 30–32.

37. St John Hope, 'Architectural History, I', 198–216.

38. *Textus Roffensis* (ed. Herne, 1720), fol. 172 tells us that Gundulf started with 22 monks (in 1082–83), and that when he died in 1108 there were 60 monks.

39. St John Hope, 'Architectural History, II', 4–6, and *Textus Roffensis*, fol. 211b.

40. It is possible that there was a never a cloister south of the cathedral nave, and that it was Gundulf who carved out the large episcopal precinct south-west of the cathedral.

41. H. C. Darby and E. M. J. Campbell ed., *The Domesday Geography of South-East England* (Cambridge 1971), 550.

42. T. Tatton-Brown, 'The Evolution of "Watling Street" in Kent', *Archaeologia Cantiana*, 121 (2001), 121–33.

43. Much building work is documented at the priory in the 12th and early 13th centuries, and these are fully discussed in St John Hope, 'Architectural History, II'.

44. St John Hope, 'Architectural History, I', 227. Four days earlier they had consecrated the new Canterbury Cathedral.

45. See John Goodall in this volume, 265–99.

46. See Richard Halsey in this volume, 61–84.

47. London, British Library, Cotton MSS, Vespasian A22, fol. 30.

48. Prior Ralph, who died between 1203 and 1214, was said to have roofed and partially leaded the church.

49. A. C. Harrison, 'Excavations on the site of St. Mary's Hospital, Strood', *Archaeologia Cantiana*, 84 (1969), 139–60.

50. Just to the north of it, the early-19th-century St Margaret's Mews lies in the bottom of the ditch.

51. St John Hope, 'Architectural History, II', 11, quoting BL Cotton MSS, Vespasian A22, fol. 31.

52. St John Hope, 'Architectural History, II', 12, quoting BL Cotton MSS, Nero D2, fol. 132.

53. There is still a small market here, though the whole area was devastated in the later 19th century when the railway embankments came.

54. Livett, 'Medieval Rochester', 50–55; St John Hope, 'Architectural History, II', 12–16; Harrison and Flight, 'Roman and Medieval defences'; and Flight and Harrison, 'Rochester Castle'. Livett's views seem to come nearest to the truth, but the below-ground archaeology has been on too small a scale to provide the answers.

55. Built in the early 1960s; see Harrison and Flight, 'Roman and Medieval defences'.

56. Livett, 'Medieval Rochester', 53.

57. H. M. Colvin ed., *The History of the King's Works*, II (1963), 808; and Ashbee, this volume, 255–60.

58. Allen Brown, *Rochester Castle*, 18.

59. Ashbee, this volume, 261.

60. St John Hope (1898), 276, quoting BL Cotton MSS, Faustina B5, fol. 89.

61. Cottingham's tower was replaced by a new tower and spire in 1904, but something of the early-14th-century timberwork survives around the inner walls of the ringing chamber.

62. Illustrated in St John Hope, 'Architectural History, I', 284 before its restoration.

63. All the documents relating to this agreement are fully transcribed in St John Hope, 'Architectural History, II', 16–21.

64. The still crenellated ('embattled') wall can be seen in the fine view of the city of Rochester from the west in J. Harris, *History of Kent* (London 1719) (see front cover). The south gate of the city is also well shown, but the outer gate of the priory is just outside the engraving on the right.

65. The foundations of this gateway have not yet been found archaeologically, but a small section of the wall was recorded in 1998, where the lane from Prior's Gate joins St Margaret's Street.

66. St John Hope, 'Architectural History, II', 23–24.

67. Colvin, *King's Works*, 811; and Allen Brown, *Rochester Castle*, 29.
68. Harrison, 'Rochester East Gate', 131.
69. The castle was taken and sacked by insurgents on 6 June 1381.
70. L. C. Hector and B. F. Harvey, *The Westminster Chronicle, 1381–1394* (1982), 2–3.
71. R. H. Britnell, 'Rochester Bridge, 1381–1530', in N. Yates and J. M. Gibson ed., *Traffic and Politics* (Woodbridge 1994), 43–59.
72. Colvin, *King's Works*, 814.
73. Now, rather incongruously, with an 1872 staircase running up through it.
74. Even the large priory vineyard (now 'The Vines') had its surrounding stone wall completely rebuilt in 1384–85.
75. St John Hope, 'Architectural History, II', 25.
76. Only this gateway still contains its original wooden doors.
77. It was first called a 'palatio' under Bishop Richard Young in 1412; St John Hope, 'Architectural History, II', 60–65.

Gundulf's Cathedral

RICHARD PLANT

Little remains of the first post-Conquest cathedral church at Rochester. The most substantial surviving fragments of earlier Romanesque work are the western two bays of the crypt, which has been truncated by Gothic rebuilding. The area has been subject to limited archaeological investigation, and the date, form, and extent of the original crypt have provoked a variety of interpretations. This paper will discuss the historiography of the crypt, and attempt to place the surviving fabric and its possible eastern termination in the context of Anglo-Norman and other continental buildings.

CONTEXT

ACCORDING to Bede, the cathedral was founded by King Ethelbert of Kent in 604 and dedicated to St Andrew.[1] A case has been made for some foundations and walling uncovered at the west end of the church in 1888 and 1894 to be the remains of the early cathedral church.[2] They represent the remains of a single-aisled building, with a nave approximately 42 ft by 28 ft and an apse at the east end. The assumption that this was the Anglo-Saxon cathedral has been challenged by McAleer,[3] principally on the grounds that the building is too small to be a cathedral church, and that Bede mentions a *porticus* in which Bishop Tobias (693–726) was buried,[4] which was not found during archaeological investigation. However, the investigation of the western part of the church was only undertaken with a probe, and while the absence of porticus or transepts was noted, the matter could only be properly settled by full excavation.[5] As for the size of the building, the nave of the earlier building is in fact wider than the central nave of the current building. The best argument in favour of its having been an ecclesiastical structure is that there were burials on the chord of the apse, and that burials in the immediate vicinity were aligned with the building.[6] Whether this represented the sole cathedral church, or indeed the church of 604, is at present impossible to say.

If this was the cathedral church, the new building was displaced to the east, and the orientation changed. In both respects this is somewhat like the situation at Winchester, where the new cathedral deviates further from true east than the Old Minster in order to conform to the Anglo-Saxon street grid. At Rochester the new cathedral is aligned with the Roman wall, as was the castle keep, so that the keep and the cathedral face each other across Doddingherne Lane (now Boley Hill and King's Head Lane), in a manner also found at Lincoln.[7]

DOCUMENTARY HISTORY

ON the broad outlines of the reconstruction of the cathedral there are no differences of opinion.[8] Gundulf, formerly at Christ Church Canterbury, was consecrated as the

second Norman bishop by Archbishop Lanfranc in 1077. In *c.* 1083 he and Lanfranc replaced the five secular canons he found there with twenty-two Benedictine monks, a number which had risen to sixty by the time of Gundulf's death in 1108. According to the *Textus Roffensis* written 1122/23, Gundulf 'built entirely anew, as it appears today, the Church of St Andrew'.[9]

There is no evidence that the church was begun immediately after Gundulf's arrival, and there is indeed a possibility that work was not begun until the 1080s, when the finances had been put in order and the monks introduced.[10] The translation of St Paulinus into the new cathedral church in *c.* 1088 may mark the completion of the crypt, or the entire eastern arm; nothing is known of the position of the saint, beyond that he was placed in a new shrine paid for by Archbishop Lanfranc.[11] The new foundation received financial support from Lanfranc,[12] and the monks and bishop perhaps played an important role in Lanfranc's conception of his metropolitan status.[13] The position of dependence of the relatively impoverished diocese on its metropolitan neighbour may, however, have preceded the Conquest.[14]

The perceived dependence on Canterbury has, as shall be seen, played a major role in the interpretation of the architectural and archaeological remains of the cathedral at Rochester, one persistent argument being that Rochester Cathedral should have been a copy of Canterbury. Against this should perhaps be set Gundulf's reputation as a builder in masonry, especially of royal castles. He was involved in the construction of the Tower of London, and, on account of his skill as a builder, Rochester Castle.[15] What this means in terms of Gundulf's planning of the cathedral church is hard to establish. It is unclear whether Gundulf's role would correspond (in contemporary terminology) to that of an architect or of a project manager. One quality of projects associated with Gundulf is that well-cut ashlar is sparingly used, whether at the cathedral, the Tower of London, Rochester Castle, or the nunnery at West Malling.[16]

It is possible that, as Lanfranc's assistant, Gundulf was involved in the post-1070 reconstruction of Canterbury Cathedral, as the priors were in the rebuilding at Canterbury after 1096.[17] Whether experience of other building projects would make Gundulf more or less likely to follow an earlier model it is impossible to say. The most impressive surviving building associated with Gundulf, the White Tower in London, appears to follow a pattern of great-tower building established earlier in the century at Ivry-la-Bataille (Eure).[18] However, Christ Church Canterbury may not have seemed an adequate model by the 1080s, a point that will be addressed further below.

The church has been the subject of extended discussion in print; it has been the subject of two monographs, one by W. H. St John Hope,[19] the other by J. P. McAleer,[20] both of whom preceded their final publication with shorter articles on the Romanesque fabric. There have been a number of other articles, and a recent book by Colin Flight, which uses archaeology and textual analysis to provide a portrait of the cathedral and its community.[21] McAleer's work is invaluable in pulling together much of the evidence previously collected on the building.[22]

OUTLINE OF THE PHYSICAL EVIDENCE

Nave

A number of 19th-century excavations revealed the outline, if little detail, of the original Romanesque nave, which was of the same eight-bay length as the current one. The line of the west front, which had a two-order portal, with shafts for which the tufa

bases survived, was also found.[23] Though St John Hope believed that Gundulf did not finish his nave,[24] this seems unlikely, both because the *Textus Roffensis* states that Gundulf (who lived until 1108) built the church 'as it appears today', and because a short section of standing walling uncovered at the west end was plastered.[25] Excavation also revealed that the aisle walls rested on several types of foundation, with breaks in the west bay of the south aisle wall and in the third bay from the west on the north. The eastern foundations had a lower level of gravel with chalk above; at the west they were composed of a lower layer of flints in sand and lime, with four layers of alternating sand and chalk above. However, in the north-west bay the lowest level was a bed of mortar, followed by five layers of alternating flints and 'red sandy mould' with flints in mortar on top.[26] At Canterbury Cathedral a change in foundation type was noted in the nave during excavation in the 1990s.[27]

The voussoirs of some of the eastern arcades on the south side of the nave towards the aisle are made of tufa, as is the head of the lowest window in the south-west stair vice. As tufa is generally associated with early work at Rochester, the question arises whether some of Gundulf's work survives in the arcades. Richard Halsey makes a strong case elsewhere in this volume for the retention of much of Gundulf's work. One or two problems remain, however: if the arcades were retained while the piers were refaced, one might not expect the arcades to sit as well as they do on the piers, despite occasional irregularities. From the meagre evidence of the rest of the building, it is unlikely that there was ashlar to be stripped from the piers and replaced with the current facing, though the possibility cannot be discounted.[28]

Transept

THERE is very little evidence for the transept. St John Hope reconstructed a peculiar narrow structure, based on observations by J. T. Irvine, who noted a break in footings and a strip of tufa stones on the south wall of the transept, and reconstructed a transept about two-thirds the width of the present one.[29] As McAleer pointed out, however, these stones are probably to be associated with the west range of the cloister.[30] There is little evidence for projecting transept chapels. In the light of the cloister of *c.* 1120 to the south, and of the free-standing tower on the north, there may have been none. The latter, which survives in part, is too close to the transept to allow a chapel between the two, unless construction of the tower entailed the destruction of the chapel. The only other possible evidence, raised by Flight, is that there were galleries in the transepts, as, according to a miracle collection of the mid-12th century, relics of St Ithamar were placed on a 'lofty vault towards the north'.[31]

Free-standing Tower

THE free-standing tower between the north choir aisle and the north transept has been known as Gundulf's tower only since the 18th century.[32] Its date and purpose are unclear, though it seems likely that it was intended for bells, and represents a comparatively rare survival of a type once much more common. As for the date, recent excavation shows that the foundation trench of the tower cuts through foundations of Gundulf's crypt and is therefore later, though it could still be of Gundulf's period.[33]

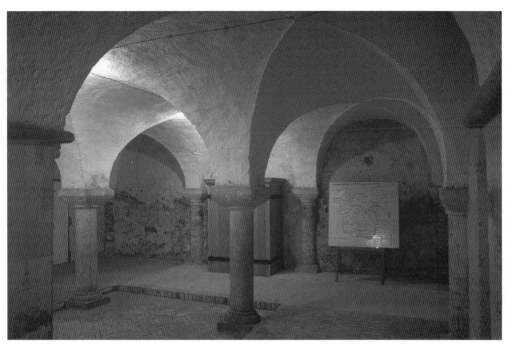

FIG. I. Rochester Cathedral: crypt, central vessel looking south-west

EAST ARM

Standing Fabric

IT may be that the solid walls of the western two bays of the presbytery date from
Gundulf's period, but they were refaced *c.* 1200, and have not been investigated. The
most substantial remains of the early Norman cathedral are in the crypt. These remains,
and the interpretation of the associated archaeological investigations, have provided
the most enduring controversy about Gundulf's cathedral.

The west wall of the crypt is about 32 ft to the east of the eastern crossing piers. The
crypt has three aisles, the outer ones divided from the central vessel by massive piers.
The central vessel is divided in turn by monolithic columns into three aisles (Fig. 1). All
surviving bays are covered with groin vaults, which are not divided by transverse
arches. The groins of the vaults have been emphasised by pinching the plaster into a
point. The vaults spring from square responds in the aisles, and from half-shafts, or the
columns, in the central vessel. At the east end of the Romanesque section of the crypt,
the Romanesque supports have been replaced by large Gothic ones, supporting the
eastern crossing above, though the vaults to the west, and partly between them, appear
to be original (Fig. 2). On the interior face of the north and south supports for the
crossing piers, Romanesque capitals, which must still be *in situ*, and which once
presumably topped half-shafts, survive embedded in the Gothic masonry (Fig. 3). They
have been cut back to the plane of the wall, but otherwise appear to have been similar
to the capitals further west.

41

FIG. 2. Rochester Cathedral: crypt, central vessel, south aisle, looking west from Gothic crypt

Most of the cut stone in the crypt, forming the walling and even the half-shafts, is of tufa; however, there is some use of Reigate stone in the bases of the shafts and abaci in the aisles, and the monolithic columns and their capitals are of Marquise stone, from near Boulogne (Pas de Calais).[34] The capitals are inverted flat pyramids, of a type sometimes called tectonic, while the bases have a pronounced lower torus, looking rather like a cottage loaf (Fig. 4).

These various elements find some comparative material in English and Norman buildings, which may help suggest a date for the remaining fabric. The stone from Marquise was used in a number of buildings in Canterbury in the post-Conquest period, and, as Richard Gem has pointed out, was sometimes imported ready carved.[35] Tufa is generally associated with early buildings in Kent, and while Reigate is usually not considered to have been used at an early date after the Conquest, recent investigation of the Tower of London has revealed its use there below a level dated (by dendrochronology) to before 1081.[36] The lack of transverse arches dividing the vault bays finds its most immediate local parallel in the dormitory undercroft at Canterbury Cathedral, of the 1080s.[37] In Normandy undivided vault bays are found in the crypt of La Trinité, Caen (begun *c.* 1060, with the crypt probably added some years later),[38] and in the crypt of Bayeux Cathedral, which was dedicated in 1077, and perhaps begun twenty years or more earlier.[39]

The bases are of an unusual type,[40] as are the capitals. These turn up at Ickleton near Cambridge, usually dated *c.* 1100,[41] and at the dormitory undercroft in Canterbury (Fig. 5). This latter comparison may be considered the most important, not only because of the close institutional and personal connections between Canterbury and Rochester, but also because the capitals are made of the same stone, Marquise.[42]

Fig. 3. Rochester Cathedral: crypt, embedded Fig. 4. Rochester Cathedral: crypt, northern
capital at south-east of central vessel column

There are two other important considerations about the crypt. The first is that it was once at least one bay longer to the east in its central vessel. This is suggested by the capitals embedded in the Gothic piers at the east, which have the same east–west dimensions as their counterparts further west in the crypt, indicating that they probably supported a further vault to the east. As for the vaults themselves, they are, whether Gothic or Romanesque, plastered and painted. A superficial examination indicates that the Romanesque vaults, smoother in finish than the Gothic vault butted up against them, continue between the Gothic supports, particularly on the south side of the central vessel (Fig. 2). Indeed, on the south side, the Romanesque vault continues well to the east of the surviving Romanesque capital, and the junction of rough later work and smooth earlier work low on the south side could be interpreted as the line of the groin vault springing above the embedded capital (Fig. 3). It would be foolish to put too much weight on these observations without proper archaeological investigation, but they suggest that there were at least three bays to the central vessel of the crypt, and there is no sign of their turning to form part of an apse. The trajectory of these presumed Romanesque vaults further indicates that the central vessel of the next bay of the crypt also had three aisles.[43]

The second consideration is that the west wall of the crypt has always been where it is, east of the crossing piers by a distance equivalent to roughly two bays of the

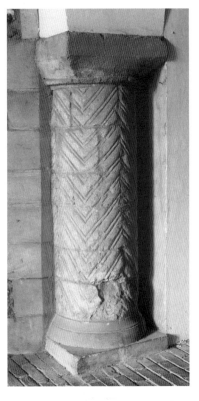

Fig. 5. Canterbury Cathedral: column formerly in dorter undercroft

Romanesque nave. The resulting minimum length of the choir, five bays, is unusually large, especially when set against the eight bays of the nave, and, as we shall see, there is evidence for one more bay at the east end. The position of the crypt, occupying only the eastern part of the choir is hard to parallel in English architecture;[44] the best comparison is again the crypt of La Trinité in Caen, seemingly added to the choir of the church after part of the building had been completed, and dated by Baylé to around 1080.[45]

The sum of the readily discernable evidence is for an eastern arm, with crypt, which it is difficult to parallel in the first generation of post-Conquest architecture in England. Both stylistic and petrological evidence suggest a date before 1090.

Archaeology

THE archaeological investigation of the east end of the building took place in the nineteenth century, and little work has taken place since. The first investigation, at the east end of the crypt, was conducted by Arthur Ashpitel in 1853. His findings, using a boring rod rather than excavation, were interpreted by him as revealing an eastern end terminating square, with four bays to the crypt, rather than the three that can be inferred from the standing fabric.[46] His findings were later re-investigated by William St John Hope, who wondered whether Ashpitel had discovered a cross wall on the chord of the apse, and to that end dug a series of trenches.

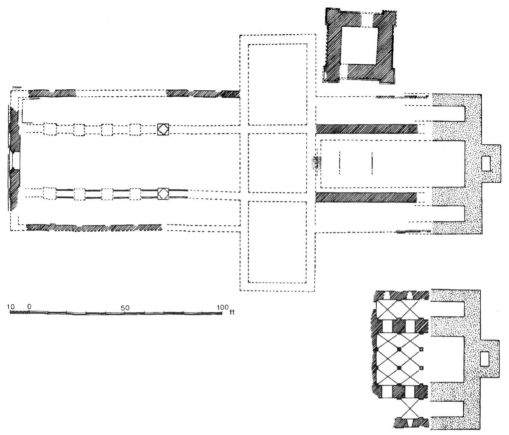

FIG. 6. Plan of the Romanesque cathedral, incorporating Hope's findings at the east end.
After R. Gem, 'The Significance of the Eleventh-century Rebuilding of Christchurch
and St Augustine's, Canterbury'

During these excavations, he also discovered a small, square-ended axial chapel, $6\frac{1}{2}$ft long by 9ft wide, about one third the width of the central vessel of the crypt.[47] He claims to have traced the foundations of this axial chapel to the junction with the foundations of the east wall, which, to his surprise, he found were otherwise square, as Ashpitel had described (Fig. 6). The chapel itself he described in a letter to G. G. Scott's clerk of works, J. T. Irvine, as 'utterly contrary to what we expected'.[48] He also claimed to have established that the crypt aisles finished square at the same point as those of the main vessel, and to have dug to the east of the square termination to establish that there was no apse beyond this.

A number of aspects of St John Hope's presentation of the evidence gleaned in the crypt are questionable. In the first place his description of the make up of the foundations altered slightly between communication to Irvine and publication. The shape of the chapel also altered slightly between his letters to Irvine, which included sketches, and publication, though perhaps unpublished sketches should not have too much evidentiary value.[49]

45

The west end of the crypt was excavated in 1872 by J. T. Irvine, for the installation of the organ wind trunks, in a section that was, for its era, meticulously recorded. Irvine recorded a tunnel cut by workmen from the crossing, down and through the west wall of the crypt, and his section of this excavation was later published by St John Hope.[50] During this he cut through a number of floor levels and identified the lowest, which was used as a roof in the eastern part of his tunnel, as Gundulf's. This floor level abutted the west end of the crypt some 5ft 7in. below the current floor level.

Interpretation

THE plan St John Hope proposed is unusual in an Anglo-Norman context and has been repeatedly challenged, the first time (in print at least) by F. H. Fairweather, by Sir Alfred Clapham,[51] and in recent years by Colin Flight and J. P. McAleer. Fairweather, publishing in 1929, did not reject the evidence of St John Hope's excavations outright, but proposed that the choir had originally terminated with apses in echelon, and that the square choir that St John Hope excavated and the surviving work in the crypt dated from the time of Bishop Ernulf (1114–24) or later.[52] When considering Fairweather's objections, it should be born in mind that they were not confined to the east end, and other aspects of St John Hope's reconstruction of the cathedral may have undermined the credibility of the plan as a whole. Four aspects of his criticism need comment.[53]

Firstly, the foundations found by St John Hope appear to be different from those assumed to be Gundulf's under the nave.[54] St John Hope's description of the foundations of 'his' east end are inconsistent: 'rubble, flints and liquid mortar' in a letter to Irvine, and the mortar of such poor quality that his man 'cut through two walls before I ascertained this fact';[55] yet in publication he claimed that they were 'rather better than those in the nave'.[56] The objection would carry greater weight were it not that, as noted, there are two or more sorts of foundation under Gundulf's nave.

Secondly, there is a change in axis in the church. While this is noticeable on the south side of the nave, there is no reason why this should not have taken place during the first phase of construction rather than at the later period favoured by Fairweather.[57]

Thirdly, Fairweather objected that the lowest floor of the choir recorded by Irvine fitted badly with the crypt, meeting it well below the crown of the vaults. When questioned about precisely this problem by St John Hope, Irvine argued the possibility that there had been flights of steps to the upper level at the sides of the presbytery that he could not see.[58] For Colin Flight the material found by Irvine provides the crux of the case against the crypt's being from the first phase of the cathedral. Irvine's annotation to his section notes the different technique of each face of the wall of the crypt (cut stone versus 'rough flints and grouting built against ground'. Flight interprets this as meaning that the wall was cut through the ground ('trench built' is his phrase), which was in part fill, and must therefore postdate both fill and floor.[59] This is a strained interpretation of 'built against ground', which is no more than a statement of what Irvine found, the difference in finish probably attributable to the difference in visibility. Furthermore, St John Hope too had his doubts about the levels of floor and crypt vault, and put to Irvine that the floor he thought was Gundulf's was in fact Saxon.[60] Irvine was convinced that wall and floor were coeval, and that the wall cut through no earlier structure, nor through the floor at this point, which he would have been able to ascertain by damage to the floor. For him the evidence would not 'allow any supposition of [the wall's] being cut through, as our excavation completely cleared the under surface of the layer of flints over which the plaster floor lay'.[61]

Finally, Fairweather objected that a square-ended plan was unlikely in the 11th century, a point of view that has been shared by other scholars since, notably Flight and McAleer. Indeed, one suspects that without this objection no others would have been raised. Both Fairweather and Flight accepted that a square end had been discovered and believed that the work with which it was associated, the remaining Romanesque crypt, had to be pushed to a later date.[62] Both, therefore, postulated an earlier, shorter, apsidal termination.

McAleer, however, rejected the findings of St John Hope's archaeology altogether. He believed the surviving crypt to be from Gundulf's time (a later date being 'stylistically impossible').[63] He (rather tentatively) suggested that what St John Hope might have found were foundations for the later Gothic supports, though in his sketch sent to Irvine, St John Hope shows the Gothic crypt piers only partly sitting on his chapel.[64]

McAleer pointed to one anomaly in the crypt aisles, that the eastern vault responds are entirely Gothic, and speculated that apses sprang at this point in the aisles.[65] However, the trajectory of the vault shows that there must have been some sort of Romanesque responds (the vaults would not otherwise meet the wall), and their replacement is no more easily explained by the springing of lateral apses at this point. McAleer produced a plan that showed an apse after three bays of the central vessel, in other words with its apex in line with St John Hope's east wall.[66] In his text, however, he argued for a central vessel of two straight bays, followed by an apse, which the evidence of capitals embedded in the Gothic work discussed earlier renders impossible.[67] All the critics of St John Hope's plan reconstruct an apsidal termination to the church. A final suggestion, by Tim Tatton-Brown, broadly speaking accepts St John Hope's excavation, but speculates that St John Hope uncovered the foundations for an apse at the east end of his excavation, but cut away for the square foundations for the late-12th-century piers.[68]

While the plan of the east end as reconstructed by St John Hope has a number of features that are hard to parallel in early post-Conquest architecture, the square end has aroused the most opposition, as this feature is often understood as a 12th-century phenomenon in English architecture. Given the involvement of Lanfranc in the construction of the church and the establishment of the monastery, Rochester, for these historians, should have looked like Canterbury. McAleer's rejection of the east end is explicitly because he sees it as being too 'precocious', as he puts it;[69] he rejects it on 'developmental grounds', concluding that, 'innovation or invention were not to be expected at the minor see, especially considering the close relationship between Lanfranc and Gundulf'.[70]

Clearly other buildings built by Gundulf or Lanfranc may help assess the likelihood of a square east end, and indeed the nunnery church at West Malling, founded by Gundulf and dedicated, with installation of the first abbess, in 1106, has been used as such. The first excavation of the site was published by F. C. Elliston-Erwood, a supporter of Fairweather's view of Rochester, in 1954.[71] This revealed only the form of the axial chapel, which was, to his surprise, rectilinear (15ft by 21ft), but he concluded that since 'all chapels of this type and period are apsidal', the eastern chapel must be an addition. Although he could not find the body of the choir, he concluded that it must have been apsidal. A later excavation, by Martin Biddle, concurred with Elliston-Erwood's dating of the axial chapel after the rest of the church, but discovered that the choir proper had also probably been square-ended.[72]

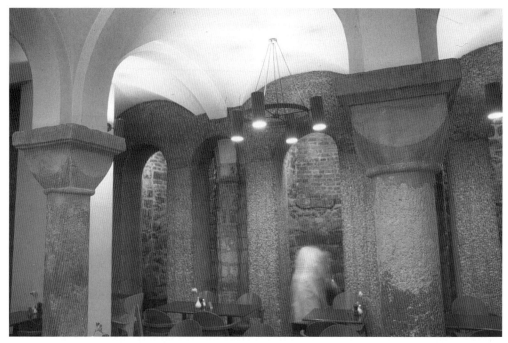

FIG. 7. St Mary-le-Bow, London: central vessel looking east

Gundulf certainly built apsidal buildings; at St Barthlomew, on the Rochester Chatham boundary, the apse of the hospital chapel appears to be of late-11th-century date and to be part of Gundulf's foundation.[73] However, surprisingly, the building that many commentators presume to have been the model for Rochester, Christ Church Canterbury, has never had its east end very fully examined; the only report is of foundations with a '(doubtfully) apse-like curve' from an investigation in 1888.[74]

Two other buildings associated with Lanfranc were square-ended. One is the excavated church of St Gregory's Priory in Canterbury.[75] The other is St Mary-le-Bow in London, where the Romanesque structure under the Wren church is in many ways the closest comparison for St John Hope's Rochester east end: three aisled, with large square piers dividing the central vessel from the aisles, and the central vessel divided into three aisles by monolithic columns (Fig. 7). The eastern wall of the building is square, with niches. It appears to have been the lower storey (at roughly ground level) of a two-storey church on land owned by Canterbury Cathedral in the City, and has been convincingly dated to Lanfranc's time by Richard Gem.[76]

It could be objected that none of these buildings is a major church, but collectively they indicate that a square east end was not entirely alien to the works of Gundulf and Lanfranc. Furthermore, the precocity of a square east end is greatly exaggerated by both Fairweather, for whom the next example does not occur for 'two thirds of a century',[77] and McAleer, who compares the arrangement to St Cross in Winchester, of c. 1160.[78] Much closer in time are the related churches of St John in Chester, of c. 1100, and Hereford Cathedral, probably begun between 1107 and 1115.[79] At both churches the east gable wall would have risen square above an axial eastern chapel of lesser width than the main vessel; in the case of Hereford the impression of a square east end

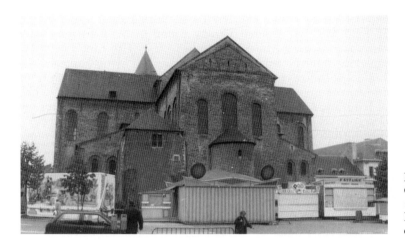

FIG. 8. Sainte-Gertrude, Nivelles (Brabant Wallon), Belgium, from the east

is accentuated by the fact that the arch leading to the chapel is smaller than the chapel itself, and approximately half the width of the main vessel of the choir.

When opponents of St John Hope's east end speak of the precocity of the design, they tend to ignore the rather feeble axial chapel. Closer in plan for the east end as a whole, including the axial chapel, are three churches in Belgium. Two no longer stand in their original form, Saint-Laurence in Liège (though the crypt here was probably an outer one),[80] and Saint-Hermes at Ronse/Renaix (Oost-Vlaanderen), where the crypt was dedicated in 1089, with an axial chapel of small proportions at the east end of a square-ended choir.[81] Finally, there is the standing example of Sainte-Gertrude at Nivelles (Brabant Wallon) dating from the middle of the 11th century; the chapel at Nivelles is open to the main vessel only at crypt level, and through a door at upper level (Fig. 8).[82] The effect of the principal difference between Nivelles and Rochester, the lack of aisles at the former, would have been somewhat lessened by the (probably) solid walls of Gundulf's choir. Nivelles has chapels flanking the west end of the choir. While sources in Flanders or the Empire have been proposed for a number of features in English Romanesque,[83] any understanding of these buildings as a source for Rochester is impeded by our ignorance of the functions of these chapels.

There are, however, more examples of square-ended chapels at buildings within the mainstream of Anglo-Norman Romanesque before 1100: at Lincoln on the transepts, and (probably) the axial chapel at Canterbury as rebuilt from 1096.[84] There were also square 'radiating' chapels at Winchester, which may have contributed to the development of the rectangular ambulatory in English architecture.[85] However, Rochester's choir, with its small axial chapel, finds little echo in the subsequent development of English Romanesque east ends.

While scholars whose focus has been more narrowly concentrated on Rochester have often discounted the possibility that Rochester should deviate too far from the model of Canterbury, general works have been more willing to accept the oddities of St John Hope's east end.[86] This may be in part because of the evident dynamism of English Romanesque in the thirty years after the Conquest. Furthermore, while Canterbury was evidently important in introducing a number of Norman features to England,[87] it cannot have served as the sole source for what was to follow in English architecture, even in buildings that appear to resemble it closely. Canterbury appears to have been a

somewhat reduced version of Saint-Étienne in Caen (Basse Normandie): it had simple cruciform piers, rather than the two-ordered variety found at Saint-Étienne; and subsequent buildings, such as St Albans Abbey (begun in 1077 by Lanfranc's nephew, Paul), increased the complexity of the Norman piers rather than following Canterbury's lead.[88] Nearly all the buildings following Canterbury in the east of England were of greater absolute dimensions, and in particular, a number had much longer choirs. The most telling criticism of Lanfranc's cathedral church is that the choir was replaced by one much larger within twenty years of the completion of the building. Given the close links between the two institutions, the inadequacy of the Canterbury east end is more likely to have been apparent to the Rochester community than to any other, and in this context, the great length of the Rochester choir is perhaps less surprising. Quite how this choir arranged on two levels operated, is hard to reconstruct, and it was an experiment that, along with the diminutive axial chapel, would not be repeated.

ACKNOWLEDGEMENTS

My thanks to Eric Fernie, whose paper at the conference on the invisible elements of Gundulf's church formed the basis of the first part of this article; to Richard Halsey, Peter Draper and Malcolm Thurlby; and above all to Tim Tatton-Brown for sharing his compendious knowledge of the building.

NOTES

1. *Bede's Ecclesiastical History of the English People*, ed. B. Colgrave and R. A. B. Mynors (Oxford 1969), 254–57.
2. G. M. Livett, 'Foundations of the Saxon Cathedral at Rochester', *Archaeologia Cantiana*, 18 (1889) 261–78, esp. 262–68; G. M. Livett, 'Medieval Rochester', *Archaeologia Cantiana*, 21 (1895) 18–19.
3. J. P. McAleer, *Rochester Cathedral, 604–1540: An Architectural History* (Toronto, Buffalo and London 1999), 8–17.
4. *Bede's Ecclesiastical History*, 556–59.
5. Livett 'Medieval Rochester', 18–19.
6. Livett, 'Saxon Foundations', 261–69.
7. Eric Fernie, *The Architecture of Norman England* (Oxford 2000), 117 and fig. 93 (Winchester), 108 and fig. 86 (Lincoln).
8. A recent summary of evidence is to be found in M. Brett, 'The Church at Rochester, 604–1185', in *Faith and Fabric: A History of Rochester Cathedral 604–1994*, ed. N. Yates and P. Welsby (Woodbridge 1996), 1–27, esp. 11–22.
9. *Textus Roffensis*, ed. T. Hearne (Oxford 1720), 143, 'novam ex integro, ut hodie apparet, aedificavit'.
10. McAleer, *Rochester Cathedral*, 27–28.
11. For the shrine, see John Crook's article in this volume.
12. *The Life of Gundulf, Bishop of Rochester*, ed. R. Thomson (Toronto 1977), 40; *Regestrum Roffense*, ed. J. Thorpe (London 1769), 120; Eadmer of Canterbury, *Eadmeri Historia novorum in Anglia*, ed. M. Rule (Rolls Series, LXXXI, 1884), 15.
13. M. Brett, 'Gundulf and the Cathedral Communities of Canterbury and Rochester', in *Canterbury and the Norman Conquest: Churches Saints and Scholars*, ed. R. Eales and R. Sharpe (London 1995), 15–25.
14. Brett, 'Church at Rochester', 10.
15. London, *Textus Roffensis*, 212 'praeesset operi magnae turris Londoniae'; Rochester Castle, *Textus Roffensis*, 146, where he is described 'in opere caementarii plurimum sciens et efficax erat'.
16. For West Malling, see T. Tatton-Brown, 'The Buildings of West Malling Abbey', *Architectural History*, 44 (2001), 179–94, esp. 179–81.
17. Prior Ernulf (1096–1107) was credited with the work by William of Malmesbury (*Willelmi Malmesbiriensis Monachi de Gestis Pontificum Anglorum*, ed. N. E. S. A. Hamilton (Rolls Series, LII, 1870), 138), Prior Conrad

(1108/9–1125) by Gervase of Canterbury (*The Historical Works of Gervase of Canterbury*, ed. W. Stubbs (Rolls Series, LXXIII, 1879), 2 vols, I, 12).

18. For Ivry, see E. Impey, 'The "Turris Famosa" at Ivry-La-Bataille, Normandy', in *The Seigneurial Residence in Western Europe AD c.800–1600*, ed. G. Meirion-Jones, E. Impey and M. Jones, BAR International Series 1088 (Oxford 2002), 189–210. Ivry would have been known to Gundulf, as it is only twenty miles from his first abbey, Bec, and on the route to Paris. My thanks to Edward Impey for this reference.

19. W. H. St John Hope, *The Architectural History of the Cathedral Church and Monastery of St Andrew at Rochester* (London 1900), republished from *Archaeologia Cantiana*, 23 (1898), 194–328, and *Archaeologia Cantiana*, 24 (1900), 1–85.

20. McAleer, *Rochester Cathedral*.

21. C. Flight, *The Bishops and Monks of Rochester 1076–1214*, Kent Archaeology Society Monographs, VI (Maidstone 1997).

22. A number of his conclusions are anticipated by F. H. Fairweather, 'Gundulf's Cathedral and Priory Church of St Andrew, Rochester: Some Critical Remarks on the Hitherto Accepted Plan', *Archaeol. J.*, 86 (1929), 187–212.

23. Livett, 'Saxon Foundations', 261.

24. St John Hope believed that Gundulf did not finish the nave; see St John Hope, *Architectural History*, 18–19.

25. McAleer, *Rochester Cathedral*, 47; Livett, 'Saxon Foundations', 276.

26. The details, with observations drawn from archival sources, are most easily accessible in McAleer, *Rochester Cathedral*, 30–33, where he notes that earlier recording had found foundations like those at the east in the north-west bay. For a suggested chronology of the nave, see op. cit., 45–47. See also J. P. McAleer, 'Some Observations on the Building Sequence of the Nave of Rochester Cathedral', *Archaeologia Cantiana*, 102 (1985), 149–70. The original publication of the foundations was Livett, 'Saxon Foundations', 269–78. The foundations under the west front appear to have differed yet again.

27. K. Blockley, M. Sparks and T. Tatton-Brown, *Canterbury Cathedral Nave: Archaeology, History and Architecture* (Canterbury 1997), 23–24.

28. See McAleer, *Rochester Cathedral*, 42–44, and Richard Halsey's article in this volume.

29. St John Hope, *Architectural History*, 16–18.

30. McAleer, *Rochester Cathedral*, 38.

31. Flight, *Bishops and Monks*, 148, who acknowledges that the story may be derived from Canterbury. The miracle stories and their architectural implications are discussed by Crook elsewhere in this volume.

32. T. Tatton-Brown, 'Observations made in the Sacrist's Checker Area Beside "Gundulf's Tower" at Rochester Cathedral', *Archaeologia Cantiana*, 107 (1990), 390–94; McAleer, *Rochester Cathedral*, 18–25.

33. J. P. McAleer, 'The Tradition of Detached Bell Towers at Cathedral and Monastic Churches in England and Scotland (1066–1539)', *JBAA*, 154 (2001), 54–83; my thanks to Tim Tatton-Brown, for informing me about this excavation. A report is in progress by Alan Ward of the Canterbury Archaeological Trust.

34. For the stone in the crypt, see B. Worssam, 'The Building Stones of Rochester Cathedral Crypt', *Archaeologia Cantiana*, 120 (2000), 1–22, and his article in this volume.

35. R. Gem, 'Canterbury and the Cushion Capital: a Commentary on Passages from Goscelin's "De Miraculis Sancti Augustini"', in *Romanesque and Gothic: Essays for George Zarnecki*, ed. N. Stratford (Bury St Edmunds 1987), 2 vols, I, 83–101; B. Worssam and T. Tatton-Brown, 'The Stone of the Reculver Columns and the Reculver Cross', in *Stone Quarrying and Building in England AD 43–1525*, ed. D. Parsons (Chichester 1990), 51–69, esp. 56–62.

36. For Reigate in general, see T. Tatton-Brown, 'The Quarrying and Distribution of Reigate Stone in the Middle Ages', *Med. Archaeol.*, 45 (2001), 189–210; for the Tower, Bernard Worssam in E. Impey ed., *The White Tower*, forthcoming. The Reigate stone is found in facing of the Tower, in a position below a drawbar hole containing wood felled between 1049 and 1081. My thanks to Jeremy Ashbee for this information.

37. F. Woodman, *The Architectural History of Canterbury Cathedral* (London 1981), 40–45.

38. M. Baylé, *La Trinité de Caen: sa place dans l'histoire de l'architecture et du décor romans* (Geneva 1979).

39. M. Baylé ed., *L'Architecture normande au moyen age* (Caen 1997), I, 38–39.

40. Without close parallel in S. Rigold, 'Romanesque Bases in and South-East of the Limestone Belt', in *Ancient Monuments and their Interpretation: Essays presented to A J Taylor*, ed. M. Apted (Chichester 1977), 99–138.

41. D. Park, 'Romanesque Wall Paintings at Ickleton', in *Romanesque and Gothic*, 159–69. The grounds for dating the building are not very clear: perhaps the most 'modern' feature of the building is the spur base, the earliest appearance of which in England appears to be in Durham Castle chapel, *c.* 1080.

42. T. Tatton-Brown, 'Building Stones in Canterbury *c.*1070–1525', in *Stone Quarrying and Building in England AD 43–1525*, ed. D. Parsons (Chichester 1990), 70–82, esp. 73.

43. My thanks to Richard Halsey for encouraging me to look at these vaults.

44. At Christchurch Priory (Dorset) the central crypt (of three) lies under the eastern part of the choir.

45. Baylé, *La Trinité*, 38–40.

46. A. Ashpital, 'Rochester Cathedral', *JBAA*, 9 (1854), 271–85, esp. 275; he expected to find an apse, but finding none where he expected to 'on proceeding eastward, the distance of two bays more, the foundations of a huge rubble wall were found . . . eight feet thick. This wall appeared, as far as could be discerned (as there was no opportunity for digging not to mention a thorough excavation) to form the straight or flat end of the old church-shewing the probability that ther had been no apsis'.

47. St John Hope, *Architectural History*, 11–16; W. H. St John Hope, 'Gundulf's Tower at Rochester, and the First Norman Church There', *Archaeologia*, 49 (1886), 323–34.

48. Kept at the Medway Archives and Local Studies Centre, DRc/Emf77/81. The letter is dated 20 October 1881, one page is shown in McAleer, *Rochester Cathedral*, ill. 18.

49. Medway Archives, DRc/Emf 77/81 (McAleer, *Rochester Cathedral*, ill. 18): the chapel appears longer north–south than east–west in the sketch, and steps inwards at the east rather than having the clasping buttresses of the published plan. An excavation in the eastern crypt in the 1990s failed to uncover the eastern extremity of St John Hope's eastern chapel, as it should have done if his plans had been accurate. My thanks to Tim Tatton-Brown for discussing this with me; see the unpublished report on this by Alan Ward, 'Excavations at Rochester Cathedral, 1990–1995' (Canterbury Archaeological Trust 1997).

50. St John Hope, 'Gundulf's Tower', facing p. 326, also in Flight, fig. 11, 128.

51. A. W. Clapham, *English Romanesque Architecture After the Conquest* (Oxford 1934), 24, judged St John Hope's reconstruction 'neither reasonable nor probable'.

52. Fairweather, 189–91, 199–212.

53. He also claimed that Reigate was a stone generally used later than the late 11th century (Fairweather, 201), though equally early examples have been noted above; that the loftiness of the crypt indicated a later date (Fairweather, 201), a subjective assessment that is not borne out by comparison with other early crypts; and that the area to the west of the crypt where Fairweather would have liked the apse to have been has not been excavated (Fairweather, 204).

54. Fairweather, 'Gundulf's Cathedral', 201–02.

55. Letter to Irvine, Medway Archives, DRc/Emf/77/81.

56. St John Hope, *Architectural History*, 18 (note).

57. McAleer, *Rochester Cathedral*, 193, n. 51, citing R. Gem, 'The Origins of the Early Romanesque Architecture of England' (unpublished Ph.D. thesis, Cambridge University, 1973), 547–48.

58. Medway Archives, DRc/Emf 77/85.

59. Flight, *Bishops and Monks*, 126–69. He describes it as 'unambiguous stratigraphic evidence', 198.

60. Medway Archives, DRc/Emf 77/84.

61. Letter of November 1885, Medway Archives, DRc/Emf 77/85. Irvine claimed that 'it seems quite evident that no church covered the space before the building of the crypt' in his notes on the excavation; Medway Archives, DRc/Emf 77/2, December 1874.

62. For Flight *c.* 1110, built as a response to the new choir at Canterbury; see Flight, *Bishops and Monks*, 193.

63. McAleer, *Rochester Cathedral*, 37.

64. McAleer, *Rochester Cathedral*, 35. The sketch is Medway Archives, DRc/Emf 77/81; see McAleer, *Rochester Cathedral*, ill. 18.

65. McAleer, *Rochester Cathedral*, 35–36.

66. McAleer, *Rochester Cathedral*, ill. 9.

67. McAleer, *Rochester Cathedral*, 44.

68. T. Tatton-Brown, 'Archaeology of Rochester Cathedral', in *The Archaeology of Cathedrals*, ed. T. Tatton-Brown and J. Munby (Oxford 1996), 109.

69. McAleer, *Rochester Cathedral*, 44.

70. McAleer, *Rochester Cathedral*, 49–50.

71. F. C. Elliston-Erwood, 'The Plan of the Abbey church of the Benedictine Nunnery of St Mary, West Malling, Kent', *Antiq. J.*, 34 (1954), 55–63.

72. The excavations have only been partly published (M. Biddle, *Med. Archaeol.*, 6–7 (1962–63), 316), but were discussed at the nunnery during the conference. The plan of the excavation is in R. Gilchrist, *Gender and Material Culture: The Archaeology of Religious Women* (London and New York 1994), 52, fig. 13; Tatton-Brown, 'Buildings of West Malling', 179–81.

73. VCH, *Kent II* (London 1926), 216–17.

74. C. F. Routledge, J. B. Sheppard and W. A. Scott Robinson, 'The Crypt of Canterbury Cathedral', *Archaeologia Cantiana*, 18 (1889), 253–56, at 254. The eastern termination of Saint-Étienne in Caen has not been investigated at all to the best of my knowledge.

75. The phases of construction of this buildings are controversial; T. Tatton-Brown, 'The Beginnings of St Gregory's Priory and St John's Hospital in Canterbury', in *Canterbury and the Norman Conquest*, ed. R. Eales and R. Sharpe (Canterbury 1995), 53–86; M. Hicks and A. Hicks, *St Gregory's Priory, Northgate, Canterbury: Excavations 1988–91* (Canterbury 2001), 1–9. Whatever the reconstruction of the phases of construction, the choir of the building was square.

76. R. Gem, 'The Romanesque Architecture of Old St Paul's and its Late Eleventh-Century Context', in *Medieval Art, Architecture and Archaeology in London*, ed. L. Grant, *BAA Trans.*, x (Leeds 1990), 59–61.

77. Fairweather, *Bishops and Monks*, 187.

78. McAleer, *Rochester Cathedral*, 50. Why he rejects the parallel with Hereford and Southwell (1108/9–14), both of which he mentions, is unclear.

79. Chester, R. Gem, 'Romanesque Architecture in Chester, c. 1075–1117', in *Medieval Archaeology, Art and Architecture at Chester*, ed. A. Thacker, *BAA Trans.*, xii (Leeds 2000), 31–44. Hereford, M. Thurlby, 'Hereford Cathedral: The Romanesque Fabric', *Medieval Art, Architecture and Archaeology*, ed. D. Whitehead, *BAA Trans.*, xv, 15–28; A. Clapham, 'Hereford Cathedral', in *RCHME Herefordshire: II, South West* (London 1931), 90–120.

80. H. Kubach and A. Verbeek, *Romanische Baukunst an Rhein und Maas*, 3 vols (Berlin 1976), II, 714–15.

81. A. Cambier, 'Het 850–jarig jubileum de inwijdig der romaanse Sint-Hermeskolliagiaal te Ronse', *Annales de la cercle historique et archéologique de Renaix et du Tenant d'Inde*, 29 (1980), 5–54.

82. X. Barral y Altet, *Belgique Romane* (La-Pierre-qui-Vire 1989), 75–113, with earlier literature.

83. R. Plant, 'English Romanesque Architecture and the Holy Roman Empire' (unpublished Ph.D. thesis, Courtauld Institute, 1998).

84. J. Bilson, 'The Plan of the First Cathedral Church of Lincoln', *Archaeologia*, 62 (1911), 543–64.

85. R. Plant, 'La Cathédrale de Winchester: ses sources et son influence', in *L'Architecture Normande en Europe: identités et échanges*, ed. M. K. Meade, W. Szambien and S. Talenti (Marseilles 2002), 55–62.

86. Fernie, *Architecture of Norman England*, 115–17; R. Gem, 'The Significance of the Eleventh-Century Rebuilding of Christchurch and St Augustine's, Canterbury', in *Medieval Art and Architecture at Canterbury before 1220*, ed. N. Coldstream, *BAA Trans.*, v (Leeds 1982), 1–19.

87. Gem, 'Significance'.

88. Blockley, *Canterbury Cathedral Nave*, 25. The Canterbury piers were irregularly cruciform, with a narrower respond facing the main vessel.

Bishop Gundulf's Door at Rochester Cathedral

JANE GEDDES

Dendrochronology has established that a small door in Rochester Cathedral can be dated to 1075–1107 and is therefore part of Bishop Gundulf's original building. Its ironwork decoration, of three saltire crosses, recalls Andrew, the patron saint of the cathedral.

IN Rochester Cathedral there is a small door decorated with some rather primitive ironwork. Dendrochronology has established conclusively that the timber for this door was felled between 1075 and 1107, and the door is therefore an original survivor of Gundulf's Cathedral. This paper provides some context for the door and aims to explain why its discovery is significant.[1]

The little door[2] presently hangs in the north-east transept, inside the cramped north-east turret stair that leads up to the triforium passage and lapidarium. The door is clearly reused and was constructed in three stages (Figs 1, 2 and 3).

1. Originally it was made for a narrow flat-topped doorway (1.89 by 0.82 m) and was four boards wide (Fig. 1). It would have been held by strap hinges on the back because its entire front is covered by geometric decoration in iron.[3] Three saltire crosses are placed one above the other, and three circles interlaced through them. There are short scrolls at the top and bottom. Several clusters of old nails and nail holes might reveal further scroll patterns. The top and bottom circles each have two conspicuous holes on their vertical axis, and the central circle has two holes near its centre. These correspond to fixings for the type of vertical cogged bolt used on the door at the foot of the staircase to the Muniment Room at Salisbury Cathedral. This 13th-century locking device consists of a cogged wheel in the centre of the door, turned by a handle on the front. Connected to the wheel are long bolts reaching to the top and bottom of the door, firmly attached at both ends. There are traces of red paint on the central area of the door that may belong to this phase (see below). On the upper right side are patches of thickly textured blue-grey paint. Some of this has spilt on to the iron and it therefore appears to be later than the red paint, and probably post-medieval.

2. The board on the hanging edge and the segment across the top were added to the originally square-topped door, in order to make it fit its present round-topped doorway, constructed in the 13th century. Keyholes on the present hanging edge show the door was enlarged before it was reversed.

3. The door was subsequently reversed so that the face with the decorative ironwork hung on the rear, and hinges were attached to the original opening edge. Horizontal

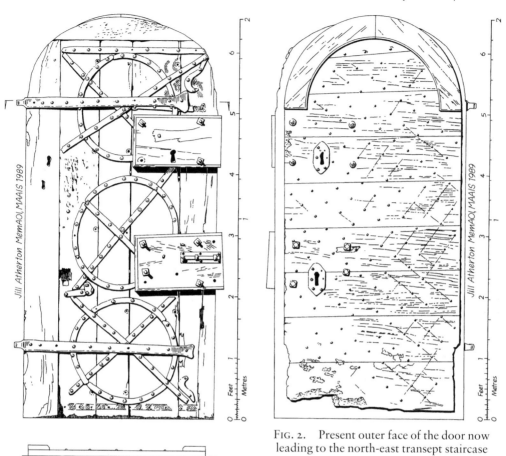

FIG. 1. Original outer face of the door now
leading to the north-east transept staircase

Jill Atherton

FIG. 2. Present outer face of the door now
leading to the north-east transept staircase

Jill Atherton

cross-boarding was applied to the new exterior of the door, capped by curved boards
around the head (Fig. 2). There is a faint lattice pattern scored across the door, a feature
particularly found in the later 15th century, but extending into the 16th century. The
carpentry is very crude and was obviously applied when the original framing of the
door was no longer viable. When the door was reversed, two enormous box locks were
added on the back, and the crude strap hinges applied.

The dendrochronology result is particularly satisfactory. Dan Miles has developed a
micro-boring technique, which provides an accurate cross-section of all the tree rings
with the minimal damage. He was able to extract a minute core through all the old
boards. Three of the boards, coming from a single tree, spanned the years 936–1066.
One also had the heartwood/sapwood transition, which allows an accurate felling date

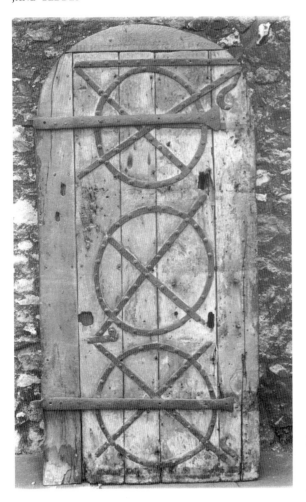

FIG. 3. Original outer face of the door
now leading to the north-east transept
staircase

John Crook

range of 1075–1107 to be estimated. The fourth board spanned 822–1011. Adding twenty-five unmeasured rings to the outer end of the sequence, this provided a *terminus post quem* of 'after 1045'. All these dates fit with Gundulf's building campaign of 1083–1108. The best matches for ring widths centred on data from London, suggesting that the timber was of local origin, from north-east Kent.

There is no evidence regarding the door's original location. We can only deduce that it was sufficiently esteemed in the 13th century to be reused. However, the date establishes that it was made for Gundulf's cathedral and was presumably part of the east end, which was replaced in the 13th century. Its uneroded condition and the presence of red paint that may be original suggests that it has always been an interior door. One possible location would be at the entrance to the small axial chapel at the east end.[4] Richard Plant compares the square east end and axial chapel at Rochester with the church of Sainte-Gertrude, Nivelles (Brabant Wallon), Belgium, where, unusually, a door closes the chapel from the presbytery.[5]

There is another possible parallel at Canterbury Cathedral. Here there was a little door in the north choir aisle, leading up stairs to the Chapel of St Faith. The wall and doorway were part of Conrad's choir, built from the 1130s. During the fire of 1175, the wall was scorched to its present pink colour, and the door obviously burned too. However, part of its ironwork survived, and the door was subsequently remade under William of Sens. Dendrochronology, carried out by John Fletcher, demonstrated that the door was indeed made after the fire, with a felling date around 1175, but the poor fit between the C-hinges and decorative iron straps suggests that the hinges were reused from the original door.[6] Perhaps the Rochester door was in a similar location, leading to a side chapel or to a small staircase to an upper chapel.

The choice of saltire crosses in circles at Rochester is significant because Rochester Cathedral is dedicated to St Andrew. The same pattern becomes almost a leitmotif elsewhere in the cathedral. It is found in the spandrels of the 12th-century nave tribune; on the entrance to the chapter-house; on the west front; and on the 19th-century replica floor tiles in the south-east transept. The powerful association attached to this motif may account for the door's preservation.

Ironwork on many church doors makes reference to the patron saint. This is because during the consecration ceremony, the bishop stands at the main door of the church and invokes the saint to protect his building. The bishop addresses the patron saint as 'the ever vigilant guardian and inseparable door keeper' and asks the saint to intercept the attempts of evil humans with his shield. He invokes the cross for protection: 'To you, holy cross, we commend this church, that you may be a help meet here, that you may firmly interpose the shield of your divine protection against the fierce darts of all enemies.'[7] The need for such protection is more obvious at the main entrance to a church, so its appearance on a minor door at Rochester is unusual and may therefore indicate the entrance to a special chapel.

The pattern of three saltire crosses on top of each other is very ancient. An example is illustrated in the 9th-century Bible of S. Paolo fuori le Mura, Rome, made in Reims c. 870. In Sweden saltire crosses in slightly different arrangements are used at Perstorp (Skåne), Hammesjö and Vänge.[8] In these examples there is no specific relationship with St Andrew.

Very few English Romanesque doors are covered with geometric patterns, and the closest parallel to Rochester is the early-12th-century door, with intersecting circles, at Little Hormead, Hertfordshire.[9] However, J. F. Pearson was aware of another early door, with superimposed intersecting circles, at Skipwith, Yorkshire. Here the door was already in a poor condition when it was drawn by John Buckler in 1813. Pearson made a fairly accurate attempt to reconstruct it at Skipwith in the 1880s, and went on to reuse the same pattern when he came to restore the great west doors of Rochester Cathedral in 1888 (Figs 4 and 5). So the noble doors on Rochester's west front are in fact based on those of a small parish church in Yorkshire. In transferring this design, Pearson overlooked an important iconographic consideration.

Both Skipwith and its neighbouring parish church at Stillingfleet, within a few miles of York, are dedicated to St Helen. In this area, she enjoyed a particular cult, because her son Constantine was reputedly in York when he was declared emperor. St Helen is known for the Invention of the True Cross and for its dispersal to the four corners of the earth, hence the appearance of the four-fold cross at both Skipwith and Stillingfleet.

So, although Pearson's bold guess at the original appearance of the west doors of Rochester was roughly appropriate for the date, about the 1160s, his slavish attempt to

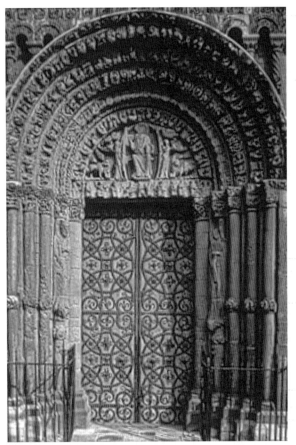

FIG. 4. Rochester Cathedral: west door, designed by
J. F. Pearson

Tim Tatton-Brown

FIG. 5. Skipwith, Yorkshire: door as
reconstructed by J. F. Pearson

Jane Geddes

recreate a genuine Romanesque design missed the point that these doors were uniquely designed for their particular location.[10]

Little is known about the original west doors at Rochester. Daniel King drew some rather schematic scrolled hinges on them in the mid-17th century.[11] When Samuel Pepys visited in 1661, he observed 'the great doors of the church, as they say, covered with the skins of Danes'.[12] What he probably saw was remnants of leather under the ironwork. Theophilus recommended that such leather be stained red, and indeed we have already seen that there are traces of red on the little door at Rochester.[13] Several other doors, at Copford and Hadstock in Essex, for example, retained scraps of leather romantically called Daneskins, the latter example recently proved to be cowhide.

The dating of the door by Dan Miles should be put into context. Until recently, most ancient doors have been dated by the style of their ironwork and techniques of carpentry construction. John Fletcher pioneered the use of dendrochronology for this purpose, but the task was complicated by the lack of straight cross-grain edges on the

curved tops of doors, and the physical inconvenience of measuring rings on top of a ladder in a dark porch. Dan Miles's micro-bore technique avoids these problems, although extracting the core itself is not entirely simple. Further problems are that many stout, broad door planks have too few rings to be useful, or the rings are too uniform to produce a signature graph.

At both Staplehurst, Kent, and Stillingfleet, Yorkshire, where the boards were examined with gamma radiography, the rings were too wide and too few to obtain a result. At Durham Cathedral, the north door of the nave produced satisfying evidence that it was indeed constructed at the same time as Ranulf Flambard's nave. The estimated felling date was 'after 1105', which coincides with the construction of the nave in 1127 and the roof in 1133. Because the south-west door of the nave is constructed in exactly the same way, this too must be part of the original structure.[14]

At Kempley, Gloucestershire, there is a suite of doors of complicated carpentry construction that are contemporary with the early-12th-century fabric of the church. On the west door, one board produced a heartwood/sapwood boundary date of 1103, allowing a proposed felling date range of 1114–44. This was appropriate for the appearance of the ironwork and surrounding stone work within the first quarter of the 12th century.[15] Research following the Rochester investigation has so far produced two older doors. The north door at Hadstock Church, Essex is of 'after 1034', likely c. 1050–75, and thus contemporary with its 1060s doorway. The door at Westminster Abbey Chapter House vestibule (called 'Pyx') has a date range of 1032–64.[16]

These advances in scientific dating methods are changing the importance of doors, chests and other timber work as historical documents. Hitherto, they required external evidence to corroborate their date. For instance, a door needed to be in its original doorway, or a chest needed an inscription or heraldry of some sort to be securely dated. Within the hierarchy of datable objects, doors in their original context were the most important. Old doors reused in a new doorway in roughly the same place (like an old nave door moved out to a new aisle) came second, but displaced orphans like the Rochester door could provide few clues apart from their iron bands. Dendrochronology is reversing this order of importance. The firm date for the Rochester door proves that it belonged to Gundulf's original building works, and provides evidence from part of the building that no longer exists. An architectural context is no longer required to provide historical validity for these unique craft objects.

NOTES

1. I would like to thank Tim Tatton-Brown for drawing my attention to the door and making all the arrangements for its recording. The Society of Antiquaries kindly provided a grant, which enabled Dan Miles of the Oxford Dendrochronology Laboratory to produce the scientific report. John Crook photographed the door when it was carried outside. The Friends of Rochester Cathedral funded Jill Atherton to produce the measured drawings. D. Miles and M. J. Worthington, 'Tree Ring Dates', *Vernacular Architecture*, 33 (2002), 81–102.

2. Present size 1.95 by 0.99 m; originally 1.89 by 0.820 m.

3. Without splitting the door apart, it is impossible to see how the door was originally framed or suspended. I assume the original strap hinges were on the back, but there is a problematic small strap grooved into the wood beneath the top circle on the right. This is too small to be an effective door hinge: it does not reach the edge of the door, and there is no corresponding groove or strap at the bottom of the door.

4. E. Fernie, *The Architecture of Norman England* (Oxford 2000), 115.

5. Richard Plant, pers. comm.

6. Jane Geddes, *Medieval Decorative Ironwork in England* (London 1999), 308, fig. 4.35.

7. ibid., 41, 43.

8. ibid., 133; Lennart Karlsson, *Medieval Ironwork in Sweden*, II (Stockholm 1988), 378, 199, 546.

9. Geddes, *Medieval Decorative Ironwork in England*, 132.

10. ibid., 133, 61, 67–69.

11. Daniel King, *The Cathderall and Conventuall Churches of England and Wales* (London 1672), pl. 9. A later schematic illustration from 1850 by Sir George Scharf is reproduced in D. Kahn, 'The West Doorway at Rochester Cathedral', in *Romanesque and Gothic Essays for George Zarnecki*, ed. N. Stratford, II (London 1987), pl. 2.

12. R. Latham and W. Matthews ed., *The Diary of Samuel Pepys*, II (London 1970), 70.

13. Theophilus, *On Divers Arts*, ed. and trans. J. G. Hawthorne and C. S. Smith (New York 1979), 26–28.

14. C. Caple, 'The Durham Cathedral Doors', *Durham Archaeological Journal* (1998), 14–15, 131–40.

15. B. Morley and D. Miles, 'The Nave Roof and Other Timberwork at the Church of St Mary, Kempley, Gloucestershire: Dendrochronological Dating', *Antiq. J.*, 80 (2000), 294–96.

16. Hadstock: D. Miles, M. J. Worthington and M. Bridge, 'Tree Ring Dates', *Vernacular Architecture*, 35 (2004), 95–113. Westminster: D. W. H. Miles and M. Bridge, *The Tree Ring Dating of Early Medieval Doors at Westminster Abbey, London*, English Heritage, *Centre for Archaeology Report*, 38/2005 (2005), 8, 16.

The Twelfth-Century Nave of Rochester Cathedral

RICHARD HALSEY

The Romanesque nave of Rochester Cathedral is remarkable for the variety of its pier designs and for the floorless middle storey. No firm dates are recorded, but Philip McAleer's argument for construction after the 1137 fire is supported here. However, it was not a new build, for much of the core work of the nave built by Bishop Gundulf before his death in 1108 was retained, so dictating the overall design and proportions. It is also suggested that the west façade owes much to Gundulf's work, with the west door inserted in the 1150s. Both the design and a number of decorative elements of the nave and the west façade are likely to reflect contemporary Canterbury work. St Botolph's Colchester, c. 1140, now provides the nearest visual parallel for the arcaded west front, though this and Rochester are probably both developments of a lost Canterbury façade.

EXTENT AND DATE OF THE ROMANESQUE FABRIC

LIKE most of its contemporaries, the Romanesque nave of Rochester Cathedral has been altered in subsequent centuries (Fig. 1, Col. Pl. I). The two eastern arcade bays were entirely rebuilt in the second quarter of the 13th century (possibly the start of a nave rebuilding), but the corresponding north aisle wall remains. In the second half of the 15th century, the whole clerestory was replaced, omitting the wall passage. The new three-light windows do not relate to the Romanesque bays, but are uniformly spaced externally and their apex is approximately in line with the clerestory windows of the transepts. This campaign most likely included the rebuilding of the nave roof (which was in turn replaced in 1804) and the insertion of the eight-light west window.[1] As so much Romanesque stone is reused, the Romanesque clerestory and façade had probably survived intact until then.

Although the walls have been much rebuilt, the nave aisles retain their late-11th-century width. From the existing walls, it appears that new windows were inserted in the 13th century (south aisle) and 15th century (north aisle). The addition of the three-bay 'nave' to the south-west transept chapel in the early 16th century entailed the removal of the walls of the three easternmost bays of the south aisle. Rebuilding in the 1660s, heightening in 1802, and Victorian restoration mean that only limited Romanesque fabric is now visible. However, three 12th-century bays survive at the east end of the north nave aisle, and the two western bays probably also date to this time (but with at least the external string-course reset). On the south side, the stumps of external pilaster buttresses are visible today. Together with other evidence discovered during 19th-century restorations, this may give five 12th-century bays at low level.[2]

61

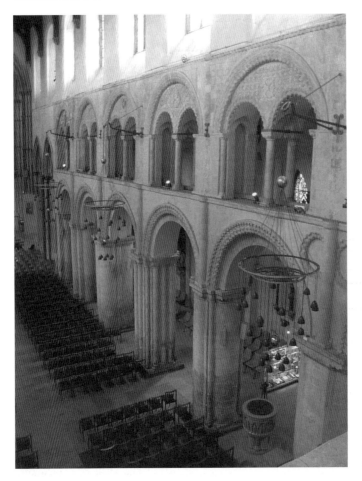

FIG. 1. Rochester
Cathedral: south nave
elevation, looking east

Only about half the west-front stonework is of 12th-century date: the whole middle section with the window was rebuilt by Cottingham in 1825, the whole north-west stair turret has been rebuilt twice, and the majority of the other pinnacles above aisle parapet level are rebuilt too (Fig. 19a and b).[3] Before Philip McAleer's studies, St John Hope was the standard work on Rochester, incorporating accounts of excavations and various findings during the restorations of Sir George Gilbert Scott and J. L. Pearson.[4] St John Hope relied on the first-hand observations of J. T. Irvine, Scott's clerk of works, and the Revd G. M. Livett, the cathedral precentor. St John Hope thought that Bishop Ernulf (1114–24) had basically built the nave, although he acknowledged that Ernulf's predecessor, Bishop Gundulf (1076–1108) had built some of it before his death in 1108. However, St John Hope did not believe that the whole nave was completed by 1124, on stylistic grounds, and therefore presumed that Ernulf had not completed the work either.[5]

There are four pieces of evidence that together suggest that Gundulf did build a nave to exactly the same scale as the current building.

1. The *Textus Roffensis* account of the 1120s states that during Gundulf's episcopate he 'built entirely anew, as it appears today, the church of St Andrew which was almost ruined by age'.[6] No-one else is credited with building the church in the 12th century.

2. In 1888, the footings and lowest courses of an earlier Romanesque west front, immediately below the present one, were discovered, together with a single central door with three orders, including their bases, and up to 2.5ft of internal plaster.[7]

3. By 1107, the parochial altar of St Nicholas in the nave was in use.[8]

4. There is also the negative evidence that, given the specific account of the monastic buildings Bishop Ernulf erected, the contemporary *Textus* would surely have credited him with building the nave if that is what he had done.

McAleer is surely right to conclude that the 8 May 1130 consecration by the Archbishop of Canterbury in front of the king and his court has no relevance to the constructional history. It was more of a political demonstration, a few days after the consecration of the Glorious Choir at Canterbury, which included a royal gift to the monastery.[9]

Regrettably, nothing is recorded of any building work by the bishops who follow Ernulf. All three were closely related with Christ Church Canterbury, not least Walter (1148–82). He had been archdeacon at Canterbury, and his brother was Theobald, Archbishop of Canterbury (1138–61). Nothing is known either about the role played in the building works by the priors of Rochester, though it may be assumed that they would be unlikely to spend priory money on parochial purposes. It would be useful to know just how the parishioners of St Nicholas's altar exercised their rights. A charter of Gundulf dated 1107–08 divides the nave between priory (east) and parish (west), and it is probable that the 13th-century rebuilding of the eastern two bays marks this division.[10] If this was the principal (and only?) parish 'church' of the thriving town of Rochester,[11] then the citizens were surely anxious to maintain their altar and rights on the cathedral site, given that the Archbishop of Canterbury was building a magnificent new castle on their doorstep, and his protégé, the bishop, was rebuilding the cathedral and monastery. This division also raises interesting questions about the patronage of the west front.

Of the two fires at Rochester reported by Gervase of Canterbury, in 1137 and 1179, both of which 'entirely destroyed the church', the level of destruction at the latter date can be dismissed as a gross exaggeration, at least for the nave, as stylistically every writer agrees that it must have been completed by the mid-12th century. There is no visible fire damage either, which suggests 1137 as the earliest date for the nave.[12] The extent of the 1137 fire was severe enough for the monks to be lodged at other monasteries until their domestic quarters had been rebuilt.[13] As far as we know, the monastery flanked the east end, and if this area alone had been destroyed in 1137, then the monks could have used the nave and lived in temporary accommodation adjacent to it. However, it could be assumed that housing both parochial and monastic uses in whatever survived of Gundulf's nave would not have suited either party. If even part of the western nave survived the fire, it is likely that the main occupants, the parishioners, strongly argued their case to stay, as they had nowhere else to go. The sum of this evidence, therefore, suggests that the existing nave was built following damage from the fire of June 1137, as McAleer concludes.[14]

63

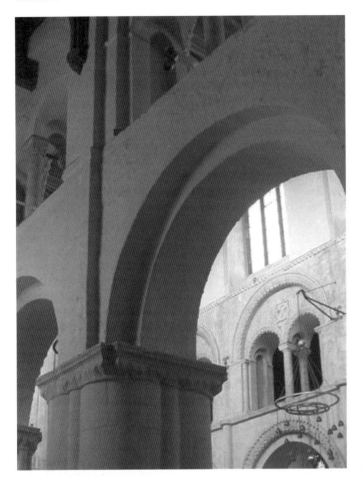

FIG. 2. Rochester Cathedral: south nave arcade, side aisle

THE CASE FOR RECASING

McALEER argues that St John Hope, working on the first-hand evidence of Irvine and Livett, was wrong to think that any of Gundulf's nave survived above ground. St John Hope agreed with Irving that the use of plastered tufa in the south nave arcades (especially in the spandrels towards the aisles and for both unmoulded orders of the arcade towards the aisle) (Fig. 2) indicated that the south arcade was essentially Gundulf's, recased on the nave side with an outer chevron order, after the fire. The lack of a systematic use of tufa in the north arcade and the use of Caen voussoirs, including an outer chevron order towards the north aisle and leaf-spurs to the westernmost pier bases, demonstrated that it was built later to match the south. St John Hope argued that work had begun on the south to provide a basis for the adjacent cloister to be built. As McAleer points out, there is no physical evidence for a cloister adjacent to the nave. From a careful examination of Irving's papers, McAleer also shows that the use of tufa was 'sporadic and not exclusive' and 'could just as well be explained by its re-use'. In particular, McAleer argues that the southern piers cannot be recasings, as they are not thicker than the arcades they support and they stand on low chamfered plinths, just as

the demonstrably later north piers. Finally, for McAleer, there was no motive for recasing as 'it is difficult to imagine that much labour or material was thus saved, or for what reasons this cumbersome procedure might have been undertaken'.[15]

There are a number of reasons to agree with Irvine and St John Hope that much of Gundulf's work does survive within both the present arcades (and possibly also existed in the aisle walls until they were rebuilt in the 1660s). Excavations have shown that the present nave stands exactly on Gundulf's foundations — barely fifty years old in 1137 — including the west front and the aisle pilaster buttresses inside and out. This establishes the whole nave plan, including the current bay sizes, as being Gundulf's. Elsewhere a 12th-century rebuilding of a late-11th-century church invariably entailed an expansion in scale, most spectacularly of course at Christ Church in Canterbury. If the monastery was so totally destroyed that the monks had to leave the site, it seems reasonable to suppose that the adjacent east end had to be refurbished, if not rebuilt, after the 1137 fire. The combined cost of this work would have taxed the relatively slender resources available,[16] and it can be expected that an economical solution was sought. We know from Gervase's account of events at Canterbury after the fire of 1174 that the monks there were keen to retain as much old fabric as possible, an understandable reaction that I have witnessed myself following cathedral and church fires in recent years. It is not difficult to cut away fire-damaged ashlar, back to the flint and mortar core, and to reface. There would be much to be gained in terms of lower labour and material costs, as well as time, in comparison with a total rebuilding.

The primary reason for thinking that the present nave incorporates much of Gundulf's core work is that it has the proportions and scale of a 'first-generation' Anglo-Norman 11th-century church. Having a taller arcade than middle storey puts Rochester into the line of descent from Cerisy-la-Forêt (Manche), to Lanfranc's Christ Church, Canterbury and then Winchester, Chichester and other first-generation churches, many with sub-divided middle storeys.[17] Although major buildings of the 1120–50 period are missing, they would appear to have continued this trend, at the expense of the middle storey. Of particular relevance to Rochester is the Glorious Choir at Canterbury, begun in 1096 but consecrated in 1130, where the arcade columns were about half as tall again as Rochester, but within a comparable elevation height. There are many irregularities in the Rochester arcades (more noticeable on the south than the north), and unless poor laying out and shoddy workmanship are blamed, these anomalies are best explained as the result of a refacing/repair project.

1. There are some oddly shaped arches, with the outer chevron order towards the nave often not running in parallel to the plain inner order (Fig. 3).

2. There is some awkwardness in the relationship of the arches to the piers, especially in the outer chevron orders. If the pier centres were established by Gundulf, the variety of piers that we see now would not have existed in his time. Some of the arch diameters and springing points will, therefore, have had to change with the increased scale of the piers.[18] This becomes particularly clear towards the west, as the penultimate bay, with the octagonal pier on its west side, is narrower than those to the east (Fig. 4).

3. The retention of the arcade core may imply that more core work above the arches was retained. The middle-storey nook-shafts have no relationship to the outer chevron orders of the main arch (except at the junction with the west wall), and the infill arches they support are set on a plane behind their scalloped capitals (Fig. 5). The latter are

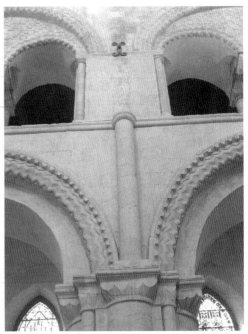

FIG. 3. Rochester Cathedral: south nave arcade arches, fourth bay from the west, showing distortion due to misalignment of the recased piers

FIG. 4. Rochester Cathedral: north nave arcade spandrel, second pier from the west. The mast is central to the tribune arches, but not to the pier capital; the main arcades are wider to the west and the chevron arch misses the capital

not inconsistent with other nave capitals, but do not alter in style to the west, like the capitals of the central colonettes. The nook-shafts themselves course with the walling between them, and so all the visible masonry is post-1137. It could be a refacing of an existing core, retained to support the clerestory above.

4. Perhaps because the piers are so varied, the half-shafts in the spandrels of the arcades sit irregularly on the capitals — sometimes not at pier centre — and the coursing of these shafts with the spandrels is distinctly odd on the south side (though it has to be said that coursing everywhere in the 12th-century work at Rochester can be irregular) (Fig. 4).

5. The chamfered plinths below both the north and south arcades are made from a number of stones. Some plinths are better aligned than others with the pier elements above them, and many appear to have been augmented with small corner stones from an original shape that corresponds to the cruciform plan of the easternmost piers (Fig. 6). This suggests that the plinths may well be Gundulf's, designed to support a cruciform pier. Unfortunately, they have all been painted to imitate Purbeck marble, so obscuring detailed examination, and it is no longer possible to establish whether the small stones are repairs to areas damaged in the fire.

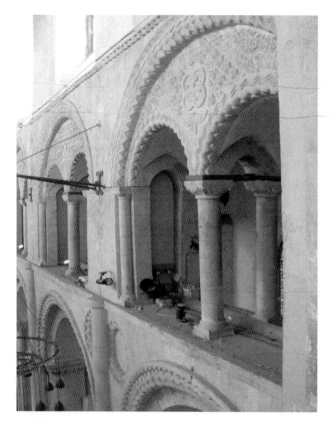

FIG. 5. Rochester Cathedral:
south nave elevation, middle storey
of the westernmost bay

FIG. 6. Rochester
Cathedral: north nave
arcade plinth and
bases, third pier from
the west

The combined evidence supports the argument that at least the cores of Gundulf's arcade, and most probably also much of the corework of the two storeys above, were retained. The use of prominent leaf-spurs only on the four westernmost bases and the changes to the middle-storey capital style have led most writers to suggest that the north arcade was the later one and worked on from east to west.[19] The discrepancies noted above between north and south arcades support this view, but rather than allowing a cloister to be built, as St John Hope thought, I suggest that this enabled the parochial altar of St Nicholas to continue to function on the north side. Perhaps the fire damage was not so great here. The north nave arcade is clearly much better finished, benefiting from the experience gained from refacing the south side. The only exception to this is the surface of the spandrels of the main arcade to the aisles, which today appears rougher on the north: however, this may well be the result of post-medieval replastering of the south.

Without an archaeological investigation of the walling, it cannot be established now how much (if any) of Gundulf's work above the arcade was kept after 1137, and his clerestory is long gone. A fire that burnt off the main roof would have caused greatest damage to stonework at floor level, once the burning timbers had fallen. Refacing of the main piers would remove this evidence. A fire confined to the tribune roof would damage the middle stage and clerestory, but would not necessarily cause much damage to the main arcade below, if Gundulf's aisles were vaulted (as they surely were). If the fire was predominantly in the monastery to the south of the east end, the nave walls could well have been left standing, without some, or all, of the roofs, and with stonework damaged by burning timber at ground level and to the arches of the middle storey.

The reuse of Gundulf's cores is the most frequently accepted explanation for the heavy penultimate piers, which are of an elongated octagonal form, and for the narrower penultimate bay. These indicate an intention to build west towers, such as existed at both Christ Church and St Augustine's Abbey in Canterbury. If Gundulf had built towers, then they would surely have been retained, so it must be concluded that none was erected. If the post-1137 masons had totally removed the piers and the superstructure above them, then they could have evened out the widths of the two western bays to meet the existing west front. This would have been a major exercise, and the easiest and most economical option — simply repeating Gundulf's layout — was adopted. It is likely that the original piers were of compound form; the use of elongated octagons here may have been inspired by the octagonal columns of the Glorious Choir. The recessed, chevron-framed circles on the south side (Fig. 7) were presumably an effort to 'disguise' the large blank spandrel, an experiment not repeated on the north, perhaps because of the difficulties in cutting the ashlars. It is noticeable that the half-shaft stones are applied to the circles behind and not coursed with them.[20] The archaeological evidence for the addition of extra material around the north-west corner of the west front is puzzling; it was presumed by Irvine (who found it) to be a strengthening preparation for a tower some time in the mid-12th century.[21] Perhaps this modest strengthening was simply in preparation for an enlargement of Gundulf's corner stair turret.

THE STYLISTIC CONTEXT

DEBORAH KAHN has demonstrated good parallels for the detailing of Rochester nave and west façade (chevron, diaper work, the use of onyx marble, proto-dogtooth,

FIG. 7. Rochester
Cathedral: south nave
arcade, chevron-
decorated recessed
circles on the spandrel of
the westernmost
octagonal pier

FIG. 8. Christ Church,
Canterbury: Treasury,
exterior decoration of
the upper storey

and some of the leaf forms) in the work attributed to Prior Wibert (1153–67) at Christ Church, Canterbury.[22] McAleer is also surely right to draw attention to the similarity in spirit at Rochester and Canterbury,[23] clearly seen in a comparison of Wibert's Treasury and the Rochester west front (Figs 8 and 9). A post-1137 date for Rochester suggests that the Rochester masons went to Canterbury, rather than vice versa. However, this is likely to be a regional workshop, developing ideas throughout Kent from the Glorious Choir at Christ Church (1096–1130), which was widely admired by contemporaries for its decoration. The east range of the Rochester cloister must have

FIG. 9. Rochester Cathedral: innermost south staircase turret of the west front. The springing of the south nave clerestory blind arcade is behind the downpipe

Check
Photos

produced a similarly rich overall effect to the nave elevation, but there are hardly any common details, suggesting different workshops. It is very clear that the cathedral repertoire is much richer than that used at the adjacent castle (1127–34).

This richness is particularly clear in the variety of the nave pier designs. Bridget Cherry found it 'difficult to decide whether Rochester should be interpreted as an isolated outlier of the [eastern England] group, or whether it is the sole survivor of related buildings in Kent', and although recognising that Canterbury could have been the source for both Rochester and eastern England, 'there is no surviving evidence in Kent for the use of the compound pier of eastern type'.[24] For McAleer, 'the predominance of the pier design in the design of the elevation . . . is as unusual in a Romanesque context as it is common in the early Gothic'.[25] There is a little evidence for the use of compound forms at Canterbury, in the work of Wibert. The pier at the base of the Water Tower appears to have been formed of pairs of shafts attached to a hollow circular core. The broad transverse arches of the Dark Passage formed in the undercroft of Lanfranc's dormitory spring from triple shafts like those of the fifth pier from the east at Rochester (Figs 10 and 11). Wibert's Infirmary arcade piers are not dissimilar to the sixth pier at Rochester, in the use of large half-shafts with thin angle-shafts between them.

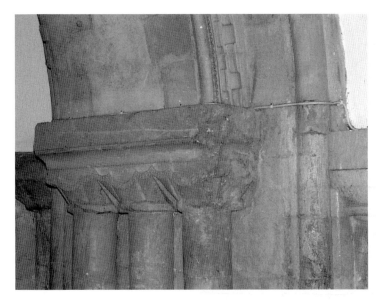

FIG. 10. Christ Church, Canterbury: Dark Passage, triple-shaft respond

The extraordinary quatrefoils of the fourth piers are compared to Great Paxton (Huntingdonshire) by Cherry, but the east/west faces of the Ely nave tribune minor piers are closer in scale and date, if not so exact a match. Without the great early-12th-century churches of Kent — or London or Essex — the source of Rochester's variety is uncertain, though I suggest that the links between these areas were stronger than we now think.[26]

Whatever the source or sequence of the nave arcades, what we see today poses a major question. Were there any vaults to the aisles, with tribune galleries or roof spaces at the middle storey, as can be found at all other 12th-century churches of this scale?[27] The evidence is contradictory. Uneven masonry to the aisle spandrels has been taken to indicate that vaults have been removed, though that to the spandrels of the north arcade includes a suspiciously horizontal line (Fig. 11), which (with a corresponding recess in the intervening pilasters) suggests that a wooden floor, rather than stone vaulting, has been removed.[28] However, there is no indication of any removed vaults at the west end of either aisle, particularly on the south, which is not known to have been refaced or rebuilt. Secondly, there is no decoration, not even a string-course, to the aisle side of the middle-storey arcade, which may suggest that these arches were not designed to be seen from the ground, as they are now. Thirdly, the varied nave piers all include an element to support a transverse arch across the aisle, but this element now supports only a flat pilaster rising up to the aisle roofs (except on the west responds, where the pilaster has a nook-shaft). Fourthly, the outer aisle walls have internal responds to support a transverse arch across the aisle (with external pilaster buttresses) in the normal Romanesque manner, though all but the two at the east end of the north nave aisle belong to the 1660s rebuilding.

However, it is those two original responds at the east end of the north aisle, with the west end evidence, that demonstrate that there were no vaults over the aisles of the post-1137 nave (Fig. 12). The original fabric of these two responds appears to rise to a level at least 3 ft above arcade capital level.[29] Not, of course, that their opposing piers

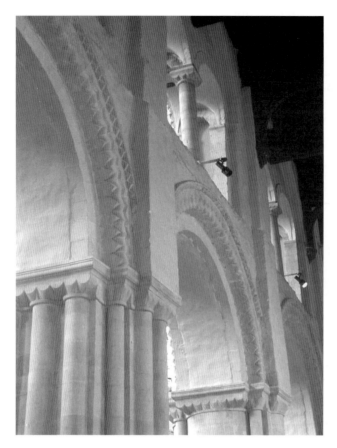

Fig. 11. Rochester Cathedral:
north nave arcade, facing into
the aisle

exist in 12th-century form, as they were rebuilt in the 13th century. There is a slim
possibility that these two eastern bays of the nave were always different, being part of
the original monk's choir and so somehow continuous with the level of the choir above
its crypt, as at Winchester for instance. However, there is no fabric evidence for such
an idea. The siting of these responds belongs to Gundulf's late-11th-century church,
and they are likely then to have supported transverse arches between groin vaults.[30]
Today, their miniature nook-shafts begin only at aisle window cill level and finish
below a billet moulding that may indicate aisle window nook-shaft capital level (a
short length still exists west of the westernmost pilaster). This upper level is much too
high for the springing point of a transverse arch at the capital level of the main piers
opposite. Such delicate nook-shafts do not appear on 11th-century pilasters, but are
commonly used at Rochester on the west façade (internally and externally) and are,
therefore, a post-1137 feature. There is a similar nook-shaft to the pilaster rising above
the abacus of the west respond of the north arcade on the aisle side, finishing in a
capital under a string-course at the base of the middle storey (Fig. 13). The equivalent
pilaster on the south has no nook-shaft, but it is crossed by a moulding at middle-storey
base level (as on the other south nave arcade pilasters). Both these elements clearly
preclude the building of any vault in the western bays. The evidence of the fragmentary

FIG. 12. Rochester Cathedral:
eastern bays of the north nave
aisle wall

surviving 12th-century fabric therefore demonstrates that no aisle vaults existed after
1137.[31]

The scarring in the spandrels of the main arcades needs to be explained, though, and
an obvious explanation is that vaults have been removed. When would this have
happened? The ambulatory vaults were removed from the east end of St Augustine's
Abbey, Canterbury around 1165.[32] At Waltham Abbey, the Romanesque nave aisle
vaults were probably removed in an early-13th-century remodelling exercise, perhaps
in an attempt to match up with the rebuilt east end.[33] However, once it is accepted that
the current arcades contain the core work from Gundulf's arcade, it becomes clear that
the scarring results from the removal of Gundulf's groin vaults after 1137. The
horizontal set-back visible on the pilasters and spandrels on the north side of the nave
arcade may then correspond to a wall-plate linking triangular trusses supporting the
subsequent taller aisle roof.[34] It is now impossible to determine how the post-1137
aisles were roofed and presented internally. The existing Vulliamy 1847 roof is clearly
much higher and shallower, being sprung from the walls heightened in 1802. The
inclined blind arcading to the parapet of the aisles on the west front probably gives the
original profile. Internally, these roofs could have been ceiled and decorated, supported
either on timber trusses, or possibly supported on transverse quadrant arches rising

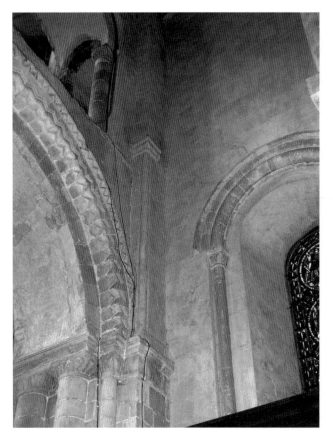

FIG. 13. Rochester Cathedral: west respond of the north nave arcade, aisle side

from the aisle pilasters to the base of the clerestory, a feature of middle-storey roofs like those at Durham.

The extraordinary passageway of the middle storey is also part of the argument for the post-1137 church having no aisle vaults, as it provides an east–west access along the length of the nave at this level.[35] The lack of a proper floor at mid-storey level elsewhere has not resulted in the creation of such a passageway; east–west access is achieved via wooden walkways placed above the vaults, as still exist at Lincoln. Nothing similar survives anywhere else in England, although these passages could be seen as a development of high-level wall passages above a main arcade (as in Tewkesbury nave for instance), or the wall passages seen in many transepts (e.g., Norwich). Blocked up since Scott's work of 1875–76,[36] the Rochester passage ran right through the walls and between the intermediate pairs of colonettes (Fig. 5). At the west end both passages connected to the walkway above the west door, in front of the lowest tier of internal arcading, presumably connecting with the transepts at the east end (Fig. 14). Their creation, immediately below clerestory passages that also connect across the west front, indicates that limited high-level circulation was important, though it is unlikely that any priest would ever have run nimbly along them.

McAleer suggests a liturgical function for the passages across the west front,[37] and as Rochester followed the customs of Christ Church, Canterbury, then perhaps there was

74

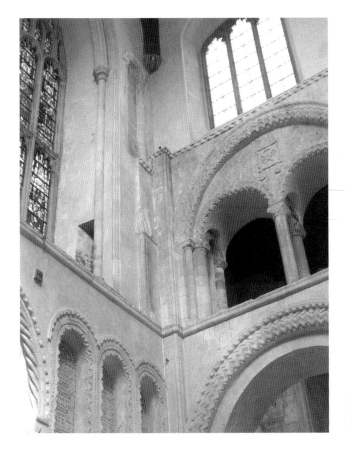

FIG. 14. Rochester Cathedral: junction of the north nave arcade with the west front

a predecessor for the nave passageway there. The interpretation of Gervase's description of the elevation of the Glorious Choir is disputed. Willis's reconstruction of a low blind arcade at the middle stage, with a dropped sill clerestory passage above, has been challenged by Francis Woodman, who reconstructs three alternative tribune designs.[38] A fourth design, similar to the elevations of St Bartholomew's, Smithfield (London), or Malmesbury Abbey (Wiltshire) could fit Gervase's description too. Whatever it looked like, Gervase wants to tell us that there was a solid wall broken by dark openings running all around the choir, though unfortunately he does not state its purpose. Whether something like the Rochester middle-storey passage, especially the widely spaced pair of colonettes, did exist somewhere in the early-12th-century choir at Canterbury (perhaps to cross the eastern 'transepts'), can now only be speculation. The decision having been made to retain Gundulf's nave but remove the aisle vaults, presumably to make taller aisle windows, the creation of a mid-level passageway would have entailed tunnelling through the surviving masonry above the main piers. The irregularity of the small arches still visible at either end of the tunnels may suggest that they are facings rather than integral with the building of the wall and vaulted passages.[39]

The resulting post-1137 elevation therefore follows the proportions of Gundulf's nave, completed before his death in 1108, and probably planned soon after the establishment of the Benedictine priory by Archbishop Lanfranc in 1082/83. A principal

difference lies in the use of bay-dividing wall-masts starting at the top of the main arcade capitals, rather than from floor level. (These masts no longer exist above the main arcade, but the scarring from their removal when the clerestory was built in the 15th century is plain.) There was no central space vault, and as the replacement stones to the saw-tooth clerestory string-course are so few, the masts must have risen to the wall-plate to support tie-beams (as can be seen now in the Winchester transepts). Although all the arcade piers have a central vertical element to their nave side, the wall-mast only connects visually with it on the easternmost piers, and even there it is smaller and clearly differentiated. The depth of the pier capitals and abaci creates a distinct horizontal line for the masts to sit on, and the masts themselves are then firmly crossed by a string-course above and below the middle storey. The resulting impression is of an elevation formed of horizontal layers, rather than the vertical bays that are likely to have existed in Gundulf's elevation. The layered arcading of the west wall, inside and out, also has a distinctly horizontal emphasis, an emphasis following the layered elevation of the Glorious Choir at Canterbury (1096–1130).

The choir of Peterborough Cathedral, begun by 1117 but possibly planned by Abbot Ernulf (1107–14), previously Prior of Christ Church (1096–1107) and later Bishop of Rochester (1114–24), also has wall-masts that begin above a series of varied pier designs. Bridget Cherry links the Peterborough use of alternating octagonal pier forms to the Glorious Choir.[40] The Peterborough tribune spandrels are diapered, like those at Rochester, and the Canterbury choir is most likely the source for both buildings (and possibly the use of wall-masts from capital level too). Diaper is certainly very evident in the early-12th-century Ethelbert Tower of St Augustine's Abbey and in Prior Wibert's mid-century work at Christ Church.

In his article 'The Construction of the West Door of Rochester Cathedral', Ron Baxter identifies the west door tympanum and column figures as an insertion of *c.* 1160 into a doorcase of *c.* 1140. However, the plain stonework behind the left-hand shaft-ring has been carved away to allow the ring to be inserted, and there is carving on the back of the ring, now hidden (Fig. 15). This reinforces Ron Baxter's argument for off-site prefabrication, but also implies that the ashlar frame for the door was in place before the ring was carved, *c.* 1140. The outer shaft is of two pieces of onyx marble,[41] presumably once matched on the right-hand side, where 1888 limestone shafts now exist. Similar onyx shafts are used in the work of Prior Wibert (1153–61) at Canterbury, for instance to the north entrance to the crypt from the north transept, and the infirmary cloister. The present doorway is certainly narrower than its predecessor, discovered by Livett,[42] and set further to the south of centre too. It is feasible, then, that Gundulf's west door survived until the west front was rebuilt at the end of the nave campaign, say in the late 1150s. The various discrepancies pointed out by Baxter may therefore be attributable to a confusion with the older, bigger dimensions of Gundulf's doorway.

There are many discrepancies between the north and south sides of the west front, not all of which can be explained by the ground level, rising quite quickly to the south, or the repeated rebuildings of the north-west corner (Fig. 16).

— From either the centre line of Gundulf's west door or the existing door, the façade extends further north than south.
— The north aisle bay enclosing arch is wider and slightly lower than that on the south.

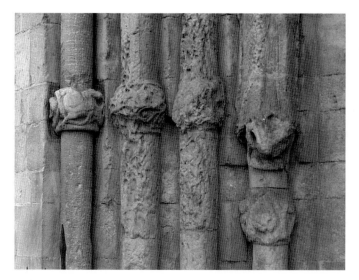

Fig. 15. Rochester Cathedral: northern jambs of the west door. The outer shaft ring sits in a rough recess dug out of the surrounding ashlar stonework

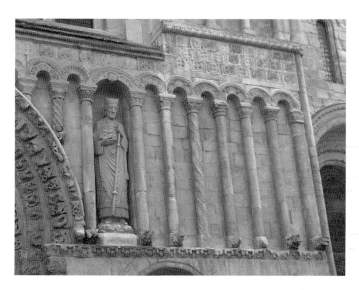

Fig. 16. Rochester Cathedral: lowest tier of arcading to the south of the west door. The shafts are supported on projecting sculptured corbels

— The north aisle west window is set lower in the arch than its southern equivalent, and set further to the south in the bay (and so off-centre to the enclosing arch).

— The northern inner stair-turret flanking the west window is larger, and the triple arcade of its lowest register more widely spaced than on the south side.

— The apex of the southern arched recess beside the west door is cut off by the string-course above (Fig. 16).

— The south aisle west window plane is at a distinct angle to the enclosing arch above, which is not the case on the north (Fig. 17).

FIG. 17. Rochester Cathedral: west window of the south nave aisle. The window's plane is at an angle to the enclosing arch and stonework of the west front

Are some of these inaccuracies perhaps due to a refacing of Gundulf's façade, at the end of the post-1137 nave campaign? Before Pearson carried out his work in the 1880s, indeed, when Cottingham was remaking the central west window in 1825, the major structural problem with the façade was perceived to be the detachment of the external facing from the core, which is more likely to happen if they are not part of the same build.[43] The present façade may owe more to its predecessor than we think.

Parallels have been drawn by Deborah Kahn between much of the architectural detailing of the west front and Wibert's contemporary work. However, two specific details suggest that the Ethelbert Tower at St Augustine's Abbey is a major source of inspiration for the designer of the Rochester façade. Both Philip McAleer and Richard Gem have argued that the tower was built in c. 1100, providing parallels for some of its features in the post-1096 cathedral crypt.[44] The tower had superimposed blind arcades to its corner stair-turrets, with much diaper work and decorated string-courses, just as at Rochester. The four shafts of the lowest range of arcading rise from sculptured corbels and not bases, just like the arcading around the west door at Rochester (Fig. 16). Secondly, the square turrets of Ethelbert's Tower taper into an octagon, also decorated with blind arcades, just as at Rochester. By contrast, Prior Wibert's c. 1160 stair towers at Christ Church, Canterbury (with extensive use of diaper and arcading in a very similar character to Rochester) remain resolutely square to roof level, though staircases to the angled eastern choir chapels possibly finished octagonally (Fig. 18). Perhaps the Ethelbert Tower, although possibly two generations earlier, provided the inspiration for the large octagonal turrets on the Rochester west front; given its date, Gundulf's façade may have had similar features.

Chris Miele has shown that when Cottingham renewed the west window in 1825, he also removed much Romanesque diaper work that survived in the spandrels, though it is most likely that these carved stones had been rearranged when the window was created in the mid-15th century.[45] The diaper types can be found in the existing west façade, but the survival of one or two grotesque heads in a roundel provide another link to Christ Church and its much more sophisticated roundels, discovered in the cloister arcade walling, but thought to have come from Wibert's choir screen.[46]

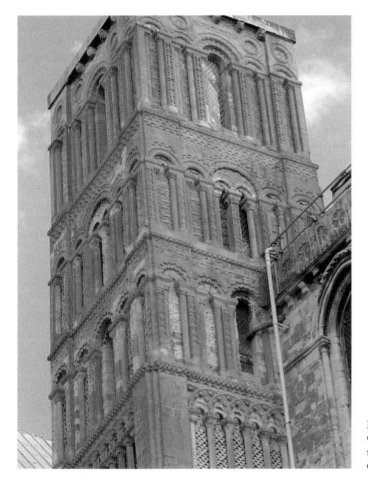

Fig. 18. Christ Church, Canterbury: north-west staircase tower to the south-east transept

Roundels, also reset, can be seen in the late-12th-century church at Barfreston near Canterbury, flanking a round wheel-window that has parallels at Patrixbourne (Kent), whose south door sculpture is linked to that of Rochester's west door. Barfreston's chancel arch responds also use large shaft-rings, like those on the Rochester west door, and similar to excavated examples from both Canterbury abbeys.

The use of a large round window in these parish-church east end elevations is likely to reflect the design of a principal elevation of a major church, at Rochester or Canterbury — the post-1174 transepts at Christ Church have large round windows, without tracery. From what remains internally at Rochester, there were at least two levels of arcading across the west front, both with passages running across the façade. The lower was approached from the stair-turrets at the outer corner of each aisle, and also could be accessed from the nave middle-storey passageway. The upper level presumably linked with the nave clerestory passage, via the staircases flanking the west window, and could have run in front of the base of a large round window. Doors exist for a third passage at gable base level.[47]

79

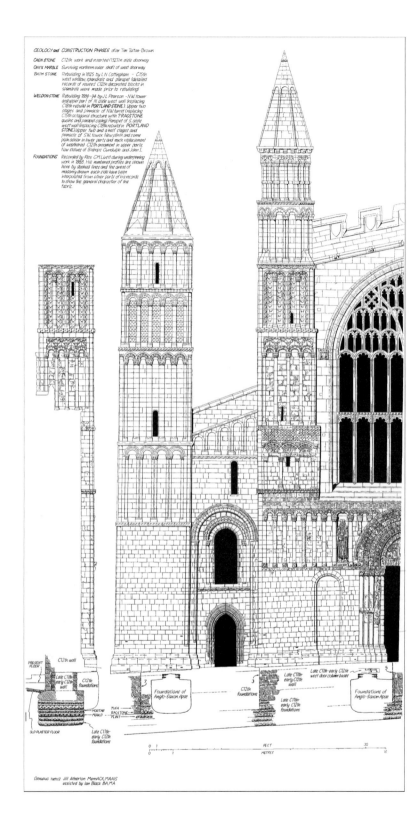

GEOLOGY and CONSTRUCTION PHASES after Tim Tatton-Brown

CAEN STONE C12th work and inserted C12th aisle doorway

ONYX MARBLE Surviving northern outer shaft of west doorway

BATH STONE Rebuilding in 1825 by L N Cottingham. - C15th
west window, spandrels and parapet (detailed
records of reused C12th decorated blocks in
spandrels were made prior to rebuilding)

WELDON STONE Rebuilding 1889-94 by J L Pearson - N W tower
and upper part of N aisle west wall (replacing
C18th rebuild in PORTLAND STONE.) Upper two
stages and pinnacle of N W turret (replacing
C15th octagonal structure with ? RAGSTONE
quoins and parapet coping. Parapet of S aisle
west wall (replacing C18th rebuild in PORTLAND
STONE.) Upper two and a half stages and
pinnacle of S W tower. New plinth and some
pink ashlar in lower parts and much replacement
of weathered C12th ornament in upper parts.
New statues of Bishops Gundulph and John I.

FOUNDATIONS Recorded by Rev. G H Livett during underpinning
work in 1888. His membrane profiles are shown
here by dashed lines and the areas of
masonry drawn each side have been
interpolated from other parts of his records
to show the general character of the
fabric.

PRESENT
FLOOR C12th wall

Late C11th-
early C12th
wall C12th
foundations

TUFA
MORTAR
MOULD TUFA
RAGSTONE
'PLAN'

OLD PLASTER FLOOR Late C11th-early
C12th
foundations

Foundations of
Anglo-Saxon Apse

C12th
foundations Late C11th-early
C12th
wall

Late C11th-
early C12th
foundations

Late C11th-early C12th
west door column bases

Foundations of
Anglo-Saxon Apse

0 1 FEET 30
0 1 METRES 10

Drawing traced Jill Atherton MemACIL MAAIS
assisted by Ian Block BA,MA

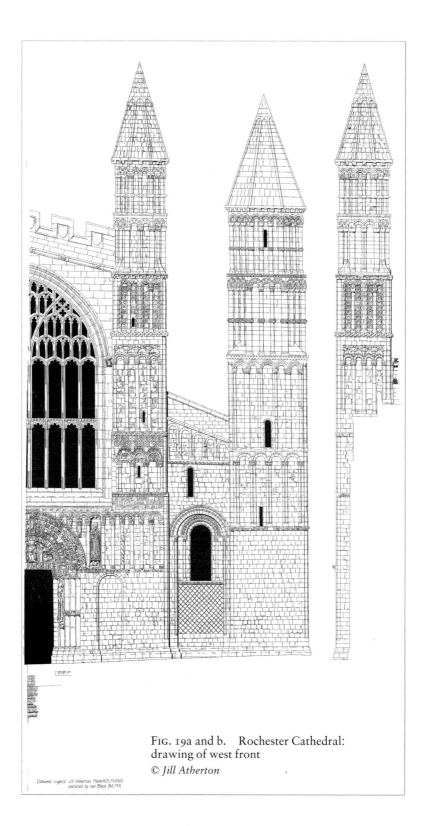

FIG. 19a and b. Rochester Cathedral: drawing of west front

© Jill Atherton

Just such an elevation still exists at St Botolph's, Colchester (Essex), across the Thames estuary, with a lower passage equivalent to tribune floor level and an upper passage across the front of the big round west window. The latter is lower than the nave clerestory passage, because the Colchester nave elevation follows the East Anglian norm of having tribunes little smaller than the aisles. Externally, there are further parallels with Rochester: the blind arcading (particularly as it collides with the central door, though there are no corbel bases to the shafts) and the two tall recesses either side of the central doorway. These blind recesses at Rochester, with the taller enclosing arches at the end of each aisle, may have been a continuation of shallow external arches articulating the nave clerestory or aisles, a feature seen in both Canterbury abbey churches. From what is left of the west door capitals and other decorative details, I believe that St Botolph's is nearer 1140 in date than the 1160 given by Philip McAleer, following published sources.[48] There are other links between Rochester and Colchester, beyond proximity, that could promote an architectural link between them.[49] Another Essex priory known only from excavation, the Benedictine Earls Colne, had a similar west-end plan to St Botolph's, possibly laid out after its foundation c. 1100–05, but nothing is known of the elevation.[50]

However, as Colchester had towers to each end of its screen façade and three doors, as well as an internal elevation in the East Anglian tradition, it is unlikely to be a direct source. In his extensive exploration of the development of the English west façade, the closest parallel that McAleer has found to Rochester is Lindisfarne Priory (c. 1135–40), with its single west door and enlarged corner stair-turrets. As Lindisfarne is rather remote from Rochester and very much within the Durham orbit, it too would seem unlikely to be a direct source. It is more likely that both Colchester and Rochester are derived from lost buildings in Essex and Kent (or even London): as McAleer establishes, these were only two of many English façades using ranks of arcading in the first half of the 12th century.

CONCLUSION

THE various rebuildings and modern restorations, coupled with imprecise documentary evidence and a lack of contemporary buildings, make firm conclusions about Romanesque Rochester difficult to reach. On the evidence presented in this article, the following may be concluded.

— Gundulf's nave, completed by his death in 1108, was rebuilt after the 1137 fire, presumably because it had been badly affected by it. The 11th-century dimensions and much of the core work were retained, at least to arcade height internally, and probably higher in the west façade.

— Because there was much reuse of Gundulf's core work, there are a number of discrepancies in the masonry and setting out, particularly on the south arcade. This, together with some stylistically more advanced features, suggests that the north nave elevation used less of Gundulf's work and was completed after the south, possibly to accommodate continued use of the parochial altar of St Nicholas after the fire.

— Gundulf's aisle (groin) vaults were removed but not replaced, to gain larger windows. To retain east–west access at middle-storey level, possibly for liturgical purposes, a passageway was incorporated within the thickness of the nave elevation, again allowing more light into the main space.

— The splendidly varied nave pier designs are part of an overall decorative richness that would seem to continue the approach and forms first seen in Canterbury, particularly in the Glorious Choir after 1096, but probably developed throughout the south-east of England.

— The highly decorated façade of Rochester Cathedral is firmly in a local mid-12th-century English Romanesque style, with some decorative details and the octagonal stair turrets sourced from Ethelbert's Tower at St Augustine's Abbey, Canterbury. However, it is possible that its overall form owed something to its predecessor built by Gundulf, also looking to Canterbury for inspiration.

ACKNOWLEDGEMENTS

I am most grateful to Tim Tatton-Brown for sharing his thoughts and arranging high-level access for me. Anyone studying Rochester Cathedral is also indebted to Dr Philip McAleer for his enormous diligence in bringing together previous often contradictory accounts in his numerous studies.

NOTES

1. J. Philip McAleer, *Rochester Cathedral 604–1540: An Architectural History* (Toronto 1999), 159–61.

2. ibid., 30–32, 58–59, 60. The decorated internal string-course to the west bay of the south aisle is surely of the 1660s.

3. ibid., 59–60.

4. W. H. St John Hope, *The Architectural History of the Cathedral Church and Monastery of St Andrew at Rochester* (London 1900).

5. McAleer, *Rochester Cathedral*, 75, concludes the nave was totally rebuilt in the 1140s. E. C. Fernie, *Architecture of Norman England* (Oxford 2000), 260, dates the nave to the 1120s, without further comment, but A. W. Clapham, *English Romanesque Architecture II: After the Conquest* (Oxford 1930), 143, dated it 1140–50.

6. McAleer, *Rochester Cathedral*, 28.

7. ibid., 32; G. M. Livett, 'Foundations of the Saxon Cathedral at Rochester', *Archaeologia Cantiana*, 18 (1889), 274–75, and pl. II nos 3 and 5.

8. McAleer, *Rochester Cathedral*, 45.

9. ibid., 67–68. For the gift of Boxley church, see Martin Brett, 'The Church at Rochester, 604–1185', in N. Yates and P. A. Welsby ed., *Faith and Fabric: A History of Rochester Cathedral 604–1994* (Woodbridge 1996), 23.

10. M. J. Swanton, 'A Mural Palimpsest from Rochester Cathedral', *Archaeol. J.*, 136 (1979), 125–35.

11. A. Oakley, 'Rochester Priory, 1185–1540', in *Faith and Fabric*, 35.

12. Gervase of Canterbury, *Historical Works*, ed. W. Stubbs (Rolls Series, LXXIII, 1879–80), I, 100 (1137 fire), 292 (1179 fire). McAleer, *Rochester Cathedral*, 68 (and 84 for the 1179 fire). The only visible fire-reddened Romanesque stones are those reused in the buttress blocking the east end of the north nave arcade, inserted under the 13th-century arch at an unknown date, to reinforce the central tower supports; ibid., 104.

13. VCH, *Kent*, II (1926), 122.

14. McAleer, *Rochester Cathedral*, 73–75.

15. ibid., 42–44, figs 19 and 20. B. C. Worssam, 'A Guide to the Building Stones of Rochester Cathedral', *Friends of Rochester Cathedral: Report for 1994/95* (1995), 25.

16. See Brett in Yates and Welsby, *Faith and Fabric*, 24–25. The priory was also heavily in debt in the early 1140s.

17. Richard Gem, 'The Significance of the 11th Century Rebuilding of Christ Church and St Augustine's Canterbury in the Development of Romanesque Architecture', in *Medieval Art and Architecture at Canterbury before 1200*, ed. N. Coldstream and P. Draper, *BAA Trans.*, v (London 1982), 13.

18. Gem, 'Canterbury', 12, fig. 5 suggests that the existing easternmost nave piers are Gundulf's. Their simple cruciform design is certainly consistent with a late-11th-century date; however, the masonry tooling, joints and stone size are all consistent with post-1137 work. The same pier form exists in Prior Wibert's Treasury undercroft at Canterbury Cathedral. McAleer, *Rochester Cathedral*, 217 n. 37 notes that Richard Gem considered the Rochester piers to be reproductions of the 11th-century design in his 1973 Ph.D. thesis. McAleer

also rejects the idea of the piers being Gundulf's, as 'these piers stand on simple, large, square chamfered bases like all the others'.

19. McAleer, *Rochester Cathedral*, 43, rejects the refacing concept, but agrees on stylistic grounds that the south arcade was built first.

20. Similar chevron circles are used on the spandrels of the Green Court Gate to Christ Church, Canterbury, and the upper storey of Wibert's transept staircase towers on the cathedral (Fig. 18).

21. McAleer, *Rochester Cathedral*, 31.

22. D. Kahn, *Canterbury Cathedral and its Romanesque Sculpture* (London and Austin 1991), 103, 169.

23. McAleer, *Rochester Cathedral*, 74. Further comparative details are the extensive use of miniature nailhead within mouldings and the multi-sided pyramids used within the lowest string-course of the Rochester west front, and the hood-mould of the Canterbury Aula Nova staircase.

24. B. Cherry, 'Romanesque Architecture in Eastern England, *JBAA*, CXXXI (1978), 24–25.

25. McAleer, *Rochester Cathedral*, 73–74 and 77–78.

26. An intriguing personal link is the appointment of Prior Conrad of Christ Church, Canterbury, to be Abbot of St Benet Holme, near Norwich, in 1126.

27. McAleer, *Rochester Cathedral*, 69–70.

28. McAleer, ibid., 70 suggests that the uneven masonry shows 'preparation for, or at least the intention to erect, vaults'.

29. McAleer, ibid., 70 suggests the 'extension' to each of these responds came after the decision to abandon vaulting during construction.

30. Gem, 'Canterbury', fig. 5.

31. The existence of a single, 12th-century, diagonally placed corbel on the aisle side of the penultimate south nave pier — as though to support a diagonal rib — is inexplicable.

32. Gem, 'Canterbury', 10.

33. E. C. Fernie, 'The Romanesque Church at Waltham Abbey', *JBAA*, CXXXVIII (1985), 52.

34. Such a line is not visible on the back of the south arcade, nor does Irving report one. This could mean that the south aisle roof was constructed differently to the north, or that these spandrels were finished differently — after 1137, or in subsequent restorations.

35. J. Newman, *West Kent and the Weald*, 2nd edn (B/E, repr. 1980), 474, asserts that no vaults can have been built, because of the existence of the middle-storey passage.

36. McAleer, *Rochester Cathedral*, 220, n. 50.

37. ibid., 82.

38. F. Woodman, *The Architectural History of Canterbury Cathedral* (London 1981), 65–72.

39. McAleer, 223, n. 67 asserts that the passageway was built with the arcade, but with no supporting evidence. Like Clapham, *After the Conquest*, 55 n. 2, I believe it possible for the passageway to have been 'contrived in the thickness of the [existing] main wall'. Unblocking one of the passages and investigating the walling could answer this question.

40. B. Cherry, 'Eastern England', 25.

41. Tim Tatton-Brown, 'Building Stone in Canterbury c.1075–1525', in *Stone: Quarrying and Building in England*, ed. D. Parsons (Chichester 1990), 74–75.

42. G. M. Livett, 'Foundations', 274.

43. C. Miele, 'The West Front of Rochester Cathedral in 1825: Antiquarianism, Historicism and the Restoration of Medieval Buildings', *Archaeol. J.*, 151 (1994), 400–19. Livett, 'Foundations', 277, also refers to 'hideous shores' to the west front before Pearson's work.

44. Richard Gem ed., *St Augustine's Abbey, Canterbury* (London 1997), 117: a date 'early in the abbacy of Hugh (1108–26) seems likely, if not already in the interregnum following Wido's death c.1093'. J. Philip McAleer, 'The Ethelbert Tower of St Augustine's Abbey, Canterbury', *JBAA*, 140 (1987), 96–99.

45. Miele, 'West Front', 415.

46. Kahn, *Canterbury Cathedral*, 169.

47. J. Philip McAleer, 'The West Front of Rochester Cathedral: The Interior Design', *Archaeologia Cantiana*, 103 (1986), 27–43, gives a full description.

48. J. Philip McAleer, 'The Significance of the West Front of Rochester Cathedral', *Archaeologia Cantiana*, 99 (1983), 139–58. McAleer, *Rochester Cathedral*, 78–83 summarises his extensive research into the place of Rochester's west front in English west façades.

49. The king's steward, Eudo Dapifer (d. 1120), who built St Botolph's, was a benefactor of Gundulf's Rochester, and as he built Colchester Castle, he may well have worked with Gundulf, who was also renowned as a builder. When Eudo founded the Benedictine Abbey of St John in Colchester, Rochester supplied the first monks.

50. F. H. Fairweather, 'Colne Priory, Essex and the Burials of the Earls of Oxford', *Archaeologia*, 87 (1937), 275–95.

The Construction of the West Doorway of Rochester Cathedral

RON BAXTER

The west doorway of Rochester Cathedral has generally been considered to be a curiously English mixture of French styles, combining the radiating voussoirs and many of the motifs of Aquitainian portals with the Christ in Majesty iconography and column figures of the Île-de-France. Earlier studies have concentrated on stylistic features of the carving, but an examination of its structure reveals that an elaborate composition of the 1140s was deliberately modified some twenty years later in response to avant-garde changes in French portal design.

THE west doorway of Rochester Cathedral (Fig. 1) has attracted a good deal of attention in the literature, and this is as it should be, since it is clearly a high-quality work and of a form unique in England.[1]

It has five orders, with a tympanum, lintel and a carved label. The inner order is supported on half-columns, and the other four on detached *en délit* nook-shafts with foliate and figural shaft-rings. On the second order are two column-figures: male on the left and female on the right. The male figure is crowned, carries a sceptre, and is usually identified as King Solomon. The female has lost most of her head and bears a scroll. She is generally called the Queen of Sheba. The nook-shafts and half-columns of the embrasure are topped by elaborately carved block-and-cushion capitals with foliate imposts. The tympanum depicts Christ enthroned in a mandorla supported by a pair of standing angels and surrounded by the four symbols of the Evangelists. The lintel is joggled and carved with twelve seated Apostles, of which the outer two are enclosed in medallions, separated from the others by colonnettes and carved in much lower relief. The five orders of archivolts are made of radiating voussoirs carved with human, monstrous and foliage motifs. Unusually the inner archivolt rests on the lintel, and between the first and second archivolts is a barley-sugar twist roll, carved on the voussoirs of the second order.

The doorway is entirely Caen stone, except for the outermost nook-shaft on the north jamb, which is of onyx marble.[2] The corresponding shaft on the south side is a 19th-century replacement. The use of onyx marble was very rare in 12th-century England, but it also occurs in the mid-century work at Canterbury Cathedral, in the Treasury, the infirmary cloister, and the north entrance to the crypt.

There was a major restoration of the doorway by J. L. Pearson in 1888, but fortunately drawings made by George Scharf in 1850 make clear both the pre-restoration state of the sculpture and the extent of the restoration in the upper part of the doorway.[3] In 1850, most of the sculpture was in a fair condition, with the exception of the left side of the label and the left side of the outer order of archivolts, both of which were practically eroded away. Pearson replaced all of this with entirely invented

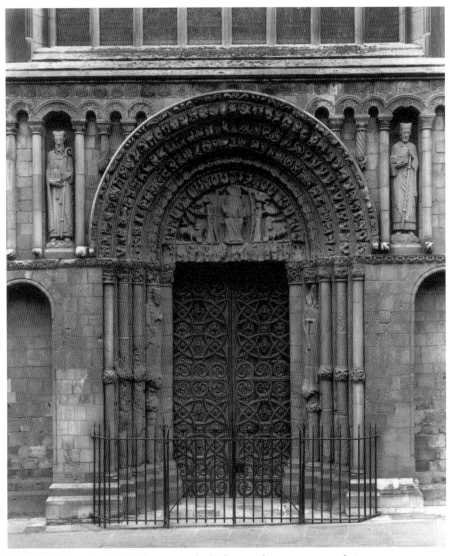

FIG. 1. Rochester Cathedral: west doorway, general view
Conway Library, Courtauld Institute of Art

motifs. The remainder of the archivolt and label, along with the tympanum and capitals, appear to have remained unaffected by Pearson's restoration.

With its radiating voussoirs, column-figures and Christ in Majesty tympanum, the doorway seems more like a French portal than an English one, and the literature has focused on this single aspect, and in particular on the design and stylistic parallels with sculpture in various regions of France. As early as 1859, Ferguson noted that the ensemble should be deemed continental rather than English,[4] and a century later a similar position was taken by Fritz Saxl, who omitted it from his survey of English

12th-century sculpture on the grounds that 'it was merely an imitation of French work and conveyed nothing of the English contribution'.[5]

The first detailed treatment of the portal to have a significant impact on later writers is found in E. S. Prior and A. Gardner's magisterial survey of 1912.[6] Their suggestion was that the portal we see today was the result of three separate campaigns. The original west front of *c.* 1130 was overlaid with a richer scheme some ten years later, and the head of the doorway and column-figures were inserted at a later stage, after the 1137 fire, but before *c.* 1180. This interpretation was largely followed by both Boase and Stone in the 1950s.[7] Stone, for example, dated the nook-shafts with their shaft-rings and capitals to the 1130s, and the tympanum, archivolts and column-figures to 'soon after the middle of the century'.[8]

As so often in the field of English Romanesque sculpture, interpretations of the second half of the 20th century were conditioned by the published opinions of George Zarnecki. Rochester is an especially interesting case, because Zarnecki changed his mind twice about it. His earliest thoughts, published in 1953, visualised two campaigns of work.[9] On the one hand, 'the radiating voussoirs of this doorway are so entirely Poitevin in character that they could have been executed by a sculptor from that region'.[10] On the other, the tympanum and column-figures were more typical of Early Gothic Île-de-France sculpture, and Zarnecki was inclined to connect this influence with the arrival of French sculptors in Canterbury for William of Sens's rebuilding of the choir.[11] He therefore suggested that the original doorway dated from *c.* 1160, when the nave was completed, and that the tympanum and column-figures were added *c.* 1175. He disagreed with Stone and Boase in attaching the archivolts to the same campaign as the supports (except for the column-figures), and in identifying two distinct sources of French influence.

By 1963 he had changed his mind:

at one time I believed that these two column-figures were later insertions, but now, after the recent cleaning of the façade, it is clear that they were part of the original scheme and date from *ca.*1175.[12]

In the same paper he introduced the destroyed Colchester Moot Hall window into the argument:

another work of the same workshop existed in Colchester until it was destroyed shortly before 1845 ... as at Rochester, the radiating voussoirs of Aquitaine were used in conjunction with column-figures.[13]

By 1972 his view on the dating, though not the number of campaigns, had changed again. The reason for the change rested on the discovery of a single, joggled voussoir at Dover Priory, presumably carved before the dedication of 1160, and attributed to the same workshop. Zarnecki redated the Rochester portal to *c.* 1160, a date that has generally been accepted.[14]

What stands out from all this is that discussions of the doorway, even those related to the number and order of campaigns of work involved, have centred on perceived stylistic anomalies rather than on the archaeology of the portal itself. However, in what follows I shall attempt to demonstrate that a close examination of the doorway's construction can clarify many of the points of contention found in the literature.

CONSTRUCTIONAL ANOMALIES

A close examination of the portal reveals five disjunctive features demanding an explanation: four in the tympanum and archivolts, and one in the embrasures.

1. Asymmetry of the Doorway

A head-on view of the doorway very soon reveals that the upper levels are shifted slightly but distinctly to the right of the embrasure (Fig. 1). The first clue is the figure of Christ, which is displaced from the centre-line of the doors. Likewise, the inner edge of the first order of archivolts lines up with the edge of the impost on the left, but not on the right. Similar displacements may be seen in the positions of the second and third orders, and it is not until we reach the fourth that symmetry is at last achieved. This might be dismissed as insignificant, were it not that there is clear evidence, on one side at least, of where the archivolts were meant to fall on the imposts. Between the first and second imposts is a step, obviously meant to accommodate the barley-sugar twist roll separating the first two archivolts. On the right the roll is displaced outwards from this step by a good 10–15 cm (Fig. 2). The step is not so obvious on the left side, but here the roll falls in the expected position.

2. Trimming of the Tympanum

THE tympanum is made up of ten small pieces of Caen stone, many of which have been trimmed (Fig. 3). At the lower left of the tympanum, the lion of St Mark stands on a square fillet which, since it makes a turn at the angle, must originally have surrounded the entire tympanum but has been trimmed away subsequently. The return does not appear on the right corner at all, and there are other signs of trimming on the right edge, where the wings and tail of the eagle and the wings of the angel and ox have all been shortened. Perhaps the most striking piece of trimming is the mandorla, which is a distinctly odd shape. Its top is discontinuous with its sides, and its bottom is missing entirely, along with most of Christ's footstool.

3. Trimming of the Inner-order Voussoirs

THE voussoirs of the inner order have also been trimmed. This is most obvious at the one o'clock position, alongside the eagle symbol on the tympanum (Fig. 3).

4. Relationship of the Lintel to the Inner Archivolt

THE lintel is joggled, which is to say that it consists of stones, eight in this case, that interlock like the pieces of a jigsaw puzzle. This technique is rare in England,[15] though not unknown in Normandy, where several uncarved joggled arches may be seen in the west range of monastic buildings at Jumièges.[16] The Rochester lintel is unusual in extending well beyond the tympanum on either side to support the curtailed inner archivolt. It has also been shortened on the left, where the outer Apostle has lost part of his roundel.

5. Shaft-rings

BOTH Boase and Stone noted that if, as they contended, the column-figures were later insertions, the shaft-rings of the inner order of nook-shafts would have had to be moved, and this is exactly what seems to have happened. In the original design, all eight shaft-rings formed a horizontal row at the mid-line of the embrasure.

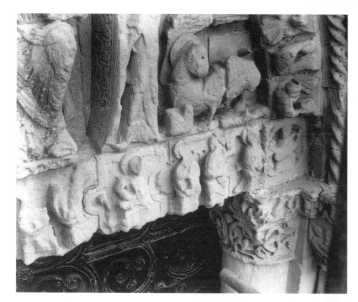

FIG. 2. Rochester Cathedral: west doorway, right-hand end of lintel and impost from above. Note the disjunction between the barley-sugar twist roll and the step on the impost where it was intended to fall

Conway Library, Courtauld Institute of Art

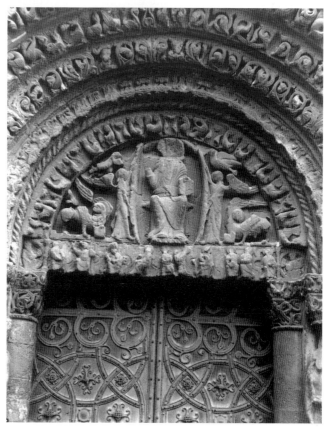

FIG. 3. Rochester Cathedral: west doorway, tympanum and lintel

Conway Library, Courtauld Institute of Art

THE MODIFICATION OF THE PORTAL

THE drastic trimming that was necessary to accommodate the tympanum demonstrates that it cannot have been an original feature of the design, but must have been available when the decision was taken to insert it. The trimming was complex, and decisions had to be taken about which parts of the carving could be lost without doing too much violence to the overall design. The figure of Christ and the top and bottom of the mandorla are carved on three blocks of equal width, laid on the central axis of the tympanum (Fig. 4). The lowest of these blocks was cut back at the bottom, removing the entire lower part of the mandorla and the bottom of the footstool. The blocks on either side were cut back at the top and sides, causing the losses to the Evangelist symbols noted above. The whole was reassembled with Christ placed lower down and the awkward disjunction between the top and sides of the mandorla that we see today. Looking at the pattern of the stone removed, it is striking that the losses are greatest on the central axis of the tympanum and on the right-hand side. If Christ is restored to his original height, and assumed to occupy the central axis, the original semicircular form of the tympanum can be reconstructed (Fig. 5). Despite these major modifications, it was still not possible to accommodate the tympanum, and the intrados of the inner archivolt had to be trimmed slightly to fit in what remained of the Eagle of St John. To support the inserted tympanum it was necessary to provide a lintel that rested on the imposts, and to accommodate that, the lowest voussoirs of the inner archivolt had to be removed (Fig. 2). It may well be that the decision to use a joggled lintel was related to the practicalities of inserting the tympanum.

It must have been during the insertion of the lintel that it was discovered that the original arch was not centrally placed, but was significantly shifted to the right, and that there was thus less space available for the stone showing the last two Apostles on the left, which had to be shortened slightly.[17]

There is no way of knowing, of course, whether the column-figures were inserted at the same time, but it seems likely. The coursing of the column-figures, with a break at the same level as the tops of the shaft-rings on the other shafts, allows us to reconstruct the sequence of events (Figs 1 and 7). The old nook-shaft was removed and the sections above the shaft-ring discarded. Each column-figure was carved on two blocks of Caen stone, the upper block being the same height as the discarded section of shaft. The lower section of the old shaft, with its ring, was then cut to size, and the whole reassembled.

THE ORIGINAL PORTAL

THE original scheme looked much more like an Aquitainian portal, with its multi-ordered composition and radiating voussoirs (Fig. 9). The use of half-column supports for the inner order was also common in this area, especially in Poitou-Charente, where it was used in combination with nook-shafts at Chalais and Aubeterre (both Charente), and at Saint-Nazaire at Corme-Royal (Fig. 6), the Abbaye aux Dames at Saintes, and the gateway of the former hospital at Pons (all Charente-Maritime). Tcherikover dates the portal at Saintes to c. 1120–30, and I suspect that the remainder were completed by c. 1140.[18] A date in the 1140s would thus seem likely for the original portal at Rochester. Shaft-rings were not a feature of Aquitainian portals, however, although they had some local popularity in Kent, where they appear on chancel arches at Hythe and Barfreston.[19]

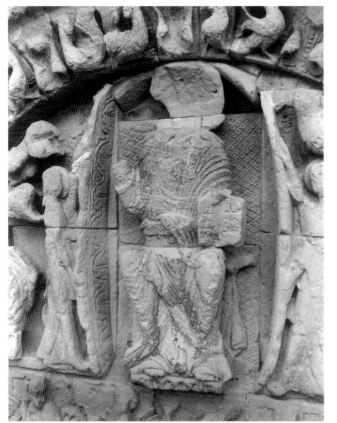

FIG. 4. Rochester Cathedral:
west doorway, tympanum,
Christ in Majesty

*Conway Library, Courtauld
Institute of Art*

FIG. 5. Rochester Cathedral:
west doorway, tympanum,
reconstruction showing the
original position of Christ

Ron Baxter

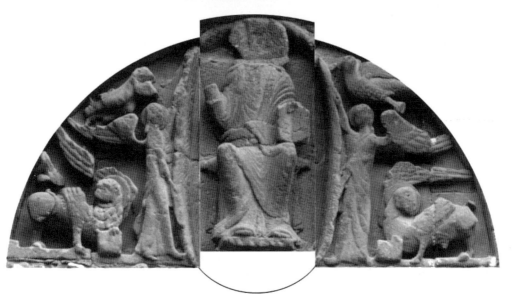

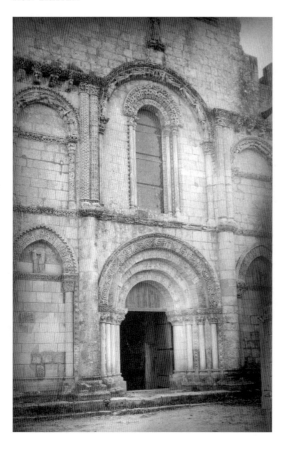

FIG. 6. Corme-Royal, Saint-Nazaire
(Charente-Maritime): west front
Conway Library, Courtauld Institute of Art

THE REMODELLED PORTAL

THE addition of a Christ in Majesty tympanum with an appropriate lintel and column figures can only have been a response to the exciting changes in portal design that swept outwards from the Île-de-France in the wake of the unveiling of the Royal Portal at Chartres. More specifically the remodelling at Rochester owes a good deal to the Chartrain south portal of Le Mans Cathedral, normally dated before 1158, since it seems to belong with the nave rebuilding, which was completed in that year.[20] The female column-figure at Rochester, with her scroll held in her left hand, supported by her right, her long plaits, and long knotted girdle, is practically identical to one at Le Mans (Figs 7 and 8). In the light of this, it seems reasonable to place the remodelling of the west doorway of Rochester in the 1160s.

 The final question to be addressed concerns the inserted tympanum. Although it contributes to the Île-de-France appearance of the ensemble, in formal terms its composition is closer to the Burgundian models on which the Royal Portal group was based. Unlike Chartres and Le Mans, the Rochester tympanum includes a pair of angels supporting Christ's mandorla, as well as the four Evangelist symbols surrounding it. The same elements are found on the north narthex portal at Charlieu (Loire), although there Christ's throne is much more elaborate and the supporting angels are carved with

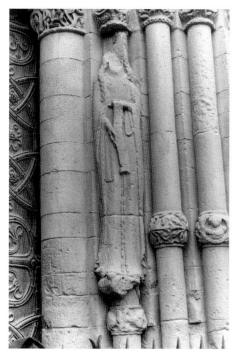

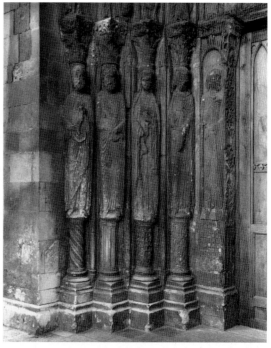

FIG. 7. Rochester Cathedral: west
doorway, female column-figure
Conway Library, Courtauld Institute of Art

FIG. 8. Le Mans Cathedral: south doorway, left
embrasure. The female column-figure third from left
has the same design as the Rochester queen
Conway Library, Courtauld Institute of Art

extreme contrapposto. The west portal of Semur-en-Brionnais (Saône-et-Loire) has a similar composition, but here the symbols are in a different sequence, and the angels have two pairs of wings. Both the west tympanum of Cluny III and the small Majesty tympanum from Saint-Benigne at Dijon (Côte d'Or), now in the Departmental Museum, had four supporting angels rather than two, but in spite of this difference, it is the latter that perhaps offers the closest Burgundian parallel to the Rochester composition (Fig. 10). Dating from *c.* 1160, this is significantly later than the other Burgundian examples, and is discussed by Sauerlander as much in terms of its Île-de-France contemporaries as its local progenitors.[21]

Whatever the tympanum's art-historical ancestry, it must have been carved with a different setting in mind before the decision to include it in the remodelling programme was taken. It must have been produced, along with the column-figures, in the 1160s, and it may be that the initial intention at that time was to rebuild the west doorway completely along Chartrain lines.

93

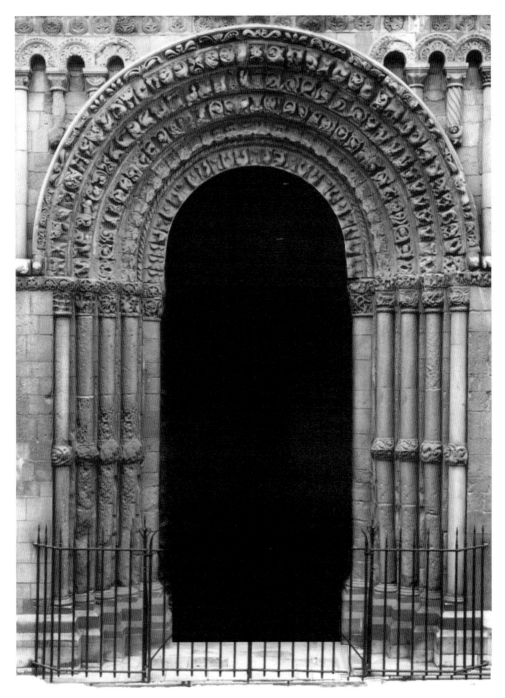

FIG. 9. Rochester Cathedral: west doorway, reconstruction of the original design
Ron Baxter

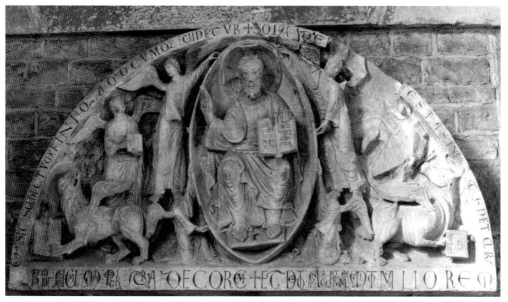

FIG. 10. Dijon, Saint-Benigne (Côte d'Or): tympanum now in the Musée Départmental des
Antiquités de la Côte d'Or

Conway Library, Courtauld Institute of Art

ACKNOWLEDGEMENTS

I should like to thank Hazel Gardiner of the Corpus of Romanesque Sculpture in Britain and Ireland for her invaluable work in producing two reconstructions, and Kathryn Morrison for her help in the analysis of the portal structure, and for her perceptive comments on the many draft stages through which this paper has gone.

NOTES

1. See especially W. H. St John Hope, *The Architectural History of the Cathedral Church and Monastery of St Andrew at Rochester* (London 1900); E. S. Prior and A. Gardner, *An Account of Medieval Figure Sculpture in England* (Cambridge 1912), 201; G. Zarnecki, *Later English Romanesque Sculpture* (London 1953), 39–40; T. S. R. Boase, *English Art 1100–1216* (Oxford 1953), 205–06; L. Stone, *Sculpture in Britain: The Middle Ages* (Harmondsworth 1955), 84–85; G. Zarnecki, 'The Transition from Romanesque to Gothic in English Sculpture', in *Acts of the 20th International Congress of the History of Art*, I (New York 1963), 152–58 (reprinted in G. Zarnecki, *Studies in Romanesque Sculpture* (London 1979)); G. Zarnecki, 'A Twelfth-century Column-figure from Minster-in-Sheppey in Kent', in *Kunsthistorische Forschungen Otto Pächt zu seinem 70. Geburtstag* (Vienna 1972) (reprinted in Zarnecki, *Studies*, XIV, 1–9); J. P. McAleer, 'The Significance of the West Front of Rochester Cathedral', *Archaeologia Cantiana*, 99 (1983), 139–58; D. Kahn, 'The West Doorway at Rochester Cathedral', in *Romanesque and Gothic: Essays for George Zarnecki*, ed. N. Stratford, 2 vols (Woodbridge (Suffolk) 1987), I, 129–34.

2. B. Worssam, pers. comm.

3. Kahn, 'West Doorway', 130.

4. J. Ferguson, *Handbook of Architecture* (London 1859), 852.

5. F. Saxl, *English Sculptures of the Twelfth Century* (London 1954), 15.

6. Prior and Gardner, *Medieval Figure Sculpture*, 201.

7. Boase, *English Art*, 61, 205–06; Stone, *Sculpture in Britain*, 84–85.

8. Stone, *Sculpture in Britain*, 84, 85.

9. Zarnecki, *Later English Romanesque Sculpture*, 39–40.

10. ibid., 39.

11. ibid., 40.

12. Zarnecki, 'Transition', 155.

13. ibid.

14. Zarnecki, 'Minster-in-Sheppey', 9 n. 20.

15. But note the example from Dover Priory published by Zarnecki 'Minster-in-Sheppey', 9 n. 21.

16. Kahn, 'West Doorway', 133, also cites northern French examples at Presles (Val d'Oise), Trucy and Villier-Saint-Paul (Oise).

17. It is possible that the outward displacement of the archivolts on the right took place when the tympanum was fitted, but the wholesale rebuilding that this would have necessitated, along with the lintel evidence, makes this less likely.

18. A. Tcherikover, *High Romanesque Sculpture in the Duchy of Aquitaine c.1090–1140* (Oxford 1997), 118–24.

19. Stone, *Sculpture in Britain*, 85, considers the shaft-rings to be East Anglian.

20. W. Sauerlander, *Gothic Sculpture in France* (London 1972), 386. A date shortly before 1158 is also accepted by S. L. Ward in her 1984 Ph.D. dissertation, *The Sculpture of the South Portal of Le Mans Cathedral* (reprinted Ann Arbor 1984), 53. Polk's dating of the portal to the late 1130s (T. E. Polk, 'The South Portal of the Cathedral at Le Mans: Its Place in the Development of Early Gothic Portal Composition', *Gesta*, 24 (1985), 47–60) is unconvincing. McAleer, 'West Front', 150, notes that the Rochester façade design also has parallels with the west front of Le Mans, which hints at a continuing relationship between the two cathedrals.

21. Sauerlander, *Gothic Sculpture*, 389–91.

The Late Twelfth-Century East End of Rochester Cathedral

PETER DRAPER

This article reassesses the significance of the east end of Rochester Cathedral in the context of the diversity of experiment evident in late-12th-century architecture in England. Following a brief review of the documentary evidence for the building and its patronage, Philip McAleer's proposed starting date in the 1180s is supported, with the presbytery and eastern transepts completed by the early years of the 13th century, but it is suggested here that there was a probable break, due to the Interdict of 1208–13 and to financial problems, before work proceeded on the choir and choir aisles. The most important model for the rather spare design is seen to be the eastern transepts at Canterbury, although some of the distinctive aspects, such as the aisleless presbytery, owe more to a sense of continuity with the earlier church on the site. With the revised earlier dating, Rochester can now be recognised as a more up-to-date design for the period than previously thought and to have had a more significant role in the formation of the distinctive character of an important group of buildings in the early 13th century.

IN most general accounts of early Gothic architecture in Britain the modest, two-storeyed east end of Rochester Cathedral has rarely received positive comment, suffering particularly in comparison with the exceptional quality of the seminal late-12th-century rebuilding of nearby Canterbury (Figs 1 and 2).[1] The tendency for the new work at Rochester to be considered on the margins of the main developments resulted from St John Hope's dating of the work to the early years of the 13th century, associating it with the cult of St William, a pilgrim from Scotland who was murdered near Rochester in 1201.[2] This dating placed Rochester after the new work at Chichester and at Lincoln, leaving the design in a seemingly isolated position, unfashionably conservative, with no immediate context.[3] In part, this is a historiographical problem that affects other buildings of the period, not just Rochester. The architectural history of the last quarter of the 12th century has been dominated by discussion of a relatively small number of buildings, with insufficient allowance being made for the remarkable variety of experiment in this period and for the diversity of ways available to prelates and religious communities to express their aspirations.[4] A reassessment of the significance of Rochester in a wider context depends on the exploration of a number of questions concerning the dating of the rebuilding of the east end, the reasons it was undertaken, and the identification of those responsible for initiating it. The three questions are closely interrelated.

The architectural and historical evidence for the dating of the rebuilding of the east end is inconsistent and difficult to reconcile with what seems to be a coherent and, on the face of it, reasonably continuous building campaign. The first issue to be confronted is the common assumption that the new work was undertaken to accommodate the cult

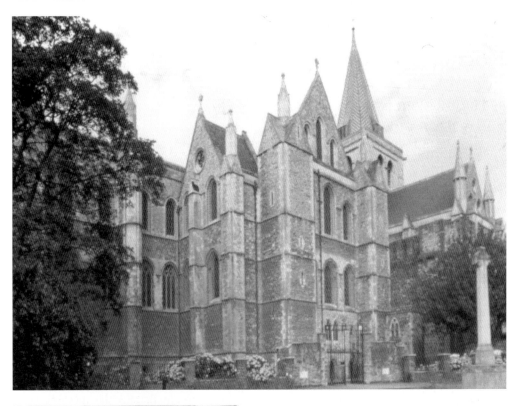

FIG. 1. Rochester Cathedral: east end, from the north-east

Peter Draper

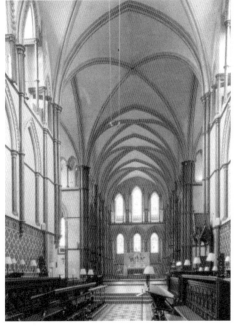

FIG. 2. Rochester Cathedral: east end interior, looking east

Peter Draper

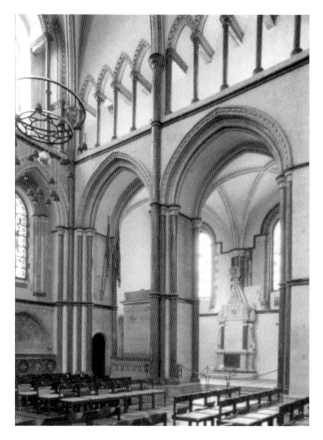

FIG. 3. Rochester Cathedral:
north-east transept, east side
Peter Draper

of William of Perth, a cult that finally resulted in some kind of formal recognition, although not formal canonisation, by the Pope in 1256. It is not known where the body was placed initially, when it was brought into the church after the murder. The first reference to the position of William's shrine is in an entry in the *Flores Historiarum* under the year 1278, in which it is stated that Bishop Walter of Merton was buried on the north side of the church near to the shrine of St William (Fig. 3).[5] This unusual siting of the shrine in the north-east transept, and the fact that the transept shows no sign of having been designed to accommodate a major shrine, make it highly unlikely that the new east end was constructed after 1201 as part of the promotion of the cult. Nor is there any indication that the layout of the new work was modified during construction to take account of the new cult. It is far more likely that the cult of William was an opportunist one and that a convenient location was found for it within an existing, albeit very recent, building.[6] The north side of the church provided a convenient position, allowing access for pilgrims from the side of the church facing the town and well away from the cloister, thus minimising any disturbance to the daily life of the monastery.

If the rebuilding of the east end is dissociated from the murder and local sanctification of William of Perth, other possible reasons why it was undertaken need to be considered. The most obvious is that the reconstruction was necessitated by the

recorded fire of 1179. According to Gervase of Canterbury, 'on the fourth of the ides of April . . . the church of St Andrew with its offices, and the city, was consumed by fire and reduced to cinders'.[7] On the grounds, universally accepted by medieval chroniclers, that a good story can be made better by lavish use of hyperbole, this account can scarcely be accepted at face value; indeed, any effects of the fire on the church would seem to have been confined to that part east of the crossing, since there is no obvious fire damage visible in the nave. The actual extent of the damage can never be known, but some repair and reconstruction is likely to have been required, and the opportunity may have been taken to enlarge the church. If it is accepted that some rebuilding was necessitated by the fire, that would provide a *terminus post quem* of 1179; evidence still needs to be sought as to how long after that date work began. From the 1170s until the early years of the 13th century there are several references to gifts, particularly of vestments, from priors Silvester (1177–80), Richard (1180?–82), Aluredus (1186) and Osbern (1189x90), as well as bishops Waleran (1182–84) and Glanville (1185–1214), yet with no indication that a major building enterprise was under way.[8]

An alternative possibility is that this was an ambitious new building, not necessarily connected in any way with the fire, undertaken following the recent expansion at Canterbury, to provide a much grander setting for the liturgical offices, to provide more chapels (four at each level in the new eastern transept), and to enable the monastic choir to be relocated east of the crossing, more conveniently situated at the level above the crypt, so that a flight of stairs no longer separated the liturgical choir from the presbytery. While the form of the new work may offer clues to the degree of architectural ambition underlying the design, an important aspect of any such interpretation is the identification of the patrons of the new work.

There is no direct evidence as to who was responsible for the initiation of this substantial enlargement of the church. It is notable, however, that all the subsequent documentary references to patrons through the first half of the 13th century, such as the covering of the roof with lead, are to priors or sacrists, though allowance should be made for the possible bias of the sources in favour of the monastic community, especially in relation to the long-running dispute with Bishop Glanville.[9] If the new work was undertaken by the community (through one or more of its office holders) it could be seen, not so much as an attempt to rival Canterbury, since Rochester was hardly in a position to aspire to that, but as an attempt to assert a degree of independence from Canterbury, and to establish the autonomy of the community and of the diocese. This seems to have been achieved *de facto* by the mid-13th century.[10]

On the other hand, if the leading light in the enterprise was the bishop, the rebuilding may have been initiated at the end of the episcopate of Walter (1148–82), or during that of his successor, Waleran (1182–84), but most of the work would have been done under Gilbert Glanville (1185–1214), as could be implied by the position of his tomb on the north side of the presbytery (if it is his tomb and if it is *in situ*).[11] If the dominant patronage was episcopal, the distinctive architecture of Rochester may be seen in a rather different light, especially when its form and manner is set in the context of other Benedictine houses in the second half of the 12th century. Glanville was a scholar and a jurist, who had been archdeacon of Lisieux and a clerk of Archbishop Baldwin. Like other bishops of his time, he was at odds with the monks of his cathedral monastery, supporting Archbishop Hubert Walter in his dispute with the monks at Canterbury in 1198, and successfully asserting his own rights as bishop over the monks at Rochester in a long, acrimonious dispute.

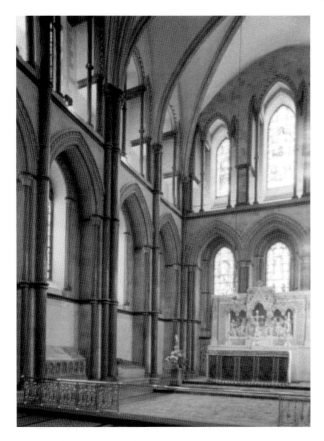

FIG. 4. Rochester Cathedral:
presbytery, north side, showing the
tomb of bishop Glanville
Peter Draper

Glanville is recorded as having made a number of donations of vestments and furnishings to the cathedral, including a stained-glass window for the Chapel of St John, the inner chapel of the north-east transept, but the only reference to him as a builder is that he completed the cloister in stone.[12] According to a later, 14th-century source, he was buried 'a parte boreali predicte basilice'.[13] This is normally assumed to be the presbytery and to confirm the identification of the tomb in the embrasure to the north of the high altar, the position usually reserved for founders (Fig. 4).[14] If this is correct, his burial in 1214 offers a *terminus ante quem* for the presbytery. This accords well with the references to Ralph the prior, who 'caused the great church to be covered in and for the most part to be leaded',[15] and to Prior Helias as being responsible for the leading of the roofs of the great church, together with the part of the cloister adjacent to the dormitory.[16] There is some uncertainty about the dates when Ralph de Ros was prior: 1199–1202 according St John Hope, but Knowles cites references in 1193, 1202, 1203 and in or before 18 May 1208.[17] Helias is referred to as prior in 1214, but by 1218 the prior's name is given as William. The references to covering the roofs with lead in the early years of the 13th century are, at the very least, indicative of a fairly advanced stage in the work, although the position of the roofs within the church is not specified, and it may be that the priors were supervising the construction rather than paying for it. Later, however, the sacrist, William de Hoo, who became prior in 1239, is said to

have built the choir from the proceeds of the offerings to St William.[18] This would then refer to the liturgical choir, which the monks entered in 1227.[19] The church was not dedicated until 1240.[20]

Of these documentary references, the date of the entry into the choir is the one most difficult to reconcile with the expected progress of the work, had it been started in the 1180s and pursued without significant interruption, as McAleer argues. He suggests that the choir 'probably followed directly upon completion of the minor east transept', possibly the work of the same master mason. The 1227 date is rather inconvenient for this proposed continuity, to such an extent that McAleer is inclined to disregard it.[21] It is, however, an event of such significance to a monastic house that it is very unlikely that a mistake would be made about the date. The consistency of the architecture in the presbytery and eastern transepts does not suggest a very protracted building campaign, but there are differences in the detailing of architectural features in the choir. The obvious — perhaps too convenient — solution is to separate the construction of the new east end from the subsequent campaign on the choir, provided that a plausible explanation can be offered for such a gap in the building history.

The most likely cause is the presumed disruption caused by the Interdict and, in its immediate aftermath, the invasion by Louis of France and the siege of Rochester in June 1215, during which it is recorded that John's men sacked the cathedral, 'and such was the depredation of the church of Rochester that not even a pyx with the body of Christ remained on the altar' — a poignant image for a largely monastic readership.[22] The effects of the Interdict, however, are notoriously difficult to assess. At the outset in 1208, it is unlikely that anyone thought that it would last long, but once the episcopal and monastic assets were sequestrated by the king, building work would have ground to a halt. Even so, the duration of the Interdict (around five years) is too short a time to provide reliable evidence for dating on the basis of any minor stylistic differences discernible when work resumed. At Rochester there is the additional complication of the protracted and, doubtless, cripplingly expensive dispute between Bishop Glanville and the monks. The need for economy resulting from the financial crisis may account for the decision to retain as much as possible of the earlier fabric when it came to remodelling the liturgical choir (see below).

In the particular circumstances at Rochester, it is quite plausible that there should have been a gap of a decade or more between the completion of the new work to the point where it could be used, and its continuation into the former presbytery to form the new choir. In the intervening period the new presbytery and eastern transepts could have provided adequate space for the liturgy with temporary stalls set up beneath the eastern crossing. The consecration date of 1240 is less of a problem, because consecration dates so often bear little relation to an identifiable stage in building work; the consecration at Rochester may have been one of a number that followed the injunction by the papal legate in 1239 that consecrations should not be unreasonably delayed. What then is the evidence for a break in the work or any change of plan at the point where the eastern transepts adjoin the choir? To assess this requires consideration of aspects of the archaeology of the new east end.

The new work was designed, as was commonly the case, so that it could be laid out around the existing church and substantially built with minimal disturbance to the liturgical life of the monastery. The archaeological evidence for the sequence of building — the absence of wall ribs in the western parts of the crypt and their appearance in the eastern parts, taken in conjunction with the change from the use of Bethersden 'marble' for shafts at the west end to Purbeck further east — indicates that

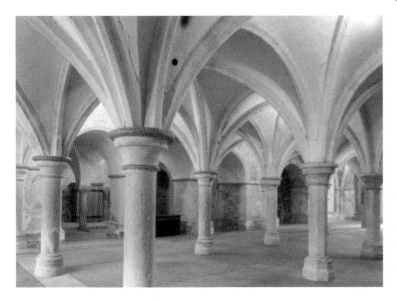

FIG. 5. Rochester
Cathedral: crypt
beneath the eastern
crossing, looking
north-west, showing
the junction with the
earlier crypt

Peter Draper

work started at the west, no doubt so that the junction and levels could be securely aligned with the existing church, as was done at Canterbury in 1174/5.[23] But why was the junction with the existing church effected where it was? Was it always intended to be a junction, or merely a temporary pause in a comprehensive scheme to rebuild the entire east end? And can the arrangement of this junction be used as evidence of the form of the earlier east end?

The decision to extend the crypt under the new work in order to maintain the floor level of the existing presbytery may be taken as an indication that it was not intended to demolish all of the former east end. The new east end was not built from the earlier east wall, so part of the existing crypt had to be demolished to make way for the new east transepts, as is shown by the surviving responds embedded in the strengthened piers on the line of the west side of the east crossing (Fig. 5). These prove that the earlier crypt did not end at this point and that it extended at least one bay further east. It is not clear, however, on what basis the springing point for the new work was chosen, because it does not seem to relate in any obviously logical manner to St John Hope's hypothetical reconstruction of a long rectangular east end for the earlier church and his presumed position of the high altar and eastern shrine chapel.

In fact, the layout of the new work is not very accurate; there is a notable, though unexplained, deflection of the north wall of the new presbytery towards the north, resulting in a marked irregularity in the 'square' of the central crossing. The irregularities in the layout suggest that adaptations had to be made to accommodate existing features and that geometrical precision was not a high priority. This lack of consistency makes it difficult to reconstruct the underlying geometry with much confidence, but a few observations can be made on the basis of St John Hope's measured plan. The dominating constraints were the solid walls of the earlier presbytery, as these determined the north–south dimension of the projected eastern crossing, and the position of the north wall of the cloister, which limited the southern extent of the south transept. No such constraint applied to the north transept, which was made slightly larger, although both transepts approximate to a significant

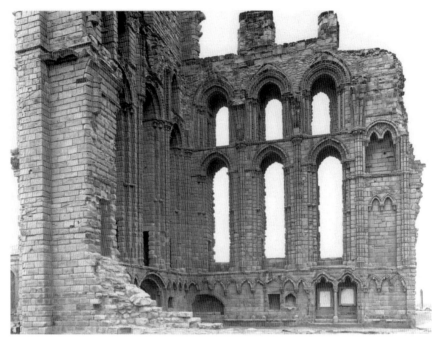

FIG. 6. Tynemouth Priory: presbytery, looking south
K. Galbraith

dimension of the crossing 'square'. This same square was employed for the two bays of the choir, though whether these were generated east to west or west to east remains an open question, but one which has important implications for the interpretation of the initial ambition for the new east end. Evidence relating to this can also be found in the transepts, where the decision to make the inner bays substantially larger than the outer ones led to unavoidable distortion of the intermediate rib of the sexpartite vaults. This inequality in the width of the bays is a consequence of springing the arches of the crossing from the inner corners (rather than the centre of the crossing piers) and of aligning the intermediate piers on the west side with the existing walls of the former presbytery aisles. This awkward adaptation of the layout of the new work to the existing building again strongly suggests that, initially at least, it was not intended to rebuild the former presbytery entirely. Trying to understand the new work in the terms I have suggested highlights difficulties with St John Hope's reconstruction of the liturgical arrangements of the earlier east end, notably the discrepancy in the space allocated to the choir and choir altar compared with the presbytery and the high altar. St John Hope's inconsistent drawing of the extent of the solid walls is also of concern, but from my point of view, it matters only that the former presbytery was aisleless.

Within the wider context of late-12th-century architecture, the design of the aisleless east end at Rochester is unusual for this class of building, though it is not without contemporary parallels. When compared with the more common aisled forms, whether apsidal, as at Canterbury, or rectangular, such as the church of the hospital of St Cross, Winchester, the absence of aisles has led to such negative interpretations of the design as: 'Rochester was reconstructed with its high altar jammed into an eastern chapel with

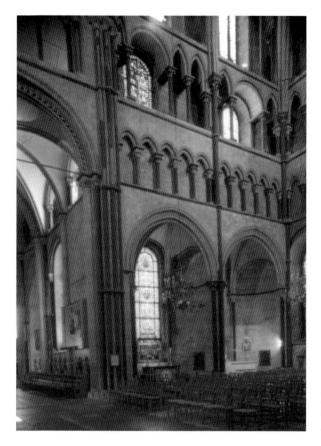

Fig. 7. Canterbury Cathedral:
south-east transept, east side
Peter Draper

only two narrow bays behind it.'[24] A more positive approach had been taken by Francis Bond, who argued that the form was chosen to permit better lighting for the altar, though the parallels he cited were not close or convincing.[25] A telling comparison can be made with the new, aisleless east end of another Benedictine monastery, at Tynemouth (Fig. 6). The differences, however, are instructive and suggestive. At Tynemouth the tall lancets rise above an arcaded dado, and all features of the elevation are richly decorated as befitted a building designed to house a substantial shrine, even though the detached shafts were not of a polishable stone as was becoming fashionable in the South-East. Despite the use of polished 'marble' shafts at Rochester (Figs 2 and 3), the elevation there is notably more restrained in decoration, almost chaste by comparison with the surface decoration at Tynemouth.

The deep recesses in the presbytery in which the windows are set constitute the most striking aspect of the internal elevation at Rochester. If these recesses were intended for tombs, this would be a very early example of such explicit provision for burial space in a presbytery so close to the high altar and, in this regard, the prominent position of Glanville's tomb may be compared with the discreet placing of Archbishop Hubert Walter's tomb against the wall of the ambulatory in the Trinity Chapel at Canterbury. These tall recesses were also an effective means of achieving a degree of monumentality in a relatively modest building and at the same time maintaining an unusually consistent

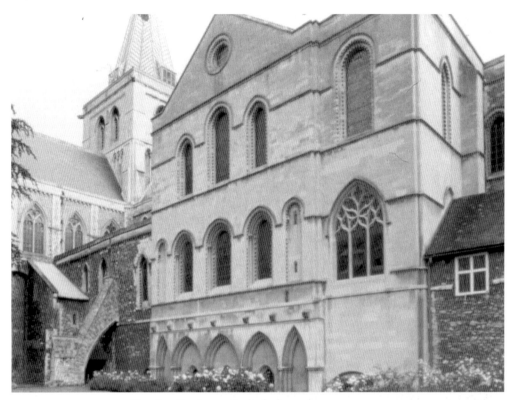

FIG. 8. Rochester Cathedral: south-east transept
Peter Draper

articulation with the east chapels of the east transepts. The most likely source for the use of heavy Purbeck vault shafts and sexpartite vaults lies in the eastern transepts of Canterbury of 1179–80, which also provide a parallel for the handling of blind arcading with awkwardly stilted lateral arches (Fig. 7). The parallels with Canterbury extend to the use of a quadripartite vault over the crossing and the narrow west bay of the presbytery.

This search for precedents or parallels, however, may underplay or obscure what may be termed the 'internal' history of the building: the ways in which the new work was designed to maintain a sense of continuity with the existing building. Having developed a liturgy accommodated within the solid walls of the earlier presbytery, there may not have seemed good reason to change or to disrupt that link with the traditions of the monastery, hence the aisleless presbytery of the new work. Considering the architecture of Rochester in this way may also help to explain other apparent anomalies in the design, such as the heavy buttress turrets of the east face of the presbytery and the north façade of the north-east transept (Fig. 1).

In the transept, these turrets contain quite generous staircases, whereas in the presbytery the staircases run only from the clerestory to the level of the passage across the east façade and the roof. There is no obvious reason why, by this date, these large turrets should have been thought necessary as buttresses. There is also no sign that

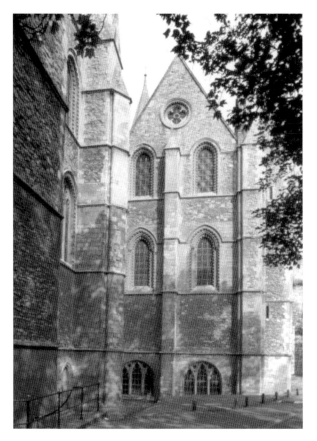

FIG. 9. Rochester Cathedral: north
side of the presbytery and east façade
of the north-east transept
Peter Draper

there were ever such towers on the south-east transept, which was built up against the cloister, necessitating the accommodation of the staircase on the south-east corner within the substantial thickness of the wall (Fig. 8). This wall, however, subsequently developed a marked outward lean, and its outer face had to be largely rebuilt in the early 19th century by Cottingham. On the other hand, it may be significant that the heavy turrets appear on the aspect of the church visible from the main road, where the new work would be seen in conjunction with Gundulf's tower, with its comparably heavy buttressing on the corners; there may also be an echo of the west front turrets. These buttress turrets would have been seen as positive features, had the *en délit* shafts been built on the corners as intended; the present rather clumsy appearance is considerably exacerbated by heavy restoration. Here it is worth drawing attention to the more sophisticated design of the intermediate buttresses of the presbytery (Fig. 9), corresponding to the internal sexpartite vault, where again the intended *en délit* shafts would have made their appearance more similar to the buttresses of the Trinity Chapel at Canterbury or to the more complex design of the buttresses at Lincoln.

Two further problematic aspects of the east end need to be discussed. The first concerns the west side of the south-east transept, where two blind arcades correspond to the arcades opening into the chapels on the east side (Fig. 10). These arches also appear on the west face of the wall, with mouldings of the same degree of elaboration

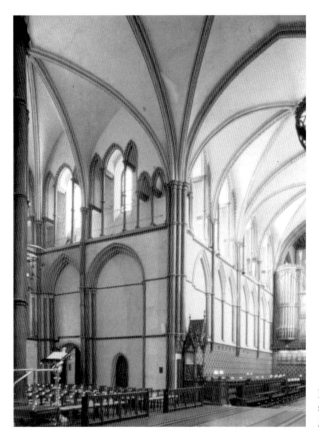

FIG. 10. Rochester Cathedral: south-east transept, west wall
Peter Draper

and with a similar, large vaulting shaft rising between them (Fig. 11). The inner arch was presumably intended to open into the south choir aisle, as on the north side (Fig. 12), but it had to be blocked in order to effect an entrance into the new crypt. The door in the outer bay has elaborate mouldings only on the west side, indicating that it was to serve as the access to the eastern transepts; this is an unusual position for such a door, necessitated by the solid wall of the liturgical choir (the former presbytery). The present arrangement of the south choir aisle is the result of more than one change of plan, but the shafts and arcading on the south face of the south wall of the choir make it clear that some monumental arrangement was intended in this space, a sort of grand vestibule from the cloister and, perhaps, from the bishop's palace to the west of the cloister. On the basis of the archaeological evidence, one can only speculate how the surviving arches and shafts would have related to the wall adjacent to the cloister and how this space would have been vaulted. The arrangement in the north-east transept differs, in that while the monumental arch in the inner bay opens into the north choir aisle, the outer bay of the west wall has a small external door that may have served as a discreet entrance for pilgrims before the construction of the Sacrist's Checker. Beside it is a door giving access to the staircase in the corner turret.

The second aspect is a feature unique to Rochester: the provision of spacious 'rooms' above the eastern chapels of the eastern transepts, the intended functions of which are

FIG. 11. Rochester Cathedral: south choir aisle, west face of the west wall of the south-east transept

Peter Draper

not at all clear. The chambers are well lit by two lancet windows, which continue the line of the presbytery clerestory (Fig. 1), and although there is no sign of an internal vault, the inner walls backing onto the presbytery are provided with two blind arches supported by a detached shaft with fully formed base and capital (Fig. 13). The chamber on the north side, accessible by a generous staircase, has been referred to as the 'treasury', but there is no sign of the strong doors that would be necessary for a treasury. The corresponding space on the south side has been referred to as the 'indulgence chamber', where penitents or invalids could be auditors of the services. This explanation is totally implausible, as the narrow vice providing the only access on this side (blocked up in 1825) would certainly not have been suitable for invalids, and there is only a very small door opening from the chamber into the church through which any sound could have come. The provision of these unique chambers, whatever their intended purpose, had significant consequences for the overall architectural design. Externally, the east transepts are given an impressive east façade (Fig. 9),[26] while internally, these chambers block the walls at clerestory level on the east side of the transepts and in the western bay of the presbytery, where a blind arcade is provided in place of the clerestory windows. The simplicity of this arcading and the blank areas of wall above add noticeably to the generally plain character of the architecture of the new east end (Fig. 14).

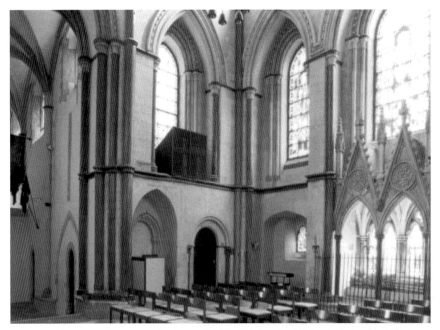

FIG. 12. Rochester Cathedral: north-east transept, west and north walls
Peter Draper

CONCLUSION

ROCHESTER has been seen as somewhat anomalous in the context of architecture in England in the first two decades of the 13th century and has tended to be marginalised in most histories of the period. Its modest size, its aisleless presbytery, and its two-storey elevation, linked with the apparently secure date of 1227 for the monks' entry into the new choir, suggested a design that was somewhat out-of-date. However, by relocating this design into the 1180s, the context changes significantly. The east end of Rochester becomes a close off-shoot of the most up-to-date architecture of that decade.

In previous accounts of Rochester there has been an assumption, tacit or explicit, that the somewhat 'spare' manner was a consequence of financial constraints. Rochester was certainly a very poor diocese, as well as being politically dependent on Canterbury. In the 1291 *Taxatio*, in which Winchester registered an annual income of around £3,000, and Canterbury, Ely and Durham over £2,000, Rochester came in at under £200. This economic constraint may be reflected in the relatively modest height of the new work and in the protracted building campaign, especially in the subsequent construction of the western transepts. Although the architecture of the new east end is certainly of rather different character to the ostentatious decoration of parts of the earlier 12th-century nave and west front, it is not obviously a cheap building, in that the arcade mouldings are quite complex and there is extensive use of Purbeck marble. Yet the way in which the marble is used, especially in the heavy vaulting shafts, with a preponderance of turned rather than foliate capitals, taken together with the simple, narrow profiles to the ribs in the vaults, suggest that this comparatively simple manner

FIG. 13. Rochester Cathedral: north-east
transept, chamber above the eastern chapels
Peter Draper

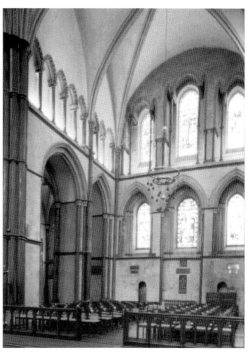

FIG. 14. Rochester Cathedral: south-east
transept, east and south walls
Peter Draper

was the result of a conscious aesthetic. If so, what was the context for this architecture
and how should this aesthetic be interpreted?

The two major buildings that are likely to have exerted the greatest influence on
Rochester Cathedral are Canterbury and the nearby royal foundation at Faversham.[27]
The almost complete loss of King Stephen's foundation of the 1150s and 1160s leaves a
serious gap in our understanding of major buildings in Kent in the second half of the
12th century, but fragments demonstrate that Purbeck marble was used in the church,
possibly quite extensively, influenced, no doubt, by the architecture of Stephen's
brother, Henry of Blois, at Winchester and Glastonbury.[28] Thus Canterbury remains
the most obvious surviving source, especially the eastern transepts with their large
Purbeck shafts and small-scale arcading. However, the generally spare manner may
also derive from the new crypt beneath the Trinity Chapel. This possibility is important
when interpreting the use of this restrained manner of architecture in the presbytery of
a Benedictine monastic church, since at first sight the restraint may seem more
appropriate to a reformed house of Augustinian canons. We should not assume that all
influence from Canterbury would derive from the sumptuous effect of the Trinity
Chapel and shrine area.

The interpretation of Rochester raises important historiographical questions, too,
not least about the ways in which contemporaries in the 12th century would have read
this architectural vocabulary.[29] If work commenced in the 1180s, the obvious links with
the transepts at Canterbury would have allowed Rochester to be seen as a decidedly

up-to-date design. The earlier dating for the start of work is also of considerable significance in relation to the association of Rochester with a group of buildings in the south-east which Virginia Jansen has associated with the patronage of the reforming circle around Stephen Langton.[30] She identified in this group a chaste, almost austere manner, dating its beginnings to *c.* 1215, and arguing that it reached its high point at Salisbury Cathedral and in the choir of the Temple church, London. It has recently been suggested that one building in the group, Hubert Walter's palace chapel at Lambeth, is more comfortably datable to the 1190s than the 1220s.[31] This would accord well with the revised dating for Rochester, which must now be seen as the earliest major building in this important group of buildings, occupying a much more significant place in the genesis of its distinctive architectural style. As a postscript, it may be noted that Elias de Dereham was in the household of Hubert Walter by the late 1190s, and was no doubt familiar with the emerging east end of Rochester, as well as with the new work at Lambeth.[32] Insofar as Elias was instrumental in promoting this distinctive southern manner in the early 13th century, given his documented connection with several of the key buildings, Rochester may well have been important in the formation of his architectural taste.

NOTES

1. The east end was heavily restored by George Gilbert Scott from 1871: the exterior was largely refaced, and the east wall of the presbytery was restored to its 'original' form, with lancets replacing an inserted Perpendicular window 'which was very offensive to the Dean and others'; see *Personal and Professional Recollections*, ed. G. Stamp (Stamford 1995), esp. 349–51.

2. The fundamental study of the building complex is that of W. H. St John Hope, 'The Architectural History of the Cathedral Church and Monastery of St Andrew at Rochester, I: The Cathedral Church', *Archaeologia Cantiana*, 23 (1898), 194–328, and 'The Architectural History of the Cathedral Church and Monastery of St Andrew at Rochester, II: The Monastery', ibid., 24 (1900), 1–85. St John Hope's interpretation and dating strongly influenced later writers: for example, T. S. R. Boase, *English Art 1100–1215* (Oxford 1953), 256, '. . . begun c.1210 after the murder of a Scottish pilgrim, William of Perth, had provided them with a popular martyr'; and J. Newman, *West Kent and the Weald* (Harmondsworth 1969), 453, 'The money for it came from the offerings at the shrine of St William of Perth, a baker murdered at Rochester in 1201'.

3. While not referring to the cult of William of Perth, support for the early-13th-century dating is found in F. Bond, *Gothic Architecture in England* (London 1906), 189: 'About 1200, eastern transepts were set out by the Benedictines of Rochester and Worcester'; and G. Webb, *Architecture in Britain: The Middle Ages* (Harmondsworth 1956), 79: 'begun c.1200 and seems to have been completed by 1227'.

4. For a review of the historiography of Rochester, together with the fullest discussion of the documentary and archaeological evidence, see J. McAleer, *Rochester Cathedral 604–1540: An Architectural History* (Toronto 1999), 106–10; for the architectural context, see ibid., 126–27. For the wider context, see P. Draper, 'St David's Cathedral: Provincial or Metropolitan?', in *Mélanges offerts à Anne Prache*, ed. F. Joubert and D. Sandron (Paris-Sorbonne 1999), 103–16.

5. 'Eodem anno obiit Walterus de Mertone, episcopus Roffensis, et sepultus est honorifice in ecclesia eadem in parte boreali juxta sepulchrum sancti Willelmi'; *Flores Historiarum*, ed. H. R. Luard (Rolls Series, xcv, 1890), sub anno 1278.

6. There is no sign of any additional decoration or modification to the architecture on the east side of the north-east transept, where the shrine must once have stood. For the possible locations of the existing shrines of Paulinus and Ythamar, see J. Crook's article in this volume, 126.

7. *Gervasii Cantuariensis Opera Historica*, ed. W Stubbs, 2 vols (London 1879–80), I, 292. An alternative date of 1177 is given in the *Annales Ecclesiae Roffensis*; see O. Lehmann-Brockhaus, *Lateinische Schriftquellen zur Kunst in England, Wales und Schottland vom Jahre 901 bis zum Jahre 1307*, 5 vols (Munich 1955–60), II, 395, no. 3738. For this date see M. Brett, *Faith and Fabric*, 29, n. 143.

8. See Lehmann-Brockhaus, *Lateinische Schriftquellen*, II, 395, nos 3739–47.

9. In the chronicle sources at Canterbury, for example, there is no reference to financial contributions by Archbishop Richard.

10. The monks of Rochester began asserting their independence of Canterbury from the late 12th century with the election of Bishops Waleran (1182–84) and Gilbert Glanville (1185–1214). Bishop Benedict of Sawston (1214–26), the choice of the monks, was consecrated at Oxford. On the death of Bishop Sandford (1227–35), Archbishop Edmund refused to accept the election as bishop of Prior Richard Wendene (1235–50), but the election was eventually upheld by the Pope, together with rights of chapter to elect, and he was consecrated in 1238. In the late 13th century, a formal petition was made to Canterbury for licence to elect and it was formally granted; see McAleer, *Rochester Cathedral*, 87.

11. His successor, Bishop Benedict, is recorded as having built only the 'aulas episcopatus', *Registrum Roffense*, ed. J. Thorpe (London 1769), 141.

12. 'Fecit claustrum nostrum perfici lapideum', *Registrum Roffense*, 633.

13. The phrase 'a parte boreali' is open to interpretation, as in the comparable reference to the position of the burial of Bishop Hugh at Lincoln.

14. In London, British Library, Cotton MSS, Nero DII, fol. 127v, where he is described as: 'inter fundatores confundator sicut Saul inter prophetas'.

15. 'Radulfus Bretun … et fecit magnam ecclesiam tegere, et plurimam partem plumbare', *Registrum Roffense*, 122.

16. 'Helias prior fecit plumbare magnam ecclesiam … Partem claustri versus dormitorium plumbare fecit', *Registrum Roffense*, 122–23.

17. St John Hope, 'Architectural History, I', 232; D. Knowles, C. N. L. Brooke and V. London ed., *The Heads of Religious Houses: England and Wales 940–1216*, 2nd edn (Cambridge 2001), 64.

18. 'Willelmus de Hoo sacrista … fecit totum chorum … de oblationibus s. Willelmi', *Registrum Roffense*, 125.

19. 'Introitus in novum chorum Roffensem' [a.1227], *Annales Ecclesiae Roffensis*, 347.

20. 'Eodem anno [a.1240] dedicata est ecclesia Roffensis a Domino Ricardo episcopo eiusdem loci et episcopo de Bangor [Ricardo]', *Annales Ecclesiae Roffensis*, 347.

21. McAleer, *Rochester Cathedral*, 129.

22. 'Et depraedata est Roffensis ecclesia, adeo nec pixis cum corpore Christi super altare remaneret', *Annales Ecclesiae Roffensis*, 347.

23. The introduction of wall ribs to the vaults as work progressed cannot be taken to mark stylistic progress, since, as McAleer points out, wall ribs appear in the upper church in the chapels of the transepts, but not in the high vaults.

24. B. Nilson, *Cathedral Shrines of Medieval England* (Woodbridge 1998), 78.

25. F. Bond, *Gothic Architecture in England* (London 1906), 176.

26. The existing north gable was reconstructed by Scott on the basis of indications of such a pitched roof in the south room, rediscovered by his son; see *Personal and Professional Recollections*, esp. 349–51.

27. For the excavation report and plan, see B. Philp, *Excavations at Faversham* (1965), fig. 4 opposite p. 7, and fig. 9 on p. 34.

28. For a Purbeck marble capital from Faversham, see *English Romanesque Art 1066–1200* (Arts Council Exhibition, Hayward Gallery 1984), catalogue entry 146; Y. Kusaba, 'Henry of Blois, Winchester, and the Twelfth-Century Renaissance', in *Winchester Cathedral: Nine Hundred Years*, ed. J. Crook (Chichester 1993), 69–80.

29. As I have argued elsewhere in connection with St David's; see Draper, 'St David's Cathedral', 103–16.

30. V. Jansen, 'Lambeth Palace Chapel, the Temple Choir and Southern English Gothic Architecture c.1215–1240', in *England in the Thirteenth Century*, ed. W. M. Ormrod (Harlaxton 1985), 95–99.

31. T. Tatton-Brown, *Lambeth Palace: a History of the Archbishops of Canterbury and their Houses* (London 2000).

32. A. Hastings, *Elias of Dereham: Architect of Salisbury Cathedral* (Salisbury 1997).

The Medieval Shrines of Rochester Cathedral

JOHN CROOK

In the later Middle Ages, Rochester Cathedral could boast three local saints: Paulinus, Ithamar, and William of Perth. By a fortunate chance their cults are typical of three major periods of saint-making activity in England. Thus, the cult of St Paulinus (Rochester's second bishop), which grew up in the early 7th century, is representative of saint-making patterns that had first developed in Merovingian Francia and which are observable at other places in England in the period following St Augustine's mission. The cult of Ithamar, Paulinus's successor as bishop of Rochester, was the product of a new interest in indigenous saints in the first half of the 12th century. Finally, the cult of St William of Perth may perhaps be seen as a somewhat belated response to the 'rival' cult of St Thomas of Canterbury.

This article explores the beginnings of the three cults, attempting to illuminate their origins and main features with reference to cults elsewhere. The architectural setting of the cults is then discussed. Of the setting of the relics of St Paulinus in the pre-Conquest cathedral almost nothing is known. Rather more information is available concerning his cult, and that of Ithamar, in the Romanesque cathedral, and this sheds some light on the much debated question of the form of the east end of that church. Finally, there is limited archaeological and documentary evidence for the final position of the shrines of the three saints within the cathedral after the 13th-century reconstruction of the eastern arm and the 14th-century remodelling of the presbytery area.

INTRODUCTION

THE cult of saints played a central role in medieval church life. The ecclesiastical calendar was primarily defined by the great festivals relating to the life of Christ — Christmas, Easter, Ascension, Whitsun, Trinity Sunday — but between these key reference points came the feasts of the saints: first the apostles and martyrs of the early church, then more recent saints, notably confessors, who had not died for their faith but had led exemplary lives. Amongst the latter were many local saints. The renown of some local saints was widespread and influential: England celebrates St Alban, St Edmund, St Dunstan, St Swithun, and Sts Wulfstan and Oswald of Worcester, to name but a few. Rochester Cathedral has since its foundation been dedicated to St Andrew the Apostle, but in the later Middle Ages it could boast three additional saints whose cults were quintessentially local: two pre-Conquest bishops, Paulinus and Ithamar, and a later, popular figure, William of Perth. By a quirk of fortune these cults typify three major periods of saint-making in England. In this paper I shall attempt firstly to set the veneration at Rochester of each of the three saints in its wider historical context, then to investigate the physical setting of the cults, notably the shrines containing the saints' bodily remains, their 'relics'.

THE CULTS OF PAULINUS AND ITHAMAR IN THE PRE-CONQUEST PERIOD

OUR knowledge of the actual lives of the two saints derives entirely from Bede; there are no contemporary written *vitæ*. Paulinus is remembered as the apostle to Northumbria, having accompanied the Kentish princess Æthelburh thither as her chaplain when she was to marry King Edwin. Paulinus was consecrated bishop for this purpose in 625, and became the first bishop of York two years later, but he returned south after Edwin's defeat at Hatfield Chase (633), ending his days as the third bishop of Rochester. He died on 10 October 644, and this day — his obit — would later be celebrated as his main feast-day. Bede tells us that Paulinus was buried in the sanctuary (*secretarium*) of his cathedral church, which King Æthelberht had built.[1]

Ithamar was Paulinus's successor, a Kentish man and the first native English bishop; Bede commented that he was nevertheless 'the equal of his predecessors in learning and in holiness of life'.[2] Richard Sharpe has pointed out that 'Ithamar' was an adopted name from the Old Testament, Ithamar being one of the four sons of Aaron and founder of a line of priestly succession.[3] The name was perhaps conferred on the bishop at his consecration, and was particularly appropriate for one who was first in the succession of English prelates. He died *c.* 660; the exact date is unknown and the feast-day later celebrated, 10 June, commemorates the first translation of his relics. As we shall see, his cult probably began only in the mid-12th century.

Between Bede and the Norman Conquest there is almost no evidence for the cult of Paulinus. It appears to have developed during the 8th century. Bede, writing *c.* 730, gives no indication that he was regarded as a saint, merely calling him 'most reverend' (*reuerentissimus*), but within fifty years Paulinus had acquired at least one title of sanctity: in 788 King Offa of Mercia granted land 'to the church of St Andrew the Apostle and the bishopric of the castle which is called Rochester, where blessed Paulinus lies ["ubi beatus Paulinus pausat"]'.[4] The feast of St Paulinus, 10 October, occurs in pre-Conquest calendars from widespread locations.[5] His cult (but not Ithamar's) also features in the well-known Old English list of saints' resting-places, *Secgan be þam Godes sanctum þe on Engla lande ærost reston*.[6] The earlier of the two principal surviving manuscripts of this text, part of the *Liber Vitæ* of Hyde Abbey, Winchester, states that 'Ðonne resteð Sanctus Paulinus on Hrofe ceastre',[7] and has been dated to *c.* 1013.[8] Paulinus's body at Rochester is also mentioned in an early-11th-century addendum to an Old English homiliary based on Ælfric's homilies, which states that St Paulinus 'was buried here and here yet lies ["⁊ her gyt aligð"]'.[9]

It is instructive to compare the development of Paulinus's cult with that of other English local saints of the 7th–8th centuries, such as Cuthbert and Etheldreda. The way in which these individuals became saints derived from patterns current in Merovingian Francia. During the 7th century the Frankish sanctoral was enriched by a substantial number of confessors, both men and women, whose cult was frequently promoted by their successors in office: typically a bishop, abbot, or abbess would exhume and enshrine the body of his or her predecessor — a procedure which conferred prestige on the promoter, who might in turn eventually become a saint. Likewise in England the elevation of the miraculously incorrupt body of St Cuthbert by Bishop Eadberht in 698, eleven years after his death, or that of St Etheldreda (Æthelthryth), first abbess of Ely, by her sister, Abbess Seaxburh, in 695, followed patterns previously established in Francia.

Rochester Cathedral, on the other hand, was a product of the Roman mission, and Frankish influence was less pronounced. The cathedral probably took its dedication

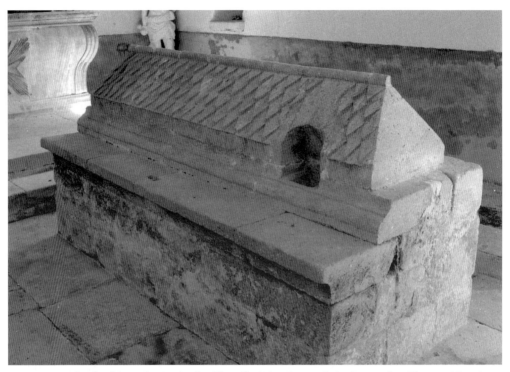

FIG. 1. Tomb of St Lotharius in the Chapelle Saint-Loyer, Saint-Loyer-des-Champs (Orne)
John Crook

from St Andrew's monastery on the Celian Hill, where Augustine had been prior. Paulinus was a Roman, and it should be noted that the enthusiasm for elevating saintly bodies was not a feature of saints' cults in Rome itself — in the late 6th century Pope Gregory had condemned the practice as an aberration introduced by 'the Greeks'.[10] It is therefore quite likely that Paulinus's body lay undisturbed until it was translated into the new cathedral in the late 11th century, just as the bodies of the early archbishops of Canterbury remained undisturbed in Roman fashion at St Augustine's Abbey, outside the city walls, until 1091.

There is, of course, no way of telling what Paulinus's tomb-shrine may have looked like. One may perhaps postulate a raised monument over the grave, which would allow the faithful to get near to the remains beneath. Possible continental parallels include the tomb of St Lotharius at Saint-Loyer-des-Champs near Argentan, Orne (Fig. 1), but the absence of evidence makes further speculation futile. All one can say is that the tomb must have remained an identifiable feature of the Anglo-Saxon church of Rochester from 644 until the 1080s.

THE CULT OF ST PAULINUS AT THE NORMAN CONQUEST

IT is a commonplace to state that the new churchmen of Anglo-Norman England regarded English saints' cults with suspicion, even disdain. Dom David Knowles wrote of the 'disrespectful attitude' of the new Norman abbots towards the Old English

saints: 'even the great name of St Cuthbert was not proof against Norman scepticism';[11] Sir Richard Southern described the 'contempt in which [the native saints at Christ Church, Canterbury] were held by the Norman Conquerors'.[12] More recently, however, Susan Ridyard and David Rollason have demonstrated that Norman prelates quite rapidly accepted, even promoted, local cults; by the 1090s native cults were in full vigour.[13]

Thus at Canterbury, Archbishop Lanfranc, whose recorded comments have been regarded as the most extreme example of Norman distrust of English saints, took care of the bodies of his saintly predecessors, and commissioned from Osbern a biography of St Ælfheah, whose sanctity he had previously queried;[14] Osbern's *Life of St Dunstan* was possibly also commissioned by Lanfranc. Furthermore, the dedicatory preface to a *Life of St Edith* (Eadgitha) addressed to Lanfranc *c.* 1078 by another hagiographer, Goscelin of Saint-Bertin, refers to the archbishop as 'the most efficaceous vicar ["efficacissim[us] . . . uicari[us]"]' of St Dunstan', which suggests that Lanfranc would have been flattered rather than insulted to be considered the patron of an English saint.[15]

Lanfranc was also credited with promoting St Paulinus's cult at Rochester. The post-Conquest documents relating to Rochester's saints have recently been reassessed as a group by Colin Flight,[16] who argues that the earliest source for the post-Conquest cult of Paulinus was a lost, early-12th-century book of his miracles (*miracula*), whose text is partly preserved in a 14th-century transcription published by John of Tynemouth in his *Sanctilogium*.[17] The Rochester monks certainly owned a volume of the miracles of Sts Paulinus and Ithamar (as well as a book of Ithamar's miracles) by 1202, when they were included in a surviving book-list,[18] but no mention is made of the work in an earlier list in the *Textus Roffensis*, datable to the 1120s;[19] some uncertainties therefore remain about Tynemouth's source.

According to the text used by John of Tynemouth, Archbishop Lanfranc made himself personally responsible for the elevation and enshrinement of Paulinus, raising the saint's bones from the earth and 'placing them together honourably in a shrine [*scrinium*]'.[20] This version of events must, however, be compared with that provided in the *Vita Gundulfi*, which tells a different story, crediting Gundulf himself with organising the translation, rather than Lanfranc, who is not mentioned:

That venerable father [Gundulf, bishop of Rochester (1077–1108)], having convened with great solemnity the monks and clergy of the convent, as well as a great multitude of lay people, at the sepulchre of the most holy confessor Paulinus (who had been laid to rest in the old church), caused the treasure of his holy relics to be translated into the new church and to be laid in a place which had decently been prepared for this purpose.[21]

This change in emphasis is part of the evidence adduced by Flight for a later date for the *Vita Gundulfi* than the 1114x1124 period proposed by its most recent editor;[22] Flight suggests that the *Vita* was a piece of polemic contrasting the virtues of the monk-bishop, Gundulf, with those of the secular Bishop John I (1125–37), and accordingly dates the text to Bishop John's episcopate.[23] It is certainly true that all later sources revert to crediting Lanfranc with Paulinus's translation. For example, in a list of benefactors included in the early-13th-century so-called *Registrum Roffense* (British Library, Cotton MSS, Vespasian AXXII), Gundulf was remembered only for minor gifts of vestments and books, whereas Lanfranc 'caused the body of St Paulinus to be raised up and to be placed in a silver feretory ["in feretro argenteo"] which he himself had had made . . . He also gave the cross which stands over the feretory ["qui stat super

feretrum"] of St Paulinus . . .'.[24] The passage was subsequently copied almost verbatim in the Rochester manuscript of the *Flores Historiarum* (BL Cotton MS, Nero DII), dating from the early 14th century,[25] and here the chronicler adds another detail: silver from the *feretrum* was later used by the monks to pay the legal expenses of their dispute with Bishop Gilbert Glanville (1185–1214). These purported descriptions of the Romanesque shrine should evidently be accepted with caution, as they probably reflect the situation at the time of writing rather than the state of affairs in a period long past.

The emphasis in the *Vita Gundulfi* on that bishop's role as a promoter of saints' cults is, however, consistent with the assertion of various non-Rochester writers that he participated in several post-Conquest translations. Eadmer recalled that, during his own childhood, both Gundulf — not yet a bishop — and Abbot Scotland were present when Dunstan's body was translated at Canterbury Cathedral, soon after the fire of 1067.[26] According to Goscelin, it was Gundulf himself who presided at the translation of Augustine and his successors at St Augustine's Canterbury in 1091, though his participation is hardly surprising, as he was standing in for the archbishop during the long interregnum between Lanfranc and the eventual consecration of Anselm.[27] In 1102 Gundulf is also said to have been present at the examination of the body of Edward the Confessor.[28] In the light of his interest in saints' cults, it might be expected that the bishop would indeed have played a significant part in the saintly translations at Rochester.

The debate over who was responsible for the translation, and the significance of the apparently rival claims, is, however, something of a side issue. The two early accounts agree, at least, that Paulinus's newly enshrined body was honourably displayed when it had been translated into the late-11th-century cathedral, though the year of the event is unrecorded; a date in the late 1080s seems probable, for which the death of Lanfranc in 1089 (if he was responsible for the translation) may provide a *terminus ante quem*. None of the sources employs a commonplace of hagiography, namely that his body was miraculously incorrupt: the relics presumably consisted of disarticulated bones; John of Tynemouth's source actually calls them 'ossa sancti Paulini'.[29]

The sources we have cited give few indications of the appearance of the Romanesque shrine. One would expect the bones to have been placed in a receptacle of the kind commonly called a *scrinium* by contemporary writers, and that the *scrinium* would have been supported on some kind of masonry base, perhaps simply a slab supported on pillars. The terminology at first seems inconsistent, even contradictory: Tynemouth's source states, indeed, that Lanfranc put the relics in a *scrinium*, but the *Registrum Roffense* says that they were placed in a *feretrum*. Technically a *scrinium*, a word which in its Latin origins means a chest or box, was the actual container, while the *feretrum* (feretory) was a supporting structure or bier. However, many medieval writers tended to use the terms more or less synonymously, and other occurrences of *feretrum* in the *Registrum Roffense* confirm that the compiler of that text merely used the word as his preferred alternative to *scrinium*. Thus the two Rochester accounts seem to be referring to the same item by different words.

Comparison with other cults suggests that the container for Paulinus's newly exhumed bones was essentially a wooden box, probably covered in decorated silver panels, an Anglo-Norman version of the opulent Anglo-Saxon reliquaries such as the one provided at King Edgar's expense for the remains of St Swithun at Winchester — the latter *scrinium* probably survived until *c.* 1450, when its precious decoration was melted down.[30] The existence of this kind of embellishment at Rochester seems to be supported by the alleged spoliation of Paulinus's shrine to raise funds in the time of

Bishop Glanville. Shrines were frequently despoiled in this way, often by churchmen: the same thing had happened at Ely in the time of Bishop Nigel (1133–69), incurring the censure of the compiler of the *Liber Eliensis*.[31]

Although we have only limited evidence for the appearance of the shrine, there are somewhat better indications of its location within the Romanesque cathedral. In studying this question we are inevitably hampered by our lack of knowledge about the form of the east end of the late-11th-century church. As noted elsewhere in this volume, the question has polarised into two main interpretations: a triapsidal plan, or the square-ended plan proposed by St John Hope.[32] Whatever the precise form of the Norman east end, it is undoubtedly the most likely location for Paulinus's shrine. The best documentary evidence occurs in the miracle stories relating to the cult of St Paulinus and, later, of St Ithamar. However sceptical one may be about much of the content of such stories, it is unlikely that they would have misrepresented the architectural setting; this would have been familiar to the monks who were the principal audience for the *miracula*.

According to John of Tynemouth's source, immediately after Paulinus's relics had been brought into the new cathedral church, a sinful woman successfully sought a cure at the *sepulchrum* (the term often denotes a shrine rather than a tomb, in hagiographical texts).[33] She soon relapsed into her evil ways, 'like a dog returning to its vomit'. When further tribulations brought her back to the church she was less successful; she intended bringing a votive taper to the shrine, but got no further than 'the first step' before being violently repulsed by the saint. Only after she had convinced Bishop Gundulf of her true repentance was she able to reach the relics and leave her gift. Another version of the same story occurs in the *Vita Gundulfi*.[34] The incidental reference to the steps shows that the shrine was located in a part of the church that was at a higher level than the body of the cathedral: this could only be the east end, which was raised above the crypt. The location is supported by comparative evidence. The normal position for a shrine in a major Anglo-Norman church was immediately behind the high altar, as was the case with the shrines of Sts Edmund, Alban, Swithun, and Cuthbert.[35] It is to be expected that Rochester would conform with such exemplars, thus demonstrating that the cult of the local saint was as prestigious as the other major cults.

THE CULT OF ST ITHAMAR

BEFORE following the subsequent movements of St Paulinus's bones, we must examine the growth of the cult of St Ithamar. As already mentioned, there is little certain evidence for the cult until the later 12th century, with the composition of a collection of *miracula* preserved in Corpus Christi College, Cambridge, MS 161.[36] This compilation of various saints' legends is broadly datable in its present form to the late 12th–early 13th centuries, but its editor argues from internal evidence that the text relating to Ithamar was composed in the 1150s.

According to this source, the remains of the saint had been translated at least twice during the first half of the 12th century. The first translation was said to be during the time of Bishop Gundulf 'from the place where he had first been buried into a certain high vault on the north side [of the new cathedral]'. Some time later, after an elderly monk had been cured of his failing sight through the action of the saint, Gundulf moved the reliquary chest (referred to as a *theca*, the Greek equivalent of *scrinium*) to a 'more honourable place' ('in loco decentiori') in the presbytery, where the bones would be accessible to all; many miracles occurred there. Finally the relics were replaced in a

'new and more worthy reliquary' ('de priore t[h]eca . . . in novam et decentiorem') by Bishop John (1125–37), who had also been cured of an eye complaint through the powers of the saint. This event took place on an unspecified 10 June, the date which was thereafter celebrated as the saint's feast-day.

In the early 14th century the compiler of the Rochester version of the *Flores Historiarum* dated the third translation of the relics to 1128, but there is no corroborative evidence that it occurred in that year.[37] All one can safely infer is that the cult had almost certainly come into being by the middle of the century.

There are some problems with the version of events in the *miracula*, notably the fact that the two translations said to have taken place in Gundulf's time are not mentioned in his *Vita*, so the attribution to this bishop could be retrospective, and not necessarily indicative that the cult was up and running before Gundulf's death in 1108. As for the purported first translation into the 'vault on the north side', Colin Flight points out the similarity between this tradition and the location of the relics of early archbishops of Canterbury, also said to have been located 'above a vault on the north side' in Lanfranc's cathedral.[38] Flight suggests that the author of the *miracula* imported the story wholesale (without adapting it to the geography of Rochester, where, unlike Canterbury, the monastery lay south of the cathedral), and that the out-of-the-way location was a convenient way of obscuring the fact that Ithamar's cult was a completely new creation.[39] On the other hand, if bones identified as those of Ithamar were not retrieved from the Anglo-Saxon church before its demolition in the time of Gundulf, the cult centred on his supposed relics from the mid-12th century must be a complete fabrication.

The Corpus Christi *miracula* do provide some indications of the manner of Ithamar's enshrinement — at least at the time of their composition. In one miracle, a deformed dumb woman sought a cure from the saint; we are told that having climbed up the steps as far as the entrance to the presbytery, she was able to see Ithamar's *feretrum* 'in the distance' (*eminus*).[40] It was not long before the hoped-for cure took place. The author of the *miracula* and his fellow monks were singing the saint's festival mass in the choir at the time, and from there they could hear the noise of the excited populace, rushing 'as if to a spectacle' ('quasi ad spectaculum') to witness the miracle.[41] As with the first post-Conquest miracle of St Paulinus, this story preserves precious details about the position of the shrine, which was apparently in the raised eastern arm, above the crypt. The word *eminus* implies, furthermore, that the shrine was well to the east, at some distance from the top of the steps.

In another miracle story involving Ithamar, an aged monk claimed to have dreamt that he was standing by the (high) altar, from where he saw Sts Peter and Andrew, Paulinus and Ithamar, standing on 'the beam which overhangs the cross ["que imminet crucem"]' and pointing at the reliquary chests (*capsas*).[42] Cumulatively, these fragmentary circumstantial details suggest that the relics of the saint, like those of Paulinus discussed above, were located at the east end of the Romanesque church, behind the high altar. If the east end was apsidal, the beam could have been located on the chord of the apse, as at Bury St Edmunds;[43] the monk in the last miracle may have dreamed that the saints were pointing down at the shrines beyond the altar.

Finally, Ithamar's *miracula* also provide some detail about the shrine itself. It is called a *feretrum*, and on one side was a depiction of the saint, which was used by a widow suffering from chronic fever to create holy water through contact with the image.[44] There is not much to go on here, but the 'image' might plausibly have been in bas-relief, perhaps *repoussé* metal: the creation of holy water by contact with a tomb

or shrine is a hagiographical commonplace for which many parallels occur in Merovingian Gaul.[45] The *feretrum*, like that of Paulinus, was presumably raised up on some sort of shrine-base to form a composite monument.

THE SHRINES OF PAULINUS AND ITHAMAR IN THE THIRTEENTH CENTURY

AFTER the establishment of the cult of Ithamar, the development of the cults of the two Anglo-Saxon saints continued in close parallel, and they may be considered as a pair. We must now investigate what happened to the cults when the eastern arm, the presumed original location of the shrines, was remodelled, probably after the fire of 1179.[46]

Some important evidence for the likely position of the shrines in the 13th-century eastern arm was discovered and, inevitably, destroyed during Sir George Gilbert Scott's restoration work in 1873. At that time the original floor level of the presbytery was reinstated, and the remains of a large platform in the middle of the presbytery were found buried beneath the higher floor levels of the 14th century and later. Unfortunately, the discoveries were totally inadequately recorded, even by the standards of the day. The archaeological record seems to consist solely of St John Hope's reworking of 'notes' made by Scott's clerk of works, Mr C. R. Baker King,[47] and two contemporary photographs of the remains of the platform taken by Mr King, preserved in the collections of the Society of Antiquaries (Fig. 2).

The discoveries of 1873 consisted of a mass of rubble, identified as the high-altar platform, together with 'a short length of the lowest step on the north side, and a longer piece on the south'. These steps were, however, not uniform throughout their length. West of a line corresponding to the main bay division in the centre of the presbytery the bottom step on each side was 1 ft (305 mm) broad, with an 'ashlar wall' behind it; to the east of that line, the corresponding rear wall was of plastered rubble and extended further forward over the step, which was therefore only 9 in. (229 mm) broad. These features are clearly shown in Mr King's south-west view of the platform. One large block of the step towards the east end of the platform had survived; another next to it to the west had been robbed out. The 'ashlar wall' comprised two courses, and was therefore not the riser to the next step but the lower part of a retaining wall at the side of the platform. In fact, St John Hope's use of the phrase 'the lowest step' is confusing. As he himself realised, and as is clear from the photographs, there was only a single step (really better defined as a wide plinth or bench) supporting what appears to have been the side wall of the platform. He plausibly suggested that the change in the nature and alignment of those side walls, corresponding precisely to the major bay division of the presbytery, indicated the position of the high altar, which he thought could have been set against a screen or reredos on that line. This seems plausible, and one may perhaps go further and speculate that the blocks forming St John Hope's 'steps' survived in the area in question because they were protected, during the 14th-century remodelling, by a feature such as a screen or wall and could not therefore be robbed out as the blocks further east and west clearly were. Militating against this interpretation, however, is the absence of any indication that a screen or wall ever abutted the wide vaulting responds of the north and south walls of the presbytery: the masonry and Purbeck shafts appear to be original and undamaged.

The investigators were unable to determine the westwards extent of the platform. St John Hope's plan seems to indicate the eastward limits of the step on the south side, though this is at variance with what he shows on the north. King's photographs, on the

FIG. 2. Rochester Cathedral: photographs taken by Mr C. R. Baker King of the north side of the high altar platform (above) and the south side (below) during the works undertaken by George Gilbert Scott in 1873

Society of Antiquaries of London

other hand, suggest that the platform extended at least as far as the west end of the Arundel tomb (an insertion of 1400, as discussed below).

Until 1963 further evidence for the platform survived in the 13th-century crypt below the presbytery. This consisted of a pair of long, narrow piers, aligned to the arcade of the crypt and extending by half a bay to east and west of the second pair of pillars from the east, which they completely encased. Their position is still discernible in the discolouration of the crypt vault in rectangular patches on either side of the pillars, which confirms that the inserted piers were 0.5 m wide by 3.35 m long. They were described by the architect Emil Godfrey prior to their removal as being constructed of

... rubble stonework with worked stone quoins, having small chamfer stops at top and bottom ... some plaster remains on piers, in places covering stonework. Retain traces of masoning, done in ½" single red line, with double line representing vertical joints. [. . .] These two small structures seem almost coeval with the crypt itself . . .[48]

Further observations were made when the piers were demolished. Much of the masonry of the crypt was reddened and spalled owing to some unrecorded fire; the two pillars encapsulated within the inserted piers, however, had been protected and were described as being in 'mint condition'.[49] The plaster of the piers was also reddened; the painted decoration appears to have been on a new layer of plaster applied on the piers. If we knew the date of the fire, this would provide a *terminus ante quem* for the insertion of the piers. All one can safely say is that the character of the plaster decoration seems to confirm Emil Godfrey's view that the piers were 'almost coeval with the crypt itself'. St John Hope associated these piers with the platform that had been discovered immediately above them, suggesting that they had been inserted in order to provide additional support for the platform, and this seems entirely plausible. The fact that the piers were so obviously an afterthought suggests, however, that at first they were not considered necessary, or that the platform was a weightier affair than first envisaged. The length of the inserted piers in the crypt is not necessarily indicative of the length of the platform, as they could have been intended to give extra support only to the heaviest features, namely the high altar and, possibly, a wall or screen behind it.

Let us now consider the possible implications of the 13th-century platform for the position of the shrines of Paulinus and Ithamar. One thing is immediately clear from the plan (Fig. 3). If the high altar was located between the second and third bay of the presbytery, there would not have been room for the shrines to stand, as has sometimes been suggested, in front of the altar on either side of the platform — a position analogous to that suggested for the shrines of Sts Dunstan and Ælfheah in Canterbury Cathedral. It is certainly quite implausible that they could have been located immediately over the reinforcing piers (as is the case with the later shrine of St Swithun at Winchester, where similar supports were inserted in the crypt in 1476),[50] for they would have been far too close together (only 2.86 m between centres). They would have impeded the view of the high altar even if, as McAleer tentatively suggests,[51] it was located towards the east end of the platform. The problem would have been the same if the shrines were further west still, in the first bay of the presbytery and west of the altar platform.

St John Hope's suggested location for the 13th-century high altar seems the most satisfactory interpretation of the evidence, and provides a reason for the intrusive supports in the crypt. If, however, we accept this location for the altar, at the east end of the western half of the platform, the eastward extension of the structure requires explanation. The best interpretation is that it was here that the shrines were located. The eastern part of the platform, distinguished as we have seen by a different treatment of the lateral walls, was at least 3 m long and would have provided ample room for two shrines consisting of masonry shrine-bases supporting the precious reliquaries. The platform could be regarded as the equivalent of the 'feretory platforms' at Durham and Winchester, both Romanesque in origin but remodelled in the 13th century. Furthermore, the shrines in this location would have stood in the same relation to the high altar as they had done in the Romanesque east arm, so the new arrangement may have been a conscious updating of the former layout.

The height of the platform is unknown. St John Hope postulated the usual three steps up to the altar, giving an estimated height of 23 in. (585 mm). If the eastern part

JOHN CROOK

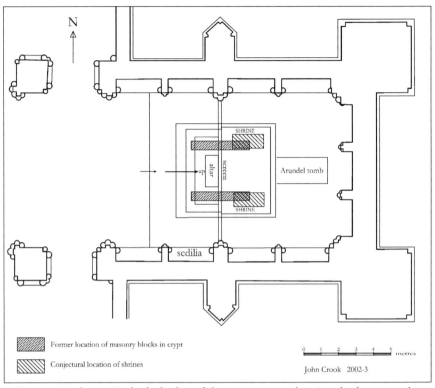

FIG. 3. Rochester Cathedral: plan of the eastern arm, showing the former 13th-
century high-altar platform and conjectural screen, the location of the inserted piers in
the crypt, and the conjectural location of the shrines of Sts Paulinus and Ithamar

John Crook

of the platform lay beyond a wall or reredos, it might not have risen so high. St John
Hope suggested it was 15½ in. (394 mm) in height, basing this measurement on the
height of the top of the Arundel tomb of 1400. (In fact before Scott's intervention the
tomb-slab appears to have been 415 mm above the present floor.) This height would
have allowed for two access steps to the eastern half of the platform.

The arrangement at Rochester may have been intended to channel the movements of
pilgrims visiting the shrines and to prevent them from swarming over the high-altar
steps. The insertion of the wide platform created, in effect, a rectangular ambulatory
around it, with aisles only 1.73 m wide to north and south and a somewhat larger space
at the east end. This ambulatory was at the same level as the main level of the
presbytery, which was originally tiled with '4¾-inch tiles', whose impressions were
discovered in 1873.

According to this interpretation, a pilgrim to the shrines would have entered the
presbytery, whose general level was just one step higher than the eastern transept (the
single modern step may be further east than in the 13th century), then made his way
along a quite narrow ambulatory between the side walls of the presbytery and the high-
altar platform with its lateral walls and single bench-like step. He may then have passed
through some sort of barrier into the area behind the altar. Behind the altar, in the

124

feretory area, the platform was possibly just two steps high rather than the three postulated before the high altar.

One other feature may possibly support the notion that the shrines were located at the east end of the presbytery. Towards the south end of the eastern wall of the presbytery a blocked, round-headed doorway is visible externally, its sill level with the 13th-century floor level. Its modest size (1.25 m wide), its lack of ornamentation, and its position could suggest that it was not intended for use by a large number of people; it could, however, have provided a quick, unceremonious route to enable the shrine-keepers to travel between the claustral buildings and the shrines. Any evidence for an access stair (which could have been merely a wooden structure) would have been removed by post-medieval refacing of the lower part of the east wall of the presbytery.

THE SHRINES IN THE FOURTEENTH CENTURY

SIGNIFICANT alterations took place in the presbytery in the 14th century. Those areas of the main floor level not occupied by the platform were raised by about 415 mm. The distance may be measured from the 'tide-mark' on various parts of the walls and on some of the monuments in the embrasures, and from the cutting back of the bases of the main shafts of the vaulting responds. Sedilia were installed in the second bay from the west, on the south side, and a large piscina was inserted into the north wall of the easternmost bay. Below it, just 20 mm above the new floor level, a small armoire was also created. All these features are consistent with the 14th-century floor level. When the 13th-century floor level was reinstated in 1873, two extra steps had to be provided in front of the sedilia.

It is not clear to what extent the 13th-century platform was altered in the 14th-century works. The floor tiles and usable masonry, such as most of the blocks forming the steps, were evidently removed. The area surrounding the platform was raised by about 415 mm, a level which may have been determined by that of the suggested feretory platform at the eastern end. The height of the sedilia and other insertions is entirely consistent with the final floor level, confirming its 14th-century date. The east–west position of the sedilia is, however, consistent with the location postulated for the 13th-century high altar, so it is possible that the altar was not moved at all. (The inserted piscina, being on the north side, cannot have been intended as an adjunct to the high altar.) Conceivably new high-altar steps were created above the 14th-century general floor level, raising the altar higher still. Unfortunately, subsequent alterations in this part of the cathedral have long erased any evidence.

The shrines themselves were certainly reconstructed in the mid-14th century. A late-medieval Rochester chronicle states that in 1344 Bishop Hamo of Hythe paid 200 marks for the new shrines, which were made of 'marble and alabaster'.[52] The reconstruction of the shrines does not necessarily indicate that they were in a new position. Rochester was not alone in having new shrines for its major local saints in the 14th century. In the same way, the shrine of St Alban had been reconstructed by Abbot John de Maryns in 1302–08, and that of St Edburg of Bicester was rebuilt between 1294 and 1317.[53] Finest of all these reconstructions was the shrine of St Erkenwald in Old St Paul's Cathedral, dating from 1313–26, whose construction is documented and whose appearance is known from an engraving by Wenceslaus Hollar.[54] Some of these shrine-bases have survived in part, and some have been reassembled from surviving fragments. The brief account of Bishop Hamo's work suggests that the new shrines at Rochester consisted

of a monumental shrine-base in contrasting materials: dark Purbeck marble, and light-coloured alabaster, supporting the *scrinia* containing the saints' relics.

There is, however, no evidence that the shrines moved far from the position we have postulated for them in the 13th century. As already noted, one Rochester worthy, Sir William Arundel (d. 1400) sought burial behind the high altar,[55] which may indicate that he wished to lie close to the two shrines in death.

THE CULT OF WILLIAM OF PERTH

THE third cult at Rochester presents fewer archaeological problems. The inception of St William's cult is noted in the Rochester manuscript of the *Flores Historiarum*: 'in that time [1201] St William of Perth was martyred outside the city of Rochester and was buried in the cathedral church of Rochester, while displaying miracles.'[56] William was a baker from Perth in Scotland, who was setting off on a pilgrimage to the Holy Land accompanied by a down-and-out whom he had taken in and who now acted as his servant and companion. The youth was evidently mentally unstable, and murdered his benefactor while the pair were on their way to Canterbury.

This is probably the limit of our factual knowledge of William of Perth, and the rest is the stuff of hagiography. According to his *Vita*, quoted by John of Tynemouth,[57] the body was discovered by a lunatic woman who washed it, adorning the head with a garland of honeysuckle. When she put on the garland next day she was miraculously restored to sanity. She told the people of Rochester, who came out and brought the body to the city. It was laid to rest in the cathedral and eventually became the focus of a cult. Amongst the earliest references to William as a saint is an entry in the *Registrum Roffense* stating that Hubert de Burgh, royal justiciar 1219–30, 'gave the middle window next to St William ["ad sanctum Willelmum"]'.[58] According to the Rochester version of the *Flores Historiarum*, Bishop Laurence obtained the canonisation of 'blessed William the martyr' in Rome in 1256.[59] The same text provides the information that in 1277 Bishop Walter of Merton was buried 'in the northern part of that church, near to the tomb of St William ["iuxta sepulchrum S. Willelmi"]', which securely fixes the position of the shrine.[60]

The inception of the cult took place during the aftermath of the murder, canonisation, and translation of Thomas Becket, and it is often suggested that it was a local response to that cult. If so, it seems to have proceeded rather slowly. Another aspect of the cult needs to be addressed. According to the *Registrum Roffense*, the sacrist William of Hoo (prior from 1239) rebuilt the whole choir from oblations left at St William's tomb-shrine.[61] As already noted, work on the replacement of the eastern arm probably began soon after the fire of 1179; it is improbable that works were still continuing so late as 1227, when the monks 'entered the choir',[62] and some later refurbishment may be involved. Despite these uncertainties, the reference serves to illustrate one aspect of the cult, namely its value in fund-raising.

The references to the 'central window' and the survival of Bishop Merton's tomb clearly indicate the site of St William's tomb-shrine: it was located in the recently built north-east transept. There is one false trail. Until quite recently, a detached Purbeck marble slab in that transept was displayed to visitors as part of the shrine of St William. John Blair has now convincingly shown that it formed part of the first tomb of Bishop Walter de Merton and that it was intended to support the bishop's effigy created by John of Limoges.[63]

Is it possible to locate the tomb more precisely? Here, any evidence has been destroyed by Gilbert Scott's repaving of the eastern transept. (A tiny fragment was noted in the middle of the north-east transept by St John Hope, but has also been replaced since 1898.)[64] The most likely location is a central position, towards the north end of the transept and just south of the tomb of Walter de Merton, who would thus have lain next to the saint. We know nothing of the form of the shrine; if it was reconstructed in the late 13th/early 14th century, it might have resembled the tomb-shrine of St Thomas Cantilupe at Hereford (d. 1282). His surviving tomb in the north transept of that cathedral was built in 1287 when his successor, Richard Swinfield, was promoting the cult; many miracles subsequently occurred there.[65]

THE SHRINES AT THE REFORMATION

THE records are silent on the destruction of the shrines at the Reformation, which is regrettable, as precious information might have been given on their final form. John Hilsey, bishop of Rochester during this period (d. before 25 March 1540), was a vehement opponent of relic cults, and from late in 1540 Henry VIII was creating a palace from the monastic buildings right outside the cathedral.[66] The shrines were probably taken down in 1538 during the first wave of destruction. Whereas some fragments of medieval shrines have survived in other cathedrals and churches, the disappearance of the three Rochester shrines seems to have been total.

NOTES

1. *Bede's Ecclesiastical History of the English People*, ed. B. Colgrave and R. A. B. Mynors (Oxford 1969), 254–57.
2. *Bede*, ed. Colgrave and Mynors, 256–57.
3. R. Sharpe, 'The Naming of Bishop Ithamar', *English Historical Review*, 117, no. 473 (2002), 889–94.
4. A. Campbell ed., *Charters of Rochester*, British Academy Anglo-Saxon Charters, I (London 1973), 14 (item 12).
5. F. Wormald ed., *English Kalendars before A.D. 1100*, Henry Bradshaw Society, LXXII (1934).
6. F. Liebermann, *Die Heiligen Englands* (Hanover 1889); D. W. Rollason, 'Lists of Saints' Resting-places in Anglo-Saxon England', *Anglo-Saxon England*, 7 (1978), 61–93.
7. *Liber Vitæ: Register and Martyrology of New Minster and Hyde Abbey, Winchester*, ed. W. de Gray Birch, Hampshire Record Society (London and Winchester 1892), 87–96, at 92.
8. Rollason, 'Lists', 68.
9. K. Sisam, 'MSS Bodley 340 and 342: Ælfric's "Catholic Homilies", part I', *Review of English Studies*, old ser., 7 (1931), 7–22, at 10–11.
10. *Monumenta Germaniae Historica: Epistolae*, I, ed. P. Ewald and L. M. Hartmann (Berlin 1891), 265.
11. D. Knowles, *The Monastic Order in England* (Cambridge 1949), 118–19.
12. R. Southern, *Saint Anselm and his Biographer* (Cambridge 1966), 249.
13. S. J. Ridyard, '*Condigna veneratio*: Post-Conquest Attitudes to the Saints of the Anglo-Saxons', *Anglo-Norman Studies*, 9 (1986), 179–206; D. Rollason, *Saints and Relics in Anglo-Saxon England*, chap. 9: 'Englishness and the Wider World', 215–39.
14. Eadmer, *The Life of St Anselm, Archbishop of Canterbury*, ed. R. Southern (Oxford 1962), 51.
15. A. Wilmart, 'La légende de Sainte-Édith en prose et vers par le moine Goscelin', *Analecta Bollandiana*, 56 (1938), 5–101 and 265–307, at 38.
16. C. Flight, *The Bishops and Monks of Rochester*, Kent Archaeology Society Monographs, VI (1997), 55–69.
17. *Nova Legenda Anglie: as collected by John of Tynemouth, John Capgrave, and others, and first printed . . . by Wynkyn de Worde a.d. mdxvi*, ed. C. Horstman, 2 vols (Oxford 1901), II, 312–16.
18. B. Rye, 'Catalogue of the Library of the Priory of St Andrew, Rochester, A.D. 1202', *Archaeologia Cantiana*, 3 (1860), 47–64.

19. R. P. Coates 'Catalogue of the Library of the Priory of St. Andrew, Rochester, from the Textus Roffensis', *Archaeologia Cantiana*, 6 (1866), 120–28.

20. *Nova Legenda*, ed. Horstman, II, 314.

21. Translated from *The Life of Gundulf, Bishop of Rochester*, ed. R. Thomson, Toronto Medieval Latin Texts, VII (Toronto 1977), 41–42.

22. *Life of Gundulf*, ed. Thomson, 3–4.

23. Flight, *Bishops and Monks*, 40–44.

24. London, British Library, Cotton MSS, Vespasian AXXII, fol. 87v; *Registrum Roffense*, ed. J. Thorpe (London 1769), 120.

25. *Flores Historiarum*, ed. H. R. Luard, 3 vols (Rolls Series, xcv, 1890), II, 20.

26. *Epistola Eadmeri ad Glastonienses*, in *Memorials of St Dunstan, Archbishop of Canterbury*, ed. W. Stubbs (Rolls Series, LXIII, 1874), 412–22, at 413.

27. Goscelin, *Historia Translationis S. Augustini episcopi*, I.viii, in *Patrologia Latina*, ed. J.-P. Migne, CLV (Paris 1854), cols 13–46, at 17.

28. *Lives of Edward the Confessor*, ed. H. R. Luard (Rolls Series, III, 1858), 156.

29. *Nova Legenda*, ed. Horstman, II, 314.

30. J. Crook, 'King Edgar's Reliquary of St Swithun', *Anglo-Saxon England*, 21 (1992), 177–202.

31. *Liber Eliensis*, ed. E. O. Blake, Camden Society, 3rd series, XCII (1962), 289–90 and 335.

32. Plant, in this volume, 41–50.

33. *Nova Legenda*, ed. Horstman, II, 314–15.

34. *Vita Gundulfi*, ed. Thomson, 41–42.

35. J. Crook, The *Architectural Setting of the Cult of Saints in the Early Christian West, c.300–c.1220* (Oxford 2000), 182–209.

36. D. Bethell, 'The Miracles of St Ithamar', *Analecta Bollandiana*, 89 (1971), 421–37.

37. BL Cotton MS, Nero DII, fol. 110v: published by H. Wharton, *Anglia Sacra*, 343. The passage is, however, tacitly rejected by Luard in his edition (*Flores*, ed. Luard).

38. *Vita Beati Bregwini, auct. Eadmero*, in *Patrologia Latina*, ed. J.-P. Migne, CLIX (Paris 1865), cols 753–60, at 758.

39. Flight, *Bishops and Monks*, 65–66.

40. *Miracula Ithamari*, ed. Bethell, 436.

41. ibid., 437.

42. ibid., 436.

43. Crook, *Architectural Setting*, 192–93.

44. *Miracula Ithamari*, ed. Bethell, cap. vii, 426.

45. Crook, *Architectural Setting*, 27–31.

46. J. P. McAleer, *Rochester Cathedral 604–1540: An Architectural History* (Toronto 1999), 126–32.

47. W. H. St John Hope, 'The Architectural History of the Cathedral Church and Monastery of St Andrew at Rochester, I: The Cathedral Church', *Archaeologia Cantiana*, 23 (1898), 194–328, at 308–10.

48. RIBA Library, DRc/DE/209/IV (Emil Godfrey archive). I am grateful to Bernard Worssam for providing a transcript of this material.

49. RIBA Library, DRc/DE/209/IV: Emil Godfrey to the civil engineer R. W. B. Birch.

50. J. Crook, 'St Swithun of Winchester', in *Winchester Cathedral: 900 Years*, ed. J. Crook (Chichester 1993), 57–68, at 66.

51. McAleer, *Rochester Cathedral*, 267, n. 154.

52. BL Cotton MS, Faustina BV; Wharton, *Anglia Sacra*, I, 375.

53. N. Coldstream, 'English Decorated Shrine Bases', *JBAA*, 129 (1976), 15–34, at 18–19.

54. ibid., 24–25.

55. Saul, in this volume, 175.

56. *Flores Historiarum*, ed. Luard. II, 124.

57. *Nova Legenda*, ed. Horstman, II, 457–59.

58. BL Cotton MS, Vespasian AXXII, fol. 91v; *Registrum Roffense*, ed. Thorpe, 124.

59. *Flores Historiarum*, ed. Luard, II, 414.

60. ibid., III, 50.

61. BL Cotton MS, Vespasian AXXII, fol. 92; *Registrum Roffense*, ed. Thorpe, 125.

62. BL Cotton MS, Nero DII, fol. 134; *Flores Historiarum*, ed. Luard, II, 189.

63. J. Blair, 'The Limoges Enamel Tomb of Bishop Walter de Merton', *Friends of Rochester Cathedral: Report for 1993–4* (1994), 28–33.

64. St John Hope, 'Architectural History', pl. II.

65. R. C. Finucane, *Miracles and Pilgrims: Popular Beliefs in Medieval England* (London 1977), 173–88.
66. H. M. Colvin and J. Summerson, 'The King's Houses, 1485–1660', in *A History of the King's Works*, ed. H. M. Colvin, IV.ii (1982), 1–364, at 234–37.

The Early-Thirteenth-Century Choir-Stalls and Associated Furniture at Rochester Cathedral

CHARLES TRACY (with an Appendix by CECIL HEWETT)

The antiquity of the choir-stalls at Rochester Cathedral is not generally realised on account of their restored Victorian appearance. George Gilbert Scott's reconstitution of the furniture was carried out in a scholarly way, and has preserved for future generations a reliable representation of the form of the monument. The restoration process is described in some detail here, and an attempt is made to place these unique choir-stalls in a stylistic context, not only in terms of the so-called 'vestry' screenwork in the cathedral itself, but also the later choir fittings at Christ Church, Canterbury.

THE CHOIR-STALLS

THE survival of choir-stalls before the 14th century in Northern Europe is a great rarity. In Germany there are some 12th-century seats at Ratzeburg, near Lübeck, Schleswig-Holstein (Fig. 1). Such survivors from the early Gothic period as there were by the 18th century in France, Belgium and Germany were either replaced with baroque furniture, or finally succumbed to the depredations of the Revolutionary and Napoleonic periods. Some of the fine early-13th-century choir-stalls from Lausanne Cathedral (Vaud) still have a toe-hold in the nave of that building.[1] In France one can only point to the mid-13th-century choir-stalls from the former abbey church of Notre-Dame de la Roche, Le-Mesnil-Saint-Denis (Seine-Saint-Denis), a few miles south of Paris.[2] The abbey was placed under the rule of the regular Augustinians in 1226. The roof timbers of the choir and nave are reported to have been dated by dendrochronology to 1232–50.[3] The seats at Hastière-Lavaux (Dinant) and Gendron-Celles (Dinant) in Belgium are of the late 13th century. In England a complete set of stalls of this period survives at Salisbury Cathedral, from shortly after 1236,[4] and three oak columns with stiff-leaf foliage, possibly from the early Gothic stalls at Peterborough Cathedral, c. 1240.[5] Whatever the original purpose of the Peterborough fragments, the stylistic similarity of their capitals with those on the cathedral west front is undeniable.[6]

A complete set of choir-stalls, consisting of eight return and forty-four lateral seats, fifty-two in all, albeit almost entirely of 19th-century reconstruction but dating in its component parts from before c. 1227, is found at Rochester Cathedral (Fig. 2 Col. Pl. II). The furniture can be dated precisely to the 'introitus in novum chorum' noted in the cathedral records,[7] and tradition has it that it was first used at the consecration of Bishop Sandford (1227–35). It was reconstructed, apparently according to the original design, under the supervision of George Gilbert Scott in 1872. The firm

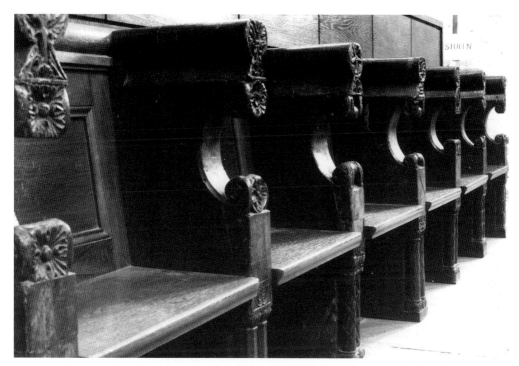

FIG. 1. Ratzeburg, near Lübeck (Schleswig-Holstein), Germany: choir-stalls
James King

of joiners used was Heaton, Butler and Bayne, of Covent Garden, whose own original contributions are of the highest standard (Fig. 3). During the previous three hundred years, the furniture had undergone various transformations. In 1541 the low arcaded railings in front of the lateral stalls were enclosed by new desks, incorporating the *parchemin* panelling that is still *in situ*.[8] St John Hope claimed that the 'various names and dates scratched upon the old painted decoration of the quire walls show that it was not until after the 16th century' that any further changes were made.[9] Although an injunction of Archbishop Laud states 'that there should be a new fair desk in the choir', it seems that no substantive changes were made to the furniture during the 17th century. The stalls survived the Civil War unscathed,[10] and probably remained unaltered until 'Very considerable alterations and improvements were made in 1742 and 1743, under the direction of Mr Sloane. New stalls and pews were erected, the partition walls wainscotted and the pavement laid with Bremen and Portland stone. The choir was also newly furnished ...'.[11] Most of this refurbishment was removed by L. N. Cottingham some eighty years later, in 1825–26, when new stalls and canopies designed by Edward Blore were erected.

When Gilbert Scott restored the cathedral, between 1872 and 1875, much of the original work was found to be still remaining under recent accretions. A description of these and an account of the restoration work was given by Baker King in 1874, as follows.

Upon the removal of the wooden pews, the lower parts of the ancient stallwork [Fig. 4] on the north side and sides of the choir were found to be tolerably complete, and the whole design and

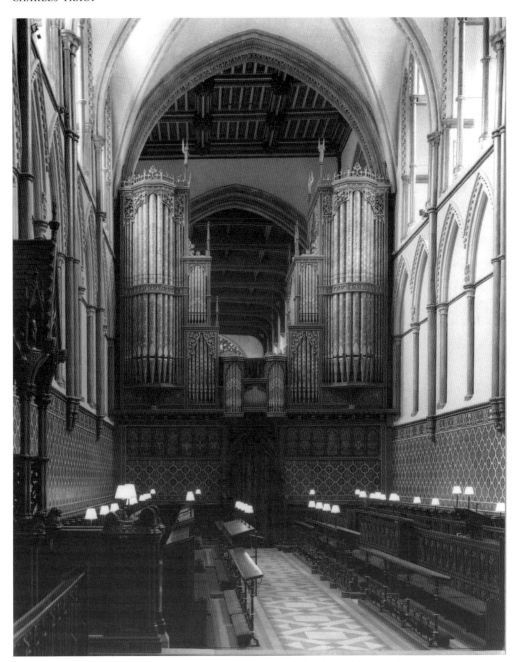

FIG. 2. Rochester Cathedral: view of the choir from the east
Dr Henry Teed

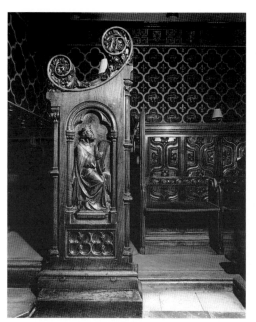

FIG. 3. Rochester Cathedral: north dignitary's
choir-stall end, from George Gilbert Scott's
1872 restoration. Note the mid-16th-century
parchemin desk panelling to the right

Dr Henry Teed

FIG. 4. Rochester Cathedral: choir-stalls,
north side, looking east

Dr Henry Teed

detail of the upper part, with the exception of the capping, could be made out from the fragments
which were discovered.

The arrangement consisted of one row of stalls on each side of the choir, with their desks. Each
side had two gangways, dividing the desks into three lengths. No portion of the returned stalls nor
of their platforms remained.

The platforms or wooden floors were of unusual width, having 4ft 9in. projection from the walls,
and giving a space of 2ft 9in. between the seats and book-desk. The front cill of the platform rested
on the ancient stone plinth, 7ft 5in. deep, having a roll moulding on the top angle. The whole of the
floor and plinth had been raised 10in. or 11in. and the plinth and joists were resting on modern
brickwork.

The stalls had been divided, not by elbows rising from the floor in the usual way, but by divisions
above the seat-level, tenoned into brackets about 5in. wide, which project from, and are framed
into the continuous cill next the wall level with the top of the seats. The brackets and back cill were
rebated for the seats, and there were marks of hinges but no portions of the misericords below.

The seats had been very low, only 13½ in. from the floor, but the stall divisions were 2ft 1in. in
height above the seat. The addition of a capping of 4in. in thickness makes the total height of a
little more than 3ft 6in., the ordinary height of stalls.

By removing the brickwork, and lowering the bottom of the stone plinth to the level of the choir
floor, the stall capping fits exactly to the line of the old painted decoration of the side walls. [Scott
was in the process of lowering the choir floor to its pre-14th-century level, which would have
necessitated a concomitant reduction in the height of the stalls.] The stone plinth remains, but is
now concealed by the floor of the next grade of seats.

133

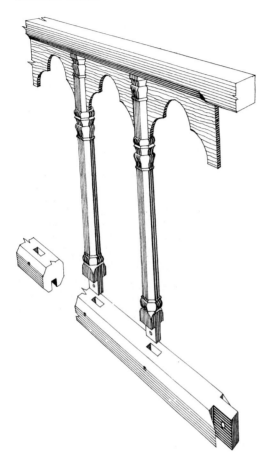

FIG. 5. Rochester Cathedral: perspective and 'exploded' view of part of the choir screen

C. A. Hewett Estate

The desks were nearly perfect, they have merely been repaired, and have had two or three missing shafts supplied.

The wooden screen [Figs 2 and 5], upon removal of the deal canopies, was found and had only one ancient door post, that on the southern side, and this was much mutilated. At about the level of the springing of the small arches are slight remains of the figure of an angel, which appears to have stood on a corbel with a cresting of foliage, the whole carved in the solid with the post [Fig. 6]. Rather lower, on the east face of the post, was a mortice, but there was no further indication of the further design of this portion. The north door post had been replaced by a post of fir. The old top beam remained throughout the length of the screen, the part over the doorway being stop-chamfered, and having remains of painting. There were no mortices for arched ribs, and it is evident that the old entrance had been square in form.

The upper panels were originally open, the boarding having been introduced during the late fitting of the choir.

The decoration found on the desk fronts [Col. Pls III and IV] remains untouched, as does a considerable portion of the lower panel of the wall paintings.[12]

The passage is an invaluable first-hand account of the condition of the furniture when it was rediscovered, and of the subsequent restoration. Indeed, Baker King and Gilbert Scott's unpicking of the post-medieval pews and other accretions was a triumph

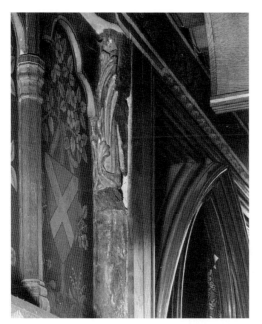

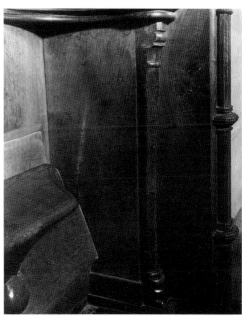

Fig. 6. Rochester Cathedral: return of the choir-stalls, fragment of carving on the south side of the entrance

Dr Henry Teed

Fig. 7. Rochester Cathedral: original column in front of the seat standard in the north-east corner of the lateral stalls

Dr Henry Teed

of 19th-century archaeology. The form of the stalls, which we know to be authentic, is of great interest, because it does not conform to the pattern established in later monuments (see the Appendix). The seat standards do not rest directly on the ground, but sit on brackets tenoned into the seat rail. This conformation is reminiscent of stone sedilia, where the cill is undercut, though even the choir-stalls at Ratzeburg have standards that rest on the ground. Little of the restored monument at Rochester is ancient. The seat rail survives in many parts, as does the underside of the projecting brackets. A single ancient example of the column that fronts the seat standards survives in the north-east corner (Fig. 7). All the misericords at Rochester are modern.

There were never any substalls at Rochester, this probably being the rule for monastic churches. There were fifty-two seats, rather fewer than monastic Peterborough Abbey (70) and Westminster Abbey (66).

The low arcaded railings in front of the lateral stalls consist of a series of trefoiled arches, carried by slender octagonal shafts with stout ones at the ends, supporting a thick moulded capping (Fig. 8, Col. Pl. IV A–C).[13] Similar uprights and roll mouldings are found on the seating, and the arcading of the pulpitum. The style is of plate tracery, fictively pierced in the spandrels. The roll moulding underneath the bracket supporting the seat standards is emphasised at the sides by undercutting, giving the impression of a Romanesque moulding. The low arcaded railings are a mere 56 mm in height from the top of the plinth on which they rest. They offer no provision for books. In any case, as St John Hope remarked, monks used none. He suggested that they were 'for the brethren to rest their elbows on when they were kneeling "prostrati super formas"

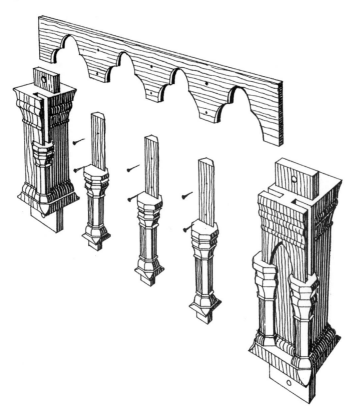

FIG. 8. Rochester Cathedral: perspective and 'exploded' view of the low arcaded railing in front of the later choir-stalls

C. A. Hewett Estate

during certain parts of the services'.[14] This interpretation appears to be vitiated by the fact that the Latin word *forma* is usually translated as bench. The preposition *super* is used in the Constitution of Hirsau, Book I, to describe where the clerics sat, for example, 'super sedilia' or 'super scamnum', both referring to the seats in choir-stalls.[15] Someone who is 'prostratus super formas' occupies a bench and kneels in front of it. In the Hirsau document we are given to understand that these individuals would use footstools (*scabella*) placed in front of them to kneel on. The low arcaded railings at Rochester are too formal and decorated to be benches, nor are they footstools. Their function must have been that of a fence-screen to demarcate the monks' stalls.

It is difficult to find anything stylistically comparable to the Rochester woodwork. Columns in the architecture of this period were usually rounded, yet here they are polygonal. On the low arcaded railings paired columns occur every so often, linked by an arch device surmounted by a sort of coping. This is somewhat reminiscent of a Romanesque corbel. However, the most characteristic feature of the Rochester woodwork is the way that, in the arcading of the pulpitum, the uprights are carried through to the cornice, terminating in another moulded capital. At the back of the low arcaded railings the same device is employed, but there is no second capital. On the pulpitum arcading this column extension is halved, so as to accommodate the horizontal plate-tracery panel behind. It fills no constructive purpose, and one can only suppose that the designer may have been looking to such masonry systems of 'linkage' as the nave triforium at Amiens Cathedral (Somme), of after 1220.

The solid wall behind the single row of monastic stalls on each side of the choir, as well as the lower portion of the pulpitum, is decorated with a single heraldic diaper design of 14th-century date. Quatrefoils enclose golden leopards of England on a red ground, with blue interspaces, each charged with a fleur-de-lis of France. Along the bottom is a narrow band of flowers and interlaced ribbon work. At the top is a broader band of panels, each containing a shield.[16] According to Gilbert Scott, the armorial bearings of the latter could not be recovered, and it was agreed that they should be filled with the arms of the bishops of Rochester.[17] The design of this upper zone is slightly different each side. St John Hope believed that the heraldry must derive from the quartered arms of Edward III, first adopted in 1340. If he was correct, this painting scheme would have been devised sometime shortly after 1340, as part of the refurbishment of the church by Bishop Hamo of Hythe between 1340 and 1350.

Evidence of the original 13th-century painting scheme was found by Scott on some wooden panels from the return stalls behind the prior's stall on the north side,[18] where the new scheme, of the time of the mid-14th-century refurbishment, had been placed over it (Col. Pl. III A–B). The surviving portion, now displayed in a wooden frame in the south-east transept, discloses the original scheme, which was formerly covered up. Surprisingly, some areas of these panels seem only ever to have received a simple tracing in two colours of the background design. Perhaps this is simply under-drawing, and this portion of the surface was neither overpainted, nor ever intended to be exposed. Painted on oak boards, the design was described by one writer as 'resembling a rough copy of some Scottish tartan'.[19] It consists of interlocking diagonal frets of coloured and quartered lozenges, and offers no cut-off point at top or bottom. The panels with surviving paintwork measure 1.41 m x 0.87 m, which is 150 mm taller than the panels behind the return stalls. Apparently the painted area of the panels originally reached down well below the level of the stall seat-capping, and the panelling itself went down to the floor. It has never been established just how far to the east the original painting scheme reached.[20]

Curiously, in his elevation drawing of the arcade at the top of the screen on the south side of 1867–68, J. T. Micklethwaite shows six openings, instead of the five that there are now.[21] He demonstrates that the entrance side of the seventh opening has been interrupted, thus implying that the arcade originally ran continuously across the top from north to south, and above the entrance door. As we have seen above, Baker King believes that the original entrance door was straight-headed. He also tells us that the decorated panels, filling the arcading in the upper zone, are modern. The architrave, with its two-stepped stop chamfers, is ancient. The rails are chamfered on both east and west sides. Moreover, the evidence for painting on the western side of the lower portion of the pulpitum, which is accessible to view under the organ loft on the south side, indicates that in the first place there were no immediate encumbrances. We know that the wooden pulpitum originally consisted of two parallel screens, that on the nave side aligning with the westernmost projection of the piers.[22] The boards on the south-west side under the organ loft are sized and gessoed, and there are traces of vermilion, and a much more general layer of plum red, similar to the colour on the 14th-century stall decorative scheme. Moreover, there are traces of medieval coloured patterning, which may yet be recoverable under the flaking layer of modern paint. This suggests that the west side was redecorated in the 14th century, although quite why that should have been necessary in a presumably enclosed and dark space we cannot say. According to Vallance, by about 1320, the nave-side screen of the pulpitum had been replaced by a

stone one. The post-medieval history of this component of the cathedral's furnishings is dealt with in some detail by him.[23]

The cathedral is known to have reaped a considerable bonanza from the offerings at the shrine of William, the Scottish baker, who was converted into a local saint and martyr by carefully orchestrated publicity.[24] The funds accruing from this exercise subsidised the building of the sacrist William de Hoo's new choir and its furnishings.[25]

In Northern Europe in the 13th century, it is probable that most choir-stalls, like those at Rochester, had no superstructure at all. Unfortunately there are so few extant 13th-century French examples that it is impossible to make any generalisations about that country, beyond noting that this was the case at Notre-Dame, Paris.[26] The massive stone parclose walls found at Rochester, and also in Prior Conrad's choir at Canterbury Cathedral,[27] provided shelter from draughts, and ensured that the daily offices were undisturbed by visiting pilgrims. At Rochester the choir is contained in the eastern arm of the church, following the precedent set in the early 12th century by Christ Church, Canterbury. In all of the Norman greater churches in England the ritual choir had been either wholly in the nave or astride the crossing. The walls of the choir at Rochester are nearly 6 ft thick, and are presumed to have been adopted from Bishop Gundulf's 11th-century presbytery.[28] Enclosing walls were sometimes decorated in various ways (see below).

St John Hope believed that the fragment of sculpture on the return stalls, immediately to the south of the entrance on the level of the wooden panelling arcade (Fig. 6), was part of the 13th-century bishop's canopy, and that originally there would have been another canopy for the prior on the north side. It seems to be part of a cloak curling up at the hem into a stiff-leaf element. From its position and scale, it is more likely that it belonged to one of a pair of figures supported on corbels flanking the entrance, than to a stall canopy. It seems unlikely that canopies were provided for the dignitaries in the first place. St John Hope was probably correct to claim that the bishop's throne at the south-east end of the stalls, erected during Bishop Hamo of Hythe's episcopate, was the first to be placed in that position.[29] As in most other English cathedrals, up to that time, the bishop would have had a special stall to the south of the entrance. It was only from the start of the 14th-century that it was fashionable to create a special throne for the bishop in English cathedrals, as we find at Exeter, Wells, Durham, Hereford, Lincoln, and St David's.[30] These were usually made of wood, such as the one placed in the same position at Christ Church, Canterbury at some time after the completion of the Corona.[31]

There is little doubt that the present conformation of the pulpitum façade is all of one build, even though there seems to be a change to the carving behind the angel's garment hem when you look at it from the side. Here, the small trefoil leaf at the back has been neatly included, and there is a slot for it, but this passage does not necessarily amount to a chronological disjunction. If, for the sake of argument, the upper portion of the screen had been added in the late 13th century, it would have looked uncomfortably old fashioned. In any case, the close similarity of the mouldings on the pulpitum façade with those on the low arcaded railings of the stalls seems to clinch the argument.

The main formal stress at Rochester is the combination of woodwork at floor level with a band of painted decoration above. In an early-19th-century history of the cathedral it is claimed that 'formerly there were episcopal portraits in each of the niches of the stalls; one of them a picture of Bishop John de Shepey [sic] d.1360'.[32] It is difficult to imagine where these images would have been placed in the medieval scheme, except

possibly under the arcades of the return stalls, which had been traditionally pierced. Perhaps they were newly painted after the Civil War and placed on boards blocking the upper lights of the pulpitum, or perhaps part of Mr Sloane's 18th-century wainscoted scheme.

Apart from the uniquely early and idiosyncratic joinery of the stalls, the surviving fragments of the 13th-century and 14th-century schemes of decoration make them doubly interesting. The low arcaded railings are so well preserved because, from the 16th century, they were encased inside later woodwork.[33] They are unparalleled survivals from either England or Northern Europe. Their decoration is painted over a layer of plaster or white lead. The mouldings are picked out in vermilion, green and yellow, the small panels that occur at intervals between the shafts being painted green. The spandrels of the arches are decorated with single lights and round windows, painted in black (Col. Pl. IV A–C).[34]

The refurbishment of the choir at Rochester invites comparison with that at the very beginning of the 14th century at Christ Church, Canterbury. In the latter case, Prior Eastry provided a new set of seventy stalls with his comprehensive refurnishing of the ritual choir. There was a double row of thirty-five seats on each side, including twelve return stalls. In 1298–99, two payments were made to Reginald Noldekyn, amounting to £38 18s. 3d. 'pro novis stallis in choro', and 'pro novis stallis inferioris chori faciendis'. In 1304–05, the huge sum of £839 7s. 9d. was spent by Eastry on providing the choir with three new doors, rood-loft, and the elaborate stone parclose screen. This work also included a comprehensive internal renovation of the Chapter House. The often cited painting by Thomas Johnson of the choir taken from the pulpitum, dated 1657, shows the seating to have been of a somewhat utilitarian design, but altogether different from that at Rochester.[35] This is confirmed in the anonymous painting in the Paul Mellon Collection at Yale of an identical view taken before 1705.[36]

From the Johnson painting it can be seen that the seat backs of Eastry's stalls were panelled with boards decorated with traces of red and gold paint. Gilbert Scott's account of the well-preserved east face of the pulpitum at Canterbury, which he was able to examine, was published in 1875.[37] This side of the screen had not been visible since the late 17th century, when it was refaced with baroque stalls in the Wren manner by Roger Davis. Scott provides a much fuller confirmation of the decorative scheme than can be intuited from Thomas Johnson's painting, which omits the pulpitum (Figs 9 and 10). The former recalls that between the seat-capping and the base of the arcading above 'was a space of about a yard in height. In the original screen these spaces were boarded with oak and decorated in colour, a beautiful border running along its upper edge (with heraldic lions and fleurs-de-lis interspersed), and the rest being spangled with gold rosettes on a green ground'.[38] The lower portion was probably supposed to represent a curtain. Importantly there were two stone canopies for the principal dignitaries. In conclusion, the writer adds:

The whole constituted a somewhat unusual instance of a cathedral choir with no canopies to any of its stalls but to those of the two greater dignitaries. The same, however, is found to have been probably the case at Rochester, though in that case the western screen is of wood, and the stalls along the sides are backed by walls decorated in colour instead of screens, the same coloured decoration being applied to the close portion of the western screen.[39]

Gilbert Scott was incorrect to suggest that canopyless choir-stalls were a rarity in the 13th century. Both here and in continental Europe most examples at that time were

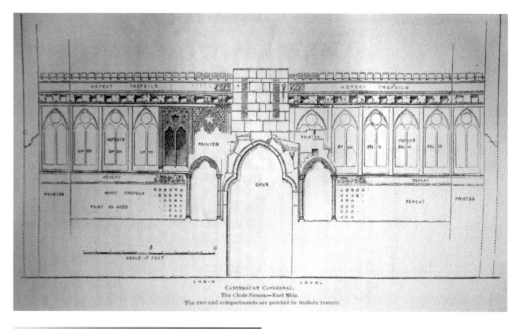

FIG. 9. Canterbury Cathedral: east side of the early-14th-century pulpitum screen. After George Gilbert Scott, 'The Choir-Screen in Canterbury Cathedral' (see note 37)

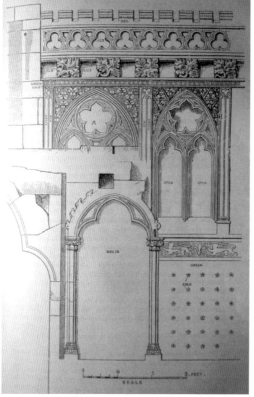

FIG. 10. Canterbury Cathedral: east side of the early-14th-century pulpitum screen, detail of the north side. After George Gilbert Scott, 'The Choir-Screen in Canterbury Cathedral' (see note 37)

probably both canopyless and backed by a solid wall, like those at Xanten (Nordrhein-Westfalen), Germany, of the mid-13th century.[40] As at Rochester and Canterbury, the enclosing walls were sometimes painted, sculpted, or decorated with tapestries. Iron hooks for such were recorded by Scott on the cornices of the lateral and western screens at Canterbury. In England painted decoration was also commonly employed at this time, both decoratively and iconographically. A reference to it from the 12th century takes us to St David's Cathedral where, as we are told in his biography, Gerald of Wales composed a special verse to be inscribed above his stall. However, probably the most impressive instance was the cycle of fifty biblical types and antetypes painted on the back panelling of the stalls at Peterborough Abbey, *c.* 1230–50.[41] Similar schemes crop up in stained glass at Canterbury Cathedral, and in manuscripts.[42] Unfortunately the Peterborough ensemble was broken up and dispersed in 1643.

THE VESTRY

THE so-called vestry in the south aisle, made of oak and just east of the steps to the crypt, also deserves consideration in this context (Figs 11 and 12). It is close in style to the choir-stalls and must be part of the same campaign. It has been fitted in above the entrance to the crypt, adjacent to the steps leading towards the south-east transept. The planking of the east–west section is modern, as is that along the top section of the north–south portion, and the battens hiding the joins. In addition, the cornice is post-medieval throughout. The entrance is from the south-east transept. Although there are no motival comparisons between the vestry and the choir-stalls, the similarity of the mouldings and the use of faceted uprights is proof enough of their contemporaneity (Figs 5, 6, 7 and 12). The central upright of the vestry has the only crocket capital to appear on any of the woodwork. The vestry screens were originally painted. On the old portions there are remains of the original decoration of red with dark blue stars. Interestingly, the walls of the vestry are double-skinned, the inside being lined with plain vertical overlapping planks.

There does not seem to be any evidence that the structure has been moved at any time, although it is hard to explain the anomaly that at the east end the post is without a capital, and appears to have been crudely abbreviated at some time. The all too evident restoration may have been carried out under Lewis Cottingham, as there is an inscription on the modern exterior panelling on the south side, dated 1822.

We do not know if the present function is authentically medieval in origin. In greater churches vestries are rarely mentioned, although at Durham, for example, *The Rites* speak of a 'revestry', also in the south choir aisle.[43] The existing stone entrance door has been dated to *c.* 1300 when, it is thought, the south transept was completely reconstructed. Both western walls of the south transept and the doorcase into the vestry are of this date.[44] There must always have been an access door here, as it was the only place for one. Given its inconspicuous and convenient position, the space defined by these wooden parclose screens is perhaps more likely to have been used as a vestry than anything else.

POSTSCRIPT

A historiography of the Rochester Cathedral choir-stalls would not be complete without a brief reference to the controversy over the origins of the fragmentary furniture at Barming Church, near Maidstone. In June 1939, Dr Francis Eeles, the

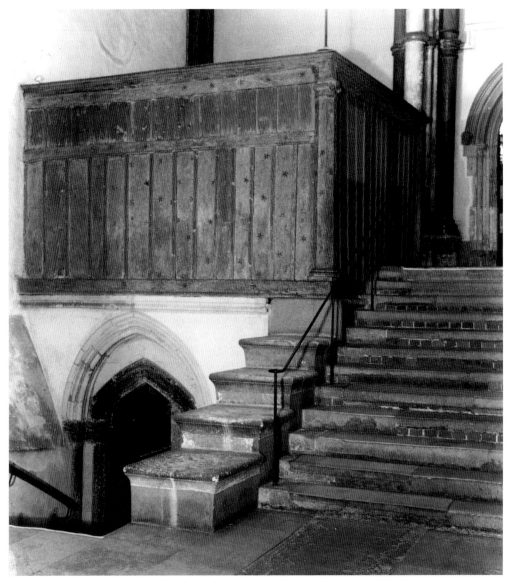

Fig. 11. Rochester Cathedral: 'vestry' at the head of the south choir aisle
Dr Henry Teed

secretary to the General Council for the Care of Churches, tried to claim that the Barming woodwork had been stolen from Rochester Cathedral. 'I should like to see Barming show its loyalty to the Bishop and Dean of Rochester by giving them back', he said at the annual festival of the Friends of Rochester Cathedral. The bishop agreed with him. However, Barming parishioners were indignant. 'It is not a question of loyalty to the Bishop and Dean', said the rector to an *Evening Standard* reporter. 'The

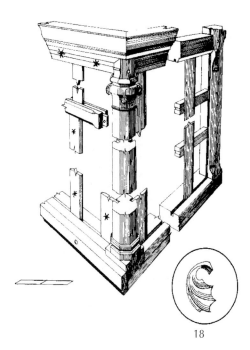

FIG. 12. Rochester Cathedral: perspective and
'exploded' view of the south end of the 'vestry'
C. A. Hewett Estate

stall-ends did not come from Rochester Cathedral in the first place. They were presented to Barming Church (in 1871) by two brothers, named Beaumont, farmers in the parish. They went to Flanders for a holiday, saw the stall-ends in a shop, bought them and presented them to the then Rector of Barming, Mr Carr.'[45] In a retraction, published in *The Times* newspaper on 24 June, Dr Eeles hastened 'to withdraw any suggestion that the Barming stall-ends had come from Rochester Cathedral'. The writer added:

. . . beneath the stalls of Rochester Cathedral are remains of massive thirteenth-century work, little seen and known, the survivors of drastic alterations. It was not unnatural to assume that these wonderful Barming stall ends formed part of that scheme. Rochester would be really the only reasonable possible local source. The definite evidence provided by Mr Sharp (the then rector of Barming) now seems to make it safe to assume a Flemish or neighbouring origin.[46]

APPENDIX
THE CARPENTRY OF THE CHOIR FURNITURE

The Choir-stalls

THE low arcaded railings in front of the lateral stalls are grouped into four- and five-bay widths (Fig. 8). At each end is a stanchion. These are tenoned into the 'platform' or plate, and the top cill. Between two stanchions are mortises for the free-standing colonettes. These are halved for the planks, which are carved into four trefoiled arcades and chamfered. The planks were nailed on to the halved colonnettes with two thin nails. This was done on a bench. The whole group was then pushed into the mortises, and the top cill was added and pegged into the two stanchions. The arches are painted in the original red, white and green.

The wooden choir-screen has seven trefoiled arches between its ends and the doorway, and was mutilated in early times. The pilasters at the top are rebated through the plank, and tenoned into the top and bottom rails (Fig. 5). The bottom rail is chamfered into an octagonal shape, as shown, and is chase-mortised through the bottom end.

The Vestry

THE structure consists of two wooden walls and three posts, being inside 12 ft 7 in. long on the west, 10 ft 6 in. long on the south, and 8 ft high. It has an oak frame with vertical oak boards, having vertical splayed ends (Figs 11 and 12). These are used in the 13th-century cope chest at Wells Cathedral, which also has the same vertical boards.[47]

The vestry was made in the carpenter's workshop, but not pegged. It would have been assembled and pegged together on site. The frame has three rails, being mortised and tenoned into the three posts. These rails have chased mortises to hold the boards. The central post has a carved capital and base, and an octagonal shaft. It has three leaves carved into it, as shown. Assembly started from the north post, the boards being put into the base chased mortises, and the two rails were then pegged into the wall post. The top rail was pegged into the same post. The middle post was then fitted in the same way. The last post is 6 in. from the stone arch, and the gap is covered by an original vertical board.

The low arcaded railings, the pulpitum and the vestry are all chase-mortised, and could have been made by the same carpenter, who was using a rare plane. The boards would not have been manufactured on site, and were probably made by water mill, and obtained from London.

ACKNOWLEDGEMENTS

I am grateful to the Dean and Chapter for giving me full and free access to the furniture for the purpose of research, and for allowing the photographs used to illustrate this paper to be taken. Dr Henry Teed and Dr John Crook have provided some excellent photographs, and Paul Woodfield generously gave up his time to prepare the drawing: my grateful thanks to all of them. The estate of the late Cecil Hewett has kindly given permission to use two of our former colleague's outstanding isometric drawings. For welcome advice on the joinery I am indebted to the late Cecil Hewett, as well as Hugh Harrison and Paul Woodfield. Finally, my thanks to those who contributed their useful comments on the vestry during the conference.

NOTES

1. E. Bach, *Les stalles gothiques de Lausanne* (Zurich 1929).
2. C. Tracy, *English Gothic Choir-Stalls: 1200–1400* (Woodbridge 1987), pl. 4.
3. For a 19th-century description of this furniture, see Auguste Moutié, *Cartulaire de l'Abbaye de Notre-Dame de la Roche* (Paris 1862), 224–28, pls 22–29.
4. Tracy, *English Gothic Choir-Stalls*, 5–7 and pls 12–25. The making of the furniture at Salisbury has been pushed back some years by the discovery of an entry in the Close Rolls dated 18 June 1236 for the gift of twenty good oaks to make the stalls; see G. Simpson, 'Documentary and Dendrochronological Evidence for the Building of Salisbury Cathedral', in L. Keen and T. Cocke ed., *Medieval Art and Architecture at Salisbury Cathedral*, BAA Trans., XVII (1996), 10–19, table 1.
5. Tracy, *English Gothic Choir-Stalls*, pl. 6.
6. C. R. Peers, VCH, *Northamptonshire*, II (1906), 444. The west front capitals are illustrated in Tracy, *English Gothic Choir-Stalls*, pl. 6.
7. W. H. St John Hope, *The Architectural History of the Church and Monastery of St Andrew at Rochester* (London 1900), 108.
8. St John Hope, *Architectural History*, 108.

9. ibid., 108.

10. '. . . the Seats and Stalls of the Quire escaped breaking down . . .', *Mercurius Rusticus* (London 1685), 135.

11. The words of a Mr Denne, quoted by St John Hope in *Architectural History*, 108.

12. C. R. Baker King, 'Choir Fittings in Rochester Cathedral', *The Spring Gardens Note-Book*, II (1879), 75.

13. The extant capping is mostly 19th-century workmanship, but an original section survives at the north-east end.

14. St John Hope, *Architectural History*, 110.

15. *Constitution of Hirsau*, in *Patrologia Latina*, ed. J.-P. Migne, XXIX (Paris), col. 961.

16. For a full discussion of the painting, see S. Robertson, 'On a Wall-painting in Rochester Cathedral Choir', *Archaeologia Cantiana*, 10 (1876), 70–74, figs 70–71.

17. G. G. Scott, *Personal and Professional Recollections* (London 1879), 350.

18. S. W. Wheatley's careful examination of the screen panelling is recorded in A. Vallance, *Greater English Church Screens* (London 1947), 48.

19. R. C. Hussey in Robertson, 'Wall-painting'.

20. Vallance, *Church Screens*, 48.

21. *Spring Gardens Sketch Book*, II (1867–68), pl. 46.

22. Vallance, *Church Screens*, 48.

23. ibid., 48–49.

24. Anon., *History and Antiquities of Rochester Cathedral* (Rochester early 19th century), 10.

25. St John Hope, *Architectural History*, 52.

26. D. Gillerman, *The Clôture of Notre Dame and its Role in the Fourteenth-century Choir Program* (New York and London 1977; Ph.D. thesis, Harvard University, 1973).

27. See the monk Gervase's description of Prior Conrad's choir at Canterbury Cathedral, in W. Stubbs, *The Historical Works of Gervase of Canterbury*, I (London 1879), 12.

28. St John Hope, *Architectural History*, 52.

29. St John Hope, *Architectural History*, 110.

30. For the throne at Lincoln, see C. Tracy, 'A Medieval Bishop's Throne at Lincoln Cathedral', *Apollo*, new series, 155, no. 479 (January 2002), 32–41.

31. C. S. Phillips, 'The Archbishop's Three Seats in Canterbury Cathedral', *Antiq. J.*, 29 (1949), 26–36.

32. Anon., *History and Antiquities*, 12.

33. St John Hope, *Architectural History*, 110–11.

34. E. W. Tristram, *English Medieval Wall Painting: The Thirteenth Century* (Oxford 1950), 593.

35. M. Sparks, 'The Refitting of the Quire of Canterbury Cathedral 1660–1716: Pictorial and Documentary Evidence', *JBAA*, 154 (2001), fig. 1.

36. ibid, fig. 8.

37. G. G. Scott, 'The Choir-Screen in Canterbury Cathedral', *Archaeol. J.*, 32 (1875), 86–88.

38. ibid., 87.

39. ibid., 87.

40. R. Klaphek, *Der Dom zu Zanten* (Berlin 1930), 130. Illustrated in Tracy, *English Gothic Choir-Stalls*, pl. 3.

41. S. Gunton, *History of the Church of Peterborough* (London 1686), 334; M. R. James, 'On the Paintings Formerly in the Choir at Peterborough', *Proceedings of the Cambridge Antiquarian Society*, IX (1894–98), 178–94.

42. L. F. Sandler, 'Peterborough Abbey and the Peterborough Psalter in Brussels', *JBAA*, 33 (1970), 36–49.

43. J. T. Fowler, *The Rites of Durham*, Publications of the Surtees Society, CVII (Durham 1903), 22.

44. See further the article by Jennifer Alexander in this volume.

45. *Evening Standard* (16 June 1939).

46. C. Tracy, *Continental Church Furniture in England: A Traffic in Piety* (Woodbridge 2001), cat. no. M/1.

47. C. A. Hewett, 'English Medieval Cope Chests', *JBAA*, 141 (1988), 108–11.

The West Transept of Rochester Cathedral

JENNIFER S. ALEXANDER

Rochester's west transept marks the completion of the remodelling of the east end in the Gothic period and reflects the earlier work further east in its design. It is evident that two different masons worked on the north and south transepts and that the builder of the choir was responsible for the start of work on both parts. The crossing area was also rebuilt at this time, although its construction did not proceed in a single campaign. A date in the first half of the 13th century is proposed.

INTRODUCTION

ROCHESTER'S west transept was built as part of the remodelling of the east end of the cathedral during the 13th century, but the masons were constrained, in a way that is unprecedented in any other major church building, by the unusual arrangement of the eastern limb of the building. The north-west transept is butted up hard against Gundulf's tower on the east, which was as high as the transept until the early 19th century. The south-west transept had to accommodate both a complex choir aisle on its east side, and the west range of the cloister, sited, unusually, to the east of the transept. Architectural differences between the two arms of the transept suggest that they belong to different building campaigns, but not, perhaps, to different periods (Figs 1 and 2).

Although the west transept is unlikely to have been built by the same mason as the late-12th-century choir and east end, its construction brought to fruition the plans for remodelling the east end. It is evident that many of the design ideas in the transept reflect ideas in use further east, and perpetuate the concept of a thick-walled building of great mass over which there are diaphanous clerestory and soaring high vault, its springing taken at a prodigiously high level (Fig. 3). Specifically, the transept continues the resistance to the concept of the pier that is found in the east end, where the choir has solid walls and the presbytery walls are articulated by tall arched recesses; the chapels of the east transept do not open from an arcade supported by piers, instead the arches spring from heavy sections of wall fronted by groups of shafts, with the wall thickness stressed by the continuation of Purbeck marble string-courses between the capitals on the arches at front and back. The same effect can be seen in the north-west transept, in the opening into the altar recess in the east wall: rather than construct a single arch with a deeply moulded head, the mason has chosen to build a series of arches separated by blank walling, with the inner and outer arches joined by a Purbeck marble string-course. The incomplete arches of the south-west transept would also not have met above a pier, but echo the eastern transept arrangement on a less substantial scale. It is only in the remodelled part of the nave that Gothic piers occur, but they are massive, and of unusual proportions.

146

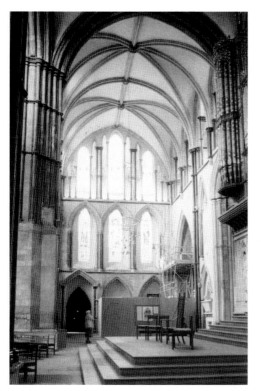

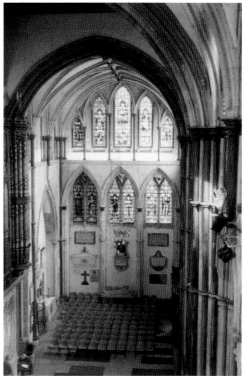

FIG. 1. North-west transept from the south
Jennifer Alexander

FIG. 2. South-west transept from the north
Jennifer Alexander

THE DOCUMENTARY EVIDENCE

THE only documentary evidence for the Gothic rebuilding seems to be a list of the works of monastic officials added, at an unknown later date, to a list of benefactions.[1] The text states that William of Hoo, sacrist, built the choir from the aisles ('fecit totum chorum a predictis alis') and that this was financed from offerings at the shrine of William of Perth. It continues to state that Richard of Eastgate, monk and sacrist, began the north 'ala' (aisle or arm) of the new work towards the portal of the blessed William, which brother Thomas of Mepeham 'fere consummavit'. William of Hoo was prior from 1239 to 1242 and presumably sacrist before that; Richard of Eastgate succeeded William as sacrist, presumably in 1239; and Thomas of Mepeham was sacrist in 1255, but not before. Richard of Waldene, monk and sacrist, made the 'ala' on the south towards the court. His dates are not known. Two further dates are important: 1227, when the monks entered the choir, and 1240, when the building was dedicated. None of these references is related directly to the construction of the transept however, although 'the portal of the blessed William' may refer to the door in the north wall of the transept through which pilgrims would have entered the church.

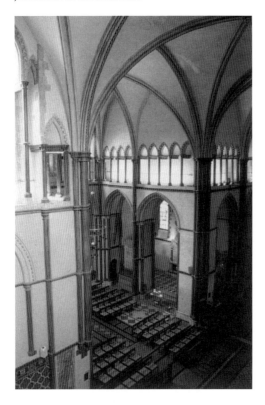

FIG. 3. North-east transept from the south-west

Jennifer Alexander

THE WESTERN CROSSING

IT is evident from the fabric that the rebuilding of the crossing was undertaken during the reconstruction of the east end, but was not completed in a single campaign, since the design is not carried through consistently. Additionally, Rochester's western crossing joins the Gothic choir to the Romanesque nave, and the extent to which the earlier work in this area influenced the construction of the new crossing must be established, although there are no traces of its fabric visible above ground.

St John Hope reconstructed the Romanesque building with a continuous nave arcade that opened into narrow transept arms to north and south, without an articulated crossing. He proposed that the transept internal width was the same as the length of the nave bays, that is 4.92 m (15 ft), but that the transept was as long as the present one (see Fig. 14). According to this reading, when the choir was rebuilt the Romanesque cores of the choir walls were recased and new, larger, piers were built at its west end to form the eastern crossing piers. The respond to the north-east crossing pier was found in 1872 to be resting on an earlier base of very similar size, but St John Hope was unwilling to accept that this provided evidence for an earlier, developed crossing, as Fairweather noted.[2]

In St John Hope's account of the rebuilding, the first pair of Romanesque nave piers to the west was removed, and the next pair was recased and enlarged to form the western crossing piers. The length of the new crossing was therefore the same as the

length of two bays of the Romanesque nave. None of this has been tested by excavation,[3] and before accepting St John Hope's plan a further piece of evidence needs to be considered. The two eastern bays of the nave south arcade show a marked deviation southwards to the south-west crossing pier, to allow the two sides of the crossing to align squarely. It is shown on St John Hope's plan, but he does not discuss this in his text. His conjectural plan of the Romanesque building shows the arcade aligned perfectly, but it also appears to show the south wall of the choir in a different place in the Romanesque building than that shown on his plan of the current building, despite his assertion that the Gothic builders retained the site of the choir wall and merely refaced its rubble core. The southward deviation does not continue into the choir and it can only have been connected with the need for an aligned crossing. The date of the crossing piers and of the laying out of the east end of the nave south arcade needs to be established at this point.

The masonry St John Hope reported beneath the north-east crossing pier respond must relate to an earlier, probably 12th-century, pier that was large enough to be a respond to a crossing pier. The south-west pier was inspected in the 1820s, and its flint core was identified both as Romanesque, and comparable to work at the castle.[4] It is, therefore, also on the site of a previous pier. Although the nave arcade arches have been replaced, the Romanesque clerestory string is still in place, which means that the deviation of the south arcade must have occurred during the Romanesque period. This, therefore, places the Gothic crossing, and transepts, on the same site as their predecessors. The 13th-century builder was rebuilding an existing crossing and would have had the advantage of leaving parts of it standing while work on the new transepts progressed.

The Crossing Piers

THERE are a number of differences between the east and west crossing piers, and St John Hope and McAleer stress the significance of the use, or absence, of Purbeck marble in defining the construction sequence (Figs 4 and 5). However, the basic design of the piers is consistent, and the modifications are the result of a change of plan that occurred when the crossing arches were raised. This is most evident on the south-west pier.[5] Rising from octagonal bases, the piers present a flat pilaster section to the cardinal faces, separated by monolithic shafts and moulded capitals. Annulets are used at intervals to attach the shafts to the core, linked across the pilaster sections by short string-courses. The two eastern piers are identical and support a moulded crossing arch with a billet hood-mould and a band of massive dog-tooth in the soffit. The north-west pier (Fig. 5) was evidently carried up to capital height before the north transept west wall had reached clerestory level, since its form does not allow for the shaft of the clerestory arcade. An additional capital, of different profile, has been added to support the end of the arcade (Fig. 6).

The lower sections of the south-west pier retain the characteristic pilaster section to the east and south faces, but additional masonry, together with a shaft, has been applied to the nave side of the pier (Fig. 7). The decision to do this seems to have been made once the massive pier capital had been cut and the remaining crossing arches designed. As has been widely noted, the design of the east crossing arch was not adopted for the other three arches, and instead of the recessed dog-tooth, a heavy roll moulding was used for the arch soffit. This receives no support from the flat pilaster

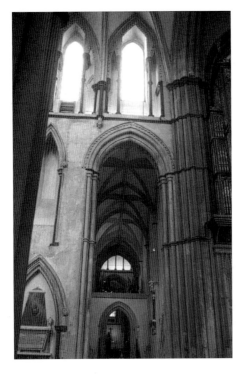

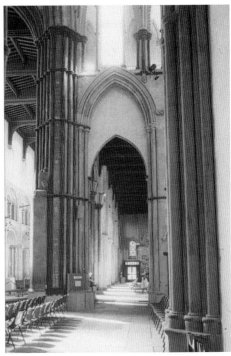

FIG. 4. North-west transept: east wall,
south bay
Jennifer Alexander

FIG. 5. North-west transept: west wall,
south bay
Jennifer Alexander

FIG. 6. North-west crossing pier, with
clerestory arcade shaft on the right
Jennifer Alexander

FIG. 7. South-west crossing pier from the
north-east
Jennifer Alexander

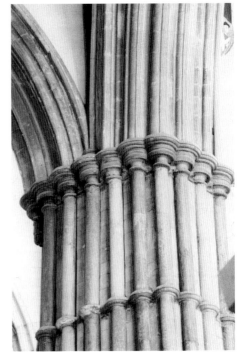

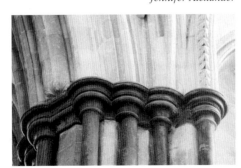

face of the pier, so a section of foliage has been used to terminate the moulding above the pier capital (Fig. 6, on left), except above the south-west pier, where extra capitals support it. On the east face the capital has a short hanging shaft, but on the nave face the shaft descends towards the base of the pier, backed by extra masonry (Fig. 7). In short, changes of detail in the design of the west pier capitals and the use of a narrower annulet suggest that the west piers were built after the east ones, but that the basic pier form was retained for both sides of the crossing.

The construction of the eastern side of the crossing included the two arches into the choir aisles, since the same distinctive design of pier is carried round from the crossing piers. The moulded string-courses of the choir elevation are continued to form annulets, and their cessation on reaching the transept walls marks the end of this part of the building project (Fig. 4). The responds in the choir aisle bays have the same design, and it is evident that the choir campaign extended as far as the arches from the transept into the choir aisles. St John Hope's suggestion that the east crossing piers were started before the choir clerestory was built seems unnecessarily complicated, and it is more probable that the piers arose with the choir walls to which they are attached.

In comparing this work with that further east the new design of the crossing piers becomes apparent, but affinities with the east end suggest that there was no break in construction at this point. The piers of the east crossing are quite different, consisting of a simple bundle of heavy Purbeck marble shafts consistent with the design of the presbytery (Fig. 8). However, the unusual moulded string-courses that form the annulets on the western crossing piers have their origin in the east end, defining the base of the clerestory and creating other horizontal divisions in both the presbytery and choir elevations. As a result the height chosen for the capitals of the blind arches of the choir walls also dictates the springing of the choir aisle arches, since the string-course forms the abaci for both sets of capitals. Less successfully, the heavier string-course of the top of the choir dado turns onto the pier at a rather meaningless height, owing to the drop in floor level in the crossing (compare Figs 4 and 8).

The piers on the eastern side of the main crossing can be dated to the end of work on the choir, that is before the monks' entry into the choir in 1227, and represent a change of design for this part of the building rather than a change of master mason. The piers resemble a more substantial version of the piers under the proposed south-west tower of the west front at St Albans, built as part of the campaign that ran from *c.* 1195 to 1214 and was finished *c.* 1235.[7]

The relationship between the two western piers of the main crossing and the arches into the nave aisles is more complex. The nave aisle arches seem to be more a response to the east choir arches than a continuation of their design, although the basic form of the jambs, excluding one south-aisle jamb, is the same as that of the eastern arches. The very tall north aisle arch reflects the arch into the choir aisle opposite, but uses a different arch moulding and a steeper arch that breaks through the string-course of the clerestory (Fig. 5).[8] The arch, including the inset lower arch that was to form the end of the nave aisle vault, was built in two stages. One side was built with the crossing pier to which it belongs, but the north jamb is part of the work on the transept west wall. The two sides are not well aligned, and the discrepancy is evident in the twisting of the arch. The arch into the south aisle is much simpler; it rises to the height of the proposed aisle vault, and there is blank walling above. Here again the two arch jambs belong to different campaigns, and the north side has needed an extra capital to accommodate the arch-moulding (Fig. 9).

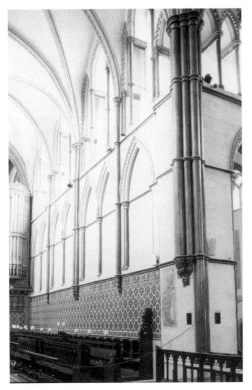

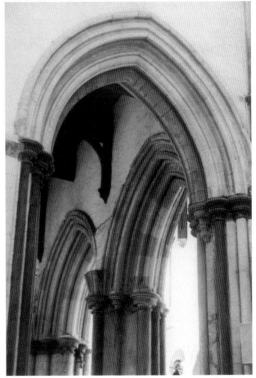

FIG. 8. Choir north wall from the south-east
Jennifer Alexander

FIG. 9. Arch into the south aisle of the nave
from the south-west transept
Jennifer Alexander

THE NORTH-WEST TRANSEPT

THE north transept appears to have been built from east to west, with the east wall the first part to be built, and work continued in an anti-clockwise direction (Fig. 1). For the east wall, there is evidence of a changeover from the choir builder to a new mason, after the choir aisle arch and most of the clerestory bay next to the tower had been built. In the remaining space in this bay the new mason's work is tentative and the design unresolved (Fig. 10). A lancet window, now blocked, and a moulded arch, also blocked, beneath it, are both offset so that the hood-mould of the arch is squeezed by the vault shafts at the end of the bay, and the height of the arch precluded any development of the vault shaft annulets as a string-course at the base of the lancet. Additionally the jambs of the lancet are treated in a way that is not found elsewhere in the transept, with a filleted roll instead of a hollow chamfer, used with the Purbeck marble shafts. By contrast the equivalent section of the west wall (Fig. 11) has the same layout, of a lancet window above a blind arch flanking the aisle arch, but here the integration into the arcades of the first and second storeys has been achieved with the arches more centred on the bay, and string-courses connected to shaft-rings. The east wall has the least integration between the clerestory bays and those of the wall beneath, particularly in the north bay, which is filled with the tall arch into the shallow eastern

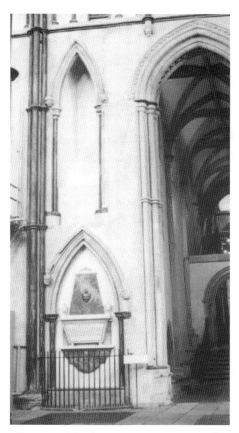

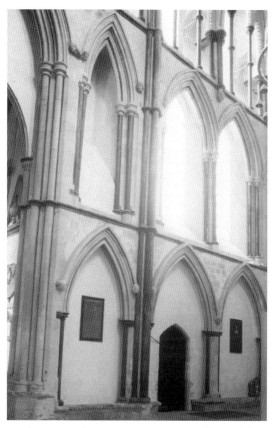

FIG. 10. North-west transept: east wall,
south bay
Jennifer Alexander

FIG. 11. North-west transept: west wall, south bay
Jennifer Alexander

chapel. It is in the north-east corner that a consistency in the design first appears, with
the introduction of the three-storeyed elevation for its north and west walls, although
the correspondence between the ground and upper two levels is not always precise
(Fig. 1).

Figure sculpture makes an appearance as head stops to hood-moulds in the north
transept, and black marble shafting is used throughout. There are differences in
treatment between the three levels on the north and west walls, in the use of freestone
rather than Purbeck marble for the moulded capitals in the middle level, and in the
proportions of the capitals. A characteristic feature of the north-west transept is the use
of the stopped hollow chamfer beside the wall-shafts, with the capital cut off flush with
the wall plane. Only on the triple capitals between the windows is a fully rounded form
used. On the basis of the capital design the lower level of the three walls of the transept,
including the large arch into the recess in the eastern wall, may have been built together
before any work was done on the upper levels, with the exception of the bay next to the
tower on the east side, discussed above.

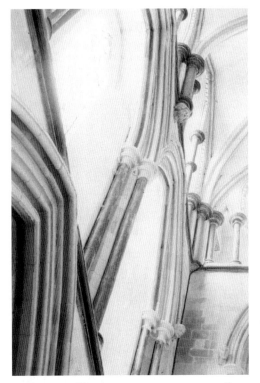 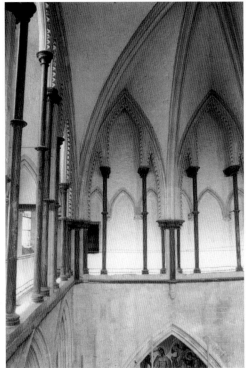

Fig. 12. North-west transept: west wall, showing distorted arch-heads
Jennifer Alexander

Fig. 13. North-west transept: east clerestory end bays
Jennifer Alexander

The west wall was the last to be built above arcade level. The mason was evidently working between the two fixed points of the north-west crossing pier and the corner of the north and west walls of the transept. Window arches are misaligned (Fig. 12), there have been problems fitting the clerestory windows, and the diagonal arches die into the clerestory screen wall. It is also apparent that the *congé* is used consistently on the west wall for the middle-level arches and high vault springing, but is not used on the north wall, and it only appears once on the east side, for the main vault transverse springer.

The North-West Transept Clerestory

THE mason of the north-west transept introduced a new method of building the clerestory. The design of the arcade screen is almost the same as that of the choir, sharply pointed dog-tooth mouldings with arched heads over the windows, but the dog-tooth in the transept is more tightly packed and has a tiny roll moulding at its edges. The main visual difference is the introduction of a triangular head to the arch, first used in the bay next to the tower (Fig. 4), and then for the whole east and west, but not north, clerestories. This is a reworking of the geometry of the window heads of the east end, where the vault over the window does not follow the shape of the arch, but rises vertically from behind the capital before forming an arch over the window. The

transept form is a more logical design that retains the vertical element and finishes in a triangular head. Clearly the flanking arches for the bay next to the tower on the east had already been cut before the change to the arch shape had been made, as they have the previous dog-tooth design and stand on the taller shafts used in the earlier period. The next bay, and all subsequent bays, use shorter shafts and integrate them with the vault shafts.

Structurally the most important development is the replacement of the Purbeck marble lintels, which crossed the clerestory passage behind the arcade shaft capitals, with diagonal arches to support the masonry abutment of the high vault. The effect of the changeover is strongly marked, since these arches remove the need for the arcade screen to be supported for much of its height; instead it is braced by slender iron stays. The change happens in two stages: the diagonal arches are introduced, used after the tower bay on the east wall, but the lintels were only replaced by iron bars after the whole east clerestory was complete (Fig. 13).

Further evidence for a change of master mason to construct the north-west transept can be found at the junction between the top of the clerestory wall and the vault. The transept wall rib is squeezed out in the bay next to the tower by the width of the dog-tooth moulding, since this was cut, like the choir ones, without provision for a wall rib for the vault. Similarly, the crossing piers were not designed for transepts with high vaults, the springing of the diagonal rib has been added in each case, and the hood-mould of the arch shaved off to fit it in. As noted above, the north-west crossing pier also had to be modified to accommodate the clerestory arcade since it too, was not the work of the transept designer (Fig. 6).

The high vault consists of two bays of sexpartite rib vaults with ridge ribs (Fig. 1), supported on the outside by heavy buttresses at the ends of the bays. The main-vault springer descends to the ground as a group of three slender Purbeck marble shafts, with the minor ribs on short Purbeck marble shafts on corbels at the clerestory string. The naturalistic foliage on the bosses places the vault at the end of the century, but its sexpartite configuration with a ridge rib would otherwise suggest a date around the end of the first quarter of the 13th century, contemporary with the main transept vault at Lincoln.

The North-West Transept Chapels

SINCE the transept builder had very little space on the east side, he was unable to build a projecting chapel, and instead created a deeply arched recess in the east wall, lit by a window on its north reveal, that butts up against the Gundulf tower (see Fig. 14). Evidence from 15th-century wills establishes that the rood altar was in the north transept, between the north door and the altar of St Ursula, and that it occupied the recess.[9] Recent archaeological investigation of this area has found traces of the corbels for a rood beam within the thickness of the rear wall, together with iron fixings that may have been for the figures, all contained within an area of 15th-century reworking. A 13th-century piscina, with Purbeck marble shafts, was also found within the recess, establishing that this was an altar site from its inception, but it is not known if it shared the later dedication.[10] Owing to the small size of the recess, the congregation of this chapel must have occupied the north bay of the transept, and been separated from those visiting the chapel of St Ursula beside it in the blocked arch by screens that have not survived. In addition, pilgrims visiting St William's shrine in the east end would

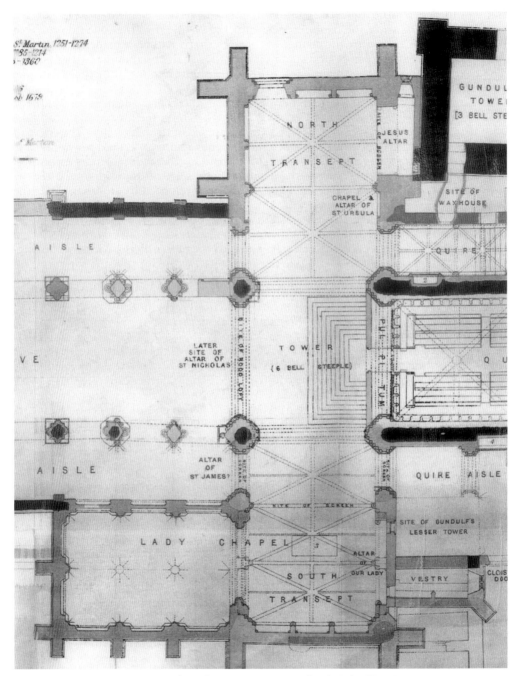

FIG. 14. Plan of western transept (after St John Hope)
Jennifer Alexander

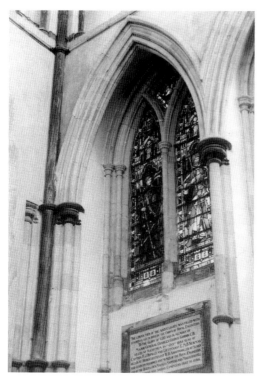

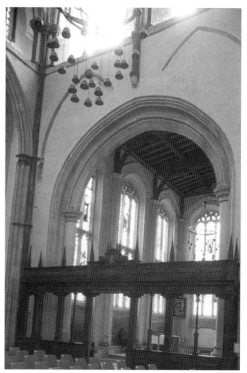

FIG. 15. South-west transept: south-east corner
Jennifer Alexander

FIG. 16. South-west transept: west wall
Jennifer Alexander

have needed to have a path from the north door, and presumably one from the nave, so these screens could not have extended across the whole width of the transept.

THE SOUTH-WEST TRANSEPT

THE south-west transept differs in design from the north, but it has been modified, and later restoration has obscured its original appearance. It reverts to a two-storeyed elevation, bringing the arches of the terminal wall down to ground level, since there was no need for a portal here. However, it also introduces a new aesthetic, which, had the scheme been realised, would have made the two transepts look very different (compare Fig. 2 with Fig. 1). In the north-west transept, two of the three walls have a discrete middle zone with sections of blank wall flanking the windows and, originally, Purbeck marble shafts in the corners. In the south-west transept, wall arcades spanning two storeys were intended to continue around all three walls in an uninterrupted sequence, with the arches springing from the south-east (Fig. 15) and south-west corners. The single vault shafts, which would have descended between each of the arches to the floor, would have stressed further the integration of the transept elevation in a way that was not achieved in the north-west transept. The design is a development of the presbytery elevation, but it achieves a much greater lightness by the use of larger arches, thinner walls and single vault shafts. In terms of decoration, the south-west

transept is less elaborate than the north, the head stops have gone, except in a minor way in the west clerestory, as has the complex multiple shafting to the clerestory screen on the terminal wall. However, the stopped hollow chamfers that accompany the wall shafts are still used, with the capitals cut off flush in the same way.

The South-West Transept Wall Arcades

MORE evidence for the two-storeyed arcade survives on the west than the east wall, with parts of both jambs and most of the arches, with the exception of the hood-moulds, preserved (Fig. 16). Project these arches down and, as St John Hope's plan shows (see Fig. 14), they would have ended on a section of thin wall, resembling the arrangement in the east transepts. There is little trace of the east-wall arches, and only the south-east jamb (Fig. 15) survives, next to the large arch into the shallow recess that replaced the arcade. However, the relationship between the shaft and the adjacent arcade is so similar to that of the shaft and arcade opposite, in the south-west corner (Fig. 16), that a reconstruction based on the west wall is plausible. The construction of the shallow recess required considerable thickening of the wall in this area, so it is possible that the arcade plan was never completed on the east side.

The south wall has three large two-light windows with Y-tracery filling the heads of the arches, but the arrangement of the east and west walls may not have followed this pattern. The three arches each span about 2.5 m (8 ft), and the projected two arches of the other walls would have been about 3.3 m (11 ft) wide, making any windows very broad. While this is not impossible, it does raise the question of whether these arches were instead intended to lead into an aisle. That would have involved taking over part of the claustral buildings that lay behind the wall, and so the scheme was perhaps dropped before it had advanced very far.

Evidence for an aisle on the west side is stronger (Fig. 16). The early-16th-century Lady Chapel is now sited on the west side of the transept, as at Waltham Abbey, but there is evidence for the earlier use of the transept itself as the Lady Chapel. There is documentary evidence for the Lady Chapel's being in the new work in the 14th century: a document of 1376 sites it on the south side of the church, and as late as 1389, in a request for burial in the Lady Chapel, it is described as 'iam de novo constructa', presumably the most recent work undertaken in the cathedral.[11] As McAleer notes, the arch from the transept into the later chapel is aligned with the two arches buried in the wall above, not with the centre of the chapel, and the best parallels for it are from the 14th century, not the 16th century.[12] This suggests that the arch replaced the arcade to allow more space for the west end of the Lady Chapel in a western aisle. When the later chapel replaced the aisle, the arch remained. The new building is not centred on this arch, and the line of the wall-ribs of the 16th-century vault show that, had the vault been constructed, the lack of alignment would have been conspicuous.

The South-West Transept Clerestory

THE three clerestories differ from each other, although they all retain the idea of a screen in front of the windows, and the east and south windows have flanking shafts and capitals. The south wall design is perhaps the least successful of the three: the outer arches are angled awkwardly to connect with the shallow angle of the enclosing arch, and the relationship between the windows and their flanking blind arches is confused (Fig. 2). On the east side, the bay next to the tower repeats the arrangement of the north

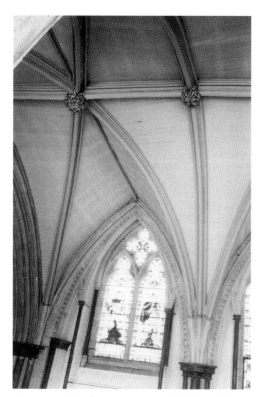 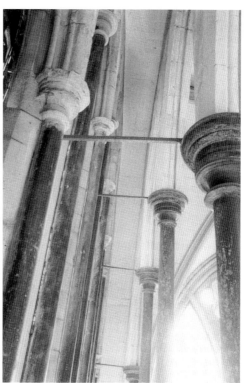

FIG. 17. South-west transept: high vault bay
next to the crossing
Jennifer Alexander

FIG. 18. South-west transept: south clerestory
from the east
Jennifer Alexander

transept: the first shaft has the choir clerestory design, with its bracing spar, and the
clerestory string for the first bay is the early double version (Fig. 17). The mason for the
south-west transept, who took over at this point, retained the heavy dog-tooth
moulding around the outside of the arch, but used very slender Purbeck marble shafts,
which rise nearly to the head of the flanking arches to create a wide space for the
windows behind.

The moulding is not the only idea shared with the north transept: the triple Purbeck
marble shafts with round moulded capitals that divide the bays are very similar to those
on the north side, both in design and scale, and it has to be considered that the east
clerestory was originally intended to resemble that of the north transept closely,
although with wider bays, since three rather than four bays were planned. The same
Purbeck marble triplets are used on the west screen as well. This suggests that the
south-west transept had been built up to the level of the clerestory screen by a builder
swapping ideas with the builder of the north-west transept, before the decision to use
tracery at clerestory level had been made.

The use of bar-tracery on the south wall is somewhat tentative, present only at
ground level, with stepped lancets in the clerestory — though both levels have window
shafts and capitals, and we have no way of knowing what was intended for the

windows of the east and west walls at a lower level. The restoration of the clerestory windows has been thorough, and early drawings show little evidence for the form of the east windows. Scott was confident of his restoration of the west clerestory, but his restored east windows show tracery of a later type than that of the other walls, and McAleer is surely right to attribute its form to a later remodelling, if not to Scott's imagination.[13] The use of the *congé* is very limited here, found only above the inner capitals of the lower south windows.

The South-West Transept Vault

THE south-west transept has a timber rib vault that St John Hope places in the 1280s, whereas McAleer dates it to the 1340s on the evidence of the bosses. Both describe the timber vault as a change of plan and consider that a stone vault was intended, presumably because the vault has springers and wall-ribs made of stone.[14] However, as Hearn and Thurlby observe, this is not an unusual arrangement for a timber vault.[15] Timber vaults have advantages over stone ones in terms of cost and weight, and high vaults of timber painted to resemble stone are hard to distinguish from stone ones as, for example, at York Minster. For Henry III this appearance, coupled with the speed and ease of construction, led to his specifying a timber vault for Windsor in 1243, based on the examples at Lichfield, as Thurlby notes.[16]

Rochester's vault is a three-bay quadripartite rib vault, with a ridge rib and minor transverse ribs in the centre of each bay and carved bosses at the intersections (Fig. 17). Chester has a very similar timber vault to Rochester's, planned during the building of the choir in the second half of the 13th century, but raised only in the 19th century on the stone wall-ribs and springers provided by the original builders.[17] The lack of buttresses demonstrates that a stone high vault was not intended at Chester, whereas at Rochester buttresses are provided between the clerestory windows. However, the south-west transept buttresses are much lighter than those of the north transept and, most tellingly, the transept south clerestory provides no abutment for a stone vault, consisting of two thin walls joined only by iron stays, in contrast to the solid masonry of the clerestory at the opposite end of the transept (Fig. 18). Clearly a timber vault was always intended over the south transept at Rochester.

Similarities between the Chester and Rochester vaults may however be attributable to their restoration histories. Sir George Gilbert Scott was working on both Chester and Rochester cathedrals during the early 1870s and carried out restorations of timber vaults at both sites. Between 1868 and 1876, he modified the choir vault at Chester of 1848, replacing deal ribs and lath and plaster with oak ribs and more suitable boards, and in 1873 he suggested similar action for Rochester's south transept, where he found the 'oak ribs much decayed and threatening to fall . . . spaces between them, formerly boarded, are now of lath and plaster'.[18] Both vaults now share the same plan of single bays with a ridge rib and a minor rib that joins the centre of the bay to the head of the clerestory window. At Chester there is a boss at this point (visible in drawings of the vault before Scott's restoration), whereas at Rochester the rib breaks into the head of the wall arch.[19] Is it possible that Scott introduced the minor ribs? The timber vault over the nave at Warmington church is the only example of a vault with planked webbing that omits the minor rib, and it is present in all the major church examples (Fig. 19). It serves to disguise the join between the planks of the web and provides them with a firm anchorage. If planking was used originally, then the minor ribs are likely also to be original at Rochester. However, the other timber vault at Rochester, over the

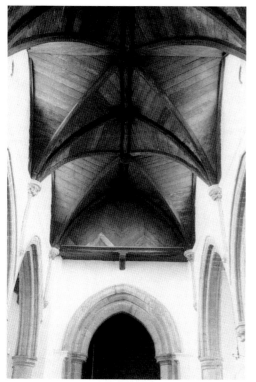

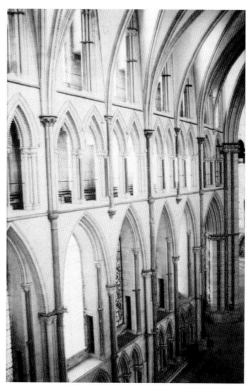

FIG. 19. Warmington: nave high vault from
the east

Jennifer Alexander

FIG. 20. Lincoln: south-west transept, west
wall from the south

Jennifer Alexander

south choir aisle, has lath and plaster webbing attached to timber ribs not visible below
the vault, and Scott's assertion that the transept vault was originally planked may not
have been correct. If that is indeed the case, then it is likely that Scott introduced the
minor ribs with the new planks.

CONCLUSION

ROCHESTER is a small-scale building with modest ambitions. It was a monastic
church with a relic to encourage offerings, and we are told that William of Hoo was
able to build the choir on the proceeds of the shrine. The documentary evidence
provides little reference to work on the western transept, apart from the brief mention
of the work on the north side that Richard of Eastgate started between *c.* 1239–55 and
which Thomas of Mepeham completed after that date.

 It is evident that two different masons worked on the north and south and that they
were at work at a similar time. There were exchanges of ideas, but the visual aesthetic
of the two arms is quite different, or would have been, if the designer of the south arm
had not been constrained to adopt the niche idea for the east wall from the north
transept. The most conspicuous difference between the two arms of the transept is the

use of Y-tracery for the south windows, but a date in the first half of the 13th century, perhaps *c.* 1240, would fit the architectural evidence for both north and south transepts. The two vaults seem to have been delayed in construction, but there is no evidence that they were not designed at the same period as the buildings they cover. Neither arm of the transept displays architectural ambition. Comparison with the west transept of Lincoln (Fig. 20) or the east transept at Salisbury, both also of the first half of the century, reveals a lack of spatial complexity at Rochester, with the wall only voided by a passage at clerestory level. The builders seemed resistant to outside influences, drawing on the earlier structure for design ideas and being little influenced by work outside the cathedral walls. Perhaps the problems of the site layout, with structures sited immediately to the east of the transept that were to be retained, gave the masons little scope for extravagant architectural displays.

ACKNOWLEDGEMENTS

The vergers at Rochester deserve my particular thanks for their help. Brian Hodgkinson provided valuable assistance with fieldwork. I should like to thank Tim Tatton-Brown for sharing his expertise on the building with me, and Tim Ayers for his helpful editing comments.

NOTES

1. London, British Library, Cotton MSS, Vespasian AXXII, fol. 92, cited by both W. H. St John Hope, 'The Architectural History of the Cathedral Church and Monastery of St Andrew at Rochester, I: The Cathedral Church', *Archaeologia Cantiana*, 23 (1898), 194–328, at 240, and J. Philip McAleer, *Rochester Cathedral, 604–1540* (Toronto 1999), 106.

2. F. H. Fairweather, 'Gundulf's Cathedral and Priory Church of St. Andrew, Rochester: Some Critical Remarks upon the Hitherto Accepted Plan', *Archaeol. J.*, 86 (1929), 187–212, at 199. As McAleer notes, the siting of this respond also makes St John Hope's reconstruction of a narrow transept implausible; see McAleer, *Rochester Cathedral*, 40–41.

3. A small excavation in the north side of the crossing was undertaken in 1968 and a foundation for a sleeper wall was encountered, although this was interpreted as Anglo-Saxon in date. It has only been published in the *Friends Annual Report* for 1968. I am grateful to Tim Tatton-Brown for bringing this to my attention.

4. McAleer, *Rochester Cathedral*, 260–61, n. 128, and Diana Holbrook, 'Repair and Restoration of the Fabric since 1540', in *Faith and Fabric: A History of Rochester Cathedral 604–1994*, ed. Nigel Yates (Woodbridge 1996), 185–216, at 204. This divergence of the nave south arcade was noted by Fairweather, but interpreted as part of an elaborate realignment of the choir and its crypt, and his theory has not been widely accepted; see Fairweather, 'Gundulf's Cathedral', 202–03.

5. Trying to distinguish between freestone and Purbeck marble is almost impossible in the crossing area, since both types of stone have been covered in a heavy brown varnish that disguises them completely. As early as 1799 the crossing piers were noted to have been painted to resemble marble; see Holbrook, 'Repair and Restoration', 196. McAleer's analysis of the piers results in a complex construction sequence that would have involved the builders in considerable difficulty, requiring piecemeal reworking of the Romanesque piers, which is not evident in the piers themselves; see McAleer, *Rochester Cathedral*, 120–22. Examining the relationships between these piers and the adjacent structures reveals a simpler and more logical building sequence; see further below.

6. St John Hope, 'Architectural History', 247.

7. Stuart Harrison, 'The Thirteenth-century West Front of St Albans Abbey', in *Alban and St Albans: Roman and Medieval Architecture, Art and Archaeology*, ed. Martin Henig and Phillip Lindley, BAA Trans., xxiv (Leeds 2001), 176–81.

8. McAleer attributes this to the springing of the arch's being aligned with the capitals of the middle level of the west wall, but since the arch is wider, it rises higher. The east arch also has its springing predetermined, but it is a less acutely angled arch, and it was this type of arch that the builder of the west side wanted to avoid. There is also little, if any, difference in the widths of the two arches; see McAleer, *Rochester Cathedral*, 102.

9. St John Hope, 'Architectural History', 289–91.

10. T. Tatton-Brown, 'The Jesus Altar Area of the North Transept in Rochester Cathedral', *Friends of Rochester Cathedral Report 2000/2001* (2001), 13–18.

11. St John Hope, 'Architectural History', 264.

12. McAleer, *Rochester Cathedral*, 161–62. His comparisons with mouldings of 1380–90 from Canterbury's nave seem rather too late however.

13. McAleer, *Rochester Cathedral*, 253, n. 75.

14. St John Hope, 'Architectural History', 265, and McAleer, *Rochester Cathedral*, 155.

15. M. F. Hearn and Malcolm Thurlby, 'Previously Undetected Wooden Ribbed Vaults in Medieval Britain', *JBAA*, 150 (1997), 48–58.

16. Malcolm Thurlby, 'Glasgow Cathedral and the Wooden Barrel Vault', in *Medieval Art and Architecture in the Diocese of Glasgow*, ed. Richard Fawcett, *BAA Trans.*, XXIII (Leeds 1998), 84–87. Timber vaults seem to have been built over the choir as well as over the transepts at Lichfield.

17. Virginia Jansen, 'George Gilbert Scott and the Restoration at Chester Cathedral, 1819–1876', in *Medieval Archaeology, Art and Architecture at Chester*, ed. Alan Thacker, *BAA Trans.*, XXII (Leeds 2000), 81–97.

18. Holbrook, 'Repair and Restoration', 208.

19. Scott's recreation of the choir vault at Ripon from the 1860s, in which he reused the medieval vault bosses, also results in a similar design of vault, but there the wall ribs are timber, and Scott introduced a boss at the intersection above the windows; see N. Pevsner and P. Metcalf, *The Cathedrals of England Midland, Northern and Eastern England* (Harmondsworth 1985), 292.

The Medieval Monuments of Rochester Cathedral

NIGEL SAUL

Despite heavy losses, the series of medieval monuments at Rochester is one of the most interesting in any English cathedral. It is possible to detect influences from a number of sources. Bishop Glanville's monument, a hipped chest, was clearly inspired by Archbishop Walter's at Canterbury, while the marble effigy of Bishop de St Martin in the presbytery and the lost effigy of Bishop Merton, in their different ways, drew on metropolitan influence. In addition to the relief effigies, the cathedral once had a fine collection of brasses. All of these are now lost, but in many cases their despoiled slabs survive. It is sometimes maintained that no brasses were laid in the cathedral before the Black Death. The suggestion is made here, however, that a fine slab at the entrance to the north choir aisle is in fact of pre-Black Death date.

RELATIVELY few medieval monuments survive complete in Rochester Cathedral. Time and the activities of iconoclasts have together exacted a heavy toll. The most striking of the monuments are the half-dozen or so relief effigies of pre-Reformation bishops. Hardly less splendid in their heyday, however, were the magnificent memorial brasses, the outlines of which can be seen in the despoiled slabs in the floors. In view of the heavy losses, it is hardly surprising that the monuments have received little scholarly attention. St John Hope touched on the relief effigies in passing in his magisterial paper on the cathedral, while A. G. Sadler catalogued the slabs in his survey of lost brasses in southern England,[1] but the monuments have never been the subject of discussion in their own right. This is unfortunate. Although hardly the most impressive series in an English cathedral, they constitute a highly distinctive one, and the brasses included some of the finest produced in medieval England.

The study of burial and commemoration in the cathedral is aided by the survival of plentiful documentary sources (see Appendix). Among the most informative of these are the various recensions of the Rochester chronicle which, besides detailing the succession of bishops, often gives details of the bishops' burial places.[2] Alongside the chronicle evidence we can set the not inconsiderable number of wills of clerks and layfolk buried in the cathedral. The bishops' wills are mostly to be found in the archiepiscopal registers at Lambeth, while those of the laity are in either the Prerogative Court of Canterbury registers or those of Rochester Consistory Court.[3] The testamentary evidence is particularly valuable in indicating the existence of monuments that are now lost. Mention should also be made of the accounts of Bishop Walter de Merton's executors, which are our sole source for the remarkable effigy of the bishop destroyed at the Reformation.[4]

By comparison with the documentary evidence, the antiquarian record is disappointing. The two earliest records of the cathedral's monuments are both brief. One is

a catalogue of the episcopal tombs by John Weever, written in the 1620s in characteristically erratic mode, and the other a series of notes by an army officer who passed through the city in 1635.[5] Unfortunately, we lack a wide-ranging survey of the monuments from the period before the Civil War of the kind that Dugdale made for St Paul's. This absence is all the more regrettable, because it was probably in the Civil War that many of the brasses were torn up and sold.[6] From the 18th century, however, we have a first-rate witness in the person of John Thorpe, a local doctor and antiquary, who described the monuments in greater detail than Weever and helpfully provided a floor plan.[7] Thorpe's work in recording the episcopal monuments, which formed part of a larger study of the history and antiquities of the Rochester area, was a model of its kind. From the early 19th century, we also have a series of drawings of despoiled slabs by the water-colourist, Thomas Fisher.[8]

Taking the documentary sources in conjunction with the physical evidence of the monuments, we can form a reasonable view of the pattern of commemoration in the cathedral in the Middle Ages. The general picture that emerges is of a high-quality series of monuments, dominated by the effigies of the bishops themselves, which yielded little or nothing in magnificence to those in the greater cathedrals. In the manner of their commemoration, the bishops of Rochester, though scarcely the richest of the episcopate, showed themselves more than capable of holding their own against their wealthier cousins.

A number of influences helped to shape the character of commemoration in the medieval cathedral at Rochester. In the first place, there was the city's location, roughly half-way between London and Canterbury. This made it easy for Rochester patrons to pick up and assimilate influences from the two most significant ecclesiastical centres in southern England. Canterbury influence can be seen most clearly in the shrine-like monument to Bishop Glanville, which was inspired by that of Archbishop Hubert Walter (d. 1205) in Canterbury Cathedral. Surprisingly, however, the influence of Canterbury was not as strong at Rochester as might be supposed. There are no parallels at Rochester to the standard Canterbury type of episcopal monument, of alabaster or marble, along the side of the choir, and under a shrine-like canopy. This was probably because the continuous walls of the Rochester choir made such planning impossible. Altogether stronger than Canterbury influence is that of the capital. A taste for the high-quality work of the London marblers is evident in the magnificent tomb of Bishop Laurence de St Martin (d. 1274), which was strongly influenced by Westminster work of the period. Further evidence of a taste for metropolitan funerary art is to be found in the fine series of brasses once to be found in the cathedral. Large-scale brasses were patronised by bishops and senior clergy from the earliest days of brass engraving and attested their keenness to be commemorated with appropriate splendour.

A second influence on the commemorative character of Rochester was the cathedral's status as a Benedictine priory. Cathedrals served by monks, as Rochester was from the late 1080s, did not generally exhibit the magnificent memorials of officiating clergy found in the secular cathedrals. In the grandest of the secular churches, such as Lincoln and St Paul's (not to mention more poorly endowed Hereford), there were once extravagant series of brasses to pluralist canons.[9] In the monastic cathedrals, ambitious commemoration was less common. Wealthy prebendal canons could easily afford tombs or brasses on the grand scale; monks vowed to poverty could not. Generally, in the monastic cathedrals only conventual officials and senior monks were commemorated by high-status monuments. At Durham, for example, according to the *Rites of*

Durham, a survey compiled in the 1590s, the priors of St Cuthbert's, after the mid-1340s, were commemorated by brasses in the cathedral.[10] At St Albans in about 1470, Robert Beaunor, an aged and distinguished monk, was honoured by a brass in the abbey presbytery. At Rochester very few members of the monastic community appear to have been buried in the cathedral priory. Only the burial of Prior John Sheppey (in the Lady Chapel) is definitely attested.[11] Conceivably, some of the early cross-slabs may be memorials of priors: they are certainly of high enough quality to have been commissioned by senior officials. Among the later memorials, however, only the curious slab, from which the brasses have been ripped, on the wall of the north transept can be associated, even tentatively, with a monk;[12] and none of the surviving floor indents has an outline suggesting the figure of such a person. In the light of this evidence, it seems very unlikely that there was a tradition of monastic commemoration in the cathedral itself. The monks of St Andrew's were almost certainly buried in the monastic cemetery to the north of their church. At another Benedictine establishment, Durham Priory, the monks were buried in the 'centory' (cemetery) garth throughout the Middle Ages.

The third and last factor that influenced the pattern of commemoration in the cathedral was its popularity as a burial place with the laity. A surprising number of laity from Rochester and the surrounding area were interred within its walls.[13] The reason for the popularity of burial in the cathedral may have been the existence, for many centuries, of a parish altar dedicated to St Nicholas in the nave. The presence of this altar gave rise to repeated disagreements between the monks and the parishioners, however, and in 1423 it was removed. Nonetheless, burials of laity in the cathedral continued, and a couple of positions were particularly favoured. One was in the vicinity of the image of Our Lady of Grace, which stood in the nave, and the other in front of the altar of St Ursula, which was near the corner of the north transept and the choir aisle.[14] Friends and benefactors of the monks, however, could command prestigious positions further east. Sir William Arundel, for example, a former constable of Rochester Castle who died in 1400, managed to secure an honorific position behind the high altar.

Inaugurating the medieval monuments today is a small group of early non-effigial monuments. The first of these, now placed on the south side of the presbytery, takes the form of a large Purbeck marble coffin covered by a plain stone slab. Traditionally, the monument is attributed to Bishop Gundulf, although it almost certainly dates from half a century or more after his death. Unfortunately, there are no diagnostic features that allow it to be dated with any precision. The other monuments in the group all have decoration in relief. In the south choir transept against the end wall is a well-preserved Purbeck marble cross-slab with a voided head, three pairs of floral trails springing from the stem, a stepped base and a wide chamfer surrounding the whole. In a recess at the end of the opposite transept is a second cross-slab, this one with four paddle-shaped leaves and a central clasp-like feature. In the presbytery is a third marble cross-slab, this one of more unusual design: the slab is of coped shape with hipped ends, a stem running along the ridge and pairs of foliage sprigs, alternately single leaves and wheels, spilling down the sides (Fig. 1). Brian and Moira Gittos suggest a 12th-century date for this last monument on the evidence of the foliage — which is probably right.[15] The other two probably date from the early to mid-13th century, although it is hard to be at all precise. It is likely that all three monuments commemorate either bishops of Rochester or priors of St Andrew's.[16]

FIG. 1. Coped Purbeck marble slab, probably 12th century, presbytery, south side

In the presbytery is to be found a fine series of 13th-century episcopal tombs. These are all set in the tall arched recesses that form such a striking feature of this part of the building — and which, as St John Hope suggested, were probably constructed with burials in mind. The earliest of the three is that in the third bay on the north side, generally attributed to Bishop Glanville. It takes the form of a Purbeck marble sarcophagus with an arcade of seven arches filled with foliage in front and, over it, a sloping roof, now mutilated, but originally adorned with seven mitred busts.[17] The tomb was clearly inspired by Archbishop Walter's very similar tomb in Canterbury Cathedral. Archbishop Walter died in 1205, and Glanville nine years later. As Christopher Wilson has written, it is difficult to find a convincing context for Archbishop Walter's tomb in contemporary monumental practice.[18] If its stylistic sources are obscure, however, it still produced some local ripples. Bishop Glanville's tomb is Rochester's nod in the direction of Canterbury. Neither tomb, however, produced any other recorded progeny.

In the bay immediately to the east of the Glanville tomb is the superb marble monument to Bishop Laurence de St Martin, who died in 1274.[19] The bishop, whose figure is carved in deep relief, is shown in mass vestments with arms raised, under a heavy gabled canopy supported by shafts sprouting foliage (Fig. 2). The canopy is rendered with exceptional delicacy and minuteness of detail. This very high-quality piece is the last in a series that includes the effigies of Bishop Kilkenny (d. 1256) at Ely,

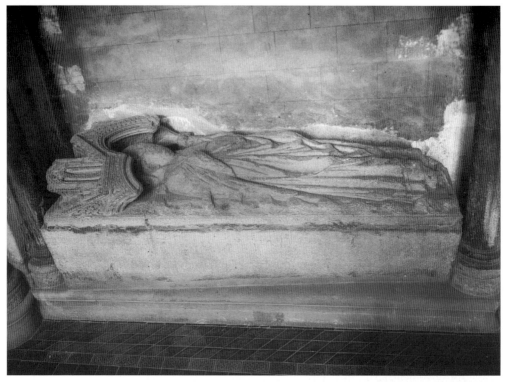

FIG. 2. Monument of Bishop Laurence de St Martin (d. 1274), presbytery north side
Conway Library, Courtauld Institute of Art

Archbishop Gray (d. 1255) in York Minster, and an unidentified bishop at Carlisle.[20] Almost certainly it is the work of a tomb master who worked in London and not Corfe. A close analogy for the architectural details — the canopy gable and the side shafts — is found in the architectural panels of the Westminster retable, commissioned by Henry III and probably dating from the 1260s.[21] Bishop de St Martin's executors probably accorded him the privilege of a high-quality monument because of his achievement in securing the canonisation of Rochester's local saint, St William of Perth.

Opposite the St Martin tomb, on the south side, is another Purbeck marble episcopal effigy, that of Thomas Inglethorp (1283–91).[22] This monument is of very similar design to the St Martin tomb, consisting of a recumbent effigy under a gabled canopy resting on side-shafts with ivy-leaf capitals (Fig. 3). The handling of the drapery, however, is simpler and coarser than on the earlier effigy, and the canopy design much simplified.[23] In all probability, the tomb, like that of St Martin, is the work of a London master. Assuming that it was executed after the bishop's death in 1291, and not in his lifetime, it may well be the latest episcopal effigy in this medium.

In between the tombs of St Martin and Inglethorp chronologically come two other monuments in other parts of the church — those of Bishop Bradfield (d. 1283) and his predecessor Bishop Merton (d. 1277). Both are very different in character from those that we have discussed so far. For one thing, they are not in the traditional burial place of the bishops of Rochester, the presbytery. Bradfield's monument is at the western

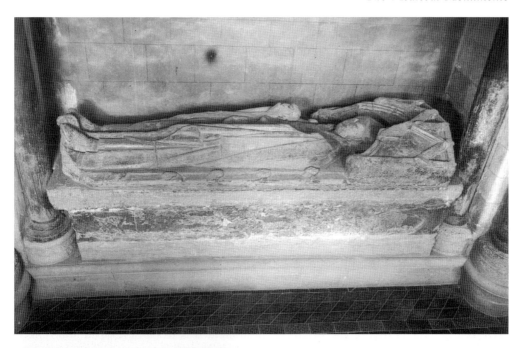

Fig. 3. Monument of Bishop Thomas Inglethorp
(d. 1291), presbytery, south side
Conway Library, Courtauld Institute of Art

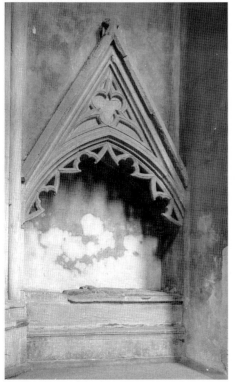

Fig. 4. Monument of Bishop Bradfield (d. 1283),
south choir aisle, north side
Conway Library, Courtauld Institute of Art

entrance to the south choir aisle, and Merton's in the end wall of the north choir transept.[24] Bradfield's choice of burial place is hard to explain, but Merton's was probably a product of the bishop's desire to be near St William's shrine, immediately to the south in the middle of the transept.[25] Merton's burial in the transept end wall probably helped to popularise this position for episcopal burials. In the late 13th and 14th centuries, a whole series of burials in this position followed, for example those of Pecham at Canterbury, William de la Marche at Wells and Charlton at Hereford.

Bradfield's and Merton's monuments, at least in their original form, were both remarkable compositions. Bradfield's is notable for being the earliest high-quality example of a type to become popular later, the ciborium tomb (Fig. 4). The key elements of the ciborium tomb, as L. L. Gee has identified them, were a chest, usually set against a wall, with a canopy enclosing and surmounting it — almost in the manner of a shrine.[26] Each of these elements is represented in the Bradfield monument, even if the enrichments that appeared later are missing. The monument is almost certainly a work of the pioneering London-based architect, Michael of Canterbury, who early in his career had been the master mason to Christ Church, Canterbury, and was later responsible for the Cheapside Cross in London and St Stephen's Chapel in the Palace of Westminster.[27] The gabled canopy on the monument shows several of the hallmarks of Michael's style — notably, in the apex, a trefoil with split cusps, which is paralleled in window tracery at Chartham (Kent), and, below, the pierced pendant cusping of the arch, which shows an awareness of the decorative detailing of French cathedral architecture. The design of the Bradfield monument was to be developed and refined further in the monuments in Westminster Abbey of Aveline, countess of Lancaster, and her husband Edmund, both of the 1290s, and of Aymer de Valence, earl of Pembroke, of the 1320s; Aveline's monument in its turn was to be the source for Archbishop Pecham's tomb at Canterbury. The Bradfield monument is thus significant in giving Rochester a key role in the process of dissemination of the court style in monumental art. It should be added that the effigy that currently occupies the tomb does not belong, dating from at least twenty years earlier.

Walter de Merton's monument is of a different kind again. Taking bold advantage of its end wall position, it is conceived as a highly architectural composition. Over the effigy rises a tall vaulted double canopy on clustered marble shafts, lit from behind by a double window pierced in the wall: 'bang up to date', as John Newman puts it (Fig. 5).[28] More avant-garde than the canopy, however, was the effigy itself, which is now lost but which can be visualised from the entries in the executors' accounts.[29] The commission for the effigy was given to a master craftsman of Limoges. The Limoges workshops had long enjoyed a reputation for making fine enamelled candlesticks and other portable items. By the 1240s they had branched into tomb-making. Among surviving monuments, their work is represented by the effigies of Archbishop Maurice at Burgos (Castille and Léon); Blanche and John, the children of St Louis, now at the former abbey of Saint-Denis; Blanche de Champagne now in the Louvre; and William de Valence in Westminster Abbey. Walter de Merton's effigy would have been similar to these. In all probability, it consisted of a wooden core encased in panels of Limoges enamel and mounted on a base-plate of diapered and enamelled copper. John Blair has identified a Purbeck marble slab now set in a recess to the west of the tomb as very likely the slab on which the base-plate was fixed.[30] Walter de Merton's monument may be regarded as the most cosmopolitan of all the medieval monuments in the cathedral. Merton was a leading figure in church and state, and twice served as chancellor of

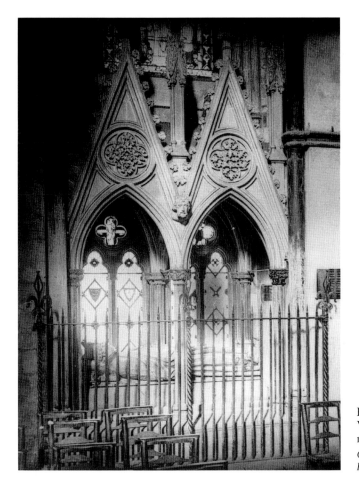

Fig. 5. Monument of Bishop Walter de Merton (d. 1277), north choir transept

Conway Library, Courtauld Institute of Art

England (1261–63, 1272–74). It is thus hardly surprising that he should have been commemorated with such splendour.

At the southern end of the north choir transept, near the junction with the choir, is the monument to Bishop Sheppey, who died in 1360.[31] Like Walter de Merton's tomb, this is much restored. For some three or four centuries it was wholly concealed behind a solid wall of chalk and masonry.[32] It was the unlikely person of Lewis Cottingham — not someone usually considered sympathetic in his handling of medieval fabrics — who discovered it in 1840, restored it to view and reconstructed the gable, which was unfortunately damaged beyond repair. The recumbent effigy of the bishop is of clunch and remarkably preserves some of its polychrome (though this is much restored by Cottingham). The bishop is shown in an alb with brown and gold apparels, a pink dalmatic diapered with black flowers, and a red chasuble lined with green and powdered with a gold cruciform device. His gloves are white with jewelled backs, and from the wrist hangs a golden fanon set with crystals. The mitre is richly gilded and jewelled. The restored canopy, with its arched gable and flat quatrefoiled top, is of characteristic early Perpendicular form, and was well suited to the monument's open

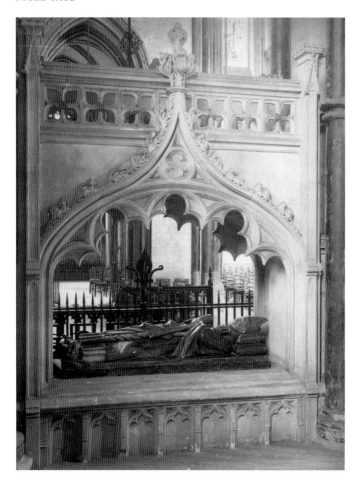

Fig. 6. Monument of
Bishop John de Sheppey
(d. 1360), north choir
transept, south-east side
*Conway Library, Courtauld
Institute of Art*

position under an arch (Fig. 6).[33] Sheppey was a senior figure in government and served
as treasurer of England from 1356 to his death.[34] His tomb is an elegant, if somewhat
standardised, example of the work of the metropolitan tomb makers of the day.

The last in the series of pre-Reformation monuments to bishops is the plain chest,
without an effigy, of Bishop Lowe, who died in 1467. In the seventy or so years that
separated Lowe's death from the Reformation, Rochester's bishops were all translated
elsewhere.[35] Accordingly, their tombs are found elsewhere. Bishop Lowe made
provision for his tomb in his lifetime — he says so in his will.[36] He chose a position for
it against the wall near the junction between the northern choir transept and the
presbytery. In the 1870s, Scott moved it to its present position further to the north. The
monument takes the form of a high tomb of stone, whose only decoration is heraldic.
There are seven shields on the long side and two on the short. Around the chamfered
edge is an epitaph (restored) asking for God's pity on the commemorated, while along
the base are scrolls bearing words reminding the onlooker of the transience of earthly
glory. The austerity of the monument may be accounted for by John Lowe's
background as a mendicant. In his early years, he had been a member of the Austin

community at Droitwich (Worcestershire) and he later became prior of the Austin house in London and provincial prior of the order in England.[37] To a mendicant, particularly an Austin, a showy tomb of the kind much favoured by the episcopate at the time, for example by Kemp at Canterbury, would have had little appeal. In Lowe's taste may be sensed something of that reaction against showiness that elsewhere produced the cadaver tombs characteristic of the late Lancastrian period.

Alongside the relief monuments, there was once a magnificent series of brasses. Over time, these all fell victim to the hazards of iconoclasm, piecemeal damage and neglect. However, a number of the despoiled slabs remain, many of them in an excellent state of preservation. From these we can reconstruct with some accuracy the appearance of the brasses in their heyday.

The earliest of the series is the one now at the west end of the north choir aisle, at the foot of the steps. This was a magnificent composition, consisting of the indent of the figure of a bishop with crocketed crozier and a shield on either side, under a triple canopy with broad inhabited side-shafts and, above the central finial, a narrow super-canopy, which may have contained the Holy Trinity. A marginal epitaph of fillet form encloses the composition (Fig. 7). Sadler, in his survey, attributed the slab to Bishop Thomas Brinton, who died in 1389, but this is unlikely to be the case.[38] Everything about the slab points to a date of some half a century earlier. In the first place, the indent of the effigy shows a recess for a joining bar. This is a feature rarely found on brasses after the Black Death, and certainly on none later than 1370. Secondly, the figure was shown tilted slightly to the left, as the indents for the twin points of the mitre show. Such a position was never employed on London-made brasses of the late 14th century, on which the figures were always shown frontally. Thirdly, and finally, the elaborate, rather top-heavy canopy design belongs to the years before the Black Death. By the period after the Black Death, canopy design had become much simplified. The brass indents that offer the closest parallels to this one at Rochester are two from *c.* 1320–30 — those attributed to Bishop Ketton (d. 1316) at Ely and Bishop Beaumont at Durham (engraved *c.* 1320–30). If the case for an early date is accepted, then whom can this mighty slab commemorate? If we rule out all the bishops whose monuments we have already considered, we are left with only two candidates — Thomas de Wouldham, a former prior (1291–1317), and his successor the long-lived Hamo de Hethe, who died in 1352. Wouldham's date of death would fit the likely date of the brass very neatly. Just one factor counts against him, and that is his relative obscurity; the sheer splendour of the brass seems to call for a more distinguished commemoratee, in which case the candidacy of Hamo de Hethe should be canvassed. Hamo's date of death — 1352 — is too late: no large-scale brasses were produced in England in the immediate aftermath of the Black Death. However, it was by no means uncommon for bishops to commission their monuments in their lifetime, as we have seen in the case of Bishop Lowe. Hamo's name is sometimes associated with a recessed tomb of *c.* 1350–70 just to the south-east of the slab, but only on the evidence of Weever's often unreliable word.[39] While it remains the case that Wouldham is the strongest candidate for the brass, the possibility should be left open that it commemorates Hamo.[40]

Immediately next to this problematic slab is another of 14th-century date, though in this case clearly from the second half of the century. The condition of the slab is not good and the surface is badly worn. Nonetheless, the outlines of the brass inlays can still be made out. In the centre is the indent of the figure of a bishop with mouth and head scrolls, and a shield on each side with, over him, a single canopy with slender side shafts. A thin marginal inscription surrounds the composition. Sadler attributed the

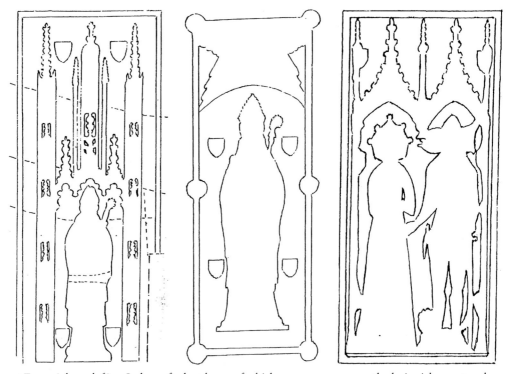

FIG. 7 (*above left*). Indent of a lost brass of a bishop, *c.* 1320–30, north choir aisle, west end

FIG. 8 (*above centre*). Indent of the lost brass of Bishop William Wells (d. 1444), presbytery floor

FIG. 9 (*above right*). Indent of the lost brass of Sir William Arundel (d. 1400) and his wife Agnes, behind the high altar

Figs 7, 8, 9 are from Sadler, Indents of Lost Monumental Brasses

brass to Thomas Trilleck (1364–72), and the attribution is almost certainly correct.[41] Trilleck was the younger brother of John Trilleck, bishop of Hereford, who died in 1360 and was commemorated by a very similar brass in his own cathedral.[42]

The next slab in order of date is another immense one, on the opposite side of the cathedral, in the south transept. Like the 'Wouldham' slab, it is excellently preserved. Its design follows the standard episcopal pattern: in the centre is the indent of the bishop's figure mitred and carrying a crozier, his right hand raised in blessing. Above rises a fine triple canopy with wide side-shafts and triple finials, and surrounding the whole is a marginal epitaph. The slab can be dated to roughly the second or third decade of the 15th century, the closest parallels being with the brass of Archbishop Cranley at New College, Oxford, of 1417. The Cranley brass was a product of London style 'B', and this one probably was too.[43] Sadler identifies the brass as that of Bishop Young, who died in 1418, and again the attribution is almost certainly correct.[44] Young requested burial in the Lady Chapel, the eastern part of which occupied the south transept.[45] Unusually for a Rochester memorial slab, then, this one occupies almost exactly the position in which it was laid.

In the centre of the choir is the last in the series of episcopal indents, this one with the outline of a brass of less conventional design. The figure in the middle is the usual one of a bishop in mass vestments. Above it, however, rises a bizarre canopy with fretty edges, which merge with the top line of the marginal epitaph and the corner medallions at its extremes (Fig. 8). The most likely explanation of the design is that in place of the conventional canopy there was a representation of two winged angels bearing the deceased's soul up to heaven, with clouds and divine rays above. It is evident from the outline of the figure that the brass dated from roughly the second quarter of the 15th century. Sadler suggested that it commemorated Bishop Wells, who died in 1444, again almost certainly correctly.[46]

We have seen that it is unlikely that there was a tradition at Rochester of the burial and commemoration of senior monks in the cathedral. Only one surviving indent can be associated with a monk, and then only tentatively. This is the curious slab now on the wall of the Jesus Chapel in the north transept.[47] It shows the outline of a priest with foot inscription, around him an Annunciation scene and, above, an indent probably for a Trinity, on either side of which is a kneeling figure. The whole is enclosed by a lozenge-shaped inscription with symbols at the corners. The brass was a highly unusual composition, which suggests close personal interest by the patron. Whom it commemorated is not known, but a member of the monastic community is certainly possible. On stylistic grounds the monument may be dated to *c.* 1500.

Among the despoiled slabs commemorating the laity, the most impressive by far is that behind the high altar for a knight in armour and his wife. This survives in excellent condition, the outlines of the inlays being exceptionally clear. The knight and his wife, whose figures are near life-size, are shown holding hands beneath a tall double canopy, from the side-shafts of which are suspended shields. Around the perimeter is a marginal epitaph (Fig. 9).[48] On stylistic grounds the slab can be dated to *c.* 1400, or very shortly after. It is almost certainly a product of the London workshop known as style 'A'.[49] Close parallels to the outlines of the figures are found on other 'A' brasses of this date, for example those at St Saviour's, Dartmouth (Devon) and Little Shelford (Cambridge-shire). The slab can be identified with fair certainty as that of Sir William Arundel K.G., constable of Rochester Castle, who died in 1400, and his wife Agnes. Arundel asked in his will to be buried in Rochester Priory, to the rear of the high altar — precisely the position in which the slab is to be found today.[50] Interestingly, there is evidence that the commission was executed very quickly after his death. In September 1401, when Agnes made her own will, she requested burial 'under the tomb where my husband and I are pictured'.[51] It is evident from this that within a year of the husband's death the brass was in position. It is sometimes maintained that lengthy delays could attend the commissioning and laying of brasses, and the unhappy saga that attended John Paston's proposed tomb is usually cited in this connection. John, the judge's son and head of the Paston family, had died in 1466, yet a full twelve years later his burial place at Bromholm (Norfolk) was still unmarked; Margaret, his widow, complained to her sons that the lapse was bringing dishonour on the family.[52] The Paston story is instructive; but there is reason to feel caution in generalising from it. Roger Greenwood has shown, on the basis of the Norfolk evidence, that most testators expected their memorials to be in place for their first anniversary.[53] The evidence of the Arundel tomb at Rochester provides grounds for believing that their expectations were not always disappointed.

Before the losses of the 17th century, there were a number of other high-status tombs and brasses in the cathedral. The celebrated preacher Bishop Brinton, who died in 1389,

almost certainly had a brass to his memory. In his will Brinton requested burial next to the grave of his predecessor Trilleck, and since Trilleck was commemorated by a brass, it is very likely that Brinton was too.[54] In the following century, two other bishops probably had monuments to their memory: John Bottisham (d. 1404) and John Langdon (d. 1434). Both bishops in their wills requested burial in the cathedral, and Langdon for one gave such very precise instructions about his place of interment as to suggest that he had commemoration in mind.[55] Among the senior laity known to have been buried in the cathedral, two in particular may be presumed to have had prestige monuments. These were Sir Richard Arundel and the judge, Sir William Rickhill. Richard Arundel (d. 1419), a chamber knight of Henry IV and Henry V, was Sir William's younger brother and is likely to have followed his sibling's tastes in being commemorated by a brass.[56] Judge Rickhill (d. 1407), who requested burial next to Prior Sheppey's tomb, may also be presumed to have been commemorated by a brass, for brasses were much favoured by the judiciary at this time.[57] But of these monuments and the many others that once graced the cathedral's pavements, not a trace survives. A number of late-medieval indents were uncovered in the 19th century in the course of restoration, but for the most part these were fairly small. The better preserved of their number were gathered in the north choir aisle, and the remainder in the crypt. Among those that can be made out today are a half-effigy of a knight and his wife, c. 1400, and a civilian and two wives with Trinity above, c. 1500, both in the crypt, and various other civilians and wives of c. 1500 in the choir aisle.[58]

One last monument deserves to be mentioned, because of its implications for our understanding of commemoration at medieval Rochester. This is a large early-14th-century incised slab, which Greenhill recorded in the crypt in 1948, but which is now apparently lost.[59] The slab was already badly worn when Greenhill saw it, but was still impressive in character. It consisted of the large single figure of a priest or a civilian under a canopy, with the head and hands of the figure inlaid with marble or composition. The stone was Tournai marble. The slab was evidently imported: it was probably made in Tournai or Namur. Among the burgess élites of eastern England in the 14th century imported slabs with inlays were very popular. A large series is still to be seen in the nave at Boston (Lincolnshire). In Kent, however, such slabs were less common. It would be interesting to know whom the Rochester slab commemorated. If it was a civilian — a burgess — it was probably someone who enjoyed trading connections with the Low Countries. However, if it was a priest, who is likely to have lacked such connections, then a number of questions arise. How was the contract with the Flemish *tombiers* set up? And why did the client go to a Flemish *tombier* at all? The normal instinct of the clergy at this time would have been to contact a London workshop. In the absence of evidence about the commemorated, however, these are issues about which we can only speculate.

The possibilities raised by the Flemish slab remind us again of the cosmopolitan nature of commemoration at medieval Rochester. Although Rochester was one of the poorer English sees, its cathedral was the setting for a fine series of episcopal monuments. Walter de Merton's effigy was one of the most splendid of its day. After the third quarter of the 15th century, when the practice began of translating Rochester's bishops elsewhere, the series of episcopal effigies came to a close. However, the many distinguished laity buried in the cathedral commissioned brasses and tombs right down to the Reformation. The many well-preserved indents to be seen in the cathedral provide an insight into the funerary riches that have been lost.

APPENDIX

THE BISHOPS OF ROCHESTER AND THEIR BURIAL PLACES

Siward, 1058–75	Monk and abbot of Chertsey	
Ernost, 1076	Monk of Bec	
Gundulf, 1077–1108	Monk of Bec, Caen and Canterbury	Buried at Rochester
Ralph d'Escures, 1108–14	Monk and abbot of Sées; Archbishop of Canterbury, 1114–22	
Ernulf, 1115–24	Monk and prior of Canterbury, and abbot of Peterborough (see administered for three years by John, bishop of Sées)	
John, 1125–37	Archdeacon of Canterbury (not a monk)	
Walter, 1148–82	Archdeacon of Canterbury (brother of Archbishop Theobald)	
Waleran, 1182–84	Archdeacon of Bayeux, clerk of Richard of Dover, archbishop of Canterbury	Buried at Rochester
Gilbert de Glanville, 1185–1214	Archdeacon of Lisieux, clerk of Baldwin, archbishop of Canterbury	Buried at Rochester
Benedict of Sanston, 1215–26	Precentor of St Paul's, London	Buried at Rochester
Henry de Sandford, 1227–35	Archdeacon of Canterbury	Buried at Rochester
Richard de Wenden, 1238–50	Bishop's official and rector of Bromley	Buried at Westminster Abbey
Laurence de St Martin, 1251–74	Royal clerk and archdeacon of Coventry	Buried at Rochester
Walter de Merton, 1274–77	Chancellor of England	Buried at Rochester
John de Bradfield, 1278–83	Monk and precentor of Rochester	Buried at Rochester
Thomas Inglethorp, 1283–91	Dean of St Paul's, London, and archdeacon of Middlesex	Buried at Rochester
Thomas de Wouldham, 1292–1317	Monk and prior of Rochester	Buried at Rochester
Hamo de Hethe, 1319–52	Prior of Rochester, 1314–17	Buried at Rochester
John de Sheppey, 1352–60	Treasurer of England	Buried at Rochester
William Whittlesey, 1362–64	Bishop of Worcester, 1364–68; archbishop of Canterbury, 1368–74	Buried at Canterbury
Thomas Trilleck, 1364–72	Dean of St Paul's	Buried at Rochester
Thomas Brinton, 1373–89	Proctor of the English Benedictines at the Papal Curia	Buried at Rochester
William de Bottisham, 1389–1400	Bishop of Llandaff, 1385–89	Buried at Blackfriars, London

John de Bottisham, 1400–04	Graduate of Cambridge, probably brother of William de Bottisham	Buried at Rochester
Richard Young, 1404–18	Bishop of Bangor, 1400–04	Buried at Rochester
John Kemp, 1419–21	Bishop of Chichester, 1421; of London, 1421–26; archbishop of York, 1426–52; of Canterbury, 1452–54	Buried at Canterbury
John Langdon, 1422–34	Envoy to Council of Basle	Buried in the Charterhouse, Basle
Thomas Brown, 1435	Bishop of Norwich, 1436–45	Buried at Norwich
William Wells, 1437–44	Monk and abbot of York	Buried at Rochester
John Lowe, 1444–67	Bishop of St Asaph, 1433–44	Buried at Rochester
Thomas Rotherham, 1468–72	Bishop of Lincoln, 1472–80; archbishop of York, 1480–1500	Buried at York
John Alcock, 1472–76	Bishop of Worcester, 1476–86; bishop of Ely, 1486–1500	Buried at Ely
John Russell, 1476–80	Bishop of Lincoln, 1480–94	Buried at Lincoln
Edmund Audley, 1480–92	Bishop of Hereford, 1492–1502; bishop of Salisbury, 1502–24	Buried at Salisbury
Thomas Savage, 1492–96	Bishop of London, 1496–1501; archbishop of York, 1501–07	Buried at York
Richard Fitzjames, 1496–1503	Bishop of Chichester, 1503–06; bishop of London, 1506–22	Buried at St Paul's Cathedral, London
John Fisher, 1503–35	Chancellor of the University of Cambridge	Buried at St Peter ad Vincula, Tower of London

Sources: London, British Library, Cotton MSS, Nero DII; Lambeth Palace Library, Register of Archbishop Arundel, I, fols 166v, 206v; Thorpe, *Custumale Roffense* (London 1788); F. Godwin, *De Praesulibus Anglie Commentarius* (Cambridge 1743); C. Flight, 'John II, Bishop of Rochester, Did Not Exist', *English Historical Review*, 106 (1991), 921–31; surviving monuments at Rochester and elsewhere.

ACKNOWLEDGEMENTS

I am grateful to Nicholas Rogers and Tim Tatton-Brown for their comments on this paper.

NOTES

1. W. H. St John Hope, 'The Architectural History of the Cathedral Church and Monastery of St Andrew at Rochester, I: The Cathedral Church', *Archaeologia Cantiana*, 23 (1898), 194–328; A. G. Sadler, *The Indents of Lost Monumental Brasses in Southern England, Volume 5: Kent, Part II* (privately published 1976), 7–27.

2. The most useful of the recensions is London, British Library, Cotton MSS, Nero DII, a version of the *Flores Historiarum*; for the details of bishops' burial places, see fols 179v–84v. Extracts from the Rochester chronicles are printed as the 'Historia Roffensis' in *Anglia Sacra*, ed. H. Wharton, 2 vols (London 1691), I, 356–77. The succession of priors is given here at 392–94, probably from BL Cotton MS Vespasian AXXII.

3. Rochester Consistory Court wills are indexed in L. L. Duncan ed., *Index of Wills Proved in the Rochester Consistory Court between 1440 and 1561* (Kent Archaeological Society 1924). Short extracts from wills of the bishops of Rochester and Rochester townsfolk are given in L. L. Duncan ed., *Testamenta Cantiana. West Kent* (London 1906), 60–62.

4. J. R. L. Highfield ed., *The Early Rolls of Merton College, Oxford*, Oxford Historical Society, n.s., 18 (1964), 137.

5. J. Weever, *Ancient Funerall Monuments* (London 1631), 308–16; W. B. Rye, 'Norwich Officers in 1635', *Archaeologia Cantiana*, 6 (1866), 62–64.

6. The chronology of destruction at Rochester is unfortunately unclear. Although the cathedral was spared the attentions of a parliamentary force that passed through the city in 1642, it appears to have suffered later. In reply to an enquiry from Bishop Warner, after the Restoration, the dean and chapter said that a local shoemaker, John Wyld, had taken down and sold iron and brasswork from the cathedral's monuments; J. Thorpe, *Custumale Roffense* (London 1788), 172.

7. Thorpe, *Custumale Roffense*.

8. Fisher's drawings survive scattered among the collection of rubbings and topographical drawings in the Society of Antiquaries. Currently, they are not listed or catalogued. Mr D. R. Hutchinson, however, is in the process of working on a list. Fisher (*c.* 1781–1836), like Thorpe, was a native of Rochester.

9. For St Paul's, see W. Dugdale, *History of St Paul's Cathedral in London* (London 1658), 60, 72, 76, 78, 84; and for Hereford, S. Badham, 'The Brasses and Other Minor Monuments', in *Hereford Cathedral. A History*, ed. G. Aylmer and J. Tiller (London 2000), 331–35.

10. *Rites of Durham*, ed. J. Raine, Surtees Society Publications, XV (1842), 19, 20, 26, 30. The first prior to be buried in the cathedral, and not the garth, was John Fossour, in the 1340s.

11. Judge Sir William Rickhill in his will of 1407 requested burial in the cathedral next to the 'stone', where Prior John Sheppey intended to be buried ('iuxta lapidem ubi Johannes Schepeye nunc prior eiusdem ecclesie se disposuit iacere'); Lambeth Palace Library, Register of Archbishop Arundel, I, fol. 234. Rickhill's widow then identifies this place as the Lady Chapel; *Register of Henry Chichele, Archbishop of Canterbury 1414–1443*, II, ed. E. F. Jacob (Oxford 1938), 161. The wording which William Rickhill employs suggests that Sheppey had ordered his memorial — very likely, a brass — in his lifetime.

12. Discussed below, 175.

13. See the testamentary evidence collected in *Index of Wills Proved in the Rochester Consistory Court between 1440 and 1561* and *Testamenta Cantiana. West Kent*.

14. St John Hope, 'Architectural History', 287–92.

15. B. and M. Gittos, 'List of Purbeck Marble Coffin-Shaped Slabs, Part IX — Kent (Additions and Corrections)', *Church Monuments Society Newsletter*, 14, i (1998), 23–24.

16. Perhaps, more likely, bishops. It seems that the early priors, in conformity with the practice of the time, were buried in the chapter-house: graves were found inside the door in 1936.

17. Illustrated and discussed by Thorpe in *Custumale Roffense*, 188–89.

18. C. Wilson, 'The Medieval Monuments', in *A History of Canterbury Cathedral*, ed. P. Collinson, N. Ramsay and M. Sparks (Oxford 1995), 456.

19. The effigy can be identified as St Martin's because, according to the chronicler, the bishop was buried on the northern side of the high altar ('iuxta maius altare a parte boriali'); BL Cotton MS Nero DII, fol. 179v.

20. For discussion, see E. S. Prior and A. Gardner, *An Account of Medieval Figure Sculpture in England* (Cambridge 1912), 585.

21. The retable is illustrated in P. Binski, *Westminster Abbey and the Plantagenets. Kingship and the Representation of Power, 1200–1400* (New Haven and London 1995), 153–55.

22. The local chronicler noted Inglethorp's place of burial as he did St Martin's ('iuxta magum altare ex parte australi'); BL Cotton MS Nero DII, fol. 184v.

23. Prior and Gardner, *Medieval Figure Sculpture*, 600.

24. The tomb in the choir aisle can be identified as Bradfield's from the statement of the Rochester chronicler, who says Bradfield was buried in the south aisle 'iuxta hostium crubitorum'; BL Cotton MS Nero DII, fol. 182.

25. Bradfield may have wanted to attract the intercessory prayers of the monks: his tomb is opposite the main door to the cloister and close to the entrance to the crypt.

26. L. L. Gee, '"Ciborium" Tombs in England, 1290–1330', *JBAA*, 132 (1979), 29–41. Strangely, Gee overlooks this tomb at Rochester.

27. Wilson, 'The Medieval Monuments', in *History of Canterbury Cathedral*, 461.

28. J. E. Newman, *West Kent and the Weald* (B/E, 1969), 463.

29. *Early Rolls of Merton College*, 137.

30. W. J. Blair, 'The Limoges Enamel Tomb of Bishop Walter de Merton', *Church Monuments*, 10 (1995), 3–6.

31. In his will Sheppey said that he had decided on the place for his burial in association with the prior ('cum consensu prioris'); Lambeth Palace Library, Register of Archbishop Islip, fol. 169v.

32. The building of the wall may have been prompted by fears for the stability of the tower; G. F. Palmer, *The Cathedral Church of Rochester* (London 1899), 28, 99.

33. Fragments of the original canopy, with polychrome, are preserved in the Lapidarium.

34. For Sheppey's career, see A. B. Emden, *A Biographical Register of the University of Oxford to A.D. 1500*, 3 vols (Oxford 1957–59), III, 1683.

35. The only one to remain at Rochester was John Fisher, who was executed in 1535.

36. St John Hope, 'Architectural History', 322–23.

37. For Lowe's career, see Emden, *Biographical Register*, II, 1168–69.

38. Sadler, *Indents of Lost Monumental Brasses in Southern England*, 13. Sadler was followed by Rogers who, accordingly, maintained that at Rochester 'there is no evidence for episcopal brasses in the period before 1350'; see N. Rogers, 'English Episcopal Monuments, 1270–1350', in *The Earliest English Brasses. Patronage, Style and Workshops, 1270–1350*, ed. J. Coales (London 1987), 40. The implication of the present argument is that this is not the case.

39. Weever, *Ancient Funerall Monuments*, 314: 'buried by the north wall'.

40. Perhaps Hamo commissioned the brass at around the time he built the tower and spire, in 1343?

41. Sadler, *Indents of Lost Monumental Brasses in Southern England*, 10–11. Trilleck's will, in which he requests burial in the cathedral, is Lambeth Palace Library, Register of Archbishop Whittlesey, fols 126v–27. Since his successor Thomas Brinton asked to be buried next to Trilleck's grave in the new Lady Chapel, we know that Trilleck was buried in the Lady Chapel (Lambeth Palace Library, Register of Archbishop Courtenay, fol. 231r).

42. For the careers of the Trillecks, see Emden, *Biographical Register*, III, 1905–08.

43. For London marblers' workshops in the late Middle Ages and the terminology by which they are identified, see J. P. C. Kent, 'Monumental Brasses: A New Classification of Military Effigies, c.1360–c.1485', *JBAA*, 3rd series, 12 (1949).

44. Sadler, *Indents of Lost Monumental Brasses*, 7–8.

45. *The Register of Henry Chichele, Archbishop of Canterbury 1414–1443*, ed. E. F. Jacob, 4 vols (Oxford 1938–47), II, 165–66.

46. Sadler, *Indents of Lost Monumental Brasses*, 9, 11.

47. ibid., 6–7.

48. ibid., 22–23. The slab is discussed by W. B. Rye, 'Tombs of Sir William Arundel and Others in Rochester Cathedral', *Archaeologia Cantiana*, 13 (1880), 141–45. Today, the slab is raised slightly above the floor. However, there is no evidence that it was intended for a tomb: there is no chamfered edge. Presumably, it originally lay flush with the floor, so as not to impede a processional route.

49. For London style 'A', see Kent, 'Monumental Brasses: A New Classification of Military Effigies'.

50. Lambeth Palace Library, Register of Archbishop Arundel, I, fols 172v–73.

51. ibid., fols 183–83v.

52. *Paston Letters and Papers of the Fifteenth Century*, ed. N. Davis, 2 vols (Oxford 1971–76), I, nos. 212, 311.

53. R. Greenwood, 'Wills and Brasses: Some Conclusions from a Norfolk Study', in *Monumental Brasses as Art and History*, ed. J. Bertram (Stroud 1996), 92–96.

54. Lambeth Palace Library, Register of Archbishop Courtenay, fol. 231.

55. Lambeth Palace Library, Register of Archbishop Arundel, I, fols 206–06v; *Register of Henry Chichele*, II, 556–58. Langdon asked to be buried in the nave of the cathedral between the two columns nearest to the Lady Chapel. In the event, he died and was buried at Basel, but his commemorative plans at Rochester may still have been carried out.

56. Sadler, *Indents of Lost Monumental Brasses*, 22–23.

57. Lambeth Palace Library, Register of Archbishop Arundel, I, fols 243–44. Rickhill, a justice of common pleas, resided at Islingham in Frindsbury, his manor on the west bank of the Medway opposite Rochester. He established a chantry in the cathedral shortly before his death; see St John Hope, 'Architectural History', 295. His widow, Rose, in her own will asked to be buried with him (*Register of Henry Chichele*, II, 161); she identifies the place of burial as the Lady Chapel. Other justices commemorated by brasses of this period include Sir John Cassy at Deerhurst (Gloucs.); 1400, Sir Hugh Holes at Watford (Herts.), 1415; and Sir John Martyn at Graveney (Kent), 1436. Martyn was one of Bishop Langdon's executors.

58. Sadler, *Indents of Lost Monumental Brasses*, 19–21, 24–27; anon., 'Rochester Cathedral Indents', *Transactions of the Monumental Brass Society*, 8 (1943–51), 133–37.

59. F. A. Greenhill, 'An Incised Slab at West Wickham', *Archaeologia Cantiana*, 61 (1948), 106–08; idem, *Incised Effigial Slabs*, 2 vols (London 1976), II, 27. In his note on the slab, dated 10 September 1948, Greenhill records its measurements as approximately 124 inches by 64 inches. I am grateful to Mr J. Coales for allowing me access to Greenhill's note.

The East Cloister Range of Rochester Cathedral Priory

JOHN McNEILL

In a century noted for the way in which the planning of monastic precincts was regularised, that of Rochester Cathedral Priory looks out of place. This aspect alone makes the invitation to review the 12th-century east cloister range irresistible. That it also incorporates narrative imagery makes it even more remarkable. This last may be an accident of survival — the great majority of English Romanesque cloisters have vanished, and the evidence that remains is too fragmentary for it to be possible to assess whether figurative imagery was widely used in Anglo-Norman cloisters. What follows, therefore, amounts to no more than a brief account of the 12th-century status of the east cloister range, and some speculations as to its associations.

THE east range of Rochester Cathedral Priory now consists of a chapter-house, roofless and stripped of most of its facing stone, a day-stair portal and the west wall of the dormitory undercroft. It was reduced to something close to this within a quarter-century of the Dissolution. For immediately after the priory was dissolved in April 1540, Henry VIII seized the buildings for conversion into a royal residence. Within eighteen months the refectory had become the great hall, and the chapter-house and dormitory had been converted into the king's lodgings.[1] This was presumably when the sills of the upper windows of the chapter-house were cut back and large ragstone corbels, held in place by Tudor brickwork, were put in to support a new upper passageway to the king's chambers above the east cloister walk (Fig. 1).[2] In 1550 or 1551, the palace was acquired by George Brooke, Lord Cobham who, having apparently already begun its demolition, in 1558 sold it back to the dean and chapter, who in turn demolished most of the rest.[3] The ruins were subsequently recorded by John Thorpe in 1769, partly excavated by St John Hope in the early 1880s, and excavated again by St John Hope, in the company of George Payne, in 1898. They were variously probed and restored between 1936 and 1938 (when the chapter-house portal was reopened and toilets were installed behind a section of the dormitory undercroft west wall), and finally, between 1989 and 1992, they were cleaned, recorded and repaired under the expert supervision of Tim Tatton-Brown, in the course of which the earliest surviving piece of medieval English structural ironwork was discovered, unfortunately burst out of its lead casing, holding together the tympanum of the day-stair portal.[4]

Assessing what was there before 1540 is complicated. When St John Hope dug out most of the dormitory undercroft in the 1880s, he left two inspection pits where one can still see the western half-columnar responds and scallop capitals of what he established was a three-aisled, groin-vaulted hall, approximately 42 ft wide internally, which ran for at least 91 ft south from the chapter-house (Figs 3 and 4).[5] The outer face of its western wall gave onto the east walk of the cloister (Fig. 2). This wall is

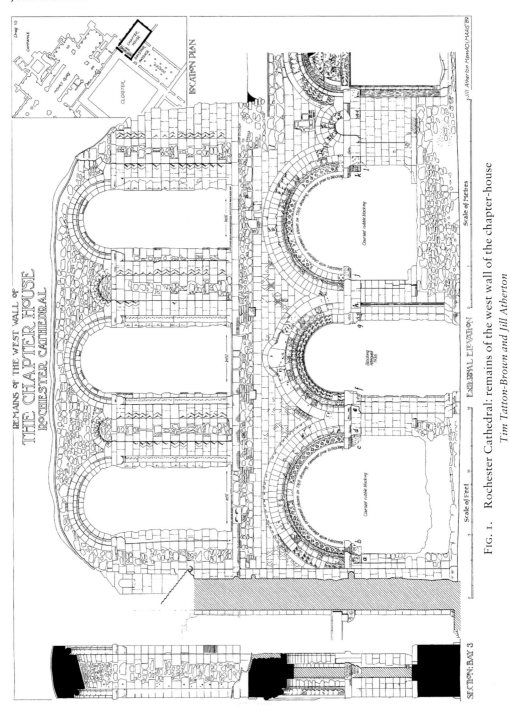

FIG. 1. Rochester Cathedral: remains of the west wall of the chapter-house
Tim Tatton-Brown and Jill Atherton

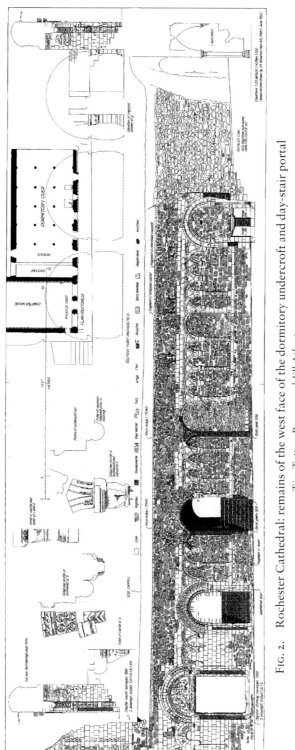

FIG. 2. Rochester Cathedral: remains of the west face of the dormitory undercroft and day-stair portal

Tim Tatton-Brown and Jill Atherton

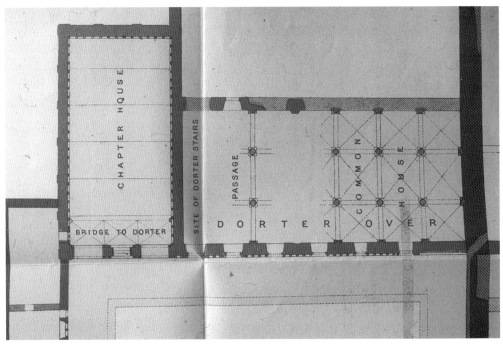

FIG. 3. Rochester Cathedral Priory: plan of the east range
W. H. St John Hope

FIG. 4. Rochester Cathedral: capital on the inner
face of the dormitory undercroft west wall
John McNeill

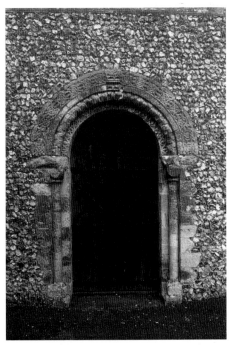

FIG. 5. St Michael and All Angels, Throwley
(Kent): west portal
John McNeill

articulated, from south to north, by a doorway (its iron hinge-pins visible behind the lower jambs); four intersecting blind arches; a window (its right embrasure *in situ*); four arches; a blocked opening (a doorway probably inserted in 1540–41 and blocked in 1936); four arches; toilets (inserted in 1936 where, again, a doorway had been created, probably in 1540–41); three arches; and a 12th-century portal. The wall corresponds to five of the six bays of the dormitory undercroft that it was possible to excavate. Most importantly, St John Hope established that the windows and doors were aligned with the centre of each bay. As those western openings featuring Tudor brickwork show no evidence of having been doorways earlier, one can assume these were originally windows. Moreover, St John Hope also noted that the north entry was aligned with a portal in the east wall, and that this bay was open to the next bay south, after which a broad flat pilaster was used as a respond — implying a cross-wall.[6] This suggests that the two northern bays were used as a passage and parlour. The remaining four bays were all one room, entered from the south portal.[7] St John Hope was unable to excavate behind the portal to the left of the dormitory undercroft, and decided that this must have been the day-stair entrance by simple process of elimination.[8] Finally, the chapter-house closed the east cloister range to the north.

As it is clear that the east cloister range predates the construction of the present presbytery and choir, two related questions arise. By what route did monks process from the east range into the Romanesque choir, and why was the cloister not built south of the nave? Without further excavation neither question can be satisfactorily answered, but a couple of tentative suggestions may be made. In the first place, the east cloister range lay east of the Romanesque presbytery, so a night-stair can be ruled out. Indeed, the design exploits this fact, for the height of the chapter-house is such that, when a night passage was eventually constructed in the 14th century, it was necessary to throw a three-arched bridge across the inner face of the chapter-house entrance.[9] The monks must therefore have entered the church via the north walk, though one should not assume that this was in the same position as the later medieval north walk. It is far more likely that the line of the Romanesque choir aisle walls was continuous with that of the nave aisles, in which case the Romanesque north walk almost certainly lay north of its successor. This also makes better sense of the design of the east range, allowing an additional bay north of the chapter-house so that the chapter-house entrance would not have been uncomfortably positioned in the north-east angle of the cloister. It also means that the building of a new presbytery following the fire of 1179 necessitated the building of a new north cloister walk. As the scorching of the Caen stone facing of the dormitory undercroft is most likely the result of the burning of the cloister roofs during this fire, it is probable that the cloister walks had to be rebuilt regardless. There is certainly ample documentary evidence for their reconstruction post-1179. Bishop Gilbert de Glanville (1185–1215) is recorded as having 'caused our cloister to be finished in stone',[10] while Elias the prior (c. 1214–17) caused 'part of the cloister towards the dorter to be leaded', 'caused the lavatory and frater door to be made' and 'bought the shingle with which the cloister towards the frater was covered'.[11]

Why the cloister was so unconventionally sited is altogether more problematic. When Farley Cobb excavated the triangle of land between the south great transept and west front in 1937, he found no evidence of claustral buildings.[12] So there is no case for the cloister's having been moved. And as Gundulf constructed 'all the necessary offices for monks as far as the capacity of the site allowed' one has to accept that the first Romanesque cloister must have occupied a position more or less coincident with the present one.[13] All subsequent rebuildings were then organised around this unorthodox

situation. Rochester is in select company here, and what is most striking about the distinguished list of Romanesque east cloister ranges that project east of the presbytery — Old Sarum Cathedral, S. Sofia at Benevento (Campania), Saint-Trophime at Arles (Bouches-du-Rhône), Sant Pere de Rodes (Catalonia) — is that each is odd in its own way, and probably for its own reasons. Rochester is equally idiosyncratic, and it seems unlikely that the decision to adopt an eastern position for the cloister was taken positively, or in isolation from decisions on the position of other buildings, which is another reason for thinking it was probably taken under Gundulf.

The fundamental problem in assessing Gundulf's role as a planner is that little of his work survives, and the order in which he went about commissioning the monastic buildings is uncertain, but we do know he built extensively: a cathedral, castle, hall, necessary offices for the monks, and an infirmary and associated chapel.[14] These were all built within sight of each other and within sight of the topographical feature that dominates the Medway side of Rochester, Boley Hill. If Gundulf began planning the conventual precincts around the time he replaced the cathedral canons with Benedictine monks, that is c. 1080, he may have been forced into considering the future development of the Medway side of Rochester as a whole. For although he did not rebuild the castle in stone until 1087–89, a castle was already there, probably on the same site. Boley Hill is steepest to the south of the existing cathedral nave, and the problem with siting the cloister here would have been two-fold. Construction of the dormitory and refectory would have necessitated a major relandscaping, and the garth would have been directly overlooked by the castle. If one were to place the bishop's hall here, the earthworks could be kept to a minimum and a more appropriate situation for a bishop, opposite the castle, achieved.[15]

All this is pure speculation, but if something like the above layout was adopted, the end result would be similar to Arles, where the archbishop's palace and courtyard lie south of the cathedral nave with the conventual ranges further east, though the reason is again site-specific, and there is no reason why precincts that developed in this way should be related.[16]

SCULPTURAL COMPOSITION AND THE EAST RANGE WORKSHOP

GUNDULF may be the ghostly presence behind the monastic geography of Rochester, but he had no hand in shaping the masonry that survives today. Even St John Hope concluded that the east cloister range could be no earlier than Ernulf's episcopacy (1114–24), a dating that found support in a comment in the *Textus Roffensis* to the effect that Ernulf built the dormitory, chapter-house and refectory.[17] Emboldened by George Zarnecki, most modern commentators have opted for an even later date — Deborah Kahn for the late 1140s and Malcolm Thurlby for c. 1160–70.[18] However, the most subtle intervention has been that of Tim Tatton-Brown, who contends that the ragstone core of the east range is Ernulf's, as are the upper west windows of the chapter-house, and the responds and scallop capitals of the inner wall of the dormitory undercroft, while the rest is refacing necessitated by the damage caused in the fire of 1137.[19] Tatton-Brown is right to draw attention to the old-fashioned, early-12th-century style of the triple-scallop capitals in the dormitory undercroft (Fig. 4), the simple cushion capitals used in the upper west windows of the chapter-house, and the ease with which the thick ragstone rubble core could have been refaced. Yet is the sort of rich beaded sculptural ornament used in the east cloister range really so incompatible with simple cushion and scallop capitals that the two must have been produced at

186

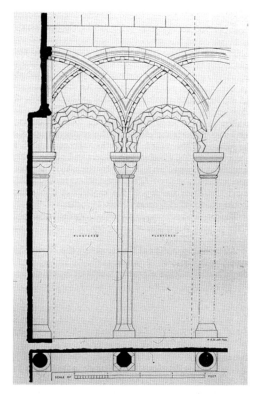

FIG. 6. Rochester Cathedral: intersecting blind arcading discovered on the east interior wall of the chapter-house

W. H. St John Hope

different dates? In the context of, say, a modest Kentish parish church such as Throwley (Fig. 5), one would have no hesitation in seeing capitals and arch as contemporary, but the situation at Rochester is clearly more complex, and it is impossible to address it without looking first at how sculpture is used in the east cloister range.

The most obvious point to make is that although the sculpture is organised as a series of discrete compositions — dormitory undercroft interior, west face of the dormitory undercroft, day-stair portal, chapter-house entrance, chapter-house interior — certain motifs are allowed to run. The use of alternating cylindrical and octagonal columns for the intersecting blind arcading in the interior of the chapter-house and along the west face of the dormitory undercroft is one case (Figs 2 and 6), and there are many others. The beaded rope pattern used on the necking of the chapter-house portal north capital forms the basis for the enriched chevron found around the edge of the day-stair tympanum. The simple-scallop capital supporting the blind arcading on the east interior wall of the chapter-house is of the same type used for the dormitory undercroft blind arcading (Figs 7 and 8). The distinctive, and seemingly old-fashioned, foliage of the day-stair entrance lintel is a variation on that of the chapter-house portal capital frieze (Figs 9 and 10). Most remarkably, the extremely unusual bases employed across the chapter-house entrance façade were simplified for use on the west wall of the dormitory undercroft (Figs 11 and 12). Furthermore, this subtle balancing of the parts with the whole is as apparent at a macro-level as it is at the level of the individual motif. Take, for example, the way in which the height of the entrances to the dormitory undercroft passage, day-stair and chapter-house is graduated from south to north, or

FIG. 7. Rochester Cathedral: capital on the east interior wall of the chapter-house

FIG. 8. Rochester Cathedral: capital on the west face of the dormitory undercroft

FIG. 9. Rochester Cathedral: detail of the day-stair portal lintel

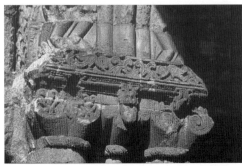

FIG. 10. Rochester Cathedral: chapter-house portal, north capital frieze

FIG. 11. Rochester Cathedral: chapter-house portal, south jamb bases

FIG. 12. Rochester Cathedral: west face of the dormitory undercroft, base

Figures 7–12: John McNeill

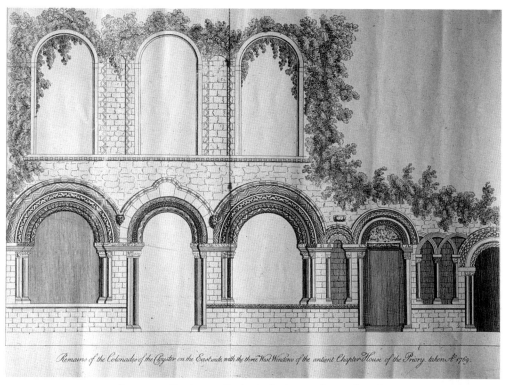

Remains of the Colonades of the Cloyster on the East side, with the three West Windows of the antient Chapter House of the Priory. taken A.º 1769.

FIG. 13. Rochester Cathedral: chapter-house façade
From John Thorpe, Custumale Roffense *(1788)*

the manner whereby the keystone of the outer order of the chapter-house portal, narrower than either of the flanking openings, protrudes upwards, lending an appropriate accent of ascent to the subject, while simultaneously bringing the apex of the hood-mould up to the level of that of the flanking arches (Fig. 13). The organisation of the detached columns is subject to a similar cross-compositional discipline, and the basic pattern seems to be octagonal Tournai marble for the portals, with cylindrical columns of onyx marble alternating with octagonal columns of Caen stone in the blind arcading (Fig. 2).[20]

The counterweight to this unifying impulse is contrast, and not simply contrasts between the various parts that make up the east range, but contrasts within them. Two examples should suffice to make the general point. The first concerns the chapter-house entrance, where the openings flanking the central portal are intended both to complement the portal and to draw attention to its importance. Consequently, the treatment of the bases and of two orders of the arches above the flanking openings mimics the respective areas of the portal. Everything else is differentiated, strikingly so at capital/abacus level and in the outer order of the arches, and an almost modal contrast with the portal is achieved by restricting the sculptural vocabulary to foliage and geometric ornament alone (Fig. 13). The second concerns the use of intersecting blind arcading, which seems to be distinguished according to location; a relatively simple form is employed on the west face of the dormitory undercroft, and an

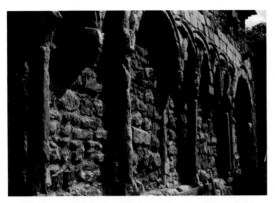

FIG. 14. Rochester Cathedral: west face of the
dormitory undercroft, intersecting blind arcading
John McNeill

FIG. 15. Rochester Cathedral: east
interior wall of the chapter-house,
intersecting blind arcading
John McNeill

appreciably more complex form found within the chapter-house, which uses sub-arches
and geometric ornament in addition to mouldings (Figs 14 and 15). The only section of
intersecting blind arcading to survive from the chapter-house is on its east wall, now
immured in the head verger's flat, where the arcading is sandwiched between courses of
plain ashlar.[21] It is impossible to say whether the ashlar facing above the blind arcading
of the north and south walls was similarly treated, but the west wall was not.[22] Here,
the ashlar facing was carved with a diagonal lattice pattern. It is possible this was
replicated in paint on the east wall, or indeed that more ambitious types of wall-
painting were used, but it is clear that within the chapter-house there were contrasts
between zones of carved stonework and zones where the wall surface was sheer, as well
as contrasts between east and west. In short, carved stonework is deployed across the
east cloister range in rhythmically sophisticated ways, and there is no reason to doubt
that the outward forms were designed as a whole, or that they were produced by a
single sculptural workshop. The capitals of the interior of the dormitory undercroft
and upper west wall of the chapter-house lie slightly outside the range of material one
can unquestionably attribute to this workshop — but, as will be argued below,
sculpture at a site with which they were closely connected suggests they were capable
of extending their interest in contrasted forms to embrace these old-fashioned types of
cushion and scallop capital as well.

Figurative Imagery and the East Range Workshop

ON balance, the sculptors responsible for the east cloister range seem to have been
brought together for the specific purpose of working on the cloister. There are
similarities with the sculpture of the cathedral nave and west front, but these seem
more likely to be the result of workshops with similar backgrounds picking up on each
others' work, than the result of the same sculptors working sequentially on nave,
cloister and west front.[23]

 The aspect of their work that has provoked most comment is the figurative sculpture
above the day-stair and chapter-house portals, and because the forms and subjects are

so unusual, they are worth dwelling on. The tympanum over the day-stair entrance shows, or showed, Abraham sacrificing Isaac (Fig. 16). This is carved across six stones, above a lintel constructed of three stones that depicts fish-tailed monsters and foliage. The lintel foliage is similar to that of the chapter-house portal abaci and is of a type that ultimately derives from the late-11th-century capitals in the Holy Innocents Chapel at Canterbury Cathedral. The fragment of inscription still legible on the tympanum reads '*ARIES PER CORNUA*', a form of words which does not appear in Latin versions of the Old Testament. The text can therefore have been based only loosely on the Vulgate, or, more probably, consisted of a series of short phrases designed to act as literal pointers. Abraham is at the centre, and an angel sweeps in from the left to stay his sword hand. Isaac is to the right, held by the hair, with a ram caught in a thicket at the bottom right, and what are likely to be two servants at the bottom left. Iconographically, the most curious element is the hand of God appearing from a cloud accompanied by the word '*RAS*'. The latter has been interpreted as a misreading of '*PAX*' — but '*RAS*' is what it says, a sequence of letters meaningless in itself. The alternatives seem to be that '*RAS*' is graffiti, an abbreviation for *rasitio* ('to shave') — or formed the final three letters of a six-letter word which continued to the other side of Abraham's head. A mangled version of 'vepres' — a thorn bush — is the only word in the Vulgate account of the sacrifice of Isaac which might fit, and '*RAS*' is in the wrong position for this to work. *Patras* in a dog-Latin sense of father, or patriarch, perhaps best fits the bill, as this is God's reward to Abraham — 'I will multiply thy seed as the stars of the heaven' — though it has to be said that all the suggested alternatives are fairly tenuous.[24] This aside, in the biblical account God only appears to Abraham to instruct him to sacrifice Isaac, that is at the beginning of the chapter, so the Rochester tympanum would therefore seem to be something of a conflation of most of Genesis 22.

Tympana depicting Old Testament scenes are far from common in Anglo-Norman England, and Rochester is unique in depicting the Sacrifice of Isaac, though given the destruction of the vast majority of Anglo-Norman conventual precincts, this may not be saying much.[25] The one capital supporting the tympanum still legible — that to the south — depicts two Evangelist symbols, those of Matthew and John, and it hardly seems rash to assume that Mark and Luke were represented to the north. This raises the possibility that the Sacrifice originally formed part of a typological sequence, and that we have lost its companion Crucifixion. If so, the only feasible locations for the Crucifixion would have been at the opposite end of the processional route into the cathedral choir, that is a portal off the north cloister walk, or at the head of the day-stair. It may be significant in this respect that when a new access route to the dormitory was created in the 14th century, its portal juxtaposed representations of Church and Synagogue.[26]

Two final aspects of the day-stair portal are worthy of comment. Its threshold consists of three interlocking stones, of the same tongue-and-groove type as turns up on the cathedral west portal, and on a fragmentary stone probably from a lintel at Dover Priory.[27] The rectangular door frame is articulated by an astonishingly classicising continuous moulding.[28]

The chapter-house portal is even more unexpected in the context of what is known of Anglo-Norman sculpture, but is badly eroded and the outer order of the entry arch can be reconstructed only from John Thorpe's engraving (Fig. 17).[29] The keystone is bulbous. The individual motifs are sunk and framed. The majority of voussoirs are arranged as symmetrical pairs, and the principal subject is the Ascent of Alexander. Any one of these features would be unusual; their combination conspires to create what

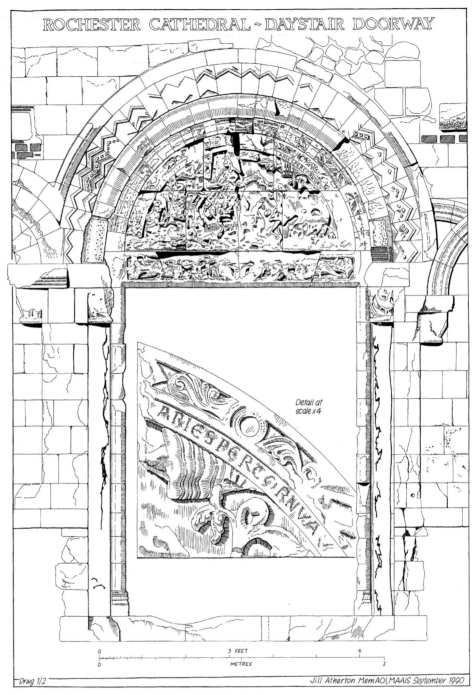

FIG. 16.　Rochester Cathedral: day-stair portal tympanum
Jill Atherton

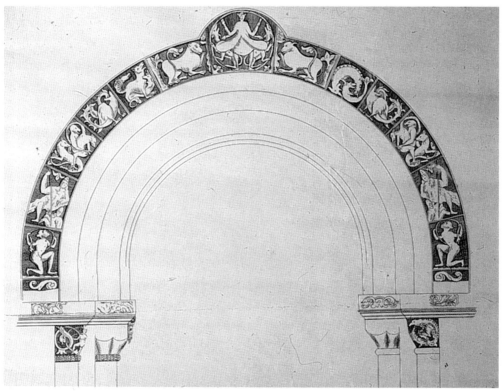

FIG. 17. Rochester Cathedral: outer order of the chapter-house portal
From John Thorpe, Custumale Roffense *(1788)*

is arguably the most puzzling spectacle in English Romanesque sculpture. The bulbous keystone is used aesthetically to raise the apex of the chapter-house portal so as to match the apexes of the flanking openings, but otherwise only turns up in England in two Berkshire parish churches, St Mary, Bucklebury, and St Laurence, Tidmarsh.[30] Sunk and framed voussoirs are unusual outside Italy, and the few examples scattered across the rest of Romanesque Europe have never been studied as a group.[31] Their apparently independent employment in Islamic and Christian buildings suggests a derivation from late antique buildings, a suspicion reinforced by the existence of an important group of early-7th-century sunk and framed terracotta voussoirs from the area around Nantes (Loire-Atlantique).[32] The symmetry is equally elusive, and it is not confined to the arch. The dragons and foliage on the abaci of the chapter-house portal are loosely symmetrical, and the projecting heads of the capitals probably originally mirrored each other also, though Thorpe does show two contrasting headstops supporting the portal hood-mould: a bearded figure (south) and a moustachioed and horned figure (north). None the less, there is a remarkable interest in symmetrical pairings. Taking the outer order of the chapter-house portal from bottom to top, the Thorpe engraving shows S-shaped leaves; Serpentarius (derived from classical depictions of the ancient constellation Ophiuchus, figured as a man holding a serpent); male harpies lancing fallen figures; three entwined animals; a pair of grotesques; a quadruped

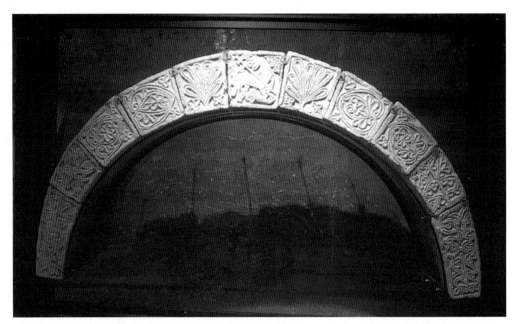

FIG. 18. Bitonto Cathedral (Apulia): reconstructed 11th-century arch now in crypt
John McNeill

above a smaller animal opposite a pair of sea-horses (the one asymmetric pairing); lions; and finally the Ascent of Alexander. Symmetry is obviously found in arches that use modular and bi-modular voussoirs, as in those arches using billet moulding, or chevron, or four-petal flowers elsewhere in the east range, but paired designs are exceptional in a multi-motif arch. Rochester sculptors evidently developed a taste for reversing their designs and carving them in batches of two, as the cathedral west portal also experimented with symmetrical voussoirs. However, the chapter-house portal is likely to be earlier than this and, other than the fragments of some frustratingly unlocalised late-11th-century arches from Bitonto Cathedral (Apulia) (Fig. 18), what it most recalls is the type of pairing of capital designs across elevations that became established in the late antique period, and which underwent something of a revival in 11th-century Italy and France.[33]

Finally, the principal subject, the Ascent of Alexander, was a staple of English late medieval misericords, but is rare in 12th-century England, where its most celebrated appearance is on a tympanum at Charney Bassett (Berkshire).[34] The legend has a long iconographical history, and ultimately derives from the romance of Pseudo-Callisthenes, who describes how Alexander attempted to reach heaven with the help of two griffons, urging them to carry him upwards by holding two lances tipped with meat above their heads. In Byzantium, the Ascent of Alexander tends to be treated as an image of triumph and heavenly bliss, and Alexander assumes the dress of a Byzantine Emperor. In the West, it is generally a symbol of overweening pride. The most extensive sculptural scheme to feature the subject in the late Romanesque West is at Freiburg im Breisgau (Baden-Württemberg), where the entrance to the chapel of St Nicholas juxtaposes Alexander with a mermaid giving suck to her baby and underlines this with

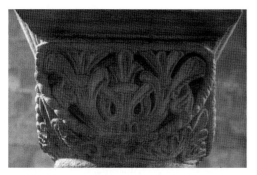

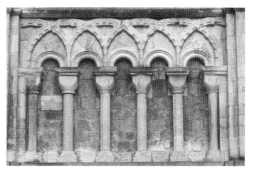

FIG. 19. Canterbury Cathedral: Holy Innocents Chapel, east face of east capital

John McNeill

FIG. 20. Canterbury Cathedral: detail of the south face of the south-east transept

John McNeill

a well-known allegory of the unrepentant sinner.[35] The appearance of Alexander over the chapter-house portal at Rochester may be equally admonitory, but the sculptural ensemble is less obviously a summary of sins than that at Freiburg, and the only memory of Pseudo-Callisthenes is a distant one, if indeed it is really there at all. Pseudo-Callisthenes follows the story of Alexander's ascent with the story of his immersion in the sea, and many early instances of the Alexander story match his flight into the air with a water image — Jonah and the Whale in the east, a mermaid at Freiburg. There may be a memory of this air/water juxtaposition in the appearance of sea-horses in the one anomalous asymmetric pair of voussoirs at Rochester.

The chapter-house portal is not the sort of composition sculptors are going to develop by themselves. With the exception of the subject, everything about it looks backwards, and even the Alexander legend was known in the West by the mid-10th century, which leads one to suspect that the sculptors were presented with a model, either verbal or visual. What sort of model and why, is now difficult to say. As far as I am aware, no other early medieval or Romanesque portal in Europe combines all the features of the Rochester portal. Although one could point to late-11th- and 12th-century European portals that are archaicising in similarly allusive and formal ways, they are all attached to ancient foundations, whereas a monastic chapter had only been introduced to Rochester as recently as 1080. If the portal had been intended to draw attention to Rochester's status as the second most ancient bishopric in England, one would expect to find it attached to the cathedral church. The monks were parvenus. This only really leaves the possibility of a personal and somewhat exotic interest in the past on the part of a patron.

Sculpture Associated with the East Range Workshop

IF the east range workshop was pushed into reinterpreting the past by an interested patron, its sculptors probably needed little persuasion, for they were clearly adept at breathing new life into established forms. Their touchstone was Anselm's crypt and choir at Canterbury Cathedral, and they skilfully integrated a number of its motifs into the new work at Rochester. The foliage of the abaci of the chapter-house portal capitals and lintel of the day-stair portal is derived from that of the capitals in the Holy Innocents Chapel (Figs 10 and 19), and the type of intersecting blind arcading that

195

survives on the east wall of the chapter-house is a simple adaptation of that used on the exterior of Anselm's choir (Figs 15 and 20).[36] The foliage capitals used in the openings flanking the chapter-house portal are also straightforward beaded versions of the simplified two-register Corinthian capitals used as responds in the Canterbury crypt. The most startling of these borrowings however are the richly moulded profiles given to the cut-backs of the abaci (Figs 21 and 22). Anselm's crypt at Canterbury is the *locus classicus* for moulded abaci in Anglo-Norman England, and the only buildings with which one can compare it for variety or virtuosity are St John's Chapel in the Tower of London, Malmesbury Abbey, and the east range at Rochester. Given this relationship with Anselm's work at Canterbury, one can sympathise with St John Hope for believing that the east range was completed under Ernulf. However, all the above borrowings are integrated with elements that cannot be earlier than the 1140s: the bases, the entrance to the dormitory undercroft passage, the Tournai marble columns. Moreover, the east range workshop is most closely paralleled by the sculptors responsible for the Aula Nova and Vestiarium at Canterbury Cathedral, who similarly saw Anselm's crypt and choir as a sculptural reference point.

The relationship between the sculpture of the Rochester east range and that assumed to have been produced for Wibert at Canterbury is so close that some sculptors probably worked at both sites. Taking the details first, the encircled saltire crosses used on the abaci of the openings flanking the chapter-house portal at Rochester turn up on one face of an abacus in the Vestiarium (Figs 23 and 24). The undulating intersecting circles decorating the entrance to the Rochester dormitory undercroft passage are related to the pierced and interlinked circles used on the fragmentary shaft that survives from the Canterbury dormitory portal.[37] The diagonal lattice pattern found on the Rochester chapter-house west wall is virtually identical to that of the south wall of the north crypt entrance at Canterbury (Figs 25 and 26).[38] Finally, the extraordinary bases, their profiles decorated with bands of zigzag or semicircular ornament, are cousins of those used on the Aula Nova staircase, and indeed of a base excavated from the royal chapel at Faversham Abbey (Figs 27–28 and 12).[39]

The detailed parallels indicate a direct connection, but what is even more impressive is the evidence for a shared approach to sculptural composition. Both sites make extensive use of coloured shafts in exotic materials — witness the dark shafts used at the head of the Aula Nova staircase, or the onyx marble of the stairway itself (Fig. 29). Both frequently work up details from Anselm's crypt or choir, and either give them new settings, as in the distinctive threaded billet used in the blind arches of the west face of the Canterbury Great Gate and on the entrance to the Rochester dormitory undercroft passage (Figs 30 and 31), or face them with new types of geometric ornament, as in the intersecting blind arcading of the Vestiarium and eastern transept towers at Canterbury, or the interior of the chapter-house at Rochester. At Canterbury, in particular, one is conscious of the way in which geometrically rich areas are occasionally countered by simplified forms, the simpler forms being used to showcase the novelties, the juxtaposition of beaded strapwork and fretwork arches with old-fashioned types of cushion and scallop capitals on the west arcades of the Vestiarium being a good example — different in manner to the use of contrast at Rochester, but evidence of a similarly subtle approach to sculptural composition (Fig. 32).

These connections suggest a date in the mid-12th century for the Rochester east range. The dating of Faversham Abbey is precise. It was founded in 1147, and the first burial in the royal chapel dates from 1152.[40] The evidence for dating the Great Gate, Aula Nova and Vestiarium at Canterbury is more circumstantial. All three are generally

FIG. 21. Rochester Cathedral: chapter-house entrance, north-west capital of the north opening

FIG. 22. Canterbury Cathedral: crypt capital

FIG. 24. Canterbury Cathedral: intermediate pier of the ground storey of the Vestiarium, detail of abacus

FIG. 23. Rochester Cathedral: chapter-house entrance, capital on the north side of the north opening

FIG. 25. Rochester Cathedral: detail of the inner face of the chapter-house west wall

FIG. 26. Canterbury Cathedral: detail of the south face of the north entrance passage to crypt

Figures 21–26: John McNeill

FIG. 27 (*left*). Base from Faversham Abbey
Brian Philp

FIG. 28 (*below*). Canterbury Cathedral: Aula Nova staircase, base
John McNeill

attributed to Wibert's term as prior at Canterbury (1152x54–1167) and, although Wibert's obits credit him only with the construction of a new hydraulic system, there is no reason to doubt this wider attribution.[41] The point at which the sculpture of the Rochester east range and Canterbury comes closest is in the ground storey of the Vestiarium. Determining which came first is impossible on purely stylistic grounds — all one can observe is that in the wake of the damage caused by the fire of 1137, Rochester's need was the greater. The seriousness of this fire led a scribe at St Augustine's, Canterbury to add a note of it to the *Vita Gundulfi*, and it was recorded by John of Worcester. Indeed, in a list of grievances drawn up c. 1203, one Rochester monk went so far as to claim that the damage was such that 'the monks had been dispersed among several abbeys, a few only remaining at Rochester'.[42] However, assessing the chronology of rebuilding and repair work from the documentary sources is fraught. The fact that the see was vacant between 1137 and Ascelin's appointment in 1142 was hardly conducive to large-scale rebuilding work, and Ascelin (1142–48) had serious litigation problems with his archdeacon and the monastic community. Something must have been done, however, at least to bring the choir back into use and house the monks. Stylistically, the post-1137 Romanesque sculpture at Rochester looks most likely to have been executed in the order nave, cloister, west front, though there were undoubtedly overlaps between these campaigns. In the nave, it is clear that elements of the core of the pre-1137 cathedral were retained to act as a scaffold for the later Romanesque rebuilding.[43] Did something similar happen to the east cloister range, as argued by Tim Tatton-Brown? Was it temporarily patched up, before the damaged ashlar facing was removed and the range was then refaced — the rubble core, vaulted dormitory undercroft, and upper stages of the chapter-house west wall being retained from Ernulf's range? This cannot be ruled out, but the stylistic case is weakened by the evidence that at both Canterbury and Rochester mid-century styles are used alongside old-fashioned designs in contexts that are wholly mid-century. The capitals of the west

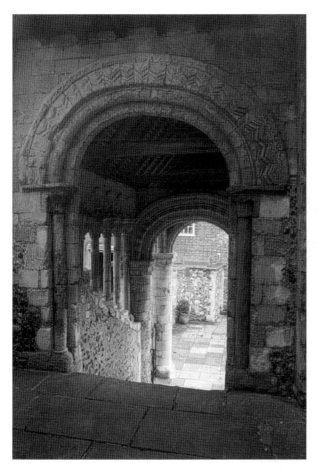

FIG. 29. Canterbury Cathedral:
head of the Aula Nova staircase
John McNeill

face of the Vestiarium are an instance of this, and capitals that are similar to the triple scallops of the inner wall of the Rochester dormitory undercroft are used in the undated, though probably mid-12th century, passage connecting the great cloister and choir at Canterbury (Fig. 33).[44] The old-fashioned capitals cannot on their own carry the case for an Ernulfian core,[45] and if one removes these, the archaeological evidence is at best ambiguous.

As such I tentatively suggest that what survives of the east range dates in all particulars from after 1137. It is possible that the origin of both the Rochester east range workshop and one of the sculptural workshops employed by Wibert at Canterbury are to be found at Faversham, though the state of research into Faversham Abbey is in its infancy. A date of *c.* 1150 is certainly plausible for the start of work on the Rochester east range and, in the absence of more material from Faversham, I am provisionally inclined to see Rochester as the locale where a number of important elements in the mid-12th-century sculptural styles of Canterbury first come together.

Finally, the question of patronage has been left hanging. It has been argued above that the Rochester east range workshop had uses for two distinct manifestations of the past. One is in essence a sculptor's link with the past — a fascination borne by local

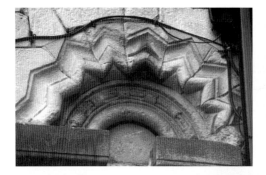

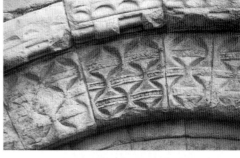

FIG. 30 (*above left*). Canterbury: outer face of
the Great Gate, detail
John McNeill

FIG. 31 (*above*). Rochester Cathedral:
dormitory undercroft passage portal, detail
John McNeill

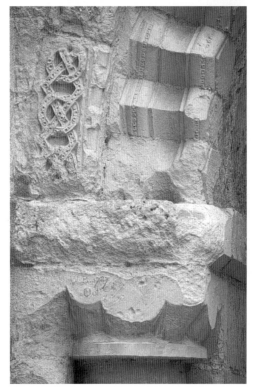

FIG. 32 (*left*). Canterbury Cathedral: west
face of the Vestiarium, detail of the north-west
arch of the ground storey
John McNeill

stone-carvers for the work of their predecessors at Anselm's Canterbury — which led
them into a world of contrasts. The second finds expression in exotic stones and fancy
portals, neither of which feature prominently in the observable hinterland of Kentish
sculpture before *c.* 1150. Would that we were able to locate the source of the onyx
marble used at Rochester and Canterbury. Was it re-used from a local Antique
building? Or taken from a cargo of polished stones conjured out of the Mediterranean
in much the same way that Henry of Blois arranged the shipment of marble statuary
from Rome?[46] Would that we also had a firmer grasp of the early stages of the
architectural use of Tournai and Purbeck marbles. What was the wider situation

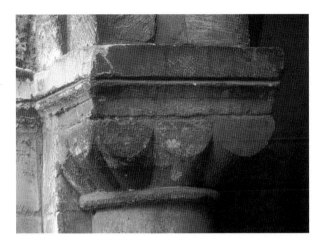

FIG. 33. Canterbury: day passage, capital

John McNeill

originally enjoyed by the fragmentary octagonal Tournai stone shaft discovered at St Augustine's Abbey, Canterbury? Was the solitary Purbeck capital surviving from Faversham once one of many, and how was it deployed? At Rochester, columns of Tournai and onyx marble are used in a context that is notably antique, alongside a portal featuring sunk-and-framed voussoirs, images of classical constellations, and continuous casement mouldings.

Whether this was true of other early Kentish examples of the use of coloured stones it is impossible to say, but a feeling for antique statuary is a quality associated with a pioneer of Tournai stone in another part of southern England, Henry of Blois.[47] And an interest in the antique is certainly a hallmark of Archbishop Theobald's household at Canterbury.[48] The extraordinary choice of an antique intaglio of Mercury as a privy seal by Thomas Becket, while in Theobald's service some time before 1154, is the most striking visual evidence for this, and one suspects its air of showy erudition is representative of the level of interest at Canterbury outside the intellectual circle of John of Salisbury and Master Vacarius.[49] Ultimately, it is this household that provided Rochester with a new bishop when, a few days after the death of Ascelin in January 1148, Walter, archdeacon of Canterbury and brother of Archbishop Theobald, was elected to the post; and it is Walter (1148–82), I would suggest who, like bishops Gundulf and Ernulf before him, provided the monks at Rochester with a new east cloister range.

ACKNOWLEDGEMENTS

Tim Tatton-Brown first suggested I should offer a paper on the east cloister range, and his encouragement, guidance and undiminished enthusiasm were fundamental to this article. I am tremendously grateful. The staff at Rochester Cathedral were also unfailingly generous, and I particularly wish to single out Colin Tolhurst, head verger, who, at times inconvenient to him, was ever prepared to escort me around his flat. Peter Fergusson was enormously helpful, not only reading a draft of this article with a kindly eye, but also sharing his unrivalled knowledge of Wibert's work at Canterbury. Finally, I should like to thank my wife, Anna Eavis, whose constructive comments on the text made for great improvements, and who was happy I should spend far too much time writing it up while we were moving house.

JOHN MCNEILL

NOTES

1. H. M. Colvin ed., *The History of the King's Works*, IV (London 1982), 234–37.
2. T. Tatton-Brown, 'The East Range of the Cloisters', *Friends of Rochester Cathedral: Report for 1988* (1988), 4–8; idem, 'The Chapter House and Dormitory Facade at Rochester Cathedral Priory', *Friends of Rochester Cathedral: Report for 1993–94* (1994), 21.
3. T. Tatton-Brown, 'Cobham Hall: The House and Gardens', *Archaeologia Cantiana*, 122 (2002), 2.
4. Thorpe's engravings were eventually published in J. Thorpe, *Custumale Roffense* (London 1788), as pls xxxiii, xxxvii and xxxviii. Hope's account of his discoveries in the east cloister range can be found in W. H. St John Hope, *The Architectural History of the Cathedral Church and Monastery of St Andrew at Rochester* (London 1900), 170–81. For the more recent work, see T. Tatton-Brown, 'The Chapter House and Dormitory Facade at Rochester Cathedral Priory', *Friends of Rochester Cathedral: Report for 1993–94* (1994), 20–28.
5. St John Hope, *Architectural History*, 178; see also the plan opposite 220.
6. St John Hope, *Architectural History*, 179.
7. Hope assumed this was the warming room, which is possible, though there is no evidence for its function; see St John Hope, *Architectural History*, 179.
8. St John Hope, *Architectural History*, 177. The obvious alternative is a sacristy, which would be unusual in this position, but makes better sense of the imagery. However, this would displace the day-stair to a point south of where Hope was able to excavate, beyond the south-east angle of the cloister walks, and, as the day-stair must also have acted as the night-stair for reasons developed below, Hope's identification is likely to be correct.
9. Tatton-Brown, 'Chapter House and Dormitory Facade', 21. This bridge formed part of new access system linking the east cloister range with the choir, bringing the monks into the south-east transept via the so-called chapter-room portal. The latter has been associated with a reference to the making good of certain defects in the church, dormitory and refectory by Bishop Hamo of Hythe in 1342, and the same date should be assigned to the bridge. 'Anno regni regis Edwardi [III] xvj [1342] Episcopus Refectorium Dormitorum et alios defectus in ecclesia sumptibus suis pro majori parte fecit reparare.' London, British Library, Cotton MSS, Faustina BV, fol. 88; and St John Hope, *Architectural History*, 83. The reroofing of the chapter-house is later, however, as the corbels depicting angels holding shields belong, stylistically, to the second half of the 15th century. Two such corbels, from the north-east angle of the chapter-house, survive in good condition inside the present head verger's flat.
10. J. Thorpe, *Registrum Roffense* (London 1769), 633.
11. BL Cotton MS Vespasian AXXII, fol. 90; Thorpe, *Registrum Roffense*, 122.
12. E. F. Cobb, 'Explorations on the South Side of the Nave', *Friends of Rochester Cathedral: Third Annual Report* (1938), 22–24.
13. P. Sawyer ed., *Textus Roffensis: Rochester Cathedral Library Manuscript A.3.5. Early English Manuscripts in Facsimile* (Copenhagen 1957), fol. 172.
14. St John Hope, *Architectural History*, 138–41, outlines the documentary basis for Gundulf's patronage.
15. T. Tatton-Brown has reached the same conclusion. See the plan of Rochester Castle and Cathedral reproduced in E. Fernie, *The Architecture of Norman England* (Oxford 2000), fig. 60.
16. For Arles, see J. Thirion, 'Saint-Trophime d'Arles', *CA* (1976), 360–479.
17. St John Hope, *Architectural History*, 170–71, 180.
18. D. Kahn, 'Romanesque Architectural Sculpture in Kent' (unpublished Ph.D. thesis, University of London, 1982), 58; M. Thurlby, 'Transitional Sculpture in England' (unpublished Ph.D. thesis, University of East Anglia, 1976), 51.
19. Tatton-Brown, 'The East Range of the Cloisters', 6–8; idem, 'The Chapter House and Dormitory Facade', 20–21.
20. The onyx marble column at the south end of the dormitory undercroft façade was polished and reset under Martin Caroe, surveyor to the fabric, in 1987.
21. This was first published by St John Hope, who illustrates one octagonal and one cylindrical column; see St John Hope, *Architectural History*, 173. Subsequently, the cylindrical column has been boxed in, so, for the moment, it is not possible to ascertain whether the interior of the chapter-house alternated cylindrical columns of onyx marble with octagonal columns of Caen stone, as on the west wall of the dormitory undercroft.
22. The inner faces of the north and south walls of the chapter-house have been stripped of their facing stone, though the pitting of the wall surface caused by the removal of the deeper stones used for the capitals and arch springers makes it clear the lateral walls supported intersecting blind arcading.
23. See further the articles by Ron Baxter and Richard Halsey in this volume.
24. For 'RAS', Joseph Spooner has also suggested 'RA(PTU)S' (as in 'aries per cornua raptus'), or '(PAT)RAS' ('you are accomplishing', a word spoken by God?); personal communication.

25. See the 'Index of Subjects, Figures, &c.', in C. E. Keyser, *A List of Norman Tympana and Lintels* (London 1904), 61–65.

26. See n. 9 above. The chapter-room portal is illustrated in St John Hope, *Architectural History*, 84, fig. 33.

27. The Rochester Cathedral west portal lintel and Dover Priory fragment are discussed in D. Kahn, 'The West Doorway of Rochester Cathedral', in *Romanesque and Gothic: Essays for George Zarnecki*, ed. N. Stratford (Woodbridge 1987), 133, pls 19–20.

28. Deborah Kahn was similarly struck, noting 'this rare design is likely to have derived from an Antique model, though this would be difficult to prove'; see D. Kahn, 'Romanesque Architectural Sculpture in Kent', 67. Mouldings running continuously from the jamb around the underside of the lintel were occasionally used in Romanesque buildings, as in the late-11th-century west nave aisle portals of Le Mans Cathedral (Sarthe), or in medieval buildings that consciously set out to emulate antique models, as with the western entrances to St Mark's, Venice, but they are far more abundant in Roman and late antique architecture.

29. Thorpe, *Custumale Roffense*, pls xxxvii and xxxviii, opposite 161. Thorpe also illustrates the day-stair portal as pl. xxxiii, 151.

30. Kahn, 'Romanesque Architectural Sculpture in Kent', 65 and pl. 44b.

31. In northern Italy, sunk and framed voussoirs were used occasionally in buildings datable to the end of the 11th century, becoming commonplace during the second quarter of the 12th century, particularly in work associated with Master Niccolo; see G. H. Crichton, *Romanesque Sculpture in Italy* (London 1954), pls 15, 16 and 22 for illustrations. The best parallel for Rochester is to be found in the voussoirs from three 11th-century portals discovered during the 1991 excavations at Bitonto Cathedral (Apulia). All of these are sunk and framed, and because the voussoirs are tapered, it has been possible to reconstruct two arches, making it clear the voussoirs were arranged as symmetrical pairs (Fig. 18). The Bitonto sculpture has yet to be satisfactorily published, but for a summary account, see F. Moretti, 'Messaggi e simboli del bestiario medievale', in *Bitonto e La Puglia tra Tardoantico e Regno Normanno*, ed. C. S. Fioriello (Bari 1999), 225–46. Significant non-Italian Romanesque sites that employ portals with sunk and framed voussoirs include Montivilliers (Normandy), Sant Pere de Galligants at Girona (Catalonia), Saint-Aubin at Angers (Anjou), Saint-Père at Chartres (Eure-et-Loire), and Tournai Cathedral (Hainault).

32. The Musée Dobrée in Nantes (Loire Atlantique) holds a number of Merovingian terracotta voussoirs from Saint-Similien at Nantes and Saint-Martin-de-Vertou (Loire-Atlantique), most recently and convincingly discussed in S. Millet, 'Les premières implantations chrétiennes à Nantes et dans sa proche région des origines au Xème siècle' (unpublished mémoire de maîtrise, Université de Nantes, 1999), 88–99, who dates them to the first quarter of the 7th century.

33. For an enthralling discussion of paired capitals, see N. Stratford, 'Romanesque sculpture in Burgundy. Reflections on its geography, on patronage, on the status of sculpture and on the working methods of sculptors', in *Artistes, Artisans et Production Artistique au Moyen Age*, ed. X. Barral i Altet, III (Paris 1990), 240–42 and 251–52. With the exception of the Auvergne, the use of paired capitals seems to have gone into marked decline on the Continent during the first quarter of the 12th century.

34. J. Romilly Allen first recognised the Charney Bassett tympanum as an Ascent of Alexander; see J. Romilly Allen, *Early Christian Symbolism in Great Britain and Ireland before the Thirteenth Century* (London 1887). See Keyser, *A List of Norman Tympana and Lintels*, fig. 71 for an illustration. For the later medieval examples, see C. Grossinger, *The World Turned Upside Down* (Manchester 1997), 150–51. The best discussion of the early iconographical development of the Alexander legend remains C. S. Frugoni, 'An Ascent of Alexander', *Journal of the Warburg and Courtauld Institutes*, 33 (1970), 305–07.

35. Frugoni, 'An Ascent of Alexander', 306–07.

36. Intersecting blind arcading using sub-arches was almost certainly first used at Canterbury, either on the north-west tower of St Augustine's Abbey, or on the exterior dado arcade of Anselm's Glorious Choir. Thereafter, it became the type of intersecting arcading preferred in south-eastern England and, probably following its use in the chapter-house at Worcester Cathedral, in the west. In East Anglia and the north, most intersecting arcading does not use sub-arches. The majority of arches in the exterior dado arcade at Canterbury Cathedral are modern, though clearly accurate, restorations. Except for the south-east transept, where fancy columns are used, the columns are alternately cylindrical and octagonal, as at Rochester. The main difference between the Rochester east range and the Canterbury choir is the detailing of the arcade: at Rochester the sub-arch is embellished with chevron, the lower section of the intersecting arches uses a conventional billet rather than threaded billet, and the outer section of the intersecting arches is moulded.

37. For an illustration of the Canterbury dormitory portal shaft, see D. Kahn, *Canterbury Cathedral and its Romanesque Sculpture* (London 1991), ill. 208. The Rochester dormitory undercroft passage portal is illustrated in Fig. 24 above.

38. A characteristically subtle aspect of the Rochester design is that the over-and-under patterns formed by the intersections of the sunk mouldings alternate from junction to junction. At Canterbury, the intersections are

unvaried. For a convincing attribution of the Canterbury Cathedral crypt entrances to Wibert's priorate, see D. Kahn, *Canterbury Cathedral and its Romanesque Sculpture*, 114–17.

39. The Faversham base was published as Fig. 12 No. 12 in B. J. Philp, *Excavations at Faversham, 1965* (Crawley 1968). Mr Philp assures me that all the material originating from the Faversham excavations was delivered to the appropriate authorities in Faversham in two batches following assessment and publication. However, despite the best efforts of Clive Foreman, to whom I extend grateful thanks, neither he nor I have been able to locate the base in the stone store of the Fleur-de-Lis Heritage Centre at Faversham. For the moment, therefore Brian Philp's drawing remains the only record. The rarity of this type of enriched base was touched on by Stuart Rigold, who wrote 'Carving, other than mouldings, can almost be ignored as a factor in English bases in [which] context the ascription to Ernulf (1114–24) of the exceptionally delicate ornament, with scalloped hoods and pearls, in the east claustral range of Rochester becomes acceptable'; S. E. Rigold, 'Romanesque Bases, in and south-east of the Limestone Belt', in *Ancient Monuments and their Interpretation: Essays Presented to A. J. Taylor*, ed. M. R. Apted, R. Gilyard-Beer and A. D. Saunders (Chichester 1977), 126. However, Rigold's extraordinary refusal to examine bases from any perspective other than that of their sectional profile significantly diminishes the usefulness of his article.

40. Philp, *Excavations at Faversham*, 5.

41. The financial and estate management problems that make building work within the conventual precincts unlikely during the 1140s, and which preceded Theobald's deposition of Prior Walter in 1152 are discussed in A. Saltman, *Theobald, Archbishop of Canterbury* (London 1956), 56–64. Wibert's association with the building of the Great Gate and Aula Nova can be adduced from his repossession of the necessary land at the north-western edge of the medieval precincts, and though he may have begun planning the expansion of the monastery during his term as subprior (1148–1152x54 — one document does refer to Wibert, subprior, buying land 'ad opus ecclesiae nostrae') it seems unlikely actual work began before Theobald appointed him prior in 1152x54; see Kahn, *Canterbury Cathedral and its Romanesque Sculpture*, 98, and W. Urry, *Canterbury under the Angevin Kings* (London 1967), 206 and 221–25.

42. C. Flight, *The Bishop and Monks of Rochester 1076–1214* (Maidstone 1997), 204.

43. See the article by Richard Halsey in this volume, 65.

44. F. Woodman, *The Architectural History of Canterbury Cathedral* (London 1981), 77–78.

45. The most striking example of the use of old-fashioned capital forms alongside elaborate mid-12th-century sculpture is the west front of Castle Acre Priory, where the capitals of the main portal are simple cushions. The clerestory of Peterborough Cathedral similarly uses cushions in combination with beaded and reed scallop capitals. The juxtaposition of smooth surfaces at capital level with deeply cut and varied arch orders is a phenomenon in English mid-12th-century sculpture that would repay further investigation.

46. Henry of Blois' acquisition of ancient statues in Rome is recorded by John of Salisbury, 'Cum vero episcopus preter absolutionem se nihil optinere posse videret, accepta licentia rediens veteres statuas emit Rome, quas Wintoniam deferri fecit'; M. Chibnall ed., *The Historia Pontificalis of John of Salisbury* (Oxford 1986), 79.

47. G. Zarnecki, 'Henry of Blois as a Patron of Sculpture', in *Art and Patronage in the English Romanesque*, ed. S. Macready and F. H. Thompson (London 1986), 160, and Y. Kusaba, 'Henry of Blois, Winchester and the 12th-Century Renaissance', in *Winchester Cathedral Nine Hundred Years*, ed. J. Crook (Chichester 1993), 69–79.

48. See M. R. James, *The Ancient Libraries of Canterbury and Dover* (Cambridge 1903), 3–12, for an insight into the range and very great number of classical texts in Canterbury Cathedral Priory library by the late 12th century, and N. Ramsay, 'The Cathedral Archives and Library', in *A History of Canterbury Cathedral*, ed. P. Collinson, N. Ramsay and M. Sparks (Oxford 1995), 350–51, for an illuminating discussion.

49. U. Nilgen, 'Intellectuality and Splendour: Thomas Becket as a Patron of the Arts', in *Art and Patronage in the English Romanesque*, ed. S. Macready and F. H. Thompson (London 1986), 146–47.

Who Were the Monks of Rochester?

JOAN GREATREX

Although there is comparatively little surviving evidence about the lives of the successive generations of men who formed the monastic community at Rochester, we can, nevertheless, piece together some interesting and significant information concerning individual monks between 1083 and 1540. The fact that they were largely responsible for the design, construction, and periodic alteration and embellishment of their church and conventual buildings is surely a strong recommendation that we should endeavour to make their acquaintance.

The question of the identity of the Rochester monks can be approached in several ways. Two of these I will pursue in this paper: first, by drawing attention to their surnames which were, for the most part, toponymic and therefore likely indicators of the location of their family origins; secondly, by focusing on some of those monks whose characters, careers, interests and other activities were noted by their contemporaries, and were recorded for posterity in chronicles, registers and official documents. The Rochester Benedictines were by and large unremarkable men, just as monastic life was, and is generally, unremarkable; but the cathedral church and monastic precinct still bear the visible imprint of their presence which, through paucity of evidence, we may at times be tempted to overlook or underestimate.

INTRODUCTION

THE diocese of Rochester occupies the western third of Kent, a county unique in its possession of two cathedrals, both of which were monastic throughout the Middle Ages.[1] The cathedrals of Canterbury and Rochester were Anglo-Saxon foundations, but only Canterbury was home to monks before the Norman Conquest. Appointed to the see of Rochester in 1077 by Archbishop Lanfranc, his former superior at the abbeys of Bec (Eure) and Caen (Caen), Gundulf installed twenty-two monks in 1083 to form his cathedral chapter. By the time of his death some twenty-five years later, the monastic community had almost trebled in size.[2] Unfortunately, there are no completely reliable figures for later years, because the numbers given in extant priory records refer only to the monks who were present at a particular election or visitation, or were provided with items of clothing at a particular date. On all such occasions there were absentees about whom no more than a passing mention was usually made; for example, there were always a few, probably never more than three or four, residing at the small cell or dependency at Walton St Felix (Felixstowe), in far away Suffolk, near the coast and just beyond the Essex border.[3] All but the first two dates for which numbers are supplied in the Appendix are subject to these qualifications; they are therefore lower than the actual number, and the apparent decline in numbers in the 16th century can be partially offset by the admission of twenty-eight within a period of seventeen years.[4]

The two lists of priors in the Appendix reveal further uncertainties and discrepancies with regard to the precise dating of the years in office of some of the monks who ruled

the cathedral monastery and its cell. However, more information continues to come to light in the wake of ongoing research, and I have here summarised information derived from my most recent work and two latest volumes of *Heads of Religious Houses*, in which the editors have now reached the year 1377.[5]

For comparative purposes we should note that of the eight Benedictine cathedral monasteries of medieval England, Rochester, Bath and Coventry were the smallest in terms of the size of their monastic chapters. In the two centuries between the Black Death and the Dissolution, the population of all three hovered between twenty and twenty-five, approximately a third of the number in the community at Christ Church Canterbury.[6] However, the daily office chanted by these three monastic communities resounded in cathedral churches that differed significantly in their proportions: the overall length of Rochester Cathedral was only 324 ft, over 60 ft less than that of Bath, and about 100 ft less than that of Coventry.[7]

It is important to bear in mind that studies of the monastic personnel at Rochester, like those of the priors, have been severely hampered by the loss of a large proportion of the medieval records that once existed; only fragmentary remains of the priory registers survive, and only eight of the annual accounts of the monastic officials or obedientiaries. At Norwich, by contrast, well over a thousand account rolls have been preserved, and about nine priory registers. Nevertheless, to date, the names of 480 monks of Rochester have been identified, in contrast to only 360 for Bath and 315 for Coventry.[8]

MONKS IDENTIFIED BY TOPONYM

BEFORE attempting to interpret the map in Figure 1, we must be aware of the problems that beset medieval monastic nomenclature. Although it was usual for monks to be distinguished by the name of their native village or town (toponym) rather than by their family name (patronym), this seemingly useful means of locating their family origins is neither simple nor straightforward; it is fraught with complications and requires qualification. The 480 monks of Rochester identified to date can be divided into five broad categories. The first of these consists of approximately 210 monks who can be identified by means of their toponyms; most of the locations from which these toponyms derive are included among the 100 or so place-names marked on the map. This may appear a disappointingly small fraction of the total $(\frac{7}{16})$, until the other categories are defined, namely the 130 monks known only by their Christian names or initials; the 40 with toponyms deriving from as yet unidentified place-names; a further 70 with what are either family names or unknown place names; and about 30 whose toponyms suggest more distant family origins, ranging from Buckinghamshire to Cornwall, and from Oxford and York to Ireland. Thirty-five or so monks, known by both toponym and patronym, are scattered through all the groups; these will also require a brief comment. The significance of the 210 monks whose places of origin have been located and plotted on the map now becomes clear, for it is by means of an analysis of this group that a partial answer to the question posed in the title can be broached.

The distribution of place-names on the map suggests that the monks were by and large local men from both sides of the diocesan boundary, within an approximate range of twenty miles from Rochester. Not surprisingly, there was a degree of overlap in the catchment areas of the two cathedral monasteries of Kent. Maidstone, for example, well within the twenty-mile radius but in Canterbury diocese, was the probable home

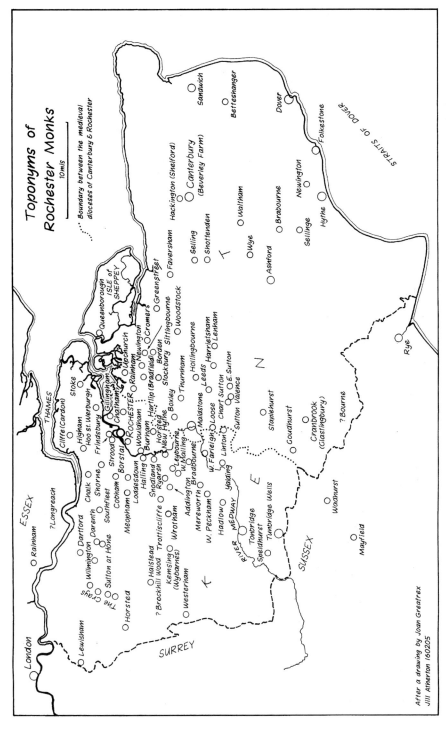

FIG. I. Locations referred to in the text

town of nine Rochester monks and also of nine Canterbury monks. Again, six monks named Malling (Rochester diocese) are found at Christ Church, but only three at Rochester; four monks with the name Faversham (Canterbury diocese) were at Canterbury, and three at Rochester; there were four monks at Canterbury from the Isle of Sheppey (Canterbury diocese), yet seven at Rochester.[9] It does seem surprising that nine Rochester monks used the toponym Canterbury, while only two Canterbury monks took the name Rochester (both in the 13th century). Both Canterbury and Rochester attracted recruits from London, thirteen in each case; and two of the Rochester Londons used two toponyms, introducing a mobility factor that must be taken into account. Ralph London, alias Clyff, and Thomas London II, alias Lincoln (both mid-15th century) may provide examples of families who moved from one location to another, but when and in which direction cannot be determined. We may postulate that Ralph London's family moved from London to Cliffe, about three miles due north of Rochester across the Medway, or a move on the part of Thomas London's family from London to Lincoln, or even vice versa, but no more than that. Other Rochester monks' names may also have resulted from a family migration; Thomas de Wouldham, for example, prior and bishop in the late 13th century, was also known as Southflete. These two villages are close to each other and to Rochester, and Thomas's retention of both toponyms may imply continuing family connections in both places.[10]

Supervision of the priory's properties would have required the periodic presence of Rochester monks and priory officials on rounds of their estates, and it is often thought that these visits may have played a role in influencing young boys in these neighbourhoods to seek admission to the cathedral priory. Within the vicinity of Rochester these possessions included the manors of Frindsbury, Darenth, Southfleet, Wouldham and Stoke, and the churches of Darenth, Hartlip and Hoo; further afield, the manor and church of Haddenham in Buckinghamshire also pertained to the monks. Together, these places account for some thirty of the monks so far identified by toponym. Over a period of three and a half centuries, these findings are not remarkable, but they are similar to what has been noted in recent studies of the monastic personnel at Worcester and Ely cathedral priories.[11] Haddenham, in the Vale of Aylesbury and a priory possession by 1100, had probably been the early home of four Rochester monks, including the reputed author of the *Annales Ecclesiae Roffensis*.[12]

I have already suggested that some of the other distant places whose names appear as monastic toponyms may perhaps be explained through family relocation; however, there is another possible explanation, geographically closer at hand, for which I can offer two examples. The toponym Glastonbury (variously spelled), which applied to one monk of Rochester, and incidentally to three monks of Christ Church, may have derived from a manor of that name within the parish of Cranbrook (in Canterbury diocese, but closer to Rochester Priory). Also, the Rochester monk John de Beverlee may have come from the manor and family of that name, which survives as the name for a farm in the parish of St Dunstan outside the Walls, now suburban Canterbury.[13]

MONKS IDENTIFIED BY FAMILY CONNECTIONS

FORTUNATELY, we are not limited to seeking the monks' family origins by means of these somewhat speculative efforts to pinpoint them on the map. In a few instances we have scraps of information about their relatives. Many of the early generations of monks and their relatives were remembered as benefactors: Elviva of Winchester, for

example, sister of the monk Nicholas II, gave vestments to the community, but Nicholas is known only by his baptismal name, and his toponym was not likely to have been the same as hers.[14] Richard de Claudevilla or Clovilla (late 11th/early 12th century) came from Oakleigh near Higham, where his father William was a tenant of Godfrey Talbot.[15] Prior Alexander de Glanville (1242–52) was probably a descendant of the Norman family of Ranulf the justiciar (d. 1190) and related to the Rochester bishop, Gilbert de Glanville (d. 1214), though a previous connection with Rochester is uncertain.[16] John de Faversham I (fl. 1330) had a brother whose name was Thomas de le Hore of Wrotham; de le Hore may have been the patronym that John left behind when he entered the cathedral priory, though the connection between Wrotham and Faversham is a matter of conjecture.[17] We are on more solid ground with Hamo de Hethe, monk, prior and bishop during the first half of the 14th century. His childhood was spent in Hythe (Kent), one of the Cinque Ports, where he lived with his parents, Gilbert and Alice Noble, who were parishioners of St Leonard's church there. His brother John held land in Freckenham, one of the episcopal manors, and it is possible that Peter de Hethe, a younger contemporary in the monastic community, was also a relative; he occurs as Bishop Hamo's chaplain in 1330.[18] The inclusion of a Raymond Pelegrin (or Pelegrini) as monk between 1358 and 1361 is puzzling since there were two contemporaries, one older and one younger, of that name, both secular clergy active in several dioceses, but not in Rochester.[19] These and other examples furnish us with evidence, admittedly meagre, but they are probably typical of the majority of the Rochester monks of whose family backgrounds no information has survived.[20]

MONKS ASSOCIATED WITH CONSTRUCTION IN THE CLOISTER

THE Rochester monks' collective memory kept alive the architectural achievements of those of their brethren who had zealously maintained and restored the outward and visible structures, ensuring that these never ceased to provide an appropriate setting for the inner and unseen spiritual formation of the individual and the community. The names of about twenty monks are associated with building programmes and various projects to maintain, renovate and embellish both church and cloister. Although some modernisation was carried out in the 15th century, all the monks whose personal initiatives and exploits have been preserved occur during the 250 years after Gundulf. Unfortunately, the two centuries prior to the Dissolution are short on documents that record the involvement of individual monks in the priory's building history.

I am not concerned here to enter the debate on the many remaining uncertainties, nor to attempt to reconcile contradictions in the interpretation of architectural or archaeological evidence.[21] Using documentary sources, which are themselves problematic, because often ambiguous and unverifiable, I will simply draw attention to some of the notable achievements attributed to monks and monk bishops. The earliest of these in the cloister is Ernulf, monk and prior of Christ Church before his appointment as bishop of Rochester in 1114. He was remembered as responsible for the construction of the dormitory, chapter-house and refectory, which had presumably not been completed by the time of Gundulf's death.[22] A contemporary of Bishop Ernulf was Hugh de Trottiscliffe, who was reputedly in charge of the construction of the infirmary chapel some time before 1126, when he left to become abbot of St Augustine's Canterbury.[23] Further work was carried out by Prior Silvester, who may have served in the office of cellarer before being raised to the priorate c. 1177x80; the *Registrum Roffense* states

that he installed three windows in the east wall of the chapter-house at Rochester and saw to the construction of the dormitory, refectory and *hostilerium* (guest quarters) at the cell at Walton St Felix.[24] In the 1180s, Prior Alfred added a window to the dormitory 'ultra lectum prioris', and Osbern de Shepey, sacrist and briefly prior, provided a *camera* for the prior next to the infirmary and a window over the altar of St Peter.[25] About twenty years later, Heymeric de Tunebrigge (Tonbridge), *tempore* Prior Ralph de Ros, supervised the construction of a cloister walk between the dormitory and the infirmary, according to St John Hope's interpretation of the entry in the *Registrum*.[26] Ralph de Ros had two *camerae* constructed for his own personal use as prior, a hostelry for guests of the monastery, and a brewery to supply the community.[27] The work of his successor, Elias, can still be seen in what remains of the refectory door and the *lavatorium* in the south walk of the cloister.[28] At an unknown date, probably around the same time, Luke, the monk cellarer, undertook the construction of the main gate (*porta*) of the monastery at the south-west corner of the cathedral church.[29] In the first half of the 14th century, John de Shepey's long priorate (1333–52) provided the opportunity for him to supervise repairs to several of the domestic buildings in the cloister, including the infirmary and dormitory, and to set in motion the reconstruction of the refectory and guest hall.[30]

MONKS ASSOCIATED WITH THE BUILDING OF THE CATHEDRAL CHURCH

IT is highly probable, if not certain, that construction of the cathedral nave was under way in Bishop Ernulf's day and continued during the episcopate of some of his immediate successors who were not monks.[31] In the late 12th and early 13th centuries, priors Ralph and Elias were involved in the roofing of the church in lead, while Heymeric, in the same period, was responsible for the insertion of windows over the crypt altars of the Trinity and of St Michael.[32] As sacrist, Elias had entered regular contributions of twenty shillings on his annual account 'ad novum opus' in presbytery and quire.[33] The next documentary record states that Richard de Eastgate, sacrist (?1227x40), continued the 'new work' with the construction of the north *ala* towards St William's gate, which Thomas de Mepeham, also sacrist, brought to near completion.[34] St John Hope, quoting Robert Willis, translated *ala* ('wing') as the north-west transept; more recently McAleer has referred to it as the north aisle.[35] To William de Hoo, a third sacrist and contemporary, is attributed construction of the 'whole choir' ('totum chorum'), made possible through the offerings collected at St William's shrine; it was completed by 1227 before he became prior.[36] Some forty or fifty years later, in the 1280s, or more probably the 1290s, Richard de Walden, sacrist, is recorded as being in charge of the construction of the south-west transept (*ala*).[37] If the sources are reliable, this monk was a skilled worker in wood, for 'with his own hands he made the beam over the high altar carved with the apostles and with St Andrew standing above'.[38] Prior Hamo de Hethe was elected bishop by the monks in 1317 and held office for over thirty years. During this time, he raised the height of the new central bell-tower of the cathedral church, leaded its roof, and installed four new bells. The marble and alabaster work in the shrines of the two 7th-century bishops Sts Paulinus and Ithamar has also been attributed to him; some redecoration in the choir was probably also his work.[39] The names of a few of the monks have been recorded in commemoration of their personal contributions to the adornment of the interior of the church and to its furnishings. Two of these were Walter de Cornubia and Roger de Saunford, whose

devotion to St Edward the Confessor prompted them, in the late 13th century, to embellish the altar dedicated to him and place there an image of the saint.[40] Some, like Geoffrey de Tonbridge and Robert de Hoo, made or donated vestments; others, like Osbern de Shepey, copied or procured books.[41]

MONKS ASSOCIATED WITH STUDY IN THE CLOISTER AND UNIVERSITY

WITHOUT books there can be no learning, and cathedral monasteries like Rochester were centres of learning, for young boys, as well as for novices and studious monks. Attached to the monastic almonry there was customarily a school, which is known to have been functioning at Rochester in the late 13th century and probably much earlier.[42] Even at the larger and more fully documented Christ Church cathedral priory, little is known about the almonry school, and the same is true for Rochester; not more than six names of boys who became monks are recorded at Canterbury, and a mere three at Rochester.[43] One of the latter was John de Bradefeld, who was precentor at Rochester in the 1270s; his musical talent had no doubt been spotted while he was attending the almonry school some years before. His humble and amiable manner had so endeared him to his masters, superiors and brethren that in 1278 they were divinely inspired, so they thought, to choose him as their bishop. However, they soon rued the day for, as the chronicle records, 'he became another man' ('sed mutatus in virum alium').[44] We learn from a letter sent to Pope Clement VI in 1345 that John de Shepey, who was at that time prior, had also received his early education in the cathedral almonry school, where he had shown such promise that after his profession he had been sent to Oxford. His election to the episcopal throne in 1352 proved, unlike the earlier choice, to have been an exercise in good judgement on the part of the monastic chapter.[45] The third almonry scholar, Robert de Gelham, has been identified only by inference. He was in priest's orders by 1295 and would therefore have been in the school some ten or more years earlier, when he wrote his name and personal commendation in the margin of a 12th-century volume containing Isidore of Seville's commentary on the Octateuch and Jerome's commentary on two of the letters of St Paul. The 'Robertus de Gelham est bonus puer' on folio 84 may have been a pen trial arising out of a Latin class, but the volume in question is unlikely to have been in use as a text in the almonry school.[46] Young Robert seems to have continued his studies within the cloister, since his name has been inserted in two volumes, both of which are now in the Royal Collection in the British Library. One is a copy of Nicholas de Gorran's *Commentary on the Psalms*, a recent work, written by this French Dominican who was still alive at the time of Robert's profession. The second volume is the *De fide ad Gratianum imperatorem* of Ambrose of Milan, which was in the Rochester cloister by 1122/23, according to the earliest catalogue of the library.[47]

Two of Robert de Gelham's contemporaries were sent to Oxford: John de Shepey (the first prior by this name) and John de Whytefeld, who were students in the theology faculty in the 1320s and 1330s. Shepey was probably regent master at Gloucester Hall in 1333 following his inception.[48] Whytefeld, who may have also obtained his doctorate, made the monastic headlines three years later by his provocative preaching at the visitation of the priory by Bishop Hamo: the latter, robed and seated on his episcopal throne, was told that he owed his position to the assembled chapter who had elected him, and that therefore he, a monk, was visiting his fellow monks *ut fratres* not *ut subditi*. It was later said in Whytefeld's defence that some of his brethren were responsible, because they had plied him overabundantly with wine beforehand.[49]

Higher learning in a university setting is not conspicuous at Rochester; only nine monks in addition to Shepey and Whytefeld have been identified as Oxford students, of whom four are known to have obtained degrees. One of them is Thomas Wybarn, B.Th. by 1467, who, fortunately for us, had a penchant for inscribing monastery books not only with his name but also with an aphorism: 'Qui servare libris preciosis nescit honorem, illius a manibus sit procul iste liber.' This admonition reveals him to be a bibliophile, since it has been found along with his name in some fifteen extant manuscripts. Was he also a long-time student in the cloister as well as at Oxford?[50] At least two of the volumes accompanied him to the university, because there is a note in one to the effect that it was placed in the Chicheley loan chest in 1467, and the other was sent to a binder in Cat Street the same year.[51] As a collection his volumes reflect a fairly broad range of interests. The titles include three patristic authors: four volumes of Augustine, two of which had been copied by monks in the Rochester scriptorium during the 12th century, Jerome's letters and Gregory the Great's *Moralia* on Job.[52] Other more recent scriptural expositions and commentaries were also represented: Gilbert Foliot on the Song of Songs and Nicholas of Lyra on the Old Testament.[53] Sermon preparation was probably envisaged by the presence of *Flores psalterii*, a composite volume that also contained short expositions and notes on some eighty selected passages from the Gospels.[54] Augustine's treatises *De trinitate* and *De doctrina christiana* were in the theological section, along with essential commentaries on Peter Lombard's *Sentenciae*; Wybarn had two such commentaries by the Franciscan authors Bonaventure and Alexander de Hales.[55] History was not neglected: Roman authors such as Solinus and Lucan, the *Historia Britonum* attributed to Nennius, and the universally popular *Historia scholastica* of Peter Comestor, a biblical history from the Creation to the Ascension.[56] Finally, there were grammatical works by Bede and Alcuin, and the *Policraticus* of John of Salisbury, a treatise on political morality.[57]

The library volumes were consulted by successive generations of monks, some of whom, like Wybarn, have fortunately left us their names on the flyleaves. Thomas de Horsted, for example, who was precentor around the middle of the 14th century, was Wybarn's predecessor in making use of two volumes; one of these was Gregory's *Moralia* for which he compiled a lengthy *tabula* or index bound into the volume to assist future readers like Wybarn.[58] Horsted also made several acquisitions for the library including the highly desirable *Concordancia biblie*, a unique work of reference newly completed by the Dominicans at Saint-Jacques in Paris, and John de Bromyard's up-to-date *Summa praedicantium*, a collection of homiletic material.[59] The *Flores psalterii* in Wybarn's collection had previously been in the hands of Territius, a 13th-century infirmarer.[60] Only two printed books have survived, but their presence suggests that John Noble, precentor in 1510, was very conscientious, in the first case by replacing manuscript volumes, as is evidenced by an Augustine work, and in the second case by purchasing new books, such as a work by Ludolph the Carthusian printed in Paris in 1506, which had had a very limited circulation in manuscript form.[61]

We know next to nothing about Rochester monks as authors. The name of Ernulf, prior around 1100, is attached to a volume of verse, *De conflictu vitiorum et virtutum*, which is listed in the 1202 catalogue but has not survived.[62] Ralph, another early prior who probably succeeded Ernulf, is the author of several extant theological treatises.[63] The chronicle attributed to Edmund de Hadenham may in fact be the work of the contemporary prior, John de Reynham.[64] Some of Bishop John de Sheppey's sermons have been preserved, and also a poem about St Ursula reputed to have been composed by Edmund Hatfeld at the request of Henry VII's mother, Margaret Beaufort.[65]

UNRULY MONKS

LASTLY, there were a few unsettled and disobedient monks. Prior William de Hoo, for example, after three turbulent years in office resigned and transferred to another house and order, in his case the Cistercian abbey at Woburn, Bedfordshire.[66] John Cray spent at least fifteen years (1387–1402 or later) moving from one house to another; he tried the Carthusians in both London and Coventry, the Cluniacs in Bermondsey, and the Franciscans in Cambridge; he also made an unauthorised journey to Rome. The latter incident furnishes us with a contrasting picture of two strikingly different characters: the forbearance of the second Prior Shepey in his role as father of the community dealing with a prodigal son whose repentance does not appear to have been as whole-hearted as in the parable.[67]

CONCLUSION

WE may reasonably conclude that the cathedral priory, which had 'put down deep roots in local society' in its early years, continued to draw its recruits mainly from the region until the Dissolution.[68] It seems clear also that the monks were assiduous in maintaining and improving their church and cloister buildings, and that they, or at least a significant number of them, cared for and made use of their library. We may affirm that, by means of their names, their buildings, their books and their misdemeanours, the monks of Rochester may be known or, at least, glimpsed.

APPENDIX

ROCHESTER CATHEDRAL PRIORY

Numbers of Monks

Date	Number
1108	60 (at the death of Gundulf)
1210	60 (acc. to J. C. Russell)
1317	35 (present at an election)
1385/6	24 (provided with clothing)
1415/6	25 (provided with clothing)
1496	19 (cited to visitation)
1532	23 (present at election)
1534	20 (Act of Supremacy)
1540	13 (awarded pensions)

Note further:

1511: 6 admitted
1514: 7 professed

1522: 7 professed
1527: 8 professed

Priors of Rochester

Ernulf, occ[urs] before 1107
Ralph, occ. before 1107
Ordwinus, 1107x08–25
Thomas, [c. 1128x37]
Brien, c. 1145–?48

Reginald, occ. 1155, 1160
William de Borstall, [c. 1160x80]
Silvester, c. 1180
Richard, 1181–82
Alfred, c. 1182–86

Osbern de Shepey, occ. 1189–90
Ralph de Ros, c. 1193–1203x08
Elias, c. 1214–17
William, c. 1218–22
Richard de Darente, c. 1225–38
William de Hoo, 1239–42
Alexander de Glanville, 1242–52
Simon de Clyve, 1252–62
John de Reynham, 1262–83
Thomas de Wouldham, 1283–91
John de Reynham (again), 1292–94
Thomas de Shelford, 1294–1301
John de Greenstrete, 1301–14
Hamo de Hethe, 1314–17
John de Westerham, 1320–21

John de Speldhurst, 1321–33
John de Shepey I, 1333–c. 1350
Robert de Southflete, c. 1351–61
John de Hartlepe, 1361–80
John de Shepey II, 1380–1419
William Tonebregg, 1419–45
John Clyve, 1445–60
Richard Pecham, 1460–?68
William Wode, ?1468x75
Thomas Bourne, c. 1480–94
William Bisshope, 1494–1509
William Fresell, 1509–32 (from St Albans)
Laurence Mereworth, 1532–38
Walter Boxley, 1538–40

*Monk Bishops of Rochester (*monks of Rochester)*

Gundulf, 1077–1108
Ralph d'Escures, 1108–14
Ernulf, prior of Canterbury, 1114–24
Ascelin, prior of Dover, 1142–48
*John de Bradfield, 1278–83
*Thomas de Wouldham, 1291–1317
*Hamo de Hethe, 1319–52
*John de Shepey I, 1352–60
[John de Hartlepe, 1372]

Thomas Brinton, monk of Norwich, 1373–89
[Thomas Chillenden, monk of Canterbury, 1404]
[Thomas Spofford, abbot of St Mary's York, 1421]
John Langdon, monk of Canterbury, 1421–34
William Wells, abbot of St Mary's York, 1436–44

Priors/Custodes of Walton St Felix/Felixstowe

Aufredus, occ. 1174x81
Fulk, ?c. 1180
Robert de Walton, ?c. 1202
Alan, occ. 1217x23
John, occ. 1291
John de Mepeham, occ. 1328
Robert de Southflete, occ. before 1350
John de Hartlepe, occ. before 1361
John Morel, occ. before 1382

Henry Raundes, 1382–88
Nicholas de Frindsbury, occ. before 1393
Thomas de Harriettesham, 1388–93, 1393–?
John de Ealding, occ. before 1412
John Sutton, 1412–?
Richard Pecham, 1463 and after ?1468
William Waterford, 1497/98
Robert Rochestre, occ. before 1528
Richard Faversham, 1528

ACKNOWLEDGEMENTS

I am grateful to Mark Bateson and John Crook, who came to my aid by clarifying several points for me during the course of writing this paper.

NOTES

1. Apart from the cathedrals of Bath and of Wells, which were in the same county; however, unlike Rochester, they were in the same diocese and shared the same bishop.
2. *PL*, 159, cols 820–21, and *Textus Roffensis*, ed. T. Hearne (Oxford 1720), 143.

3. It is hard to believe that in 1307 there was a prior and thirteen monks at Felixstowe as reported in *Calendar of Inquisitions Post Mortem* (1904–), IV (1913), 302.

4. The admission numbers, however, may themselves be offset, if there were in the same period an unusually high number of departures or deaths.

5. D. Knowles, C. N. L. Brooke and V. London ed., *The Heads of Religious Houses: England and Wales*, I, 940–1216, 2nd edn (Cambridge 2001); D. M. Smith and V. London ed., *The Heads of Religious Houses: England and Wales*, II, 1216–1377 (Cambridge 2001).

6. These figures arise out of my own research into primary sources.

7. For the comparative measurements of Rochester and Bath, see John Harvey in *Cathedrals of England and Wales* (London 1974), 218–43. The length of Coventry cathedral has been established by recent excavations; see M. Rylatt, 'Revisiting the Archaeological Evidence for the Priory', in *Coventry's First Cathedral*, ed. G. Demidowicz (Stamford 1994), 68.

8. These are the total numbers to be found in J. Greatrex, *Biographical Register of the English Cathedral Priories of the Province of Canterbury, c.1066–1540* (Oxford 1997) (hereafter *BRECP*). References to printed texts and manuscripts are given in this volume.

9. *BRECP*, under the names in the Canterbury and Rochester sections.

10. ibid., 617 (R. London), 617–18 (T. London), 648–49 (Wouldham).

11. This conclusion is based on my own research; see J. Greatrex, 'The Local Origins of the Monks of Worcester Cathedral Priory', *Transactions of the Worcester Archaeological Society*, 3rd ser., 16 (1998), 143–53; the Ely study has not yet been published.

12. *BRECP*, 608, 610. Authorship of the *Annales*, which ends in 1307, has also been attributed to John de Reynham I, prior; see *BRECP*, 629 and R. Sharpe, *A Handlist of the Latin Writers of Great Britain and Ireland before 1540*, Publications of the Journal of Medieval Latin (Brepols 1997) (hereafter Sharpe, *Handlist*), 107, 299.

13. *BRECP*, 606 (Rochester), 168–69 (Canterbury). Glastinbury/Glassenbury manor in Cranbrook parish is referred to by J. K. Wallenberg in *The Place-Names of Kent* (Uppsala 1934), 320–21, and Beverley farm in St Dunstan Without parish, ibid., 501; both are also in E. Hasted, *The Topographical Survey of the County of Kent*, 4 vols (Canterbury 1797–1801), III, 45 (Glassenbury), III, 575 (Beverley). These are all 15th-century monks.

14. *BRECP*, 623.

15. ibid., 596.

16. ibid., 606.

17. ibid., 603.

18. ibid., 611. For Hamo's episcopal career, see R. M. Haines, 'The Episcopate of a Benedictine Monk: Hamo de Hethe, Bishop of Rochester (1317–1352)', *Revue Bénédictine*, 102 (1992), 192–207.

19. See *BRECP*, 626; and John Le Neve, *Fasti Ecclesiae Anglicanae 1300–1541*, 12, *Introduction, Errata and Index*, comp. J. M. Horn (University of London 1967), 154.

20. Where accounts of the hostiller or guestmaster survive, there is often a record of visiting relatives. At Rochester there are no accounts, and only two hostillers, Walter de Rawe and John de Leycestria, are known by name (*BRECP*, 608, 628).

21. For 15th-century alterations and renovation, see J. P. McAleer, *Rochester Cathedral, 604–1540: An Architectural History* (Toronto 1999), 153–63, and ibid., passim for discussion of the unresolved problems in building chronology, etc.

22. *BRECP*, 602; McAleer, *Rochester*, 258 n. 111; C. Flight, *The Bishops and Monks of Rochester, 1076–1214*, Kent Archaeological Society Monograph Series, VI (Maidstone, 1997) (hereafter Flight, *Rochester*), 195. See also London, British Library, Cotton MSS, Vespasian A.xxii, fol. 86.

23. *BRECP*, 644.

24. ibid., 637 (Silvester), and *Registrum Roffense*, ed. J. Thorpe (London 1769) (hereafter *Registrum Roffense*), 121.

25. *BRECP*, 589 (Alfred or Alured), and *Registrum Roffense*, 121; *BRECP*, 635–36 (Osbern), and *Registrum Roffense*, 121.

26. *BRECP*, 631–32, and *Registrum Roffense*: '[Heymeric] fecit claustrum versus infirmitorium', 123. See also W. H. St John Hope, *The Architectural History of the Cathedral Church and Monastery of St Andrew at Rochester* (London 1900), 190–91.

27. *BRECP*, 632.

28. ibid., 602, and Flight, *Rochester*, 234. The old 'lavatorium' had been provided by the sacrist named Thalebot, who had also constructed a clock, to which his name was given; his dates are unknown, but see *BRECP*, 642.

29. *BRECP*, 618.

30. ibid., 634–35.
31. e.g., Bishop Gilbert de Glanville 'fecit claustrum nostrum perfici lapideum & organa nobis fieri fecit', *Registrum Roffense*, 633; see also the remarks in McAleer, *Rochester*, 240, n. 15 and 258, n. 111. It should be borne in mind that there were two disastrous fires, in 1137 and 1179, which did untold damage to the cathedral and cloister.
32. *BRECP*, 644.
33. *BRECP*, 602 (Elias III); *Registrum Roffense*, 122–23; and St John Hope, *Architectural History*, 37, 40.
34. *BRECP*, 601 (Eastgate), and 622 (Mepeham).
35. St John Hope, *Architectural History*, 47, where he explains that the north-west transept is opposite St William's gate, a translation that surely makes more sense than McAleer's use of the word 'aisle' in his *Rochester*, 106.
36. According to *Registrum Roffense*, 125, but see Flight's comments in his *Rochester*, 225, and those of McAleer, *Rochester*, 107–08. Hoo was prior 1239–42.
37. *BRECP*, 645 (Waledene); Walden's dates were unknown to both St John Hope, *Architectural History*, 47, and McAleer, *Rochester*, 106. The wording was 'alam australem versus curiam', *Registrum Roffense*, 125.
38. *BRECP*, 645.
39. St John Hope, *Architectural History*, 83; J. Thorpe, *Custumale Roffense* (London 1788), 184–85; St John Hope, *Architectural History*, 117; McAleer, *Rochester*, 147, 156, and 270, n. 180. In 1342, Bishop Hamo also contributed most of the sum needed to repair the refectory and dormitory; see H. Wharton, *Anglia Sacra*, 2 vols (London 1691), I, 375.
40. *BRECP*, 598 (Cornubia), 633 (Saunford).
41. ibid., 644 (Tunebregge), 612 (Robert de Hoo I), 635–36 (Shepey).
42. See *Registrum Roberti Winchelsey Cantuariensis Archiepiscopi, A.D. 1294–1313*, ed. R. Graham, Canterbury and York Society, 2 vols (1952, I; 1956, II), II, 841, in which one of the injunctions of 1299 was specifically addressed to the almoner concerning the almonry scholars, who were to be 'in competenti numero sicut antiquitus consuevit'.
43. Four of the Christ Church monks are named in *The Chronicle of John Stone, Monk of Christ Church, 1415–1471*, ed. W. Searle, Cambridge Antiquarian Society Octavo Publications, XXXIV (1902), 106; the entry is dated 1468. William Ingram I (*BRECP*, 209) and John Kebull (*BRECP*, 213) are two others.
44. *BRECP*, 593.
45. ibid., 634–35 (John de Shepey II, the first of two priors by this name).
46. ibid., 605; the MS is BL Royal 3 MS B.i, where his name occurs in the margin of the commentary on the letter to Titus.
47. ibid., 605. The earliest Rochester book catalogue has been printed in *English Benedictine Libraries: The Shorter Catalogues*, ed. R. Sharpe, J. Carley et al., *Corpus of British Medieval Library Catalogues*, IV (British Library 1996) at B77. The Ambrose volume is no. 42 (p. 481) in the list. Its British Library identification is Royal MS 6 C.iv, and that of Gorran, Royal MS 2 C.V.
48. *BRECP*, 634.
49. ibid., 647.
50. ibid., 649–50, where the MSS are listed. The sixteenth surviving MS, now Cambridge, Trinity College, 610, is almost certainly his; it lacks his name but has a portion of the verse.
51. BL Royal MS 2 C.I (Chicheley chest); BL Royal MS 6 D.II (Cat Street binder).
52. Humphrey the precentor, *BRECP* 613–14, copied ('scripsit') BL Royal MS 5 B.IV, and an unnamed monk was probably the scribe who wrote the Augustine volume that is now BL Royal MS 5 B.XII. The remaining two Augustine works are BL Royal MSS 5 C.VIII and 5 D.IX; those of Jerome and Gregory are BL Royal MSS 6 D.II and 6 D.VII respectively.
53. Now BL Royal MS 2 E.VII (Foliot), BL Royal MS 4 A.XV (Lyra).
54. BL Royal MS 4 B.VII.
55. The *De trinitate* is BL Royal MS 5 B.IV, and the *De doctrina christiana* is one of several treatises in BL Royal MS 5 B.XII; Bonaventure's commentary, which may have been the gift of the monk bishop John Shepey (Sharpe, *Shorter Catalogues*, IV, B83.6) is now BL Royal MS 10 C.XII. Hales's commentary is incomplete, consisting of book three only; BL Royal MS 9 E.XI.
56. These volumes are now BL Royal MS 15 A.XXII (Solinus and Nennius); Cambridge, Trinity College MS 610 (Lucan); BL Royal MS 2 C.I (Comestor). There were several other copies of Peter Comestor in the Rochester library; see Sharpe, *Shorter Catalogues*, IV, B79.105, B82.6 (Bishop Hamo's copy), and B83.3a. Another copy recently came to light and was sold at Christie's on 28 November 2001, lot 10. The scribal activities of Osbern de Shepey before he became prior included a copy of Comestor's *Historia*, which he 'perfecit'; see Sharpe, *Shorter Catalogues*, IV, B81.12.

57. Cambridge, Trinity College MS 1128 (Bede and Alcuin and other miscellaneous treatises); BL Royal MS 12 F.VIII (Salisbury).

58. *BRECP*, 613; the *tabula* is found on fols 268–96 in BL Royal MS 6 D.VII.

59. *BRECP*, 613. The Concordance is now BL Royal MS 4 E.V; Bromyard's *Summa* is BL Royal MS 7 E.IV.

60. *BRECP*, 642.

61. ibid., 624.

62. Sharpe, *Shorter Catalogues*, IV, B79.165.

63. *BRECP*, 627–28; he later became abbot of Battle. The Rochester copy is now BL Royal MS 12 C.I.

64. Sharpe, *Handlist*, 107 (Haddenham), and 299 (Rainham).

65. *BRECP*, 635 (Shepey), 609 (Hatfeld).

66. ibid., 612–13.

67. ibid., 598 (Cray), 635 (Shepey).

68. This conclusion bears out remarks in an unpublished typescript by Martin Brett which he kindly lent to me and from which I quote; see also Flight, *Rochester*, 200, n. 11 for a similar comment.

William St John Hope (1854–1919) and the Historiography of Rochester Cathedral

ALEXANDRINA BUCHANAN

In the pages and notes of this volume, the work of St John Hope (Fig. 1) is mentioned frequently. This alone may be testimony to the continued importance of his book, The Architectural History of the Cathedral Church and Monastery of St Andrew at Rochester *(London 1900), to the historiography of the cathedral it treats. As yet, no subsequent architectural historian or archaeologist looking at Rochester has done so completely independently of what St John Hope said, or did not say, about its structure. In a way, therefore, his book forms as important a part of the architectural history of Rochester Cathedral as the stones of the fabric or the contemporary archival evidence. My aim in this essay is to look more closely at St John Hope's methods within their contemporary context. The angle from which I shall approach is not to establish whether he was right or wrong, but rather to consider what might have influenced his asking the questions he did, and his presentation of the answers he reached. However much we may wish otherwise, a building cannot tell us its own history. The clues are there, lurking in the fabric and in the archives, but we have to seek them out and scrutinise them. What clues we seek and how we evaluate their significance is, to a large degree, culturally determined. Similarly, the manner in which we present our conclusions will take a certain form depending on our relationship with past scholarship and the expectations of our intended audience.*

ST JOHN HOPE's acquaintance with Rochester began in 1881, when he was appointed, fresh from Cambridge, as an assistant master in the King's School.[1] Aged twenty-six, he was already a keen archaeologist. His family were all antiquarians — his father, the Reverend William Hope, vicar of St Peter's, Derby and chaplain to Earl Ferrers, had an interest in local history, his uncle Robert John Hope was extremely interested in heraldry, and his younger brother Robert was also to write on antiquarian topics. The two boys were educated first at their local school, then in 1865 they both started at St John's College, Hurstpierpoint in Sussex. At school, St John Hope's interest in antiquities was fostered by the chaplain, Joseph Thomas Fowler, best known today as the editor of the *Rites of Durham*. St John Hope and Fowler appear to have recognised each other as kindred spirits — as Fowler recalled many years later: 'Sir William used to visit churches with me when he was a boy at Hurstpierpoint, and he now regards me as his "father in archaeology".'[2] Fowler moved to Durham in 1869, but the two remained in touch. A letter of 1872 from St John Hope to Fowler survives, mentioning a contribution St John Hope had made to an article by Fowler in the *Yorkshire Archaeological Journal*.[3]

St John Hope appears to have been an extremely precocious young man. His first solo article, on the misericords of Lincoln Cathedral, was published in *The Sacristy* in

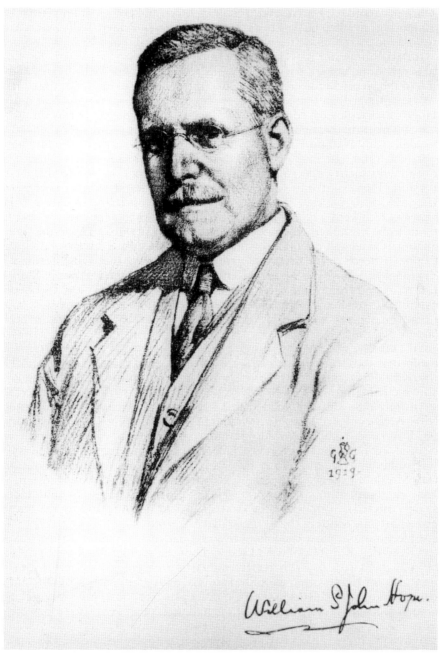

Fig. 1. William St John Hope, monogrammed 'G G' and dated 1919
from A. H. Thompson, *A Bibliography of the Published Writings of
Sir William St John Hope Litt.D., D.C.L.* (Leeds 1929)
Cambridge University Library

1872, when he would have been seventeen or eighteen and not yet at university.[4] Going up to Cambridge in 1877, he was too late to have known Robert Willis, who had died in 1875, and too early to have been guided around by Willis and Clark's *Architectural History of the University of Cambridge*, published in 1886. However, he did form friendships with the work's co-author, Willis's nephew John Willis Clark, and other members of the Henry Bradshaw circle. Their contribution to antiquarian scholarship, however, lay primarily in the field of manuscript studies, and it seems that most of St John Hope's archaeological education was done in the holidays. Here again, he shows evidence of a maturity beyond his years. He was a founder member of the Derbyshire Archaeological and Natural History Society in 1878, and a year later we find him both on the Council and as editor of the Transactions.[5] He seems to have been a prime mover behind the society's decision to undertake excavations on the site of Dale Abbey, which St John Hope started to supervise in the summer vacation after his first year at university. He also appears to have instigated the Society's so-called Vigilance Committee, which kept a watch on local restorations, though one of the first targets turned out to be his father's own church.[6] Sadly, we can only imagine the politics of this situation. On a happier note, we find him writing in outrage to the churchwardens of All Saints' Church in Derby about a rare wooden effigy then lying headless in the vault. Through St John Hope's personal efforts, the entire tomb was put back together, the head recovered from those who had stolen it, and the effigy sent to London for conservation.[7] Through the Derbyshire society he came into contact with J. C. Cox and began a correspondence with M. H. Bloxam, who was at that time the main authority on monastic planning.

St John Hope's early interest in monastic excavation was to last throughout his career and it is the field with which he is perhaps most closely associated. Having moved to Kent, he soon became involved with local excavations, at St Radegund's near Dover, West Langton and Lewes Priory, where he dug with the architect Somers Clarke.[8] In July 1883, the combined meeting of the Royal Archaeological Institute and the Sussex Archaeological Institute invited him to speak on the Lewes remains, which brought his name before a wider antiquarian audience.[9] The president of the architectural section of the congress was J. T. Micklethwaite, partner of Somers Clarke, who was to become one of St John Hope's closest associates. Although a practising architect, Micklethwaite was an equally accomplished architectural historian, with a particular interest in liturgical matters. As a result of the congress, St John Hope was immediately elected a member of the Archaeological Institute and by the autumn of 1883 he had become editor of the *Archaeological Journal*.

The subject of monastic archaeology was of great current interest, for it was within living memory that Robert Willis had worked out the standard monastic groundplan, the first in England to do so.[10] Thereafter, monastic archaeology was transformed from a vague search for treasure and ghoulish thrills to a programmatic series of campaigns to uncover the known elements in their expected place. St John Hope was amongst the first to attempt a paper reconstruction of the buildings of an excavated monastic site in three dimensions, as he did for Dale.[11] However, it could be suggested that his long association with monastic archaeology was not entirely beneficial. His approach, though meticulous for the 1870s, was hardly innovative. His primary aim was to uncover the original plan and the main building phases. He was only able to devote small amounts of time to digging, and thus worked to uncover as much as he could as quickly as possible. His results were published straight away in admirable articles but he kept no archive of on-site notes and recorded information solely in drawings rather

than also using photographs.[12] The methodology of monastic excavation remained stagnant until the mid-20th century, and whilst we cannot blame St John Hope personally for this, he was nevertheless closely involved with Brakspear, Peers and the other archaeologists who were to be responsible for forming the national policy on monastic sites.[13]

St John Hope's interest in excavation and in monastic planning is very evident in his work on Rochester. St John Hope describes having undertaken a number of excavations, not just that at the east end, but also within the precinct. These, as he admitted, were partial but nevertheless form a valuable record. In treating both church and monastic buildings, St John Hope would have been guided not just by his personal interests but also by the model provided by Robert Willis's work on Canterbury, which had been undertaken and published as two separate projects.[14]

St John Hope saw his relationship with Willis as being purely that of the disciple. He was naturally conservative, so had no inclination to represent himself as an innovator. Indeed, why should he have wanted to innovate, when Willis was accepted as having provided the blueprint for architectural history? Although St John Hope had not personally been acquainted with Willis, many of his contemporaries had known the great man. Moreover he was in direct contact with Clark, who was Willis's executor and keeper of his uncle's papers. Clark gave St John Hope full access to this resource and the archive has suffered as a result.[15] It can be little surprise to learn that St John Hope borrowed useful notes when he was invited to speak on specific cathedrals to the Royal Archaeological Institute. He looked for the notes on Rochester but they were found to be missing.[16] He was supplied with a partial transcript by Willis's closest friend and collaborator, D. J. Stewart.[17] St John Hope published the largely accurate copy of Willis's notes on the Early English work in its entirety, noting that 'The architectural history of this part of the church cannot be better described than in the words of the late Professor Willis'.[18] Here again, we have proof of St John Hope's belief in his own subservience. Willis's method, as he himself described it, was 'to bring together all the recorded evidence that belongs to the building [. . .]; to examine the building itself for the purpose of investigating the mode of its construction, and the successive changes and alterations that have been made to it; and lastly, to compare the recorded evidence with the structural evidence as much as possible'.[19] On the face of it, this would seem to provide an accurate portrayal of St John Hope's methodology as well. Most of the typical features of Willis's work are reproduced in St John Hope's — the full quotation from the sources in footnotes, the chronological arrangement, the algebraic style of discussing complex structural sequences. His plans use colours to demonstrate the successive phases of building, a technique introduced by Willis, and in one plan he uses tissue paper to show the crypt overlaid by the choir, a technique modelled on *The Architectural History of the University of Cambridge*, though attributable to Clark's editorship. Yet in fact, without St John Hope's really being aware of it, the concerns of architectural history had moved on since Willis's day.

The first difference between the work of Willis and St John Hope may be found in their attitude to what we should now define as archaeology. St John Hope was an active excavator, whereas Willis was not. One of the only occasions on which Willis became involved in below-ground archaeology was at Lichfield, where he made a couple of brief visits to report on the uncovering of the original apse.[20] His participation was minimal, though to observers it seemed crucial to the success of the endeavour. As an onlooker recalled:

He knew as it were by instinct what was hidden under the soil. 'Dig *there*', he said, and the base he wanted came to light. 'Open out the earth *here*', and the solid piece of stone, which he had been looking for to complete his imaginary plan, was straightaway disclosed to view. He seemed to have made up his mind, before he entered the Cathedral, what he should discover; and lo! There it was ready to hand.[21]

For Willis, the act of uncovering was rather that of the magician — proof to an incredulous audience of that which he had known all along. Part of the drama of his lecture at Glastonbury was his sounding out the position of the high altar with a crowbar — but he specifically denied the value of digging to try to discover the remains of St Edgar's chapel, which were known to have existed at the east end.[22] At Rochester he had part of the south wall of the nave stripped of plaster to prove the date of the walls from the form of the masonry. The section was then left bare as a memorial, but is no longer visible.

It could be argued that St John Hope's more hands-on approach was symptomatic of his residence in Rochester whilst he undertook the research. It is notable, however, that Willis undertook no below-ground archaeology in Cambridge and very little of the stripping-off plaster variety either. The difference was rather one of personal mentality. Willis tackled architectural history primarily as an intellectual puzzle: he tried to work out the sequence of the building from documentary evidence before he arrived on site and then looked to the structure to confirm his conclusions. St John Hope's approach was far less cerebral than Willis's. He was most confident in uncovering evidence, far less in its analysis. Not for nothing did he leave the architectural interpretation of some of his major digs to Bilson and Brakspear.[23]

The next difference lies in St John Hope's and Willis's attitudes to documentary evidence. Despite Willis's primary reliance on documentary evidence, his research in this area was also far less thorough than St John Hope's. Although Willis was fully capable of reading medieval documents, the sources he preferred were the notes and publications of 17th- and 18th-century antiquaries. When we revere the mass of documentary sources quoted in *The Architectural History of the University of Cambridge*, we are in fact paying tribute to Clark, who sought them out and transcribed them. When Willis wrote on Rochester, he had not studied the Rochester manuscripts themselves but had used the editions published by Hearne and Thorpe. St John Hope, on the other hand, seems to have made full use of the archival sources, compared published editions with their manuscript originals, and altogether showed himself a true student of Clark.

Nevertheless, with regard to Rochester, we do have rare evidence that Willis examined at least one original document. There is a transcript of a charter in the Cambridge papers — largely accurate, though Willis had some problems with abbreviations. Since it was unpublished before St John Hope, Willis must have seen the original. It is an indenture of 1327 between the prior and convent and the parishioners of the altar of St Nicholas in the nave of Rochester Cathedral, relating to an oratory that the chapter were to erect for the parish. Independently of each other, St John Hope and Willis both suggested that the chapel was attached to the north door of the west front. Willis cited structural evidence to suggest that it was on the exterior of the front; St John Hope thought it was at the west end of the north aisle. Unfortunately the north-west turret has been totally rebuilt on two separate occasions (in the 18th and late 19th centuries) and so there remains no archaeological evidence above ground level.[24] The sharing of premises by lay and monastic users was something in which Willis was to become particularly interested two years after his Rochester lecture, when in 1865 he

lectured on Sherborne.[25] Whether he was already aware of the Sherborne dispute when he came upon the Rochester document, or whether his knowledge of Rochester provided a background for his Sherborne research is unclear, but it does provide a pattern that may be of interest. For St John Hope, whose churchmanship was rather different from Willis's, the conflict between priory and parish was not a matter he wished to stress, and he described it merely as 'the usual quarrels'.

Willis's religious position is unclear, but he certainly did not have High Church sympathies and was very happy to expose the imperfections of the medieval Church. St John Hope, on the other hand, had a father who had been a member of the Cambridge Camden Society and had been educated at a High Church boarding school.[26] He became a member of the St Paul's Ecclesiological Society, founded by J. Wickham Legg in 1879, to which he read his first paper on Rochester Cathedral. He was also a founder and Council member of both the Henry Bradshaw Society, founded 1890, which published liturgical texts, and of the Alcuin Society, founded in 1897, devoted to the Book of Common Prayer. After he moved to London, he worshipped at the famously ritualist church of St Mary Magdalene, Munster Square, and was said to have referred frequently and with satisfaction to the work that he and Micklethwaite had done there in helping to establish a standard of liturgy on historical principles.[27] Earlier generations of ecclesiologists had looked abroad for models of altars and liturgical arrangements. St John Hope and his brethren, however, stressed that medieval English models were in keeping with national usage and were therefore preferable to imported sources.[28] In line with this research to serve present needs, St John Hope was summoned in 1899 by Lord Halifax to give evidence for the defence, when the carrying of lights in processions was challenged in the church courts.[29] All in all, this provides a picture of St John Hope as a progressive Anglo-Catholic — the type of Anglican to whom Percy Dearmer's *Parson's Handbook* and the church furnishings of Ninian Comper were to appeal. His churchmanship was not perhaps obvious to his contemporaries: it was said that 'It is probable that only a few at any time thoroughly realised the full force of his convictions which were no small part of his influence upon medieval studies, and were so intimate a part of his general consciousness of life that they never needed to be thrust into notice'.[30] Nevertheless, St John Hope's convictions exerted a perceptible influence on his work, which again differentiate it from that of Willis.

In his lecture on Salisbury, Willis stated:

A building like this, erected for a special purpose is like a machine. No man can understand the construction of a machine unless he knows the purposes to be carried out by it. No one can understand the reasons for the peculiar erection of these old churches unless he enters to a certain degree into the state of the ritual at the time they were built.[31]

However, on the whole, Willis tended to avoid liturgical analysis, probably to differentiate his work from that of the ecclesiologists. St John Hope, on the other hand, took great interest in the liturgical arrangements of Rochester and devoted an entire section to a reconstruction of the spatial progression of the weekly procession.[32] He tried to establish the positions of all the altars, which are shown on his plans complete with all five crosses; he noted remaining parts of the screens and altar furniture and listed the various images in the church. Observations such as 'The only remaining traces of the altar of St Ursula are the broken iron fastenings, on the chamfers of the recess in which it stood, for the ridels or curtains at the ends of it', would never have been made by Willis and probably owe a great deal to the influence of Micklethwaite, whose notes in the British Museum are full of such observations.[33] Micklethwaite had

spoken on Rochester to the St Paul's Ecclesiological Society in 1881 and mentioned St John Hope's work, so they must by then already have been in communication, and had probably met through Somers Clarke.[34] It was to Micklethwaite that St John Hope turned in his attempt to interpret the arrangements in the crossing at Rochester, and it was Micklethwaite who provided the suggestion that the narrow transepts St John Hope posited for Gundulf's cathedral should have been separated from the nave by a continuation of the aisle arcades. St John Hope had queried various elements of this area in a letter dated 25 October 1882 — against the question of how the transepts and nave were joined, Micklethwaite pencilled 'arcades and triforium went slap across'.[35]

Micklethwaite's undoubted influence on St John Hope's text is largely unacknowledged and therefore hard to identify. Much more obvious is the influence of J. T. Irvine. Irvine had been the foreman for George Gilbert Scott and was a considerable architectural scholar in his own right. Having worked with Scott on most of the major cathedrals, his knowledge was very broad and his surviving notes (now in the Medway Local Studies Centre) were evidently used to their full by St John Hope.[36] Willis had been similarly dependent on restoration architects, notably Perkins at Worcester, but he was never intellectually subordinate to them. Irvine's notes, which survive elsewhere in greater quantities on other subjects, suggest that he was probably better able to analyse architectural evidence than St John Hope. Although he was privately acknowledged as an expert, however, his lower social status meant that he was rarely given a voice of his own.

Irvine brings us on to Saxon architecture. For, from the evidence of his other notes at Peterborough Cathedral Library and Bath Public Library, what interested him in particular was evidence of pre-Conquest buildings. One can see the relevance of this at Rochester, where he was particularly keen to trace remains of pre-Gundulf fabric. Here again, we see a change of emphasis from Willis, who had little or no interest in identifying existing Saxon remains, which he consistently denied as a significant element in surviving cathedral buildings. This position related to the state of scholarship when Willis began writing, when local antiquaries invariably ascribed Norman work to the Saxon period. We may note with interest that Arthur Ashpitel, speaking on Rochester before the British Archaeological Association in 1853, would have been happy to ascribe the earliest parts of the crypt to the Saxon period, had he not shown the termination to be square, a form he believed was never found in Saxon achitecture.[37] After Willis, however, there was no authoritative voice opposing Saxon attributions and they once again began to creep in. In his *Archaeologia* article on Rochester in the early 1880s, St John Hope revived the idea that the crypt could date to before Gundulf's time, suggesting that the monolithic shafts could have come from the previous cathedral.[38] This, of course, was before the excavations at the west end of the nave had revealed a building too small to have needed even such modest supports. Typically, he describes the earlier church not as Saxon, but as 'old-English'.

St John Hope was a determinedly insular scholar. In this he stood out, even to contemporaries, because, contrary to popular perception, not all Victorian and Edwardian scholars believed in the automatic superiority of the English. Willis was very happy to waive all claims to English originality in architecture, and St John Hope's fellow, John Bilson, was constant in his assertion of French priority. St John Hope, however, made it a principle not to correspond with foreign scholars unless absolutely necessary, not to go to congresses abroad, and to study only national art products.[39] One of his major contributions to scholarship is his study of alabasters, which he

proved to have had an English provenance, despite now being found in far greater quantities elsewhere.

This English orientation is particularly noticeable in the earlier article, where he noted the square east end as a national characteristic already beginning to assert itself, and described the projecting eastern chapel as the germ of lady chapels such as those at Gloucester, Lichfield and Westminster. In this case he must have meant the projection, rather than the form, for two of the examples he quotes are apsidal. The continuation of the nave arcades across the transept was cited as possibly a pre-Conquest feature, as at Deerhurst. These observations were dropped in the book — either he had changed his mind or he felt that such personal interpretations were suitable for a preliminary article, but not for a scholarly monograph.

The final difference between Willis and St John Hope may be identified in their contrasting attitudes to restoration. When we left St John Hope's career, he was rising rapidly through the ranks of archaeology. He was soon to become a Fellow of the Society of Antiquaries, and then, in 1885, the new post of Assistant Secretary was advertised, paid at a rate of £200 a year plus accommodation in the Society's new rooms in Burlington House. From a field of seventy-five applicants, St John Hope was appointed. He moved in with his wife, and their son Maurice was born and brought up there.[40] Even more than his role in the Archaeological Institute, it was his position within the Society of Antiquaries that gave St John Hope his position of power in the world of antiquarianism. St John Hope's appointment was part of a reconfiguration of the role and functioning of the Society. The results of this period of refocusing were as follows: a closer association with the younger archaeological societies; the establishment of a research fund; increased intervention in the preservation sphere; a greater public role, with a series of exhibitions; an increase in the size and importance of the Library, and the creation of a library catalogue. St John Hope played a significant role in all these activities and was crucial to the re-emergence of the Society to prominence after the moribund years of the mid-19th century.

From the point of view of Rochester, the most important aspect of St John Hope's role was the new fighting stance the Society of Antiquaries had chosen to take with regard to restoration. At Rochester, the Society stood up against the replacement of the medieval pulpitum screen; it also opposed the activities of Pearson at other sites, notably Peterborough and Westminster.[41] Although his stance is not blatant, St John Hope's text does contain a number of criticisms of restorations undertaken at Rochester, drawing particular attention to the work of Pearson. He was less critical of Scott, though he did condemn the removal of the monument of Bishop John Lowe from the north-east transept. Typically, his condemnation was couched in terms of the liturgical topography — it should not have been moved especially because it was a 'landmark', showing the position of the golden image of St Andrew mentioned in the bishop's will.[42]

The problem of contemporary architectural activity with regard to church buildings ties together all St John Hope's concerns and gave justification to his method. As Micklethwaite pronounced at the Lewes RAI Congress, the task of architectural history was to educate patrons.

The first lesson to be taught them is that their duty towards an old church is not to 'restore' but to preserve it. And this will generally best be done by shewing them how it came to be what it is; how it grew from a perhaps much smaller building till it came to be what they now see; how each successive addition and alteration had a distinct use and meaning, and, however the pedantical

advocates of 'period' may jeer at it as disfigurement or an innovation, is generally an improvement to the building.[43]

Micklethwaite was prepared to tolerate even post-Reformation alterations, though even he drew the line at retaining all box pews, and it is notable that St John Hope paid far more attention to post-medieval changes than Willis would have done.

Despite my having highlighted a number of differences between the work of St John Hope and that of Willis, it should nevertheless be stressed that overall these are minor compared with the similarities, at least in terms of the two men's writings on architecture. St John Hope's interests were, of course, far broader than Willis's, and it could be argued that it is churlish to criticise particular essays within the *œuvre* of a scholar whose production was encyclopaedic in scope. In particular, his ground-breaking work on seals is celebrated in the present volume by John Cherry. Yet doubtless he would have hoped that each of his works would be judged on its individual merits: as Thompson wrote, 'he himself was the last to admit that his own conclusions were final: for him, there was always more to be learned'.[44] Moreover, in order to evaluate his contribution, such an approach is essential. In architectural historiography, St John Hope must be counted as one of those who passed on Willis's method to the 20th century. Yet the use of the phrase 'Willis's method' should be cause for concern. For St John Hope, Willis provided a technique — but not a motivation. Through close adherence to the method, St John Hope produced an admirable book, but not a particularly exciting one. As with St John Hope's archaeology, there is something of the production line about his writing. The reader of his text will experience none of the thrill of a great mind grappling with a great building, as one does with Willis at Canterbury. It should, however, be noted that in his lecture on Rochester even Willis failed to convince some members of his audience that Rochester provided a sufficient vehicle for his intellect, but the few scraps of his paper that remain show that Willis was always looking at a bigger picture. He wished to date the various portions of Rochester and analyse the motivations of its design in order to refine the stylistic sequence proposed by Rickman and define the essence of Gothic for its practitioners. St John Hope did not set the problems presented by Rochester within a wider historiographical context, as Bilson had done at Durham and was to do for the Cistercian abbeys. At a time when France and Germany were outstripping England in antiquarian scholarship, his insularity was not a happy position to take. Nor did he show the political motivations that enliven the work of Lethaby and Prior. The method he passed on thus became in his hands a dead technique. St John Hope should be revered, but with reservations.

<div align="center">NOTES</div>

1. For the basic biography of St John Hope, see the *Dictionary of National Biography*; and A. H. Thompson, *A Bibliography of the Published Writings of Sir William St John Hope Litt. D., D.C.L.* (Leeds 1929). For his family, see the entries in J. A. Venn, *Alumni Cantabrigienses* (Cambridge 1922).

2. J. T. Fowler, *Senilia. Recollections of University Life in Durham, 1858–1917* (Durham 1919), 16.

3. BL Add. MSS, 33206, fols 235–37.

4. 'The Misericordes in the Choir of the Cathedral Church of Lincoln', *The Sacristy*, 2 (1872), 255.

5. His editorship is recorded in *Derbyshire Archaeological and Natural History Society Transactions*, 5 (1883), xxix.

6. The Vigilance Committee was first mentioned in 1879: *Derbyshire Archaeological and Natural History Society Transactions*, 2 (1880), xxiv–xxv. It had been set up by 1880: ibid., 3 (1881), xx. The notice of the attack on the restoration of St Peter's Church is noted: ibid., 4 (1882), xli.

7. The wooden effigy is first mentioned in *Derbyshire Archaeological and Natural History Society Transactions*, 2 (1880), xxiii–xxiv. The subsequent story unfolds: ibid., 4 (1882), xxi; 5 (1883), xxviii–xxix; and 6 (1884), xli.

8. The St Radegund excavations were published in W. H. St John Hope, 'On the Premonstratensian Abbey of St Radegund, Bradsole in Polton, Dover', *Archaeologia Cantiana*, 14 (1882), 140–52.

9. *Antiq. J.*, 40 (1883), 445. The text of the lecture was published in *AJ*, 40 (1884), 1–34.

10. See A. C. Buchanan, 'Robert Willis (1800–1875) and the Rise of Architectural History' (Ph.D. thesis, University College London 1995), 299–326.

11. 'On the Excavations on the Site of Dale Abbey, Derbyshire', *Derbyshire Archaeological and Natural History Society Transactions*, 2 (1880), 128–34, pl. X.

12. For full details of St John Hope's publications see Thompson, *Bibliography*.

13. J. P. Green, *Medieval Monasteries* (Leicester 1992), 37–40.

14. R. Willis, *The Architectural History of Canterbury Cathedral* (London 1845), and R. Willis, 'The Architectural History of the Conventual Buildings of the Monastery of Christ Church in Canterbury', *Archaeologia Cantiana*, 7 (1868), 1–206.

15. Willis's notebook on Lincoln found its way to the RIBA drawings collection (formerly catalogued according to its provenance as the work of St John Hope), and that on Wells is in the cathedral library (St John Hope dug at Wells in 1881); those on Canterbury and Winchester are still missing.

16. W. H. St John Hope, 'Notes on the Architectural History of Rochester Cathedral Church', *St Paul's Ecclesiological Society Transactions*, 1 (1881–85), 217–30 (at 217). At this date he had apparently not had access to D. J. Stewart's notes.

17. The original notes by Willis from which the transcript was taken, reproduced in St John Hope, *Architectural History*, 40–9, may now be found in Cambridge, University Library, Add. MS 5128. St John Hope explained that he was supplied with a transcript of part of Willis's notes by D. J. Stewart. Stewart had been one of Willis's closest associates, and after his friend's death he helped to keep the legend alive. He gave advice to Clark on the master's intentions for *The Architectural History of the University of Cambridge*, and also published accounts of Ely and Norwich cathedrals, largely based on Willis's research, as he fully acknowledged. It is clear, therefore, that he either had direct access to papers held by Clark, or that some of the Willis papers in the Cambridge University Library came there via Stewart. It seems to me likely that Stewart had the missing Rochester notes too, for some of the pages have annotations in his hand. Add. MS 5128, fol. 58 is a British Museum call slip for Rawlinson's *History and Antiquities of the Cathedral Church of Rochester* (1717) in Stewart's hand, dated 11 May 1880. Since he cannot have been looking something up for Willis (who had died in 1875), it seems possible that he was intending to publish the notes on Rochester himself. Perhaps too, Stewart had more material than now survives, for there is evidence that Willis was writing his lecture up for publication. Why Stewart kept the originals from St John Hope whilst allowing him a transcript is unclear — it is also notable that the Cambridge papers contain material on the monastic buildings that St John Hope evidently did not know. There is not a substantial body of material, but it is worth noting that it exists.

18. St John Hope, *Architectural History*, 40.

19. R. Willis, 'The Architectural History of Winchester Cathedral', *Proceedings at the Annual Meeting of the Archaeological Institute of Great Britain and Ireland at Winchester, September, MDCCCXLV* (London 1846), 1–79 (p. 1), reprinted in R. Willis, *Architectural History of Some English Cathedrals. A Collection in two parts of papers delivered during the years 1843–1863* (Chicheley 1972), I.

20. R. Willis, 'On Foundations of Early Buildings Recently Discovered in Lichfield Cathedral', *Antiq. J.*, 18 (1861), 1–24, reprinted in Willis, *Architectural History*, II.

21. J. G. Lonsdale, *Recollections of Work Done in and upon Lichfield Cathedral from 1856 to 1894* (Lichfield 1895).

22. Buchanan, 'Robert Willis', 166–70. The crowbar incident was recalled by an eye-witness in the *Somerset Archaeological and Natural History Society Proceedings*, 26 (1976), 48.

23. For details, see Thompson, *Bibliography*.

24. I should like to record my thanks to Tim Tatton-Brown for discussing this point with me.

25. R. Willis, 'Sherborne Minster', *Antiq. J.*, 22 (1865), 179–99.

26. For Hope senior's membership of the Cambridge Camden Society, see the membership list compiled by G. Brandwood in *'A Church as it Should Be'. The Cambridge Camden Society and its Influence*, ed. C. Webster and J. Elliott (Stamford 2000), 405.

27. Thompson, *Bibliography*, 24.

28. A. Symondson, 'Theology, Worship and the Late Victorian Church', in C. Brooks and A. Saint ed., *The Victorian Church: Architecture and Society* (Manchester and New York 1995), 192–222.

29. Thompson, *Bibliography*, 24.

30. ibid., 23.

31. Willis, *Architectural History*, II, section 5, 24.
32. St John Hope, *Architectural History*, 217–19. St John Hope also contributed a 'Note on the Sunday procession' to J. T. Fowler ed., *The Rites of Durham*, Surtees Society, CVII (1903), 302–03, and wrote 'The Sarum Consuetudinary and its relation to the Cathedral Church of Old Sarum', *Archaeologia*, 68 (1917), 111–26.
33. St John Hope, *Architectural History*, 99. Micklethwaite's collections are Add. MSS 37504–37510.
34. *St Paul's Ecclesiological Society Transactions*, 1 (1881–85), XXXI–XXXII.
35. Letter from Micklethwaite to St John Hope, 25/10/1882: BL Add. MS 37505, fols 293–95v.
36. Medway Local Studies Centre, Rochester Dean and Chapter Archive, Emf/77.
37. A. Ashpitel, 'Rochester Cathedral', *JBAA*, 9 (1854), 271–85, esp. 275.
38. W. H. St John Hope, 'Gundulf's tower at Rochester, and the first Norman Cathedral Church There', *Archaeologia*, 49 (1886), 323–34. This idea had also been voiced by James Parker, *St Paul's Ecclesiological Society Transactions*, 1 (1881–85), XXX.
39. Thompson, *Bibliography*, 20; and J. Evans, *A History of the Society of Antiquaries* (Oxford 1956), 328.
40. Evans, *Society of Antiquaries*, 328–29.
41. A. Quiney, *John Loughborough Pearson* (New Haven and London 1979), 189, 194–98.
42. St John Hope, *Architectural History*, 129–30.
43. *Antiq. J.*, 40 (1883), 368–76 (esp. 371).
44. Thompson, *Bibliography*, 16.

Some Rochester Seals

JOHN CHERRY

This note will review the seals associated with the chapter, bishops, town, and the wardens of the bridge of Rochester. The seals of the town and the bridge wardens depict architectural features that can be compared with the actual building in one case and later illustrations in the other. The martyrdom of St Andrew, represented by either his cross or his death is well depicted. Some of the seals show the very highest quality in engraving and this raises the question of where they were made.

The Priory Seal

GUNDULF, bishop of Rochester (1077–1108), is likely, when he refounded the cathedral in 1083 as a Benedictine house, to have ensured that the cathedral priory possessed a seal. If he did, no evidence of it is extant, since the first surviving wax seal of the priory dates from the 12th century. The enthroned figure (either our Lord or St Andrew) holds an orb and cross in the right hand, and in the left hand an open book (Fig. 1). A fine 13th-century double seal replaced this. The matrix does not survive, and was presumably destroyed at the Reformation when the chapter was reconstituted. The wax seal, known from 15th-century impressions, shows on the obverse our Lord with nimbus cross in the right hand and book in left hand, resting his feet on a footstool held up by a half-length man, all enclosed in a niche of elegant architectural details. On the reverse is the martyrdom of St Andrew, with the two executioners tying the saint on a saltire cross. This is discussed below (see p. 233).[1]

Bishops' Seals

NO matrices are extant for any of the medieval bishops of Rochester. The extant series of wax impressions of the seals runs from Gundulf onwards, but is not complete. There may have been earlier seal matrices, but these have not survived. Anglo-Saxon bishops had seals from the 9th century, and it is possible that one day a metal detector may bring the seal matrix of an Anglo-Saxon bishop of Rochester to light.[2] Bishops' seals of the late 11th and early 12th century varied considerably. Sometimes the bishop was shown standing, sometimes seated; sometimes, as with Gundulf, on a circular seal and sometimes on an oval seal. The first known wax seal of a bishop of Rochester is that of Gundulf (Fig. 2). T. A. Heslop suggests it was engraved at the beginning of his episcopate (after 1077), although the only known example is from 1103. Gundulf is shown standing, wearing a short chasuble, with outstretched arms raised slightly above the horizontal.[3] The circular shape and standing-figure pose is very similar to the seal of Odo, bishop of Bayeux and earl of Kent, whose unusual two-sided seal shows Odo as a bishop with sword, earl of Kent, and as a standing bishop on the other.[4]

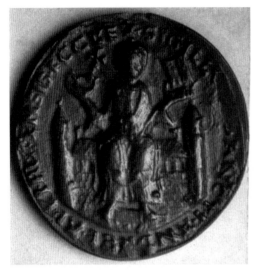

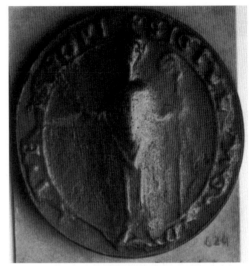

FIG. 1.　First Priory seal: Society of Antiquaries
cast B22

John Cherry

FIG. 2.　Seal of Gundulf: Society of
Antiquaries cast

John Cherry

The typical episcopal seal of the early 13th century shows a standing figure of the bishop in a pointed-oval shape. It has been pointed out that, in the mid-13th century, the dimensions of bishops' seals indicated the relative wealth of sees. For instance, Walter de Merton's seal as bishop of Rochester (height 67 mm) was only very slightly bigger than John Climping's (1254–62) as bishop of Chichester (63 mm), but considerably smaller than those of the bishops of Ely or Durham of the same period. However, it is not clear how this may have worked. Did the bishops agree the size, or was it a subtle distinction made by the goldsmiths?[5] It is worth noting that there was considerable variation in the size of the seals of the bishops of Rochester in the 13th century. Richard of Wendover (1238–50) has a seal 73 mm high (Fig. 3), while Laurence of St Martin (1251–74) one of 65 mm.

Increasingly in the 13th century, the space at the sides of the figures on episcopal seals is filled with various types of decoration. This first appears on the seal of Richard Grant, archbishop of Canterbury (1229–31), who has a niche between two smaller openings on each side of the figure, with a saint's head in profile in each, facing towards the central figure. At Rochester devices at the side of the figure first appear in the seal of Richard of Wendover (1238–50) (Fig. 3), whose seal has a cusped panel on each side of the figure containing the bust of a sainted bishop, each above a letter R (for either Richard or Rochester).[6]

Descriptions of Seals

ONE of the wax seals of the bishops of Rochester that has not survived is described in Thorpe's *Registrum Roffense*, which includes an account of the exhibition of a document of William of Bottlesham, bishop of Rochester (1390–1400):

... et ipsius patris sigillo in cera rubra sigillatum, in quo sigillo, ut mihi eidem notario apparuit, sculptae fuerant tres ymagines, videlicet, ymago sancti Andreae in medio dicti sigilli, et ex una parte

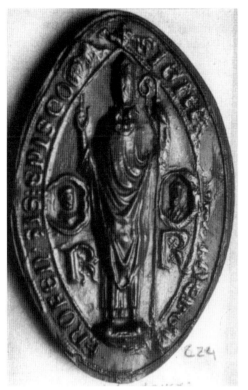 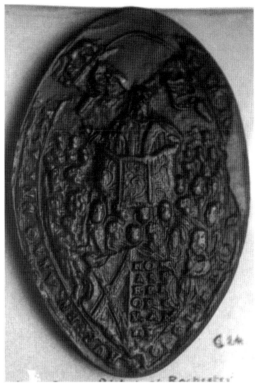

FIG. 3. Seal of Richard of Wendover: Society
of Antiquaries cast
John Cherry

FIG. 4. Seal of John Scory: Society of
Antiquaries cast
John Cherry

dictae ymaginis ymago sancti Petri, et ex parte altera ymago sancti Pauli in quodam tabernaculo sculpto, et in ipsius tabernaculi parte superiori ymago gloriosae virginis et matris domini nostri, et sub pede tabernaculi predicti ymago episcopi genuflectentis, et ex una parte dictae ymaginis, scutum habens in se figuram crucis sancti Andreae apostoli praedicti, et ex altera parte scutum armorum dicti episopi ut apparuit, et in dicto sigillo circumferencialiter scripta erant haec verba — Sigillum fratris Willelmi, dei gracia Roffen' episcopi

. . . and his seal was in red wax and on the seal . . . were three images, the image of St Andrew in the middle of the said seal and on the one side an image of St Peter, and on the other an image of St Paul, sculpted in a tabernacle, and, in the upper part of the tabernacle, an image of the glorious Virgin, the mother of our Lord, and on the one side there is the representation of the image of a shield having the device of the cross of St Andrew and on the other the shield of the said bishop, and in the around the edge of the seal is written this inscription The Seal of William, by the Grace of God, bishop of Rochester . . .[7]

David Williams has discussed other such descriptions. The seal of the Cistercian abbey of Dore, Gwent, was described by a notary in 1329 as being impressed 'in red wax, with the image of an abbot standing, clothed in abbatial vestments with a crozier in his right hand and a book in his left hand, on the right side a shield'. Williams notes the description of the seal by the archdeacon of Prague in 1336, which was a hanging

seal of white wax bearing images of God and the blessed Virgin (both seated in glory), with the legend along the perimeter. Another example relates to the Cistercian abbey of Cirta (Romania) in 1440. Both the descriptions of the abbot's seal and the monastic seal refer to the shape of the seal, the imagery contained within it, and the legend around the edge.[8]

The Seal of John Scory, Bishop of Rochester

REFORMATION of doctrine at the end of the middle ages made it necessary to change traditional forms of seals. Standing figures of bishops fully vested, wearing mitre and holding a crosier, were not appropriate for the reformed bishops any more than the depiction of saints, the Virgin and Trinity.[9] John Scory, bishop of Rochester (1551–52), had himself shown in a pulpit surrounded by eager listeners to stress the value of preaching and the sermon (Fig. 4). Scory was an interesting bishop. Starting as a Dominican friar at Cambridge in 1530, he became bishop of Rochester in 1551, Chichester in 1552, and was deprived on the accession of Mary in 1553. He made his peace with the Marian bishops and was allowed to officiate, but then left England for Holland, to return at the beginning of the reign of Elizabeth. By 1559, he was appointed to Hereford, dying there in 1585.[10]

Counter-seals

IT has been suggested by John Dalton that counter-seals, rather than the seals of dignity of bishops, offered greater opportunity for invention in both palaeography and use of devices. At Rochester this may be demonstrated by the counter-seals of Laurence of St Martin (1251–74) (Fig. 5) and Richard of Wendover (1238–50) (Fig. 3), which show respectively a standing figure of St Andrew and St Andrew with his cross.[11]

Archdeacons' Seals

THE most recent discussion of early archdeacons' seals is that of Professor Brian Kemp. He confined himself to the 12th century, and recorded seventeen seals, most of which show the archdeacon standing.[12] Archdeacons' seals dating to after 1200 were discussed by St John Hope who, in 1893, knew of only sixty-six seals for the 2,200 archdeacons in England and Wales between 1066 and 1540.[13] The seal of the official of the archdeacon of Rochester has recently been discovered in the Herne Bay area, Kent. This pointed-oval copper-alloy matrix (32 x 20 mm) (Fig. 6) shows a bust in profile of a tonsured man beneath two crossed sticks. The blackletter legend reads ' + s' officia' archidiaconi rof'es'. It is unusual, since it bears the symbol of the patron saint of the see with a head in profile beneath (the official?), and probably dates to the 14th century.[14] The arrangement is similar to that of the seal of the official of the archdeacon of Lewes, East Sussex, which shows a head above two fishes.[15]

The City Seal

THE fine seal of the city of Rochester is a copper-alloy double matrix (Figs 7 and 8). The obverse, with a legend indicating that it is the seal of the commune of the city of Rochester, bears the martyrdom of St Andrew, patron saint of the city. The clothing and the effect of the two different postures of the executioners are remarkable. The face

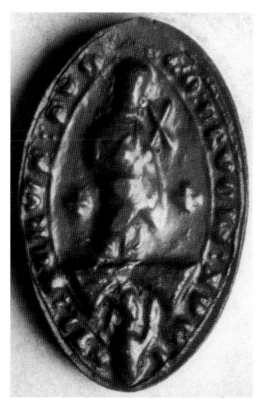

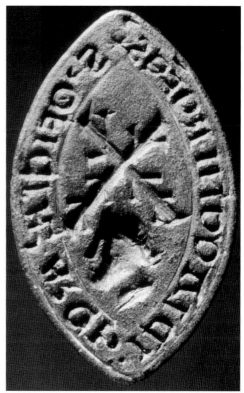

FIG. 5. The counter-seal of Laurence of St
Martin: Society of Antiquaries cast

John Cherry

FIG. 6. The official of the archdeacon's seal in
the Schøyen collection

Richard Linenthal

and tunic of the saint are finely engraved, and behind the saint's head is a twelve-foiled
nimbus. The reverse shows the castle with turrets, brattice work, fore-building and
gatehouse. Rochester provides a number of depictions on seals of St Andrew. Both the
second priory seal and the town seal have the scene of the martyrdom, where two
executioners tie the saint to the X-shaped cross. However, the two designs are quite
different. In that on the town seal, the ends of the cross reach right into the legend, to
the outer pearled border, and the figures of St Andrew and the two executioners are
engraved with greater realism; St Andrew has a cusped mitre, and his draperies hang
from his arms. In the priory seal, both the executioners are pulling the cords, but in the
town seal their gestures are more exaggerated, their calves are more muscular, and the
right-hand executioner places his foot against the hip of St Andrew.[16] Another
interesting depiction of St Andrew is on the seal of Simon de Clyve, prior of Rochester
(1252–72). This shows the prior standing on a corbel with the figure of St Andrew (with
halo) superimposed in front of him (Fig. 9).[17]

Seal Matrix of the Wardens of the Bridge

ROCHESTER is famous for its medieval bridge, and the Bridge Chapel was dedicated
to the Holy Trinity, hence the depiction of the Trinity on the seal (Fig. 10). The new

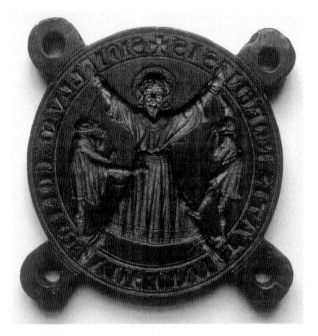

FIG. 7. The city seal of Rochester: obverse
Copyright and Courtesy of the Guildhall Museum, Rochester

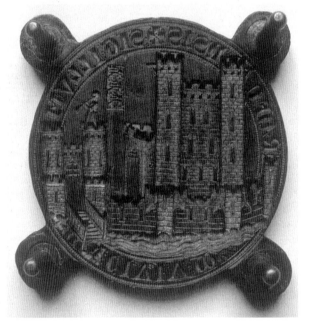

FIG. 8. The city seal of Rochester: reverse
Copyright and Courtesy of the Guildhall Museum, Rochester

bridge, virtually complete by 1391, and the acquisition of property to provide funds for its maintenance led to the creation of the Wardens and Commonalty of the Bridge, which placed the administration in a legally recognised framework of rights and

FIG. 9. Seal of Simon de Clyve, prior of
Rochester 1252–72: Society of Antiquaries cast
John Cherry

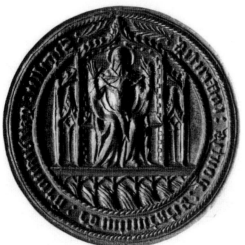 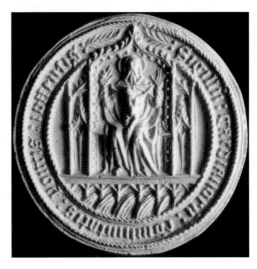

FIG. 10. The matrix and an impression of the seal of the Wardens and Commonalty of the Bridge
Reproduced by courtesy of the Trustees of the British Museum

235

responsibilities. On the confirmation of this arrangement by the King in parliament in 1421, the Commonalty established its right to have a common seal for all business relating to the bridge. The surviving copper alloy seal in the British Museum, which shows the bridge with seven arches with water flowing under it, probably dates to 1421. In 1576, Lord Abergavenny gave a new common seal, to be made of silver, to be used for the affairs of the bridge, and the 1421 seal fell into disuse. It was acquired by the British Museum in 1862 from William Webster, a well-known coin dealer.[18]

Place of Manufacture

THERE is no documentary evidence for the place of manufacture of any of these seals, though Canterbury is a likely candidate for the manufacture of seals used in Rochester, especially considering the closeness of the relationship between the bishops of Rochester and the archbishops of Canterbury. Both T. A. Heslop and W. Urry have examined the activity of seal engravers in Canterbury in the early 13th century. It is clear that there were at least two goldsmiths working for the cathedral, Simon and Nigel. We know little about them, but the provision by the cathedral for 4s. 1d. for 'preparing the little house for Simon, the goldsmith, for making a new seal' in 1221 suggests that he did not have a permanent workshop in the city.[19] It seems unlikely that the city and the bridge seals were engraved in Rochester, and they may have been engraved by London or Canterbury engravers.

APPENDIX

SIR WILLIAM ST JOHN HOPE AND THE COLLECTION OF CASTS
IN THE SOCIETY OF ANTIQUARIES OF LONDON

WHEN William St John Hope arrived at Burlington House as Assistant Secretary from Rochester in 1885, he had already indicated his interest in seals. He had spoken on seals to the Antiquaries, especially on 'The Seals of the Colleges and the University of Cambridge' (26 February 1885). In this lecture he exhibited his own collection of impressions and casts, which he had built up since his undergraduate days. It is also noted that the impressions in the possession of the Society were laid upon the table, and at the end of the lecture St John Hope presented to the Antiquaries those seals of his own that were not in its collection.[20] He had also published the seal and counter-seal of the City of Rochester.[21] He would have found an interesting body of material in the Antiquaries' cast collection. Casts and impressions had been acquired by the Society sporadically in the 18th and early 19th century, but the most valuable acquisition was the Prattinton collection of Worcestershire seals acquired in 1841. This was greatly enlarged by the bequest of the collection, numbering some 4,000 examples, of Albert Way in 1874.[22]

In the twenty-five years that St John Hope held the position of Assistant Secretary, he published at least fifteen articles on seals, and more on civic regalia that included seals. Most appeared between 1886 and 1902. The most notable were on bishops' seals (originally given as two lectures to the Society of Antiquaries on 3 and 10 February 1887),[23] and on town seals (such as those of Gloucester, Burford, Hull and Appleby). These publications culminated in the general survey of English and Welsh municipal seals of 1895.[24] In addition, St John Hope published on archdeacons' seals, and 12th- and 13th-century great seals.[25] After 1911, he published little on seals, but did include a fine series of heraldic seals of the late Middle Ages in his *Heraldry for Craftsmen and Designers*, in the Artistic Crafts series of Technical Handbooks in 1913, many of which were drawn from the Antiquaries' collection. His publications are listed in *The Bibliography of the Published Writings of Sir William St John Hope*, edited by A. Hamilton Thompson (Leeds 1929).

NOTES

1. W. de G. Birch, *Catalogue of Seals in the Department of Manuscripts in the British Museum* (London 1887), nos 2166 (12th-century seal), 2167 (13th-century seal, impression made in 1459); VCH, *Kent*, II (1926), 126. The seal assigned to the priory in VCH, namely London, British Library Harleian Charters 44.1.4 (1371), is in fact the seal of John Hertley, the prior; see Birch, *Catalogue*, no. 3920.

2. T. A. Heslop, 'English Seals from the mid-Ninth Century to 1100', *JBAA*, 133 (1980), 1–16.

3. Heslop, 'English Seals', 11; Birch, *Catalogue*, no. 2145. This is from a sulphur cast from the charter of 1103, which is Rochester Dean and Chapter muniment 778.

4. D. M. Stenton and L. C. Lloyd ed., *Sir Christopher Hatton's Book of Seals* (Oxford 1950), no. 431, pl. viii.

5. For Walter of Merton's seal, see P. Binski ed., *Age of Chivalry*, exhibition catalogue (London 1987), no. 281; also Birch, *Catalogue*, no. 2154.

6. J. P. Dalton, *The Archiepiscopal and Deputed Seals of York* (York 1992), 32–33.

7. J. Thorpe, *Registrum Roffense* (London 1769), 129–30.

8. D. H. Williams, *Catalogue of Seals in the National Museum of Wales*, II (Cardiff 1998), 1.

9. M. Aston, 'Bishops, Seals, Mitres', in *Life and Thought in the Northern Church*, ed. D. Wood (Bury St Edmunds 1999), 183–226.

10. Birch, *Catalogue*, no. 2157; *DNB*, XVII, 946–47. St John Hope refers to the seal of John Scory in the *Proceedings of the Society of Antiquaries of London*, 2nd series, 11 (1885–87), 287.

11. Dalton, *Archiepiscopal and Deputed Seals*, 7 and 29. For the seal of Richard of Wendover, see Birch, *Catalogue*, no. 2148.

12. B. R. Kemp ed., *Twelfth Century English Archidiaconal and Vice-Archidiaconal Acta* (Woodbridge 2001), xl–xlii.

13. *Proceedings of the Society of Antiquaries of London*, 2nd series, 15 (1893–95), 27.

14. In the Schøyen collection (London and Oslo), no. MJ16. It is reproduced by kind permission of the owner.

15. Antiquaries' cast collection C39.

16. St John Hope, 'The Seal and Counter Seal of the City of Rochester', *Archaeologia*, 49, 2 (1886), appendix, 453–55, with fine engravings of the seal opposite p. 454; G. Pedrick, *Borough Seals of the Gothic Period* (London 1904), 106–07; J. Cherry, 'Imago Castelli: the Depiction of Castles on Medieval Seals', *Château Gaillard*, 15 (1992), 85–90.

17. Birch, *Catalogue*, no. 3919.

18. A. B. Tonnochy, *Catalogue of British Seal-Dies* (London 1952), no. 187, 31 (BM MME 1862, 2–19, 1). The reference to the purchase is BM MME Letter Book 12 May 1886. See N. Yates and J. M. Gibson, *Traffic and Politics: The Constuction and Management of Rochester Bridge AD 41–1991* (Woodbridge 1994), 45–53.

19. T. A. Heslop, 'The Conventual Seals of Canterbury Cathedral, 1066–1232', in *Medieval Art and Architecture at Canterbury before 1220*, BAA Trans., v (1979), 1982, 94–100; William Urry, *Canterbury under the Angevin Kings* (London 1967), 112–13. See also Binski, *Age of Chivalry*, 116.

20. St John Hope, 'The Seals of the Colleges and of the University of Cambridge', *Proceedings of the Society of Antiquaries of London*, 2nd series, 10 (1883–85), 225–52.

21. See above, n. 16.

22. *Proceedings of the Society of Antiquaries of London*, 2nd series, 6 (1873–76), 200, 313, 446–48.

23. *Proceedings of the Society of Antiquaries of London*, 2nd series, 11 (1885–87), 271–306.

24. W. H. St John Hope and L. Jewitt, *The Corporation Plate and Insignia of Office of the Cities and Towns of England and Wales*, 2 vols (London 1895).

25. *Proceedings of the Society of Antiquaries of London*, 2nd series, 19 (1902), 60–65.

The Building Stones of Rochester Castle and Cathedral

BERNARD C. WORSSAM (with an Appendix by JEREMY ASHBEE)

Kentish Rag, or Ragstone, quarried near Maidstone, Kent, only 15 km or so along the River Medway from Rochester, was well suited for building Rochester Castle, and has been the principal stone for rough-walling at Rochester Cathedral at all periods. For finer work, the castle and cathedral builders made use of freestone. In the castle this was mainly Caen stone together with, as now discovered, Taynton stone. In the cathedral in the late 11th and early 12th centuries Caen stone, Reigate stone, calcareous tufa, Marquise Oolite (from northern France), and some Taynton stone were employed. In the later 12th and the 13th centuries, Caen and Reigate stones were supplemented by the exotic onyx and Tournai marbles, and the more local Bethersden and Purbeck marbles, while Taynton stone was a significant building stone in the crypt in the first phase of reconstruction of the eastern arm of the cathedral after the fire of 1179. Leading architects were employed for major 19th- and early-20th-century restoration works: L. N. Cottingham in 1825–41 made much use of Bath stone; Sir George Gilbert Scott in 1867–76 introduced Chilmark stone, from Wiltshire; and J. L. Pearson in 1888–94 and C. Hodgson Fowler in 1904–07 used Weldon stone, from Lincolnshire.

ROCHESTER CASTLE

Eleventh to Twelfth Century

THE principal building stone of Rochester Castle is Kentish Ragstone, a hard grey sandy limestone from the Hythe Formation (Lower Greensand), quarried around Maidstone (Fig. 1).[1] The castle's earliest extant stonework, dating to 1087–89, in Bishop Gundulf's time, is in the lower part of its western curtain wall, overlooking the Medway. The wall is faced with roughly shaped blocks, laid in irregular herringbone fashion, mainly of Ragstone but with some 5–10 per cent of chert (a black-weathering siliceous stone occurring as lenses within Ragstone layers in the upper part of Maidstone quarries) and a few flints. Some pieces of tufa and Roman brick in the facing and layers of chalk rubble in the wall core were recorded by Canon Livett.[2]

The castle keep was built in 1127, in the reign of Henry I, very largely of Kentish Ragstone with chert. Masons at that date seem to have been incapable of dressing Ragstone, and for carved stonework used Caen stone, a pale-yellow fine-grained limestone from Normandy, together with a significant proportion of a brownish-yellow cross-bedded shelly oolitic limestone, not hitherto recorded at the castle, and identifiable as Taynton stone, from Oxfordshire.[3] Taynton village is in the valley of the River Windrush, a tributary of the Thames, facilitating transport of the stone to

238

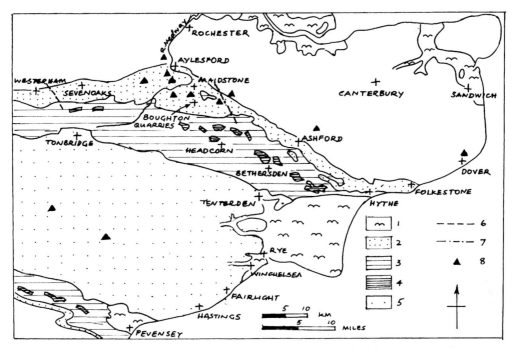

FIG. 1. Locality map, showing outcrops of formations yielding building stone. 1. Alluvium.
2. Lower Greensand. 3. Weald Clay. 4. Large-'Paludina' limestone. 5. Hastings Group.
6. Western limit of Kentish Ragstone. 7. Eastern limit of main development of chert in Kentish
Ragstone. 8. Travertine (calcareous tufa) sites recorded by Pentecost (1993)

Rochester, for the most part by water. A third variety of stone in the keep is dark-brown ferruginous sandstone from the Folkestone Formation of the Lower Greensand, probably from an outcrop near Aylesford, north of Maidstone, though this occurs only as a few large squared blocks at the base of the central pilaster buttress on the east side of the keep, with others at about the same level at the south-west and north-east corners of the keep.

Caen stone is most conspicuous externally as the small squared blocks used for quoins to the keep's corner turrets and pilaster buttresses. It also forms a double string-course at the original ground level, 1 m or so above the present ground surface, on the east and west sides of the keep. Internally it was used for dressed stonework in the chapel, and for the shafts and chevron-moulded heads of the arches of the great arcade at the second or principal floor level of the keep (reddened by burning, particularly on its north side). It was also used for the attached shafts and moulded heads of arches of the mural gallery that surrounds this floor on all four sides. However, the capitals of the arcade and the imposts of the gallery arches are of Taynton stone. The arches of the mural gallery of the third, highest, residential floor have surrounds partly of Caen, partly of Taynton stone, apparently at random. The Taynton stone has proved to be more weather-resistant than the Caen stone (Fig. 2), and its availability in larger blocks than the Caen stone made it more suitable for the arcade capitals. It was similarly used for arcade capitals in the Chapel of St John in the White Tower of the Tower of

FIG. 2. Rochester Castle: attached column flanking an arch of the mural gallery that surrounds the Great Hall, at second-floor level of the keep. The impost, of Taynton stone, shows cross-bedding etched out by weathering. Below and above it (severely corroded by weathering) is light-coloured Caen stone, and to the left is soot-encrusted Kentish Ragstone. In the background is the chevron-moulded head of an arch in Caen stone

London, dating from just before 1100 — the column shafts there are partly of Caen, partly of Quarr stone.

The imposing main entrance arch to the keep from the castle forebuilding is of Caen stone, except for four blocks of Taynton stone in the jamb on its east side. Externally, Taynton is more commonly used than Caen stone for the chevron-moulded heads, as well as for jambs, of those window openings that have not been robbed of their ashlar surrounds — mainly at the third-floor level of the keep. There is also some minor use of Taynton stone high up in quoins.

Thirteenth Century

REPAIRS to the castle by Henry III after King John's siege of 1215 included the construction in Kentish Rag of the drum tower at the south-east corner of the curtain wall, and the rebuilding with a half-round rather than a square turret of the south-east corner of the keep.[4] At the level of the wall-walk at the summit of the keep, this turret differs from the other three in having doorway surrounds of Reigate rather than Caen stone, and its quoins below the top 1–2 m of the turret (which appears to have been reconstructed in 1897–1904) are of Taynton stone, except for some (probably 1897–1904) Kentish Rag inserts. Some flat window lintels are also of Taynton stone,

and there is one remaining Taynton coping stone on a battlement merlon adjoining and bonded into the south-west corner of the turret. If not reused, this stonework would indicate a shipment from Taynton several years after the last to the cathedral (see below). The use of Taynton stone in Royal works continued, of course, into the 15th century, notably for St George's Chapel, Windsor (1475–83).

Reigate stone is a grey, soft, finely glauconitic, siliceous stone from the Upper Greensand formation. In post-medieval records it is alternatively known as firestone.[5] It made a rather late appearance in the castle, for it was in use in the cathedral in the late 11th century. In the post-1215 rebuilding of the south-east corner of the southern cross-hall, the mural gallery openings were given plain round heads in Reigate stone, and at the same time the south sides of the two eastern arches of the central arcade received plainly moulded Reigate soffits, now much decayed. Reigate stone was also used for window dressings in the south-eastern drum tower, and in the surviving western wall of Henry III's residential buildings in the castle's outer bailey, abutting against and oversailing Gundulf's western curtain.

Fourteenth Century and Later

FURTHER restoration of the castle took place in 1367–83, in the reign of Edward III. Accounts from 1368–69 show the acquisition of 55 tuns (or tons) of Beer stone (from Devon), 62 of Caen stone, 44 of Reigate stone, 43 of Stapleton freestone (a variety of Magnesian Limestone from south Yorkshire), and 195 of freestone from Fairlight, near Hastings (Fig. 1), identifiable as Cliff End Sandstone, a Hastings Group (Wealden) sandstone, shipped from Winchelsea.[6] Kentish Ragstone was obtained from Boughton Quarries, south of Maidstone, ready worked into standard shapes such as 'scuassheler' (or skew ashlar, for sloping plinths), 'crest' (for coping stones) and 'nowel' (or newell, for spiral staircases) — stonemasonry technique had clearly advanced since the days of Henry I. Chert, too hard and splintery to be dressed, was not included in this worked stone. A recently discovered 1374 inventory of building materials at the castle (see Appendix) corresponds remarkably with the 1368–69 list, and shows that only some 10 per cent of the building stone ordered six years previously remained in store. To date, Beer stone (a type of hard chalk) and Magnesian Limestone have not been identified at the castle, though some blocks of a Wealden sandstone stitch across the join between Edward III's eastern mural tower and the curtain wall to its north.[7]

Portland stone was introduced for the Norman-style north-western entrance arch to the castle in 1872. In extensive reparations between 1897 and 1904, Kentish Rag was deliberately used for quoins, jambs and arches, so that it might serve as an indicator of repairs then carried out.[8]

ROCHESTER CATHEDRAL

A guide to the building stones of Rochester Cathedral, with notes on their geology and on how to identify the different types, has been published fairly recently; it is supplemented by a detailed record of the stonework of the cathedral crypt.[9] In the present paper the types of building stone that have been used in the cathedral are described in chronological sequence.

Late Eleventh to Early Twelfth Century

ONE must start with the westernmost two bays of the crypt, dating from the time of Bishop Gundulf (1077–1108). While the surviving fragment of his curtain wall at the castle, with its rough herringbone-layered Kentish Rag, may look primitive, his crypt shows a careful ordering of stone types. The outer walls are of Kentish Rag rubble, but the interior body of the crypt is bounded by massive piers faced with squared blocks of calcareous tufa, a stone also used for the jambs of former window-openings in its north and south aisles. Tufa was widely used in south-east England in the early Norman period, but seems to have been worked out by the mid-12th century.[10] Known deposits in Kent are mostly in the vicinity of Maidstone (Fig. 1). The groin-vaulted roof of the central part of the cathedral crypt is supported by two monolithic columns of Marquise stone with cushion capitals, and by round half-columns, against the walls, of calcareous tufa with Marquise capitals. The aisles have flat tufa pilasters with Reigate stone capitals to support their vaults. Marquise stone, a pale grey, unusually coarse-grained oolite from near Boulogne (Pas-de-Calais), is elsewhere known in England only in east Kent, where it was shipped to Canterbury from France in the 1080s, but supplies seem to have been cut off soon after then.[11]

Early stonework is also seen in 'Gundulf's Tower' on the north side of Rochester Cathedral, a 12th-century free-standing bell-tower in origin.[12] Its walls are of coursed rubble of Kentish Rag with wide mortar joints, while its pilaster buttresses have tufa quoins. Within the cathedral, the south arcade has plain orders of early-12th-century date on its aisle side, which are faced with tufa beneath present-day whitewash.[13]

The chapter-house and the monks' dormitory, on the east side of the cloister, were first built, of Kentish Rag with Caen stone dressings, in the time of Bishop Ernulf (1114–24), and it seems highly likely that three remaining upper windows of the chapter-house date from this time.[14] Round shafts of oolitic limestone flanking these windows are now recognisable as being of Taynton stone, slightly pre-dating its use in the castle keep in 1127. Four shafts survive in place; a 50 cm length of another is among rubble stonework infilling a wide Norman arch beside and to the north of the chapter-house doorway.

Mid-Twelfth Century

AFTER a major fire in 1137, the lower half of the west wall of the chapter-house and an adjoining doorway into the dormitory were refaced in Caen stone, with remarkably fine carving.[15] Black Tournai marble shafts flank this doorway and that into the chapter-house. The same fire so damaged the cathedral nave and west front that they needed complete rebuilding: the present nave is therefore dated to the 1140s and 1150s, and the west front to about 1160.[16] The nave arcades rebuilt at that time (except part on the south aisle side) are faced in Caen stone, relieved only by the appearance in the diaper patterning of the infill of triforium arches towards their east end of some Reigate stone; this presages the increasing use of Reigate rather than Caen stone for interior work from the late 12th century.

Except for the great Perpendicular window, the west front, owing to late-19th-century restoration, essentially presents its mid-12th-century appearance. It would then have been faced almost wholly with Caen stone. The sculptures of King Solomon and the Queen of Sheba beside the west doorway are of Caen stone, but the shaft of the outermost column on the north side of the doorway is of onyx marble, as was,

probably, the corresponding column on the south side. From a letter dated 1894 in the cathedral archives it seems possible that other columns of onyx marble were employed in the 12th-century decorative scheme disrupted when the west window was inserted in the 15th century.[17] Onyx marble is a hard, crystalline variety of travertine that would have been imported at great expense from the Mediterranean. Weathered columns of the marble in Bishop Ernulf's blind arcade fronting the monks' dormitory undercroft, along the east side of the cloister, may have been inserted in the mid-12th century.[18] At the south end of the arcade is a column of onyx marble, found loose in the cloister and inserted in 1992 by the late Martin Caroe when cathedral architect, freshly polished so that the original appearance of the stone could be appreciated.[19]

Late Twelfth to Thirteenth Century

A second major fire, in 1179, destroyed the whole eastern arm of the cathedral; rebuilding, starting with the crypt, is believed to have taken place from *c*. 1180 to 1200. Taynton stone was used for the twenty monolithic columns and forty-eight responds that support the crypt's vaulted roof, and also, to judge from a few remnants, for a plinth course for the whole crypt and for sills to the twenty-one crypt windows. Supplies of this stone seem to have come to an end with completion of the crypt, for it has not been seen at any higher level in the cathedral.[20] Another stone, use of which was discontinued during the course of building, was a dark-grey polished snailshell-limestone from the Weald Clay, used for the entrance doorway to the crypt from the south choir aisle and for columns beside the crypt window that was originally the entrance doorway from the cloister. It was also used for the abaci of columns and for a string-course at abacus level around the walls of the western part of the rebuilt crypt, but its place was taken by Purbeck Marble (a geologically older snailshell-limestone from Dorset) farther east in the crypt. The geological name of the Weald Clay limestone is Large-'Paludina' limestone. It has lens-shaped outcrops in Kent and East Sussex (Fig. 1), and farther west in Surrey and West Sussex (where it is known as Petworth Marble or Sussex Marble). For convenience, the name Bethersden Marble is given to the stone used in Rochester.

In the south-west corner of the cloister the early-13th-century entrance to the monks' lavatorium and refectory is of Reigate stone with a doorway surround of Purbeck Marble, both badly corroded by weathering.

Internally the presbytery, architecturally perhaps the finest part of the cathedral, and the east or choir transepts, have ashlar walls partly of Caen, partly of Reigate stone, and multiple columns with shafts of Purbeck Marble, though the bases of the columns in the presbytery and in much of the south choir transept are of Bethersden Marble.

The Purbeck Marble columns attached to the south wall of the south choir transept tilt southwards at an angle, varying slightly from place to place, of about 1 in 24 (or 2.5° from the vertical), as does the wall itself in its lower part, while the piers in the first east–west row inwards from the south wall also tilt, though less markedly. Smaller columns at the clerestory level are more nearly vertical. There must therefore have been instability soon after building of the transept started, the effect of which was corrected as building proceeded. The instability was attributed by St John Hope to the absence of buttresses on the south side of this transept, owing to the presence of the cloister there.[21]

The rebuilding in Early English style of the choir, the west transepts and crossing, and the eastern two bays of the nave arcades followed that of the presbytery and choir

transepts, and continued until the last decade or two of the 13th century.[22] Walls that are not rendered are generally faced with Reigate stone. In the north choir aisle, Purbeck Marble is sparingly used, for the abaci of capitals and for some bases and annulets to attached shafts of Reigate stone. The Reigate stone east arch of the crossing and the arches from the transepts to the choir aisles also show restricted use of Purbeck Marble, but in the slightly later north transept Purbeck Marble shafts are important elements of the design. In the south transept, Purbeck Marble is used for four tall columns and two intermediate shortened ones that support the roof vaults, and for the numerous small columns around the clerestory windows.

A scheme to reconstruct the Norman nave came to a halt after only the two eastern bays on each side had been given pointed arches. A solid buttress was built into the first bay on the north side, to support the north-west tower pier. As St John Hope noted, the shafts around the first reconstructed pier on each side are detached and of Purbeck Marble, while those around the second are 'worked out of the stone' of the piers (which is Caen stone) and are partly painted dark grey, in imitation of marble.

Fourteenth to Sixteenth Century

IN the south choir transept the very finely carved early-14th-century Decorated doorway to the chapter-room/library, built at that time in the angle between this transept and the presbytery, is of Reigate stone.

A fire in the crypt, probably in the 14th century, caused reddening of the Taynton stone of many of the crypt columns, and led to the replacement of three of them with columns of Kentish Ragstone, which most unusually for this very hard stone have monolithic shafts. In the same century, the north-east corner of 'Gundulf's Tower' was given two large angle-buttresses, with quoins of a Wealden sandstone which quite possibly, like the sandstone delivered to the castle in 1368–69, came from Fairlight.[23]

The 15th-century west window of the nave was probably originally of Caen stone.[24] The window was found by the architect Lewis Cottingham in 1825 to be beyond repair, and reconstructed by him in Bath stone. The nave clerestory, faced externally with Caen stone varied with patches of red tiles set edgeways, is also of the 15th century.[25] Its plain Kentish Rag parapet probably dates from the early 19th century. Five two-light Perpendicular windows with Kentish Rag tracery survive in the north wall of the nave. A sixth has been rebuilt in Portland stone, probably in the late 18th or early 19th century. The westernmost window is of Kentish Rag and has a central mullion apparently of Weldon stone, presumably a late-19th-century repair, while in 1981 all five Kentish Rag windows received new hood mouldings and partial repairs to jambs, sills and mullions of Chilmark stone acquired second-hand from Westminster Abbey, then undergoing restoration.[26]

The Lady Chapel, originally the nave for an enlarged chapel previously confined to the south-west transept, was the last major addition to the cathedral, started in the 14th century, but only completed, except for a projected vaulted ceiling, in the early 16th century, possibly in 1512–13.[27] Its exterior stonework shows competent late-medieval masonry in its use of building stone for decorative as well as structural effect (Fig. 3). To judge from surviving remnants, quoins and windows were originally of Caen stone, but the replacement of the quoins with white Portland stone by the architect Daniel Alexander in 1801 and the later repair of the windows with Bath stone have produced a harsher effect than the Caen stone would have presented.

FIG. 3. Rochester Cathedral: the Lady Chapel, south elevation. The plinth is of Kentish Ragstone
ashlar capped by a string-course partly of Kentish Rag and partly of replacement Portland stone
(the stones with sharp arrisses). The walls and buttresses are faced with small squared ragstone
blocks. Square knapped black flints form a decorative string-course just below window sill level
and infill the front of buttresses between the quoin stones. These latter are of white Portland stone,
replacing original Caen stone. The window stonework, originally of Caen stone, which shows
some decay in the window jamb, is in part repaired with harder Bath stone

Nineteenth and Twentieth Centuries

LEADING architects were employed for the 19th- and early-20th-century restoration
works: Daniel Alexander, 1799–1804; Lewis Nockalls Cottingham, 1825–30 and
1839–41; Sir George Gilbert Scott, 1867–76; John Loughborough Pearson, 1888–94;
and C. Hodgson Fowler, 1904–07.

 Daniel Alexander's repair of the Lady Chapel included demolishing a high gable
presumably meant to take a high roof over the vaulted ceiling that was never installed;
in its place he gave the chapel its plain Kentish Rag parapet. He refaced the south wall
of the cathedral nave with Kentish Rag and reused Caen stone, and advocated galleting;
that is, sticking chips of stone in the mortar joints when walls were repointed.
Mullioned windows in the south nave wall had been repaired with Portland stone in
1783; Alexander replaced them with the present three Portland stone lancets.[28]

L. N. Cottingham, as well as rebuilding the cathedral's west window and carrying out many repairs to roofs and to the interior, took down the old spire and the upper part of the tower, replacing them with a taller tower to his own design, faced with Bath stone, with four corner pinnacles but no spire. He also strengthened the south wall of the south choir transept, which had shown continued instability during the 18th century, facing it all in Bath stone, except for a low plinth of Portland stone with a York stone capping. His Bath stone came from Combe Down quarries south of Bath, Somerset, and was probably transported via the Kennet and Avon Canal, which had been opened in 1810. The cathedral building accounts show that in 1833, in the interval between Cottingham's two campaigns, a Rochester monumental stonemason, William Brisley, over a period of three months replaced six crypt columns (except for their bases) and three capitals plus abaci of other columns, using Portland stone, York stone and Dartmoor granite, presumably from his stock, for the quite modest sum of £66 9s. 11d.[29]

Gilbert Scott carried out much restoration of the cathedral's east end and west transepts, and strengthened the south choir aisle with a bold flying-buttress from ground level. His preferred ashlar stone was Chilmark stone, from Wiltshire, a grey, fine-grained calcareous sandstone or sandy limestone. Like the closely similar Tisbury stone, the building stone used with success at Salisbury Cathedral, Chilmark stone was largely restricted to Wiltshire and north Dorset until the coming of railways. For decorative shafts on Rochester's north-west transept exterior Scott introduced Kilkenny Marble, a variety of Carboniferous Limestone from Ireland, which he had also used in Westminster Abbey.

In 1888, J. L. Pearson found that the west front of the cathedral was in a dangerous condition, with its facing not properly bonded to the rubble core of the wall, and the whole in need of underpinning owing to its foundations' having been carelessly laid in the mid-12th century.[30] He also found that the upper parts of the two outer turrets of the west front were completely missing; that the north-west nave turret had a 15th-century octagonal top in Kentish Rag (he removed it); and that only the turret at the south-west corner of the nave was in a tolerably original condition. In reconstructing the turrets to the design shown in an engraving of 1655, he made use of Weldon stone, a fine-grained oolite from Lincolnshire. This in fact provides a good match to the original Caen stone, helped by a limewash shelter coat given to the façade by Martin Caroe after stone-cleaning in 1992. Finally, in about 1894, Pearson used what is probably a variety of Weldon stone for new lancet windows on the south side of the crypt, where a medieval doorway and window openings had been blocked up in the late 18th century to help support the transept wall, above, and had been left blocked up, within a blind arcade, by Cottingham. Pearson used the same stone further east along the north side of the cloister for restoring as a tall two-light window with a Decorated traceried head an opening that had been fashioned of Caen stone, like a small doorway beside it. By the late 19th century, the opening had been walled up except at its head; St John Hope thought it had originally been the door-frame of a monks' book-closet.[31]

The last major restoration work was by Hodgson Fowler, who removed Cottingham's tower and designed the present lower tower and spire, facing the tower with Weldon stone. He reused the Bath stone from Cottingham's tower in rebuilding, complete with a battlemented Tudor-style bay window, the east end of the chapter-room/library.

APPENDIX

A MEDIEVAL INVENTORY OF THE WORKS' YARD IN ROCHESTER CASTLE

National Archives, E101 465/28 no. 14 (47 Edward III)

The following is a detailed inventory of all the building materials, tools and other goods in Rochester Castle on 14 May 1374. It represents the situation at the time of the hand-over from Prior John of Rochester, the outgoing 'master of the works', to the recently appointed William de Basyng.

Hec indentura testatur quod de precepto domini Regis Johannes prior Roffensis nuper magister operationum dicti domini regis in castro Roffe liberavit Willelmo de Basyng magistro hospitalis beate Marie de Strode contrarotulatori et supervisori operationum predictorum res et necessaria subscripta in castro predicto remanentia videlicet ix pondera dolii libere petri de Beer, i pondus dolii libere petri de Caine, vii pondera dolii libere petri de Stapilton, xxviii pondera dolii libere petri de Ffarleght, iiii peces petri de Boctone vocati Nowell, lxv pedes petri vocati Crest, (xx)iiii pedes petri vocati Spaces, cclxv pedes petri vocati tablement, lxii pedes petri vocati parpeincoins, ccxxv pedes petri vocati squarassheler, et xx pedes petri vocati urnel. Item de instrumentis fabri, i anuellum, iiii slegges, ii grossos martellos, iiii martellos parvos, ii kervynisnes, viii tonges, iii nailtols, i bicorne, i spentonge, viii punchonys, ii viles, i folour, i washer, i herthstaf, i grindston cum uno ferro ad idem, ii bolstres, i par sufflatorum, i toyer, i libram ad ponderanda diversa necessaria, ii wrestlattches, vi seruras, xliii peces maeremii querci, lxxii tabulas vocatas Wainscot, xii tabulas querci sarratas, ii fernes cum iiii rotulis eneis et iiii boltes ferreis pro eisdem, (xx)iiii scaffotloggs, ii wanges plumbi, i campanam cum apparatu, v martellos ferreos pro positoribus, iiii crowes ferreos, xv ligons, xx tribulos cum ferro, xii siuers, xl treyes, iii vasa lignea pro aqua imponenda debilia, iii cuvas, ii situlos cum cathenis ferreis pro eisdem, ii cabulas de canabo, ii cribros, i poukweyn debilem, iii ulnas panni lanei pro compotori, i sigillum pro officio, i securulum, xxxvii quartas carbonorum marinorum, i tobbe, i bussellum ferro ligatum, i grossam curtenam cum rotis, lx carratatas mortari, i piccher, i hemmer ferream, ii secura et iiii curtella ad scindendam cretam pro calce cremanda. Item pro aula et camera domini regis viii tabulas mensales, i copbord, ix paria tristallorum et xii formulas de maeremio querci. In cuius rei testimonio presentibus indenturis partes predicte sigilla sua altruatim apposuerunt. Datum apud Ffrendesbury in festo sancti Mathie Apostoli anno regni Regis Edwardi tertii post conquestum quadragesimo septimo.

This indenture witnesses that in accordance with the Lord King's command, Prior John of Rochester, lately Master of the said Lord King's Works in Rochester Castle, has delivered the following items and materials left in the said castle to William de Basyng, Master of Saint Mary's Hospital in Strood, Comptroller and Surveyor of the said Works, namely:

Nine tons of Beer freestone, one ton of Caen freestone, seven tons of Stapleton freestone, 28 tons of Fairlight freestone, four 'newel' stones from Boughton, 65 feet of 'cresting', 80 feet of 'spaces', 265 feet of 'tablement', 62 feet of 'parpen quoins', 225 feet of 'square ashlar' and twenty feet of 'urnel'.

Item, tools in the smithy, one anvil, four sledge-hammers, two large and four small hammers, two 'carving irons', eight tongs, three 'nail-tools', one anvil, one 'gripping tong', eight 'punchons', two files, one 'folour', one 'washer' [sprinkler], one 'hearth-staff' [poker], one grindstone with its iron, two bolsters, one pair of bellows and a tuyere, scales for weighing materials, two 'wrest-lacches', six locks, 43 pieces of oak, 72 panels of wainscot, twelve sawn oak panels, two cranes with their four bronze wheels and four iron bolts, 80 scaffold-poles, two lead 'wanges', a bell and its fittings, five iron hammers for the stone-setters, four iron crow-bars, fifteen mattocks, 20 iron-tipped shovels, twelve barrows, 40 trays, three damaged wooden water-containers, three tubs, two buckets with iron chains, two hemp ropes, two sieves, one damaged 'poukweyn', 3 ells of woollen cloth for the accountant, a seal for the workshop, a hatchet, 37 quarter-hundredweights of sea-coal, a tub, 1 bushel bound with iron, a large cart and its wheels, 60 cart-loads of mortar, a pitcher, an iron hammer, three axes and four knives to break up the chalk for lime-burning.

Item for the Lord King's hall and chamber, eight table-boards, a cup-board, nine pairs of trestles and twelve forms in oak.

In witnessing this business, the said parties have freely affixed their seals to these indentures. At Frindsbury, the feast of Saint Matthias the Apostle in the 47th year of the reign of King Edward the Third since the Conquest.

ACKNOWLEDGEMENTS

The author is indebted to Tim Tatton-Brown for much help and advice during the preparation of this paper. For any errors or omissions in the paper, however, the author is alone responsible.

NOTES

1. B. C. Worssam and T. Tatton-Brown, 'Kentish Rag and other Kent Building Stones', *Archaeologia Cantiana*, 112 (1993), 93–125.
2. G. M. Livett, 'Medieval Rochester', *Archaeologia Cantiana*, 21 (1895), 23–38.
3. W. J. Arkell, *Oxford Stone* (London 1947), 54–78.
4. R. Allen Brown, *Rochester Castle, Kent*, 2nd edn (EH 1986), 10–14, 40.
5. T. Tatton-Brown, 'The quarrying and distribution of Reigate stone in the Middle Ages', *Med. Archaeol.*, 45 (2001); R. Sanderson and K. Garner, 'Conservation of Reigate stone at Hampton Court Palace and HM Tower of London', *Journal of Architectural Conservation*, 3 (2001), 7–23.
6. L. B. L. (i.e., the Revd Lambert Larking), 'Fabric Roll of Rochester Castle', *Archaeologia Cantiana*, 2 (1859), 111–32.
7. Brown, *Rochester Castle*, photograph on p. 29.
8. G. Payne, 'The Reparation of Rochester Castle', *Archaeologia Cantiana*, 27 (1905), 177–92.
9. B. C. Worssam, 'A Guide to the Building Stones of Rochester Cathedral', *Friends of Rochester Cathedral, Report for 1994/95* (1995), 23–34; B. C. Worssam, 'The Building Stones of Rochester Cathedral Crypt', *Archaeologia Cantiana*, 120 (2000), 1–22.
10. G. M. Livett, 'Early Norman Churches in and near the Medway Valley', *Archaeologia Cantiana*, 20 (1893), 137–54; A. Pentecost, 'British Travertines: A Review', *Proceedings of the Geologists' Association*, 104 (1993), 23–40.
11. T. Tatton-Brown, 'Building Stone in Canterbury c.1070–1525', in *Stone: Quarrying and Building in England AD 43–1525*, ed. D. Parsons (Chichester 1990), 70–82.
12. T. Tatton-Brown, 'Gundulf's Tower', *Friends of Rochester Cathedral, Report for 1990/91* (1991), 7–12.
13. W. H. St John Hope, 'The Architectural History of the Cathedral Church and Monastery of St Andrew at Rochester, I: The Cathedral Church', *Archaeologia Cantiana*, 23 (1898), 219.
14. T. Tatton-Brown, 'The East Range of the Cloisters', *Friends of Rochester Cathedral, Report for 1988* (1988), 4–8; T. Tatton-Brown, 'The Chapter-House and Dormitory Façade at Rochester Cathedral Priory', *Friends of Rochester Cathedral, Report for 1993/94* (1994), 20–28.
15. Tatton-Brown, 'The Chapter-house and Dormitory Façade', 20, plus drawings by Jill Atherton; see also article by John McNeill in this volume, 181–204.
16. J. P. McAleer, 'The Cathedral West Front: Form, Function and Fashion', *Friends of Rochester Cathedral, Report for 1990/91* (1991), 23–36; see also the article by Richard Halsey in this volume, 61–84.
17. Diana Holbrook, *Rochester Cathedral: Repair and Restoration of the Fabric, 1540–1983* (RIBA/EH, London 1994). The letter, dated 24 June 1894, from the Dean of Rochester to J. T. Irvine, includes the passage: 'The stalagmitic [i.e., onyx marble] shafts remain in situ in the great west doorway and around and above the doorway other similar shafts entire (4ft 6in) were discovered, one was in situ in the jamb of the great window (upon the second string).'
18. Personal communication from Tim Tatton-Brown, who adds that the only other place where onyx marble was used at this time was for shafts in mid-12th-century work at Canterbury Cathedral and Priory; see Tatton-Brown, 'Building Stone in Canterbury', 74–75.
19. M. Caroe, 'From the Cathedral Surveyor', *Friends of Rochester Cathedral, Report for 1992/93* (1993), 4.
20. Worssam, 'Rochester Cathedral Crypt', 19.
21. St John Hope, 'Architectural History', 267–68.

22. ibid., 247–71; J. Newman, *West Kent and the Weald*, 2nd edn (*B/E*, 1976, reprinted with corrections 1980), 481; see also the article by Jennifer Alexander in this volume, 146–63.

23. Tatton-Brown, 'Gundulf's Tower', 9.

24. Tim Tatton-Brown, personal communication.

25. St John Hope, 'Architectural History' (1898), 278–79.

26. For this information I am indebted to Ian Stewart, Cathedral Architect; also to Diana Holbrook, *Rochester Cathedral: Repair and Restoration*, III, section 2. The Chilmark stone from Westminster Abbey had originally been used in later-19th-century restoration.

27. St John Hope, 'Architectural History', 280–81.

28. Holbrook, *Rochester Cathedral: Repair and Restoration*, 13, 79–81.

29. Worssam, 'Rochester Cathedral Crypt', 11.

30. G. M. Livett, 'Foundations of the Saxon Cathedral Church at Rochester', *Archaeologia Cantiana*, 18 (1889), 277.

31. W. H. St John Hope, 'The Architectural History of the Cathedral Church and Monastery of St Andrew at Rochester, II. The Monastery', *Archaeologia Cantiana*, 24 (1900), 32–32; Worssam, 'Rochester Cathedral Crypt', 17, 21.

The Medieval Buildings and Topography of Rochester Castle

JEREMY ASHBEE

Rochester Castle is dominated by its 12th-century keep, and studies of this single building have taken precedence in published accounts of the site. There exists a substantial body of contemporary documents describing the castle's other buildings, particularly in the reign of King Henry III (1216–72). Though these buildings have left almost no trace in the site today, some of their layout, location and appearance can be reconstructed from the evidence of medieval writs and building accounts. This reconstruction provides a valuable impression of a royal castle of middle rank, which Henry III knew well and visited frequently. A period of relative prosperity in the mid-13th century ended at Easter 1264 in a well-documented siege led by the rebel baron Simon de Montfort. The castle was badly damaged and many of its buildings were left unrepaired, to decay or to be looted for building materials. In the second half of the 14th century, when Edward III and Richard II undertook restoration and new building works, no attempt was made to replace the lost buildings of the royal lodgings. Most archaeological investigation to date has been concentrated around the perimeter defences of the castle. However, there remains considerable potential for matching the documentary evidence for the site's topography with excavation inside the bailey itself.

INTRODUCTION

ROCHESTER CASTLE is famous for a single building and a single event: the 12th-century keep and the siege of 1215, in which King John attacked and finally captured it. After this disaster, according to a contemporary annalist, 'few were prepared to put their trust in castles'.[1] In retrospect, this comment says more about John's resolution in siege-craft than the value of castles, and certainly, throughout the 13th century, his son and grandson were prepared to invest heavily in castle-building. At Rochester, the 1215 siege was not a cataclysm. In time the castle was repaired and strengthened, and for fifty years it enjoyed its period of greatest prosperity, under a king who visited it regularly and who took a personal interest in its buildings. This ended abruptly in April 1264 with another siege, this time by rebel barons attacking a royalist garrison. Though the castle held out until the siege was lifted, several of its most important buildings were badly damaged, and in terms of its functional history, 1264 rather than 1215 marks a turning-point. For the rest of the Middle Ages, the history of the castle is one of sparing use, occasional repair, general neglect and widespread vandalism.

Since the 1870s, the castle bailey has been administered as a public pleasure-ground by the City Corporation and its successors, and most visitors to Rochester Castle pay it little attention on their way to the keep. Its only other surviving buildings, two mural towers, are closed to the public, there are only a few graphics panels, and the ruined

towers and curtain walls are unlabelled. But Rochester Castle had an eventful history, at least in the 13th century, and the lawns of Castle Gardens are laid over the site of an extensive building complex. This paper sets out to describe the evidence, overwhelmingly from documents, for the lost medieval buildings inside Rochester Castle. The very few excavations carried out in and around the castle have all shown the survival of deposits to be unusually good. At present this potential is largely untapped.

The published literature mostly discusses the Norman origins of the castle, especially discrediting the idea that it was moved in the 1080s from Boley Hill, to the south of the present castle. Though this question is by no means exhausted, this paper will be more concerned with the castle in the 13th and 14th centuries, notably the building complex created by King John's son, Henry III.

THE BUILDINGS OF KING HENRY III

THE principal source of information about the buildings of Rochester Castle is a series of writs sent out in Henry III's name, authorising the sheriffs of Kent and the constables of the castle to spend money on buildings and repairs, buying goods and paying staff. The light they throw on the buildings is at best oblique. They do, however, provide certain interesting details about the layout and function of a royal castle. Rochester Castle has several features that particularly recommend it for study. As at other castles, including Dover and Windsor, disorder at the end of John's reign had left much to do in the way of repairs and additions, and the keepers of the castle were busy during this period. Second, by virtue of its location, Rochester was a castle that could expect to see the king on a regular basis. Lying one day's journey on the road from London to Canterbury and the Channel ports, Rochester received at least one and frequently more visits from the king in an average year, usually on the outward journey and sometimes on his return as well.[2]

Rochester, a castle of the middle rank, and Henry III's buildings there can fairly be seen as typical for his reign: the castle would certainly have been familiar to him, though on several of his visits, he found room for improvement, the essential subject matter of the documents. With the exception of the curtain walls and features on them, most of the buildings mentioned in the documents cannot yet be located precisely inside the castle. Occasionally the documents state how they related to one another, but only excavation will prove where exactly they stood.

The Layout of the Castle

THE bailey took approximately its present shape in the 11th century: surviving traces of Gundulf's masonry, identifiable by its pitched and herringbone coursing can be seen in the curtain wall at the south-western and north-eastern corners (Fig. 1). Minor adjustments to the line of the wall took place in the south-east corner, with the construction of the large round tower, undated but certainly in the 13th century. The other possible major addition is the 14th-century tower in the north-west salient overlooking the Medway, probably built early in Richard II's reign. It is an attractive idea that the castle ditch had previously cut this corner off, running in a smooth arc from the riverside to the north-east corner, where the main gate stood, but evidence has now come to light confirming that this was not so: 18th-century antiquarian drawings of the 'Well Tower' clearly show that the natural chalk cliff of the river-bank stood to some height even this far north.[3] The presence of high ground at this point must argue

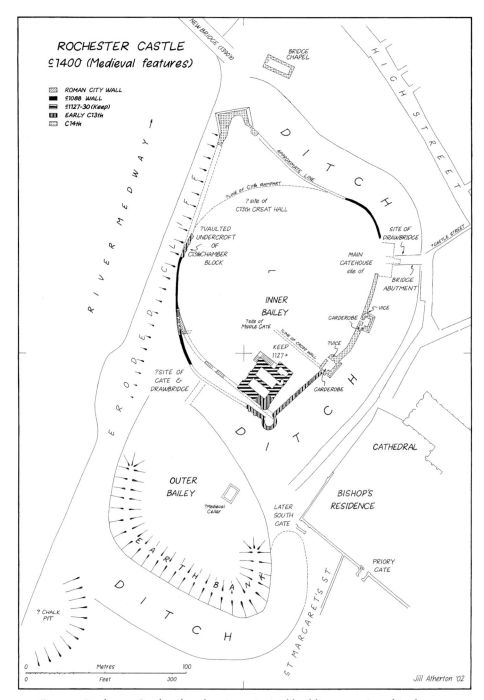

FIG. 1. Rochester Castle: plan showing principal buildings mentioned in the text
Jill Atherton

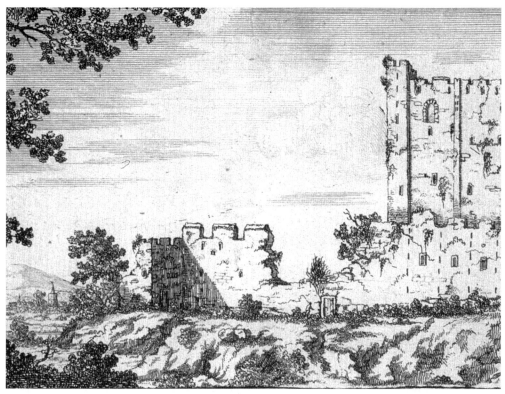

FIG. 2. Rochester Castle: south elevation, showing possible remains of the south gate. Engraving
by Francis Place, *c.* 1670

By permission of the British Library, Add. MS 32370, fol. 183, no. 3

against the idea that a Norman ditch cut across the present bailey, leaving such a
commanding outcrop on the 'city side': the site of the 14th-century tower must always
have lain inside the castle, with the ditch running outside it to the north.

There was, however, an area of high ground outside the castle to the south, known
since at least the late 13th century as 'the Boley' and now Boley Hill.[4] This consists of a
roughly rectangular enclosure with the castle ditch on its north side, the cliff of the
Medway on the west, and high banks and very deep ditches to the south and south-
east. Theories about an early castle on another site have tended to focus on Boley Hill,
but whatever its original purpose and date, the area must have formed part of the main
castle in the 13th century.[5] In particular, the castle's postern gate lay south-west of the
keep, approximately where a small arch leads through the modern wall into Castle
Gardens: this is mentioned in documents of 1225 and 1226,[6] and located in Francis
Place's engraving of *c.* 1670 (Fig. 2).[7] The documents also mention a drawbridge across
the castle ditch, which would have led directly into the enclosure: the interpretation of
Boley Hill as part of the castle is inescapable. Exactly what function it performed is
unclear, but it certainly seems to have contained buildings: Livett's plan of 1895 shows
a vaulted medieval cellar inside it. It probably served as an outer bailey, outside the city
wall and controlling access along the road to the south.[8]

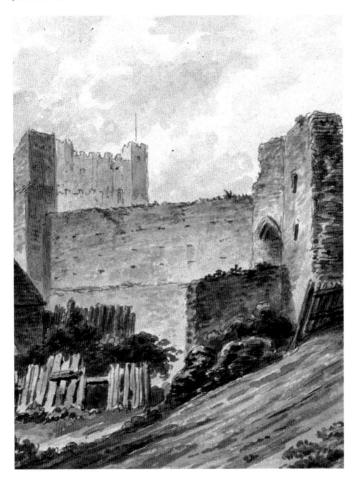

FIG. 3. Rochester Castle:
remains of north-east gate in
1785, showing squinch

*By permission of the British
Library, Add. MS 32370, fol.
204, no. 1*

The main bailey was formerly subdivided into two wards by a cross-wall with a
connecting gatehouse; the area containing the keep was known in the 14th century as
the 'Middle Ward'.[9] The cross-wall was built in 1231[10] and suffered from damage and
neglect throughout the 13th and 14th centuries, partly collapsing in 1363, and being
repaired in 1368 with the insertion of a vault in the gatehouse and a room over it.[11] Part
of its course, at least in the 14th century, can be reconstructed from the visible toothing
in the rear of the second tower of the east curtain wall; it ran part-way across the bailey
immediately north of the keep. Whether it then ran on to meet the west curtain wall is
more debatable. There is a change in level of the narrow windows in the west curtain
wall, which the clerk of works George Payne attributed in 1903 to the former presence
of the cross-wall between them, but his own and subsequent attempts to find it have
been unsuccessful.[12] It is equally possible that the cross-wall turned south somewhere
to the west of the keep, forming a small enclosure 'wrapped' around the keep with the
gate at its corner. This bears some similarity to the arrangement in a problematic plan
of 1633, showing the fleet in the Medway, effectively the oldest known plan showing
the castle, at Alnwick Castle.[13]

254

The castle's main entrance from the city was the north-east gate. This was probably a feature of the castle from the earliest phase, or at least from the 1088 rebuilding in stone. The earliest documentary reference, almost certainly to this gate, occurs in 1196–97, with payment for work to a pivoting drawbridge.[14] Despite military action in this area of the castle during King John's siege, the gate may have suffered little damage, and it was not singled out for repairs until 1237.[15] Further work occurred in 1248, with the fitting of joists over the gate-passage and the construction of a room above it.[16] 180 marks were spent on the gate over the next year.[17] In 1259, further repairs took place on the gate and the bridge outside it.[18] It is clear that the gate suffered serious damage in 1264 when the army of Simon de Montfort broke through into the castle bailey. Early in the reign of Edward I, a writ noted that during the time of the disturbance, the gate had been 'destroyed'.[19] Probably mended soon after, it fell into disrepair again in the 14th century, especially after servants of the under-constable stole lead from its roof, and much of the gate collapsed during storms in 1363.[20] Although no details survive, repairs must have taken place, since in the 18th century the gatehouse was ruined but still substantial, as illustrated by the Buck brothers and described in Fisher's *History and Antiquities of Rochester*:

The entrance into this fortress is from the north-east. Part of the portal still remains. On each side of this is an angular recess, with arches in the outward walls that command the avenues to the bridge of the castle to the right and left. Over the gateway and the recesses was a large tower. From this entrance is an easy descent into the city, formed on two arches turned over the castle ditch.[21]

The last traces of the gate were removed in 1872,[22] and no fabric now survives above ground. The bridge itself was seen and described in 1888 by the Chapter Clerk, A. A. Arnold, when it was evidently in good condition.[23] As for the gate and its mysterious side-recesses, a painting of the ruins in 1785 shows one of these quite clearly and indicates not an opening from the gate-passage onto the berm, but a squinch across the angle from the curtain wall into the side of a turret (Fig. 3).[24] This is strikingly similar to features shown on the 13th-century city seal of Rochester and must reflect a genuine detail of the castle's 13th-century design.

The King's Great Chamber

THE most important evidence for locating Henry III's royal lodgings is a surviving fragment of a two-storey building abutting the west curtain wall, overlooking the river (Fig. 4). Much of the fabric in this area dates to the 11th century, refaced and thickened inside and out in the 13th century. At ground level, the wall contains three recesses under two-centred arches, each of them with a ragged strip of sunken masonry running around the edge of the recess, as if an order of moulding or the webs of a vault have been torn away. Above this, the wall contains a line of substantial square sockets for floor joists, demonstrating that the surviving wall represents the building's 'long' axis, running north–south. The upper level contains one blocked window and the remains of a second at its northern end, largely now fallen away. The rere-arch is of an unusual elliptical shape, and the embrasure contains evidence for a much decayed two-light window in Reigate stone with round-headed openings. The remains of the northern window suggest that the rere-arches were formerly of two orders. Rubble projections flanking the surviving embrasure may represent window-seats. At the wall's southern end is the eastward return for the south gable wall. The upper window at the northern end shows that the building formerly ran on at least one more bay to the

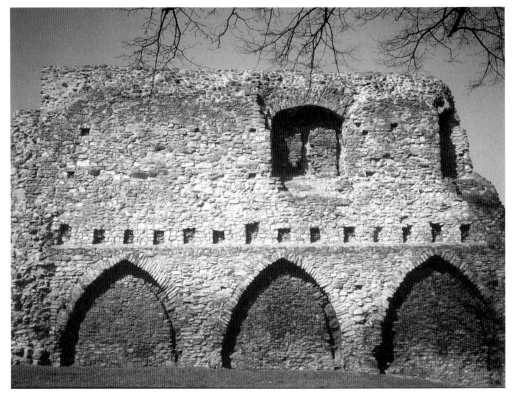

FIG. 4. Rochester Castle: west elevation of possible chamber-block
Jeremy Ashbee

north. The ruin was heavily conserved in 1903 by George Payne, who found, among other defects, that the arch over the windows needed to be reconstructed in new masonry.[25]

The likeliest interpretation of this building is as a chamber-block of the royal lodgings, a simpler version of King John's *Gloriette* at Corfe Castle (Dorset) or numerous other examples. Certain elements of its present form are confusing, notably the recesses at ground level; these have conventionally been explained as evidence that the lower level was vaulted,[26] a view which the author believes to be correct. The piers between the recesses now show no evidence of springing for a vault, but an undated sketch pre-dating Payne's repairs arguably does show the traces of springing (Fig. 5).[27] The present deep joist-sockets are missing from the sketch, as they are from Canon Livett's diagrams and description of 1895.[28] In 1903, Payne recorded that the sockets were 'fast decaying beyond recognition', and restored them; whether the present large size of the sockets is an accurate reflection of their medieval dimensions is doubtful. Nevertheless, the combination of wooden joists and a stone vault below remains awkward. Either the interpretation is wrong and the ground floor was never vaulted, or the vault and the joists represent successive phases of the building's development.

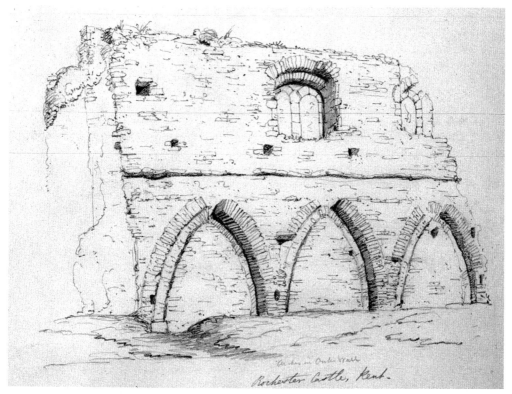

FIG. 5. Rochester Castle: west elevation of possible chamber block before restoration,
undated sketch

By permission of the British Library, Add. MS 32370, fol. 222

The presence of the building strongly suggests that the royal lodgings stood in this area of the bailey: the location on the cliff-edge with fine views outside finds numerous parallels in other royal castles, including Corfe, Scarborough (Yorkshire), and Windsor. The King's chamber was built in 1221,[29] and altered in 1233 with the insertion of a ceiling above its undercroft:[30] this confirms that it was a two-storey building. Later in the same year, the sheriff of Kent was paid for installing wainscoting and an office (*esciva*) in the cellar, mending its windows and blocking up a door.[31] The upper chamber was entered from outside by a flying timber staircase leading to a wooden porch (*oriolum*).[32] The roof was covered with tiles.[33]

Henry III's writs only speak of one chamber: there are no references, for example, to chambers specifically for Queen Eleanor, the Lord Edward or any other member of the royal family. The documents of 1233 show that the king's wardrobe likewise sat over a basement;[34] it could be considered another candidate for the ruined building, though the possible window-seats would favour an interpretation as the great chamber. The location of the wardrobe is unknown: the only other reference to it so far identified is an account for repairing 'the outer wardrobe' in the 1270s, suggesting that the building was internally partitioned.[35]

The Castle Chapels

IN Henry III's reign, Rochester Castle contained at least three chapels. One lay in the keep (mentioned by name in documents of the 14th century),[36] and in the bailey there was another, built by the sheriff of Kent in 1221.[37] In 1239, the king ordered the renewal of the rough-casting and whitewashing of the exterior, and the repainting of the interior, including a figure of (Christ in) Majesty 'in the place where it was before'. The roof was also to be replaced in such a way that the existing roof could be retained during the building works.[38] In the following year, the redecoration ended with the installation of new windows in timber. This chapel clearly lay close to the royal apartments: it was connected to the hall by a covered pentice.[39]

More information is available about a third chapel, dedicated to St Margaret. Its construction began with a verbal instruction from the king, made on site on 14 January 1244, to build a wooden chapel of two storeys.[40] It cost the sheriff £130 6s. 6d.[41] and was ready in spring 1246 for the monks of the priory to celebrate its first mass.[42] Unfortunately neither the king nor the sheriff had given sufficient thought to its planning. The upper chapel was evidently intended to serve a congregation, at least in the king's absence, but originally possessed a connecting door from the king's chamber and no other entrance. The inconvenience of this arrangement was noticed in 1249,[43] but orders to build a new entrance stair into the chapel went unexecuted until the winter of 1254, when the king sent a testy writ complaining that 'strangers' had accustomed themselves to pass through his chamber.[44] The new entrance was another wooden oriel, built on the right-hand side of the chapel (presumably the south side), which placed it 'not on the side of the enclosure [claustrum] but the other side'.[45]

From these brief entries, an outline of this part of the royal apartments emerges. From the great chamber, aligned north–south, a timber-framed two-storey chapel projected eastward. In the angle between the chapel's north side and the chamber's east wall was a courtyard, in which a wooden staircase ran up into the chamber itself and on its south side, a similar stair led into the chapel.

The Hall

LIKE all royal castles and palaces, Rochester Castle was provided with a hall (Fig. 6). This is one of the least documented examples in Henry III's estate, and of the handful of documents that mention it, several are only concerned with its destruction, an event with drastic consequences for the whole castle.

The first documentary references to the hall date to Michaelmas 1226, with payments for repairs to the 'dispensary and buttery of the castle's hall;'[46] the following spring, the sheriff was paid for ongoing work to its gutters.[47] Neither of these suggests building a hall from scratch and it is likely that Henry III's building was inherited from John, Richard I, Henry II or even one of the 12th-century archbishops. In the early 1240s, works were carried out around the hall, including the construction of a new pentice from its door to a chapel, and the building in 1241 of a new kitchen on four or six trusses (furce).[48] The salsary of 1249[49] and the almonry of 1248 may also have stood close to the hall.[50] More informative is a development of 1247:

[The sheriff of Kent] is to make two glass windows in the north gable of the hall of the said castle, one with the King's shield and the other with the shield of the former Count of Provence. He is also to make two small glass windows on either side of the said hall, each containing a picture of the King.[51]

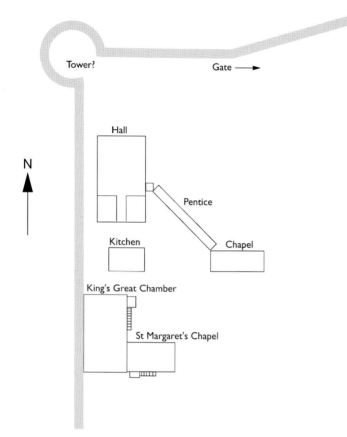

FIG. 6. Rochester Castle:
diagram showing conjectural
layout of royal lodgings
Della Cooper

This order suggests strongly that, like the great chamber, the long axis of the hall ran from north to south. Some uncertainty surrounds this, because of the contemporary fashion for side-gables (*fenestre estantive*) in great halls, allowing windows to break through the eaves of the roof and admit more light. However there is no indication that Rochester's hall was of this type, and the most likely interpretation is that the north gable formed the 'high' end of the building, while the small windows showing a king were set in the side-walls flanking the high table. The artistic commemoration of the late count of Provence, Henry's father-in-law, who had died in August 1245, was unusual. A window with his arms, again paired with Henry III's, is preserved in St Edmund's chapel at Westminster Abbey, where both shields also appear sculpted and painted in the spandrels along the south choir wall-arcade. English royal heraldry and images of a king were more common in Henry III's great halls, and with their emphasis on the royal identity, they were almost always used to decorate the area of the dais.[52]

The hall's location within the castle is hinted at in the pipe roll of Michaelmas 1233, when the sheriff was recompensed for mending 'a breach in the wall of Rochester Castle between the gate and the hall of the said castle'.[53] Interpretation of this document can become extremely conjectural, but the breach most probably lay somewhere along the north side of the castle, where the road called Castle Hill now breaks through the line of the curtain wall. The hall should stand close to the wall, somewhere in the

north-west corner of the site. This would mean that, as at the Tower of London, the royal chamber stood unusually at the 'low' end of the hall, beyond the services and kitchen.

THE SIEGE OF EASTER 1264 AND ITS AFTERMATH

THE fortunes of Rochester Castle changed dramatically for the worse on Maundy Thursday 1264, the day on which it came under concerted attack from two rebel armies under Simon de Montfort, earl of Leicester, and Gilbert de Clare, earl of Gloucester. The siege that followed is described in detail in at least five chronicles (including one written in Rochester Cathedral Priory)[54] and, very unusually, in a daily account of expenditure and food-consumption by the royalist garrison inside the castle.[55]

In outline, the events were as follows. Simon de Montfort was forced to move against Rochester in order to safeguard his position in London and prevent a royalist resurgence in the south-east. He therefore assaulted the city from the Strood bank of the Medway to the west, while his confederate Gilbert de Clare attacked from the east. The castle garrison had been reinforced on Tuesday 15 April with the arrival of the earl Warenne and William de Braose, while overall command lay with Roger de Leybourne. The castle was also well stocked with provisions, stored in the keep. Meeting with initial resistance from the citizens of Rochester, de Montfort finally crossed the Medway on Good Friday,[56] in several versions using a burning ship either to damage the bridge or to lay a smoke-screen and cover his crossing. He entered the city and set up camp in the priory, regrouping with de Clare's army. On Saturday, the rebels broke into the castle bailey, the defenders falling back into the keep, and after a 'religious truce' on Easter Sunday, fighting resumed for the following week with bombardment from siege engines and undermining of the walls. Roger de Leybourne was injured in action and most sources suggest that the castle was close to falling when, on Saturday 26 April, de Montfort became alarmed that London was about to defect to the king and lifted the siege. The royal victory was short-lived: less than three weeks later Henry III was defeated at the Battle of Lewes, and Rochester Castle was ceded to de Montfort.[57]

The castle undoubtedly suffered considerable damage in the siege. Later inquests identified known individuals who had helped undermine the walls,[58] and the writ of 1273, mentioned above, noted that the main gate into the bailey had been 'destroyed'.[59] Some of the worst damage, however, was inflicted by the defenders themselves. As a precautionary measure before the arrival of the rebel armies, Roger de Leybourne ordered the burning of several buildings in the eastern suburbs, parts of the city and the priory, and most notably 'the king's hall' inside the castle.[60] In 1275, an inquisition undertaken for Edward I confirmed that the hall had been a casualty of war, burnt by the defenders.[61]

Quite how extensive the damage was, and exactly what was done to the buildings in the critical years after the siege, are crucial to understanding the later history of the castle. On the one hand, life continued at some level immediately after the siege and several of the buildings clearly survived. For example, in 1267, the constable repaired a 'small hall' (from the materials described, probably a timber-framed building).[62] A repair account for 1273–74 mentions several buildings still functioning, including a hall (pargetted and whitened inside and out), the 'outer wardrobe', a room over a gate, a stable and a prison.[63] However, this same period also saw large-scale pilfering of materials. In 1275, the king's hall and chamber were found already to have lost 3,000 tiles to a sometime constable, John Potyn. Potyn had also removed lead, timbers from

doors and an oriel (further confirmation that not all the buildings were burnt down) and stone, with which he had built himself a cellar in the city; other timber buildings had since been dismantled and burnt.[64] By April 1281, the buildings were in sufficiently poor state for Edward I to authorise the constable 'to throw down the walls of the hall and of the chambers of the castle, long since burnt, and to remove the stones thereof and to construct buildings with them in the said castle'.[65]

Edward I did not intend the royal lodgings to be reconstructed: his writ says nothing about the new use of the stones, and they could legitimately have been reused in repairing the gate, mending the curtain wall or building a new house for someone else.

For much of the 14th century, the history of the castle is unknown, but three dilapidation surveys have survived, describing the buildings in 1340,[66] 1363[67] and 1369.[68] The first two tellingly say nothing about royal apartments in the bailey. The third survey, compiled immediately after repairs had finally been made to the curtain wall and gates, describes the progressive disintegration and robbing of the castle's buildings over a long period. In Edward II's reign the only standing structures beside the keep and the gates had been 'an old hall with a kitchen and a small stable, ruinous and worn'. In 1353 or 1354 the kitchen and stable collapsed. By 1360, much of the hall had also fallen, and worrying cracks had appeared in the stonework of the keep. The under-constable stole fallen timbers and tiles from the hall, kitchen and stable, and lead from the keep and gates. In March 1363, the already dilapidated buildings of Rochester Castle were struck by a 'great wind', which blew across the whole of southern England causing damage throughout:[69] at Rochester, the remains of the gatehouses fell down and in the hall, any tiles which previous looters had overlooked were now blown off and stolen by a servant of the under-constable. All of the references to the hall speak of defects to timber-work (contrasted with several mentions of masonry in the keep and gates). It is very likely that the hall described in the 14th century was neither Henry III's hall repaired, nor part of a palace complex rebuilt by Edward I, but a timber-framed building co-opted to serve as a hall.

The most plausible interpretation of this evidence is that Henry III's lodgings were never replaced in kind after 1264. Residential use of the castle contracted after the siege; in the immediate aftermath, there were clearly a few buildings, such as the 'small hall', that could be kept in use, but no plan was made to rebuild the royal lodgings. As the 14th century progressed, the defects of the standing buildings in the bailey multiplied. In the 1340 dilapidation survey all of the named rooms — the king's hall, the chapel, several chambers and a bakery — lay inside the keep rather than the bailey. The keep had now become the focus of the site, but by the 1360s it too was in decay. In Edward III's repairs and rebuilding between 1367 and 1370, there are no references to repairing a hall or a chamber in the bailey; works were undertaken only to the keep and to small apartments in mural towers and gatehouses. Richard II's reign saw the construction of a very large new tower, almost certainly the building whose fragmentary remains survive at the north-west corner overlooking the site on which the new Rochester Bridge would imminently be built. This was evidently extremely large and almost certainly residential in purpose, but again, was only a mural tower, not a domestic complex.[70] Rochester Castle was presumably no longer considered fit for royal residence: with the royal manor at Gravesend and the new castle at Queenborough close at hand, Edward III never needed to call on it for this purpose. In a reversal of the usual trend for abandoning castle keeps in favour of more modern residences in the bailey, the limited evidence for Rochester suggests that it was the royal apartments in the bailey that were discarded. As late as 1387, the keepers of works were still charged

with furnishing 'the king's hall and chamber',[71] but this was merely a formality and, on the evidence of the 1340 survey, the rooms with these names lay inside the keep.

CONCLUSION

THE medieval pattern of neglect and abuse continued, involving violence (as during the Peasants' Revolt),[72] plunder for building materials (as in the mid- to late 16th century, when the 'decayed walls and ruynes of Rochester castle' furnished stone for the new fort at Upnor),[73] and the parcelling-up of the bailey for gardens and tenements (a practice documented as early as the 1440s).[74] The post-medieval fabric history of the castle is at present hard to trace in detail, though antiquarian pictures and maps give some idea of the progressive decay and loss of standing remains. By the second half of the 19th century, all the major structures inside the bailey had clearly disappeared.

The classic image of Rochester Castle and Cathedral is often taken as emblematic of the close relationship between 'those who fight and those who pray', reproduced in generations of textbooks. But even in the Middle Ages, the history of the castle was not typical, and for much of its life, the castle bailey was neither full of buildings, nor a hive of activity in the way that general models would lead us to expect. It is in this context that excavation within Castle Gardens becomes a priority. Investigations to date have been very limited, the most recent being a watching brief accompanying the excavation of cable trenches in 1997. It was notable that structural and artefactual evidence was recovered from all periods running from the modern back to the 12th or 13th century; the potential to reconstruct the history of the castle in some detail clearly survives below the turf.[75] It remains for future archaeological work to confirm and refine the tenuous clues that the surviving documents have provided.

ACKNOWLEDGEMENTS

I am extremely grateful for the assistance of Tim Tatton-Brown and John Goodall during the preparation of this paper, and of Derek Renn and Bernard Worssam for many useful discussions about Rochester Castle. Steven Brindle and Stephen Priestley generously allowed me to use some of their unpublished researches on Windsor Castle. Finally, as well as making very helpful comments on the text, Alan Ward permitted me to consult his unpublished reports to Canterbury Archaeological Trust on excavations on the east rampart in 1995 and the watching brief of 1997.

NOTES

1. Barnwell Annalist, *The Historical Collections of Walter of Coventry*, ed. W. Stubbs (Rolls Series, LVIII, 1873), 266–67.

2. S. Priestley, 'Itinerary of Henry III in England 1216–72 with special reference to Henry III's periods of residence at Windsor Castle' (unpublished report, EH 1999).

3. London, British Library, Add. MSS, 32370, fol. 213.

4. J. K. Wallenberg, *The Place-Names of Kent* (Uppsala 1934), 123–24.

5. S. W. Wheatley, 'Boley Hill, Rochester, after the Roman Period,' *Archaeologia Cantiana*, 41 (1929), 127–41.

6. London, National Archives (hereafter, NA), E372/69, Kent roll; *Rotuli Litterarum Clausarum in Turri Londinensi Asservati*, II, ed. T. D. Hardy (London 1844), 98b.

7. BL Add. MS 32370, fol. 183.

8. G. A. Livett, 'Mediaeval Rochester', *Archaeologia Cantiana*, 21 (1895), plan.

9. NA, C142/145, no. 5.

10. NA, E372/75, Kent roll.

11. NA, E101 479/30, 480/1.

12. G. Payne, 'The Reparation of Rochester Castle', *Archaeologia Cantiana*, 27 (1905), 177–92, esp. 188–89; A. Ward and A. Linklater, 'An Archaeological Watching Brief at Rochester Castle 1997' (unpublished report, Canterbury Archaeological Trust 1997).

13. I am grateful to Alan Ward for discussing the many difficulties in using this survey, which is reproduced in the Guildhall Museum, Rochester, but otherwise unpublished.

14. *The Chancellor's Roll for the Eighth Year of the Reign of King Richard the First, Michaelmas 1196 — Pipe Roll 42*, ed. D. M. Stenton (London 1930), 281.

15. *Calendar of the Liberate Rolls A.D. 1226–1240* (London 1916), 258.

16. NA, C62/24 m2.

17. NA, E372/93, Kent roll; *Calendar of the Liberate Rolls A.D. 1245–1251* (London 1937), 222, 263.

18. NA, E372/103, Kent roll; *Calendar of the Liberate Rolls A.D. 1251–1260* (London 1959), 452.

19. *Calendar of the Close Rolls 1272–1279* (London 1908), 16.

20. *Calendar of Inquisitions: Miscellaneous — Chancery*, III (London 1937), 281–82.

21. Quoted in A. A. Arnold, 'Mediaeval Remains at Rochester', *Archaeologia Cantiana*, 18 (1889), 196–99.

22. Livett, 'Mediaeval Rochester', 36.

23. Arnold, 'Mediaeval Remains at Rochester'.

24. BL Add. MS 32370, fol. 204.

25. Payne, 'Reparation', 187.

26. Livett, 'Mediaeval Rochester', 32; R. A. Brown, *Rochester Castle* (London 1986), 21.

27. BL Add. MS 32370, fol. 222.

28. Livett, 'Mediaeval Rochester', fig. 7a.

29. *Rotuli Litterarum Clausarum in Turri Londinensi Asservati*, I, ed. T. D. Hardy (London 1833), 447.

30. NA, C62/7 m9.

31. *Calendar of the Liberate Rolls A.D. 1226–1240*, 207.

32. NA, C62/14 m8.

33. *Rotuli Hundredorum Tempore Henrici III et Edwardi I*, I (London 1812), 225.

34. NA, C62/7 m9.

35. NA, E101 566/1.

36. NA, C145/142 no. 5; *Calendar of the Close Rolls 1302–1307* (London 1908), 422.

37. *Rotuli Litterarum Clausarum*, I, 447.

38. NA, C62/13 m20.

39. NA, C62/14 m8.

40. *Calendar of the Liberate Rolls A.D. 1240–1245*, 211.

41. NA, E372/89, Kent roll.

42. *Calendar of the Liberate Rolls A.D. 1245–1251*, 42.

43. NA, C62/26 m14.

44. *Calendar of the Close Rolls 1253–1254* (London 1929), 285.

45. ibid.; NA, C62/32 m10.

46. NA, E372/70, Kent roll.

47. *Rotuli Litterarum Clausarum*, II, 176b.

48. *Calendar of the Liberate Rolls A.D. 1240–1245*, 25.

49. *Calendar of the Liberate Rolls A.D. 1245–1251*, 261.

50. ibid., 202.

51. NA, C62/23 m10.

52. S. Dixon-Smith, 'The Image and Reality of Alms-Giving in the Great Halls of Henry III', *JBAA*, 152 (1999), 79–96, esp. 80–81.

53. NA, E372/77, Kent roll.

54. *Flores Historiarum*, ed. H. R. Luard, II (Rolls Series, XCV, 1890), 489–90; Gervase of Canterbury, *Gesta Regum Continuata*, ed. W. Stubbs, II (Rolls Series, LXXIII, 1880), 235–36; Annales Monastici, *Annales de Dunstaplia*, ed. H. R. Luard, II (Rolls Series, XXXVI, 1866), 230–31; *The Chronicle of William de Rishanger of the Barons' Wars*, Camden Society Publications, XV (1840), 25; *The Chronicle of Walter of Guisborough*, Camden Society Publications, LXXXIX (1957), 191–92. This passage in *Flores Historiarum* is taken from BL Cotton MS Nero DII, written and illustrated in Rochester in the early 14th century.

55. NA, E101 3/3, rot. 1, m3.

56. There is a discrepancy in dates between the chronicle sources and the manuscript of the diary, which bears the annotation against Thursday 'fecerunt insultum castri': NA, E101 3/3, rot. 1, m3. Presumably the diary is correct and the chronicles placed the sacking of the city and Priory on Good Friday to give the story a theological dimension.

57. ibid., rot. 2, m3.

58. *Calendar of Inquisitions: Miscellaneous — Chancery*, I (London 1916), 233–34.

59. *Calendar of the Close Rolls 1272–1279* (London 1908), 16.

60. *Flores Historiarum*, 489; Gervase of Canterbury, 235.

61. *Rotuli Hundredorum*, 225.

62. NA, E101 3/3, rot. 2, m1.

63. NA, E101 566/1.

64. *Rotuli Hundredorum*, 225.

65. *Calendar of Patent Rolls of King Edward I, 1272–1281* (London 1901), 430.

66. NA, C145/142 no. 5; R. A. Brown, H. M. Colvin and A. J. Taylor, *The History of the King's Works: The Middle Ages*, ed. H. M. Colvin, II (London 1963), 810.

67. *Calendar of Inquisitions: Miscellaneous — Chancery*, III, 192.

68. Ibid., 281–82. The manuscript NA, C145/197 no. 15 is very worn, and many of the details cannot be checked.

69. T. B. James and A. Robinson, *Clarendon Palace* (London 1988), 39.

70. NA, E101 480/5, 480/7.

71. NA, E101 480/7 m1d.

72. *Calendar of the Close Rolls, 1396–1399* (London 1927), 171.

73. NA, E351/3543 quoted in A. D. Saunders, 'The Building of Upnor Castle', in *Ancient Monuments and their Interpretation*, ed. M. R. Apted, R. Gilyard-Beer and A. D. Saunders (London and Chichester 1977), 263–83.

74. NA, E101/20/14.

75. A. Ward and A. Linklater, 'An Archaeological Watching Brief at Rochester Castle 1997', Canterbury Archaeological Trust.

The Great Tower of Rochester Castle

JOHN A. A. GOODALL

Seriously damaged by King John during the celebrated siege of 1215, the great tower or keep of Rochester is nevertheless one of the best preserved, as well as one of the most ambitious, examples of a 12th-century great tower in England. This article offers a detailed description of the building and seeks to reconstruct its original internal arrangement in the 12th century. It also compares the structure with other great towers and attempts to infer from the design something of the function of its chambers.

THE keep or great tower of Rochester Castle is one of the prodigies of the English Romanesque (Fig. 1). A massive building on a rectangular plan, its rugged outline still dominates the modern cityscape of Rochester, dwarfing even the spire of the neighbouring cathedral. To the tops of its corner turrets it is in fact the tallest surviving Romanesque great tower in Europe. The scale of the building is in part a reflection of the importance of Rochester Castle as the fortress commanding the Watling Street crossing of the Medway. By the end of the 12th century it was one in a chain of four quite exceptionally ambitious buildings of this kind — The White Tower, Rochester, Canterbury and Dover — that punctuated this strategically vital road on its way from London to the Channel and the vast continental possessions of the Angevin kings beyond.

Great towers were a commonplace of English Romanesque castle architecture from the Norman Conquest onwards. The earliest examples of the form, such as the White Tower at London, were directly inspired by continental models,[1] but from the first, English buildings showed architectural peculiarity and by 1100 a distinct tradition of design was clearly emerging. This tradition was subject to regional variation but — broadly speaking — the most ambitious English great towers of this period are characterised by their large-scale, complex internal planning, and a remarkable richness of architectural ornament.[2] As will become apparent, the great tower at Rochester exemplifies this developing tradition and was, moreover, materially to influence its subsequent development.

THE HISTORY OF THE GREAT TOWER

ON the dating and patronage of the great tower at Rochester, historians are universally agreed. In January 1127 Henry I granted custody of Rochester Castle to William de Corbeil, archbishop of Canterbury (1123–36), and to his successors in perpetuity. As part of the grant, the king also gave permission for the construction of a fortification (*municio*) or tower in the castle, denominations that illustrate the defensive qualities of the proposed building.[3] That the terms of this grant were acted upon is made apparent by Gervase of Canterbury, who records that William de Corbeil built a noble tower of outstanding size at Rochester.[4] In combination these documentary references suggest

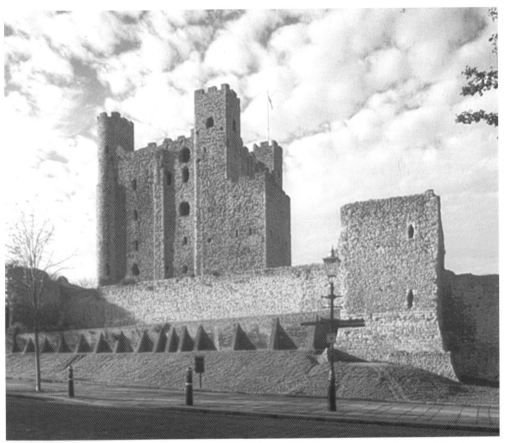

FIG. 1. Rochester great tower: view from the north-east over the castle ditch and walls. To the north (right) is the forebuilding; the south-east angle (left) of the castle was rebuilt after 1215

that the tower was begun after 1127 and was completed — or largely so — before the archbishop's death in 1136.

In deference both to this documentation and to William de Corbeil's reputation as a patron of architecture — amongst other projects he completed the new cathedral church at Canterbury and oversaw the re-foundation of Dover Priory — the great tower of Rochester has generally been understood as an explicitly archiepiscopal building project,[5] Indeed, it has even been suggested that the royal grant of the castle and the licence to build were a *quid pro quo* to the archbishops for Henry I's recent construction of the great tower at Canterbury during the vacancy of the see (1109–14).[6] However, if Henry I was the builder of the tower at Canterbury, and even supposing that the construction of this huge building could in any way be understood to be an unacceptable exercise of royal authority, the truth of the matter would appear to be more complex.

Quite apart from the problems attendant on the conventional distinction drawn between the royal and private ownership of castles in this period,[7] it has been clearly demonstrated that the king retained a direct interest in Rochester.[8] What the 1127

charter granted was not absolute control of the castle, but the right of the archbishop to exercise the king's power there. Moreover, the documentary evidence indicates that this did not prevent direct Crown involvement with its affairs. For example, there is a royal charter of *c.* 1129 concerning the reorganisation of the castle guard and the grant of a lodging within the castle.[9] Even more striking is the evidence of royal expenditure on the fabric. The Pipe Rolls for 1166–67, 1170–71, 1172–73, 1174–75, 1190–91, 1191–92, 1193–94, 1195–96, 1196–97, 1202–03, 1203–04, 1206–07 and 1208–09 record that money was spent on the castle in these years.[10] Some of the early payments in this series might be explained in terms of Archbishop Becket's exile and the vacancy of the see after his murder in 1170.[11] But both the sums involved and the continuation of payments, even after the custody of the castle was confirmed in the archbishop's hands in 1204, show that there were other concerns at play.[12] As we shall see, this joint interest in the castle may have been of material importance in determining the design of the great tower.

Although the terms of William de Corbeil's custody of Rochester Castle may not have been as straightforward as has usually been assumed, there seems no reason to doubt the essential circumstances of the tower's construction as suggested by the documentary evidence. The period of nine years between 1127 and 1136 is a short, but perfectly plausible, time scale for the construction of a great tower on this scale. Although we have no early-12th-century records to give an impression of the speed at which a great tower might have been raised, the Pipe Rolls of Henry II do provide good, later information on this head. According to these, for example, the tower at Newcastle upon Tyne took five years to build (1172–77) and that at Dover (Kent) probably eight (1181–89).[13] Added to this, there are no obvious building breaks in the original fabric, and the tower employs a consistent vocabulary of architectural decoration, with chevron, nook-shafts, scallop capitals and heavy roll mouldings, details that would accord well with a single building campaign in the first half of the 12th century.

The great tower of Rochester stands at the southern extreme of the oval castle enclosure created by Bishop Gundulf in the late 11th century. Of the relationship of the tower to the internal layout of the castle nothing is known before the 13th century. It then stood within the so-called Middle Ward, an enclosure created by a cross-wall that partitioned off the southern portion of the castle interior. The precise line of this cross-wall is not known, though the stubs of it possibly survive as projections in the east and west curtain.[14] Other buildings, however, must have existed within the castle enclosure in the 12th century. Whether, and in what way, the great tower related to these lost structures is a matter for speculation.[15]

Within the Middle Ward, the medieval ground level was about one metre higher than at present. The clearest evidence for this is provided by the stretch of 14th-century wall to the east of the great tower. On both the interior and exterior of the castle, the foundation arches of this wall have been partially exposed by the removal of earth. That this high ground level was not a creation of the late Middle Ages is suggested by the battered plinth running round the western and eastern sides of the great tower. (For convenience, the compass points used in the description of the tower reflect the orientation of the chapel, its liturgical east being read as true east.) The plinth is defined at the top by two courses of cut Caen stone, which must always have stood exposed, but its lower section is roughly constructed of rubble and was presumably buried.

The fabric of the great tower is remarkably well preserved, but it does — famously — bear the scars inflicted during King John's siege in 1215. During the course of this siege, a mine was driven under one corner of the building and fired. The full extent of the

masonry collapse it caused is clearly visible in the fabric today as a huge V-shaped gash rising up from ground level to either side of the south-east corner of the great tower. Despite the breach, the defenders continued to hold the building from the line of an internal spine-wall until they were starved out several days later.[16] Sections of the Caen stone facing to the cross-wall were evidently torn away by the collapse, and much of the masonry in the northern half of the tower has been burnt pink by fire. This latter damage was presumably either caused by the fire of the mine or incendiary attack during the subsequent fighting.[17] Similar fire damage can be found within the North Gate at Dover Castle, which was mined by Prince Louis the following year.[18] By the time the fighting ceased, nearly the whole interior must have been gutted.

Following his accession, Henry III thoroughly restored the castle. Work to the great tower was evidently undertaken in two principal stages. The masonry repairs to it, including the reconstruction of the whole south-east angle of the tower from the foundations, were probably completed in 1227.[19] These were roughly executed and are easy to identify, employing Reigate stone facings (in contrast to the Caen of the 12th-century fabric). Significantly, no attempt was made to copy the lost arrangement of wall openings or the original decoration. It is interesting to compare the form and detail of the masonry repairs with Henry III's contemporary work at Dover, notably the new towers of the Constable's Gate. But it was not until 1232–33 that the tower was re-floored and its roof leaded.[20] Presumably, therefore, the building stood as a masonry shell for five years before being fully restored. In 1240, Henry III instructed that the whole building be whitewashed, an order which — intriguingly — follows closely upon the whitewashing of the Tower of London in March the same year.[21]

Subsequent to its reconstruction, the great tower was never again substantially altered, and for the sake of completeness it is worth setting out briefly what is known of the later history of its fabric. The building appears never to have been used as a royal residence after the siege, the king favouring instead the domestic apartments in the bailey below. It did undergo repairs, however, in 1256 and 1259.[22] In 1264, the tower was again attacked, but seems to have survived without sustaining serious damage.[23] Further unspecified repairs are documented in 1270 and 1275, and in 1306 the great tower was employed as a prison in which the earl of Strathern could be safely detained without chains.[24] Three dilapidation reports of 1340, 1363 and 1369 note that the roof and floors of the tower were in decay, and some repair may have been undertaken around this time.[25] The last documented repairs to the tower as a complete structure took place in Richard II's reign.[26]

Of the fortunes of the great tower in the 15th and 16th centuries no particulars are known. It probably remained in rough repair, however, throughout this period, as did the remainder of the castle.[27] The great tower may also have served some role in the unhappy reception of Anne of Cleeves at Rochester in 1540.[28] James I granted Rochester Castle to Sir Anthony Weldon and, if not already a ruin by then, the tower must quickly have become one. Samuel Pepys appears to have seen it as a ruined shell on 2 October 1665, because its vertiginous interiors spoiled the delights of a visit that presented him with objects of more than merely architectural interest:

Thence to Rochester; walked to the Crowne, and while dinner was getting ready, I did there walk to visit the old Castle ruines, which hath been a noble place; and there going up I did upon the stairs overtake three pretty maids or women and took them up with me, and did *besarlas muchas vezes et tocar leur mains* and necks, to my great pleasure: but Lord, to see what a dreadful thing it is to look down praecipices, for it did fright me mightily, and hinder me from much pleasure which I would

have made to myself in the company of these three if it had not been for that. The place hath been very noble, and great in former ages.[29]

In view of this description, the reported sale of timbers from the great tower in the 18th century must either be a fabrication, or refer only to the remains of floors.[30]

The first good drawing of the great tower — a view from the south-east — was taken by Francis Place within a decade of Pepys's visit (see Fig. 2 of Jeremy Ashbee's article, p. 253).[31] This shows the building essentially in its present condition. The earliest depiction of the tower interior was produced much later, by Edward King, to illustrate his long (and rather eccentric) description of the tower in 1786.[32] Again, the building is shown in much its present condition, though one important change in the form of the spine-wall will be discussed below. Some undocumented repairs appear to have been undertaken by the earl of Jersey in the 1820s, when a surviving well-head (dated 1826) was inserted in the spine-wall. In June 1870 the castle was leased by the City Corporation from the earl of Jersey with the intention of laying out the grounds, but following a windfall of cash resulting from selling the river dues, the Corporation bought the castle in 1884 for the sum of £6,572. Subsequently, between 1896 and 1904, George Payne was directed to undertake its repair.[33] Since that time, it has been further restored by the Ministry of Works, which received guardianship of the property in 1964. Plans have been put forward on many occasions to have the building re-floored, but at present it remains a spectacular, roofless shell.

THE DESIGN OF THE GREAT TOWER

The Exterior

THE damage wrought during the siege of 1215 and the subsequent repairs to the building have introduced an element of detective work into any reconstruction of the original form of the great tower. Having said this, the essentials of its 12th-century design are still plain to see. The building is of rubble masonry construction, detailed with cut Caen stone (setting aside a few blocks of other stone, including some Taynton). It is roughly 70 ft (21 m) square in plan, with a projecting turret on each corner. Unusually for a structure of this height, there are no horizontal string-courses or set-backs within the walls to interrupt the effect of its soaring, monolithic mass.

To the tops of the parapets the tower stands 113 ft (34 m) high, and the corner turrets project a further 12 ft (3.7 m). These turrets were probably all originally square in plan too, but that in the demolished south-eastern corner was rebuilt in the 1220s. Externally, this is now drum-shaped.[34] The original turrets are double-angled at each corner, a relatively common detail, but one made distinctive by the absence of any setbacks through the full height of the tower. This treatment is common to several buildings that probably date to the first half of the 12th-century in the south of England, such as the great tower of Guildford (Surrey), the inner-bailey mural tower of Portchester (Hampshire) and the great tower of Castle Hedingham (Essex), a building otherwise closely comparable with Rochester.[35]

Using double-angles not only accentuates the turrets within the overall design of the building, it also serves to make them read visually as paired pilaster buttresses identical to those that articulate the exterior of the tower. These buttresses are regularly arranged within each surviving façade: to the east and west there is a single, centrally placed, buttress and to the north a pair. Only one buttress, however, survives in the opposite

Fig. 2. Rochester great tower: the
northern flight of the entrance stair
rising to the forebuilding door. To the
right are the remains of the gate turret
with its plain, segmental entrance arch

southern face. It is asymmetrically positioned, a detail that suggests that a second was
lost in the 1215 collapse and never rebuilt.

Attached to the north face of the building is a subsidiary tower or forebuilding. In
reflection of its secondary importance, this is not articulated with buttresses, nor — as
we shall see — does it follow the patterns of planning and decoration apparent in the
great tower itself. The forebuilding receives the external entrance stair as it rises up the
west and north faces of the building. At the north-west angle of the tower, the stair was
spanned by a gate turret with a plain, segmental archway (Fig. 2). Now largely ruined,
this turret comprised a gate passage and a chamber above it, the latter entered through
a blocked door from the great tower itself. At its head, the entrance stair was separated
from the forebuilding by a drawbridge pit. Below, within the pit, an opening has been
smashed through into the interior of the tower. This stands in place of an original
window slit and served until the mid-20th century as the main entrance to the building.

Many of the Caen stone window facings from the great tower have been robbed out,
but sufficient remain to reconstruct the original arrangement and decoration of
windows on the exterior. The overall pattern of elements was carefully regimented and

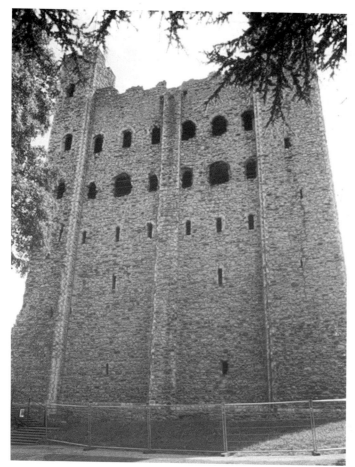

FIG. 3. Rochester great tower. The west façade of the tower is symmetrically arranged with a central buttress and five storeys of windows. It is constructed of rubble masonry with Caen facings

is best illustrated by the west façade (Fig. 3). This was probably the show front of the great tower, facing over the castle and down the Medway. Within it are five tiers of windows, each one corresponding to a storey of the building. The openings of each tier are symmetrically arranged within the façade and grow larger and richer by degrees as they rise up the building: two square-headed slits light the lower two floors, while each of the three upper levels has six windows arranged in two groups of three. On the third storey the windows are narrow, round-headed openings; those on the level above are decorated with thick roll mouldings, scallop capitals and heavy bases. Also, the central windows of each threesome within this level probably contained paired openings. The windows of the top storey are decorated in the manner of the fourth storey but with an additional external order of chevron. This hierarchical scheme of applied decoration was consistent on each face of the great tower and is also apparent on the interior (on which more below).

Such mannered ordering of detail is to be encountered widely in Romanesque great-tower architecture, but the exterior decoration of Rochester deserves particular comparison with the great tower of Castle Hedingham, which is probably an imitative

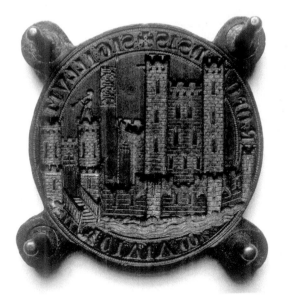

FIG. 4. The City Seal of Rochester. This 13th-century seal image captures the distinctive, rectilinear outline of the great tower, and also clearly shows the brattice sockets and beams at the wall heads of the building

Copyright and Courtesy of the Guildhall Museum, Rochester

work of the 1140s. This employs a very similar vocabulary of decorative forms in similar combination and also incorporates an order of external chevron on the upper-storey windows only. However, at Hedingham, unlike Rochester, this most richly ornamented level originally enclosed a roof space rather than a floor.[36] The striking contrast in external detailing between the austere lower and flamboyant upper floors at Rochester may also reflect a desire to emphasise the dual character of the tower as both a palace and fortress. A similar distinction is given exaggerated architectural expression at Portchester, where the great tower stands on the corner of the defences. Here the two outer façades of the building are gaunt and forbidding, while the two inner ones are treated with large windows and architectural ornament.[37]

Running just below the battlements of the Rochester great tower on the north, south and east faces are a series of large sockets, the fixings for a heavy external timber gallery or brattice. There were probably also sockets on the west face, but these are now obscured. The sockets, though badly damaged, appear to be of two types, the smaller of which correspond to the areas repaired by Henry III. This implied change in the size of timbers used during the 1220s repairs, combined with the massive scale of the sockets in the 12th-century fabric, suggests that the brattices were an original feature of the building. Each was independently accessible from a special opening (now blocked) between the battlements in the centre of the respective wall-walk.

The 13th-century counter-seal of Rochester city (Fig. 4) shows the sockets and — apparently projecting from them to either side of the tower — horizontal timbers braced from beneath. But this image shows the timbers only on the corner turrets and, confusingly, it also represents them in a form that cannot be understood as a complete brattice structure. Possibly this depiction only shows the supports for the brattices, which were permanently in place; these would then have been complemented by a superstructure in times of war. If the brattices are an original feature of the 1120s design, they are remarkable on two counts, first as the earliest surviving wall-head

brattices in English castle architecture, and second as a unique example of such defences being designed as an integral feature of a Romanesque rectangular great tower.[38]

Before proceeding to the interior of the great tower at Rochester, it is briefly worth taking stock of its overall design. To do so highlights the astonishing ambition, in English and even European architectural terms, of this building. Throughout the Romanesque period, English great towers tended to have rather box-like proportions and most substantial examples possess one horizontal dimension that equals or exceeds the height of the building.[39] But Rochester is conceived in startling contrast to this, with a relatively small ground-plan in relation to its unequalled height. Its sheer scale is further emphasised by the five storeys of windows it displays. Even the most ambitious English and French Romanesque great towers usually comprise only four storeys, and in England amongst extant great towers only Portchester, Norwich and Castle Hedingham have a fifth. Of these, only Hedingham and Norwich form appropriate comparisons,[40] and neither truly matches the internal scale of Rochester. This is true in two senses, first because both possess fewer large-scale rooms and second because the upper storey in each case originally enclosed the roof. At Rochester, however, the roof is raised to the very top of the building. Consequently, including the basement level, this great tower incorporates four complete floors, one of which rises through two storeys. Astonishingly, this is one more floor than any other great tower constructed in England before the 15th century.[41]

The Forebuilding

THE forebuilding at Rochester also deserves particular comment, though setting it in its architectural context is a complicated task. Nothing is known about the timber staircase arrangements from which stone forebuildings are believed to have derived. Moreover, before about 1140 very few stone forebuildings are demonstrably contemporary with the great towers they serve. Consequently the early development of these structures is difficult to chart. Most early stone forebuildings, however, comprise a stair and an elevated chamber, the latter enclosing a single doorway into the great tower. The earliest design of this type is probably the forebuilding of Norwich, and it has been convincingly argued that in some points this realises the details of a timber structure.[42] In the north of England, in buildings such as Bamburgh (Northumberland) and Carlisle (Cumbria), the same basic arrangement was reproduced in stone, without a separate forebuilding tower, by absorbing the stair and antechamber within one wall of the building.[43]

The Rochester forebuilding stands apart from all these examples on a variety of counts. First it is considerably taller; second, it incorporates four floors, a uniquely ambitious arrangement; and third because — as will be described — its interiors communicate at every level with the body of the great tower. Such integral planning of a stone forebuilding and great tower, although subsequently common, appears to be a novelty in English architecture at this date. One of these interiors is a chapel, a feature with only one extant English contemporary parallel — the highly idiosyncratic forebuilding at Portchester, which may be a contemporary structure (see note 37). Whether Portchester is related to Rochester or not, this detail of a forebuilding chapel also became a staple feature of English great-tower architecture in the later 12th century.

Because of its exceptional qualities, it is worth speculating on the architectural sources for Rochester. As a complete ensemble there are two earlier great towers that

may have offered precedent for this immensely ambitious and important design. The first of these is the great tower of Loches (Indres-et-Loire), which has recently been dated on the basis of dendrochronological evidence to between 1013 and c. 1035.[44] This magnificent building has rightly been discussed in conjunction with Rochester as an example of a tall great tower: it comprises four floors on a relatively compact plan and stands 108 ft (33 m) high.[45] It also possesses an integrally planned forebuilding, which incorporates a chapel in the same relative position as that at Rochester. Curiously, with the re-dating of this great tower, the forebuilding at Loches has become both the first and last important essay in this architectural form in Romanesque architecture in France.

These similarities constitute a good *prima facie* case for supposing that Loches was an architectural source for Rochester. But given the many differences between these two great towers, it is also hard to believe that their connection is direct. One potential English intermediary is the great tower at Corfe (Dorset). This structure is not satisfactorily dated and its received interpretation is in need of revision, a task beyond the scope of this discussion.[46] It is first reliably documented in 1117, but was almost certainly constructed around 1100, either by Henry I or William Rufus.[47] In the context of Rochester, the great tower of Corfe is of particular interest on two counts. First, it is a comparatively tall building in proportion to its ground plan: the structure is basically square in plan (approximately 60 by 66 ft) and stands over 80 ft high. Second, it possesses a stone forebuilding, perhaps the earliest in English great-tower architecture. Moreover, unlike Norwich, the possible alternative contender for this distinction, this forebuilding was a structure of some complexity: because each floor of the great tower was physically discrete, the forebuilding gave access to a first- and second-floor door, the latter accessible up a lost internal stair.[48] This internal stair is a unique arrangement in England, but it does find comparison in the forebuilding design at Loches. Might this point to a connection between Loches and Rochester through Corfe?

It should further be added in corroboration of this tentative suggestion that one group of buildings in the region of Corfe almost certainly influenced the Rochester commission both in spirit and form. The patronage of Bishop Roger of Salisbury (1102–39) must have served as both a model and a spur for any ambitious builder in this period, and each of his three principal castles, one of them lost, can plausibly be tied into the architectural orbit of Corfe and Rochester.[49] The great tower of Sherborne (Dorset) is integral to an entire complex of buildings, and incorporated within these is an internal forebuilding stair. This detail, as well as the curious projecting annex to the tower, are probably indebted to the design of Corfe.[50] A similar arrangement of a tower with a forebuilding and annex also existed at Old Sarum (Wiltshire), though its details can be reconstructed in various ways. A much more intriguing model for Rochester is the great tower Roger built at Devizes (Wiltshire), of which no remains exist.

The great tower of Devizes was clearly a building of outstanding architectural ambition, known both to have stood very high, and to have possessed a forebuilding with a chapel.[51] In these two details — its strong vertical emphasis and complex forebuilding — Devizes may well have directly influenced Rochester and also been a formative building in the wider development of the English great-tower tradition. All of Roger's buildings also anticipate the rich architectural treatment of the Rochester great tower. This, however, is also a feature of the most ambitious early-12th-century architecture and is equally apparent, for example, in the patronage of William de Corbeil's own early patron, Ralph Flambard, bishop of Durham (1099–1128), or another contemporary, Alexander, bishop of Lincoln (1123–48).

The Interior

THE interior of the great tower at Rochester is now without a roof or any floors. Its great height is given additional emphasis by the excavation of the ground floor in the 20th century, in the mistaken belief that it formed a basement to the original building.[52] Presumably the original ground level corresponded to the thresholds of the lowest internal doors. One consequence of these losses is that it is impossible to view the interior of the building satisfactorily from any medieval level. Also, several parts of the interior are inaccessible without a scaffold. In discussing such areas I have relied on the descriptions of those who have had thorough access to all the corners of the tower, in particular Payne and Allen Brown.[53]

The interior follows the classic form of an English Romanesque great tower (Fig. 5). It is entered at first-floor level through the forebuilding, and its floors are connected by two spiral staircases. One of these stands adjacent to the forebuilding entrance in the north-east corner turret and rises from the basement to the battlements. As will become apparent, all the internal evidence points to this being the principal stair within the building, intended for general and service access. The second stair is in the south-west turret and rises to the battlements from first-floor level. Dividing the interior of the great tower through its full height is a spine-wall, which creates two principal rooms on each floor. These substantial spaces in the body of the tower are served by subsidiary chambers and passages contrived in the thickness of the walls and, on the lower floors, also by the forebuilding chambers. Such generic features of planning aside, the great tower is very unusual, and its interiors are best described in the order in which they can be visited, starting in the forebuilding.

The Forebuilding

CROSSING over the drawbridge at the head of the entrance stair, the visitor passes through an arch into a large lobby within the forebuilding (Figs 3 and 6). This entrance archway is ornamented back and front with chevron, but the two sides are treated differently and introduce a decorative scheme that runs through the whole building. Every order of architectural ornament in the great tower is of equal dimension and can be understood as comprising two elements (Fig. 7). In some cases both elements are of roughly equal proportion (an A:A relationship) and in others, one is large and one is small (an A:B relationship). The A:B elements are all identically formed, with a small distorted bead and a large roll, but the A:A elements take two forms. Some comprise two rolls, and others a roll and hollow. To add variety to this triad of forms, the mouldings are sometimes broken to form chevron. Normally Romanesque ornament aspires to variety, and this systematised approach is consequently very remarkable. On the forebuilding entrance doorway the outer moulding is A:B (a large roll and a small distorted bead), while the inner one is one is A:A, in this case a large roll and a large hollow.

The forebuilding lobby is lit by paired windows ornamented with scallop capitals, deep bases and thick, semicircular rolls. This particular window form is next encountered on the second floor of the building, an indication that the lobby may have served as a comfortable holding space for visitors progressing to the more important upper floors. The windows could be closed with shutters, the drawbar sockets for which survive. A second archway, immediately to the visitor's right on entering the lobby, leads into the first floor of the great tower. This is more richly decorated than

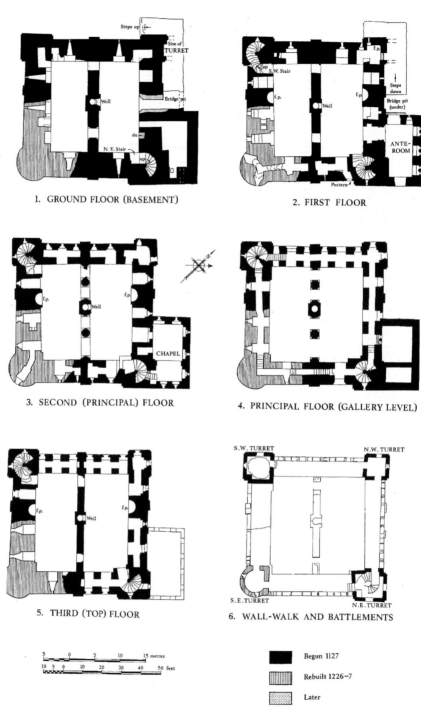

FIG. 5. Rochester great tower: floor-plans

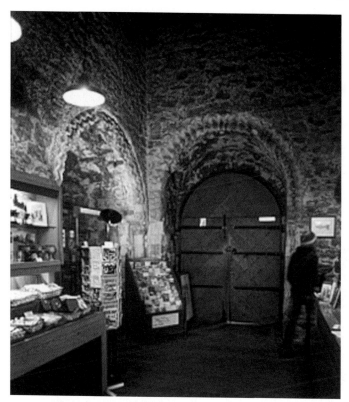

FIG. 6. Rochester great tower: interior of the forebuilding entrance chamber. To the left is the doorway to the keep interior, with its cylindrical order of chevron

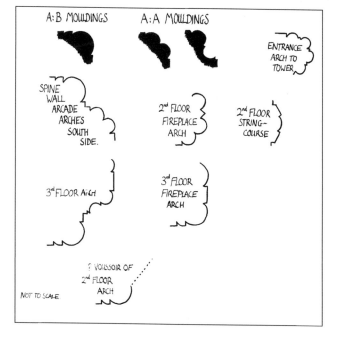

FIG. 7. Rochester great tower: mouldings of the arch orders

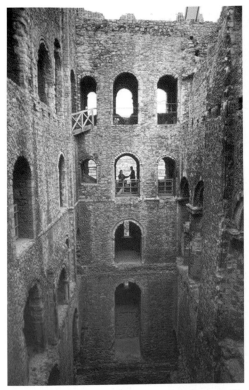 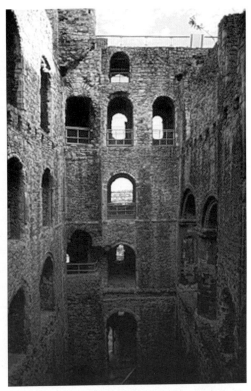

FIG. 8. Rochester great tower: southern half
of the interior looking west, showing the first,
second and third floors. The 1220s masonry
repairs after the siege are visible to the left

FIG. 9. Rochester great tower: northern half
of the interior looking east. Notice the roof scar
and drain chutes at the top of the building. The
doorways from the main stair, which rises up
the projection in the left angle, have been
partially walled up

the outer forebuilding door and is of a unique design within the building: its outer face
is cut with a very unusual form of chevron applied to a cylindrical order.[54] The door
was closed with a portcullis or drop door, an unusual arrangement at this date, but
paralleled, for example, in the earlier great tower at Colchester. Within the doorway
are two recesses, probably stone benches for porters to control access from the lobby.
On the inner face of the door the arch is cut with an A:A moulding in the form of a
large roll and a large hollow.

The First Floor

THERE are two lofty chambers divided by the spine-wall on the first floor (Figs 5 and
8). These are lit by narrow windows, the embrasures of which have been partially
infilled at a later date. Asymmetrically set towards the western end of the building
within the north and south walls is a pair of fireplaces. The fireplace overarches are
robbed out and frame backward-opening chimney flues. In marked contrast to those
on the upper floors, the windows on this level are narrow slits, without sculpted

ornament. There are mural chambers, or the remains of them, opening off the two principal interiors, but these do not communicate between the two sides of the great tower, and access between the principal rooms was provided by two doors, one to either end of the spine-wall. In the centre of the spine-wall is a well-shaft that rises the full height of the great tower. A small opening has been cut into this only on the north side of the wall, a feature reproduced on each of the upper floors. This well opening is rebated for a door.

Providing every floor at Rochester with its own supply of water suggests an elegance of living entirely in keeping with its rich interior. It is more typical for the well-head of a great tower to be situated in the basement of the building, as occurs at the Tower of London, Richmond or Middleham (both Yorkshire). The lavish provision at Rochester anticipates the complex internal piped water systems of several late-12th-century great towers, of which Dover is perhaps the most complex example.[55] Though several other great towers, such as Canterbury and Kenilworth (Warwickshire), have a well-shaft accessible on several floors, in these cases it rises in the outer walls of the building. Only at Norwich may there have been a central well comparable to Rochester.[56] The particular arrangement of the well openings at Rochester may imply that the northern chamber of each floor was subsidiary to the southern, a point further substantiated by the location of the main stair in the north-east turret. To the defenders of the great tower in 1215, the facing of the well to the north must have made their continued resistance after the firing of the mine possible.

Both the mural chambers at first-floor level in the northern half of the building had external doors. That in the north-western corner turret opened into the lost upper floor of the gate turret over the forebuilding stair and possesses its own fireplace. Within the second mural chamber in the east wall is a doorway that today opens into space beside the north-eastern turret. The function of this latter door is not clear, but it must have been a back entrance to the building. Moreover, its location beside the main stair suggests that it was a service door and perhaps communicated with a kitchen outside. This mural chamber also possesses on one side a latrine emptying outside the building. The collapse of the south-east turret has carried away all but a fragment of an eastern mural chamber to this floor. In the opposite end of the room a latrine is contrived within the window embrasure beside the south-west corner turret. Rather than emptying outside, this latrine, as well as the one on the floor immediately above it, opens into an embrasure within the basement of the great tower. Both Castle Hedingham and Canterbury appear to have adopted versions of this very idiosyncratic (and potentially insanitary) arrangement, though later damage has rendered the details difficult to reconstruct.[57]

The Basement

FROM the main first-floor entrance to the building it was possible either to walk through the body of the tower and ascend the south-west stair, or to pass immediately to the spiral in the north-east turret. This led both to the upper floors and down to the basement. Of the basement little needs to be said beyond the fact that the original floor level must have corresponded to the thresholds of the various doors that open onto it (Fig. 10). The plan of the interior broadly follows that of the upper storeys (Fig. 5), but poorly lit, undecorated, without fireplaces and faced to the south with at least one latrine embrasure, this floor must have been intended as a storage area. Leading from it are two doors into the lowest levels of the forebuilding. One leads to a forebuilding

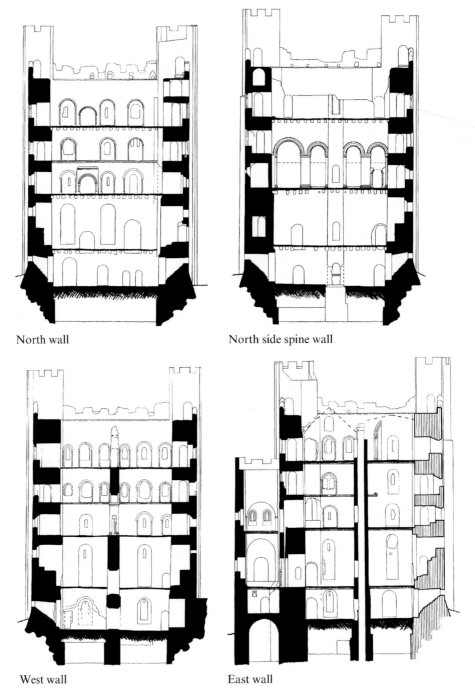

North wall North side spine wall

West wall East wall

FIG. 10. Rochester great tower: sections of the building, adapted from the RCHM survey drawings

chamber at basement level, which is today filled with a temporary office. At its eastern extreme there is a latrine or drain chute opening into a subterranean vaulted chamber beneath. This lower space is accessible down a stair from the second basement door.

The Second Floor

PASSING up the north-east stair to the second floor, the visitor entered the first grand level of the building (Figs 9 and 10). This is divided in two along the line of the spine-wall by a massive arcade. In volume, the two principal chambers are roughly the same as those on the first floor but the internal effect is completely different. The elevations within the outside walls of the tower are treated as two equal storeys divided by a moulded string-course. Within the lower storey are a series of doors and discrete window embrasures, their jambs cut with attached shafts, scallop capitals and bases. The arches of the openings are decorated with a single, sculpted order. In every case this comprises two moulded elements of the same proportion (i.e., A:A) cut as a hollow and roll. The fireplaces serving this floor are set in the same relative position as on the level below. These are ornamented with attached shafts, capitals and bases — in the manner of the other openings on this storey — and the overarch faces are ornamented with two equally proportioned elements. But in this case these are two roll mouldings, and the inner of these is broken as chevron. Both fireplaces are set in projecting wall panels, a relatively uncommon detail, but one also encountered, for example, in the 12th-century fabric of 'King John's House' at Southampton and the second-floor mural chamber of the great tower at Newcastle.

The upper storey of the second floor is a gallery level accessible from both the north-east and south-west stairs. It comprises a single, spacious barrel-vaulted passage interrupted at intervals by groin-vaulted bays. Facing one another across the passage in each bay is an external window and an internal opening. One original window from this level of the building survives above the forebuilding. It comprises a pair of openings with thick roll mouldings, scallop capitals and heavy bases. The remains of small drawbar sockets in this and the other damaged embrasures show that all the gallery windows were provided with shutters. In similar fashion to those on the lower storey, the internal faces of the inner gallery openings have attached shafts, with capitals and bases on each jamb. Their arches also possess a single, sculpted order, but these are treated with a distorted bead and a large roll of unequal proportion (A:B), the latter of which is broken to form chevron.

Contrary to conventional thinking on the subject, it now seems clear that two-storeyed internal elevations are very rare in great-tower architecture.[58] Moreover, of all extant examples, there is only one parallel for an elevation in which the upper and lower elements are of equal proportion: the second-floor chamber of Castle Hedingham. This also comprises a lower storey with numerous discrete mural openings and a continuous gallery above. Furthermore, the two storeys of the chamber at Hedingham are treated with distinct architectural mouldings and the whole decorative vocabulary of the building — with scalloped capitals, attached jamb shafts, chevron, and heavy roll mouldings — bears generic comparison to that at Rochester. All other examples of two-storey designs have unequally proportioned storeys, a detail also found in William Rufus's great hall at Westminster. It has been pointed out, however, that one rule does unite all designs of this kind: two-storeyed interiors within great towers are always contrived within a space that is the same height, or only a little higher, than the

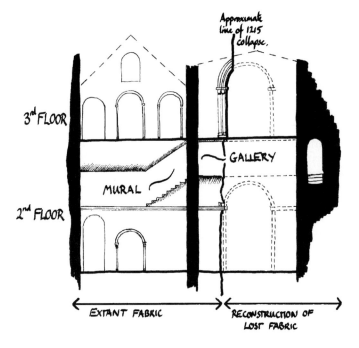

FIG. 11. Rochester great tower: section of the east wall of the keep, showing the gallery level and the possible line of the second-floor arch

principal floor beneath them.[59] To achieve this, the elevations of such interiors always incorporate at least one storey of diminished size.

As well as adding grandeur to the great tower at Rochester, there is the possibility that the gallery level was also intended to serve a particular ceremonial function. At Castle Hedingham, for example, the doorways to the gallery are ornamented on only one side, a detail that implies that there was a correct way to walk round it.[60] There is no evidence of similar treatment at Rochester, but it is curious that the gallery is the only mural space within the building that does not observe the division of the spine-wall but runs unbroken round the entire interior. Could this also have been intended for the circumambulation of the building?

For most of its extent, the gallery is at a constant level around the great tower, but there are three points at which its height changes. In the north wall and to either side of the south-west turret there are flights of steps to integrate it effectively with the two spiral staircases. Such arrangements around spiral stairs are a common feature of great-tower architecture. However, the third change in level is in the area of the south-east turret, and this provides important clues as to the design of the building prior to 1215. Immediately behind the spine-wall the east gallery rises up a flight of stairs (Figs 11 and 12). This change in height is part of the original design, and the juncture with the 1220s repair work is clearly visible within the vault and walls at this raised level. When the gallery was rebuilt after the siege, it was dropped in two stages from this high level to meet the 1120s fabric mid-way along the south wall. What the surviving fabric makes apparent, therefore, is that the gallery originally rose in the middle of the east wall and had returned again to its ordinary level in the middle of the south wall. Why?

The only suggestions that have so far been made to explain this oddity are that the mason wished to accommodate the latrine vault of the floor below and to reinforce the

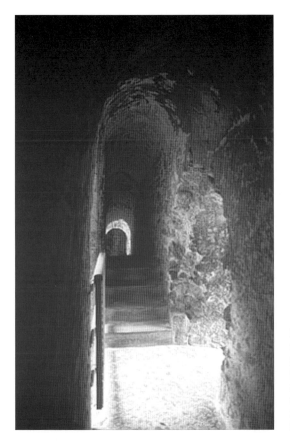

FIG. 12. Rochester great tower: view of the eastern gallery from the south. It is still possible to trace the junction of the original masonry with the repairs of Henry III around the head of this 1220s flight of stairs. The level of the raised gallery in the 1120s design corresponded to the top step in the photograph

building against the thrust of the central spine by making the wall adjacent to it solid. If this is so, it seems curious that he did not do the same in the opposite gallery (to the west), or align the raised section of the gallery more exactly with the spine-wall.[61] Much more plausible — and this can be paralleled in other buildings — is that the gallery had to rise over the top of an architectural feature that pierced the wall at the east end of the south chamber.[62] The only clue as to what this was is provided by the fragment of a string-course against the spine-wall (Figs 11 and 15). This survival, which is not marked on the guidebook drawings, is a section of the string-course that divides the upper and lower storey of the floor. A small detail, it nevertheless proves that this east elevation of the south chamber was distinctly treated: whereas on every other wall the upper-storey openings sit upon this string-course, the raised level of the gallery dislocates it from the interior articulation and makes such an arrangement physically impossible.

What could have been accommodated, however, is a large, centrally placed arch springing from the level of the string-course in the manner of the spine-wall arcade. One voussoir of this proposed arch, a worn block of Caen, may actually survive *in situ* at the end of the string-course, but the stone is so worn as to be difficult to identify securely.[63] Whatever the case, the arc of such an arch would fit within the space created by the raised gallery level, easily so if its embrasures were splayed. This arrangement has four attractions as an interpretation of the fabric. First, it would explain this

283

otherwise anomalous rise in gallery level, a feature that apparently does nothing at present except interrupt the regularity of the design. Second, a similar large arch in this position still partially survives on the floor above, and the proposed feature would match it. Third, both the use of the string-course as a springing point for an arch and, fourth, the location of a large arch at this point would accord well with the treatment of the spine-wall at this level.

The Spine-Wall Arcade

THE spine-wall that divides the second floor at Rochester is treated in a fashion unparalleled in surviving great-tower architecture (Fig. 10). To either side of the well-shaft it is pierced by two lofty arches set on massive drum columns with scalloped capitals and heavy bases with spurs. The capitals of these arches correspond in level and form to the string-course in the walls of the second-floor chambers. Within the interrupted arcade of four openings that this arrangement creates are three arches of identical size. But the fourth (to the east) is considerably larger. Although this difference in scale could be accounted for by the fact that the well is not centrally placed, the large arcade opening could also be understood to echo the form and proportions of the proposed arch in the adjacent elevation. This — to judge from the space available, the string-course fragment, and also the remains of the eastern arch on the floor above — must have been of roughly equal proportion to it. As will be argued, the east end of the south chamber was probably the most important space within the floor and may have served as a dais. Set at right-angles to one another, therefore, the large arcade opening and the proposed arch would have visually demarcated this eastern end of the room. It may be further evidence of the special status of this area that a pilaster buttress rises up the spine-wall beneath the column of the eastern arcade pier. If this is an original feature, it must have been intended to support some lost fixture at the threshold of this internal space.

The rich decoration on the two sides of the spine-wall arcade is not consistent today, the south face lacking the outer order of sculpture found on the north. Many of the outer voussoir stones on the south face of the arcade are cut in Reigate rather than Caen stone, a certain sign that they are not original. This is one of several indications that this face of the spine-wall suffered badly in the siege of 1215 and was substantially repaired in simplified form afterwards.[64] Its details cannot, therefore, be trusted. However, the surviving decoration on the north side of the arcade accords well with the overall scheme of decoration within the building (Fig. 7). The inner order of each arch is cut with two rolls of equal proportion (A:A), one of which is broken to form chevron. This treatment corresponds to the lower-storey openings within the floor and particularly the fireplaces. On the outer order, however, the arcade is moulded with a distorted bead and a large roll (A:B), the form found in the gallery openings.

Open arcades do occur within the spine-walls of several great towers, such as Middleham, Dover and Norwich, but these examples are incorporated at basement level and are without sculpted ornament. At the donjon of Beaugency (Loiret) of c. 1100 there were elegant tiers of arcades in the spine-wall, but this arrangement was not given architectural emphasis. The grand effect of Rochester is much more closely akin to the great spine-wall diaphragm arches that span the interiors of Castle Hedingham (Essex) and Scarborough (Yorkshire). In these cases the arches are a dramatic means of creating a sizeable and imposing space within a building with a central, structural partition. Although the Rochester arcade may seem similar to these

later designs, it is probably not formally allied to them. Not only is the tower sufficiently large for the unification of its interiors through the spine-wall to be unnecessary, but the arcade is a far from satisfactory solution — either visually or physically — to the problem of making the two spaces coherent. Instead it probably derives from a different feature: the blind arcades found ornamenting the spine-walls of several other Romanesque great towers.

Early antiquarian drawings show that the spine arcade was formerly filled with a masonry wall, a feature that was probably removed in the early 19th century.[65] Although most of this partition was probably a late medieval creation, it almost certainly replaced an earlier screen that was largely destroyed during the siege of 1215. One fragment of the original screen, which incorporates the remains of a door decorated on its northern face, survives in the western arcade arch (Fig. 13). Although the doorway appears rebuilt, and the screen wall that it pierces does not bond into the arcade piers, there are two powerful reasons for regarding it as an original design feature of the building. First, the chevron ornament on the arch is moulded with two equal rolls (A:A), a detail that accords with the decoration throughout the lower storey of the floor and which compares specifically with the treatment of the fireplaces and arcade-arch inner order. Second, the pattern of burnt Caen stone on the piers of the arcade clearly delineates the outline of a lost partition within at least two further arches. This partition rose to just below the level of the arcade capitals and must have been of stone to have resisted the fire. Assuming that the fire damage can be associated with the siege of 1215 (see note 18), this remaining fragment can, therefore, be convincingly read as a surviving element of a stone division designed as part of the building in the 1120s (Fig. 14).

As a blocked arcade this unique spine-wall design could be rationalised as a very ostentatious reworking of a distinctive arrangement common to other great towers. In buildings such as the White Tower at London, Dover and Scarborough the spine-wall of a principal floor is articulated on one side with a series of large, blind arches. And at Scarborough this arcade actually frames a door in one extreme of the spine-wall, in a manner reminiscent of the Rochester fragment. Blind arcading of this kind is by no means a universal feature within great towers and I have no explanation for it, but its repeated appearance in major buildings is very curious. If the designer of Rochester wished to reproduce it in an extravagant manner, the example of church architecture — say, the screened arcades of a choir enclosure — might easily have suggested this particular solution.

Despite the fact that the arcade unifies the second floor visually, I would suggest that in planning terms the two principal interiors on this level should be understood as distinct rooms. This arrangement is further implied by the fact that, as on the floor below, each interior was served by its own mural chambers. In consequence, communication between them was only possible at floor level through the screen filling the spine-wall arcade. On all the other floors of the tower there are two doors through the spine-wall, and in all probability such was originally the case here too, although — of course — only that within the screen fragment at the west end of the arcade actually survives.

The Ceiling of the Second Floor

FOR such grand chambers, the two principal rooms on this floor are a curiosity on account of their ceilings. It is generally assumed that the principal chambers of English

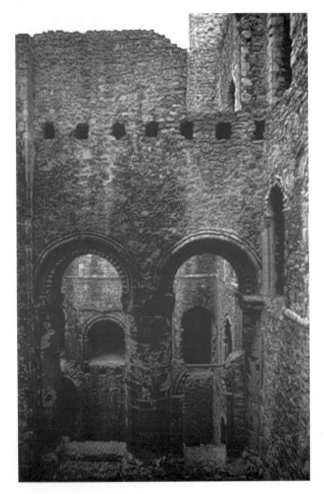

FIG. 13. Rochester great tower: the remaining fragment of the 1120s stone screen and door in the second-floor arcade as viewed from the north. Its mouldings correspond to those of the fireplace in the wall beyond

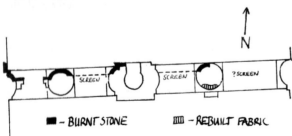

■ – BURNT STONE ▥ – REBUILT FABRIC

FIG. 14. Rochester great tower: plan of the cross-wall, showing rebuilding and fire damage

domestic buildings in the Middle Ages had open timber roofs and there is certainly a strong tradition of such treatment, particularly in the context of great halls.[66] However, because there is a further level to the building at Rochester, these second-floor interiors had to be ceiled. Their ceilings — as can be inferred from the interpenetrating levels of

the timber sockets and the attached shafts decorating certain projections within the interior — were simply the underside of the floor above. On the face of it, this arrangement looks like a utilitarian response to a practical situation, but it is worth observing that several 12th-century great towers deliberately opted for ceiled roofs within principal chambers, even at the upper-floor level. This fact seems not have received printed notice and deserves brief discussion.

It is apparent from the limited evidence available that great-tower roofs could vary considerably in form. The most common design was a simple gabled structure, usually of steep pitch, set the length of the building.[67] Alternatively, where the building possessed a spine-wall, two such roofs were usually constructed in alignment with it to form an M-shaped gable outline. Other forms of roof were employed, however, and in some of these cases ceilings appear to have been inserted beneath them. The clearest example of this occurs at Portchester, where the ridges of the original roofs coincide with the spine-wall and the sides of the building to create a W-shaped gable outline. This curiously designed roof space was evidently floored through, because there are two original doors within this level: one from the main stair and the other, now much altered, within the spine-wall; how the latter was originally accessed is not clear to me. There is also a small section of chasing visible in the ashlar facing of the south-west corner of the first floor, possibly the seating for lost ceiling panels set just below the floor.

At Castle Hedingham too the roof structure was almost certainly concealed from the interior by a ceiling. The recent reconstruction of the roof as a pyramidal structure convincingly accords with the remaining evidence. If this roof rose high enough to be visible over the battlements, it was perhaps intended to advertise the centralised planning of the interior, in much the same way as the roof of the 13th-century chapter-house at York.[68] Internally, however, such a pyramidal structure would have sat uncomfortably with the chamber beneath and the likelihood is that that it would have been obscured by a ceiling. This arrangement is further suggested by the arrangement of openings in the upper storey of the great tower. These indicate that the spine-wall never rose above its present level, a detail most readily explained if a ceiling covered the interior.

Finally, there was probably also a ceiled upper floor at Corfe, though the evidence for this is more circumstantial. It has been pointed out that the surviving gable lines of the original roofs show that they ran at right-angles to the spine-wall.[69] This is a unique arrangement in English great-tower architecture and would have created a bizarre visual disjunction had the roof been open from below. It is reasonable to suppose, therefore, that the roof was screened from the interior by a ceiling. In one sense, the existence of ceiled roofs in great towers is not surprising — it merely illustrates that castles could possess the same kinds of decoration and furnishing as churches. Yet it may be no coincidence that the buildings with evidence for this feature are familiar already in this discussion for their other points of comparison with Rochester.

The Chapel and Ancillary Second-Floor Chambers

OF the various chambers off the principal second-floor rooms something should briefly be said. The largest of these was the upper chamber of the forebuilding, which was originally entered by a doorway set immediately above the main entrance to the tower on the floor below. Curiously, the portcullis chase for the entrance arch actually drops

from the threshold of this upper door, an arrangement which must have complicated the use of both. In the past, some authorities have interpreted this space as a kitchen, but it seems much more likely to have been a chapel. Beside late medieval documentary record of the fact,[70] the physical evidence demonstrates this beyond reasonable doubt. The eastern extreme of the interior is spanned by an arch and set within this is a semi-dome. This is a segmental structure — a rare form — but is much more convincing as a chapel apse than as a chimney flue, which the kitchen interpretation demands. A passage forced through the apse wall from the north-east stair has destroyed some feature in the wall, possibly a piscina.

As a chapel, however, this forebuilding chamber has one outstanding oddity. Usually the chapel of a great tower is the most richly ornamented interior within the building, a circumstance reflecting the relative importance generally accorded in the Middle Ages to architecture with a religious — as opposed to a domestic — purpose. At Rochester, however, this pattern is reversed: the interiors of the great tower are encrusted with carved ornament but the chapel is almost devoid of it. Curiously, the only other reversal of this kind occurs at Norwich. The contrast here is not quite as striking, but again the building is otherwise unusually rich in carved ornament. In both cases, the most logical explanation is that the interior was intended to be painted. The relative austerity of the chapel is also apparent on the exterior: the windows are noticeably plainer than those of the grand forebuilding lobby below.

Only one of the five mural chambers opening off the second floor is accessible today. This chamber, at the east end of the northern hall, incorporated a latrine. There may also have been a latrine in the largely demolished mural chamber at the east end of the southern hall, as well as in the two mural chambers at the western extreme of the building. The function of the chamber in north-west turret is not clear. Its door is the only architectural feature within the floor that is not ornamented in any way, a detail which probably suggests that it served as a secondary or service chamber. There is a small fireplace in the room.

With this description of the second floor in mind, it is useful to visualise the interior in its original form. Emerging from the main, north-east stair, the medieval visitor entered into a lofty and rich interior, which was heated towards the far end by a fire (Fig. 15). The staggered arrangement of the fire, wall openings and arcade piers make it very unlikely that there were any internal partitions subdividing the space. Immediately to the visitor's right was a doorway into the chapel. Through the great arcade along the left-hand side of the room, a second chamber of the same form was visible, but access to it was barred by a stone screen. This screen was pierced at either extreme by a door. Given the medieval love for the sequential planning of spaces, it would be typical if the extant door — which is the most distant from the stair and faced towards the north — was intended as the principal entrance to the room beyond. The proposed second door may have been intended as a shortcut into the second chamber for privileged individuals. The ordinary visitor, therefore, walked the full length of the northern chamber before passing through the spine-wall into the southern. Facing the visitor at the opposite end of this reversed interior — in the east wall — was a large arch. This was flanked to the left in the spine-wall by an arcade arch of roughly equal proportion.

Passing to the top floor of the building up the north-east stair, a visitor passed three doors opening directly from the spiral. The first two gave access to the north and east gallery walks. Above these another gave access to the forebuilding parapet, which was substantially raised in the late Middle Ages.

FIG. 15. Rochester great tower: a reconstruction of the northern, second-floor chamber as viewed from the doorway of the main stair. Note the flat roof and the screen blocking the arcade

The Upper Floor

THE arrangement of the upper level of the tower broadly parallels those of the other floors. Its chief distinction from these was its height, which compares to that of a single storey in the second floor. What it lacked in spaciousness, however, was made up for by architectural display. All the internal window openings and fireplaces are cut with attached shafts, bases and scallop capitals, and their arches ornamented with chevron in the manner of the gallery openings in the storey beneath — that is to say, with a distorted bead and large roll (A:B). With one exception, the inner roll is broken to create chevron ornament.[71] There is no spine-wall arcade at this level, and instead this solid partition wall is pierced at either end by a door in the manner of the first floor, each faced to the north.

In common with both the lower floors, the mural chambers on this level do not communicate between the two halves of the building. With the exception of the single remaining original window in the south wall, which is isolated by the adjacent fireplace, they take the form of interrupted passages. It is not clear what the function of these passage chambers was. None of them can ever have incorporated conventional latrines, the gallery level below obstructing the fall of any shafts. The western walls of each of the principal interiors terminated in a splendid triple window composition arranged on one storey, but the eastern walls were quite differently designed. That to the north had a gable window opening into a vaulted mural chamber. This was accessible from the

JOHN A. A. GOODALL

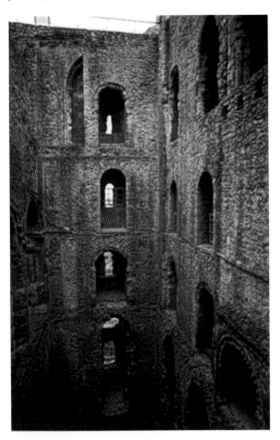

FIG. 16. Rochester great tower: southern half of the interior looking east. Note the remains of the arch in the third floor and the string-course fragment on the second. At the end of this string-course is a block of Caen stone, possibly the springer for a second arch

main stair and may have served as a guardroom. The adjacent gable requires individual description.

Set within the east wall of the southern chamber and half torn away by the collapse of 1215 are the remains of a large arch (Fig. 16).[72] The decorative forms applied to it are again drawn from the vocabulary found throughout the remainder of the building: it is decorated with attached shafts, bases and scallop capitals, and the arch is of two orders. The outer of these is cut with a distorted bead and a large roll (A:B) and the inner with an equally proportioned roll and hollow (A:A), but neither is interrupted to create chevron. Sufficient of the inside face of the arch is exposed to show that the moulding began to repeat itself on the internal face of the feature, a detail also encountered on the fireplaces of the two upper floors. The only oddity of the detailing is that the scallop capitals of this arch have additional carved ornament. It is also worth noting that, unlike every other upper floor within the south-east angle of the tower, no trace of an original mural chamber has been recorded in the area around the arch. More of this arch in a moment.

It seems logical to understand this upper floor as reproducing the arrangements of the second floor. That is to say, the visitor was intended to enter it from the north-east stair and walk the length of the principal northern chamber before passing into the southern. In this case, the second spine-wall door (towards the east of the interior)

290

could again have acted as a shortcut for privileged visitors. Such an arrangement would agree in three particulars with the physical remains. First, the facing of the spine-wall doors to the north — a detail that implies that they were to be approached from this side; second, the facing of the well-shaft opening; and third, the location of the arch in the east wall of the south chamber. Assuming this marks the most important space on the upper floor, it would be typical of medieval domestic planning if this were the most distant point from the head of the main stairs for the visitor.

This basic plan of circulation could have been complicated by internal partitions of timber, but I am inclined to doubt this. As with the second floor, the arrangement of architectural elements actually makes a complete division of either principal chamber across its full width difficult to envisage. In the southern chamber, the various openings in the side walls — the well, the doors, the windows and the fireplace — are effectively staggered across the whole length of the interior. Within the southern chamber, the need for the fireplace to stand roughly within the centre of any internal space would necessarily push any proposed partition towards the east of the room, and this potentially creates an awkwardness with regard to the large arch in the east wall. It is a subjective judgement, but an eastern chamber so created within the southern half of the building would be disproportionately small for this feature, which seems to be the focus of a large interior.

The top floor of the great tower at Rochester is unique for the period. It not only creates a fourth internal level to the building — which is in itself unparalleled in England — but it caps the two-storey interior below. This latter detail is remarkable, because every other surviving example of a two-storey elevation in a Romanesque great tower constitutes the uppermost interior of the building. What appears to have been created at Rochester, therefore, is a conventional English great tower of the very grandest form, with an extra floor dropped on the top. As will be discussed, such an arrangement may imply that the uppermost level was designed to cater for some specific additional need.

The Roof

THE parapets of the great tower were accessible from both corner stairs. Set within the wall walks at the very top of the building were two pitched roofs, both of which ran parallel to the spine-wall (Figs 9 and 16). The scars of rooflines are still clearly visible in the masonry, though it is not clear whether these relate to the original roofs or later structures. They show that the roof to the north was steeply pitched. This northern roof was drained to either side by two large gutters running east to west, one of which ran the length of the spine and discharged at either end of it; the second gutter carried the water inside the north parapet walk and then across the north-east stair-well, an eccentric arrangement preserved today. A roof of shallower pitch covered the southern half of the building. It also possessed a gutter that discharged at either end of the spine-wall, but the means of draining the southern pitch is not now apparent. Between the roofs and the parapet walks the walls of the tower were honeycombed with openings to create a dovecote. Similar arrangements are found in several later great towers, such as Conisbrough (Yorkshire) and Orford (Suffolk). As has been discussed above, there were timber galleries projecting from the parapets and these were entered through doors in the centre of each walk. Access to the upper turrets must have been by ladder or timber stair.

THE FUNCTION OF THE GREAT TOWER

HAVING described the great tower at Rochester in detail, it is now appropriate to try and understand the functions that its internal arrangements imply. The assumption that has conventionally underpinned the analysis of the largest Romanesque great towers in England is that they contained all the domestic chambers necessary for grand living, that is to say a hall (sometimes with services), a chapel and a chamber. Yet the tradition of great-tower architecture in England seems demonstrably one of form, not of function. Of the various circumstances that stand in proof of this the most important is that it is impossible convincingly to identify all these chambers in every major great tower. Moreover, the classic internal design of such buildings — a tower on a rectangular plan internally divided by a spine-wall into an even number of chambers of roughly equal proportion — does not actually comfortably conform to them at all.

Such issues aside, there is a yet more fundamental question to be addressed: can we really understand great towers as being created for some specific manner of use and — by extension — label particular chambers within them? That spaces within great towers were turned to use as occasion demanded seems to me a positive likelihood, and the practice becomes well documented and illustrated as the Middle Ages progress. This does not preclude the possibility that a great tower might have been designed with some particular system of use in mind, even if that were only to be an occasional ceremony, such as a crown-wearing. To argue otherwise in the case of Rochester would leave the sophistication and ambition of the building effectively unexplained. The mannered arrangement and articulation of the interior constitute a powerful case for an intended system of use. What follows is an attempt to understand this ideal use as it is expressed and underscored by the architecture.

Setting the storage area of the basement aside, the three upper floors could be understood as functioning broadly in one of three ways. The first possibility is that they operated together as a coherent domestic plan in which each subsequent floor was more privileged of access than the last. In such an analysis the first floor could be understood as comprising outer and service chambers; the second floor a suite of public rooms with a hall and chapel; and the third a more intimate series of withdrawing chambers. The chief problem with this interpretation is that no other domestic suite of the period is known to have been arranged around six principal chambers on this scale.[73] Presumably, therefore, something more complex is going on here.

The second possibility is that every floor functioned as an independent domestic unit, each one occupied by someone of different status. Under this analysis, every northern room would be understood as a hall and every southern room as a chamber. Amongst other things, such an interpretation would help explain the similarities of plan apparent between the floors: for example, the facts that the main entrance to each is from the north-east; that the internal pattern of circulation seems identical in every case; and also that the mural chambers do not connect between the two halves of the building. It would also explain why the doors and well-openings in the spine-wall face northwards: they serve the public, outer hall.

Interpreted in this way, the chambers could also be read as illustrating a 'high' and 'low' arrangement typical of later medieval planning. That is to say, the visitor entered at the low end of the hall and approached its high end at the opposite, western extreme of the great tower. He then entered the low end of the southern chamber, through the door at the western limit of the spine-wall, and was presented with a similar interior set out in reverse. Two details of the design tie in well with this model. First, it would

explain the special treatment of the east wall of the southern chambers on the second and third floors. These would stand at the high end of the inner chamber and would constitute the most important space on each floor. Second, the north-western stair could be interpreted as a means of privileged access, directly connecting the different chambers. It does so from their lower ends, an appropriate point of entry, and does not descend to the basement, which is not of importance to those on the upper floors.

Although the interpretation of the interior as three discrete suites of apartments stacked one above another accords well with the physical evidence, there are problems with it too. Chief amongst these is that the interiors do not conform to an obvious hierarchy of scale and ornament. The first and second floors are of comparable proportion and clearly raised — as we would expect — with the greater above the less, but the top floor should then be the richest level of all. Yet while it competes in ornament with the second, it does not do so in scale. To understand it, therefore, as simply serving a parallel function to that of the chamber below is a little awkward. This difficulty is not insuperable, but it is uncomfortable.

The third possibility is essentially a combination of these two interpretations, namely that there are two suites contained within the building. One of these comprised the first and second floors, a composition that could be formally compared with other ambitious great towers of the period. Above this, and possibly sharing the two-storey hall below as a setting for grand ceremonial, was a second set of grand apartments. In these terms, the design of Rochester could be rationalised as a very ambitious great tower on top of which another series of apartments has been added. Why this should be so might be explained by the royal interest in the castle. Could this building actually combine two palaces in one, the lower for the archbishop and the upper for the king?

In this connection, one final detail of the building deserves discussion. This article has described the remains of a richly carved arch in the east wall of the upper, southern chamber and has also argued for the existence of a second, similar arch on the floor below. Two possible explanations for these features present themselves. The first of these is that they served as openings for altars. If this is the case, Rochester would be unique on two counts; first because no other great tower contains three chapels and, second, because chapels are typically located either in the forebuilding or in the body of the interior, never in both. If the great tower at Rochester did contain two suites of apartments for the king and archbishop, however, each may have wanted his own oratory besides the forebuilding chapel and such an arrangement could make sense.

Having said this, a completely different explanation for the arches is also worth putting forward. As has been argued, neither of the upper southern chambers could easily have incorporated a cross-partition, so these arches probably stood open to the main interior of the chamber. As such, they could also have served as the frames for thrones. Stone niches of this type have been tentatively identified in the White Tower at London (at the south end of the east chamber on the first floor); in the main hall of Castle Rising (Norfolk); the west wall of the forebuilding chapel at Portchester; and — much restored — in the Old and New Halls of Pickering Castle (Yorkshire). Moreover, the tradition of such throne niches clearly persisted into the 14th century, as is shown by the superbly preserved audience chamber in the great tower at Knaresborough (Yorkshire).

Besides such stone niches, there was probably also a tradition of windows serving as ceremonial entrances to important great tower interiors. At both Dover and Scarborough, for example, the principal chamber of the uppermost floor is accessible from an inner apartment through the reveal of the window at the end of the room. That these

axial window openings were conceived of as framing royal appearances is strongly suggested by the architecture of both buildings. At Scarborough the window lights have been raised high in the opening to create a large, blind panel of masonry above floor level. This detail is presumably intended to reduce the dazzling effect of back-lighting as onlookers faced the window and the king walked through the door in its reveal or sat before it.[74]

At Dover the equivalent opening (at the south end of the eastern hall interior on the third floor) is the focus of a very complex internal arrangement. A series of discretely planned apartments, including the king's chapel, open off the doors in either side of the reveal,[75] and an external timber balcony was fixed beyond. This latter feature presumably served for public appearances by the king above the inner bailey. Equally surprising, however, is the interior onto which the opening faces. Within the eastern lateral wall of the hall immediately adjacent is the outline of a large 12th-century arch. This feature has no obvious explanation and its expression on the interior of the hall is very curious: the upper part of it opens into a mezzanine mural chamber, but this is only accessible from the suite of royal apartments connected to the chapel, not directly from the hall. Could this arch be a parallel for the enlarged arcade opening at Rochester and have served to demarcate this area of the interior as a dais in the manner, say, of a late medieval oriel?

It should be said that the overall arrangement and function of the interior as it has been outlined here are difficult to reconcile with the received residential interpretation of the building, and the question must arise as to whether the great tower at Rochester was intended principally for residence or ceremonial.[76] Two observations are worth making in this respect. The first is that none of the mural spaces within the building appears to be large enough or correctly arranged to have served as a withdrawing room. Moreover, without further partition the principal interiors are difficult to imagine as such either, particularly so if the eastern arches really were throne niches. In effect, therefore, this is a building without inner chambers. The second observation is that the great tower at Castle Hedingham, which is very clearly modelled on Rochester, seems unlikely to have had a residential function, but must have functioned in conjunction with other residential buildings in the castle bailey.[77] Could Rochester have been a functional as well as an architectural source for this design?

moveable screens? ?

CONCLUSION

VIEWED in the wider context of great-tower architecture, Rochester is an extraordinary building in almost every respect. As far as it is possible to tell, the design directly inspired at least one reworking, the great tower of Castle Hedingham. Quite how it related to other great-tower commissions of the period (and particularly Devizes) is difficult now to judge, so many being lost or imperfectly dated. Yet it was almost certainly a building of material importance in constituting the English tradition of forebuilding design. From this moment on, such structures not only become increasingly large and common in England, they also become the characteristic location for chapels. The internal decoration of the building vividly reflects the sophistication of court life in the 12th century. Indeed, its highly unusual internal planning may reflect an attempt to serve the simultaneous needs of two men of unrivalled political stature: the king and his archbishop of Canterbury. Whether or not this is the case, its interior is one of the largest, most complex, and luxuriously appointed of any great tower in 12th-century Europe.

ACKNOWLEDGEMENTS

This article could not have been written without the suggestions and help of numerous people. In particular I would like to thank Richard Eales, Rachel Moss, Duncan Givans, Stuart Hay, Tim Ayers, Kate Heard, Richard Plant, Derek Renn, Linda Monckton, Tim Tatton-Brown, Richard Morris and Bernard Worssam, besides all the members of the BAA who added their thoughts to the debate about the building during the conference. However, I must also make very special acknowledgement of the help of Jeremy Ashbee in my work on Rochester. Not only has he always been willing to share his considerable expertise, but has also generously provided me with swathes of relevant transcriptions, references, comments and many ideas. He has also read and commented on a draft of this paper. This article is deeply indebted to his research and I am very grateful to him for his generosity in sharing it with me.

NOTES

1. E. Impey, 'The Origins of the White Tower', in *The White Tower*, ed. E. Impey, forthcoming.

2. For a short discussion of this tradition, see J. A. A. Goodall, 'The Great Tower of Carlisle Castle', in *Medieval Art and Architecture at Carlisle*, ed. D. Weston and M. McCarthy, *BAA Trans.*, xxvii (Leeds 2004), 40–41.

3. London, Lambeth Palace, MS 1212, fol. 188, enrolled in *Regesta Regum Anglo-Normanorum 1100–35*, ed. C. Johnson and H. A. Cronne (Oxford 1956), II, 203, no. 1475.

4. Gervase of Canterbury, *Opera Historica*, ed. W. Stubbs (Rolls Series, LXXIII, 1880), II, 382.

5. For an outline biography of Corbeil, see W. F. Hook, *Lives of the Archbishops of Canterbury* (London 1862), 302–20. Unfortunately no surviving 12th-century elements of Canterbury or Dover Priory bear obvious resemblance to Rochester. The priory was allegedly built at great speed from 1131, though it remained incomplete at Corbeil's death. The history and buildings of the site are discussed in C. R. Haines, *Dover Priory* (Cambridge 1930), esp. 59–66 and 153–82. Corbeil also worked on St Gregory's Priory, Canterbury, for which see M. and A. Hicks, *St Gregory's Priory, Northgate Canterbury* (Canterbury 2001).

6. D. Renn, 'Canterbury Castle in the Early Middle Ages', in *Excavations at Canterbury Castle*, ed. P. Bennet et al. (Maidstone 1982), I, 73. The use of chevron and the plinth moulding of Canterbury do seem to preclude a date much prior to *c.* 1100.

7. For a sensitive discussion of this question, see R. Eales in both 'Royal Power and Castles in Norman England', *Medieval Knighthood*, 3 (1990), 49–78; and 'Castles and Politics in England, 1215–24', in *England in the 13th Century* II, ed. P. Coss and S. Lloyd (Woodbridge 1989), 23–43.

8. I. W. Rowlands, 'King John, Stephen Langton and Rochester Castle, 1213–15', in *Studies in Medieval History Presented to Allen Brown*, ed. C. Harper-Bill et al., (Woodbridge 1989), 267–79.

9. *Regesta 1100–35*, II, 231, no. 1606.

10. *Pipe Roll 13 Henry II*, 11 (London 1889), 197; *Pipe Roll 17 Henry II*, 16 (London 1893), 141; *Pipe Roll 19 Henry II*, 19 (London 1895), 88, 89, 91; *Pipe Roll 21 Henry II*, 22 (London 1897), 213; *Pipe Roll 2 Richard I*, new series, 1 (London 1925), 4; *Pipe Roll 3 and 4 Richard I*, new series, 2 (London 1926), 307; *Pipe Roll 5 Richard I*, new series, 3 (London 1927), 165; *Pipe Roll 7 Richard I*, new series, 6 (London 1929), 2; *Pipe Roll 8 Richard I*, new series, 7 (London 1930), 281; *Pipe Roll 4 John*, new series, 15 (London 1937), 211; *Pipe Roll 5 John*, new series, 16 (London 1938), 23; *Pipe Roll 8 John*, new series, 20 (London 1942), 47; and *Pipe Roll 10 John*, new series, 20 (London 1945), 97.

11. For Henry II's disagreement with Becket over the castle, see Gervase of Canterbury, *Opera Historica*, ed. W. Stubbs (Rolls Series, LXXIII, 1879), I, 174.

12. For the return of the castle and a summary of royal works, see R. A. Brown, H. M. Colvin and A. J. Taylor, *The History of the King's Works: The Middle Ages*, ed. H. M. Colvin, II (London 1963), 806–07.

13. See R. A. Brown, 'Royal Castle-Building in England, 1154–1216', *The English Historical Review*, 276 (1955), 353–98.

14. See Jeremy Ashbee's article in this volume.

15. These structures include the lodgings mentioned in the charter of *c.* 1129 (see note 9) and the *domus* repaired in 1206–07; *Pipe Roll 8 John*, new series, 20 (London 1942), 47. That great towers may have been conceived of as functioning in conjunction with surrounding buildings of scale and architectural pretension is well demonstrated in numerous contemporary castles. Of particular relevance in this context are the castles of other bishops, notably those of Roger, bishop of Salisbury (1102–39), at Devizes (Wilts.) and Old Sherborne (Dorset) and that of Henry of Blois, bishop of Winchester (1129–71), at Bishop's Waltham. The kitchen great

tower built by Henry of Blois at Wolvesey also illustrates the same interest in integrated planning. It should be stressed, however, that such arrangements are not the preserve of the castles of ecclesiastics, as the remains of grand 12th-century inner bailey buildings at Portchester illustrate.

16. The three principal accounts of the siege are the *Memoriale Walteri de Coventria*, ed. W. Stubbs (Rolls Series, LVIII, 1873), II, 226–27; *Radulphi de Coggeshall Chronicon Anglicanum*, ed. J. Stevenson (Rolls Series, LXVI, 1875), 175–76; and *Chronica Rogeri de Wendover*, ed. H. Hewlett (Rolls Series, LXXXIV, 1887), II, 148–51.

17. The fire evidently melted the roof and specks of molten lead have also been noted from a scaffold; see G. Payne, 'The Reparation of Rochester Castle', *Archaeologia Cantiana*, 27 (1905), 183–84.

18. J. A. A. Goodall 'Dover Castle and the Great Siege of 1216', *Chateau Gaillard*, 19 (1998), 91–102. The fire damage at Rochester is concentrated in the north-west side of the building, which is the opposite corner to the mine, but as there is no record of a major catastrophe later in the history of the castle, this damage is most likely to be associated with the events of 1215.

19. The work probably began under the order dated 11 March 1226, printed in *Rotuli Litterarum Clausarum in Turri Londinensi Asservati*, ed. T. D. Hardy (London 1844), II, 102. Other references appear in Pipe Roll 10 Henry III (PRO E372/70) and *Calendar of Liberate Rolls of King Henry III, 1226–40* (London 1916), 22, 23, 40.

20. *Calendar of Close Rolls of King Henry III, 1231–34* (London 1905), 38, 98, 40. There is also mention of leading for the tower roof in Pipe Roll 16 Henry III (PRO E372/76).

21. *Calendar of Liberate Rolls of King Henry III, 1226–40* (London 1916), 482. 'And to cause the tower to be whitewashed in the places ['per loca'] that were not whitewashed before.' Checking this entry against the manuscript (PRO C62/14 m8) Jeremy Ashbee has pointed out that the great tower in question is at Rochester, not Dover, as the printed calendar states. Other important great towers also received this treatment, such as Corfe in 1244.

22. *Calendar of Liberate Rolls of King Henry III, 1251–60* (London 1959), 304 and 452.

23. *Flores Historiarum*, ed. H. Luard (Rolls Series, XCV, 1890), II, 489–90, and Gervase of Canterbury, *Opera Historica*, II, 235–36.

24. *Calendar of Liberate Rolls of King Henry III, 1267–72* (London 1964), 120; *Rotuli Hundredorum Tempore Henici III at Edwardi I* (London 1812), 225, and *Calendar of Close Rolls 1302–07* (London 1901), 430.

25. Jeremy Ashbee has kindly provided me with a transcription of the 1340 survey PRO C145/142 no. 5. Those of 1363 and 1369 are respectively printed in *Calendar of Inquisitions Miscellaneous 1348–77* (London 1937), III, 192 and 281–82.

26. *The King's Works*, II, 813.

27. *The King's Works*, II, 814.

28. *Letters and Papers of the Reign of Henry VIII* (London 1896), XV, 14.

29. *The Diary of Samuel Pepys*, ed. R Latham and W Matthews (Berkeley and Los Angeles 2000), VI (1665), 249. I am grateful to Jeremy Ashbee for providing me with this reference.

30. W. Shubsole and S. Dene, *History and Antiquities of Rochester* (London 1772), 30. Their description is quoted verbatim by Grose, *The Antiquities of England and Wales* (London 1774), II, no page numbers.

31. The drawing was bequeathed to the Leeds City Art Gallery as part of the Lupton Bequest. It was also engraved.

32. E. King, 'Observations on Ancient Castles', *Archaeologia*, 4 (1786), 367–89 and pl. XXII.

33. Payne, 'The Reparation of Rochester Castle', 184–85. Tim Tatton-Brown has kindly referred me to F. F. Smith, *A History of Rochester* (London 1928) for details of the later history of the site.

34. There are only two Anglo-Norman Romanesque great towers with markedly irregular corner turrets: the White Tower in London encloses its principal stair in a drum tower, and Newcastle has one polygonal tower (clearly an original feature, despite recent suggestions to the contrary). The latter may be understood as an inherited detail from the former, since in both cases the differentiated turret is in the same relative position within the plan. Alternatively — as appears to be the case at rebuilt Rochester — the designer of Newcastle may have wished to strengthen the exposed angle of the great tower. During the conference, Derek Renn suggested that the footings of the original turret (on a square plan) could still be seen at Rochester.

35. The commonest method of buttressing the angles of English great towers is to use clasping buttresses. Setback buttresses appear to be associated with early great towers, such as the White Tower in London, Norwich, and many early French buildings. The decoration of angles with nook-shafts is probably a feature of the mid-12th century onwards, as at Peverill (Derbyshire), and Scarborough (Yorkshire). Castle Rising (Norfolk) of *c*. 1138 is probably the first example of the latter form in great-tower architecture, though the form does occur earlier in castle architecture, beside the door in the Norman Gallery at Durham.

36. P. Dixon and P. Marshall, 'The Great Tower at Castle Hedingham: A Reassessment', *Fortress*, 18 (1993), 16–23. For a detailed description of this building see also RCHME, *The County of Essex, I* (London 1916),

51–58. The rich ornamentation of roof storeys is a feature of many great towers, including, in my opinion, the Tower of London, Corfe and Scarborough. See also n. 58 below.

37. This treatment is apparent in both the principal phases of the Portchester building, which together account for the first five storeys of the great tower. The latter of these was probably undertaken *c.* 1180, but the earlier is more difficult to date. It is usually attributed to the 1130s, but it may have been begun in the 1120s in association with the foundation of the priory in the castle around 1128. If so, it is almost an exact contemporary of Rochester. For detailed survey drawings of the building, see B. Cunliffe and J. Munby, *Excavations at Portchester, IV, Medieval: The Inner Bailey* (London 1985). The early (pre-1120s) phase of the great tower suggested there on pages 12 and 75–76 is difficult to credit on the evidence presented. Similarly, the assertion on page 82 that the south forebuilding is a later addition to the great tower is not satisfactorily substantiated. To my mind, the shared foundations of the two (p. 14) and the disposition of their architectural elements argue overwhelmingly in favour of their being contemporary. In this respect, it should be noted that the feature identified in the east wall of the great tower as a blocked window on page 83 (allegedly obscured by the later addition of the forebuilding) could equally be a cupboard and is indeed rebated for a door to function as such.

38. Timber brattices could be attached to great towers at times of emergency, as occurred at the Tower of London in 1240; see *The King's Works*, II, 714. Several polygonal great towers, such as Conisbrough, do appear to have accommodated these structures. For the seal, see John Cherry's article in this volume, 232–33.

39. For example, the Tower of London, stands 90 ft (27.5 m) high to the parapet on a rectangular plan of 97 ft (32.5 m) x 118 ft (36 m) and, in its first phase of the 1120s or 30s (see n. 37), Portchester was roughly a 56 ft (17 m) cube.

40. The great tower of Portchester was raised in *c.* 1180 to include four floors, but only the first and third floors of the remodelled building appear to have intended for use. The second floor simply gives height to the tower: it is an extraordinary 30 ft (10 m) tall, has oddly arranged fenestration and internal walls untidily scarred by the rooflines of the original building; see J. A. A. Goodall, *Portchester Castle, Hampshire* (EH, London 2003), 5–10.

41. For example, the tower with five floors at Tattershall, Lincs. (under construction in 1446) and that of four at Ashby de la Zouche, Leics. (licensed 1474). There are, of course, late-14th-century tower houses, such as Nunney (Wiltshire) and Old Wardour (Wiltshire), that also incorporate four or more floors.

42. T. A. Heslop, *Norwich Castle Keep* (Norwich 1994), 29–33.

43. See Goodall, 'The Great Tower of Carlisle', 46.

44. For a full discussion of this building, see J. Mesqui, 'La Tour Maitresse du Donjon de Loches', *Deux Donjons Construits Autour de L'An Mil en Touraine*, (Société Française d'Archéologie 1998).

45. E. Fernie, *The Architecture of Norman England* (Oxford 2000), 78. For a discussion of these two buildings, see also P. Marshall, 'The Ceremonial Function of the Donjon in the 12th Century', *Chateau Gaillard*, 20 (2002), 141–51.

46. RCHME, *The County of Dorset, II, The South–East*, II (London 1970), 72–74 is now the standard account, but S. Toy, 'Corfe Castle', *Archaeologia*, 79 (1929), 85–102, and T. Bond, *Corfe Castle* (London 1883), 66–77 remain useful, as does *The King's Works*, II, 616–24.

47. See RCHME, *Dorset, II, The South–East*, I, 59 for citations of the documentary evidence. The received attribution of the great tower to Henry I (as in, for example, *The King's Works*, I, 39–41) is perfectly plausible, but is bound up with a late, and now discredited, dating for Norwich. In fact, the great tower of Corfe may equally be dated to William Rufus' reign on the basis of its architectural detailing. Certainly, the arcading on the exterior — which is perhaps best paralleled at West Malling, the Tower of London and Norwich — and also the capital types employed within it, would sit happily in the 1090s. Incidentally, in my opinion, none of the capitals are later insertions.

48. No trace of this stair now survives, but its presence can be inferred from a combination of physical evidence and the 17th-century Treswell plans of the tower.

49. For a discussion of Roger's patronage, see R. A. Stalley, 'A 12th-century Patron of Architecture. A Study of the Buildings Erected by Roger, Bishop of Salisbury 1102–39', *JBAA*, 3rd series, 34 (1971), 62–83.

50. The south annexe to the Corfe great tower is described in many authorities as an afterthought. Although its walls do not bond into those of the great tower, the structure must have been conceived of almost from the first. This is apparent, amongst other reasons, because the masonry of the square-headed first floor doorways into the annexe course right through the great tower.

51. The garrison of Devizes is described as withdrawing to a *turris eminentior* in *Gesta Stephani*, ed. K. R. Potter (Nelson Medieval Texts 1955), 70–71, presumably a reference to the great tower. This building is described by John Leland as follows: 'Suche a pece of castle worke so costly and strongly was nevar afore nor sence set up by any bysshope of England. The kepe or dungeon of it set upon an hille cast by hand is a peace of worke of an incredible coste. There appere in the gate of it 6. or 7. placis for porte colacis, and muche goodly buyldyng was in it. It is now in ruine, and parte of the front of the towres of the gate of the kepe [i.e., the

forebuilding] and the chapell in it were caried full unprofitably onto the buyldynge of Mastar Bainton's place at Bromeham scant 3. myles of.'; *The Itinerary*, ed. L. Toumlin-Smith, V (London 1910), 82.

52. Payne, 'Rochester Castle', 184–85 first gave currency to this idea, and his cross-section shows that it had not yet occurred in 1904. When the work was done, however, is not clear. Tim Tatton-Brown has suggested to me that it may have occurred before 1927, by which time the new ground-floor gate had been erected. See Smith, *History of Rochester* (1928), pl. 6, opposite 48.

53. R. Allen Brown, *Rochester Castle*, HMSO (London 1969). Note that some later editions of this guide have substantial passages of description excised. I have also referred to G. T. Clark, *Medieval Military Architecture in England*, II (London 1884), 409–19.

54. R. L. Moss, 'Romanesque Chevron Ornament' (unpublished Ph.D. thesis, Trinity College, University of Dublin, 2000), 55–56. I am grateful to Rachel Moss for help in the discussion of the decoration in the great tower. A cylindrical order also appears in the ruined bailey buildings at Portchester.

55. E. R. Macpherson and E. G. J. Amos, 'The Norman Waterworks in the Keep of Dover Castle', *Archaeologia Cantiana*, 43 (1931), 167–72. Unknown to these authors, rainwater was also channelled into cisterns at Dover or used to flush out the latrines. A less complex water system also appears to have existed in the great tower at Newcastle, a building that shares many formal similarities with Dover and was probably also designed by the same man, Maurice *Ingeniator*. The provision of running water is also a feature of mid-12th-century monastic design, as is known from the celebrated plan of such a system at Christ Church, Canterbury.

56. Heslop, *Norwich Castle Keep*, 44.

57. At Canterbury there are shafts without outlets on two levels in the south angle of the building. These have been plausibly interpreted as latrines in Renn, 'Canterbury Castle', 76. I am grateful to Derek Renn for his help in researching these features, which are now inaccessible. At Castle Hedingham the latrines in the north-east angle may originally have opened into a basement window embrasure before it was rebuilt.

58. To my mind it is now clear that many great towers that were formerly interpreted as possessing two-storey upper halls — such as the White Tower at London, Newcastle, Dover and Bamburgh — actually had countersunk roofs. Their gallery levels, therefore, were external, and the lateral walls of the top floors only single-storey. The reasons for supposing that the Tower of London had a low roof are outlined in E. Impey ed., *The White Tower of London*, Yale, forthcoming. The arguments seem more compelling than the conventional two-storey case rationalised in the light of new evidence by Fernie, *Norman Architecture*, 55–61. For further examples of low rooflines and a general discussion of the subject, see Goodall, 'The Great Tower of Carlisle', passim. Many great towers possess a second tier of windows in the gable ends of their upper chambers, but the only known examples of such buildings with two-storey lateral walls are Norwich, Castle Hedingham (Essex), and (possibly) Colchester (Essex). Middleham Castle was certainly adapted in the 15th century to incorporate a two-storey upper hall, although the guidebook argues otherwise; see J. Weaver, *Middleham Castle* (EH, London 1998), 11.

59. Jeremy Ashbee, personal communication.

60. Dixon and Marshall, 'The Great Tower at Castle Hedingham', 20. Marshall has also made this point in 'The Ceremonial Function of the Donjon', 149.

61. Clark, *Medieval Military*, II, 414, and, following him, Payne, 'Rochester Castle', 180.

62. For example at Norwich, where steps are employed to raise the gallery over a chimney flue as well as to accommodate it to different fenestration levels.

63. In support of this identification the stone tapers in the manner of a voussoir, and — more significantly — its worn surface could be read as the remains of a moulding composed of two unequal elements cut in plain, as opposed to chevron design. This is precisely the moulding form dictated for this position by wider logic of the decorative scheme.

64. See Bernard Worssam's article in this volume. The south face of the east arcade column has also been reconstituted in rubble masonry. Presumably it was also a victim of damage in the siege.

65. For example, the 1794 view by T. Hearne reproduced in *Country Life*, 196, no. 32 (8 August 2002), 66. The removal of the wall may correspond to the insertion of the well-drum in the spine-wall. This is dated 1826, and decorated with a coronet and a 'J' for the then owner, the earl of Jersey.

66. As exemplified in the nonpareil of English great halls at Westminster; see C. Wilson, 'Rulers, artificers and shoppers: Richard II's remodelling of Westminster Hall, 1393–99', in *The Regal Image of Richard II and the Wilton Diptych*, ed. D. Gordon, L. Monnas and C. Elam (London 1997), 33–59. Such pitched arrangements were certainly known too in great towers, as the smoke-stained outlines of gables within the interior of the White Tower at London show.

67. The best preserved evidence for such structures is to be found in the extant roof sockets of the great towers of Richmond and Newcastle.

68. Dixon and Marshall, 'The Great Tower at Castle Hedingham', 18. At York the spire-like form of the roof, unparalleled in chapter-houses of the period, was determined by the late and daring decision to remove the central pier of the chapter house and vault the interior in a single span with timber. This design may be partly indebted to the roofs of polygonal great towers, such as Conisbrough and Orford.

69. Jeremy Ashbee, personal communication.

70. By a process of elimination, this chamber must be one and the same as that described in the 1340 dilapidation survey of the great tower: 'Item deficiunt in capella viii fenestre que minus reperare non possunt quam vs. Et in carpantaria earundem fenestrarum xiiis ivd.'; PRO C145/142 no. 5. The reference to eight (rather than seven) windows must be a error of transcription.

71. The exception is the westernmost opening in the south wall. This variation has no apparent explanation, and the exterior window is not differentiated decoratively from its neighbours.

72. The details of this were drawn from the scaffold when they were first fully exposed; see Payne, 'The Reparation of Rochester Castle', 183.

73. The closest contenders are the massive great towers of Colchester and Canterbury, each with two spine-walls, though these designs do not compare straightforwardly with Rochester.

74. J. A. A. Goodall, *Scarborough Castle* (EH, London 2000), 19.

75. The mural chamber to the west of the opening now also communicates with the western half of the building, but this is the result of alteration in the 18th century. Formerly this chamber was discrete. For a plan of the upper floor of the building and a brief discussion of the great tower at Dover, see J. A. A. Goodall, 'Dover Castle, II', *Country Life*, 193, no. 11 (25 March 1999), 111–12.

76. Two recent discussions of the function of the tower have emphasised its ceremonial function, though they have presented its details differently; see C. Coulson, 'Peaceable Power in English Castle', in *Anglo-Norman Studies*, 23 (2000), 85–87, and Marshall in 'The Ceremonial Function of the Donjon', 141–51.

77. Dixon and Marshall, 'The Great Tower at Castle Hedingham', 19–22.

The Collegiate Church of All Saints, Maidstone

LINDA MONCKTON

In 1395 Archbishop Courtenay founded a college for a master and twenty-four chaplains in the parish church of St Mary, adjacent to his manor house in Maidstone, Kent. The church was completely reconstructed and given a new dedication to All Saints, and a large complex of college buildings was erected nearby. This article examines the circumstances of the foundation and the commencement of the building campaign. In particular, the impact of Courtenay's death on the progress of works is analysed, and it is argued that his original plans for the building of the church were never completed. The context for the architectural design of the church, in its proposed form and as executed, is then assessed.

ON 28 July 1396, William Courtenay, archbishop of Canterbury, stated that he wished to be buried in the churchyard of the collegiate church of All Saints, Maidstone. This request superseded that in his will, which had been drawn up in the summer of 1395,[1] and in which he had requested burial in Exeter Cathedral nave before the great cross.[2] This original proposal, which would have necessitated the removal of the graves of three deans to be reburied at his own expense, demonstrated Courtenay's stated wish to be buried 'in a worthy manner'.[3] One year later, he claimed to be too humble for burial within any cathedral or collegiate church, and selected a location in the churchyard at Maidstone.[4]

Setting aside for a moment the intervention (probably by Richard II) that resulted in Courtenay's eventual burial near the shrine of St Thomas Becket in Canterbury Cathedral,[5] Courtenay's deathbed wish indicates his desire to be associated in death with the college at Maidstone, which he had founded just a year before. A charter, dated 25 June 1395, was issued by Boniface XI, allowing the conversion of the parish church of St Mary 'into a college for a master and 24 chaplains and clerks'.[6] Courtenay had carefully planned the foundation, endowing it with the income of a local hospital, as is illustrated by a licence confirming the foundation issued by Richard II, which gave permission for the incorporation of a hospital and other property to the college.[7] Further licences in the following February allowed the master and college to acquire lands in mortmain and rents of up to £40 per year.[8] The church was rededicated to All Saints and completely reconstructed to reflect its new status. It is on this reconstructed building that this article will concentrate.[9]

Courtenay was a significant patron of architecture, making large contributions to the new nave and cloister at Canterbury Cathedral,[10] and to his castle at Saltwood (Kent),[11] as well as the erection of the college and church at Maidstone. After a youthful appointment to the bishopric of Hereford in 1370 (at which time he was twenty-eight), Courtenay rose quickly to the see of London in 1375, before his promotion to

Canterbury in 1381. His status and great wealth placed him on the same episcopal stage as his better-known contemporaries, such as William Wykeham, bishop of Winchester.[12] His decision to found a college of secular priests at Maidstone is inextricably bound up with the patronage of his contemporaries and his immediate predecessors. Bishop Grandison of Exeter, for example, had founded a college of priests at the parish church of Ottery St Mary (Devon) in the mid-14th century. The church was largely reconstructed at this time in a grand architectural fashion.[13]

Bishop Edington of Winchester had founded a college of priests in 1351 in association with an existing parish church at his birthplace, Edington (Wiltshire), substantially rebuilding the church at the same time.[14] Edington was Prelate of the Order of the Garter as founded at Windsor Castle by Edward III, and William Wykeham (later to be Edington's successor at Winchester) was clerk of the works at Windsor between 1356 and 1361. Both were intimately connected with the foundation of Edward III's building works at Windsor. Edward's college and palace rebuilding programmes set the standard for the foundation of collegiate establishments, which was rapidly to become a favoured form of patronage amongst the ecclesiastical and secular élite. Wykeham's own educational foundations in the 1380s and 1390s are probably the most famous of these, and Wilson has recently explored the influence of Windsor on New College, Oxford and other late-14th-century palatial structures.[15] Courtenay's decision to embark on a college at Maidstone was made a year after Wykeham had completed Winchester College (1387–94), and was contemporaneous with the construction of New College (1390–1403). Like Wykeham's Winchester foundation, Courtenay's was associated with a palatial residence rather than a birthplace.

Despite this context, Courtenay's patronage and his collegiate foundation seem to have escaped any recent detailed study. Its coverage in the published literature is essentially twofold: first, it featured in a series of antiquarian publications that describe the church or college and the controversy over Courtenay's burial place, and secondly, in the mid-20th century, John Harvey drew attention to the buildings of Courtenay's patronage in his assessment of the works of the master mason Henry Yevele.[16] More recently, John Newman said of All Saints that 'judged against national standards . . . this plainly battlemented ragstone building . . . cannot be described as spectacular'.[17] This statement raises questions about the architectural character of Courtenay's foundation and his intentions as a patron. As a result, this article will look firstly at Courtenay's patronage and aspirations in the light of the initial building campaign, and then assess the context for the architectural design of the church and college in relation to 14th- and early-15th-century architecture.

Situated to the east of the River Medway, the archbishop's manor, the church and the college form an imposing group of buildings (Fig. 1). That a church existed on this site is confirmed by the Domesday Book.[18] It is known that a manor existed near the church in the 13th century, at which time it was given to the archbishop. The status of the church, then dedicated to St Mary, subsequently grew, with a series of ordinations taking place in the late 13th and early 14th centuries.[19] In the middle of the 14th century, reconstruction of the archiepiscopal residence was begun by Archbishop Ufford, although it was his successor Islip who completed the manor, after successfully suing the administrators of Ufford's estate for dilapidations.[20] Islip also selected Maidstone as the centre for a diocesan synod in 1351,[21] demonstrating the continuing interest in the church by archbishops.

William Courtenay succeeded to the archbishopric in 1381, directly after the murder of Simon Sudbury by an angry mob during the famous uprisings in the south-east.[22]

FIG. 1. All Saints, Maidstone: view of the church and college from the west, *c.* 1750
Guildhall Library, Corporation of London

Courtenay, therefore, entered Canterbury at a time of great political unrest, but also in the middle of a great altercation between the archbishop and the monks at Christ Church, Canterbury. Archbishop Islip (1349–66) had attempted to found an educational college in Oxford from which the monks of Christ Church were excluded. He decreed that the college should be for secular students, and appointed John Wyclif as its warden. This attempt to exclude the monks, a small band of whom had originally set up camp in Oxford some years previously, angered the community at Christ Church. The solution finally reached, after all sides of the case had been put before the papal curia, was a resounding victory for the monks, with a decree in 1369 that they would have exclusive use of the college. Tension between the archbishop and the chapter seems to have continued under Courtenay (mainly in connection with the appointment of the warden of the college), and eventually he drew up lengthy new statutes in 1384. This represented only one stage in the continuing success of the monks in protecting their own interests against all 'outside' elements, including the archbishop.[23]

The chapter at Christ Church was in fact notorious for its disputes with successive archbishops and for its litigious nature. Two earlier attempts had been made to found colleges of secular priests in Maidstone by archbishops Hubert Walter and Edmund of Abingdon, in 1196 and *c.* 1239 respectively, but both of these had been thwarted by the intervention of the community at Canterbury, which perceived them as attempts to

challenge the authority and electoral rights of the chapter.[24] Similar concerns had arisen over the foundations of a college at Hackington, north of Canterbury, by Archbishop Baldwin in *c.* 1186; the proposed works were ultimately moved to Lambeth instead.[25] Although these particular projects failed, it is interesting that Maidstone was the favoured location for the later foundations. Convenient for London and sufficiently far away from Canterbury, Maidstone, with its associated archiepiscopal residence, was evidently seen as a place where the archbishop might try to exercise his personal patronage.

Towards the end of his life, therefore, Courtenay selected Maidstone for the foundation of his college. That work on reconstructing the parish church started in the following year is shown by a document dated June 1396 granting permission for Courtenay to impress twenty-four freemasons and twenty-four stone-layers for work on the buildings.[26] Courtenay, however, died on 31 July 1396. Not much in the way of building can have been achieved, but fortunately evidence exists to show precisely how far work had advanced by the time of his death, indicating that the current building does not fully represent Courtenay's ambitions.

The church, built of Kentish Ragstone with Caen stone dressings, comprises a chancel of three wide bays with narrow aisles separated by a large chancel arch from the nave, which has three (almost) equally proportioned aisles creating an unusually broad and airy church, surmounted by a small clerestory throughout (Figs 2 and 3). Its tower, originally with a spire,[27] is situated in the south-west corner, over the porch. All the present timber roofs were inserted by Pearson in the 1880s replacing late-18th-century ceilings,[28] themselves a renewal of medieval timber work.[29] One piece of evidence suggests that the construction of the new church began with the west end of the south chancel aisle. It is clear that when the outer wall was constructed, this aisle was intended to be vaulted in stone. Triple-roll responds exist on the two western bays of the aisle, and the corresponding respond in the south-west corner, of two rolls, was clearly intended to support the springing for a stone vault (Fig. 4). By the time the chancel arcade was constructed, this plan had been abandoned. In fact, the outer wall of the south aisle had been modified by the time it reached its eastern extremity, as the south-east corner contains no respond at all. It has been suggested that the earlier church of St Mary could have been to the north of the churchyard, possibly underneath the present north aisle.[30] This would, in fact, fit comfortably into the hypothesis that work started on the south side, allowing the church to continue in use during the early part of the building works.

The second conclusion to be drawn from this evidence is that this part of the building represents the original design approved by Courtenay. Accordingly, the abandonment of the design (and probable associated pause in the works) must surely coincide with his death. The masons had only been impressed for these works six weeks before he died, and the outer wall of this aisle therefore probably represents the work carried out in June and July of 1396.

Courtenay was clearly planning stone-vaulted aisles at the east end, but his plans for the chancel are not known. Stone vaults were extremely rare in late medieval parish churches,[31] and it is in the contemporary college foundations at Winchester and Arundel (West Sussex) that possible parallels must be sought. These buildings display their grandeur through timber vaults that emulate fan vaults, the latest in technology and design. Neither has aisles flanking the east end, so the planned inclusion of stone vaults in the chancel aisles at Maidstone tells us something of Courtenay's aspirations and ambitions for the foundation. Whilst the proposals for the original vaulting of the

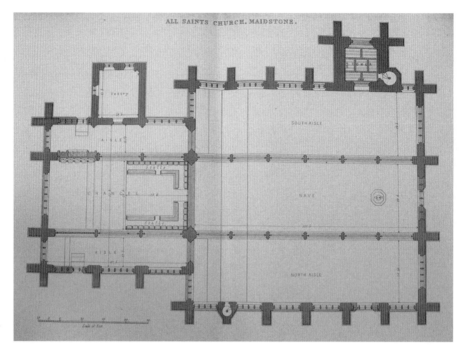

FIG. 2.　All Saints, Maidstone: plan

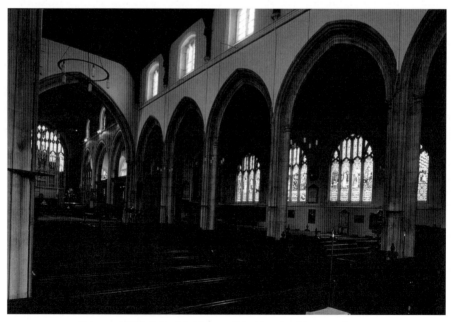

FIG. 3.　All Saints, Maidstone: interior, looking south-east
David Robinson

FIG. 4. All Saints, Maidstone: south choir aisle, springer in the south-west corner

chancel at Maidstone can only be speculation, the option of a wooden vault emulating stone construction should perhaps not be discounted. One wonders whether Newman's judgement on the church could have been made, had Courtenay's original intentions for the building been fulfilled.

Courtenay made provision for the completion of the church and college in an appendix to his will three days before he died; this states that 'what remains of his goods after the last debts and legacies had been paid be expended, at the discretion of his executors, on the construction of the collegiate church at Maidstone'.[32] Courtenay's death may have necessitated a brief halt to the works, and one may assume that his successor Archbishop Arundel took up responsibility for the works, based on his evident interest in the building: this is most clearly demonstrated by his decision to found a chantry in the south chancel aisle (the chapel being dedicated to St Thomas the martyr) in 1406.[33] Arundel was exiled in late 1396, however, only returning on the death of Richard II in 1399. That work continued during this period, presumably as directed by Courtenay's executors,[34] is clear from a record of lost medieval glass that indicates the presence of the arms of Richard II (shown as the royal arms impaling those of St Edward the Confessor) in the east window of the chancel.[35] This provides a *terminus ante quem* of 1399 for the completion of the east end of the building at least, albeit as a simplified version of Courtenay's proposals. The fact that the whole church was completed within Arundel's episcopate (by 1414) may be confirmed by the recorded presence of Courtenay's and Arundel's arms on the nave roof.[36] That the building was already in use is demonstrated by the records of ordinations being held in the church by Arundel in 1403 and afterwards.

The reconstruction of an entire church was not commonplace by the late 14th century, and only a handful of other examples in Kent fall into the same category.[37] None of these match the scale or design of Maidstone: instead of the elegant Perpendicular piers, with continuous mouldings around the arches, they tend to have the more traditional octagonal columns.[38] This is not to suggest that All Saints, Maidstone falls completely outside the church building traditions of the county; a number of features indicate its awareness of local approaches to church building,

perhaps most notably the use of three separately roofed aisles forming distinctive gables. Numerous comparisons exist at, for example, New Romney and Sutton Valence, and notably at a number of city churches, for example, Holy Cross, Canterbury, and St Botolph's, Aldgate. The tower, with its polygonal battlemented stair-tower, is also reminiscent of a range of buildings in the region (for example, the Austin Friars, London, and the parish church of Sevenoaks, Kent).[39] This next part of the paper will therefore assess the context for the architectural design of the church and college, and in particular for the initial design drawn up under the auspices of Courtenay.

Harvey has speculated that Henry Yevele worked for Courtenay in Kent at Maidstone and Meopham church, and for Lord Cobham at his nearby college foundation of contemporary date.[40] There are few architectural comparisons between these buildings and Courtenay's foundation, however, added to which there is some doubt over whether Courtenay carried out any work at Meopham at all.[41]

The college buildings at Maidstone are on a much grander scale than Cobham's, and the complex contains three significant gatehouses. The college has two large courtyards, and the one to the south, which housed the farm and fishponds, is entered by a large gatehouse. Now an isolated roofless ruin, it was once flanked by the college barns; little survives in the way of architectural detailing, although it is clear that the main entrance was separated from an adjacent pedestrian entrance by a solid wall.[42] There is a smaller gatehouse (often called the Master's Tower) in the centre of the complex. The main gatehouse into the north courtyard is entered from the road that divides the church from the college, leading down to the ford crossing of the Medway (Fig. 5). This differs from the south gateway in that, although it incorporates a pedestrian archway, this is only expressed on the northern and external faces within a single vaulted space. This articulation of the entrances places Maidstone within the genre of monastic gatehouses, for example Battle Abbey (East Sussex), 1338; Bridlington Priory (Yorkshire), c. 1388; the Great Gate at St Albans Abbey (Hertfordshire), c. 1390; and Ely Portagate (Cambridgeshire), 1397. However, it is the design of the vault that places this building firmly within a particular group of grand castle and monastery gatehouses of exactly contemporary date.

The vault is a tierceron design, with bosses at the intersections of the ribs; each boss forms a hollow ring, giving the appearance of a series of 'murder holes', as found in castle architecture of the period (Fig. 6). Early examples of this technique can be found in the Tower of London (Cradle Tower, 1342, and the Bloody Tower, 1360–62), and it was later favoured at the newly constructed castle at Bodiam (East Sussex), after 1385. The popularity of this motif, which must have been perceived as a signifier of a serious gatehouse entrance, seems to have been confined to the south-east of England for a period of about sixty years. It was not exclusively reserved for castle architecture, and can be found, for example, at the great gate at St Albans Abbey (built under Abbot Thomas, 1349–96), and the late-14th-century cemetery gate at St Augustine's Abbey, Canterbury (Kent).[43] That Courtenay was aware of these building campaigns there can be little doubt, and furthermore there was clearly a significant exchange of master masons between all of these sites.[44] The relationship between works by Courtenay and those of nearby patrons is further demonstrated by the likely similarity between the man-made landscape of moats and lakes at Courtenay's castle at Saltwood, which he began to make his chief residence in 1382,[45] and the better known setting for the fashionable new castle at Bodiam of similar date.[46]

This relationship between the architecture of Courtenay and other south-eastern commissions is clearly revealed in the original design at the parish church at Maidstone

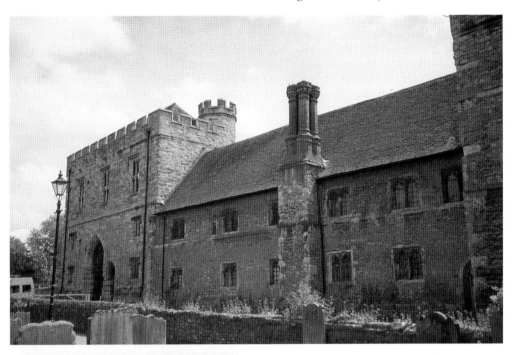

FIG. 5. Maidstone College: north face and gatehouse

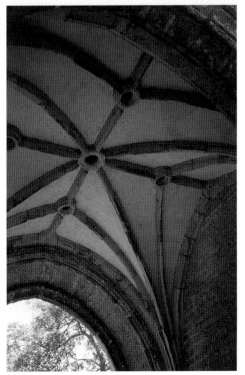

FIG. 6. Maidstone College: vault of main gatehouse

as well, and in particular in the designs of the internal elevations, tracery and fittings. The overall internal aesthetic at Maidstone, which Lethaby describes as 'the big and bare style',[47] can be paralleled in other small but high-quality buildings. The nave elevation (with its absence of vertical articulation and shallow clerestory of simple tracery) and pier design (with its lack of rolls on the north and south sides and continuous mouldings) can be compared to a number of Perpendicular buildings in the city of London, in particular to the chapel of the Guildhall (conceived *c.* 1420) (Fig. 7).[48] This chapel was one part of a costly and fashionable rebuild of the Guildhall complex, and it differs from Maidstone only in its relatively small scale. The general simplicity and loftiness of the elevations at Maidstone also tend to suggest the influence of the great friary churches of the city, which in their turn influenced parish-church design during the period. It is likely that the nave would always have been planned to be simpler than the chancel.[49]

The design of Maidstone, however, differs from these precedents in the city of London in two important aspects: the unrealised design of the south chancel aisle, and the window tracery (Fig. 8). The profile of the former has a triple respond to carry the vault, leading to an ogee moulding, or in the tracery version to a double ogee. The corner respond comprises two of the rolls from this respond. The closest comparison for this distinctive combination of details, and in fact the origin of it, is the chapter-house at Old St Paul's Cathedral started in 1332. No doubt exists in current literature as to the importance of the work by William Ramsey at St Paul's,[50] and there is well-established evidence that its design was hugely influential in great church building in the second half of the 14th century. The cloisters at Canterbury, for example, are directly influenced by those at St Paul's, the features being of comparable scale, and this is most likely the intermediary source for the works at Maidstone. This particular use of triple responds was copied in a number of high-profile buildings in the City, for example St Thomas's Chapel on Old London Bridge (Figs 9 and 10). This was reconstructed from 1384 to 1396 and shows the same approach to responds and articulation; its bases also related closely to the Maidstone type, which became standard in the late 14th century.[51]

The other aspect of Maidstone that differentiates it from many of the parish churches in London is the tracery.[52] In the nave there is a four-light window with the two tear-drop shapes: this relates directly to the works at New College Oxford (1380–86), and at Winchester College (from 1387) (Fig. 11, cf. Fig. 3); it is probably on the basis of this window design that Maidstone has been compared to the nave of Arundel parish church. It is certainly true that this particular design appears to have been *de rigueur* for any major new church or college building in the region in the 1380s and 1390s.[53] The design of the chancel aisle tracery is a broader form of the same basic design, with five lights and the added element of inverted cusps, forming what is often known as a 'lattice transom', combined with a series of supermullions. This feature again appears to have been popularised by New College, Oxford (west window). The combination of these two key elements is seen in the east window of Winchester College, from which the east window of Arundel seems to derive its inspiration, and on a grander scale in the south window of Westminster Hall (1394–1400). One might expect, therefore, the west window at Maidstone to follow this pattern, but instead it has an even number of lights and, like the nave windows in the church, deals with this by treating the outermost lights distinctly from the others (Fig. 12). The division of the central mullion (common in windows of even lights, as in those of Gloucester Cathedral south transept, for example) is here pushed up almost into the apex of the window, creating an angular

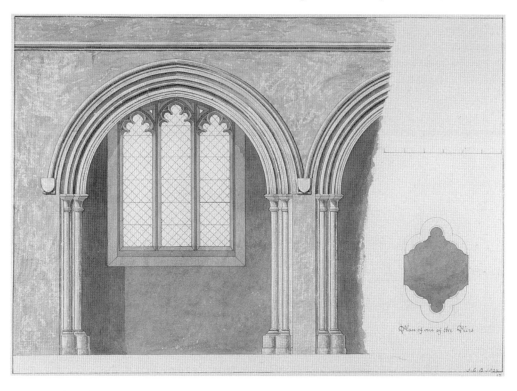

FIG. 8. Comparative moulding profiles: (i) All Saints, Maidstone: south-west corner respond in south choir aisle; (ii) All Saints, Maidstone: south choir aisle respond; (iii) Canterbury Cathedral: south and west cloisters, *c.* 1350 (after Harvey); (iv) Canterbury Cathedral: cloisters, *c.* 1391 (after Harvey); (v) St Paul's Cathedral: cloister, *c.* 1332 (after Harvey); (vi) All Saints, Maidstone: mullion and jamb

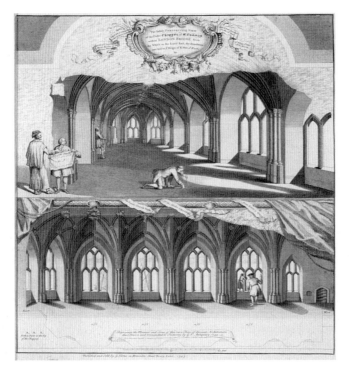

FIG. 9. St Thomas'
Chapel, London Bridge:
interior, engraving, c. 1750

*© Guildhall Library,
Corporation of London*

FIG. 10. St Thomas'
Chapel, London Bridge:
ruins of crypt showing
corner respond (E. W.
Cooke)

*© Guildhall Library,
Corporation of London*

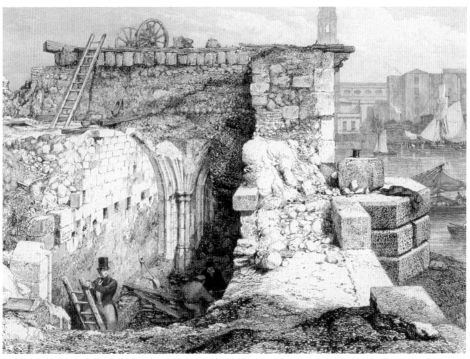

Fig. 11. Winchester College: cloisters

Fig. 12. All Saints, Maidstone: west window

head spanning two lights, the head of which is cut by a supermullion. This allows the 'lattice transom' to span the width of the window within the head of the light, thereby anticipating the drop-tracery designs later found at, for example, the Divinity School (Oxford). The origin of this separate treatment of the outer light seems to be Winchester Cathedral, where the clerestory lights are flanked on the inside by a blind panel.[54] The approach used at Maidstone was subsequently adopted at a number of early-15th-century buildings, for example, at the Guildhall chapel, *c.* 1420 (Fig. 13); the west window of St Albans Abbey, 1420–40; and the west window of Lingfield College (Surrey), *c.* 1431.

The overall influences on the tracery design therefore originate from Winchester and Oxford, with the almost contemporary works by Wykeham. This proposed link is strengthened by the use of a mullion at Maidstone, which is identical to that chosen by Wynford for his works at both Winchester Cathedral and College.

The other architectural feature of note in the church is the sedilia group, a grand canopied structure with four seats and a double piscina constructed of Reigate stone. A precise date for its erection is not known, although a number of factors suggest a date in the second quarter of the 15th century. The sedilia group backs onto the impressive tomb of John Wotton, who died in 1417 (Figs 14 and 15). His will makes reference to the location he had chosen for his burial in the south chancel aisle, close to the altar of St Thomas. There is no evidence that the tomb had been constructed before his death.[55] The indent for his brass shows that it was executed to an elaborate design similar in

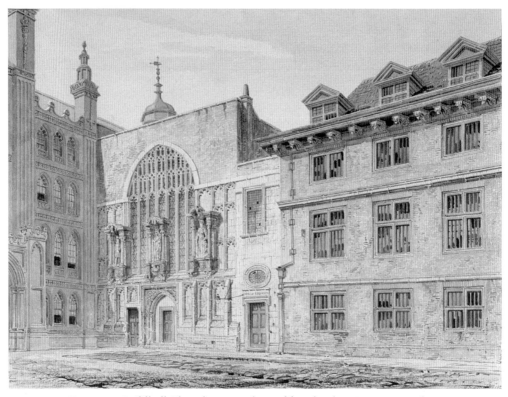

FIG. 13. Guildhall Chapel: watercolour of façade, showing west window
© *Guildhall Library, Corporation of London*

form to that for Courtenay's tomb slab in the chancel of the church. Over the tomb is an eight-bay superstructure divided into three parts that is structurally integral with the sedilia. In fact, as has been noticed previously,[56] the wall forming the back of the sedilia obscures the northernmost edge of John Wotton's brass and therefore clearly post-dates its construction. Both sides of the structure were decorated with painted arms, which were seen by Dering in 1631, although damaged by the mid-19th century and subsequently repainted. Dering records the presence of the arms of Courtenay and Arundel, as well as those of the college and the see of Canterbury.[57] As Arundel had died by 1414, these arms must represent the two greatest patrons of the Church and College rather than have any specific reference to the dating of the structure.[58] The absence of any arms to Wotton over his own tomb may be explained by the evidence of the brass, which also represented only the arms of the see of Canterbury and Archbishop Courtenay.[59] Bearing in mind Wotton's request for a humble burial, as set out in his will,[60] it is most likely that the superstructure and the sedilia were constructed under the auspices of his successors. Despite some claims that the work was not carried out until the late 15th century,[61] the sources for the design suggest a much earlier date.

The superstructure of Wotton's tomb has a direct precedent, in plan, elevation and detailing, in the tomb of Archbishop Sudbury, in the south choir aisle of Canterbury Cathedral (Fig. 16). Sudbury's monument, obviously erected after his untimely death in

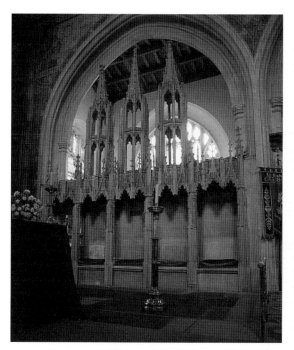

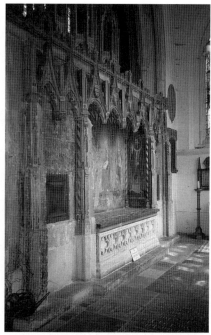

FIG. 14. All Saints, Maidstone: sedilia

FIG. 15. All Saints, Maidstone: tomb of John Wotton

1381, is a five-bay structure, largely constructed of Purbeck marble, and originally possessing an effigy of copper and gilt. Wilson has convincingly suggested that the presence of a gilt effigy, which was unique amongst 14th-century clerics, resulted from the commemoration of Sudbury, by the monks, in 'hero' and 'martyr' style.[62] The tomb equally represented high fashion in style and detail, and can be compared to contemporary works from London workshops such as the so-called Neville screen in Durham Cathedral of 1372–80.[63] In plan, the buttresses of all these three fittings conform to a design that becomes absolutely standard in English tomb design, with each buttress being set at a 45° angle to the tomb structure. In addition, the work at Maidstone copies precisely the detailing of the surface design of Sudbury's tomb, notably the small finials that intersect with the set-off to the buttresses.

This particular design, with its clear and bold forms, had been long superseded by the late 15th century, and the conscious emulation of a known tomb of political and architectural significance strongly suggests that the Maidstone sedilia group was constructed quite soon after Wotton's death. It is reasonable to suggest, therefore, that the work was carried out in the 1420s. This is confirmed by the evidence of the wall-paintings above Wotton's tomb (Fig. 17). Depicting an Annunciation scene, with a diminutive patron figure of Wotton in the centre flanked by two female saints and two sainted bishops, these paintings would be commensurate with an early-15th-century date. The elegant swaying figure of St Catherine compares with other paintings of this date, and the patron figure of Wotton has similarities with the depiction of Richard II in the Wilton Diptych.[64] No doubt grand furnishings were proposed in Courtenay's original plans, and despite the fact that the sedilia were not erected until many years

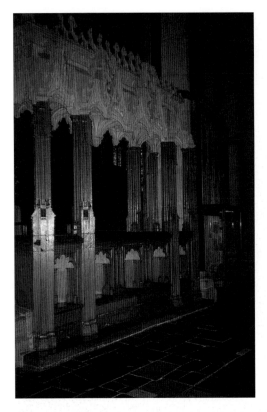

FIG. 16. Canterbury Cathedral: tomb of
Archbishop Sudbury

after his death, the design of the architecture and the paintings depended heavily on
late-14th-century precedents.

In conclusion, therefore, it is clear that Courtenay's foundation at Maidstone should
be recognised as a significant, expensive and ambitious scheme.[65] Although five of
Kent's six colleges were founded in the late 14th or early 15th century, that at
Maidstone far exceeded the others in scale and size.[66] Courtenay's foundation should
be compared rather to the earl of Arundel's at Arundel of 1380, and the duke of York's
at Fotheringhay of 1411. The architectural context for these buildings — the closely
related works in London and Canterbury described above — was determined by
Maidstone's location on a main route from London to Canterbury. The considerable
influence of Wykeham's contemporary architectural commissions resulted from the
strong affiliations amongst the patrons of the ecclesiastical élite: like Wykeham,
Courtenay was firmly anti-Lollard; both chose to create prominent collegiate institu-
tions to pray for their souls and consciously challenge any threat to traditional
religion.[67]

Courtenay would have had at his disposal a wealth of masons, associated both with
his own works at Canterbury and Saltwood, and in the immediate hinterland of
Maidstone. Most of the major architectural commissions of the day in the south-east of
England used at least some Kentish Ragstone from the Maidstone area. Among the
documented examples are works in London, at the Tower of London, the Tower
Wharf, and Westminster Hall, and in Kent, at Rochester Castle, Leeds Castle, Sheppey

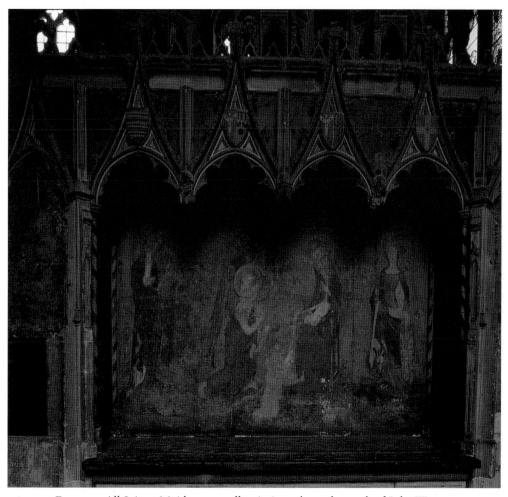

FIG. 17. All Saints, Maidstone: wall-paintings above the tomb of John Wotton
David Robinson

Castle, Cowling, and Queenborough. Masons from Maidstone are referred to in a
range of contemporary documents, illustrating where they went to work and for whom.
For example, the accounts of works for the Tower Wharf in London include Maidstone
masons and a number of masons referred to in connection with Henry Yevele originated
from Maidstone.[68] Some are documented further afield in key commissions by
Courtenay's contemporaries: one Thomas Maidstone, for example, is documented as
working for William Wynford during the construction of New College, Oxford in the
1380s.[69] It is not known at this point whom Courtenay used to design the buildings at
Maidstone, although Harvey's suggestion of Yevele is plausible, purely on the basis that
he was such an influential character in the region.

The buildings with which Maidstone compares are all in the south-eastern region,
broadly defined. When compared with the rapidly evolving and diversifying designs of

the first half of the 14th century, these buildings seem to show a remarkable level of consistency and a common approach over a period of about thirty years. Yevele was an old man by the 1390s, and much of the work for which he held responsibility was directed and executed by wardens and deputies, so it seems equally plausible that an undocumented mason working in the area at this period was responsible.[70] Whoever provided the initial design for Maidstone, the influence of the region, dominated as it was by London and Canterbury, is unquestionable. However, as we have seen, Maidstone is comparable to buildings with similar patrons rather than of those in its immediate hinterland, and Courtenay's works at Maidstone and at Saltwood demonstrate his preoccupation with the grandest of architectural commissions in the south-east.

The relative lack of attention paid by modern scholars to Maidstone, compared with parallel collegiate foundations, appears to be based on its apparent plainness. This is partly a result of the prejudice against the architectural styles of the late 14th century, which have often been considered the poor cousins of the more elaborate and decorative styles of the early 14th and late 15th centuries. The situation has been exacerbated in this case by the fact that Courtenay's plans were not fully executed. If erected to the original scheme, the status and wealth of the institution would have been more immediately apparent. Nevertheless, as completed, the college and the church would have represented clearly to contemporaries the ambitions of a high-ranking patron aspiring to modernity.

ACKNOWLEDGEMENTS

I would like to thank Mr Jeremy Ashbee and Dr John Goodall for their company on our 'progress' through Kent in preparation for this paper, and for their generosity in discussing aspects of my work. I am grateful to the Reverend Christopher Morgan Jones, parish priest of All Saints, for his kindness and hospitality. Particular thanks also go to Dr David Robinson, Mr Philip Lankester, Mr David Park, Mr Tim Tatton-Brown, Mr Jeremy Smith (Guildhall Library), and Professor Nigel Saul.

NOTES

1. Courtenay's will is undated. For a transcription, see L. Duncan, 'The Will of William Courtenay, Archbishop of Canterbury, 1396', *Archaeologia Cantiana*, 23 (1898), 55–67. In his biography of Courtenay, Dahmus suggests that the will must have been drawn up between June and September 1395, on the grounds that Edmund Stafford, referred to as bishop of Exeter in a bequest, only rose to that position in June of 1395, and that the Treasurer, Waltham, also named in the will, died in September of the same year; see J. Dahmus, *William Courtenay, Archbishop of Canterbury 1381–1396* (London 1966), 324–25, n. 13.

2. For an English translation of the will, see Dahmus, *Courtenay*, 266. Courtenay's association with Exeter was through his family: he was born in Devon in 1341, fourth son of Hugh Courtenay, 2nd earl of Devon, and Margaret, daughter of Humphrey Bohun, earl of Hereford and Essex. His parents are both buried at Exeter, and Courtenay held a prebend there before becoming bishop of Hereford.

3. ibid.

4. Courtenay pointed out a location to his squire John Boteler; see ibid.

5. There were lengthy debates in antiquarian literature concerning the eventual resting place of Courtenay because of the presence of tombs at both Maidstone and Canterbury. In 1640, Somner stated that Courtenay was buried in Canterbury as a result of an intervention in the matter from Richard II; this was based on a reference to a 15th-century chronicle by William Thorne in the cathedral records at Canterbury; see W. Somner,

The Antiquities of Canterbury or a Survey of that ancient city with the suburbs and cathedral (London 1640), 265. The chronicle refers to the body of Courtenay being committed to burial in the presence of the king, near the shrine of St Thomas. Although subsequently accepted by Hasted, who quotes the same source (see E. Hasted, *The History and Topographical Survey of the County of Kent* (London 1799), IV, 725, nn. o and p) a number of Victorian authors queried the validity of the document. Gilbert devotes a whole chapter of his book to the debate (see W. Gilbert, *Memorials of the Collegiate and Parish Church of All Saints in the King's Town and Parish of Maidstone* (Maidstone 1866), chapter 2), and Cave Browne dismisses the evidence, claiming that Courtenay was buried in the chancel at Canterbury (see J. Cave Browne, *The History of the Parish Church of All Saints, Maidstone* (Maidstone ?1889), 34–40). The loss of inscriptions and brasses compounded the issue, which was further complicated by earlier problems in identifying tombs in the church at Maidstone: it was at one time thought that the tomb in the south chancel aisle (John Wotton, d. 1417; see further below) was actually Courtenay's monument, on the basis of the heraldry; see H. L. Smith, 'Notes of Brasses Formerly Existing in Dover Castle, Maidstone and Ashford Churches', *Archaeologia Cantiana*, 1 (1858), 180–81. In an attempt to conclude the debate, M. Beazley published 'The Burial Place of Archbishop Courtenay', *Archaeologia Cantiana*, 23 (1898), 31–54. It has been suggested that the prestigious choice of location to the south of the shrine of St Thomas also resulted from royal intervention. Certainly this area of the building housed royalty rather than archbishops, and all of Courtenay's predecessors were buried further west in the choir. For the most recent accounts of Courtenay's death and burial, see Dahmus, *Courtenay*, 675, and C. Wilson, 'The Medieval Monuments', in *A History of Canterbury Cathedral*, ed. P. Collinson, N. Ramsay and M. Sparks, 472–73, esp. n. 99. For an assessment of Richard II's role in the decision to move Courtenay's body, see N. E. Saul, *Richard II* (New Haven and London 1997), 461–62.

6. A copy of this charter can be found in Cave Browne, *All Saints, Maidstone*, Appendix A(5), 233, from J. Brigstocke Sheppard ed., *Literae Cantuarienses* (London 1889), III, 45–48. Courtenay therefore appears to be organising his will (see n. 1 above) and the foundation of his college at the same time.

7. *Calendar of the Patent Rolls: Richard II A.D. 1391–1396*, V (London 1905), 635. The licence, signed on 2 August at Leeds Castle, is 'to erect the parish church of St Mary, Maydenston, into a college and to found the college'. The hospital, called the Newark, was situation on the west bank of the Medway and founded in the second half of the 13th century. It appears to have continued to operate in some form as a separate institution, but presumably managed by the college. References to the farming of property of the hospital have been found in the steward's accounts for the college; see L. R. A. Grove, 'Newark, Maidstone', in *Collectanea Historica: Essays in Memory of Stuart Rigold*, ed. A. Detsicas (Maidstone 1981), 214–24.

8. *Calendar of the Patent Rolls*, V, 658: 10 February at Nottingham.

9. The scope of this article is primarily the church of All Saints, and only occasional reference is made to the college. The college buildings, several of which still stand, deserve more detailed analysis than this article will allow. The standing buildings were altered by the then owner Lord Romney in the mid-19th century, but a detailed description of their appearance before alterations can be found in Beale Poste, who describes amongst other things the presence of a cloister walk, over 15 ft wide, with corridor above, constructed in timber on a dwarf stone wall and situated to the south of the main surviving range; see B. Poste, *The History of the College of All Saints Maidstone* (London 1847), 13–29.

10. Courtenay gave 1,000 marks to boost the works at Canterbury, and he raised 1,000 more from King Richard and other friends. His input would have helped to restart the programme of works that had begun under his predecessor Sudbury, but which encountered a delay of about a decade after Sudbury's untimely death. In his will he leaves £200, and more at the discretion of his executors, for the construction of the west walk of the cloister; see F. Woodman, *The Architectural History of Canterbury Cathedral* (London 1981), 152–53, and Dahmus, *Courtenay*, 270.

11. Courtenay was responsible for additions to the castle, in particular the large central gatehouse, which he enlarged substantially. The castle was altered in the late 19th century, when it was made habitable again. For a description of the castle before the alterations, see C. Beeston, *An Archaeological Description of Saltwood Castle* (London 1885).

12. There is some evidence that in addition to being contemporaries in the ecclesiastical sphere, Courtenay was a political ally and supporter of Wykeham: for example see Dahmus, *Courtenay*, 29, 30 and 69, where he suggests that Courtenay was principally responsible for convocation's taking a stand against the crown's request for a subsidy, unless Wykeham, who had been banished from the court in 1377, was recalled.

13. The college at Ottery was founded and the church rebuilt between 1337 and 1342; see J. N. Dalton, *The Collegiate Church of Ottery St Mary, being the ordinacio et statuta* (Cambridge 1917). Unusually, the foundation was not associated with a major palace or his birthplace, and Grandison's foundation appears instead to have been an attempt to set up a kind of family mausoleum. Not only did he use family money for its construction, but his brother Otto was buried in the nave of the church, and the manor and advowson remained with his family rather than with the bishop of Exeter at his death; see L. Monckton, 'Ottery St Mary:

Patron, Architect and its place in the Decorated Architecture of the West Country' (unpublished B.A. thesis, University of Warwick, 1992). A good introduction to collegiate foundations can be found in J. Goodall, 'Henry VI's Court and the Construction of Eton College', in *Windsor: Medieval Archaeology, Art and Architecture of the Thames Valley*, ed. L. Keen and E. Scarff, *BAA Trans.*, xxv (Leeds 2001), 247.

14. See J. H. Harvey, *The Perpendicular Style* (London 1978), 84–85. Harvey tells us that although it was intended to be a college for secular priests, the intervention of the Black Prince a year after its foundation resulted in its becoming an establishment for the canons of the order of Bonshommes.

15. C. Wilson, 'The Royal Lodgings of Edward III at Windsor Castle: Form, Function, Representation', in *Windsor: Medieval Archaeology*, 15–97.

16. Harvey does not analyse the building in any detail, though his research on the master mason Henry Yevele (fl. 1320–1400) remains the core of our understanding of this prolific designer and mason-contractor; see further n. 40 below.

17. J. Newman, *West Kent and the Weald*, 2nd edn (B/E, Harmondsworth 1976), 396–97.

18. For extracts, see (for example) Hasted, *The County of Kent*, II, 95.

19. Gilbert, *Memorials*, 3: ordinations in 1296, 1318 and 1320; Cave Browne, *All Saints, Maidstone*, 4, from archbishops' registers at Lambeth; Poste, *History of the College*, 95, lists the full extracts from the registers.

20. See for example Hasted, *The County of Kent*, II, 85, and more recently P. Clark and L. Murfin, *The History of Maidstone: The Making of a Modern County Town* (Stroud 1995), 70–71.

21. Cave Browne, *All Saints, Maidstone*, 4, quoting Archbishop Islip's Register fol. 50 and transcribed in Appendix A(3), 229.

22. Sudbury had been targeted for execution by those leading the insurrection as being, in part, responsible for the economic problems that had led ultimately to the introduction of the poll tax. He was dragged from a chapel in the Tower of London and executed on Tower Hill by the angry mob.

23. For a more detailed account of this famous altercation, see B. Dobson, 'The Monks of Canterbury in the Later Middle Ages 1220–1540', in Collinson, Ramsay and Sparks, *Canterbury Cathedral*, 102–13; see also Dahmus, *Courtenay*, 200–04.

24. The latter of these included plans for a great church at Maidstone, which were drawn up by Elias of Dereham but never implemented; see Dobson, 'Monks of Canterbury', 74, and Grove, 'Newark, Maidstone', 219, citing Gervase of Canterbury. A number of 19th-century authors refer to the attempt by Archbishop Hubert to found a rival chapter at Maidstone, for example Cave Browne, *All Saints, Maidstone*, 5 and n. 15, and Gilbert, *Memorials*, 3, and it is likely that this is a misunderstanding of the attempt by him to found the college.

25. M. Gibson, 'Normans and Angevins, 1070–1220', in Collinson, Ramsay and Sparks, *Canterbury Cathedral*, 66–67.

26. *Calendar of the Patent Rolls*, V, 719, 14 June 14 1396: 'licence for the Archbishop of Canterbury to take twenty-four masons called "fre-masons" and twenty-four masons called "ligiers" for executing certain works of a college to be by him erected at Madenston, and to pay them from his own moneys until the works are completed and meanwhile they are not to be taken by the king's officers of ministers for his work'.

27. Originally the south-west tower was surmounted by a timber and lead spire of *c*. 80 ft, lost as a result of storm damage in 1730; see, for example, Cave Browne, *All Saints, Maidstone*, 217, where he states that the details of the storm could be read in more detail in *Read's Weekly Journal* of 7 November 1730. There is also reference to the municipal seal of 1610, which shows the spire still *in situ*.

28. There exists a mid-19th-century description of the Georgian ceilings all 'plastered in wretched style'. Of additional interest are the references to the 'recent' removal of galleries from the nave and east end uncovering the sedilia and its integral piscina, described as whitewashed all over; see *Notes on English Churches by James Lewis André, F.S.A., Architect*, I (1848–58), BL Add. MS 36629, Maidstone, fols 292–94.

29. Poste, *History of the College*, 78–79, provides an invaluable description of the medieval roofs that survived until the 18th century. The description appears to be based on the memory of a local man Thomas Charles Esq. Beale Poste states that in 1790 the medieval nave roof still existed; it had a boarded ceiling with fluted and moulded beams providing a 'coffered' framework, and decorated and carved ornaments existed in lozenge shaped compartments within this framework. Stone corbels and wooden struts on the nave walls supported the ceiling. The aisle roofs had already been replaced with flat plastered and painted ceilings in 'not very good style or taste'. In 1851, a lithograph entitled 'The College of All Saints Maidstone restored to the date of its completion, A.D. 1400' by Whichcord was published in order to raise money to demolish the 'wretched plaster ceiling'; see 'Notices of New Publications', *JBAA*, 6 (1851), 159–60, and J. Whichcord, *The History and Antiquities of the Collegiate Church of All Saints Maidstone* (Maidstone 1845), 12, which refers to the old ceiling being gilded and coloured in compartments.

30. Cave Browne suggested that the old church was the same extent as the present one on the basis of 'foundations' under the nave aisle piers and the discovery of tiles said to be of the 13th and early 14th centuries.

The foundations he describes sound more like sleeper walls or foundations for the piers than the foundations of an older church, and certainly some of the tiles were discovered amongst debris, hence the suggestion that they came from an older building that was no longer *in situ*. R. H. D'Elbourn, 'Some Kentish Indents IV', *Archaeologia Cantiana*, 64 (1951), 116–29, suggests that a worn tombstone in the chancel dates to the early 14th century and is therefore from an earlier church on the site. Whilst interesting, and clearly evidence of the presence of an earlier building, none of this evidence provides any convincing information on the older church's location or extent. Tim Tatton-Brown's suggestion in notes from 'Canterbury Diocese: Historical and Archaeological Survey Maidstone, All Saints' (unpublished notes, Canterbury Diocese: Historical and Archaeological Survey), seems plausible in relation to the circumstances of the site.

31. See L. Hoey, 'Stone Vaults in English Parish Churches in the Early Gothic and Decorated Periods', *JBAA*, 147 (1994), 36–51.

32. Dahmus, *Courtenay*, 276. The codicil is dated 28 July 1396.

33. *Calendar of the Letters Patent: Henry IV A.D. 1405–08* (London 1907), 208. Arundel appropriated Northflete (in north Kent) to found two chantries, one with one chaplain at Maidstone, the other with two chaplains at Canterbury.

34. Courtenay chose as his executors the following: Thomas Chillenden, Prior of Canterbury; Adam de Mottrum, his archdeacon; Guy Mone, rector of the church of Maidstone; John Frenyngham, squire; William Baunton, rector of the church of Harrow; John Dodyington, rector of the church of Crukern; Robert Hall, rector of the church of Northfleet; and John Wotton, rector of the church of Stapelhurst. See Dahmus, *Courtenay*, 275. John Wotton was also the first master of the college. The involvement of the executors and members of Courtenay's family with the continuation of the building work may be demonstrated by the presence of family arms and those of Guy Mone on the choir stalls; see G. L. Remnant, *A Catalogue of Misericords* (Oxford 1969), and Whichcord, *Collegiate Church of All Saints Maidstone*, 13. Guy Mone seems to have become a good patron of Maidstone after he became bishop of St David's in 1397, he granted land to the church. At his death in 1407, he bequeathed a missal and portfolio to the church; see the 'Maidstone Church' note in the proceedings of the 1901 conference in *Archaeologia Cantiana*, 25 (1902), xliii. Bearing in mind the prominence of Wotton's tomb, Mone may also have been a significant force in the continuation of Courtenay's project.

35. See C. R. Councer, 'Lost Glass from Kent Churches: A Collection of Records from the 16th to 20th Centuries', Kent Archaeological Society, Kent Records, XXII (1980), 81–82. This records the presence of the arms of Richard II and William Courtenay in the east window of the chancel, and other glass (with no recorded location), including arms of various members of the Courtenay family and of the executor Guy Mone. The source for the east window glass is the drawings of Edward Dering, 1630 (London, Society of Antiquaries MS 497a, 80). By September 1395, Richard II had begun to impale the royal arms with those of Edward the Confessor, and from this point until the end of his reign the impaled arms were used in glass, plate and fittings. See J. H. Harvey, 'The Wilton Diptych: A Re-examination', *Archaeologia*, 98 (1961), 1–28, and more recently D. Gordon, 'The Wilton Diptych: An Introduction', 20, and M. Keen, 'The Wilton Diptych: The Case for a Crusading Context', 194, in D. Gordon, L. Monnas and C. Elam ed., *The Regal Image of Richard II and The Wilton Diptych* (London 1997).

36. S. Denne, 'Remarks on the Stalls near the Communion Table in Maidstone Church with an Enquiry into the Place of Burial of Archbishop Courtenay', *Archaeologia Cantiana*, 10 (1792), 268. The roofs were replaced in 1794; see n. 29 above.

37. What can only be described as rather spurious archaeological evidence was put forward to suggest that, rather than a new build, the church is merely a re-fenestration of an earlier building; see in particular Cave Browne, *All Saints, Maidstone*, 14–16, referring to 18th-century authors who also claimed the church was not of one build.

38. Queenborough (1366–68), Holy Cross, Canterbury (1380), Kingsnorth, Stansted and Headcord were all rebuilt completely in the late 14th century. None has the same details of elevation as Maidstone, nor the same scale, Queenborough for example, despite royal patronage, is a small-scale, unaisled building.

39. It seems likely that the chapel of St Thomas on London Bridge also had an octagonal tower in the south-west corner. The remnants of a turret stair are clearly visible in Norden's engraving of the bridge, *c.* 1600, and can be related to a turret-like structure visible on Wyngaerde's panorama of London, *c.* 1544; see B. Watson, T. Bingham and T. Dyson ed., *London Bridge: 2000 Years of a River Crossing*, MoLAS Monograph 8 (London 2001), 99 and 101.

40. See J. H. Harvey, *Henry Yevele: The Life of an English Architect* (London 1944), 41, where he suggests that Yevele may have advised on the works at Maidstone. In J. H. Harvey, *The Perpendicular Style* (London 1978), 130, Harvey states that Yevele 'evidently designed the college and church at Maidstone' (see chapter 4 for Yevele). See also J. H. Harvey, *English Mediaeval Architects: A Biographical Dictionary down to 1550*, rev. edn (Gloucester 1984), 358–66. Yevele is credited with a large practice of design and contracting work in the

south-east in the second half of the 14th century. He was routinely employed by senior clergymen, noblemen and royalty. He is documented at Westminster Hall, at various castles throughout the area, at St Dunstan's in the East in the city of London, and the nave of Canterbury Cathedral is generally attributed to him. It is known that Lord Cobham acted as his patron, both in Canterbury (when work was required by the king's commission to repair the city walls) and at St Dunstan's in the East, where Yevele is documented as providing a design for a new aisle. Yevele became a warden of London Bridge in 1368, and it is therefore sometimes assumed that he had a role in the construction of the new chapel of St Thomas Becket between 1384 and 1397. Yevele lived in the parish of St Magnus the Martyr, in which the bridge chapel was situated, though whether Yevele had any involvement in design is unclear. The position as warden was an administrative one, and a man, John Clifford, is described as being master mason for the bridge by 1388; see Harvey, *Mediaeval Architects*, 61, and Harvey, *Yevele*, 41. He is further documented as measuring buildings and providing stone for projects at the Tower of London. For an alternative viewpoint of Yevele's importance, see Woodman, *Canterbury Cathedral*, 160, who believed the evidence for Yevele's designing Canterbury Cathedral was slight and inconclusive. For debate over the authorship of Canterbury and the influence of Yevele, see A. Oswald, 'Canterbury Cathedral, the Nave and its Designer', *Burlington Magazine*, 75 (1939), 221–28; J. H. Harvey, 'Henry Yevele Reconsidered', *Archaeol. J.*, 108 (1951), 100–08; D. McLees, 'Henry Yevele: Disposer of the King's Works of Masonry', *JBAA*, 36 (1973), 52–71; and J. H. Harvey, 'Archbishop Simon of Sudbury and the Patronage of Architecture in the Middle Ages', *Canterbury Cathedral Chronicle*, 76 (1982), 22–32.

41. See H. Gordon Slade, 'Meopham: The Parish Church of St John the Baptist', in Detsicas, *Collectanea Historica*, 132–46. The documentary references available for the 1380s suggest that work was done to the chancel, carried out by the priory of Christ Church, Canterbury, which held responsibility for it, including the addition of a screen to create an eastern vestry similar in layout to that also added to Cobham church at a similar date. Whether Yevele was responsible for this now lost set of fittings is a moot point.

42. This gatehouse still stands as an unroofed ruin. An illustration by Buckler, dated 1819, shows the gatehouse flanked by large barns; see BL Add. MS 36368, fol. 58. For other views of college, a south-east view of the main courtyard and a north-east view of college, see fols 20 and 60, both dated 14 April 1819.

43. L. F. Salzman, *Building in England down to 1540* (Oxford 1952), 399–400. I am particularly grateful to Mr Jeremy Ashbee and Dr John Goodall for discussing these parallels with me. I am also grateful to Mr Tim Tatton-Brown for the Canterbury example, for details of which see T. Tatton-Brown, 'The Buildings and Topography of St Augustine's Abbey, Canterbury', *JBAA*, 144 (1991), 78–79.

44. See, for example, Salzman, *Building in England*, 399 and 469, and Harvey, *Mediaeval Architects*, 61, 243 and 359–66.

45. Newman, 441. Little has been written on Saltwood Castle, although Beeston, 'Saltwood Castle', which was written at the time of major additions and alterations to the castle and provides a moderately useful account of the building at this time; see also A. Emery, 'Saltwood Castle', in *The Canterbury Area. The Royal Archaeological Institute* (1994), 30–34. References to the creation of the park can be found in J. Harris, *The History of Kent in Five Parts* (London 1719), I, 383.

46. C. Coulson, 'Freedom to Crenellate by Licence — An Historiographical Revision', *Nottingham Medieval Studies*, 38 (1994), 91–92 and n. 16; T. H. Turner, *Some Account of Domestic Architecture in England*, III (Oxford 1859), 419.

47. W. R. Lethaby, *Westminster Abbey and the King's Craftsmen* (London 1906), 220.

48. C. Barron, *The Medieval Guildhall of London* (London 1974), 35–36. The hall of the Guildhall was started in 1411, and as the hall was being completed, the chapel was being conceived, c. 1420; references to work in the chapel exist as late as 1439, and it was probably being fitted out in c. 1440.

49. The division between nave and chancel was by a rood screen, which was located one bay from the east of the nave, thus creating small chapels at the east end of the nave aisles; this rood screen then returned to the chancel arch, screening off the choir stalls, which are located in their original position. The evidence for this is the doorway to the rood-loft stair in north nave aisle wall, and the upper doorway in the clerestory wall, south side.

50. For differing points of view on the designers of buildings in the early Perpendicular period, see J. H. Harvey, 'St. Stephen's Chapel and the Origins of the Perpendicular Style', *Burlington Magazine*, 88 (1946), 192–99; J. H. Harvey, 'The Origin of the Perpendicular Style', in E. M. Jope ed., *Studies in Building History* (London 1961), 134–65; J. Hastings, *St Stephen's Chapel and its Place in the Development of the Perpendicular Style in England* (Cambridge 1955); C. Wilson, 'The Origins of the Perpendicular Style and its Development to circa 1360' (unpublished Ph.D. thesis, University of London, 1979).

51. Watson, Bingham and Dyson, *London Bridge*, 109–13.

52. London parish churches favoured simple forms of tracery, most commonly of three simple cusped lights, sometime with supermullions. Many of these existed, and St Olave's, Hart Street, is an extant example.

53. Although there is a sense that the design is restricted to the south-east in the late 14th century, the influence of the great college buildings of Wykeham and the designs of William Wynford resulted in its being adopted outside the geographical area by high-ranking patrons. This seems to be the case at Fotheringhay, where a college was attached to an existing parish church in the same way as Maidstone, in 1411 by Edward of York, after which the chancel built. The nave of the existing parish church was subsequently rebuilt in similar style, according to a contract dated 1434. For a general description, see N. Pevsner, *Northamptonshire*, 2nd edn (B/E, Harmondsworth 1973), 220, and for the contract, see Salzman, *Building in England*, 505–09.

54. It is then adopted at Fromond's Chapel in the cloister of Winchester College, *c.* 1420.

55. For a transcript of Wotton's will, see E. F. Jacob ed., *Register of Henry Chichele, Archbishop of Canterbury 1414–1443* (Oxford 1937), 130–33.

56. Denne, 'Place of Burial of Archbishop Courtenay', 270.

57. London, Society of Antiquaries MS 497a. Dering records and draws the arms of the tomb and the sedilia, as well as making a full drawing of the brass indent in the condition in which he found it.

58. Noting that this was the same chapel in which Arundel had already founded a chantry in 1406, endowing the college with a priest to serve it; see n. 33.

59. See Smith, 'Notes on Brasses', 176–83, for a summary of the history of the identification of the tomb. Smith states that he could not find any evidence that Wotton had his own arms, thus explaining why Wotton had chosen the arms of the founder for his own tomb.

60. Jacob, *Henry Chichele*, 130–33.

61. Cave Browne, *All Saints, Maidstone*, 49.

62. Wilson, 'Medieval Monuments', 472.

63. Commissioned by John Lord Neville for the Cathedral, this is attributed to Yevele by Harvey based on its similarity to tombs known to have been designed by him; see Harvey, *Yevele*, 36–37, and *Mediaeval Architects*, 361.

64. The National Wallpaintings Archive, the Courtauld Institute of Art. I am particularly grateful to David Park for discussing this with me and for providing access to the Archive.

65. There is evidence for the internal decoration of the church; see the Tristram archive notes in the National Wallpaintings Archive for references to the stencilled pattern of the 'his' symbol over the internal walls of the chancel. Additionally, J. Philipott, *Villare Cantiarum* (London 1659), 228, refers to a diaper pattern of Courtenay's arms in sundry places. This suggests a richly decorated east end with completed internal decorations.

66. Cobham of course was only for five chaplains and a master, compared with Maidstone's master, twelve chaplains and eight clerks, added to the four who already served the parish.

67. I am grateful to Professor Nigel Saul for his observation in this regard.

68. See Salzman, *Building in England*, 469–70, for the reference to masons from Maidstone at Tower Wharf. These are evidently a group of men working with and for Yevele during the period. Thomas Crump (a Maidstone mason — see Salzman, *Building in England*, 461) impressed masons from Maidstone, as did John Clifford (mason of London Bridge, who also worked as a deputy to Yevele at St Albans); Lawrence atte Wode, who worked with Crump, was also a Maidstone mason. The interaction within this group of masons means that the designs of the region would have been well known to all involved in these building projects. See further Harvey, *Mediaeval Architects*, 61, 76, 84, 330 and 342.

69. Harvey, *Mediaeval Architects*, 352.

70. For example, John Clifford acts as a deputy at St Albans; see Harvey, *Mediaeval Architects*, 61, and Salzman, *Building in England*, 399. See also Salzman, op. cit., 461 and 469–70, and Harvey, *Mediaeval Architects*, 364, for further examples of Yevele's role in building projects.